TREE

TREE

Exploring the
Arboreal World

Phaidon Press Limited
2 Cooperage Yard
London E15 2QR

Phaidon Press Inc.
111 Broadway
New York, NY 10006

phaidon.com

First published 2024
© 2024 Phaidon Press Limited

ISBN 978 1 83866 779 5

A CIP catalogue record for this book is available from
the British Library and the Library of Congress.

Commissioning Editor: Victoria Clarke
Project Editor: Lynne Ciccaglione
Production Controller: Lily Rodgers
Design: Studio Chehade

Printed in China

Arrangement
The illustrations in this book have been arranged in pairs
to highlight interesting comparisons and contrasts based
loosely on their subject, age, purpose, origin or appearance.
This organizational system is not definitive and many other
arrangements would have been possible. A chronological
survey can be found in the timeline at the back.

Dimensions
The dimensions of works are listed by height then width.
Digital images have variable dimensions. Where differences
in dimensions exist between sources, measurements listed
refer to the illustrated version.

A World of Trees

What Is a Tree?

Every breath we take is possible in large part because of trees. Providing 28 percent of Earth's oxygen and absorbing about 30 percent of carbon emissions, the planet's more than three trillion trees are vital to its survival. For most, trees are a part of our daily lives: in vast forests and national parks, planted along city sidewalks or lining the paths of urban gardens, growing in pots in our offices or near our homes, where perhaps they host a favourite swing or tree house.

But what is a tree? It is a deceptively difficult question, and not one that can be answered quickly. The Oxford English Dictionary defines a tree as: 'A perennial plant having a self-supporting single woody main stem or *trunk* (which usually develops woody branches at some distance from the ground) and growing to a considerable height and size.' A fairly vague description. What about multistemmed trees with several stems or trunks, or feathered trees with low branches? Not to mention smaller trees, such as maples or birches, that vary greatly in size and shape across their species. And some trees could be defined as shrubs but in time might become a tree – when or at what size does a holly or a hazel graduate from being a shrub to a tree?

Botanically, trees are woody plants encompassing a vast range of species. They can grow to dizzying heights – such as the coast redwood (*Sequoia sempervirens*), which can reach 115 metres (377 ft) tall in their native habitat along the Pacific coast of California – or a tree can be as tiny as an Arctic willow (*Salix arctica*), which only grows up to 25 centimetres (10 in) tall. All trees produce one or several woody stems called trunks, and these contain the xylem and phloem cells used as the main conduit for transporting water and food around the tree. These trunks are covered in bark, a protective skin that can be smooth, rough or spiny, and that protects the tree from extreme temperatures, pests, diseases and herbivores. Trees increase in height and diameter each year by producing annual rings through a process called 'secondary thickening'. The age of a tree can be determined by counting these rings, each of which represents one year. Methuselah, a bristlecone pine (*Pinus longaeva*) growing in the White Mountains of eastern California is thought to be the oldest tree on earth. When it was sampled in 1957 by American dendrochronologist Edmund Schulman, it contained 4,789 annual rings, giving it an estimated birth date of 2833 BCE (see p.260).

There are two main types of trees: the conifers, or gymnosperms, which have needles and naked seeds in cones, and the broadleaves, or angiosperms, with flowers and seeds encased in a fruit. Despite their common names, botanically, palm trees and tree ferns are not truly trees but large woody herbs, as they do not perform secondary thickening to produce annual rings. The trunks of both conifers and broadleaves produce a network of main branches that divide into smaller branches and form the habit of the tree. They vary in shape and size, forming a spreading upright or weeping canopy depending on the species. Trees can be deciduous, losing their leaves each autumn, or evergreen, where the leaves are retained and stay green throughout the winter. In a natural woodland or forest, the larger dominant shade trees will compete with others, reaching for the upper levels of the canopy and taking full advantage of the higher light levels to photosynthesize and produce food.

Below ground is a hidden, intricate network of roots anchoring a tree, which also soak up and transfer oxygen, water and nutrients to the main trunk for distribution to the rest of the tree. In a woodland, these roots interconnect by a network of fungi called mycorrhizae, which originates from the Greek words *myco*, meaning 'fungus', and *rhiza*, meaning 'roots'. More commonly known as the wood wide web, the mycorrhizae act like fibre-optic cables, communicating by sending signals from one tree to another.

In the pages that follow, every element of a tree – from roots to leaves, bark to branches – is explored, and there are perhaps some unlikely trees included as well. With a more expansive definition, centuries-old genealogical trees and the intricate anatomy of the bronchial trees in human lungs can be found alongside mythological trees, such as the bodhi tree or biblical tree of knowledge, and tree deities from cultures around the world. Fantastical tree houses share pages with vibrantly rendered imaginary trees, which may have been based on real species but will not be found growing anywhere in nature.

The Evolution of Trees

Let's go back in time to the Carboniferous period between 359 and 299 million years ago and imagine walking through a dense, warm, swampy forest. The types of trees that formed these forests would bear very little resemblance to the trees that we are familiar with today. There were large fernlike plants growing to around a maximum of 8 metres (26 ft) tall, with shallow roots and little or no branches. The 'scale tree', or *Lepidodendron* – a treelike lycopod – was one of the larger arborescent plants with thick, unbranched trunks reaching 40 metres (131 ft) in height and 2 metres (7 ft) in diameter, topped with a crown of bifurcating branches (those divided into two parts). Fossils of these plants can still be found in Carboniferous coal and peat deposits, which clearly show the reptile-skin-looking bark.

It wasn't until the Permian period between 290 and 248 million years ago that trees began to develop deeper root systems to support the newly evolved branching systems, which also began to produce cones and bear seeds. Some of these tree species still grow in our forests and gardens today such as monkey puzzles (*Araucaria araucana*), the maidenhair tree (*Ginkgo biloba*), and cycads, including some palms. During the Jurassic period, 201.3 to 145 million years ago, the forest canopies were dominated by conifers, including trees such as the Wollemi pine (*Wollemia nobilis*) and the dawn redwood (*Metasequoia glyptostroboides*). Originally described from fossil records, these two tree species were only recently discovered growing in our forests. The dawn redwood, a deciduous conifer from China, was happened upon in the early 1940s by a Chinese forester during a firewood audit (see p.236). The Wollemi pine, a primitive conifer closely related to the monkey puzzle, was thought to have been extinct for more than two million years but was encountered in 1994 by David Noble, a field officer with the New South Wales National Parks and Wildlife Service, in Wollemi National Park, northwest of Sydney, Australia. Both species are considered living fossils and are still growing wild in our forests today, albeit somewhat precariously, and

they have also been preserved and planted in contemporary gardens and urban landscapes.

It wasn't until the start of the early Cretaceous period, some 140 to 135 million years ago, that the dominance of the conifers began to decline, with the earliest traces of woody angiosperms, or flowering trees, emerging. Magnolias, prized today as highly ornamental flowering plants, are some of the earliest known types of broadleaved trees. By the late Cretaceous period, around 95 million years ago, many trees that we recognize today in our treescape began to appear, such as the elms (*Ulmus*), birches (*Betula*), planes (*Platanus*), maples (*Acer*), oaks (*Quercus*) and willows (*Salix*). The first palms evolved around twenty million years later. By the Cenozoic era, around 66 million years ago, these trees had gone on to dominate the earth, and around 52 millions years ago, the gum trees (*Eucalyptus*) emerged.

Despite being affected by at least four ice ages, plate tectonics creating continental drift and the movement of continents over geological history, trees have adapted to every terrestrial habitat and can be found growing in every biome and on every continent in the world except Antarctica. There are several systems of classification that ecologists recognize to separate the different biomes, which use a unique set of physical factors, particularly climate and characteristic ecological communities that provide a home to many different tree species. These include the boreal forests, also called taiga or snow forests, that reach across the northernmost expanses of the world, with birches (*Betula*) and spruce (*Picea*) as the main trees. The Mediterranean forests with dry summers and rainy winters are home to cork oaks (*Quercus suber*) and stone pines (*Pinus pinea*). The hot, moist climate of tropical rainforests, such as the Amazon, hosts tens of thousands of tree species, including the Brazil nut (*Bertholletia excelsa*). Savannas, or dry tropical forests, are a transitional biome between forests and vast grasslands or desert, home to such species as the fever tree (*Vachellia xanthophloea*). And last, but not least, are the temperate broadleaf and conifer forests, such as the magical Hoh Rain Forest on the western Olympic Peninsula in the State of Washington, which is predominantly made up of Sitka spruce (*Picea sitchensis*) and big-leaf maple (*Acer macrophyllum*) (see p.50).

The Many Meanings and Uses of Trees

For thousands of years, trees have been the building blocks of civilization and industry. The timber processed from felled trees has provided the raw materials for innumerable forms of building, transport, furniture, tools, fuel, musical instruments and much more. In 1664 John Evelyn, a founding member of the Royal Society, published one of the first tree-related books, *Sylva, or, a Discourse of Forest-Trees and the Propagation of Timber in His Majesty's Dominions*, following a request by the commissioners of the navy for a report on forestry due to the extensive loss of mature trees to build more ships. Evelyn recommended new tree planting to meet the demands for more wood and to provide for the future. But a hundred years later, trees were still being cut down in the name of industry. From 1759 to 1765, approximately six hundred mature trees were used in the construction of a single ship, HMS *Victory*. About 90 percent of those were English oak (*Quercus robur*) – highly prized due to its durability – with some elm (*Ulmus*), pine (*Pinus*), fir (*Abies*) and Lignum vitae (*Guaiacum officinale* or *G. sanctum*), known as the 'wood of life'.

Luckily, some mature trees have managed to endure. Two of the oldest trees in Britain are yews (*Taxus baccata*): the Fortingall Yew in Perthshire, Scotland, and the Defynnog Yew in Powys, Wales. Both are estimated to be as much as five thousand years old. Yews have long been associated with churchyards, perhaps providing them a layer of protection from being chopped down, but some say that they were probably growing on the sites before the churches were built. In pre-Christian times, Druids regarded yews as sacred and used them as sites for worship. The trees were glorious and evergreen, growing to a great old age, becoming a symbol of everlasting life for the Druids, who held a strong belief in death and reincarnation. For the yews not so fortunate to be saved, their strong yet flexible timber was also used in medieval times to make the longbows for warfare. More recently, medical scientists have created successful chemotherapy drugs derived from the bark of the Pacific yew (*Taxus brevifolia*).

Another conifer, the cedar of Lebanon (*Cedrus libani*), which is native to the eastern Mediterranean, is mentioned many times in the Bible as a symbol of might and beauty. The timber, which is resistant to insect attacks, was used by King Solomon to build his temple in Jerusalem, and the Phoenicians became the first sea-trading nation in the world by building their merchant sailing ships

from cedar timbers. The tree was also prized for its resin, which was used by the Egyptians in the mummification process. In North America, the thin, white bark of the paper birch (*Betula papyrifera*) has a high oil content, making it resistant to water and weather. Indigenous communities from New England to the Great Lakes region used the bark, sewn together in sheets, for creating lightweight canoes and also as part of wigwam dwellings (see pp.94–95).

In addition to practical applications in building and craft, trees have been a source of fruits, spices and other foodstuffs for thousands of years, adding a wealth of nutrition and delicious flavours to our daily diet. Although all flowering trees (angiosperms) have fruits, we more often associate the term with culinary fruits, such as the pome fruits, which include pears (*Pyrus communis*), quince (*Cydonia oblonga*) and, of course, apples (*Malus domestica*). Around 95 million metric tons (105 million tons) of apples are produced worldwide each year – second only to the most consumed tree fruit, bananas – and the fruits are at the centre of myths and folklore across the globe. There is Snow White eating the poisoned apple given to her by the Evil Queen, plunging her into a magical slumber, and the story of Johnny Appleseed planting his fruit trees across the United States (see p.103). Add to that the most famous apple tree in the world at Woolsthorpe Manor, Lincolnshire, England, where in 1665 English physicist and mathematician Sir Isaac Newton witnessed an apple falling to the ground, leading to his theory of gravity (see p.225). This symbolic occurrence made the 'Newton's apple' variety, *Malus domestica* 'Flower of Kent', one of the most wanted fruit trees in orchards and gardens around the world today. Seeds from one of Newton's apples even went on a journey to the International Space Station in 2016, making it one of history's most travelled trees.

Nuts are also a type of fruit, originating from many temperate and tropical trees, such as the pecan (*Carya illinoinensis*), hazel or filbert (*Corylus avellana*), almond (*Prunus dulcis*) and walnut (*Juglans regia*). Archaeological digs have shown that nuts were a major part of the human diet around 78,000 years ago, the oldest evidence of which is remains of walnuts discovered in Iraq dating back to 50,000 BCE. Despite its common name, though, the English walnut was never a native to Britain. It is believed to have been introduced to Western European countries by the Romans to be grown for its edible nuts, along with the sweet chestnut (*Castanea sativa*). As with much of Roman culture, trees were associated with their gods, and the walnut was linked to Jupiter, the king of the gods – the scientific name *Juglans* is derived from the Latin *Jovis glans* meaning 'Jupiter's nut', and *regia*, meaning 'royal'.

Trees' culinary contributions also extend to spices, which are the aromatic parts of tropical trees. Cinnamon is derived from the bark of *Cinnamomum verum* (see p.257), nutmeg is the seed of *Myristica fragrans* and cloves are the dried flower buds of *Syzygium aromaticum*. Spices have been used for more than six thousand years to flavour foods and drinks: evidence of has been found in northern European settlements of hunter-gatherers dating back to 4600 BCE, and ancient Egyptians used spices for cooking food and embalming their dead beginning around 3500 BCE. The movement of spices around the world played a significant role in travel expeditions and the colonization of Southeast Asia, causing fierce competition across the Ottoman Empire and Europe for control of the spice trade. So highly prized were spices during the medieval period that they were considered as valuable as gold in Europe.

These comprise just a tiny slice of the many products derived from, and uses of, trees. And then there are: cocoa beans, which are processed for chocolate; coffee to supply the more than 4.8 billion coffee drinkers worldwide; the sweet sap of the sugar maple (*Acer saccharum*), which is boiled down to make maple syrup; latex, the liquid sap extracted from *Hevea brasiliensis* to create rubber; paper, which accounts for about 15 percent of all wood consumption; quinine from the bark of *Cinchona lancifolia*, which has been used to treat malaria since the early seventeenth century; and so much more, making trees one of our most precious natural resources.

The Plant Explorers

With trees being such desired commodities, over the centuries the treescapes in our gardens and landscapes have also been greatly enriched by intrepid explorers and plant-hunters. The earliest records of plant collecting date back to 1495 BCE, when Hatshepsut, co-ruler of ancient Egypt with Pharaoh Thutmose II, sent collectors to Punt to collect incense trees, such as myrrh (*Commiphora* sp.) and frankincense (*Boswellia* sp.), albeit primarily for their resins rather than planting in gardens (see p.234).

During the late sixteenth and early seventeenth centuries, naturalist and gardener John Tradescant the Elder and his son, John the Younger, were synonymous with the early introduction of exotic trees to Britain (see p.201). John the Elder introduced the European larch (*Larix decidua*), an important forestry tree today, and the mulberry (*Morus alba*), prized for producing silkworms. John the Younger followed in his father's footsteps, making three voyages to North America and introducing the tulip tree (*Liriodendron tulipifera*), the swamp cypress (*Taxodium distichum*) and the American sycamore (*Platanus occidentalis*), one of the parents of the London plane (*Platanus × hispanica*) that is planted extensively on city streets around the world.

Towards the late seventeenth century through to the early nineteenth century, European physicians sent to the Japanese island of Dejima as medical officers were responsible for some of the earliest introductions of exotic trees to Western gardens via the Dutch East India Company. German naturalist Engelbert Kämpfer introduced the maidenhair tree (*Ginkgo biloba*) and the Japanese pagoda tree (*Styphnolobium japonicum*). Swedish plant-hunter Carl Thunberg followed Kämpfer in 1775 and sent maples and the evergreen *Camellia japonica* to Europe. Based on Thunberg's travels, he compiled his *Flora Japonica* (1784) and *Icones plantarum Japonicarum* (1794–1805), the latter of which contained more than fifty plates of native Japanese flora. Further contributing to Japanese plant collections, German physician Philipp Franz von Siebold published two volumes, also titled *Flora Japonica* (1835), with fellow German botanist Joseph Gerhard Zuccarini, fully illustrated with many coloured botanical paintings of trees.

During these 'golden years' of plant exploration and collecting, dozens of collectors introduced important and iconic trees to the West, increasing the diversity of exotic species and forever reshaping gardens and landscapes. But among these, a few stand out. Archibald Menzies, a Scottish surgeon, accompanied Captain George Vancouver on his circumnavigation of the globe from 1791 to 1795. On his return trip he brought the monkey puzzle (*Araucaria araucana*) from Chile, relaying it to Sir Joseph Banks at the Royal Botanic Gardens, Kew in London, where it was planted along with a number of other specimens. David Douglas, a Scottish botanist, was vital to the introduction of so many conifers from the Pacific Northwest to England and beyond, including two very important forestry trees today: the Sitka spruce (*Picea sitchensis*) and Douglas's namesake, the Douglas fir (*Pseudotsuga menziesii*).

Following in the footsteps of Irish plantsman Augustine Henry, Edwardian plant-hunter Ernest Henry Wilson completed four expeditions into China between 1899 and 1911 on behalf of Kew, the Arnold Arboretum of Harvard University, and James Veitch and Sons nursery (see p.215). Wilson introduced more than a thousand ornamental plants to enrich American and English gardens, including the handkerchief tree (*Davidia involucrata*). In the later years of his travels, he carried a Sanderson glass plate camera and captured nearly four thousand glass plate negatives, forming a vast photographic archive of the landscapes, people and trees in China. A century later, I would follow in Wilson's footsteps to retake and match these images – many remain the same, largely unchanged if at all, with the same mature trees standing, albeit a little larger.

Similarly, while he did not collect plants on his expeditions, photographer Ansel Adams was pivotal in capturing the American wilderness through his iconic black-and-white images. Contracted by the US Department of the Interior to photograph the national parks, particularly Yosemite National Park, Adams endeavoured to use his work to promote environmental conservation (see p.43). But perhaps one of the most intrepid of all the travellers was Victorian artist Marianne North, who ventured across sixteen countries between 1871 and 1885, producing 848 scientifically accurate botanical paintings (see p.85). North's documentation of trees and other plants, particularly in tropical climes, continues to inform our understanding of biodiversity loss. It is a tradition that continues today, with contemporary botanical artists – such as Masumi Yamanaka, Christabel King and Rory McEwen (see pp.113, 231, 309) – who accurately draw and colour the botanical features of trees for various publications. Even in the digital age, these publications – notably *Curtis's Botanical Magazine*, which has been featuring original colour illustrations of plants since 1787 and is now the world's longest-running, continuously published botanical periodical – are still relevant for botanists today, helping to conserve precious habitats, their trees and other plants.

Trees in Art

Trees have been integral in the creation of art across the world since ancient times. In northeast Brazil, cave paintings at the UNESCO World Heritage Site at the Serra da Capivara National Park have been dated to more than twenty-five thousand years ago. In one of the paintings is a group of human and animal figures, and it includes what is possibly the oldest man-made depiction of a tree. Stone Age societies also illustrated trees in rock art, which continued during the Later Stone Age between 13,000 and 2000 BCE. At Lake Chivero Recreational Park in Zimbabwe, examples of rock art from more than two thousand years ago depict the felling of a tree (see p.68).

Olive trees (*Olea europaea*) are one of the oldest known cultivated trees in the world; their cultivation began between six thousand and eight thousand years ago and they have long been included in art and literature. Olives have been found in Egyptian tombs dating back to 2000 BCE, and in the Jewish scriptures, olives were seen as a symbol of prosperity and part of the blessing of the promised land. In ancient Greece, the Antimenes Painter depicted scenes of olive gathering on a black-figured pottery amphora in 520 BCE (see p.265), and in a now nearly universal symbol, olive branches were one of the attributes of Eirene, the Greek goddess of peace.

Dating back to the fourth century CE, Chinese landscape painting has included trees as an essential element, often to convey deeper meanings. The pine tree, for example, has been used to represent longevity, resilience and fortitude due to its evergreen nature. This tradition can also be found widely in Japanese art. The blossoms of the plum tree (*Prunus mume*) and cherry tree (*Prunus* sp.), also called *sakura*, have been perennial subjects for artists, and they are illustrated in nearly every media imaginable from folding screens and scrolls to fans and kimonos (see p.211), not just for their aesthetic appearance but also their deep symbolism. The blossoms, which emerge in spectacular fashion in the spring, represent vitality, hope and renewal, but also the ephemeral nature of beauty, due to the short blooming period. Trees, and the natural world in general, featured heavily in the art of the Edo period (1603–1867), particularly in *ukiyo-e* woodblock printing (see p.131). And there is a different arboreal art form, but perhaps one of the most quintessential, that developed in China more than a thousand years ago: *penjing*, which would later be the basis for the Japanese practice of bonsai.

In the sixteenth century, sparked by the increasing interest in the natural world during the Renaissance, artists in Europe began to see landscape as a subject in its own right rather than as just a backdrop. This paved the way for the emergence of Classical landscape painting in the seventeenth century, with artists, such as Claude Lorrain, Nicolas Poussin and Jacob van Ruisdael (see p.174), contributing to the genre. The Romantic art movement of the early nineteenth century saw artists turning their attention to painting outdoors, observing nature and landscapes *en plein air*. English artist John Constable captured the landscapes of the Suffolk countryside where he was born and raised, with trees, clouds and skies being his favoured subjects. Along with other artists of this period, such as Caspar David Friedrich (see p.246), Constable also saw trees in and of themselves as worthy of a portrait, not just as an inclusion in a landscape, such as in his *Study of the Trunk of an Elm Tree* (see p.32). Following the practice of painting outdoors, Impressionism rose to prominence in the late nineteenth century, with Claude Monet as one of its leading artists (see p.313). He dedicated his life to painting the natural world and trees in landscapes; willows (*Salix*), poplars (*Populus*), cypresses (*Cupressus*) and palm trees are just some of the species he captured in 'The Poplars' series, which depicts scenes along the banks of the Epte River near his home and studio in Giverny.

Across the Atlantic, another influential movement was emerging in the mid-nineteenth century: the Hudson River School. Artists such as Thomas Cole, Albert Bierstadt and Frederic E. Church took cues from Romanticism, painting sweeping, idealized landscapes of the heavily forest Hudson River Valley and Catskill Mountains in New York State and the surrounding Adirondack and White mountains (see pp.152, 155). With the onset of the twentieth century, American modernism emerged, and landscapes, while no longer the main preoccupation for many artists, were painted in an entirely new perspective, as can be seen clearly in the work of Georgia O'Keeffe and her depictions of the desert trees and surrounding environs (see p.261). This was also a time when photography began to be accepted as an artistic medium, and lenses were turned once again onto the landscape. Ansel Adams's images of Yosemite and the American West at large were pivotal not only in establishing landscape photography as a genre but also in using photography as a primary tool for conservation (see p.43).

Today, some of the biggest names in contemporary art continue to focus on trees as a subject, whether featured in portraits or wider landscapes: David

Hockney, Yayoi Kusama and Damien Hirst, to name only a few (see pp.15, 33, 210). And many are still following in Adams's footsteps, with innumerable works focusing not only on the beauty of the world's trees and forests but also featuring a deeper message regarding conservation and sustainability, as well as the urgency of the climate crisis. Photographers Stuart Franklin, Beth Moon, Nici Cumpston and Sebastião Salgado are documenting trees from remote islands in the Middle East to the Amazon rainforest to the waterways of South Australia, bringing awareness to these increasingly threatened habitats (see pp.12, 144, 239, 285). Artists David Nash, Marinus Boezem and Agnes Denes compose their works with living trees, using planting as a literal act of creation (see pp.112, 241, 305). New digital technologies have also allowed for works that are a confluence of science and art, from microscopic photographs of tree stems to mapping trees in urban centres in a riot of colourful pixels (see pp.63, 192).

Tree-focused works with a message of environmental concern have pervaded pop culture as well. As children, many of us read Dr. Seuss's cautionary tale *The Lorax* (1971, see p.65) about the effects of industry on the landscape, or fell in love with trees through Shel Silverstein's *The Giving Tree* (1964). And while perhaps not the main focus, trees in film have had a profound impact on audiences for generations, from Dorothy braving the fighting apple trees on her journey across Oz (see p.183) to the temperamental Whomping Willow in the *Harry Potter* films (2001–11) to the wonderfully anthropomorphic character Treebeard and his fellow Ents of Fangorn Forest in *The Lord of the Rings* trilogy (2001–3). These treasured fictional characters, though certainly not found in nature, only serve to strengthen our love of trees and bring them to the forefront of popular culture. So while the medium and style in which trees are depicted by today's creators vary greatly, common threads can be found in the vital importance trees have to the world's cultures and also to the well-being of the planet.

A Need for Conservation

In September 2021, the Botanic Gardens Conservation International (BGCI) published *State of the World's Trees*, the culmination of five years of intensive research through the Global Tree Assessment, which compiled extinction risk information on the 58,497 tree species growing worldwide. The study identified that 30 percent of tree species are threatened and at least 142 tree species (0.2 percent) are recorded as extinct in the wild. The message was clear: we cannot afford to lose any more trees and must preserve for prosperity all species that we still have growing today. There are trees, such as the Franklin tree (*Franklinia alatamaha*), that will never again grow in the wild. Botanists John Bartram and his son William first observed the Franklin tree growing along the Altamaha River in the US state of Georgia in 1765, but it had become extinct in the wild by the early nineteenth century. It only survives today in gardens around the world, including Bartram's Garden in Philadelphia, due to the seeds collected by the Bartrams (see p.281). Despite the protection offered by both national and local tree-preservation organizations, trees are still being lost. In 2023 the loss of the Sycamore Gap tree near Hadrian's Wall in England through a blatant act of vandalism brought the issue front and centre on a world stage (see p.61).

The main global threat to tree species, however, is habitat loss through a wide variety of causes: forest clearance, exploitation for timber and other botanical products, illegal logging, the spread of invasive pests and diseases, and, of course, global warming, which causes hotter, drier summers, warmer, wetter winters and extreme weather patterns. Trees are our front-line defence against climate change, only adding to the urgency for their conservation and preservation in order to protect the planet.

We often take trees for granted despite their valued contribution to our ecosystem and how much we benefit from their existence in our everyday life. Trees play a vital role in regulating services, acting as natural air-conditioners by absorbing harmful gases, such as carbon dioxide (CO_2), which is created by vehicle and industrial emissions caused by burning fossil fuels. Trees act as 'carbon sinks': CO_2 is absorbed through small pores in their leaves and turned into energy, which releases into the atmosphere the vital oxygen that we need to breathe. They are the lungs of the earth. Any strong, healthy tree will store carbon in its roots, branches and trunk, with a large, mature shade tree, such as an oak (*Quercus*) or maple (*Acer*), capable of storing up to 20 tonnes (22 tons) in its lifetime, helping to reduce the effects of climate change.

The shade provided from the leafy canopies of trees and water loss (evapotranspiration) through their leaves can lower peak summer temperatures by up to 8 degrees centigrade (14.4° F), reducing the need for air-conditioning and energy use in our homes. The canopies of trees can also provide direct and dappled shade, protecting humans (and our skin) from the harmful ultraviolet rays of the sun. Trees planted as windbreaks are permeable, which allows gusts to pass through them, making them more effective than solid barriers and reducing traffic noise. A single tree planted in a garden or on a street can reduce the possibility of flooding and the erosion of surrounding soils – rainfall is redirected by the framework of branches down the trunk to the base of the tree, where it acts as a sponge absorbing water into the soil or is taken up by the tree's roots.

In our cities, trees are vitally important to improve air quality by removing gaseous pollutants such as ozone (O_3), sulphur dioxide (SO_2) and nitrogen dioxide (NO_2). At the same time, many species of trees – particularly the London plane (*Platanus × hispanica*) – also remove dust particles, fungal spores and bacteria from the atmosphere by capturing them on their bark and hairy leaf surfaces. London plane trees are one of the iconic trees of city centres; they were planted across London, hence the name, in the eighteenth century for their ability to tolerate urban stress and absorb pollution, a practice that later expanded to New York City, Paris and other metropolises worldwide.

In addition to being vital to human survival, our trees, woodlands and forests in all the biomes around the world are precious habitats and sanctuaries for plant and animal biodiversity. The Amazon rainforest is just one striking example: almost four hundred billion trees belonging to sixteen thousand different species comprise the forest, making it the largest and most biodiverse area of tropical rainforest in the world, as well as a huge carbon sink, slowing the rate of CO_2 buildup in the atmosphere. In England, the English oak (*Quercus robur*) supports up to 2,300 species of fungi, insects, birds, mammals, mosses, lichens and ferns – 326 of these are unable to grow on any other tree species.

But even beyond ensuring our physical survival, trees play an important role in our general well-being and mental health. Despite many cultures long recognizing the importance of the natural world to human health, it is only recently that research has revealed just how true that is. Spending time in nature, or simply looking at trees, has been shown to reduce blood pressure, lower cortisol and adrenaline (hormones related to stress and anxiety) and improve moods. The concept of *Shinrin-yoku*, or 'forest bathing', which emerged in the 1980s in Japan, has become an increasingly popular form of ecotherapy. When we are relaxing among trees, we absorb compounds called monoterpenes – the key component of a tree's aroma – that are given off by the trees. These interact with our brain, reducing tension, aggression, depression and other mental stress. Studies have also shown that spending time in environments with trees and other green spaces boosts our immune system by increasing the number and activity of disease-fighting cells. This has led to countless hospitals and health centres giving better access to trees – even through a window – as a way to improve healing and aid in recovery.

A Curated Arboretum

An arboretum is a place dedicated to the cultivation of trees for scientific and educational purposes, and while the only physical trees you will encounter in this book are the pages on which it is printed, it serves the same core purpose. With the help of an international panel of experts – from conservationists, botanists and dendrologists to climate scientists, art historians and museum curators – the collection assembled here represents more than 3,500 years of tree-inspired works across geographies, artistic styles and mediums. To make the content as accessible as possible and allow the reader to delve in at any point, the book has been structured as a curated sequence of images rather than arranged by chronology or in thematic chapters. Works are cleverly paired on facing pages to highlight revealing or stimulating similarities or contrasts – some have been juxtaposed for comparative study on a common theme, while others are matched to create a visual dialogue. Looking beyond each individual work – whether a painting, sculpture, textile, ceramic or installation – and considering the pairings in conversation together allows for a greater understanding of the prevalence and vast impact of trees on cultures across the world. And hopefully the beauty and poignancy of the works in the pages that follow will raise awareness of some of the challenges our natural world is facing and will be an inspiration to continue to preserve trees for generations to come.

Tony Kirkham
Former Head of Arboretum, Gardens and Horticultural
Services at the Royal Botanic Gardens, Kew, London

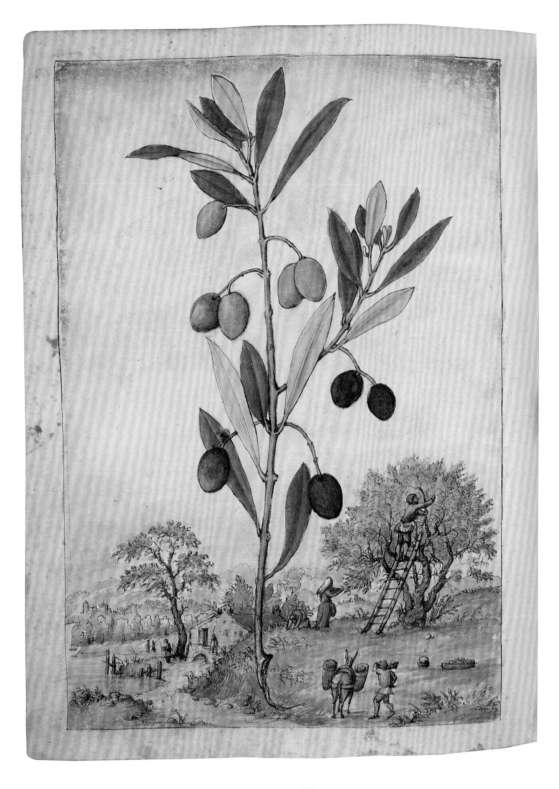

Gherardo Cibo

Olea europaea, from *De materia medica*, c.1564–84
Watercolour, 35.8 × 25 cm / 14 × 9¾ in
British Library, London

In this remarkable drawing, a sprig of olive (*Olea europaea*) with ripening fruit floats centre stage in front of a charming rural scene of the olive harvest in action. One man stands at the top of a ladder, either picking individual olives or shaking them down, while women work gathering them on the ground. In the foreground, another man is bringing baskets of olives to a donkey to load them into panniers. At the left, a fisherman stands under a tree at the water's edge next to a mill. The depiction of wooded foothills in the background lends an attractive depth to the vista,

in stark contrast to the olive twig itself, which dominates the page. Drawn almost as a botanical specimen, the unique style is that of Italian herbalist Gherardo Cibo (1512–1600). Born to a wealthy family in Genoa, Cibo later studied botany in Bologna, where he created an herbarium. His style of combining plant portraits with a background showing their habitat or against a scene of everyday life is highly characteristic. This plate is from the first volume of an Italian translation of *De materia medica* by Pietro Andrea Mattioli (1501–c.1577), a physician and naturalist of Siena.

The original Greek treatise was written in the first century CE by physician Pedanius Dioscorides, who compiled an extensive list of herbs and their medicinal value – approximately a thousand remedies that used around six hundred plants. It is the oldest work in the history of botany and pharmacology and remained the authority on its subject for more than 1,500 years.

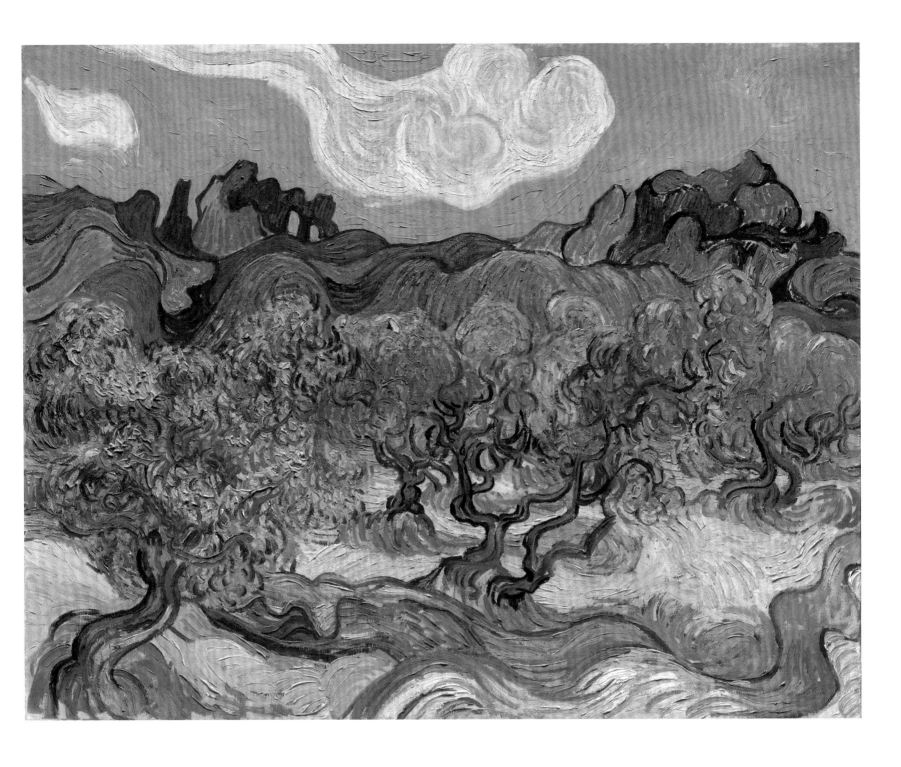

Vincent van Gogh

The Olive Trees, 1889
Oil on canvas, 72.6 × 91.4 cm / 28⅝ × 36 in
Metropolitan Museum of Art, New York

A cool palette of blues and greens dominates in this view of olive trees against a backdrop of the Alpilles, a low mountain range in Provence, France. The entire landscape – clouds, mountains, trees and earth – expresses movement and life through rhythmic, curving brushstrokes. Dutch Post-Impressionist painter Vincent van Gogh (1853–1890) made at least fifteen paintings of olive groves in 1889, after he voluntarily entered the asylum at Saint-Rémy in the south of France. His friends Émile Bernard and Paul Gauguin were painting pictures of Christ in the Garden

of Olives, but van Gogh was determined to paint the olive trees themselves, and he did so on the spot in the groves outside the asylum. The trees evidently appealed to him because of the gnarled forms their trunks and branches assume in their maturity, as well as for the silvery tones of their leaves. Olive trees have been cultivated in the Mediterranean region for thousands of years and are valued for their fruit, their wood and, above all, their oil. Legends tell that the goddess Athena planted the first olive tree on the Acropolis in Athens. Olive trees are

also associated with Christ's suffering on the eve of his crucifixion, and perhaps the artist meant the writhing forms of the trees to signify his own mental torment. Van Gogh sent this painting to his brother Theo in Paris, along with his famous *Starry Night* – his letters suggest that he saw the two works as companion pieces.

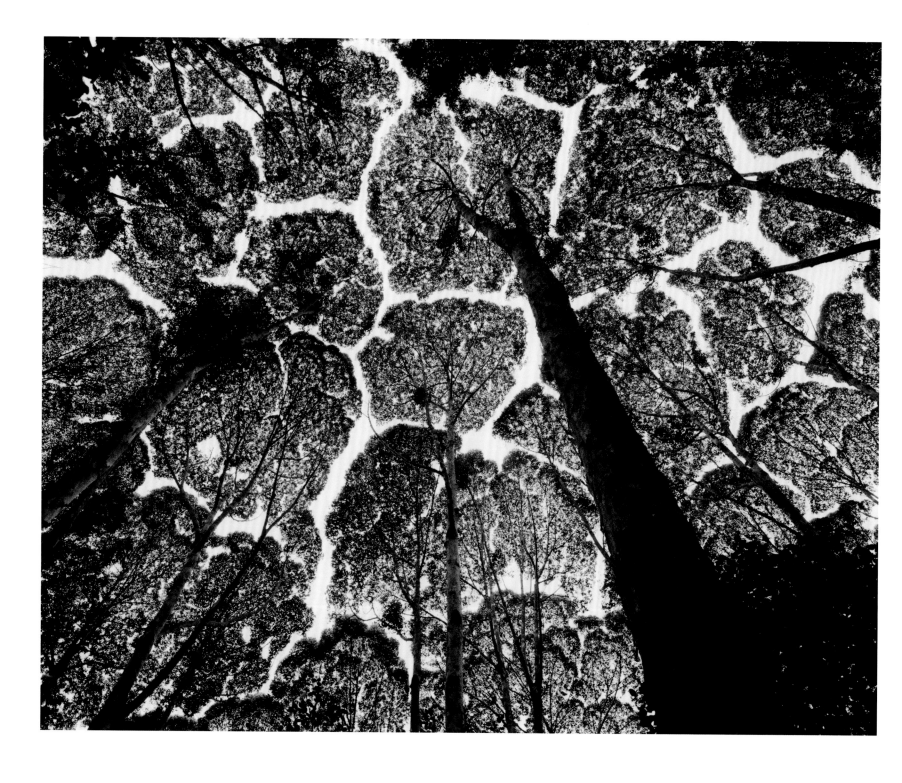

Stuart Franklin

Kepong Forest Reserve, Crown Shyness in the 'Kapur' Tree (Dryobalanops aromatica), 1997
Photograph, dimensions variable

In a striking black-and-white photograph of a dense tree canopy, British photographer Stuart Franklin (b. 1956) has captured the curious vegetal phenomenon known as crown shyness. A naturally occurring behaviour in some tree species, the crowns of fully stocked plants carefully avoid touching each other, forming a mosaic-like canopy with channelling gaps. This intriguing occurrence was first observed in the 1920s, but the exact reasons behind crown shyness are still not yet entirely understood. Some researchers believe it is a way for trees to keep their distance from each other in

order to reduce the spread of harmful insects from one to another. Others suggest it's the result of the trees' attempts to prevent branch damage and entanglements, especially during high winds. Another theory posits that crown shyness could be a light-optimization strategy through which trees give each other space, avoiding overshadowing and allowing light penetration to the forest floor. This would benefit not only the trees themselves but also other plants that partake in the breaking down of nutritious substances in the undergrowth. Here, Stuart has documented its occurrence among

the *kapur*, or camphor, trees (*Dryobalanops aromatica*) at the 545-hectare (1,347-acre) campus of the Forest Research Institute Malaysia in Kepong, near Kuala Lumpur. Kapurs are one of the 695 known species of dipterocarp – of the Dipterocarpaceae family – which are primarily hardwood trees growing in tropical lowland rainforests. As the trees mature in the forest, they often display crown shyness. In addition to illustrating this phenomenon, Franklin's photograph emphasizes the beauty and complexity of the way in which trees collaborate to develop adaptive behaviours.

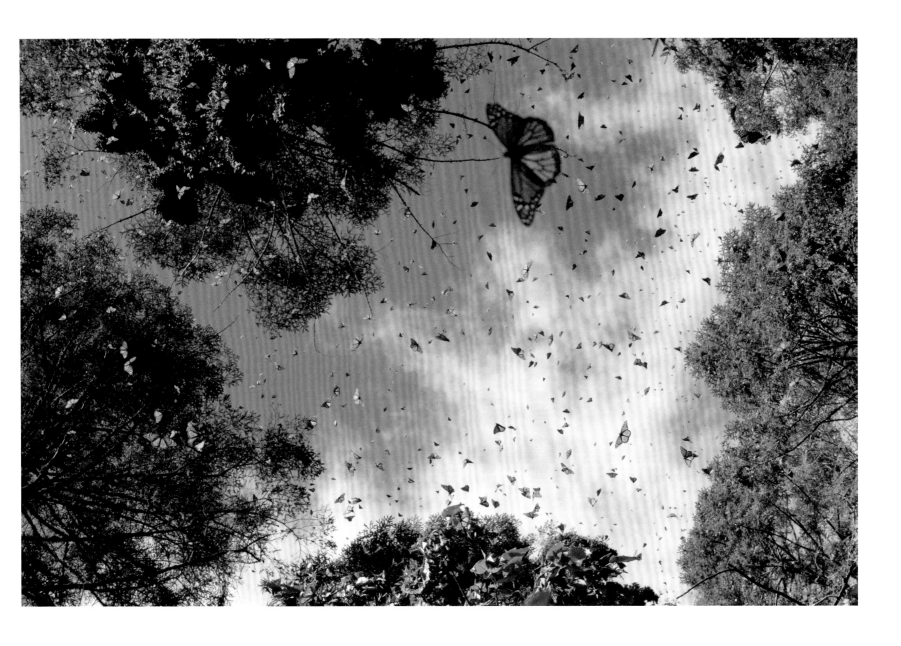

Joel Sartore

Millions of Monarch Butterflies (Danaus plexippus) Roost on
the Chincua Mountain Near Angangueo, Mexico, c.2017
Photograph, dimensions variable

A kaleidoscope of monarch butterflies, emerge from their winter hibernation on Chincua Mountain in Angangueo, Mexico, and fly up towards the crowns of nearby oyamel firs (*Abies religiosa*). Every year, these delicate creatures embark on a 4,828-kilometre (3,000-mile) trip from their breeding grounds in America's northeast to the southwest of Mexico, one of the longest known insect migrations. This journey is essential for their survival, allowing them to escape the harsh winters and find suitable conditions for mating and reproduction. During the vast distance of their migration, monarchs face numerous challenges, encountering changing weather conditions, strong winds and geographical barriers such as mountains and bodies of water. The Chincua Mountain serves as a critical roosting site for millions of monarch butterflies, where the dense forest cover and cool temperatures create a suitable environment that slows down their metabolism, allowing them to hibernate for the winter before beginning the long journey northwards in the spring. This photograph was taken by American photographer Joel Sartore (b. 1962) in an effort to raise awareness about the decline of monarch populations, which has been attributed to factors such as climate change, pesticides and habitat loss. As a result of extensive logging, the butterflies have already abandoned one of their five hibernation sites. Oyamel firs grow at very high altitudes, typically on mountaintops at between 2,400 and 3,600 metres (7,875–11,810 feet). As temperatures rise due to climate change, the lower elevations of the forest are becoming too warm to sustain the oyamel forest. With the loss of their habitat and the change to their microclimate, eventually the monarch butterflies' winter territory will no longer exist.

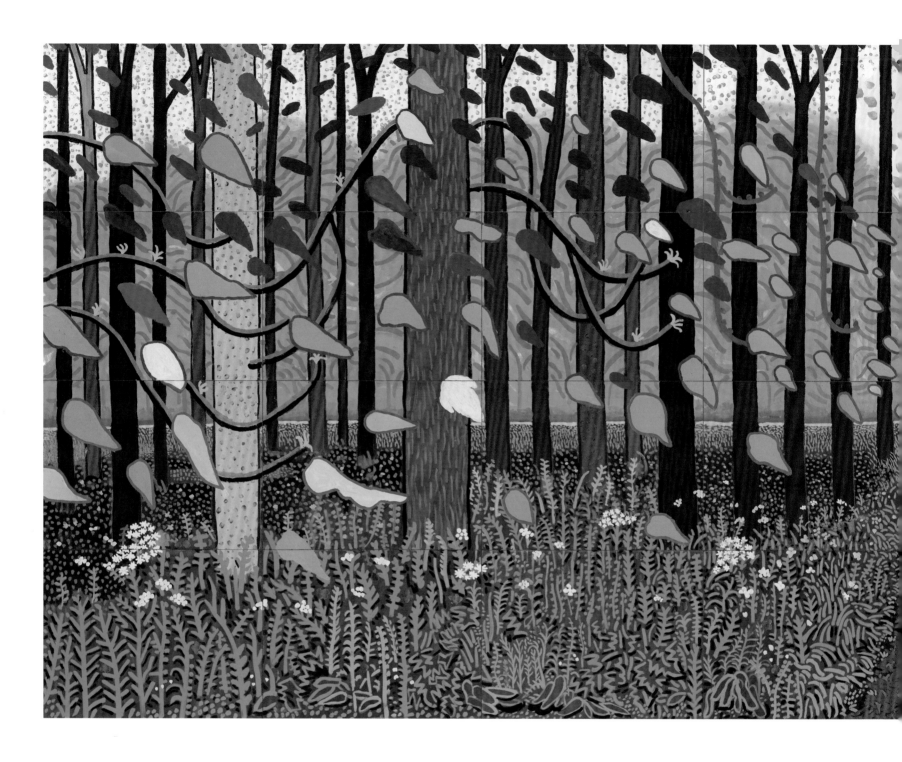

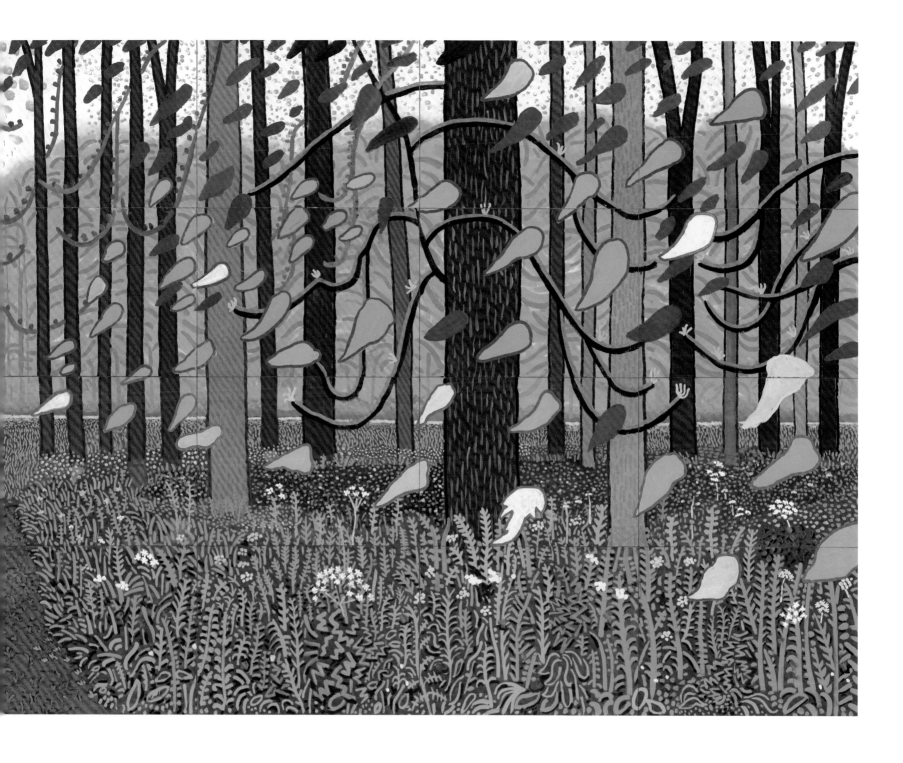

David Hockney

The Arrival of Spring in Woldgate, East Yorkshire in 2011 (twenty eleven), 2011
Oil on 32 canvases, each 91.4 × 121.9 cm / 36 × 48 in, overall 3.7 × 9.8 m / 12 × 32 ft
Musée national d'art moderne, Centre Pompidou, Paris

Spring in all its resplendent glory dances across a sprawling canvas by celebrated British artist David Hockney (b. 1937). In *The Arrival of Spring in Woldgate, East Yorkshire in 2011 (twenty eleven)*, Hockney places the viewer deep in a wood surrounded by nature, layering the picture in several distinct areas. In the foreground, a pathway quickly disappears around a bend into ground cover made up of various green shoots, dots of flowers and the buds of spring. In the middle ground, a variety of colourful tree trunks stand tall, the difference in widths creating a depth to the picture and

a sense of recession for the viewer. Emerging from the trees and curved branches are curling vines and leaves in hues of green and yellow, all nearly uniform in size, that create a dynamic sense of movement and liveliness. To mesmerizing effect, the leaves are angled in to the very centre of the picture, as if running to a single point of perspective that sits on a thin yellow horizon line. And finally, behind the rows of trees, the forest continues on, providing a lush, green backdrop to the enchanting scene. This work is one of hundreds of paintings by

Hockney, all created outdoors, that explore the natural wonders of Yorkshire, where he was born and returned to repeatedly throughout his life. After spending many years living and working in California, Hockney returned to England in 2002, turning his focus to his plein-air landscapes, reinvigorating the tradition he admired in the works of such acclaimed painters as Claude Lorrain, Vincent van Gogh, John Constable and Claude Monet (see pp.11, 32, 313).

15

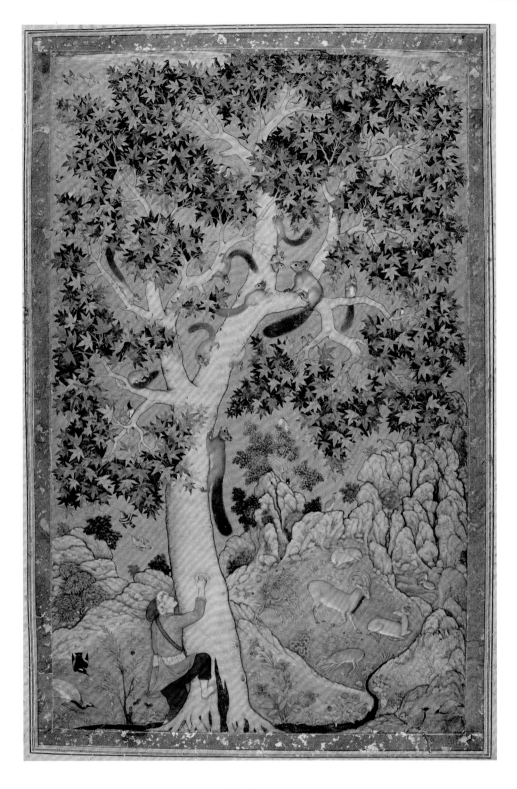

Abu'l Hasan

Untitled (Squirrels on a Plane Tree), 1605–8
Gouache with gold, 47 × 32.2 cm / 18½ × 12¾ in
British Library, London

A hunter stares determinedly up the hefty trunk of a mature plane tree, bare foot pressed against the bark and hand reaching up to a natural cleft to begin his climb. His *jama* tunic is tucked artfully into his *patka* sash, anticipating a catch of the squirrels that cavort oblivious above, their bushy tails inscribing calligraphic strokes among the branches. The painting was created by court artist Abu'l Hasan (1589–c.1630) for the Mughal emperor Jahangir, who afforded the artist 'limitless favour' for such magnificently detailed scenes. Jahangir, fourth

emperor of the Muslim Mughal rulers of majority-Hindu India, had a great love of the natural world and kept his own menagerie of wild animals gathered from India and abroad. It may have been here that Hasan had the opportunity to study the red squirrel, which is not native to the Indian subcontinent, as well as the rich variety of other animals in the work, including birds and antelopes. The allegorical tension between human and animal kingdoms is palpable, but arguably the painting's true focus is the majestic tree that commands the whole composition. The

plane tree, known across Asia and India as the chinar, was the royal tree of the Mughals, favoured in their ornamental gardens, especially in Kashmir, where Jahangir's predecessor, Akbar, planted more than 1,200 of them in the region's rich soil. The leaves depicted in this work, ablaze with autumnal colours that are so considerately and decorously dispersed, encapsulate the essence of the chinar, whose name derives from the Persian for the startling impression of fire.

16

Pierre-Auguste Renoir

Grove of Trees, 1888–90
Opaque and transparent watercolour on cream wove paper, 24.6 × 17.9 cm / 9¾ × 7 in
Art Institute of Chicago

A blaze of fiery golds, ambers and reds – mixed with splashes of green in short, light brushstrokes – forms the autumnal canopy at the centre of this painting by French Impressionist Pierre-Auguste Renoir (1841–1919). More typically associated with his still-life paintings and portraits of people – often female nudes – Renoir is seldom thought of as a landscape artist despite painting many such works during his prolific career. This small watercolour of a grove of trees makes clear the influence painting en plein air had on Renoir's work. Freeing Renoir from the constraints of the studio, where he painted friends and clients, landscape painting allowed the artist to experiment with light, colour and form. Painting outdoors forced Renoir to work faster, using much looser brushwork than is typically seen in his portraits, to imbue his trees with a sense of movement. Small dashes of broken colour indicate leaves. Fine vertical lines define clusters of spindly purple-and-white trunks that give both height and depth. The bright colours seem to melt into the soft, creamy sky around the trees and into the pale green grass in front. The painting dates to between 1888 and 1890, when Renoir lived in the south of France. In the summer of 1889, he rented a house in Aix-en-Provence from the brother-in-law of his close friend of nearly thirty years, the artist Paul Cézanne (see p.148). The colour palette of the many landscapes Renoir created there showed a clear debt to his friend's work. Late in his life, Renoir lamented the difficulty of capturing nature: 'I know that I can't paint nature, but I enjoy struggling with it. A painter can't be great if he doesn't understand landscape.'

Henry Dawson

The Major Oak, 1844
Oil on wood, 76.2 × 62.9 cm / 30 × 24¾ in
Nottingham City Museums and Galleries, UK

Sketchily painted with rich colour, an ancient oak tree spreads its branches across the sky, providing shelter for the traveller who rests on its knobby roots. The subject of this work by British landscape painter Henry Dawson (1811–1878) is the Major Oak, one of England's most famous oak trees, which still exists in Sherwood Forest, Nottinghamshire. The tree is at least a thousand years old, making it old enough to have sheltered the legendary outlaw and folk hero Robin Hood in the thirteenth century. But it takes its name from the rather more

humble soldier and antiquarian Major Hayman Rooke, who in 1790 published *Descriptions and Sketches of Some Remarkable Oaks, in the Park at Welbeck, in the County of Nottingham*, followed by a pamphlet in 1799, *A Sketch of the Ancient and Present State of Sherwood Forest*, in which he designated this tree as his favourite. The Major Oak is one of the largest oak trees in the United Kingdom, with a canopy spread of 28 metres (92 ft) and a trunk 11 metres (36 ft) in diameter. Although the Major Oak is masterfully depicted by Dawson here, the artist was essentially

self-taught. From the age of eight he worked in the lace industry in Nottingham before setting himself up as a painter. He achieved moderate success with his landscapes and was particularly proud of his ability to portray trees. The owner of this work brought it back to the artist in 1876 to ask for the addition of the figure, and Dawson wrote that he thought it was as fresh and bright as the day it was painted.

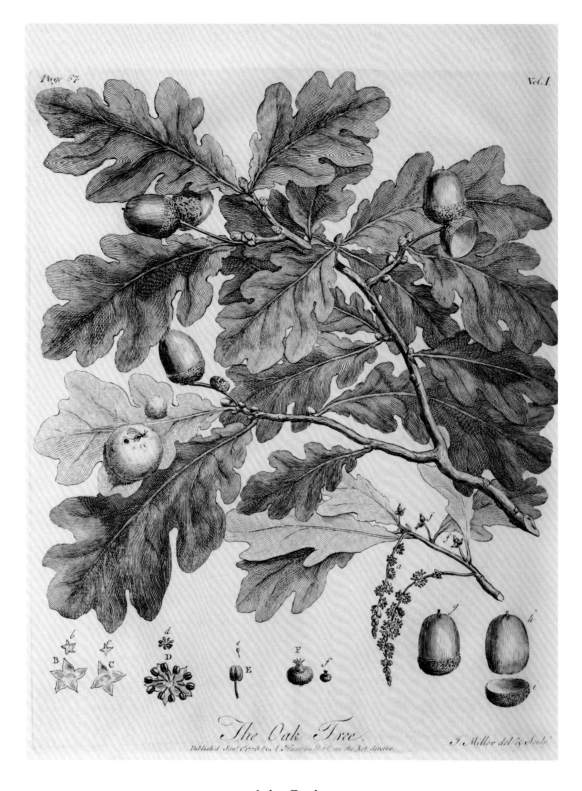

The Oak Tree.

J. Miller del & sculp.

John Evelyn

The Oak Tree, from *Sylva, or, a Discourse of Forest-Trees, and the Propagation of Timber in His Majesty's Dominions*, third edition, 1801
Engraving, 29.5 × 18.5 cm / 11¾ × 7¼ in
Wellcome Collection, London

This sprig of English oak (*Quercus robur*) bears a profusion of leaves and acorns. To the left, a tiny gall wasp lays its eggs on the tissues of the leaf, which develops into the cancerlike growth of the oak apple. The attractive and accurate drawing is also a diagram, with the constituent parts of the oak individually picked out and lettered, including petals, acorn and flower. The engraving appeared in a later, illustrated edition of *Sylva, or, A Discourse of Forest-Trees and the Propagation of Timber in His Majesty's Dominions* by English writer John Evelyn

(1620–1706). When first released in 1664, it was one of the first books to be published by the Royal Society, of which Evelyn was a founding member. Forests were at the time being extensively plundered by the Royal Navy in its demand for more ships, and Evelyn's book contains chapters devoted to individual tree species, including the oak. He suggested that the nobility should plant grand tree-lined avenues of oak trees leading to their country estates. This, he argued, would not only enhance the land but provide a useful supply of timber for warships.

Sylva is one of the most influential books on forestry ever published. In addition to his career as a writer, Evelyn was also a landowner, gardener, courtier and government official, and he had a keen interest in the new sciences. He is now best known as a diarist, having kept extensive journals of the culture and politics of his time.

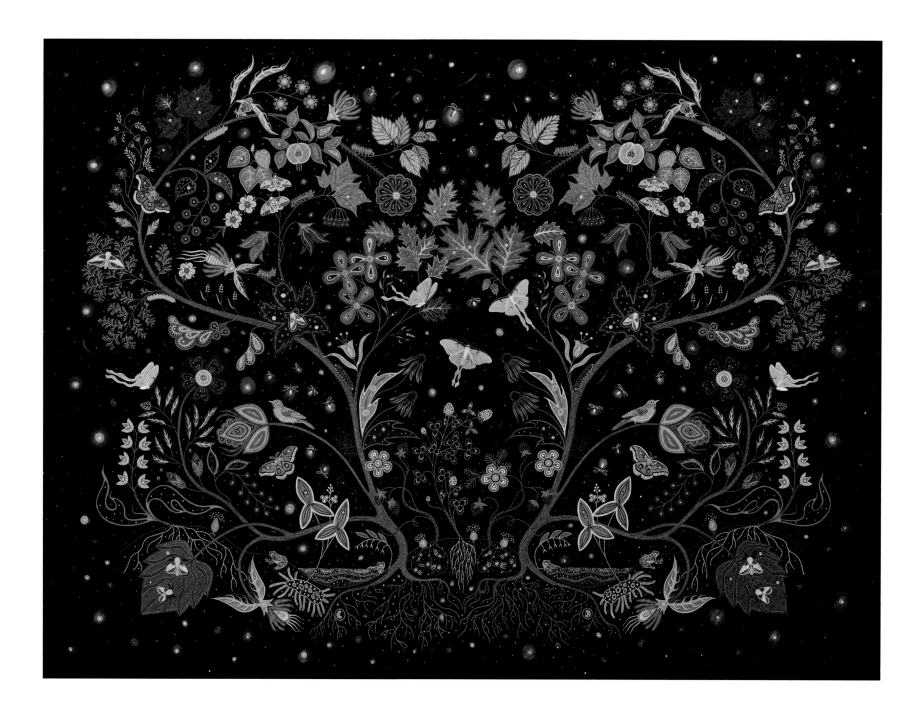

Christi Belcourt

The Night Shift, 2023
Acrylic on canvas, 1.9 × 2.6 m / 6 ft 4 in × 8 ft 6 in
Private collection

The large-scale, colourful and carefully composed paintings by Christi Belcourt (b. 1966) are inspired by the traditional beadwork patterns of Métis women and celebrate the beauty of the natural world as seen through traditional Indigenous worldviews of spirituality, biodiversity and natural medicine. Like other Indigenous communities in Canada and the United States, the Métis Nation has become a landless people, in the sense that they no longer legally own land. In this context, landscapes promote an understanding of the land as a living, sacred being. It conveys the message that

all species, including animals, plants, lands and waters, are part of a whole and have as much right to exist as humans do. This theme also highlights the Indigenous perspective of viewing the land not merely as a resource but as a vital part of their identity and spirituality – an integral component of the historical and ongoing relationship Indigenous communities have with their ancestral lands. In her paintings, Belcourt highlights native flora and fauna, particularly those that are threatened, endangered or extinct, to emphasize the need for their protection and preservation. In the nocturnal scene

of *The Night Shift*, among the twining trunks of oak, maple and beech trees are strawberries, clover, echinacea and other flowers. Frogs and fungi sit on the forest floor, birds and caterpillars perch on branches, and in between flit luna moths and fireflies. Belcourt has also said that 'the plants are teachers … connected to each other, and all other spiritual beings through the sacredness of life'. Indicative of these ideas, Belcourt's landscapes are often symmetrical and show vegetal and animal beings intertwined in harmonious ways – pieces of a larger ecosystemic tapestry, each woven perfectly together.

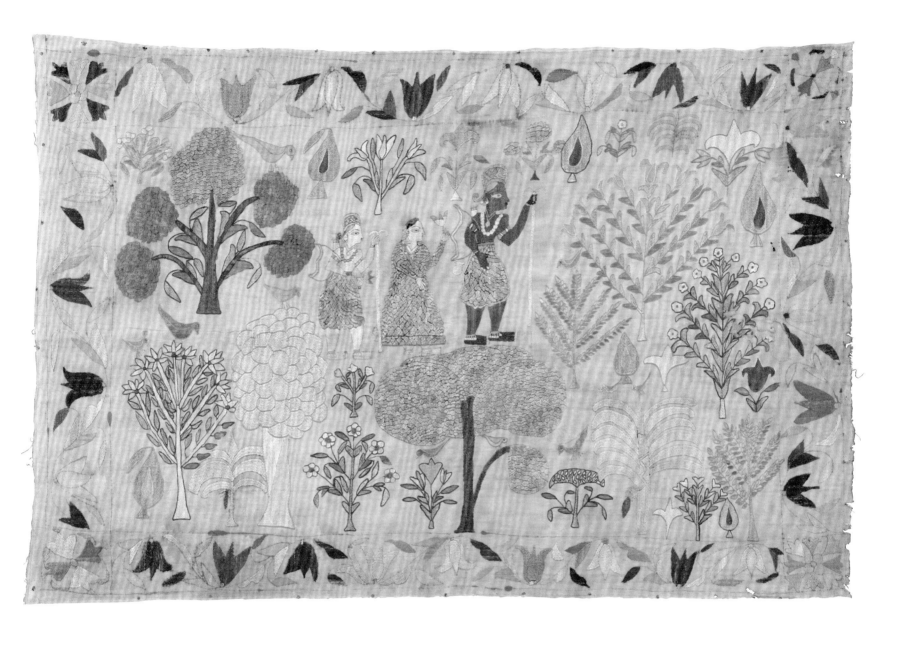

Anonymous

Ceremonial cover (*rumal*), c.1820
Cotton with silk embroidery, 61 × 96.5 cm / 24 × 38 in
Philadelphia Museum of Art

Surrounded by a lotus vine border, three figures dressed in clothes made from leaves are dwarfed by the many vibrant palms, flowering trees and tropical trees of the forest. Exquisitely embroidered, this ceremonial cover, or *rumal*, depicts a scene from the Hindu epic the *Ramayana*. Made by a female member of the Chamba court in the Himalayan foothills of India around 1820, the scene shows the god Rama, easily identified by his blue skin; his wife, Sita; and his brother Lakshmana as they head into exile in the Dandak forest following their banishment by Rama

and Lakshmana's father, King Dasharatha. Covers such as this one were stitched in the Chamba court during the eighteenth and nineteenth centuries to be given as gifts for wedding ceremonies and other major life events and celebrations. Just as with a painting, an artist most likely sketched the image in charcoal on the fabric before the women embroidered it in coloured silk thread. The *Ramayana*, a twenty-four-thousand-couplet poem divided into seven books that told the story of the life of the god Rama, was a popular subject for embroidery.

The fourteen-year banishment to the forest, illustrated here, was one of the most popular episodes in the epic. Rama, the eldest son, finds himself banished after his father accedes to the wishes of Rama's stepmother, who wants the throne for her own son, Bharata. Obeying his father and going into exile was seen as evidence of Rama's self-sacrifice, familial duty and humility.

SIBLEY'S COMMON TREES

BROAD-LEAVED TREES OF EASTERN NORTH AMERICA ILLUSTRATED BY DAVID ALLEN SIBLEY

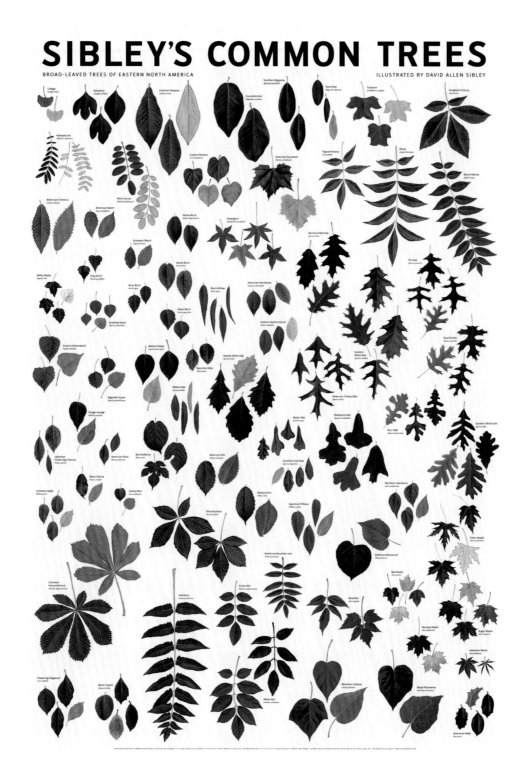

David Allen Sibley

Sibley's Common Trees of Eastern North America, 2010
Printed poster, 91.4 × 61 cm / 36 × 24 in

This colourful poster features the fifty best-known tree species in eastern North America, with each leaf beautifully painted in great detail by American artist, naturalist and ornithologist David Allen Sibley (b. 1961). Originally focused on birds, Sibley became a household name with his groundbreaking series of books *The Sibley Guide to Birds*, each one filled with hundreds of paintings of birds in every season and at every stage of life. The move to documenting trees was, Sibley says, the logical next step for an ornithologist: all too often in order to find and identify a certain species of bird, you need to be able to find the trees it tends to inhabit. Sibley found existing tree guides less than helpful because they usually relied on a key, which he found could derail the observer from the outset. So he decided to write and illustrate his own manual, *The Sibley Guide to Trees* (2009). To make tree recognition easier for the non-specialist, the book uses the same organizing principle as this poster: similar tree types – from magnolia, birch and oak to ash, maple and elm – are grouped together. Sibley's holistic approach – presenting all the notable parts of the tree – allows tree spotters to first identify the family or type of tree they are looking at before narrowing down the precise species from the information in Sibley's illustrations and written descriptions. And though Sibley's aim is easy identification and teaching people to connect to the trees right outside their doors, his eye for the nuances of natural colour and shade, and the details that separate ashes from hickories or elms from oaks, is reminiscent of the long tradition of botanical illustration.

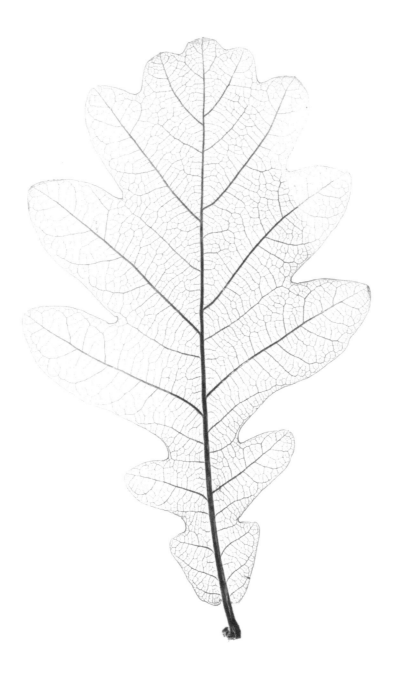

Pia Östlund

Oak Leaf (Quercus robur), Halmstad, Sweden, 2013
Nature print, 20 × 12 cm / 7¾ × 4¾ in
Private collection

So accurate is this depiction of a single oak leaf that it is hard to believe it is not the leaf itself, nor a photograph, but rather a remarkably lifelike print. All the intricate details are visible, including the central shaft and lateral veins, right down to the network of fine vessels that run throughout its translucent tissues. Taking much of her inspiration from the natural world, especially plants, Swedish graphic designer and printmaker Pia Östlund (b. 1975) uses the technique known as nature printing to create such realistic renderings. In its earliest form, in

the fifteenth century, botanists would simply apply ink to a leaf or plant and press it onto paper to leave an exact impression, known as an *ectypa*. In 1853 a more refined process was patented by Austrian illustrator Alois Auer. It involved pressing an object – typically one with a flat surface such as a leaf or pressed herbarium specimen – into a sheet of lead to make an imprint. The imprint was then copied onto a copper intaglio printing plate and printed *à là poupée* – a laborious method of hand-colouring the plate to produce greater tonal subtlety. Östlund, who

has worked closely with both the Chelsea Physic Garden and Oxford Botanic Garden, also trains others to acquire this specialized skill. Östlund uses a slightly evolved technique where the object is placed between polished metal plates and drawn through rollers to leave its impression, which can be used, after electroforming with copper, to create a detailed and faithful print true to the original.

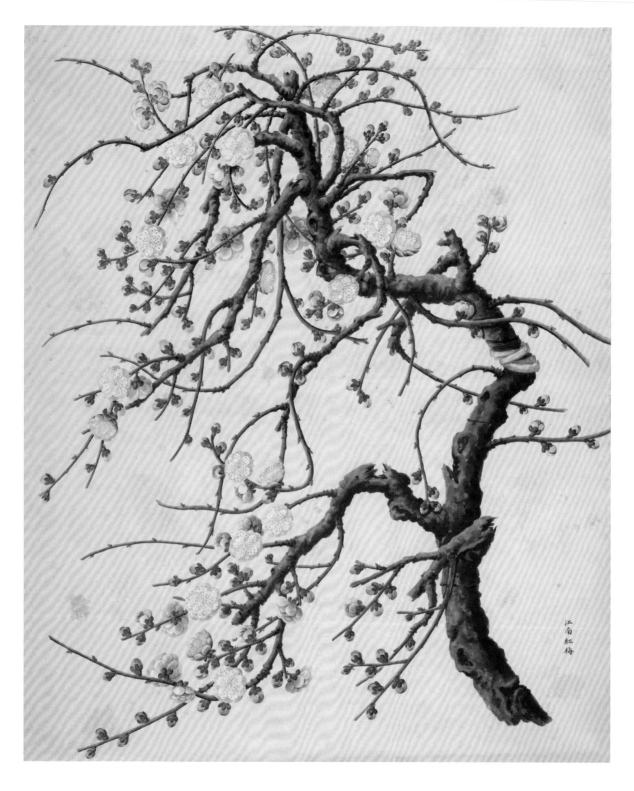

Anonymous

Prunus cv., Hybrid Tree, 1812–31
Pigments on paper, 76 × 66 cm / 29 × 26 in
Natural History Museum, London

Delicate pink blossoms and rosy buds emerge from newly green branches extending their way across the page. This botanical illustration of a *Prunus* species was commissioned by John Reeves, an English artist and naturalist who was employed by the East India Company as a tea inspector in Canton, China (now Guangzhou). When employees of the East India Company were sent to India or China, in addition to their normal jobs they were often tasked with botanizing expeditions. The eighteenth and nineteenth centuries were times of exploration and discovery, and the East India

Company's administrators in China became an important resource for research on East Asian flora and fauna. Reeves travelled to China in 1812 and returned in 1831. Before leaving for the East, he was introduced to the naturalist, botanist and explorer Sir Joseph Banks, who urged him to collect botanical specimens and send them, and drawings, to the Horticultural Society of London. Unfortunately, *fan qui* ('foreign devils') were constrained to Macau and within the port area of Canton, limiting plant-hunting further afield. Nevertheless, Reeves's work allowed him to develop local contacts, who

supplied him with plants from elsewhere in China as well as other Asian countries. Reeves commissioned Chinese artists to draw plants as precisely as possible, training them to capture all the necessary details. Although Asian techniques are visible in some drawings in the use of colour and detail, the works all reveal Reeves's teaching. Pictures were made with Chinese mineral pigments and dyes and then covered with washes of alum and animal glue solution to preserve the paint and paper. The pencils would have been supplied by Reeves from the East India Company's stationery office in Canton.

Trevor Paglen

Bloom (#a5808a), 2020
Dye sublimation print, 1.4 × 1 m / 4 ft 6 in × 3 ft 4 in

In this large-scale photograph, an explosion of blossoms has covered a tree with thousands of delicate petals, though their striking cotton candy colours appear unnatural and off-key. The image belongs to the series 'Bloom' (2020) by American artist Trevor Paglen (b. 1974), in which photographs of flowering trees and plants are assigned colours by artificial intelligence (AI) algorithms. At once familiar and strange, this is an image of a blossoming tree as seen by an inhuman eye. Paglen's multidisciplinary practice focuses on visualizing the unseen power structures and technological systems that increasingly govern contemporary life. The starting point for this project was the sense of fragility and vulnerability that Paglen felt during the COVID-19 pandemic – not because of the virus but the way that forms of sociability became reliant on online platforms and were subject to increased surveillance. Drawing inspiration from the *vanitas* tradition of seventeenth-century Dutch flower paintings, which served to remind viewers of their mortality, Paglen used a high-definition camera to photograph trees in bloom during lockdown in New York. The resulting images were fed to machine-learning programs designed to dissect the textures and spatial arrangements and then apply colours to mark differences. While Paglen's project highlights the current failure of artificial intelligence to properly understand human perception of nature, it also reveals the unsettling level of sophistication AI has already reached, prompting questions of how technologies that track faces, nature and human behaviour are being used in society, for good or for ill.

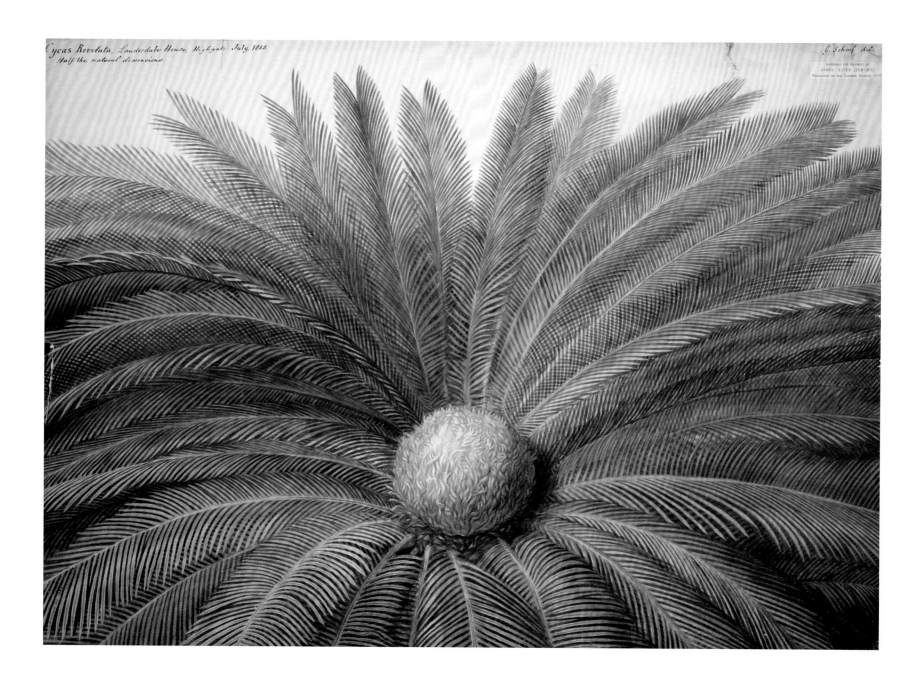

Within the image, upper left:
Cycas Revoluta, Lauderdale House, Highgate. July. 1853.
Half the natural dimensions.

Upper right:
G. Scharf del.

Anonymous

Cycas revoluta, Lauderdale House, Highgate, 1853
Watercolour on paper
Natural History Museum, London

On 6 February 1849, James Yates, a Unitarian minister, antiquary and Fellow of the Linnean Society of London, presented to the society 'a series of specimens of the natural order *Cycades*', such as the sago palm (*Cycas revoluta*) seen in this striking watercolour by an unknown artist. Offering some remarks on the species, Yates noted that female specimens were more common than male, and that 'not less than six other plants have borne fruit, and some of them two or three times', which had been observed at such renowned gardens as those at Chatsworth, in Kew,

and Lauderdale House, in Highgate, the latter being Yates's tree, which had flowered in 1845. In October 1858, Yates wrote to Sir William Jackson Hooker, director of Kew Gardens, that three male and three female *Cycas revoluta* were soon to arrive, and that he hoped to fix a time when he and some botanical friends could visit to see the plants in fruit. This remarkably detailed depiction of the sago palm's crown, or seed head, was based on one of Yates's trees at Highgate. The sago palm, though, is not a palm at all but a cycad, despite the fact that its feathery foliage

and cones resemble those of a palm. Cycads are dioecious – individual plants are either male or female – and native to southern Japan. They are one of several species of trees from which sago, a starch that is a staple food in lowland New Guinea, is extracted. Cycads are gymnosperms, meaning their unfertilized seeds are open to the air to be directly fertilized by pollination, and all parts of the plant are toxic, especially the seeds.

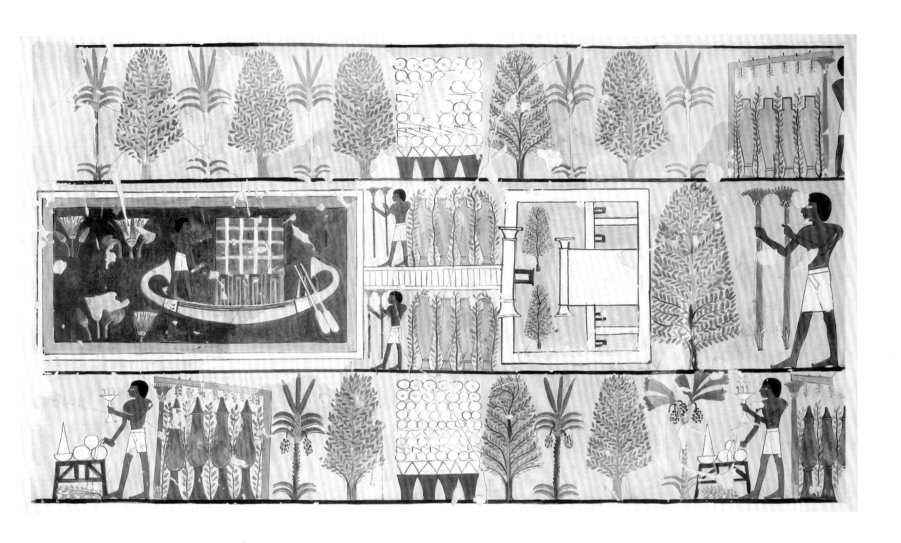

Charles K. Wilkinson

Funeral Ritual in a Garden, 1921
Tempera on paper, 71.4 × 122 cm / 28 × 48 in
Metropolitan Museum of Art, New York

The coffin of Egyptian lector Priest Minnakht glides across a pool on its way to a causeway that leads to a mortuary temple. The pool is surrounded by a lush garden, with cakes and bread piled up between date palms and other trees (possibly sycamores) in full leaf, and jars of beer and wine stand nearby, shaded by greenery. In the lowest register, two men stand before offering tables, each pouring a libation with one hand and holding a brazier with burning incense in the other. This depiction of a funeral ritual in a garden dates back

to c.1479–1425 BCE, re-created by British-born archaeologist and curator Charles K. Wilkinson (1897–1986) in 1921. Ancient Egyptians considered tomb gardens to be places in which the souls of the dead could relax and be refreshed. This required a courtyard shaded by trees, and water for the souls to drink. Each plant and tree had a symbolic meaning: date palms were associated with the sun god, Re; doum palms with the moon god, Thoth; and lettuce with Min, a fertility deity. Gardens such as this, illustrated on the wall of the tomb of Minnakht, an

overseer of granaries, on the west bank of the Nile at Thebes (modern Luxor), were intended to provide the deceased sustenance in the afterlife. In 2016 archaeologists discovered a tomb garden in Luxor that was divided into a grid of smaller beds. Two beds in the centre were set higher than the others, suggesting that they once contained trees, possibly palm, sycamore or *Persea* – evergreens belonging to the laurel family – which were connected to resurrection.

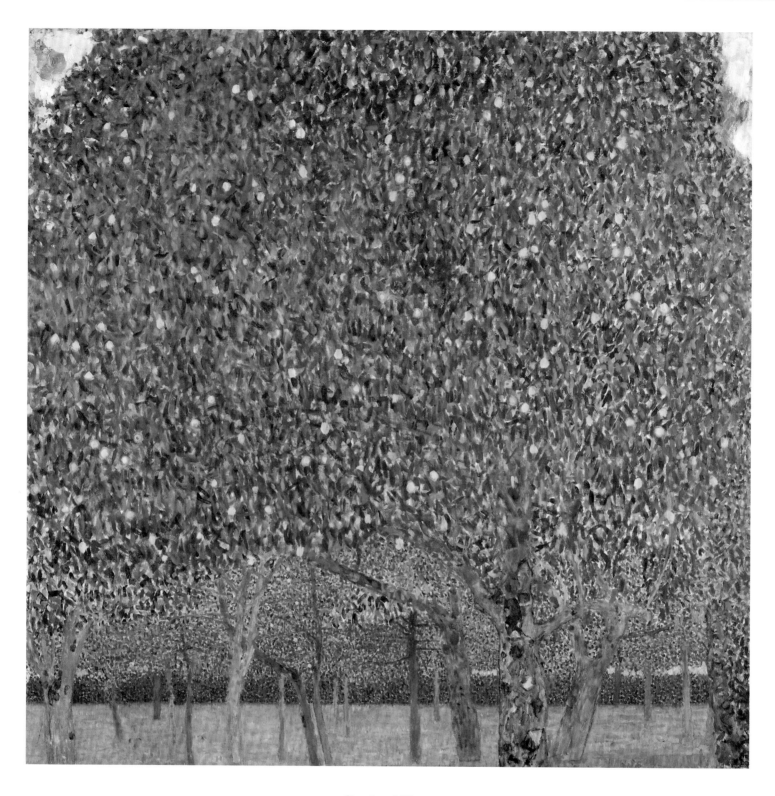

Gustav Klimt

Pear Tree, 1903
Oil and casein on canvas, 1 × 1 m / 3 ft 4 in × 3 ft 4 in
Harvard University Arts Museum, Cambridge, Massachusetts

Innumerable dabs of paint in blues, yellows, reds and greens create the leaves, blossoms and fruit of a pear tree in full bloom that dominates the front of this square canvas; behind it is a scattering of other trees disappearing into the distance. Painted in oil on canvas at the beginning of the twentieth century, this is the work of Austrian painter Gustav Klimt (1862–1918), who is perhaps better known for his paintings of women and his characteristic use of gold leaf. However, Klimt also painted many landscapes, often – as here – during his summer holidays at Lake Attersee in Austria. Heavily influenced by both Byzantine mosaics and Japanese art, Klimt created his pear tree by painting a flat field of colour made up of hundreds upon hundreds of dabs of paint to create an impression of the tree. The tree's crown contrasts with its trunk: rather than being abstracted, the bark has been drawn from life, and the grass-covered earth from which the trees grow is equally lifelike. Klimt ignored conventional perspective to create one entirely his own, here giving the impression of larger-than-life trees. As his career progressed, Klimt's work became increasingly flattened and his backgrounds shallower as he embraced Art Nouveau and other contemporary trends in painting. The left side of the tree here is much denser than the rest of it, suggesting that a portion of the work remained unfinished. Klimt began the painting in 1903, gifted it to his muse and companion, Emilie Flöge, and then later returned to work on the canvas in 1918, the year of his death.

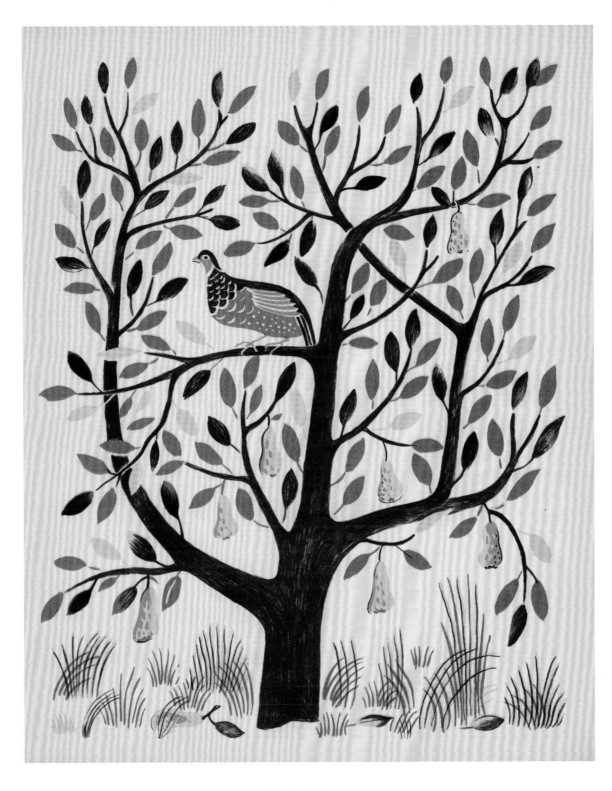

Ilonka Karasz

The Twelve Days of Christmas (Partridge in a Pear Tree), 1949
Ink on paper, 26 × 21 cm / 10¼ × 8¼ in

A decidedly modernist partridge sits in an equally modernist pear tree in this illustration for *The Twelve Days of Christmas*, which was heralded as a 'miracle of design and imagination' when it was published in 1949. The illustration is the work of Ilonka Karasz (1896–1981), the Hungarian-born American designer who took the much-loved eighteenth-century English Christmas song and, with her distinctive visual approach, turned it into a mid-century icon and publishing sensation. For the first day of Christmas, Karasz filled the page with a striking

pear tree in full leaf with ripe fruit hanging from some of its branches. Subsequent days saw the pear tree increasingly squashed into the top of the page as the partridge was joined by two turtle doves, three French hens, four calling birds and the many other Christmas gifts. Best known for her *New Yorker* cover illustrations – she created 186 between 1924 and 1973 – Karasz combined a modernist aesthetic with a love of folk art and nature, together with an innate understanding of colour and strong lines. Highly prolific, Karasz was something of a prodigy. Soon

after she immigrated to the United States at the age of seventeen in 1913, she was teaching textile design at New York's Modern Art School. In a career that spanned more than sixty years, Karasz popularized the modernist aesthetic in North America with her designs of wallpaper, textiles, furniture, interiors and wrapping paper. Once she became a mother, she designed toys and nurseries, and contributed to children's books, including *The Twelve Days of Christmas*.

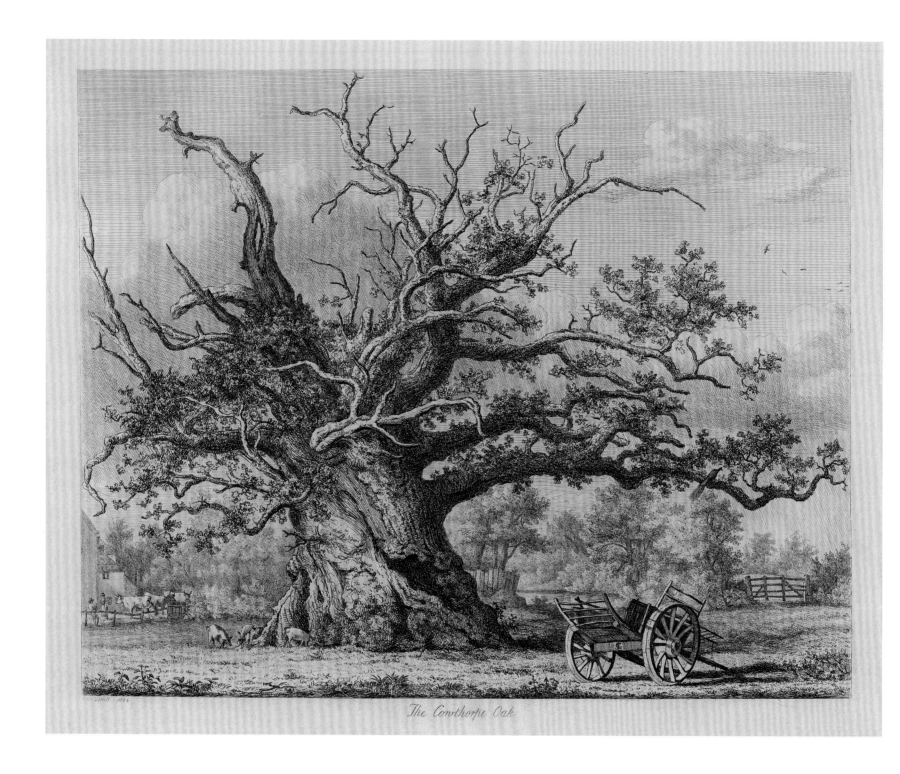

The Cowthorpe Oak

Jacob George Strutt

The Cowthorpe Oak, Wetherby, Yorkshire, from *Sylva Britannica, or, Portraits of Forest Trees Distinguished for Their Antiquity, Magnitude, or Beauty*, 1826
Etching, 38.2 × 55.7 cm / 15 × 22 in
Lloyd Library and Museum, Cincinnati, Ohio

The Cowthorpe Oak was one of the greatest oak trees in England. Indeed, from the middle of the eighteenth century, everyone who wrote about trees referred to this monstrous oak. In 1822 painter and engraver Jacob George Strutt (1784–1867) chose fifty special trees long associated with Britain – including oaks, elms, yews and ashes – to be featured in his book *Sylva Britannica, or Portraits of Forest Trees, Distinguished for their Antiquity, Magnitude, or Beauty*. Among them was the Cowthorpe Oak, which, for unknown reasons, was flipped horizontally in a mirror

image of Strutt's original drawing. When writing his descriptions, he shared the social values of trees portrayed earlier by John Evelyn in *Sylva, or, a Discourse of Forest-Trees and the Propagation of Timber* (1664), in which he influenced landowners to plant trees (see p.19). To further encourage the value of trees, Strutt published a compact edition of *Sylva Britannica* in 1830. He also provided John Claudius Loudon, the most influential horticultural journalist of his time, with an image of the Cowthorpe Oak for his *Arboretum et Fruticetum Britannicum* (1838). In 1776 the

size of the Cowthorpe Oak was drawn and recorded: the tree's circumference at ground level was 16.4 metres (54 ft), while the lower branches extended 12.2 metres (40 ft) from the trunk. Its age was considered to be around 1,600 years old in the nineteenth century, although it is now thought that 1,200 years is more accurate. The tree had died by the early twentieth century but has at least one documented descendant: in the 1870s Captain James Runciman planted a tree germinated from an acorn from the Cowthorpe Oak on his farm in New Zealand.

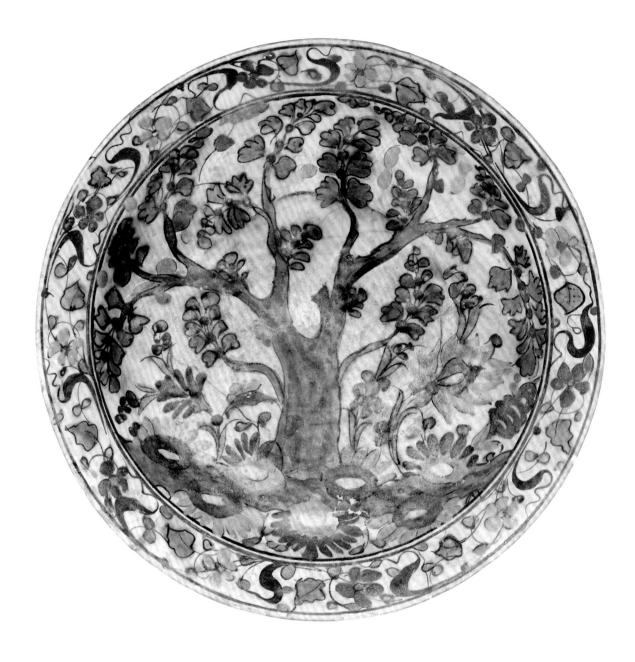

Anonymous

Dish, 17th century
Fritware with polychrome underglaze painting, Diam. 36.8 cm / 14½ in
Dallas Museum of Art, Texas

A great tree, its branches laden with ripe fruit, rises above the fertile earth below, blanketed with flowers of vivid reds and yellows. The tree shown on this fritware, or stone-paste, dish with polychrome underglaze painting and a red and yellow slip may be the tree of life – or the tree of immortality, as it is called in the Quran – the only tree in Eden. As the account goes, Satan, disguised as a serpent, told Adam to eat the fruit of the tree, saying that Allah had forbidden it because he wanted to prevent him from becoming immortal. The tree of life is often referred to as the *sidr* tree (*Ziziphus spina-christi*), associated in the Quran with the 'Lote Tree of the Farthest Boundary'; it designates the outermost boundary of the Seventh Heaven, where the understanding of angels ends. In the Prophet's vision of heaven, Muhammad is believed to have travelled with the angel Gabriel to the tree, where Gabriel stopped; from beyond the tree, Allah instructed Muhammad. The *sidr* tree is a thorny tree – reflected in its common name, Christ's thorn jujube – but it is believed that in Paradise it is thornless. Trees in the Quran are often referred to as gifts from Allah, which is unsurprising in a desert land. This dish is an example of Kubachi ware, named after the town of that name in Dagestan, in Russia, where it was first discovered. Nevertheless, scientific analysis has shown that the ware originated in Iran during the Safavid period (1501–1736), in cities including Tabriz, Nishapur, Mashhad and Isfahan, all in northwest Iran. The style, particularly the polychrome decoration, shows Ottoman influence in its imitation of Iznik ceramics.

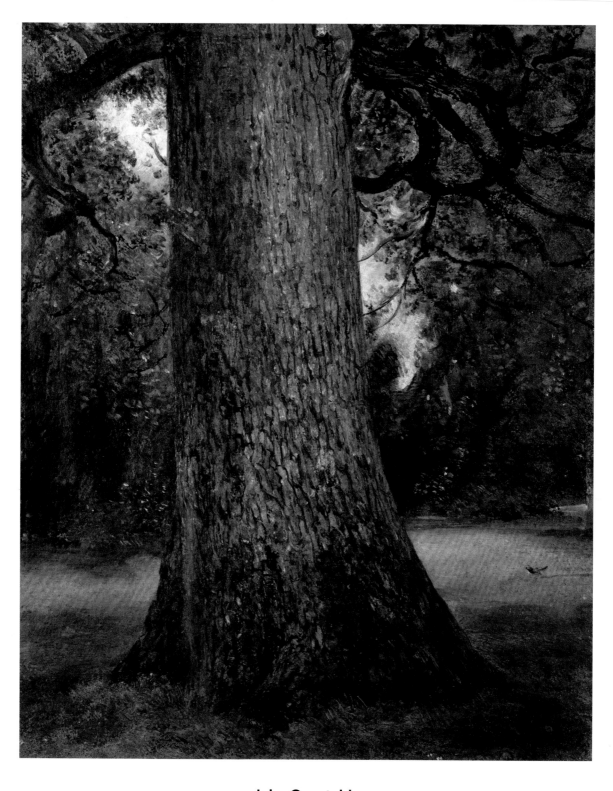

John Constable

Study of the Trunk of an Elm Tree, c.1821
Oil on paper, 30.6 × 24.8 cm / 12 × 9¾ in
Victoria and Albert Museum, London

The trunk of this elm tree has been positioned so close to the viewer that it is as if one can simply reach out and touch the deep grooves of its bark, dotted by patches of moss. Resembling a photograph, the focus has been narrowed to the remarkable character of the tree trunk, while its branches and the rest of the scene blur at the edges. English landscape painter John Constable (1776–1837) made many oil sketches in the open air, often capturing transient effects of light and weather, but in *Study of the Trunk of an Elm Tree* he has given the tree the detail one might expect from a human portrait. Constable loved trees and even gave names to some of his favourites. Portraits of named trees were a recognized category of art in his lifetime, and Constable himself exhibited a very detailed pencil tree portrait titled *Elm Trees in Old Hall Park, East Bergholt* at the Royal Academy in 1818. Tall elm trees were once an important feature throughout the landscape of England, including Constable's own home area of East Anglia. Since Dutch elm disease reached the United Kingdom from the late 1960s, mature elms have all but disappeared, except in East Sussex, where they still thrive. This sketch has provided inspiration for many artists, including Lucian Freud, who tried to copy it in 1988 when he was a student but gave up because it was too difficult, though he did finally make an etching based on it in 2003.

Yayoi Kusama

Ascension of Polka Dots on the Trees, 2021
Printed polyester fabric, bungees and aluminium staples on trees
Installation view, New York Botanical Garden

Wrapped in vibrant red fabric dotted with white, the trees of the New York Botanical Garden became a canvas for the imagination of renowned Japanese artist Yayoi Kusama (b. 1929) for her 2021 exhibition 'Cosmic Nature'. Kusama is known for transforming sculptures and the environment with her iconic polka dots, and the origin of her distinctive style can be traced back to her childhood experiences in Japan during World War II and her struggle with mental health, which often resulted in hallucinations involving repeating patterns. Kusama has been actively creating

art since the 1950s, and her works often explore themes of infinity, repetition and the relationship between the individual and the universe. In time, the motif has come to symbolize Kusama's fascination with a universal condition that binds all matter. In the late 1960s, the artist enacted happenings, or performances, by placing dot stickers or painting dots on people's bodies or in the environment. Kusama described this as an act of 'self-obliteration', linking everyone and everything via the contingency of the dots. *Ascension of Polka Dots on the Trees* is a visually

striking and whimsical scene that blurs the distinction between the natural and the artificial, suggesting a merging of the human-made world with the organic realm of nature. Kusama remakes the ordinary trees – which serve as a metaphor for life, growth and interconnectedness – into extraordinary and surreal objects, challenging traditional notions of art and nature and erasing the boundaries between the two. Over the course of six months, Kusama's 'Cosmic Nature' attracted 846,000 visitors, making it the highest-attended exhibition in the garden's history.

Tarsila do Amaral

Cartão-postal (*Postcard*), 1929
Oil on canvas, 1.4 × 1.3 m / 4 ft 8 in × 4 ft 2 in
Private collection, Rio de Janeiro

A mother monkey and her baby lounge on a lush, verdant tree cast against a picture-perfect, postcard-style landscape of peace and harmony. Tarsila do Amaral (1886–1973), a key figure in the Brazilian modernist movement, painted *Postcard* in 1929, a period marked by significant social, political and cultural changes in her home country. This was a time when the nation was transitioning from an agrarian to an industrial society, with the city of São Paulo emerging as a symbol of modernity and progress. It was amid this swift and radical change that an original

strand of Brazilian modernism sought to break away from European influences and establish a uniquely national identity in art, literature and culture. Tarsila, who often went by her first name alone, along with her contemporaries, played a crucial role in this movement, drawing inspiration from Brazil's Indigenous cultures, rural landscapes and urban transformation. *Postcard*, like many of Tarsila's works, reflects this cultural milieu. The painting is a fusion of traditional and modern elements, with the tree serving as a central symbol. Appearing frequently

in Tarsila's paintings and drawings, trees often serve as symbols of Brazil's rural past, standing in stark contrast to the geometric shapes that represent encroaching urbanization. In her body of work, trees have also served as potent symbols of life, growth and connection to the natural world. They are frequently depicted as large, lush and imposing, indicating their significance and the respect the artist has for nature's power.

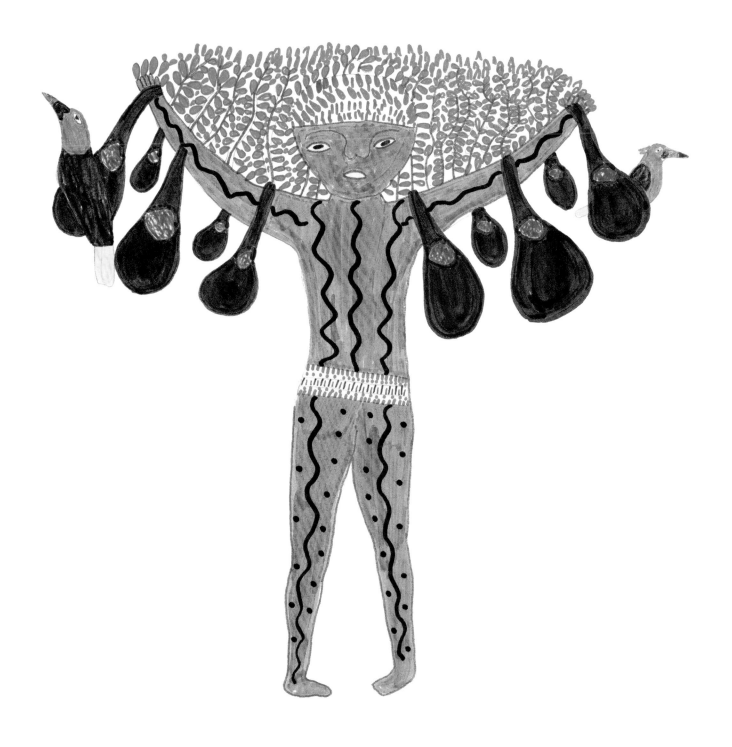

Joseca Yanomami

Espírito xamânico da árvore jatobá (*Shamanic Spirit of the Jatoba Tree*), 2003
Pen, coloured pencil and graphite on paper, 43 × 29 cm / 17 × 11½ in

Rendered in bold colours and graphic lines, the shamanic spirit of the jatoba (*Hymenaea courbaril*) is shown as an anthropomorphic entity – half man, half tree. Below the patterned material wrapped around the centre of the figure are unmistakably humanoid legs. But as the bright red-orange trunk extends upwards, the lines between human and plant begin to blur. Outstretched arms become branches, terminating in fingers that have burst into leaf. The human face is framed with a flourishing canopy of green foliage. From the branches hang the drooping, swollen nests of the crested

oropendola, woven from fibres to protect the eggs – the birds themselves sit perched on the outermost nests, with their red beaks and dazzling yellow tail feathers. Created by Amazonian artist Joseca Yanomami (b. 1971), this drawing is part of an immense body of work that focuses on the trees, birds, animals and mythology of the artist's Brazilian homeland. The Yanomami community to which Joseca belongs was largely insulated from the outside world until the mid-twentieth century, after which they were exposed to diseases, and then to the genocide inflicted by those who wanted access to the

gold on their land. The area, which spans the Orinoco river basin on the border between Venezuela and Brazil, was given protected status in the early 1990s, but the rainforest – and the communities who live there – remain under threat. The jatoba tree, also called the courbaril or West Indian locust, is common across the Caribbean and Central and South America. While its fruit, rich in starch and protein, is a major food source for Indigenous communities, it is the jatoba's hard wood that has made it a valuable commodity for the timber industry, resulting in deforestation across the Amazon.

Yoho Tsuda

Tree with Yellow Leaves, c.1980
Chromogenic print, 32.5 × 40.4 cm / 12¾ × 16 in
Metropolitan Museum of Art, New York

Golden yellow leaves surround the trunk of a ginkgo tree (*Ginkgo biloba*), carpeting the ground completely. This autumnal scene was captured by Japanese photographer Yoho Tsuda (1923–2014) around 1980 and is representative of his focus on the natural world in the later years of his career. Born in Nara, Japan, Tsuda first pursued studies in engineering before switching to film at the Nihon University College of Art. He was conscripted into military service during World War II, after which he chose photography as his path. After spending a year studying the basics at

the Osaka College of Photographic Arts, Tsuda worked for Shimada Shashinkan, a photography studio specializing in portrait photography. In 1948 he joined Naniwa Photography Club – which was established in 1904 and is the oldest photography organization still operating today in Japan – and was pivotal in its postwar development. Up until the 1960s, Tsuda's work was characterized by abstract images and largely influenced by subjective photography, which explored the inner human condition rather than the outside world. A 1961 visit to the virgin subtropical and

temperate rainforests around Japan's Mount Odaigahara was the catalyst for his transition to focusing almost exclusively on the natural world of Japan, and colour imaging became his medium of choice, as is exemplified in this image of the ginkgo leaves. Recognizable for its distinctive fan-shaped leaves, which turn vibrant yellow in the autumn, the ginkgo is one of the oldest genera of trees on Earth, having developed some 290 million years ago. Native to East Asia, ginkgoes have long been symbolic of endurance, tenacity and longevity in Japanese culture.

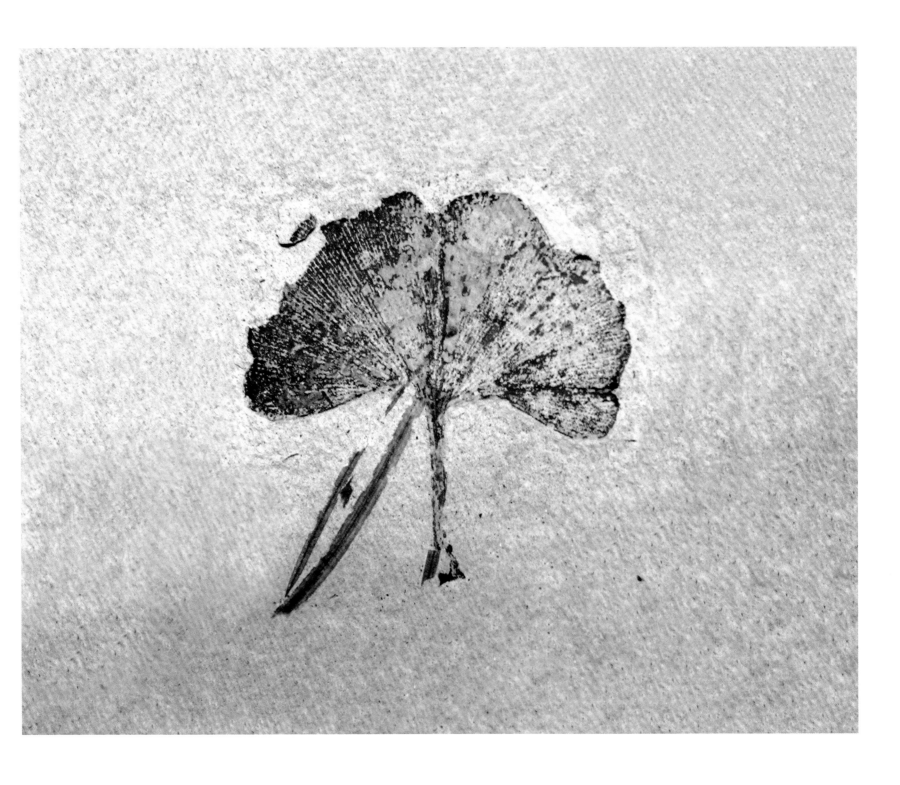

Anonymous

Ginkgo biloba leaf, *c.*49 million years old
Fossil, approx. 7 × 7 cm / 2¾ × 2¾ in
Stonerose Interpretive Center Collection, Republic, Washington

Ginkgo biloba is a gymnosperm (like conifers and cycads) and is commonly referred to as a living fossil. It is the last living species of the order Ginkgoales, which first appeared in the Permian period, more than 290 million years ago. Fossils very similar to the living ginkgo extend back to the Middle Jurassic, some 170 million years ago; dinosaurs dined on the leaves of a tree all but identical to the one in today's garden. Also known as the maidenhair tree, the ginkgo is dioecious, meaning there are separate male and female trees. Males produce small pollen cones, which, when windblown,

fertilize the ovules on the female trees, producing seeds. The outer part of the seeds contains butyric acid, which gives the trees their characteristic rancid smell. Dinosaurs and early mammals may have been attracted by the smell and ingested the nuts, thus assuring the dispersal of the species. The ginkgo became extinct in most parts of the world at the end of the Pliocene, about 2.6 million years ago, surviving only in pockets in China. It was first cultivated there around a thousand years ago, where it was grown for its nuts. The seeds are used in traditional

Chinese medicine, whereas in the West, people claim the leaves have curative properties. Today, the tree thrives on the street, where it has been widely planted in urban environments from Tokyo to Manhattan. Its toughness is legendary: it was one of the few living things to survive the atomic bomb blast in Hiroshima in 1945.

Edward Lear

Cedars of Lebanon, 1858
Watercolour on paper, 35.5 × 54.6 cm / 14 × 21½ in
Victoria and Albert Museum, London

Majestic cedar trees spread out their elegant limbs on a rocky hillside in Lebanon, the low viewpoint and the inclusion of tiny figures emphasizing their great size and grandeur. English artist and poet Edward Lear (1812–1888) made this drawing on the spot during a visit to Lebanon in May 1858. He was entranced by the cedars, which he knew from specimens in England and from the many references to them in the Bible. Contemporary writers lamented that few trees survived from the great forests of cedar that must have flourished in the past. King Solomon is reputed to have used the fragrant wood of the cedars when he built the first temple in Jerusalem in the tenth century BCE. In the eighteenth century, cedars of Lebanon became popular as ornamental trees in the English landscape gardens of landscape architect Lancelot 'Capability' Brown. On his return to Britain, Lear painted a large picture of the cedars. He supplemented the records he had made in Lebanon with firsthand study of cedars in the gardens of the Oatlands Park Hotel in Walton-on-Thames, which was built on the site of a royal palace. Lear commented on the large number of birds singing in the cedar grove in Lebanon when he was working there, and he was gratified to be told that crowds of sparrows congregated on the window ledges outside his studio in England, pining with despair because they could not get to the painting inside.

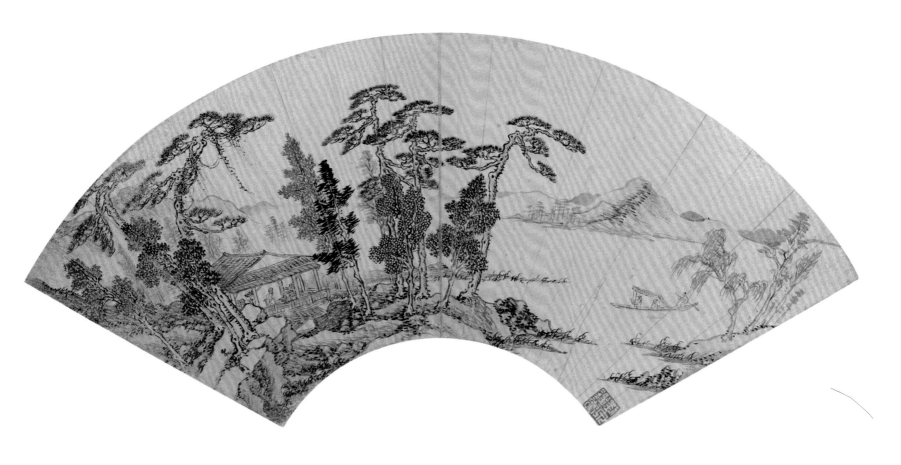

Zhou Chen

Hermit in Mountain, late 15th–early 16th century
Ink on gilded paper, 19 × 52 cm / 7½ × 20½ in
Song Art Museum, Beijing

A solitary figure – a hermit – sits in his pavilion at the edge of a lake, surrounded by rocky outcrops, towering pine trees and graceful willows, with faraway mountains across the water. This bucolic scene, painted in ink on a fan made from gilded paper, is the work of Chinese artist Zhou Chen (1460–1535). Zhou was a professional painter during the Ming dynasty (1368–1644), living and working in Suzhou, a prosperous commercial city that became a centre for scholarship and the arts in China. Zhou has created an impressionistic scene of harmonious nature dominated by trees, where the only human figures are the hermit, two visitors and the boatman who is rowing them towards the shore. On the horizon is a mountain range, barely sketched out, while in the foreground the pines are painstakingly rendered in remarkable detail, each gnarled, windswept branch and tuft of needles clearly depicted. The figure of the hermit who withdraws from the world has a long tradition in Chinese culture, and the wisdom gained from close contemplation of the natural world is widely celebrated in Chinese art. This scene is only visible when the fan is opened. As folding fans overtook rigid fans in popularity during the Ming dynasty and became a fashion item, leading artists were commissioned to paint scenes on them. Painting fans required great skill: their shape and fragility meant artists had to use very light brushstrokes to prevent any ink blotting or damage to the delicate paper.

Thornton Dial

Everybody's Got a Right to the Tree of Life, c.1988
Oil on wood, 1.2 × 3.1 m / 4 × 10 ft
Private collection

Four vibrantly coloured trees dominate this huge oil on wood painting by American artist Thornton Dial (1928–2016), each containing and surrounded by simple human figures and faces. The title of the image – *Everybody's Got a Right to the Tree of Life* – makes it clear that the artist intends it as a work of protest, affirming every person's right not just to life but to the history implicit in the concept of a family tree that Dial's work indicates. The painting and its title reference the African American folk song, or spiritual, 'Run, Mary, Run', which weaves religious themes with the shared experience of enslaved peoples, singing of the fight for freedom and the possibility of a better future. For Dial, a Black American who lived his entire life in Alabama in the Deep South, the mere fact that he – as a member of a racially oppressed group raised in the aftermath of slavery – had the ability to practice his art was, he said, 'the evidence of my freedom'. Born into a family of sharecroppers on a former cotton plantation, Dial was a metalworker for the railroad-car company Pullman until the plant closed in 1981. Self-taught, he then dedicated himself to his art, working in a number of media, including metal sculpture. Influenced by Dr Martin Luther King Jr, much of Dial's work focused on the challenges and tensions faced by Black communities emerging from shared trauma, in which he confronted America's social issues with his bold strokes of colour. Here, in the figures at the heart of each tree, he positions the Black experience as central to the tree of life, both in its historical tradition and its future growth.

Ugo Rondinone

flower moon, 2011
Cast aluminium and white enamel, 6.5 × 2.5 × 1.7 m / 21 ft 4 in × 8 ft 2 in × 5 ft 7 in
Private collection

A ghostly, lone tree sits in the austerity of the gallery space as a sombre and profound commentary on how, in time, the elements mould our bodies and experiences in ways that result in distinctive and unique architectural forms. Despite the apparent naturalness of its weathered figure, this solemn, monochromatic tree is made of cast aluminium coated with white enamel. This material transformation has transfigured it into a timeless icon that cannot decay. Evoking a sense of unending perseverance as much as of solitude and introspection, *flower moon*

and other similar works by Swiss artist Ugo Rondinone (b. 1964) are often associated with themes of existentialism. The sculptures are a testament to Rondinone's unique artistic style, which is often characterized by a blend of Surrealism, Minimalism, and Pop art. The Surrealistic influences are evident in the dreamlike and evocative quality of the piece. In this work, the moon, a celestial entity that has been employed historically to indicate the passage of time, represents the ephemeral quality of existence. And, as the Flower Moon is traditionally the full moon in May, it

signals a period, however brief, of abundance and growth. Rondinone's tree, however, stands outside of time – its growth forever frozen in its own unique temporality. While *flower moon* has captured the tree at a single moment, its clearly age-worn, weathered form vividly conjures the passage of time in our imaginations. This evocative quality is central to Rondinone's examination of the relationships between nature, emotion and the human condition that he explores in his artistic practice.

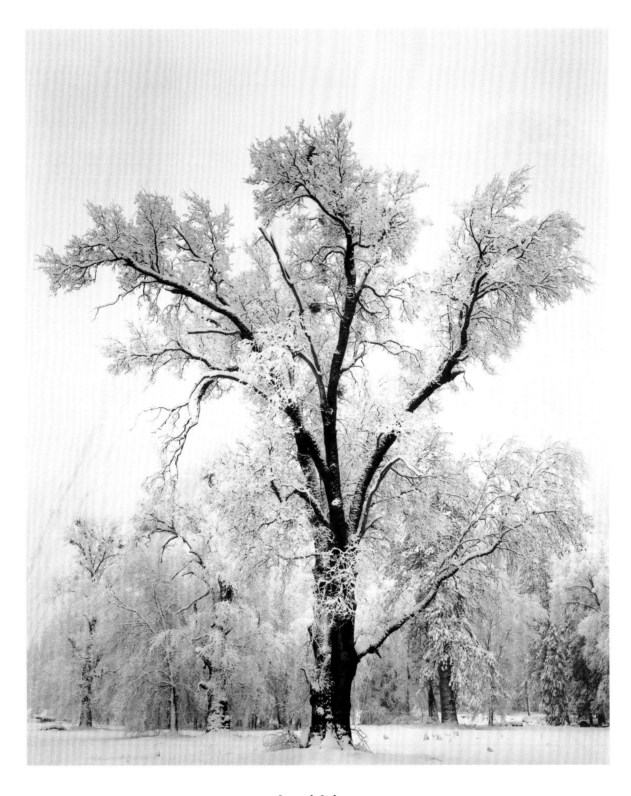

Ansel Adams

Oak Tree, Snowstorm, Yosemite National Park, 1948
Gelatin silver print, 23.6 × 19.1 cm / 9⅜ × 7½ in
Center for Creative Photography, University of Arizona, Tucson

Capturing a towering oak tree at the western edge of El Capitan Meadow in California's Yosemite National Park – its leaves and branches coated white after a recent snowfall – pioneering American photographer Ansel Adams (1902–1984) has transformed a transitory moment into a permanent embodiment of winter. Behind the oak stand other snow-covered trees and, barely visible, the outline of Yosemite's towering cliffs that lie between Bridalveil Fall and Cathedral Spires. Also a writer, teacher and conservationist, Adams is best known for his black-and-white landscapes of Yosemite,

devoid of human activity, that show the astounding grandeur and beauty of nature. Over a lengthy career, Adams was a committed environmentalist – he was awarded the Presidential Medal of Freedom in 1980 for his lifelong conservation efforts – and produced some of the most iconic images of the great American wilderness as part of a deliberate decision to record the magnificence of nature in order to demonstrate the need to preserve and protect it. Adams took his first photographs of Yosemite at just fourteen years old and then spent the rest of his life working within the

park as a photographer. The Sierra Club – for which Adams worked – published this image in 1948, and along with eleven other photographs for the same organization, it achieved iconic status. First protected in 1864, Yosemite National Park's 3,108 square kilometres (1,200 sq mi) of deep valleys, soaring cliffs, giant sequoias, meadows and magnificent waterfalls continue to attract millions of visitors annually, many of them inspired by Adams's images of the park.

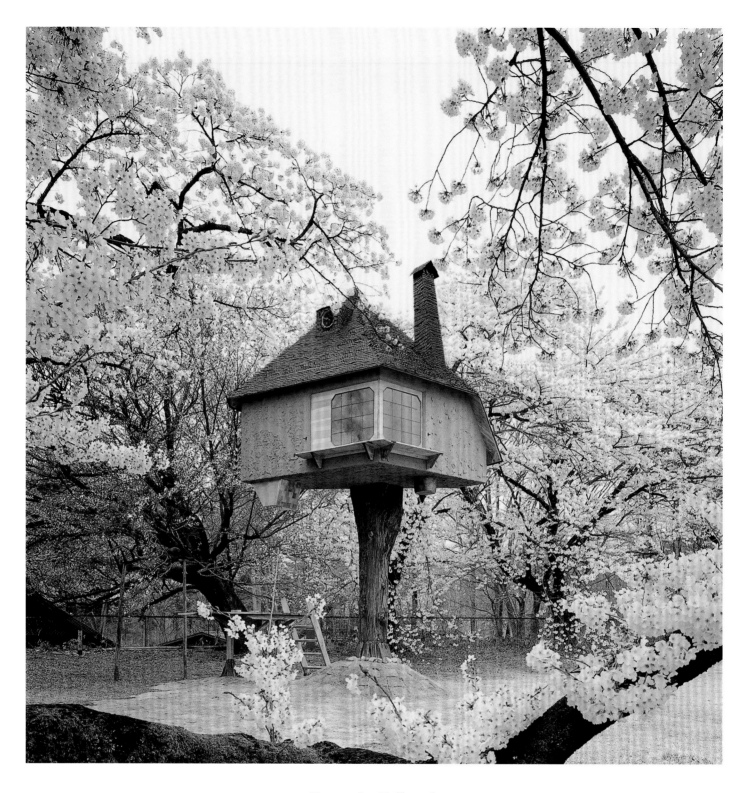

Terunobu Fujimori

Teahouse Tetsu, 2006
Earth, wood and stone
Installation view, Kiyoharu Shirakaba Museum, Hokuto, Japan

Sitting atop the trunk of a hundred-year-old cypress tree, a fairy-tale tree house nestles among a stunning display of blossom-laden cherry trees. The work of Japanese architect Terunobu Fujimori (b. 1946), the tree house is, in fact, a teahouse, located in the Kiyoharu Art Colony in Hokuto, two hours west of Tokyo. Fujimori's tree houses are well-known for their surreal and sometimes eccentric designs and constructions, seemingly defying gravity or structural integrity. Some hover, supported by cables, while others are perched on stilts. The design of this one – called

Teahouse Tetsu – features a large picture window to maximize the view of the frothy pink cherry blossoms in full bloom. The tree house is made from mostly natural materials – earth, wood and stone – and features a steep, blue-tiled roof. The building stands 4 metres (13 ft) off the ground, with the only entry via a wooden ladder. Inside is a continuation of the cypress trunk, which reaches up to the sloping ceiling. The Japanese cedar (*Cryptomeria japonica*), a conifer in the cypress family, can grow as tall as 70 metres (230 ft) and has long been used as a building

material in Japan. Since it is thought to symbolize power and longevity, it has a lengthy association with the ancient Samurai clans of Japan. Fujimori's quirky tree house combines two of the most iconic symbols of Japanese culture: the tea ceremony and cherry blossom viewing. Cherry blossom viewing takes place each spring, typically from late March until early April, the precise dates depending on latitude and that year's weather. The blossoms' short lifespan is widely seen in Japanese culture as a reminder of the fleeting nature of life.

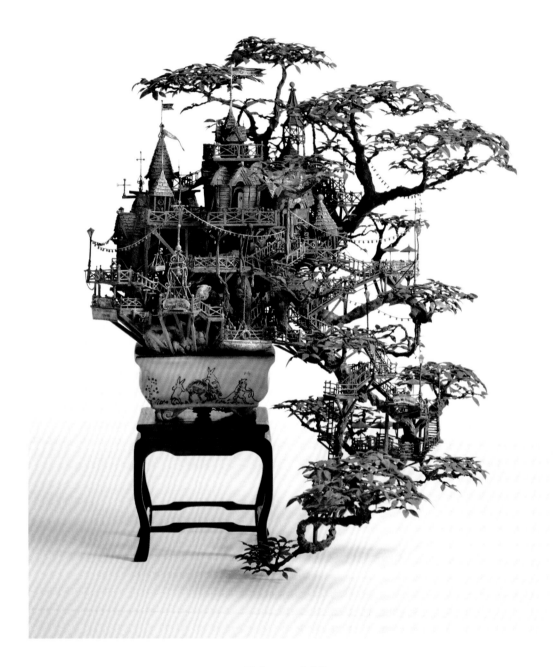

Takanori Aiba

Bonsai-B, c.2011
Mixed media, 42 × 36.8 × 48 cm / 16½ × 14½ × 19 in
Private collection

Emerging from a ceramic pot, the sprawling branches of a tree have become the unlikely home for a fantastical miniature tree house. The intricately constructed tree house is the work of Japanese artist Takanori Aiba (b. 1953), who uses his early architectural training and his experience of illustrating mazes to create a new kind of three-dimensional artwork that combines model-making with the Japanese art of bonsai – creating miniature trees through a process of pruning their branches and roots to restrict their growth and allowing them to grow in shallot pots. The inspiration for Aiba's work is his obsession, since he was a young boy, with the world in miniature. His creative process starts with a unique prompt: 'If I were a Lilliputian...', a reference to the diminutive people who appear in *Gulliver's Travels*, the 1726 novel by Jonathan Swift. Blending his childhood fascination with bonsai and his interest in miniature railways, Aiba created this tree house, complete with turrets, flags and a delicate winding wooden staircase that threads through the branches of the tree. He intended his tree house to be part of an imaginary savannah landscape, where safaris could be held in an environment that was stress-free for both animals and plants. Bonsai has a long tradition in Japan. Dating from the Heian period (794–1185 CE), bonsai is a traditional aesthetic of making perfection in miniature. Here, Aiba combines the beauty of the natural world and the beauty of the manufactured world to show the bond between humankind and nature in his Lilliputian creations.

Honoré Bouvet

L'Arbre des batailles (*The Tree of Battles*), c.1390
Vellum, approx. 35 × 26 cm / 13¾ × 10¼ in
Musée Condé, Chantilly, France

Within an illuminated border of delicately twining foliage featuring vibrant blue and red fruits and blossoms is a far darker scene: a tree with branches of war and death. The illustration is one of several in *L'Arbre des batailles* (*The Tree of Battles*) by French cleric, academic and author Honoré Bouvet (c.1340–1410). First published in 1387, the book proposed laws of war and chivalry. Rather than being aimed at academics, it was intended for public consumption and as a practical reference for knights and other officers of arms. In this richly detailed image, war rages over three layers of the tree's branches, with a cast of combatants including pikemen and knights on horseback. On the uppermost layer, on the outskirts of battle, a group of royals takes shelter beneath pavilions and receives supplication from courtiers and monks. Above their heads, Fortune herself occupies the highest position, grasping her wheel, and like Justice, she appears blindfolded. The base of the tree reveals a terrible scene, as naked figures, one trapped in the fork of a branch, are harassed and tortured by nightmarish demons complete with wings and horns.

Two angels struggle to release the victims from their torment, but the outcome of the hellish tug of war is far from certain. The tree itself emerges from the jaws of a great beast, into which the demons try to drag the writhing bodies. With Fortune at the top, the monster below and humanity in between, Bouvet's representation of the tree of battles is reminiscent of the world, or cosmic, tree that appears in mythologies across the world.

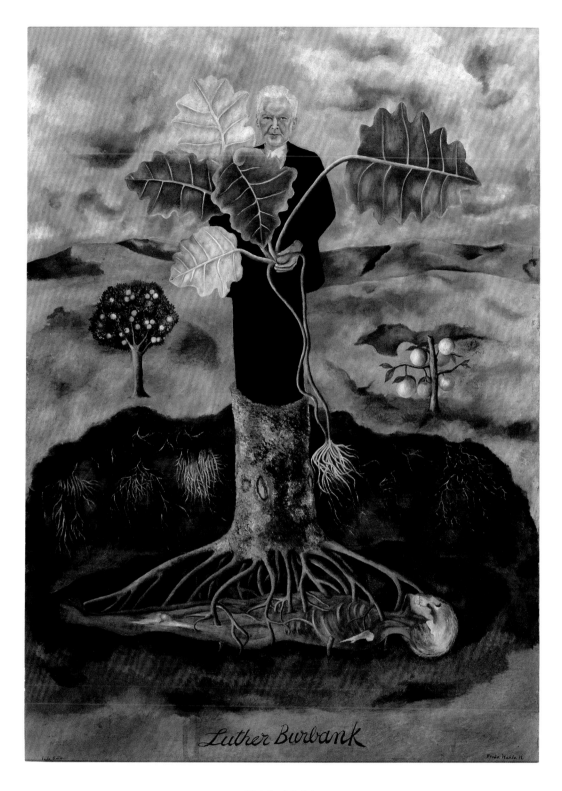

Luther Burbank

Frida Kahlo

Portrait of Luther Burbank, 1931
Oil on fibreboard, 87 × 62 cm / 34¼ × 24½ in
Fundación Dolores Olmedo, Mexico City

In this imaginatively surreal painting, Mexican artist Frida Kahlo (1907–1954) immortalizes renowned American botanist and horticulturist Luther Burbank as part man, part tree, planted in the earth. Born in 1849, Burbank was hailed as a pioneer in agricultural science and gained fame for his plant-breeding experiments, creating more than eight hundred new plant species, including the Shasta daisy and the Burbank potato, which he invented to be blight-free to help avoid social devastation such as that following the potato famine in Ireland from 1845 to 1852.

Here, Kahlo paints Burbank with one hand holding a philodendron plant – symbolizing his love of nature – his legs replaced by the trunk of a tree and his feet deeply rooted in his own corpse. (According to his wishes, Burbank was buried under a tree near his home in California.) Painted in 1931, when Kahlo was living in San Francisco during an eighteen-month sojourn, this painting was the first to portray what became one of the artist's favourite themes: the fertilization of life by death. Merging man with nature, Kahlo's depiction is symbolic of Burbank's life and work,

honouring his contributions to botany while simultaneously exploring her own fascination with the interconnectedness of all living things. Kahlo was deeply influenced by her Mexican heritage and the country's Indigenous cultures, which often revered nature as an integral part of life. Burbank, as a figure who could 'communicate' with nature and reshape it, fit perfectly into Kahlo's artistic narrative. His portrait is not just a tribute to an individual but a reflection of Kahlo's broader themes of life, death and the cyclical nature of existence.

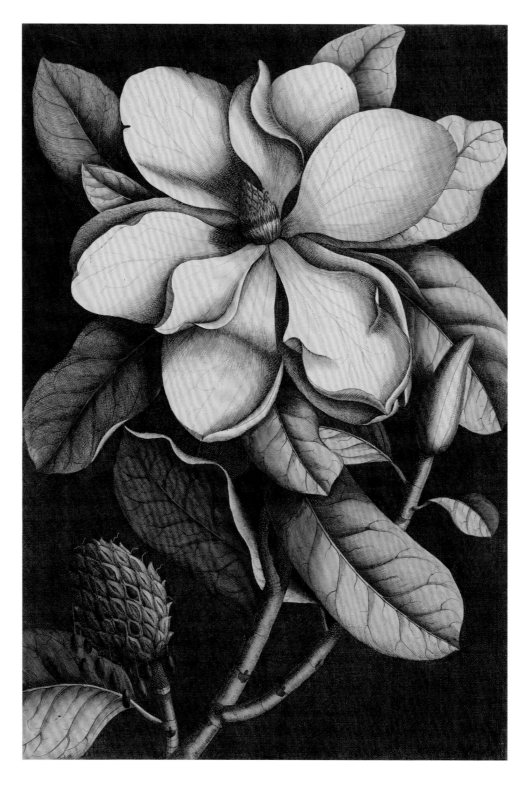

Georg Dionysius Ehret

Magnolia grandiflora (The Laurel Tree of Carolina), from *The Natural History of Carolina, Florida and the Bahama Islands*, c.1743
Hand-coloured etching, 49.5 × 33 cm / 19½ × 13 in
Minneapolis Institute of Art, Minnesota

Magnolia grandiflora, the American bull bay, or southern magnolia, is one of the most instantly recognizable trees in the world. The origins of this species can be traced to fossil records around 20 million years old, found in Idaho in the United States. This specimen, however, was painted by German botanist Georg Dionysius Ehret (1708–1770), who started drawing plants in 1736 before moving to England. There he worked as an illustrator at Chelsea Physic Garden and for private patrons, and was regarded as the finest botanical artist of the day. When Ehret created this work

around 1743, there would have been plenty of flowering specimens grown in England. Ehret depicts a fully opened flower with evergreen leaves, cinnamon-coloured indumentum on their undersides and a mature fruiting cone displaying seeds with a waxy red coat suspended by silklike threads. This hand-coloured etching is from English naturalist Mark Catesby's famous two-volume work *The Natural History of Carolina, Florida and the Bahama Islands*, published in eleven sections from 1729 to 1747. Catesby travelled to North America in 1712, living in Virginia until 1719, and then again

in Carolina from 1722 to 1726, before returning to England more permanently, spending the next eighteen years preparing this magnificent work. It was the first published account of North American plants and animals and the first to include large-scale colour plates. At the time of publication, it was hailed as a success for enlightening Europeans to the new species found in the Americas, while today there is a touch of poignancy as many species illustrated are critically endangered or extinct.

Maria Magdalena Campos-Pons

Secrets of the Magnolia Tree, 2021
Watercolour, ink, gouache and photograph on archival paper, triptych, overall 3.4 × 2.3 m / 11 ft × 7 ft 6 in
Museum of Modern Art, New York

Surrounded by magnolia trees, lush with blossoms, a woman transforms into an owl in this triptych by Cuban-born artist María Magdalena Campos-Pons (b. 1959). By her own admission, Campos-Pons's work is political, informed by geography in the broadest sense: nature, land and everything they imply. Having found her voice in post-revolutionary Cuba, Campos-Pons concentrates her work on how nature informs the body, particularly the body of an ageing woman of colour. The magnolia trees (*Magnolia grandiflora*) she paints are based on the more

than five hundred found on the grounds of Vanderbilt University in Nashville, Tennessee, where she has her studio. The trees are witnesses to history: Campos-Pons sees the majestic gardens as beautiful constructs that – like the magnificent magnolia blooms – are at odds with the horrors of segregation and the American South's history of slavery. Her choice of magnolias is intentional: they represent female energy, strength, stability and luck. A species that is twenty million years old, the magnolia has also been used across cultures for its healing properties, such

as in traditional Chinese medicine, where it is used to treat anxiety and aid sleep. *Secrets of the Magnolia Tree* stems from Campos-Pons's studies of the African Yoruba spiritual and philosophical systems that started her continuing interrogation of how nature and geography mark the human body. Her focus on this theme started in 1990 with a performance project titled *Because the human body is a tree* in Montreal, Canada, an exploration of how the body could exist and see itself through a tree.

49

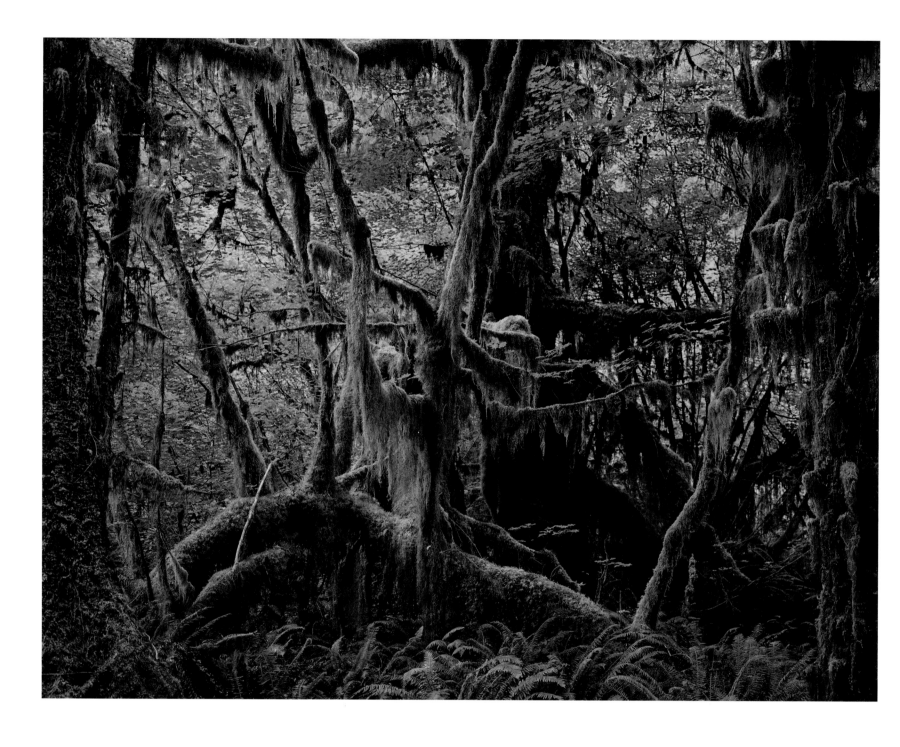

Taryn Simon

The Hoh Rain Forest, Understorey and Forest Structure, Olympic National Park, Washington, from 'An American Index of the Hidden and Unfamiliar', 2007
Tangle of branches and mosses, including Sitka spruce, vine maple, bigleaf maple, western hemlock and understorey of sword fern
Framed archival inkjet print and Letraset on wall, 94.6 × 113.7 cm / 37¼ × 44¾ in, Louisiana Museum of Modern Art, Denmark

The series 'An American Index of the Hidden and Unfamiliar', produced by American multidisciplinary artist Taryn Simon (b. 1975), serves as an inventory of hidden and inaccessible spaces in the United States. Simon travelled across the country, capturing images from virgin forests and nuclear waste storage facilities to high-security prisons and CIA offices. Each photograph represents a different facet of the American subconscious, parts of the myth of a nation that operate at a subliminal level, away from the hustle and bustle of everyday life, but that nonetheless play an important role

in the construction of a national identity. *The Hoh Rain Forest*, with its lush and ancient trees, symbolizes the untouched beauty of nature within the American landscape. Located on the Olympic Peninsula in western Washington state, it is the largest intact coastal temperate rainforest in the world. The forest receives a staggering average of nearly 330 centimetres (130 in) of rain annually, making it the wettest site in the continental United States. Part of the Olympic National Park, the Hoh is fully protected from logging and other commercial exploitation and is home to a number of rare plant and animal

species – many now listed as endangered or vulnerable. Here, Sitka spruce (*Picea sitchensis*), vine maple (*Acer circinatum*), bigleaf maple (*Acer macrophyllum*) and western hemlock (*Tsuga heterophylla*) are shown in a small visual slice of the Hoh's 4,000 hectares (10,000 acres). Simon's rainforest images work as a reminder of different timescales and realities that, in less than obvious ways, play important roles in the construction of reality – humans can never replicate the thousands of years necessary to generate a living ecosystem, but those ecosystems can be quickly lost at any time.

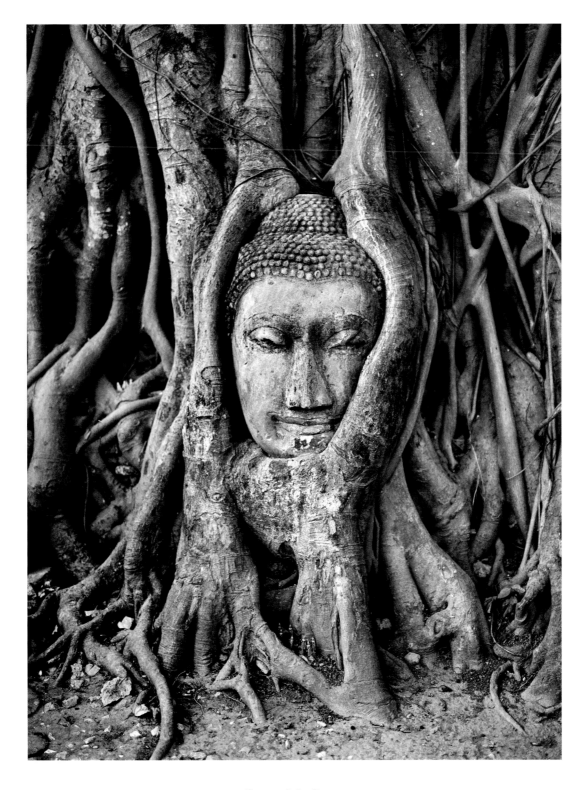

Steve McCurry

Buddha Head Embedded in the Roots at Wat Phra Mahathat, Ayutthaya, Thailand, 2004
Photograph, dimensions variable

A sandstone head of the Buddha is embedded in the roots of a sacred fig, or bodhi, tree (*Ficus religiosa*) at the abandoned Wat Mahathat royal temple in Ayutthaya, Thailand, in this image by the award-winning American photographer Steve McCurry (b. 1950). The bodhi tree has long been considered sacred by Buddhists, who believe that their spiritual leader, the Buddha, gained enlightenment under the tree around 500 BCE in Bodh Gaya, India. While that original tree no longer exists, the bodhi tree is still revered in many religious settings, and shrines were often built under the generous canopy of the long-lived sacred fig. The existence of this ancient tree and the stone head fused to it reflects the importance the tree held in the royal temple at Ayutthaya, which is said to have housed a holy relic of the Buddha – making it one of the most important sites in the empire of Ayutthaya, a Buddhist monarchy that flourished in present-day Thailand between 1351 and 1767. After the kingdom collapsed in 1767, the temple was badly damaged by fire and abandoned. Since then, nature has enveloped the ruins of the palace complex. Fascinated by the diversity of global cultures and images that speak to a universal language, Steve McCurry has spent a lifetime travelling the world to create a visual record of vanishing civilizations, ancient traditions and powerful spiritual locations. Although how and why the head came to be nestled in the bodhi's roots remains a mystery, it has been photographed by thousands of visitors to the site, revealing the enduring power and unity of nature, spirituality and art.

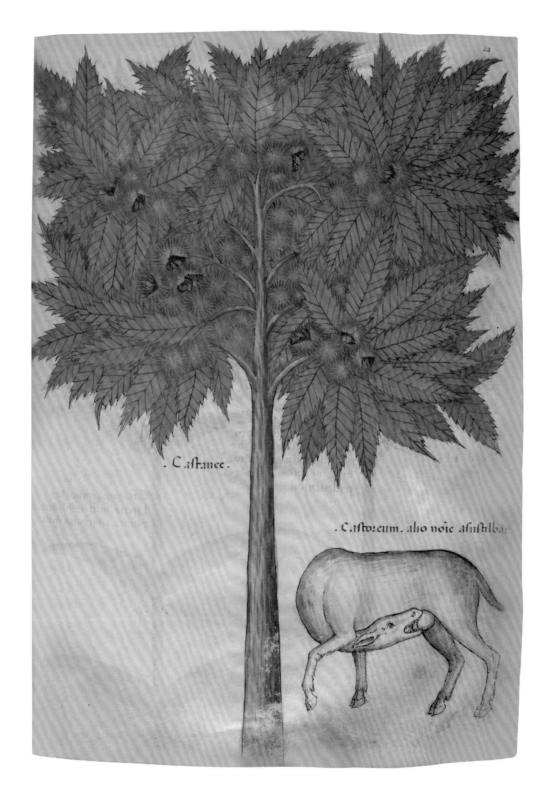

. Caftanee .

. Caftoreum . alio noie afutilbar .

Anonymous

Page from *Tractatus de Herbis*, c.1440
Colours on parchment, 36.5 × 26.5 cm / 14½ × 10½ in
British Library, London

This illustrated folio is one of nearly five hundred in a fifteenth-century edition of the *Tractatus de Herbis*, a manuscript intended to help medieval physicians and apothecaries identify plants used in their practices. As Byzantine Greeks, Arabs and others contributed to the advancement of medical science, different peoples used different terms for plants and remedies. To avoid potentially dangerous confusion, apothecaries and physicians compiled dictionaries of plant names. By means of images, the *Tractatus de Herbis* enabled medical persons to identify specific plants regardless of the language in which they were named, and so reduced the risk of a patient taking a potion different from the one prescribed. These illustrated works transformed botanical literature, being able to be used by readers of any language. This manuscript, called the Codex Sloane MS 4016, is illustrated with almost five hundred depictions of plants, animals and minerals, all of which were used to produce drugs. Here, a sweet chestnut tree (*Castanea sativa*) shades a deer or antelope in the act of castrating itself. Greek writers mentioned that the sweet chestnut is a remedy for lacerations to the lips and oesophagus, likely due to the leaves and bark being rich in tannins that act as an astringent. The leaves of the tree are also a source of natural antioxidants and have long been used in traditional medicines for treating respiratory illnesses such as coughs and asthma. However, sweet chestnut is perhaps most well-known for its starchy nuts, which, when roasted, have become a classic autumn and winter treat across East Asia, Europe and parts of the United States.

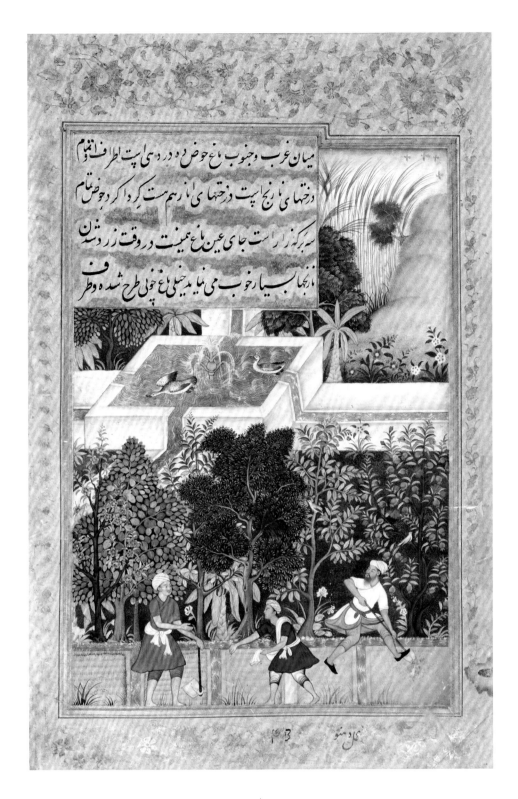

Dhanu

The Gardens of Fidelity (Bagh-e Vafa) Being Laid Out at Kabul, from *Vaki'at-i Baburi (The Memoirs of Babur)*, c.1590
Ink and pigments on paper, approx. 24 × 15 cm / 9½ × 5⅞ in
British Library, London

'The best part of the garden is when the oranges take colour – a beautiful sight.' This miniature from the memoirs of Babur (1483–1530), the first Mughal emperor, celebrates the orange and other trees in Babur's beloved Garden of Fidelity (Bagh-e Vafa), which still exists in Kabul, Afghanistan. It is believed to have been painted by the illustrator Dhanu for a translation of the original Turkic memoirs by the poet Rahim around 1590. The garden was created in 1508 to 1509 in honour of the emperor's most loyal nobles. It takes the form of a Persian *chahar bagh*,

meaning 'four gardens': an enclosed 'Paradise' garden geometrically divided into four parts by axial water channels that intersect at a central pool. Paradise gardens represent in their rills the four rivers of Paradise, flowing with milk, honey, water and wine. Date palms, fig trees and olives were grown in Paradise gardens, and Arabs introduced oranges, lemons and pomegranates; cedar and cypress trees were also common. Herbs and roses were also grown for perfumes and cooking, and grape vines were cultivated for making wine and drying into raisins.

Babur was educated, a Timurid prince and a descendent of Timur (Tamerlane) himself. His memoirs cover not just the events of his own life but range as widely as astronomy, geography, history, effective government, plants, animals, military matters, biography and family histories, poetry, music, art and artists, wine parties and human nature. He was interested in the places he lived and the people who lived there alongside him, and, of course, in gardens and the trees and other plants cultivated within them.

Anonymous

Araucaria fossil, *c.*220 million years ago
Petrified wood, Diam. 80 cm / 31½ in

The vibrant oranges and reds in this cross section of a tree trunk are only possible through millions of years of fossilization. The specimen from the Petrified Forest National Park in Arizona is an *Araucaria* conifer dating to the late Triassic period more than two hundred million years ago. Then, the climate of what is now northern Arizona was tropical, and the area was home to a vast forest of tree ferns and gymnosperms, largely conifers and some ginkgoes. There are currently fourteen different species that have been identified in the park, one of the largest

concentrations of petrified wood in the world. From the surviving logs, it is estimated that some of the trees may have grown up to 61 metres (200 ft) tall, with a trunk up to 1.5 metres (5 ft) wide. But, in addition to their size, it is the spectacular colour of their surfaces that is perhaps the most notable. The painterly surface of reds, purples and yellows is actually the result of the trees' petrifaction. When the ancient trees fell, they were quickly buried by sediment and volcanic ash, depriving the wood of oxygen and preserving it from decay. Over millennia, silica, iron oxides and other

minerals leached into the porous wood, causing its cellular structure to crystallize into a fossil and giving it a rainbow of colours. The park, which now encompasses nearly 900 square kilometres (347 sq mi) of semi-desert land, was first made a national monument in 1906 by President Theodore Roosevelt after the site became increasingly threatened by tourism and commercial interests. It was officially made a national park in 1962, and in 1988 Arizona made the petrified wood of the prehistoric conifers its official state fossil.

Bharti Kher

The Waq Tree, 2009
Fibreglass, iron and copper, 4.5 × 3 × 5.5 m / 14 ft 9 in × 9 ft 10 in × 18 ft
Installation view, Art Unlimited, Basel, Switzerland

A fallen tree rests on its side, the pale bark of its trunk and branches giving way to plump foliage in blush pinks and creamy beiges. But this is no ordinary tree. Examining *The Waq Tree* by British-Indian artist Bharti Kher (b. 1969) up close, the leaves are revealed as carefully sculpted heads – some of animals, such as horses, cattle and pigs, and some of vaguely humanoid forms. The sculpture is a modern-day interpretation of the Waqwaq Tree of myth, which grows on a faraway island in the western Pacific and bears fruit that grows into an array of living creatures,

from humans, usually female, to birds, dragons, tigers and, in some accounts, demons. The legend has origins dating back to the tenth century in Persia but persisted in a number of cultures across Asia through the seventeenth century. The mysterious island is thought to have possibly been based on Java or another Indonesian isle, and the descriptions of tree itself may have been inspired by the screwpine (*Pandanus* sp.) with its great pendulous fruit. Kher's fibreglass sculpture of the Waqwaq tree is steeped in magical realism, a theme that runs through much of

her oeuvre, whether painted on a canvas or rendered in three dimensions. By blurring the lines between reality and fantasy, human and nature, history and myth, Kher opens up her works to myriad interpretations by the viewer. Living and working between London and New Delhi, Kher frequently infuses her creations with the dualities she embraces as an artist working across cultures, aesthetics and geographies.

Olafur Eliasson and Günther Vogt

Yellow forest, 2017
Birch trees (*Betula pendula*, *B. utilis*) and monofrequency lights, dimensions variable
Installation view, Hamburger Bahnhof Museum

Many of the works by Icelandic-Danish artist Olafur Eliasson (b. 1967) are related to nature, incorporating elementary materials such as light and water to challenge perceptions of the artificial and the natural. Eliasson's captivating installations, in which viewers experience a heightened awareness of their senses, provoke a range of emotional and physical responses. Here, the artist has created his own woodland, yet *Yellow forest* exists only within the walls of museums. The arboreal installation, made in collaboration with landscape architect Günther Vogt (b. 1967),

comprises a collection of potted birch trees arranged in a circle with a path through the centre, allowing people to walk among them. The small woodland is illuminated by a ring of monofrequency lamps, which cast a strong yellow light reminiscent of autumn colours but creating a disorienting effect, causing viewers to perceive the trees in shades of black, grey and yellow. This visual interference taps into the ancient idea of forests as mystical, dreamlike places where people can lose themselves both physically and mentally. As his inspiration for *Yellow forest*, Eliasson

has cited Martin Kippenberger's 1990 installation *Jetzt geh ich im den Birkenwald denn meine Pillen wirken bald* (*Now I'll Go into the Birch Forest, for My Pills Will Take Effect Soon*), which filled a gallery with the trunks of birch trees and large wooden pills, humorously suggesting a link between forests and states of altered consciousness. Unlike Kippenberger's trees, however, Eliasson's birches are full of life and hope for the future.

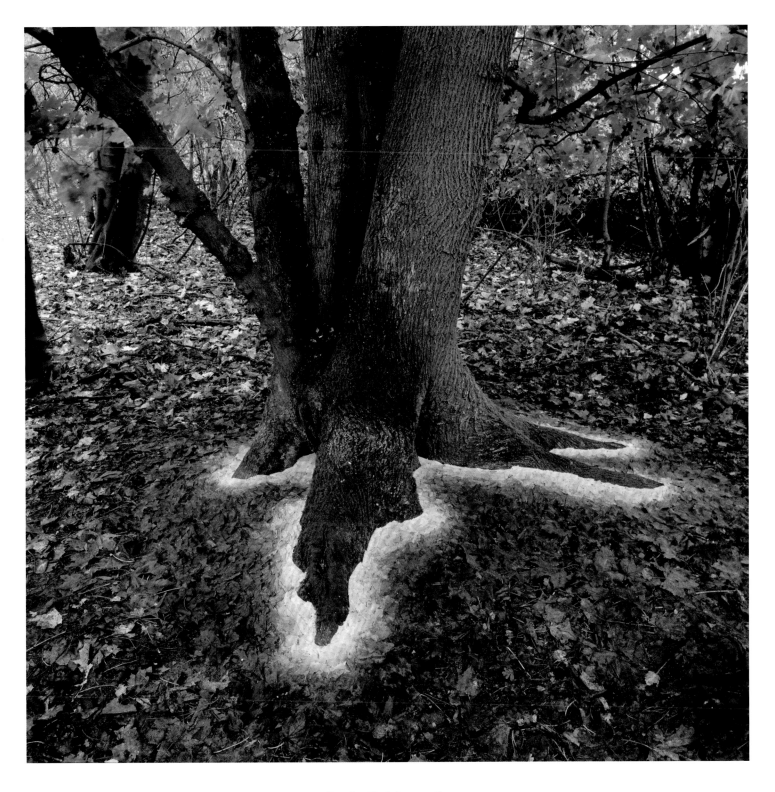

Andy Goldsworthy

Sycamore leaves edging the roots of a sycamore tree, Hampshire, 1 November 2013, 2013
Sycamore tree and leaves, installation view

A strange golden glow seems to be enveloping the base of a sycamore tree, yet despite its unearthly appearance, this image is not digitally manipulated but the document of an ephemeral artwork by Andy Goldsworthy (b. 1956) with nothing more than carefully arranged leaves. The British artist created this site-specific sculpture in an English woodland in November 2013, and as with all his works, it eventually decayed, living on only in the form of a photograph. Working primarily in the open air, Goldsworthy makes his sculptures using materials that he finds in the environment around him: twigs, stones, sand, mud, feathers, ice or, as here, fallen leaves, which he collected for their rich autumnal colours and arranged by colour gradation, from bright yellow and amber through to shades of orange and brown. Appearing synthetic but actually completely natural, the work plays tricks with our perceptions of light, space and depth. Movement, change, growth and decay are the energies that Goldsworthy attempts to tap through his art, which reflects the passage of time and highlights the transience of life. The artist has made many works with leaves, especially in autumn when the production of new chlorophyll ceases, transforming their emerald shades into a fiery array. Goldsworthy's intention is always to deepen his relationship with the landscape, not to make his mark on it or improve what he finds but to become a participant, working with nature instinctively and sympathetically in order to better understand it.

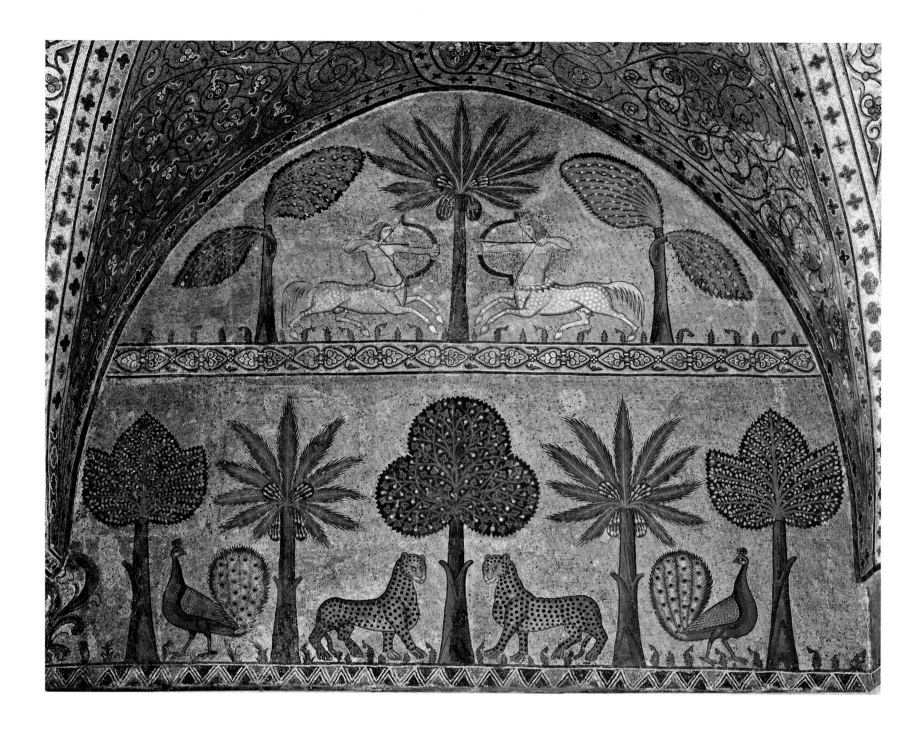

Anonymous

Mosaic in the Salle di Ruggero, 1154–66
Mosaic, W. approx. 3 m / 9 ft 10 in
Palazzo dei Normanni, Palermo, Sicily

Rendered in vibrantly hued tiles against a golden ground, this mosaic displays a date palm flanked by mythological heraldic bowmen centaurs and two lemon trees in the upper register; the lower portion shows more lemon trees and date palms, in this instance with peacocks, and two leopards on either side of an orange tree. Once upon a time, the gold backing would have gleamed, reflecting the available light, and anyone viewing it would have been reminded of the aromatic citrus groves growing in the valleys to the south of the Palazzo dei Normanni in present-day Palermo,

Sicily, where the mosaic resides. The Muslim caliphate was conquered by the Normans in the tenth century, and Roger II (also known as Ruggero; r. 1130–54) began a dynasty of unprecedented religious tolerance. Both Jewish and Muslim officials served alongside Norman Christians at the cosmopolitan court, and Roger's detractors even called him the 'baptized sultan'. The Norman kings also began a building programme that included the installation of mosaics to replicate the magnificence of the Byzantine court in Constantinople, and they imported Byzantine mosaicists

for the work. Secular mosaics had recently reemerged after centuries of adorning only churches. This mosaic was completed during the regency of Roger's son, William I (also known as Guglielmo; r. 1154–66), and it includes Persian motifs from the Sasanian dynasty (224–651 CE) – known from imported silks in the earlier Byzantine empire – and Umayyad art from North Africa. Thus, the height of medieval art – Byzantine Greek, Latin Norman and Near Eastern pagan and later Muslim art – combined in this multicultural court to create a hybrid, and very sumptuous, virtuosity.

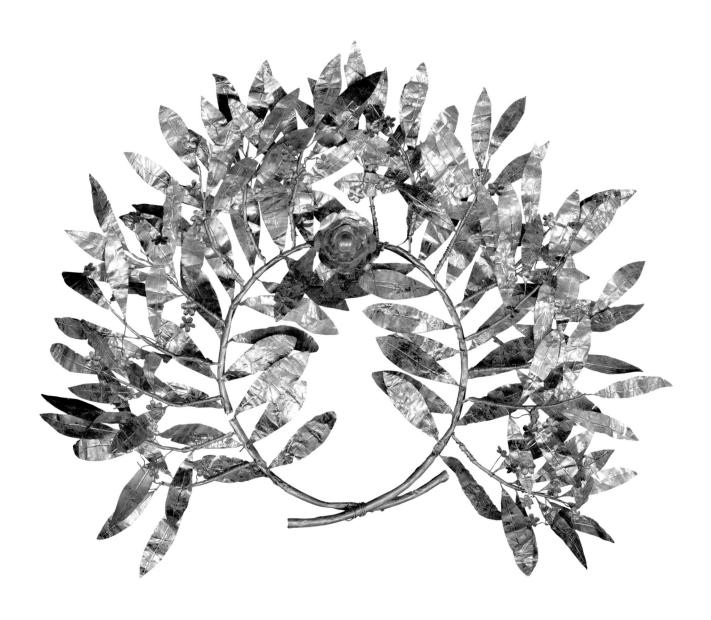

Anonymous

Myrtle wreath, 3rd or 4th century BCE
Gold sheet with repoussé and chased decoration, Diam. 38 cm / 15 in
Benaki Museum, Athens

Wreaths have symbolized power and glory in Western culture for more than two and a half millennia. Worn around the head, in the ancient Greco-Roman world they were given as prizes in athletic and poetry competitions, awarded to conquering generals and buried with loved ones as a symbol of immortality. Gold wreaths imitating myrtle leaves were particularly popular in Macedonia during the Hellenistic period (323–31 BCE), and this one, with its multi-petalled flower at the centre, may have come from there. The leaves were individually fashioned

from delicate gold sheet, with chased decoration and repoussé. Sacred to Aphrodite and as a symbol of love, ancient Greeks wore real myrtle wreaths to weddings – myrtle inferred victory in a bloodless battle – and gold versions like this one might also have been given as wedding presents. A myrtle wreath could have also implied that the wearer had been through the Eleusinian Mysteries, a secret initiation into the mystic cult of Demeter, goddess of agriculture, and her daughter, Persephone, queen of the Underworld. Other tree and plant wreaths were used

in the four series of pan-Greek games: victors at the Olympic games were crowned with wreaths of olive leaves from a sacred tree in Olympia; at the Pythian games in Delphi, successful athletes (and dancers and poets) were awarded wreaths made of laurel, sacred to Apollo; for the Nemean games at the sanctuary of Zeus, victors were crowned with celery leaf wreaths; and at Isthmia, where Poseidon ruled, winners of the Isthmian games were awarded pine wreaths.

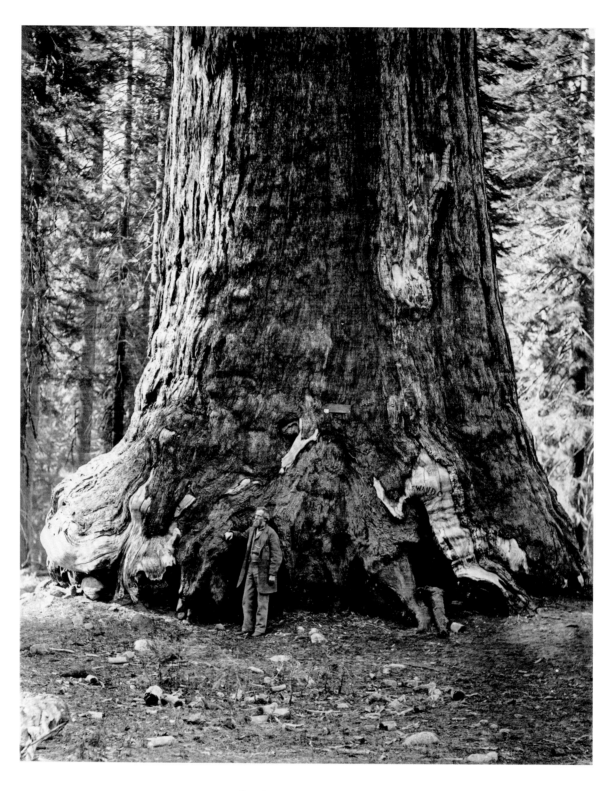

Carleton E. Watkins

Section of the Grizzly Giant, 101 Feet Circumference, 1865–66
Albumen silver print from glass negative, 33.5 × 26.6 cm / 13¼ × 10½ in
Metropolitan Museum of Art, New York

The Grizzly Giant is a famous colossal sequoia tree (*Sequoiadendron giganteum*) located in the Mariposa Grove of Yosemite National Park in California. It is one of the most majestic and oldest trees in the world, estimated to be almost three thousand years old. The tree received its name due to the rugged appearance of its bark and its massive size – it stands at an impressive height of approximately 64 metres (210 ft), with a circumference of 31 metres (102 ft). Very few trees are as storied as the Grizzly Giant. It is believed that

the tree germinated around 700 BCE, making it a living testament to the ancient natural wonders of Yosemite. It has survived numerous wildfires, storms and other natural events throughout its long lifespan and has become an iconic symbol of resilience and strength in the face of nature's challenges. When American photographer Carleton E. Watkins (1829–1916) captured this iconic photograph of the Grizzly Giant in 1864, the national park had been established for only one year. Watkins, a renowned photographer in his time, aimed to showcase the grandeur

and beauty of Yosemite through his collodion plate photographs. By including people at the base of the tree, he emphasized its immense scale. Today, the Grizzly Giant continues to stand tall and inspire awe in visitors to Yosemite National Park. It serves as a reminder of the ancient natural wonders that have captivated humans for centuries and highlights the importance of preserving and protecting these remarkable trees.

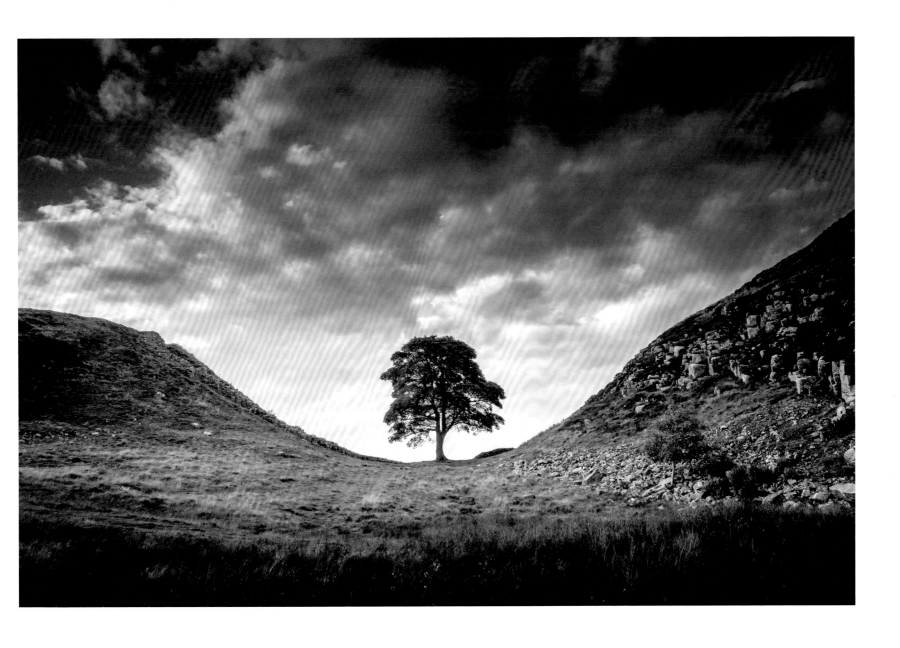

Joe Rey

Sycamore Gap, 2018
Photograph, dimensions variable

Standing for nearly 150 years, the Sycamore Gap tree was one of the most photographed trees in Great Britain, frequented by more than 1.2 million visitors to Northumberland National Park each year. This particular image of the sycamore (*Acer pseudoplatanus*) standing in a dramatic dip in the Northumbrian landscape – formed by glacial activity long ago – was taken by British photographer Joe Rey in 2018. The setting is made more memorable by its location on Hadrian's Wall, the 118-kilometre (73-mi) defensive stone fortification begun by the emperor Hadrian in 122 CE to

protect ancient Rome's British province, Britannia, from unconquered Caledonia – modern Scotland – to the north. Having been planted in the late nineteenth century by a local landowner, John Clayton, the sycamore's location made it an icon, and two years before this photograph was taken, it had been voted English Tree of the Year. Much visited, it gained international fame after it was featured in the 1991 film *Robin Hood: Prince of Thieves*, starring Kevin Costner. It sadly made headlines again in September 2023 when news spread that the tree had been felled overnight

in an act of vandalism, leaving just its stump. Seeds and cuttings were collected from the felled tree for safe storage, and it is hoped that the stump will produce new shoots in time. However, for many people the destruction of a much-loved tree became an embodiment of the increased destruction of forests and trees around the world and the urgent need to enact protections for them.

Arata Kubota

Slice of Heartland, 2015
Silk-screen prints, each 72.8 × 51.5 cm / 28½ × 20¼ in
Private collection

In 1986 the Heartland bar opened in the Roppongi neighbourhood of Tokyo, Japan. While the bar itself may be long gone – it closed after flourishing during the 1990s and early 2000s – its eponymous beer, made in collaboration with the Kirin Brewing Company, remains highly popular. Still offered in a hundred restaurants and bars across Japan, its distinctive emerald-green bottle embossed with a large tree and roots – designed by famed graphic designer Ray Yoshimura – has gained a cult following. To celebrate three decades of the beer, a group of designers

under the direction of art director Arata Kubota (b. 1981) created a three-dimensional replica of the famous tree logo. It was then sliced into a hundred cross sections – one for each of the bars and restaurants that sold the beer – that, in turn, became the basis of a hundred hand-drawn posters, each of which was framed and given out to the individual establishments. Once all hundred cross sections were finished, they were photographed individually and brought together to make a stop-motion animation, showing how the tree was assembled one section at a

time. Entitled *Slice of Heartland*, this painstaking project took eighteen months to complete – which was somewhat ironic given that Kubota initially rejected the option of hand-drawing the posters as being too time-consuming. The care and precision used to make the posters was a fitting homage to the devotion Heartland beer continues to inspire among its supporters.

Steve Gschmeissner

Lime Tree Stem, c.2010
Light micrograph, dimensions variable

This veritable kaleidoscope of colour represents a cross section of the stem of a lime tree magnified thirty times. At the centre, the white pith is clearly visible; radiating from it are the stem's constituent layers, each a different colour, from the outer bark to the layer of wood (xylem) surrounding the pith. Each of these differently coloured layers is clearly defined and can be easily seen thanks to the work of British-born photographer Steve Gschmeissner. Using a scanning electron microscope (SEM), the prolific Gschmeissner, a world leader in using the technology, produces highly magnified black-and-white images of tiny specimens that range from bacteria to hard-to-access cancer cells. His skill lies in using colour to bring the images to life. Having taught himself to use Photoshop, Gschmeissner colours each SEM rendering individually to create images that combine scientific advancement with art and photography. In a long career that began at London's Royal College of Surgeons, Gschmeissner has created more than three thousand pictures, largely of microscopic cells. The lime tree, of the family *Tilia*, is largely considered an ornamental tree, providing extensive shade as well as foliage, and is known for its fragrant flowers and soft bark. It was particularly fashionable in seventeenth- and eighteenth-century England, where many country house gardens contained a lime walk. The practice was imported from northern Europe, where the most famous of all lime tree walks, Unter den Linden in Berlin, was first planted in 1647.

Keith Haring

Tree of Life, 1985
Acrylic on canvas, 3 × 3.6 m / 10 × 12 ft
Private collection

This vibrant and dynamic artwork by renowned queer Pop artist Keith Haring (1958–1990) is a powerful representation of life, filled with pulsating lines and biomorphic shapes that exude vitalist energy. Haring, known for his impressive contributions to the modern street-art culture of the early 1980s, crafted a highly original aesthetic language that merged the influences of punk and Pop art with sociopolitical themes. *Tree of Life* stands as an affirmation and celebration of life itself, with its depiction of joyous and diverse figures in a continuously flowing network. As one of Haring's most groundbreaking pieces, it has become an iconic symbol in contemporary art, emphasizing the importance of unity and diversity. Created with acrylic on canvas, the boldly coloured piece echoes Haring's love for the work of such popular culture icons as Walt Disney, Charles Schulz and Dr. Seuss (see p.65). But the roots of its main theme reach deeper into the artist's involvement in the Jesus movement, a 1970s Christian group that introduced him to the power of art as a medium for social and political commentary. The tree of life is a recurring symbol in various religions and cultures around the world and holds significant spiritual importance. It represents the interconnectedness of all living beings and the cycle of life, death and rebirth. In many religions and mythologies, the tree of life is believed to be the bridge between the earthly and spiritual realms, serving as a source of nourishment, wisdom and immortality. It is often depicted with branches reaching towards the heavens and roots extending deep into the earth, symbolizing the connection between the divine and the underworld.

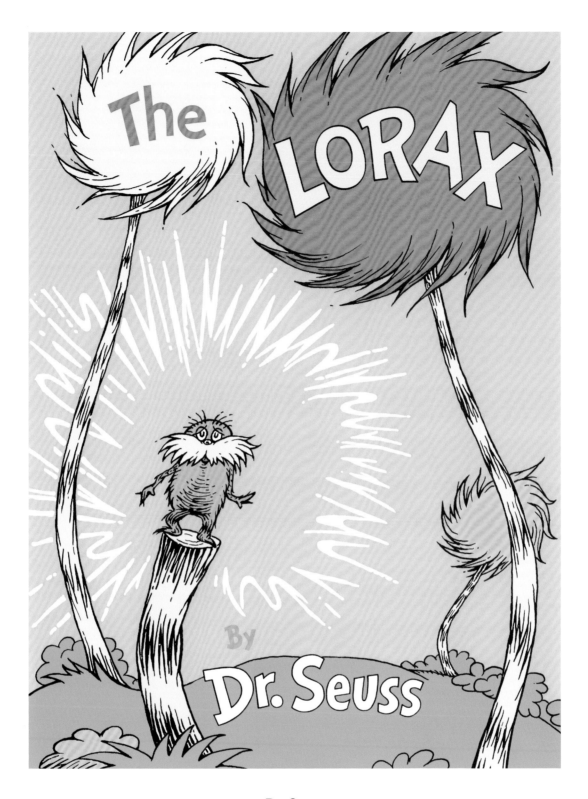

Dr. Seuss

The Lorax, 1971
Printed book, 27.9 × 21.6 cm / 11 × 8½ in

Perhaps the most recognizable children's author of all time, Theodor Seuss Geisel (1904–1991), better known as Dr. Seuss, wrote and illustrated more than sixty books, selling six hundred million copies in his lifetime alone. Seuss created a wholly unique style in which all his stories were told in rhyme, his buildings lacked straight lines, and his figures were regularly rounded and droopy. He created complex imaginary worlds filled with colourful characters, fantastical plants and animals, and outlandish machines. Geisel adopted his pen name – a combination of his father wishing him to be a doctor and his middle name – while studying at Dartmouth College as an undergraduate. In the late 1920s, he began a career as a cartoonist for several magazines, including *Life* and *Vanity Fair*, and illustrated a number of successful commercial advertising campaigns. His first book was released in 1937, and he published one nearly every year after, except during World War II, when he worked in the US Army's animation and film department. A personal favourite of Geisel's, *The Lorax* (1971) is a cautionary tale against rampant consumerism and the exploitation of natural resources. A businessman called the Once-ler arrives in the beautiful Truffula forest and, ignoring the protestations of the Lorax – who speaks for the trees – cuts them down to feed into his factories. The Once-ler continues, filling the land with pollution until there are no trees left and his business can no longer operate. The story reflects Geisel's strong views on environmental protection and was intended to inspire activism at a young age. At the end of the book, a single surviving Truffula seed, from which a new forest can grow, signals Geisel's hope for a better world.

The following Latin inscriptions appear within the image: "arbor in qua mundia nubuquodo noter sublemon ueftoburaum lncutur rum comouturur ub&egli", "fenumuaborcomalo.", "nubuquodonoror&bur puecourueludbor"

Maius

Saint Jerome's Commentary on Daniel, c.940–45
Pigments on vellum, 38.5 × 28 cm / 15¼ × 11 in
Morgan Library and Museum, New York

'The tree that Nebuchadnezzar saw is high and strong, in whose branches the birds of heaven are committed.' Thus reads the medieval Latin inscription above the fruit tree in this illustration from the Book of Daniel by a Spanish monk named Maius (d. 968 CE), who acted as both scribe and illuminator. Maius worked in the tower scriptorium at San Salvador de Tábara, in northwest Spain, though the manuscript was probably commissioned by the abbot of San Miguel de Moreruela, a nearby monastery. The inscription above the ox reads, 'I ate hay like a cow', and that above the naked man eating leaves reads, 'Nebuchadnezzar grazing grass like a cow'. The Book of Daniel is a second-century BCE biblical prophecy with a sixth-century BCE backdrop. Chapter four relates the king of Babylon's dream of madness. Nebuchadnezzar describes a dream in which an enormous tree is abruptly cut down on the order of a messenger from God. Daniel is sent for and asked to interpret the dream. He deduces that the tree is Nebuchadnezzar himself, who will go mad and live like a wild beast for seven years. This comes to pass until, at the end of the seven years, Nebuchadnezzar acknowledges that God rules all, and his empire and reason return. Saint Jerome's commentary on Daniel is frequently attached to Beatus of Liébana's commentaries on the apocalypse, as both contain visions of a biblical apocalypse. The first six chapters of the Book of Daniel comprise tales relating to Nebuchadnezzar, Balthazar, the fiery furnace and Daniel in the lions' den, while chapters seven through twelve relate apocalyptic visions.

Harry Bertoia

Untitled (bush form), c.1970
Welded copper and bronze with applied patina, 42 × 42 × 29 cm / 16½ × 16½ × 11½ in
Private collection

Standing around 42 centimetres (16 in) tall, this tiny green tree or bush form, with its tightly packed branches radiating out from a large hole, is the work of Italian-born American designer Harry Bertoia (1915–1978). Better known for his airy steel-framed Diamond Chair, which appeared in 1952, Bertoia welded this sculpture from copper and bronze, finishing it with an applied patina. The inspiration for his series of bushes and trees, which he started to make in the 1970s, was the 80-hectare (200-acre) virgin forest that surrounded his home in Pennsylvania. But it was Bertoia's

childhood in Italy that inspired him to work with metal; the skills of the Romany who visited his town to work pots and pans into shape stayed with Bertoia after he arrived in Detroit, Michigan, in 1930 at the age of fifteen. After high school, Bertoia studied art and design, and received a scholarship to the renowned Cranbrook Academy of Art, where he met Walter Gropius, Charles and Ray Eames, and Florence Knoll. Ironically, his metalworking only took off when he moved to Pennsylvania in 1950 and went to work for Knoll, a primarily wooden furniture company.

Knoll did not have a metalworking division, so Bertoia worked with the only material available – wire – and the Diamond Chair was born. From that initial fascination, he experimented: his output included silver brooches, dandelions, bronze furniture and chapel altarpieces. With the financial security the Diamond Chair brought him, by the mid-1950s Bertoia devoted himself to his sculptures, interpreting the nature that surrounded him and making his bush and tree forms from copper and bronze, each one entirely unique.

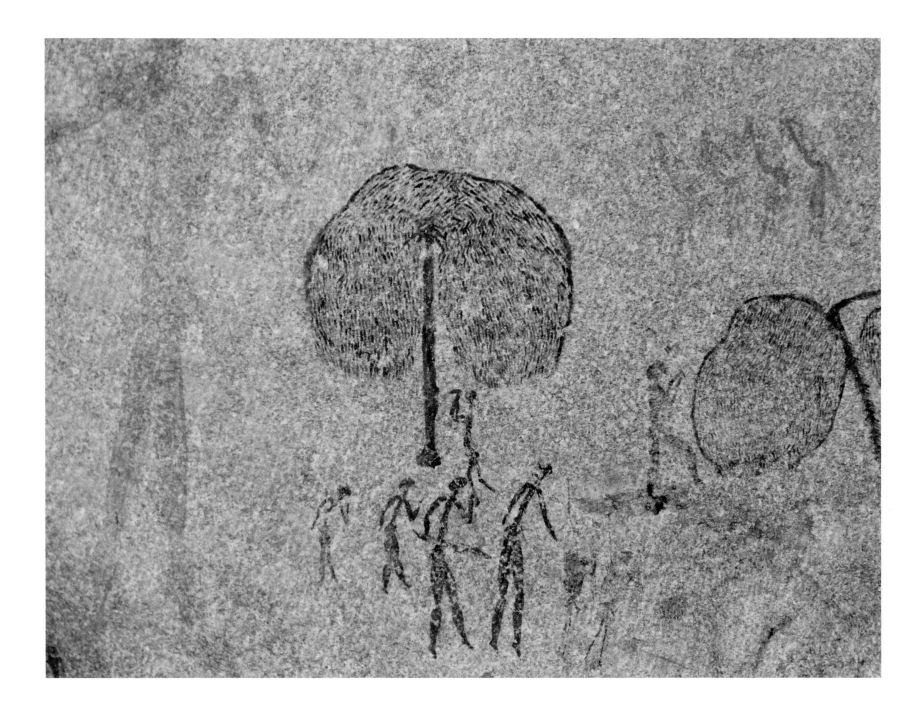

Anonymous

Rock painting, before 1st century CE
Pigment on rock
Bushman's Point, Lake Chivero National Park, Zimbabwe

Thought to have been painted at least 2,000 years ago on a rocky surface in present-day Zimbabwe, a small figure at the centre of the scene takes a bladed tool to hack away at the trunk of a magnificent tree in full foliage. Unusually, this tableau shows what appears to be a sequence of activities in the daily life of the ancient inhabitants of the region: next to the tree being felled is a fallen trunk, either the same tree after the axe has completed its work or another tree previously felled, probably for firewood or to build shelters. Also depicted

across the scene are a number of figures in the same rust red colour, including a large, faded hunter figure at the left, four smaller elongated figures in the centre and five apron-wearing dancing women at the top of the image. The painting belongs to a remarkable assemblage of rock art drawn by Indigenous hunter-gatherers at Lake Chivero, now a reservoir that supplies the Zimbabwean capital, Harare, with its drinking water. While dating the rock art throughout Zimbabwe has proved extremely difficult, archaeologists continue to discover previously

unknown sites in the granite hills of the landlocked country, often showing people engaged in everyday activities such as hunting, walking and dancing. Native animals also feature predominantly, and in some of the paintings there are complex group scenes of both people and animals. Representations of flora are relatively rare, however, making this image all the more significant.

Anonymous

The Tree of Ténéré, c.1961
Photograph, dimensions variable

For more than three hundred years, weary travellers moving with camels across the vast, inhospitable sand dunes of Ténéré – a desolate part of the Sahara in northeast Niger – were guided by a distinctive landmark: a solitary acacia, thought to be the most isolated tree on Earth. Acacias are commonly found across Africa, but this particular tree was the only living thing in a radius of 400 kilometres (250 mi). The Ténéré tree stood on many of the caravan routes that crossed the Sahara, a reminder of a time when there was water in the region. By the 1930s, the acacia was beginning

to wither, although it was still capable of producing flowers and green leaves. Its longevity was due to its extensive root system: analysis showed that its roots extended more than 30 metres (100 ft) beneath the sand as they searched for the water table in a region that receives less than 25 millimetres (1 in) of rain per year. When this image was captured by an unknown photographer around 1961, the tree had visibly deteriorated to a leafless thorn tree after being hit by a truck two years earlier; one of its two trunks was now a stump. The tree's death knell sounded in 1973,

when a drunk truck driver knocked it down. The tree's remains were removed and are now housed in the National Museum in Niamey, the capital of Niger. To commemorate the spot where the loneliest tree stood, an anonymous artist erected a metal sculpture in its honour.

Anonymous

Angel Oak, Johns Island, Charleston, South Carolina, 2006
Photograph, dimensions variable

With its lichen-covered twisting and gnarled branches, some of which graze the ground and others of which have burrowed underground, this ancient southern live oak (*Quercus virginiana*) is the largest example found in North America east of the Mississippi River. Located on Johns Island outside Charleston, South Carolina, the so-called Angel Oak might be more than four hundred years old. The tree has become a popular tourist attraction, drawing as many as four hundred thousand tourists each year. Considered to be the crown jewel of evergreen oaks, this broad-spreading tree is found along the coastal areas from Virginia to Texas. Measuring 20 metres (65 ft) tall, the Angel Oak's longest branch has a reach of 57 metres (187 ft); the tree's canopy is so wide that it produces a shade cover of 1,600 square metres (17,200 sq ft) when in full leaf. As befits any tree in the humid southern United States, the oak's branches are adorned with Spanish moss, lichen and ferns, and the tree's habit also makes it well equipped to surviving hurricanes. Now a national monument owned by the city of Charleston, the Angel Oak stands on land that originally belonged to Indigenous Cusabo communities. In 1717 the land became the property of a colonist named Abraham Waight, whose daughter Martha married Justus Angel, from whom the oak gets its name. The property was a slave-owning plantation, and stories are still told of the ghosts of the enslaved who gather beneath the Angel Oak's huge branches, their spirits protecting the tree. The magnificent oak was named a 2000 Millennium Tree and a South Carolina Heritage Tree in 2004.

Kerry James Marshall

Untitled (Vignette), 2012
Acrylic and glitter on PVC panel, 1.8 × 1.5 m / 6 × 5 ft
Private collection

A grove of trees, in full leaf and wreathed in flowering vines, silently stand witness to an ordinary, if not beautiful, everyday human experience: a young Black couple lies entwined in a passionate embrace within an idyllic environment, hearts floating above them to become musical notes in birdsong. The romantic scene is one of numerous paintings in the 'Vignette' series by American artist Kerry James Marshall (b. 1955). The series, which began in 2003 and still continues, seeks to challenge the traditional absence and erasure of Black figures in Western art and defy cultural expectations by portraying Black couples in love rather than in scenes of violence or tension. Inspired by Jean-Honoré Fragonard's late-eighteenth-century cycle of paintings *The Progress of Love*, the vignettes make reference to the flamboyance of French Rococo painting, with flourishes of glitter, floral motifs and a strong sense of theatricality. Marshall's distinctive style often manifests in ambiguous scenes in which beauty is bold and yet perhaps fleeting, and where symbols insistently flicker into unstable domains. The tire swing dangling from a branch simultaneously invokes the joyful playfulness of childhood and horrifying history of lynching in America. In this way, the trees are particularly important in the vacillating narrative, representing the long memory a single location can hold. Since the late 1970s, Marshall has dedicated his career to confronting the marginalization of African Americans in art. Celebrating the history of Black identity, his representational paintings exclusively feature people of colour, creating a new vocabulary of such imagery within art history and visual culture at large.

Dimitar Glavinov

Carved tree trunk, 2023
Photograph, dimensions variable

Carved into a tree trunk, the bark covered with moss and lichen, are three hearts with the initials of anonymous lovers permanently etched inside. Captured by the Bulgarian photographer Dimitar Glavinov somewhere in the English countryside, the photograph depicts the millennia-old tradition of arborglyphs, or tree writing. In ancient Rome, the poet Virgil wrote in *Eclogues* in the mid-first century BCE: 'Resolved am I in the woods, rather ... character my love upon the tender tree-trunks: they will grow, and you, my love, grow with them.' In William Shakespeare's play

As You Like It (1599), Orlando declares his love for Rosalind by writing on the bark of trees. Leaving a lasting mark on a tree – usually the initials of lovers and friends – has long been seen as a way to symbolize the strength and permanence of a relationship and the way in which it grows. Unlike other forms of graffiti, tree carving cannot be erased or cleaned. Over time, the bark heals in a similar way to skin, but a scar remains. When the bark's protective layer is cut open, however, it can expose the trunk to potential infection. Cell damage may occur if the cut is deep enough,

and in extreme cases, the tree starves to death because of the disruption caused to its nutrition system. Since fungal networks link many trees underground, disease can also spread from one tree to another. The potential for such damage is a largely unseen consequence of the romantic impulse that led to the initial carving of the bark.

Ryuichi Yamashiro

Forest, 1954
Silk-screen print, 104.1 × 73.6 cm / 41 in × 29 in
Museum of Modern Art, New York

This bold, monochrome silk-screen print by Japanese graphic designer, artist and illustrator Ryuichi Yamashiro (1920–1997) is not what most would immediately recognize as a forest. Intended to promote tree planting and condemn deforestation, Yamashiro's forest is not made up of roots, bark and leaves but of kanji characters from one of Japan's three alphabets. Consisting of Chinese characters introduced to Japan in the fifth century via Korea, each kanji character is an ideogram, meaning that it functions both as a symbol with its own meaning but also as a character that

can be combined with others to make words. Officially, the kanji alphabet has 2,136 characters, but in reality there are many more. For the purposes of this print, Yamashiro took the kanji character for tree, *ki* – which has a tall 'trunk' and side strokes resembling branches – and used it as the basis of his image. From there, he multiplied the character to fill the paper with different combinations of trees. In so doing, he set down various collections of trees: two tree kanji characters make the word *hayashi*, which means 'woods'; three tree kanji characters make the word *mori*, which

means 'forest'. By combining two kanji characters of two and three trees, he added 'woodland' (*shinrin*) to his forest. The pictorial quality of the kanji characters is enhanced by Yamashiro's skilful placement of different sizes and thicknesses to create a dense typographic forest, which is forced into stark perspective by the white space at the bottom of the image.

Myoung Ho Lee

Tree #12, 2008
Archival inkjet print, dimensions variable
Private collection

A solitary tree emerges from an icy winter landscape, the snow-covered ground and pristine white backdrop throwing its knotted and twisted trunk into the foreground. In his contemporary version of nineteenth-century studio portraiture, South Korean artist Myoung Ho Lee (b. 1975) takes the plain photographic backdrop out of the photographer's studio to take 'portraits' of the natural world. For his celebrated 'Tree' series, Lee photographs an individual tree with all the props and support equipment needed to hold up the backdrop before digitally removing all the extraneous objects. Leaving just the tree and the stark backdrop, he creates an elegant portrait of the natural world in which the tree is both of the countryside and the studio. The final image is simultaneously artificial and real: the tree's foliage is shown in sharp detail but also appears flattened against the backdrop, creating a tension between the traditional artistic genres of landscape and portraiture. In this image, removing so much of the context also removes any references for scale – the tree could be fully grown, towering above the viewer, or it could be a miniaturized bonsai. By placing trees at the centre of his photographs, Lee imbues each individual plant with the same character as masters of portrait photography, such as Irving Penn and Richard Avedon, who both relied on the plain backdrop to showcase their work. As Lee says, 'It's as if the tree unites all: the ground, the sky and man in between... Since a tree connects all three, I feel very much that a tree is like a universe.'

Nellie Mae Rowe

Birds Under the Lemon Tree, undated
Coloured pencil and ink on paper, 44.5 × 30.5 cm / 17½ × 12 in
Private collection

A cluster of oversized yellow fruits dominates this joyful painting of birds sitting under a lemon tree in a garden. The work of American artist Nellie Mae Rowe (1900–1982), it is typical of the colourful works for which she is best known. Self-taught, Rowe painted everyday subjects alongside her dreams and fantasies. In part, this was a response to her upbringing. The daughter of once-enslaved parents in rural Georgia, her early life was marked by segregation and oppression. Denied a normal childhood because she had to pick cotton in the fields, Rowe turned her adult home and garden into what she called her Playhouse, which she filled with found objects such as dolls, beads, bottles, stuffed animals and artworks. *Birds Under the Lemon Tree* captures a garden and a landscape of colour and activity beyond the green picket fence; the perspective suggests she painted the tree looking up from the ground. Of her childhood, Rowe said, 'I didn't have a chance to draw like I do now, and every chance I had, I would get my pencil, get down on the floor and draw until they said, "Nellie, let's go."' Living in the same house in Georgia for more than forty years, Rowe was determined that her art would be as colourful and filled with happiness as her home and garden, in a deliberate rejection of the oppression of her childhood as a Black American growing up during segregation. Rowe fiercely took control of her own narrative, painting herself, her friends, her neighbours and other members of her Black community in scenes of joy and beauty, something rarely seen in art at that time.

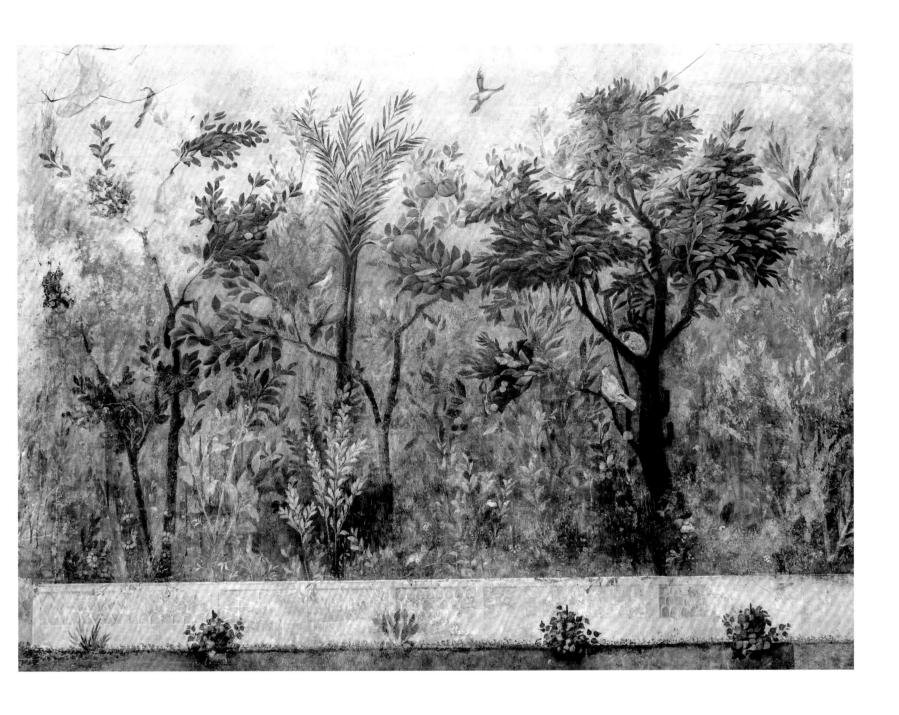

Anonymous

Garden Room fresco (detail), from the Villa of Livia, c.30–20 BCE
Fresco, overall length approx. 11.7 m / 38 ft 5 in
Museo Nazionale Romano di Palazzo Massimo alle Terme, Rome

Exotic birds twitter in the trees of a garden so realistic that individual species of birds, trees, plants and flowers can be identified – but in this paradisiacal garden, all fruits are ripe at once, and spring, summer and autumn flowers bloom at the same time. Here, the autumn-ripening quince (*Cydonia oblonga*) and the fruits of the strawberry tree (*Arbutus unedo*) shade summer-flowering yellow daisies and the evergreen laurel (*Laurus nobilis*). The Villa of Livia (known during its occupancy as Ad Gallinas Albas, the House of the White Hen) was located in Prima

Porta, a suburb north of Rome. The villa is famous for the frescos in its semi-subterranean summer *triclinium*, or dining room. They also symbolize the preferred political portrayal of the reign of Rome's first emperor and Livia's second husband, Augustus. Following decades of civil strife, the emperor wanted his reign to be regarded as a golden age with a return to traditional Roman values and morals. This illusionistic garden offered a picture of tranquillity, prosperity and abundance. According to Pliny the Elder, when Livia and Augustus were betrothed, an eagle

dropped a white hen into her lap with a laurel branch in its beak. The laurel was a symbol of peace and victory associated with Apollo and was also, being evergreen, linked with virtue and immortality. Livia planted the branch, which grew into a full grove of laurel on the estate and is the most ubiquitous plant in the garden fresco.

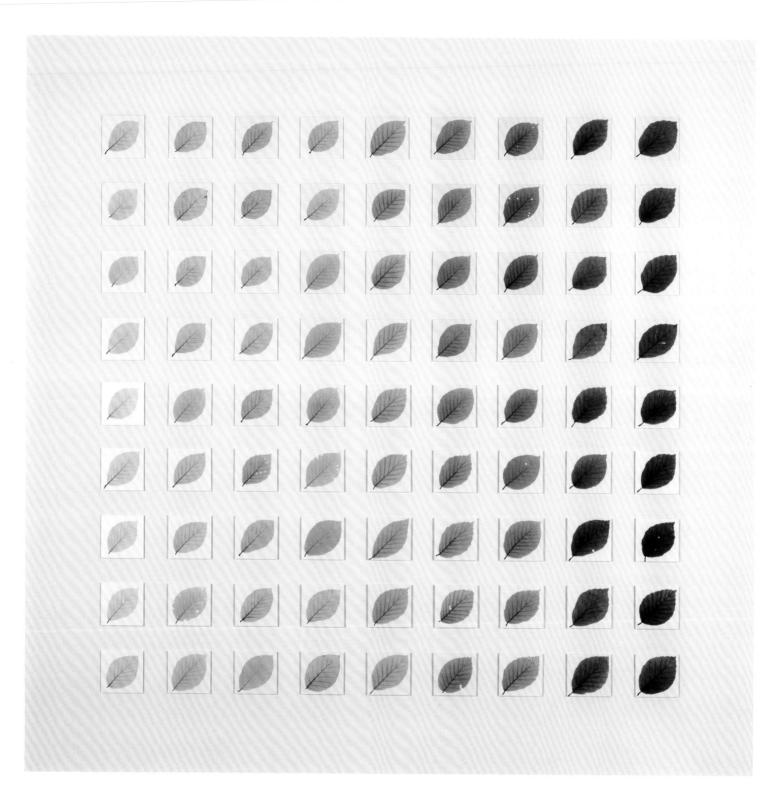

Gary Fabian Miller

Breathing in the Beech Wood, Homeland, Dartmoor, Twenty-Four Days of Sunlight, 2004
Dye destruction prints, 1.6 × 1.6 m / 5 ft 4 in × 5 ft 4 in
Victoria and Albert Museum, London

Eighty-one beech leaves are carefully arranged like objects of scientific study in this photographic print, revealing their delicate structures and vibrant green hues. A pioneer of contemporary camera-less photography since the early 1980s, Garry Fabian Miller (b. 1957) created this leafy grid entirely in his darkroom without the use of cameras or film. The British artist spent twenty-four days gathering leaves from Dartmoor in southwest England and inserted each one into a photographic enlarger where negatives or transparencies would normally be placed.

Using a method recalling the earliest days of photography, he shone light through the leaves, projecting and record-ing the individual leaf images directly onto photosensitive paper. Fabian Miller's photographic experiments exploring the subjects of time, light and colour are informed by his daily walks in Dartmoor's windswept moorland and ancient forests. This piece represents his return to work-ing with nature after a period spent exploring abstract imagery. The beech (*Fagus sylvatica*) is one of Britain's largest trees and, alongside oak, is a dominant species in

Dartmoor, with some trees known to have lived for more than three hundred years. In spring, its leaves gradually change from a bright, light green to a deep emerald as chlorophyll levels increase – a phenomenon reflected here by the gradation of colour across the grid's horizontal rows, just as photography similarly relies on the transformative power of light.

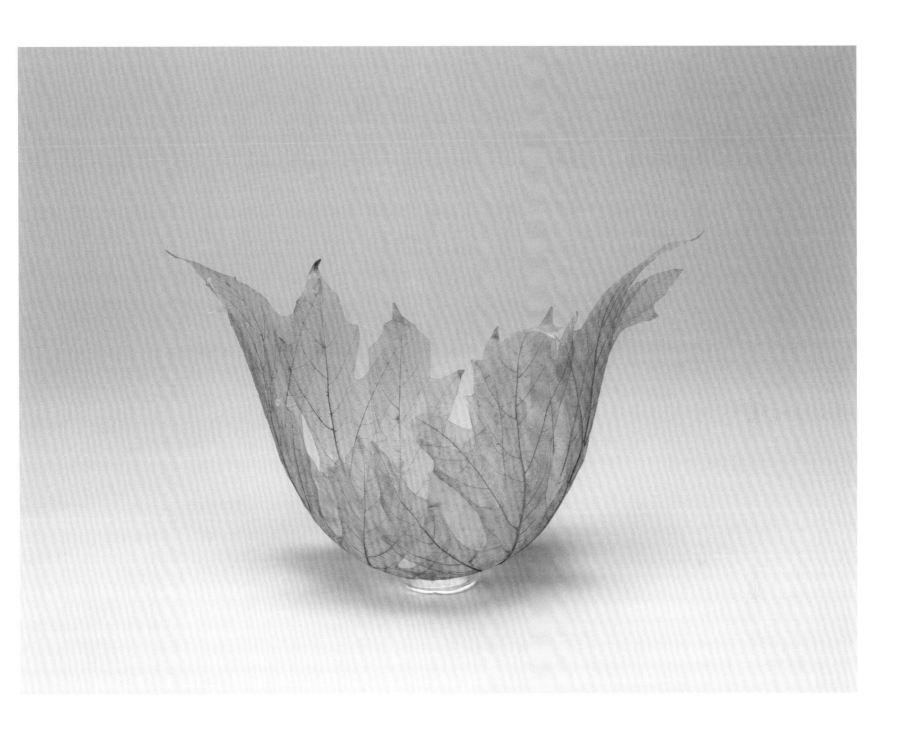

Kay Sekimachi

Leaf Vessel, c.2012
Bigleaf maple leaves, kōzo paper and watercolour, Diam. approx. 15.2 cm / 6 in
Smithsonian American Art Museum, Washington DC

Delicate, fragile and uniquely elegant, this vessel is crafted from the dried, skeletal leaves of a bigleaf maple tree *(Acer macrophyllum)*. Radiating upwards from a rounded base, the curving and overlapping leaves have been skilfully shaped by American fibre artist Kay Sekimachi (b. 1926) into a form evoking a blooming flower. Leaf skeletons have been used decoratively for centuries, as far back as the Ming dynasty (1368–1644) in China, but they didn't become popular in the West until the nineteenth century. The skeletons are created by a simple process in which the leaf tissue is removed without damaging the lacy network of veins, leaving a ghostly, intricately patterned form. Sekimachi is celebrated as a pioneer of fibre art and a skilled weaver, coming to prominence in the 1970s with her three-dimensional woven monofilament hangings. Drawn to unconventional materials in the creation of her ethereal works, she has experimented with wasps' nests, shells and antique Japanese paper, each of which she manipulates into new forms through processes of weaving and meshing. For this and similar vessels, Sekimachi reinforces the pale green and golden orange leaves with Japanese mulberry paper and light applications of paint. Looking to her familial heritage, Sekimachi finds much inspiration in the history and culture of Japan, where maple trees are considered a symbol of grace and associated with peace and serenity. Showcasing the organic beauty of the maple leaf's complex structure, her refined vessels emphasize the sculptural qualities of the material as well as its fragility.

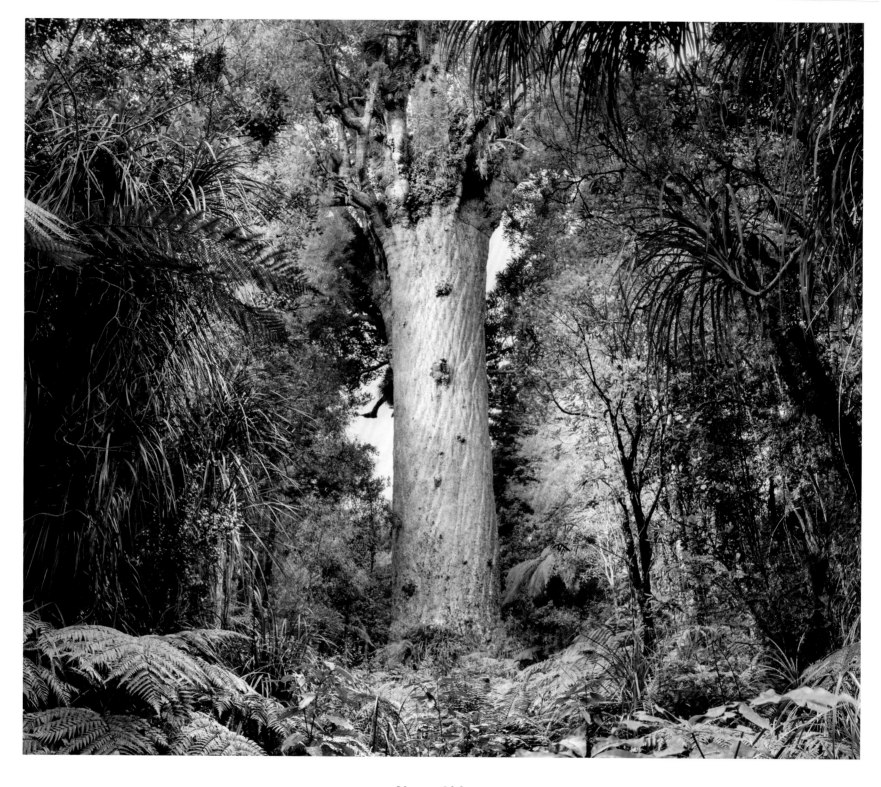

Nazar Abbas

Tāne Mahuta, Northland, 2016
Photograph, dimensions variable

Fringed by the foliage of forest trees in New Zealand, the thick grey trunk of Tāne Mahuta, a giant kauri tree (*Agathis australis*), dominates this image by Auckland-based landscape photographer Nazar Abbas. The photograph is a fitting tribute to a tree revered as the God of the Forest that is found in the Waipoua Forest on the west coast of the North Island's Northland region. Like many trees of New Zealand, the kauri is endemic, meaning it grows natively only on these islands and nowhere else. Kauris are, in fact, conifers, and while they are not the

tallest of New Zealand's trees, kauris still attain lofty heights of 50 metres (165 ft) and are by some measurements the largest in terms of volume. Undoubtedly, though, the God of the Forest is very old: estimates suggest it may have been growing for up to two thousand years. The largest living kauri tree still standing, Tāne Mahuta was revered and named by the Māori – the original inhabitants of New Zealand who came to these islands in canoes from distant Pacific shores – after the god of forests and birds, Tāne. This particular tree has survived centuries of

intensive felling following European colonization that had destroyed more than 90 percent of kauris by the start of the twentieth century. However, today it and the other surviving kauri trees face a new threat: kauri dieback disease, a soil-born fungus that attacks the tree's roots and is easily spread, largely by the boots of unsuspecting hikers. Estimates suggest that as many as one in five of the remaining kauri trees are now infected. Currently, a strict boot-cleaning policy for hikers is attempting to halt the disease and protect the remaining trees.

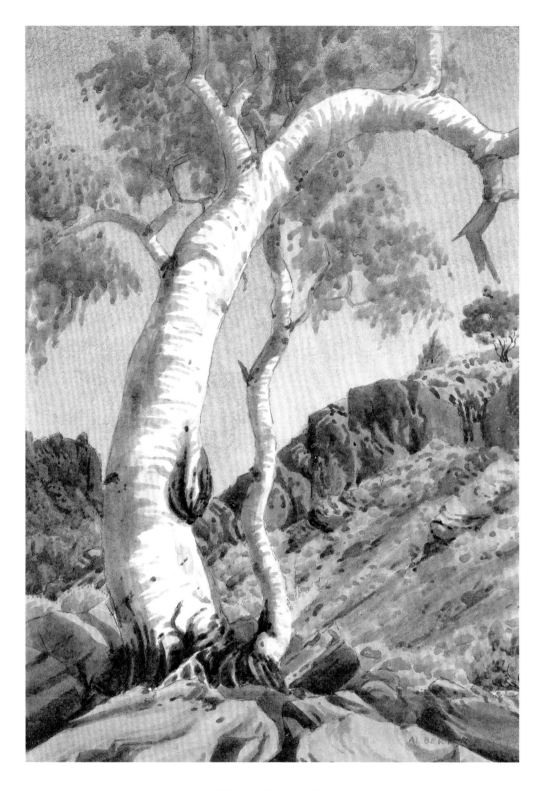

Albert Namatjira

Ghost Gum, MacDonnell Ranges, Central Australia, c.1945
Watercolour over pencil, 37 × 25.3 cm / 14½ × 10 in
National Gallery of Victoria, Melbourne

With its distinctive white bark, the ghost gum tree (*Corymbia aparrerinja*) of central Australia is aptly named. Found on the arid, rocky slopes, sand flats and dry creek beds of the MacDonnell Ranges in the far south of Australia's Northern Territory, the ghost gum typically features smooth bark and curved leaves. The tree has a long connection with Australia's Indigenous community and the cultural and religious beliefs that guide them. Here, Indigenous artist Albert Namatjira (1902–1959) paints a ghost gum against a rocky outcropping, its sturdy trunk curving upwards from its roots. In closely observed detail, the gleaming bark is splashed with pale yellow and horizontal grey stripes, marked by the passage of time and brutal weather, its feathery green foliage contrasting with the pale blue sky. Illustrating the tree's exposed roots as they search for water, Namatjira's Western-style watercolour succinctly captures the supreme effort required by the ghost gum to survive in such a harsh environment. Namatjira's landscapes portray the Australian Outback and the relationship he had with the Arrernte country, particularly the Western Lands, of which he served as a custodian. Born and raised at the remote Hermannsburg Lutheran Mission southwest of Alice Springs, he was already an accomplished craftsman before he began to paint seriously at the age of thirty-two. Under the guidance of Australian artist Rex Battarbee, he was introduced to Western traditions at an exhibition held in the mission in 1934. Long ignored by the mainstream Australian art world, Namatjira is now acknowledged as one of the country's outstanding artists, whose depictions of the Outback – long considered to be an 'empty' territory – have introduced the landscape and its trees to a new audience.

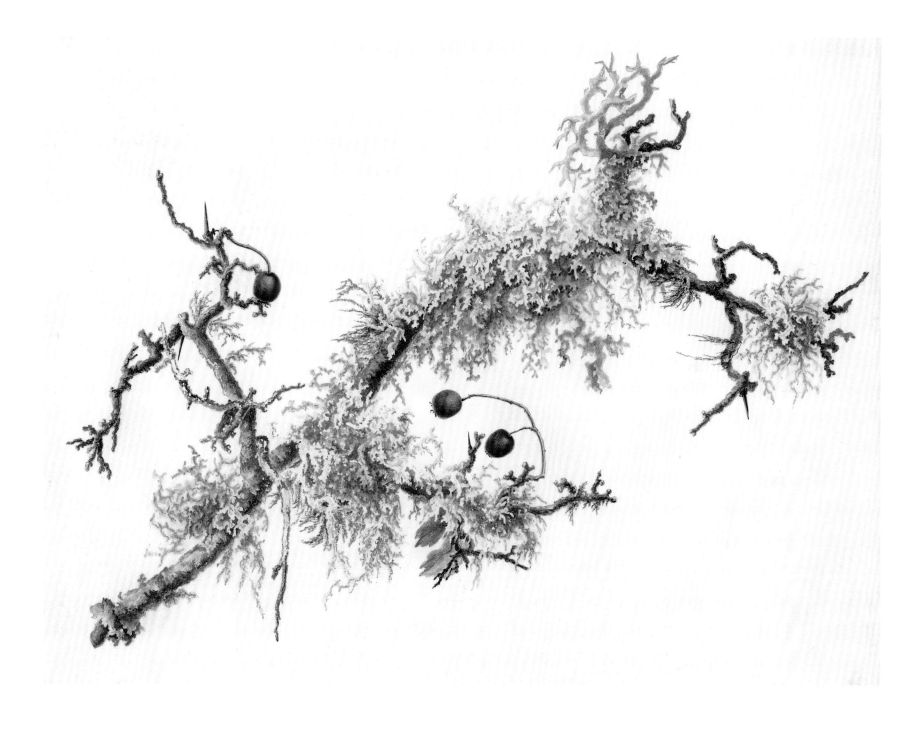

Augusta Smith

Crataegus monogyna with Lichen, c.1780
Watercolour on vellum, 22.5 × 28 cm / 8¾ × 11 in
Royal Horticultural Society, Lindley Library, London

Delicate tufts of pale green lichen envelop a branch of haw-thorn (*Crataegus monogyna*), identifiable by its distinctive red berries. A fascinating life form, lichens are actually composite organisms, each formed by the partnership of a fungus and an alga coexisting in a symbiotic relationship. The alga uses photosynthesis to produce food for the fungus, while the fungus provides shelter to the alga. Often found on the bark and branches of trees, lichens are nonparasitic, meaning they do not harm their hosts but rather support biodiversity as both food and a home for insects. Lichens come in all shapes,

sizes and colours thanks to the dominant characteristics of the fungus and can be found in every biome on Earth, even adapting to the most extreme climates. Here, however, the lichen makes its home in the English countryside, where the hawthorn is a hedgerow staple and the appearance of its blossom – frothy clusters of highly scented white-pink-red flowers – signals spring's transition to summer, typically in May. The distinctive red berries, or 'haws', that adorn its thorny bushes appear in autumn and provide food for birds into the winter months. Symbolizing rebirth, the tree is a

pagan symbol of fertility long associated with May Day, but according to English mythology, hawthorn blossoms are also linked to sickness and death and should never be taken into the home. This superstition is well-founded: the distinctive odour of its flowers is produced by trimethylamine, one of the first chemicals that forms in the decaying tissue of dead animals. Little is known of the artist, English painter Augusta Smith (*c.*1772–1845), but the watercolour was collected by the philanthropist Reginald Cory, a leading member of both the Royal Horticulture Society (RHS) and the Linnean Society.

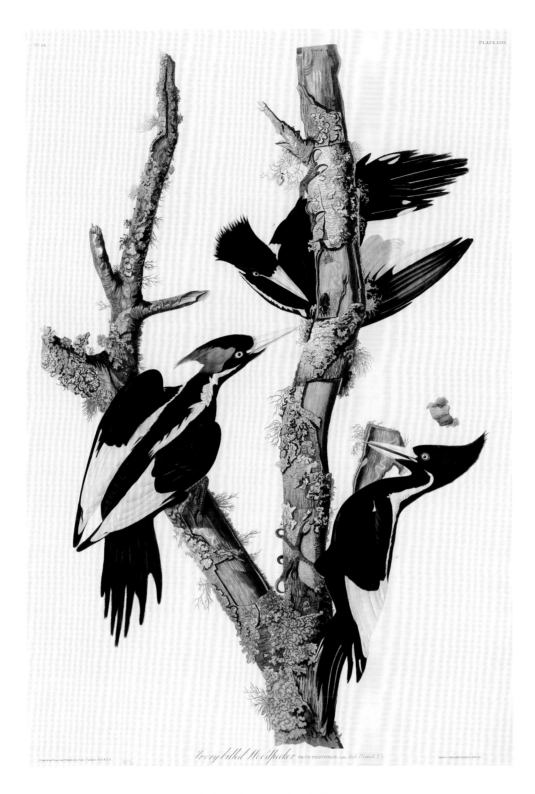

Ivory-billed Woodpecker PICUS PRINCIPALIS. Linn. *Male 1 Female 2 3.*

John James Audubon

Ivory-Billed Woodpecker, 1842
Hand-coloured lithograph, 100.3 × 67.3 cm / 39½ × 26½ in
Amon Carter Museum of American Art Libraries, Fort Worth, Texas

Named the favourite bird of French-American naturalist John James Audubon (1785–1851), the ivory-billed woodpecker (*Campephilus principalis*) is now thought to be extinct, a victim of habitat destruction. It has been estimated that a breeding pair required some 16 square kilometres (6 sq mi) of old-growth hardwood forest, but most such forests were largely destroyed by logging in the mid-twentieth century. Native to the southern United States and Cuba, the ivory-billed woodpecker ate mostly beetle larvae found in recently dead trees killed by fire, flooding or other disasters. The birds used their large bills to strip the bark from dead trees and fallen logs, including sweetgum (*Liquidambar styraciflua*), Nuttall's oak (*Quercus texana*), American elm (*Ulmus americana*), bald cypress (*Taxodium distichum*) and hackberry (*Celtis occidentalis*). In his seminal *The Birds of America*, published between 1827 and 1838, Audubon broke with the ornithological style of the day by reproducing his birds life-size and in natural outdoor settings rather than as stiff representations in front of barren backdrops. He killed each specimen, then used wires to pose them realistically, using natural props (such as the dead, moss-covered branches here) to portray them feeding or hunting. Audubon painted in watercolours, adding pastels to soften feathers and occasionally gouaches. He contorted the poses of larger birds to fit them onto the page and placed smaller ones on branches with their natural food – berries or fruit. As here, he usually depicted both male and female subjects, rendering the theatre of their lives. The pages of *The Birds of America* were organized for artistic effect and, by its final version, consisted of 435 hand-coloured prints made from copper engravings of 497 bird species.

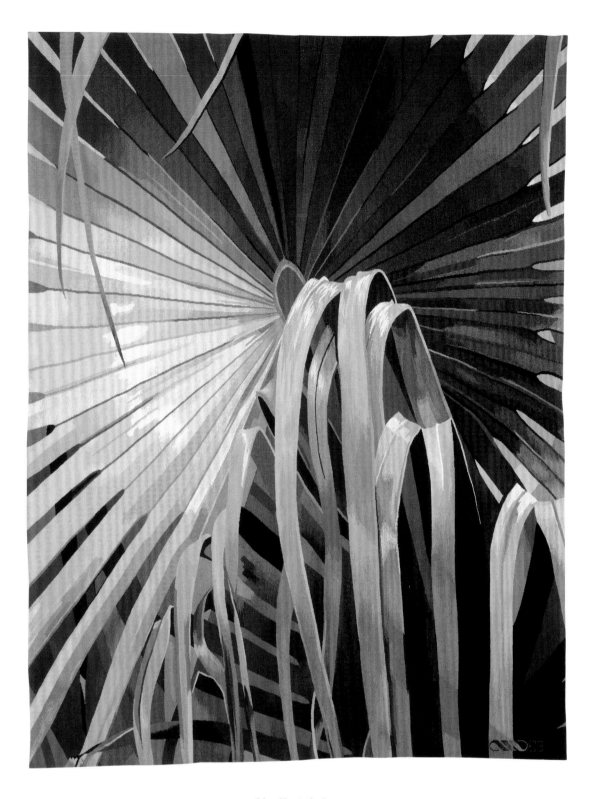

Sheila Hicks

Palm Tree, 1984–85
Wool, cotton, rayon, silk and linen, 3.7 × 2.7 m / 12 × 9 ft
Metropolitan Museum of Art, New York

This colourful burst of radiating and drooping palm fronds in yellow, green, blue, orange and purple has been hand-woven using a mixture of natural and synthetic threads. Created by renowned textile artist Sheila Hicks (b. 1934), the vibrant tapestry is a prototype for a larger, wall-sized hanging for the main auditorium at King Saud University in Riyadh, Saudi Arabia – one of fifty large-scale works she produced for the institution. Known for her innovative weavings, tapestries, fibre sculptures and textile instal-lations, Hicks has filled art galleries and public spaces around the world with voluminous forms and enticing textures. The original design – one of the Paris-based American artist's most figurative – was made in 1983, in an oasis near Riyadh. Hicks had just finished picnicking with a group of architects beneath the shade of a large phoenix palm tree when, lying back and looking up, she was suddenly struck by the splendour and size of the tree as its mass of elegant fronds swayed gently in the breeze, and she began to imagine what it might be like to live amid its canopy. The majestic phoenix palm (*Phoenix canariensis*), also known as the date palm, is native to the Canary Islands off the coast of Northwestern Africa and has been cultivated in Saudi Arabia for millennia. Growing up to 30 metres (98 ft) in height, it is impor-tant as a source of food, producing succulent dates that are a Middle Eastern staple. Celebrating Saudi Arabia's national tree, Hicks's tapestry demonstrates her ability to translate an intimate moment with nature into a dynamic public artwork.

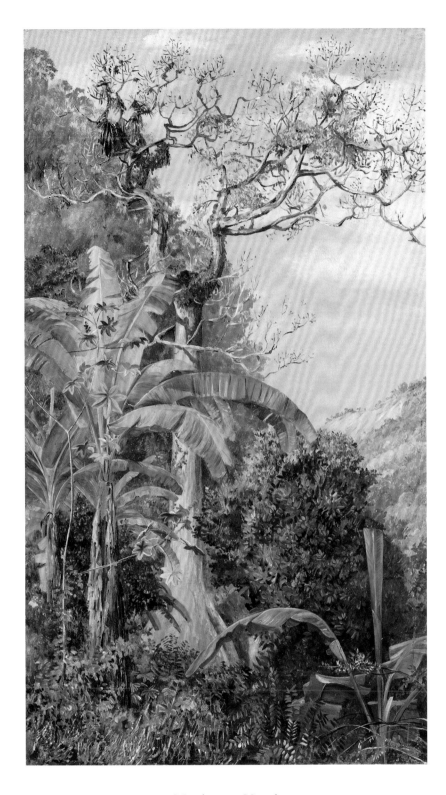

Marianne North

Great Cotton Tree, Jamaica, 1872
Oil on board, 59 × 28 cm / 23¼ × 11 in
Marianne North Gallery, Royal Botanic Gardens, Kew, London

'Every tree was a new form to me', enthused Marianne North (1830–1890) about her arrival in Jamaica by ship in late December 1871. The botanical artist soon set about recording the novel tropical trees, flowers and other plants she encountered. Her decision to use oils over watercolours and to paint directly from nature challenged traditional Victorian botanical painting and lent her images a unique style. This 'great cotton tree' (*Ceiba pentandra*) standing in its 'winter nakedness' was one striking specimen that caught North's eye. Its pale trunk contrasts sharply with

the dark tangle of vegetation all around as it stretches out its orchid-laden branches. Between 1871 and 1885, North accurately captured environmental scenes in sixteen countries – either territories of the British Empire or countries where Britain had close ties and influence. Although unusual for a Victorian woman, she journeyed alone, her path smoothed by her family's wealth and colonial connections. And on a day-to-day basis, her travels were underpinned by the Indigenous communities that provided botanical and cultural knowledge and acted as fixers,

translators, porters, sailors and domestic assistants for her. On her travels, North painted more than nine hundred species of plants in total, largely in situ. Her artworks continue to reside at the Royal Botanic Gardens, Kew, in a purpose-built gallery that the artist commissioned and paid for, and that opened in 1882. This densely displayed body of work, combined with North's extensive diaries, is contributing to our understanding of biodiversity loss and also provides a sense of the world at a time when it was undergoing extensive change at the hands of European colonizers.

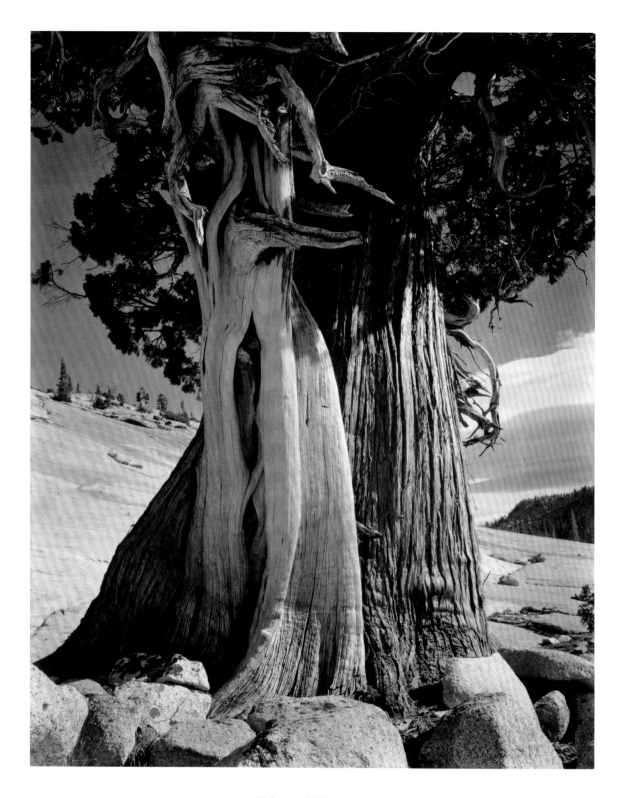

Edward Weston

Juniper, Lake Tenaya, 1937
Gelatin silver print, 24.3 × 19 cm / 9½ × 7½ in
Center for Creative Photography, Tucson, Arizona

High above Tenaya Lake, among granite pavement and boulders in the alpine region of Yosemite National Park, the Western Juniper (*Juniperus occidentalis*) can be found along the treeline. This ancient specimen, captured by American photographer Edward Weston (1886–1958) in 1937 is thought to be around one thousand years old and sits at an elevation of 2,484 metres (8,150 ft). Some have considered this venerable tree to be even older, similar in age to a Western Juniper located in the Stanislaus National Forest in California's Sierra Nevada that has been dated to 1,600 years old. (That second juniper is named the Bennett Juniper after naturalist Clarence Bennett, who started studying these junipers in the 1890s.) Western junipers were used by the Northern Paiute people for food, medicine and shelter, and the foliage has been prized for its fragrance. Weston photographed this ancient gnarled tree as part of a yearlong trip, travelling with fellow photographers Imogen Cunningham and Ansel Adams (see p.43), which was made possible by receiving the inaugural Guggenheim Fellowship. Some of his most famous highly detailed photographs of the California landscape were taken during this period on his 8 × 10 view camera. Born in Chicago, Weston spent most of his forty-year career in California, living at Point Lobos on the Monterey peninsula, with a focus on photographing people, including still lifes, nudes and portraits, in addition to landscapes. He is now regarded as one of the most innovative and influential creators behind the camera, and one of the masters of twentieth-century photography.

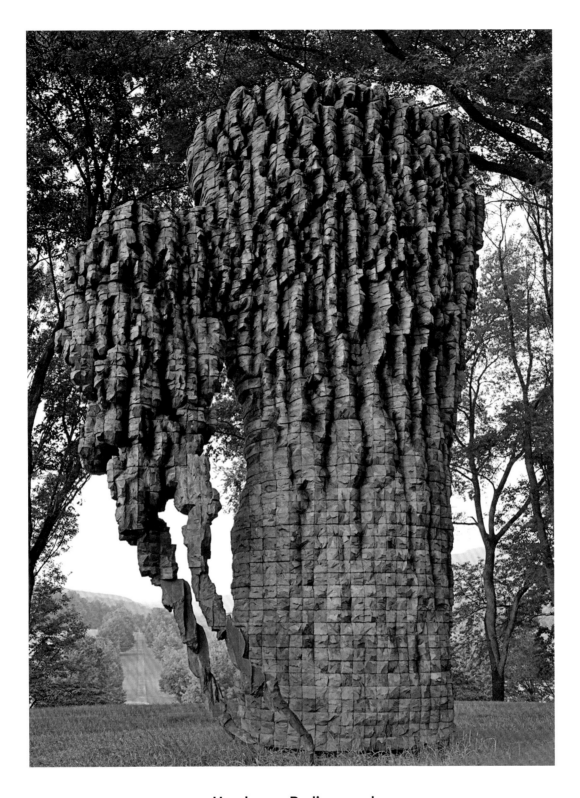

Ursula von Rydingsvard

Luba, 2009–10
Cedar, cast bronze and graphite, 5.4 × 3.5 × 2.2 m / 17 ft 8 in × 11 ft 7 in × 7 ft 4 in
Storm King Art Center, New Windsor, New York

Cedar has been the primary material for contemporary American sculptor Ursula von Rydingsvard (b. 1942) for more than fifty years. In von Rydingsvard's hands, uniform 10-by-10-centimetre (4-by-4-in) planks of this natural material – more commonly used for construction or DIY projects – are stacked and glued, then carved with a circular saw into organic, irregular forms that reconnect the timber with its origins in nature. Often producing works on a monumental scale, her sculptures evolve without preparatory sketches, and she considers this process a kind

of drawing in three dimensions. The resulting objects are finished with a layer a graphite rubbed into the surface to form a lustred patina, and some are also cast in bronze. *Luba*, which stands at more than 5 metres (17 ft) tall, is typical of her practice and blends with the verdant landscape of Storm King Art Center in Upstate New York more readily than many of the hard-edged metal sculptures in the museum's collection. While *Luba* can be considered as an abstract artwork, its title suggests a female name and, indeed, von Rydingsvard has explained the work's

winglike appendage is intended to resemble a mother's arm, cradling a child. Although much of her body of work has used cedar as the principal medium, in recent years von Rydingsvard has expanded her practice to include diverse mediums from paper and resin to bronze. No matter what material is chosen, each sculpture is a stunning interplay of abstract natural forms and the human hands that have shaped them.

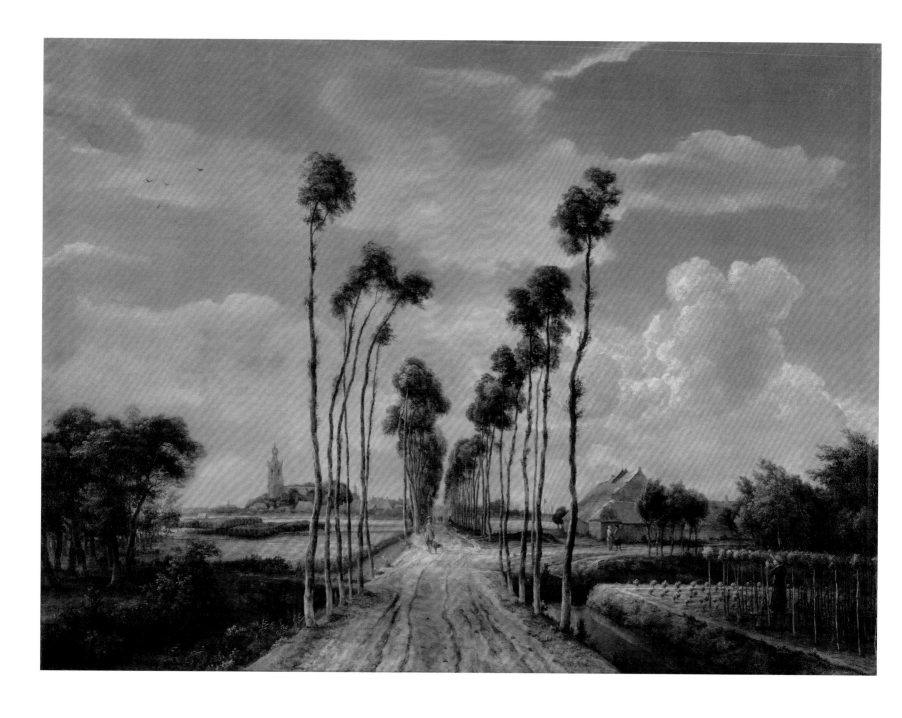

Meindert Hobbema

The Avenue at Middelharnis, 1689
Oil on canvas, 1 × 1.4 m / 3 ft 5 in × 4 ft 7 in
National Gallery, London

A series of tall, gangly poplar trees line a long rural avenue, the Boomgaardweg (now the Steneweg), leading to the coastal village of Middelharnis in South Holland. The trees appear extremely fragile, as if a breath of wind could blow them over. To the right, a nurseryman raises young poplars, taking off the side shoots so they will grow fast and straight. It seems that Dutch Golden Age artist Meindert Hobbema (1638–1709) made this work long after he had given up painting, probably for a patron living in or near the village. The details of the buildings are remarkably accurate, and it is reasonable to assume that those of the trees are too. Poplars of this kind normally have a life cycle of fifteen to eighteen years, and documents show that the trees were planted in 1664, so by 1689, the date inscribed on the painting, they would have been overdue for replacement. Perhaps the patron wanted them to be recorded before they were cut down. Or it may be that either patron or artist – or both – saw the spindly poplars, with their replacements waiting ready alongside them, as a metaphor for the human life cycle. Each older tree has its own individual character, like an elderly person, while the younger trees all look alike. The unusually centralized composition, with its strong perspective effect, has proved very influential to later artists, including Camille Pissarro, Vincent van Gogh and David Hockney (see pp.11, 15).

Lloyd Wright

Wayfarers Chapel, 1951
Glass, stone, redwood timber, plants and trees, 8.5 × 5 m / 28 × 27 ft
Rancho Palos Verdes, California

Emphasizing the harmony between human habitation and the natural world, Wayfarers Chapel sits on a California clifftop in Rancho Palos Verdes, overlooking the Pacific Ocean. Completed in 1951 by American architect Lloyd Wright (1890–1978), eldest son of the architect Frank Lloyd Wright, the Tree Chapel, as it is also known, is a quintessential example of the philosophy of organic architecture. The chapel was originally commissioned by members of the Swedenborgian Church, whose followers believe in the harmony that exists between God's world and the inner world of the mind and the spirit.

Capitalizing on its dramatic setting, Wright imbued his design with a sense of overwhelming natural mysticism. Surrounding the chapel are redwood trees, and – barely visible – local plants grow inside the structure, sprouting from the floor. Combined with an extensive use of glass in both the walls and the roof, Wright accomplished a seamless integration between outside and inside, pointing at the complex relationship that ties the soul to the materiality of the world. Wright was also greatly influenced by the work of his father, which becomes particularly apparent in the repurposing of Frank

Lloyd Wright's important pioneering concepts such as the use of native stone for the foundation and the integration of local vegetation into the landscape design. This site-specific approach was central to the context of the Prairie style, which Lloyd's father promoted at the beginning of the twentieth century as a form of resistance to the alienation caused by indiscriminate urbanization. The redwood trees – which were dwarfed by the new structure when this photograph was taken in 1951 – are not just part of the chapel's surroundings but an essential part of its meaning.

Maya Lin

Ghost Forest, 2021
49 Atlantic cedar trees, H. 11–14 m / 36–46 ft
Installation view, Madison Square Park, New York

New York City's Madison Square Park was chosen by American-born artist and designer Maya Lin (b. 1959) as the site of her six-month public artwork commission *Ghost Forest* in 2021. Composed of forty-nine felled Atlantic white cedar trees (*Chamaecyparis thyoides*) that towered over visitors to the installation – each tree was about 11 to 14 metres (36 to 46 ft) tall – *Ghost Forest* stood as a metaphor for the size of the climate change crisis threatening to overwhelm the planet. Visitors wandering through *Ghost Forest* also had the option to heighten their experience by using headphones to listen to a soundtrack of animals that were once native to Manhattan but have long since been lost. Belonging to the cypress family, the Atlantic white cedar is a narrow, cone-shaped evergreen that can grow to 25 metres (80 ft) tall. Once a common sight in the swamps and bogs of the East Coast of the United States, the species is now vulnerable to the effects of climate change and overlogging. Used by early European settlers to build everything from cabins to boats, the cedars had been massively reduced in number by the nineteenth century; since then, rising sea levels have led to the coastal pines being inundated with saltwater, causing them to die. For her installation, Lin – who rose to prominence in 1981 by winning the competition to design the Vietnam Veterans Memorial in Washington DC – used white cedars that had been cleared after falling prey to saltwater as part of a regeneration project in the Pine Barrens of New Jersey, a 445,000-hectare (1,100,000-acre) ecosystem of coastal pines.

Nicole Wittenberg

Woods Walker 2, 2021
Oil on canvas, 2.4 × 2.1 m / 8 × 7 ft

Loose and expressive brushwork combines with intense colour to evoke the vitality of summer foliage in this lush forest landscape. At the centre of the painting, a lone figure, perhaps a hiker or forest bather seeking solitude, approaches a clearing illuminated by the radiant light of a bright pink sky. Nature energizes American artist Nicole Wittenberg (b. 1979), who produced this large-scale canvas in response to an extended stay in Maine, the most forested state in the United States with about 90 per-cent coverage – a total of more than 7 million hectares

(17.5 million acres). Following in the footsteps of such American icons as Marsden Hartley, Edward Hopper and Alex Katz (see p.332), Wittenberg makes regular trips to the region's vast forests and rugged mountains, which provide inspiration for her deeply personal paintings in which observation and emotion become entangled as she strives to visualize the sensation of being in the natural world. Each work begins with a quick, plein air pastel sketch, which is later worked up in oil paint in her New York studio. While visiting Maine in 2021, the state of California was

facing an unprecedented spate of devastating wildfires. The smoke from these drifted across the United States all the way to New England, turning the sunsets there pink for a week. Wittenberg made several paintings capturing this eerie phenomenon. As she was working, she could not stop thinking about the destruction wrought by the fires and decided to donate the proceeds from the sale of these works to Art to Acres, an artist-run environmental initiative that supports the conservation and protection of forests across the Americas and around the world.

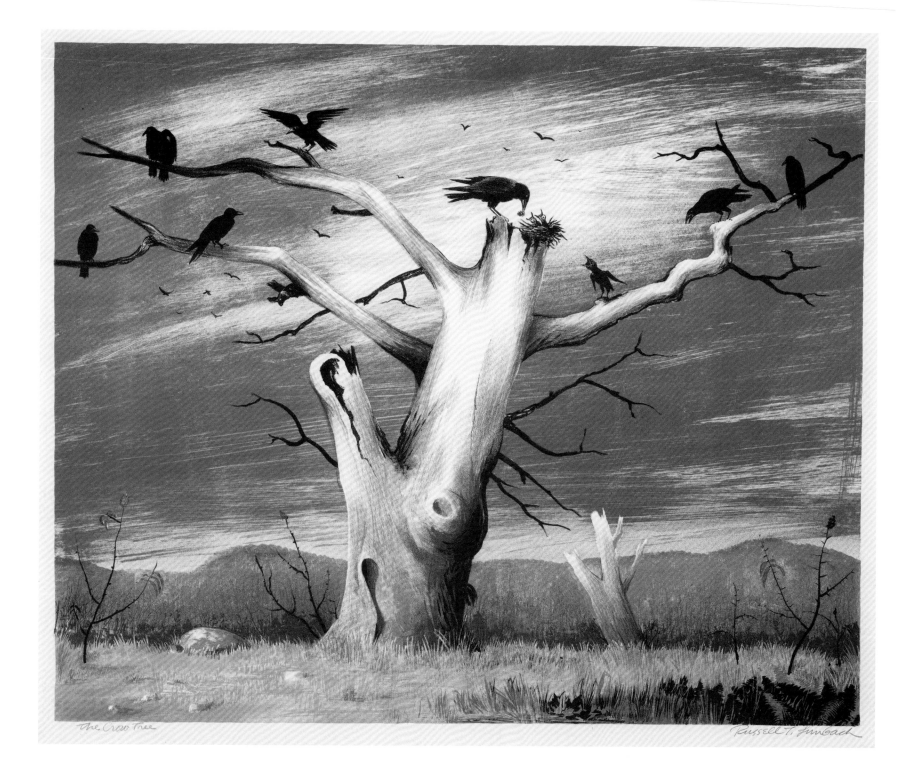

The Crow Tree, on image lower left

Russell T. Limbach, signature on image lower right

Russell Limbach

The Crow Tree, 1938
Lithograph, 40.5 × 52.2 cm / 16 × 20½ in
Whitney Museum of American Art, New York

The remains of a trunk and several branches of a dead tree play host to a murder of crows in this lithograph by American artist Russell Limbach (1904–1971). The hazy blue sky, distant forested hills and almost nude shrubs suggest a winter's day in the Midwest, perhaps the artist's home state of Ohio. A mother crow feeds her young as they sit in their nest, beaks wide open, while other crows are settled on branches, one calling to other crows flying overhead towards the tree. This bleak image perhaps reveals the troubled mindset of Limbach when he made it in 1938. Having travelled to Europe in 1928, where he studied lithography, Limbach returned to the United States in the depths of the Great Depression. The severe global economic downturn, which was prompted by the Wall Street crash of 1929, saw millions of Americans reduced to destitution. Limbach witnessed much of this firsthand when he was asked to organize the Graphics Arts Division of the Works Progress Administration (WPA) Arts Project in 1935. Under President Roosevelt's New Deal, many men who were unemployed were given jobs under the federal scheme, and the nation's artists and photographers were recruited to document their activities. While the New Deal did improve the lives of many, the 1930s in America remained a period of hardships. Meanwhile, the rise of the Nazi Party in Germany was beginning to cast a shadow of the approaching war over Europe and beyond. Limbach's tree, its leaves replaced by carrion-eating crows, strongly reflects the burdens and sorrows of the period.

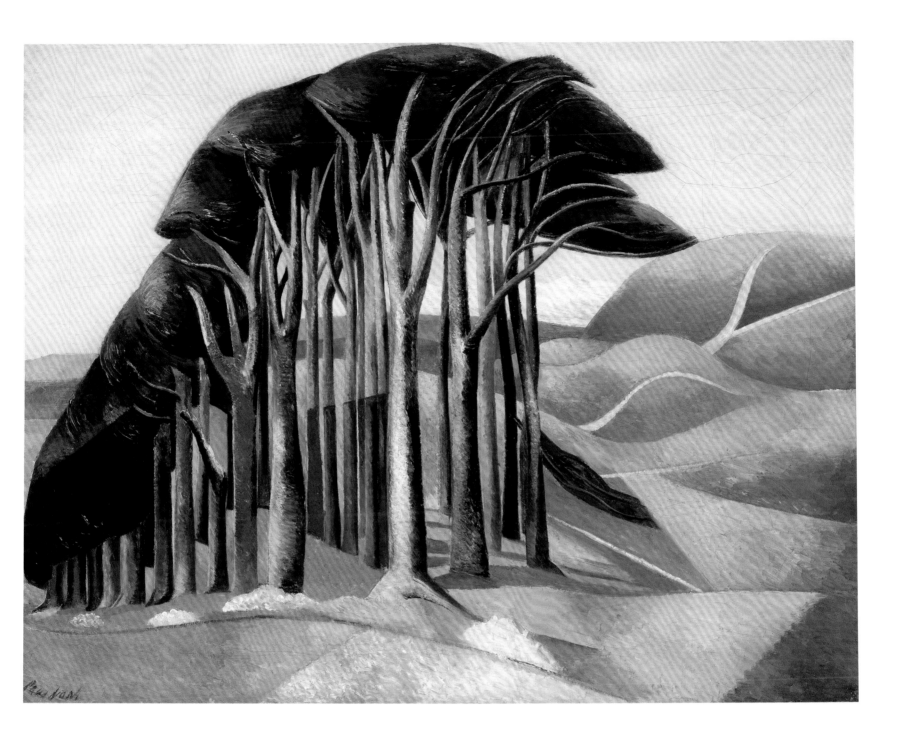

Paul Nash

Wood on the Downs, 1929
Oil on canvas, 71.5 × 92 cm / 28 × 36¼ in
Aberdeen Archives, Gallery and Museums, UK

An avenue of windblown beech trees (*Fagus sylvatica*) sits high above sea level in a range of chalk hills that rise and fall like the sea. The work of British artist and writer Paul Nash (1889–1946), *Wood on the Downs* captures the beauty of the Ashridge Estate in the Chiltern Hills, in the downland region of southern England, in late spring. The beech trees are in full leaf, the grass is green, and sunlight reflects on the white chalk of the downs. In the distance, the huge lump of chalk is the Ivinghoe Beacon, the site of an Iron Age fort surrounded by ancient burial grounds. Nash first discovered

the beacon in 1924, describing it as 'an enchanted place in the hills girdled by wild beech woods, dense and lonely places where you might meet anything from a polecat to a dryad'. Nash studied briefly at the Slade School of Fine Art in London, but it was a remark from fellow artist and teacher Sir William Blake Richmond that more deeply influenced his work: 'My boy, you should go in for nature'. This matured into a deep attachment for the English countryside. Nash's paintings are filled with the picturesque visions of his youth influenced by Surrealism and

by what Nash called *genius loci* – the inspiration provided by the location, subject, shapes and evanescence of light – which he imbued with abstract, intangible qualities of their own. Nash preferred to paint the autumnal landscapes in more muted shades, but here he is absorbed by the lighter tones of late spring, giving his beech trees the same angular structure he employed in many of his paintings as an official war artist for both World Wars I and II.

Alister Thorpe

Betula papyrifera, Paper or Canoe Birch, 2020
Digital photograph, dimensions variable

Focusing at close range on intricate patterns and shades, this image by British photographer Alister Thorpe (b. 1963) examines the bark of a paper birch tree (*Betula papyrifera*) in forensic detail. On the left, the outer, shiny bark is predominantly white and grey, but the inner bark on the right offers a range of rich brown, cream and pink hues. A particularly prominent feature of birch trees, the many horizontal lines across the bark are lenticels – pores that allow gaseous exchange between the air and the inner tissues through the otherwise impermeable layers.

Named for the colour and texture of its remarkable bark, the paper birch, also known as the American white birch or canoe birch, is a medium-sized tree – reaching around 20 metres (66 ft) tall – that is native to Canada and the United States. In older specimens, the outer bark is often almost entirely white but it flakes or tears off to reveal the brown or pink inner layers beneath. Partly due to its high oil content, this bark is very resistant to decay and is waterproof, making it a common material used by many Indigenous cultures for crafting canoes (see p.95),

containers and housing such as wigwams. Although not particularly nutritious, in the cold winter months, the bark is also a staple food for moose and white-tailed deer due to its abundance. The paper birch is a key member of boreal forests and other woodlands and is also a pioneer species, making it one of the first trees to begin growing after wildfires or other disturbances.

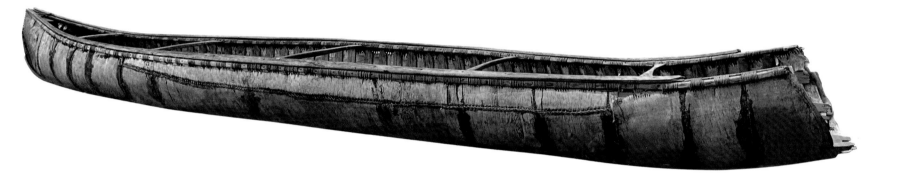

Anonymous

Wabanaki Canoe, 1729–80
Birchbark and cedar, L. 5 m / 16 ft
Pejepscot History Center, Brunswick, Maine

For thousands of years, Indigenous cultures in North America have used canoes made from the bark of birch trees. Made between 1729 and 1780, the Wabanaki canoe shown here is thought to be one of the oldest examples still in existence. The Wabanaki Confederacy comprises a number of communities extending across Maine into New Hampshire, Massachusetts and Canada. Measuring just over 5 metres (16 ft) in length, the canoe was most likely made from the paper birch (*Betula papyrifera*), also known as the American white birch or canoe birch. Birch

trees grow profusely in what is now the state of Maine, and their smooth and blemish-free trunks make them an ideal construction material. Unlike in other trees, birch bark grain runs around the tree rather than parallel to the trunk, allowing the malleable bark to be formed into curved shapes. The canoe was built without nails, lashed and sewn together with spruce roots or deerskin. Entirely waterproof, and light enough to manoeuvre around river rapids, it was stable and hard to capsize. Weighing around 18–23 kilograms (40–50 lbs), the canoe was not only

durable but strong enough to carry heavy loads, with space for two or more canoeists and compartments to stow possessions. A vital means of transportation among the riverine communities of the northeast coast, canoes allowed travel upstream to access valuable food sources when overland travel was difficult. They facilitated trade between different groups, giving access to a wider range of goods and thus promoting more settled communities.

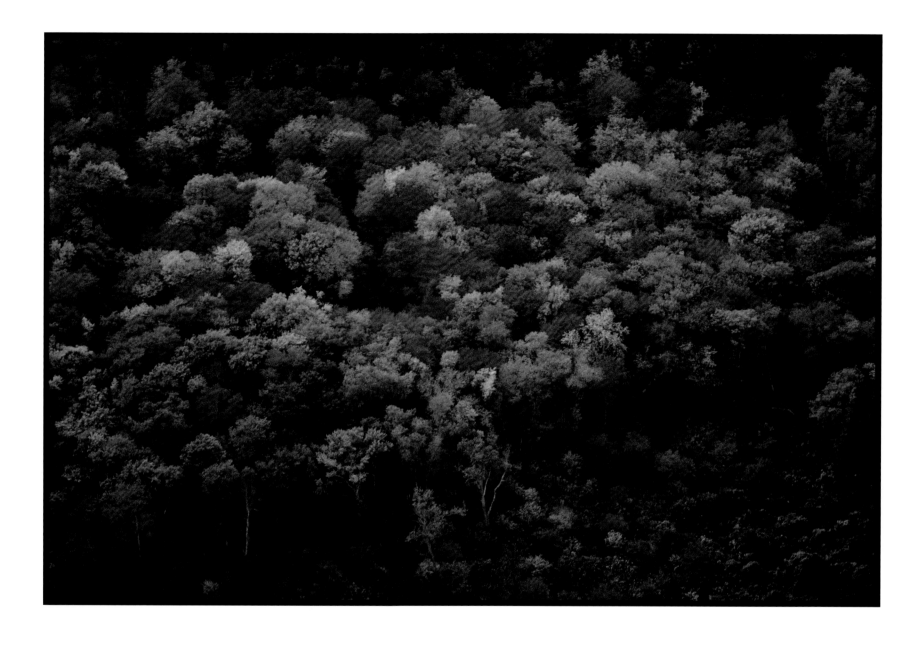

Georg Gerster

Fall Foliage Rhode Island, 1988
Photograph, dimensions variable

Pioneering Swiss aerial photographer Georg Gerster (1928–2019) captures the splendour of trees in Rhode Island during autumn as they start to change colour, creating a riot of bright red, orange and yellow against a background of summer green. For Gerster, photographing from above gave the observer a new perspective and greater insight. Rhode Island and the New England region of the United States in general have become *the* place to witness autumn's spectacular leaf displays because of the intensity of the change. As autumn descends, with the nights growing colder and the days growing shorter, deciduous trees receive fewer hours of sunlight. Their leaves, which in summer are full of chlorophyll – the green pigment that converts sunlight, water and carbon dioxide into energy for the tree – lose the green colour, revealing pigments previously concealed. These colours are xanthophylls and carotenoids, which appear as red, orange, yellow and even purple. In species such as the maple, which is found across New England, a further chemical change takes place that causes the leaves to turn a vibrant red. Following a sunny, dry summer, a concentration of sugar builds in the tree sap; this triggers the maple to release anthocyanins to get as much energy from its leaves as possible – the anthocyanins turn the leaves the gorgeous colour Gerster captures in this photograph. In New England, this process typically starts in the northern states in mid-September, reaching Rhode Island by the middle of October.

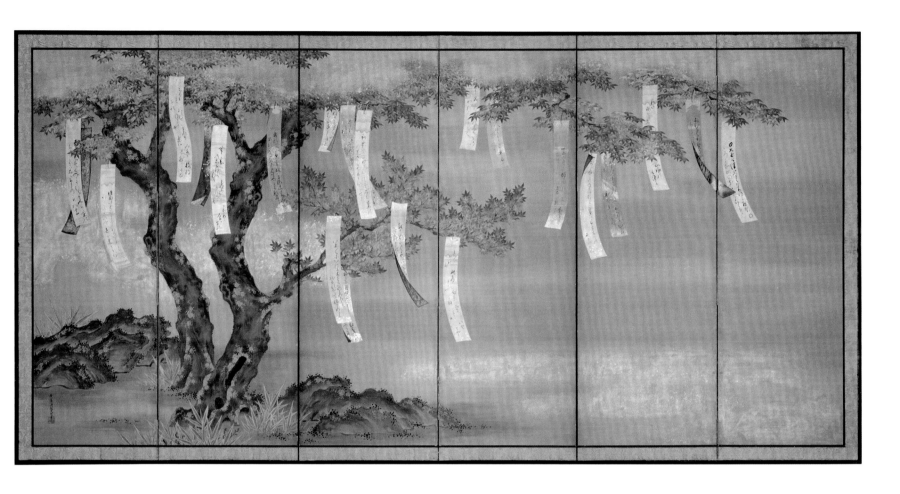

Tosa Mitsuoki

Autumn Maples with Poem Slips, c.1675
Ink, colours, gold leaf and gold powder on silk, 1.4 × 2.9 m / 4 ft 9 in × 9 ft 5 in
Art Institute of Chicago

Branches of brilliant red and gold leaves on a Japanese maple in autumn are draped with paper slips of appropriately seasonal poetry, called *tanzaku*. This is the left of two six-panelled screens (the right-hand one is painted with a blossoming cherry in spring, also with *tanzaku*) by the court painter Tosa Mitsuoki (1617–1691). Tosa would have been assisted by court calligraphers who inscribed the painted slips with poetry from twelfth- and thirteenth-century anthologies. The court and aristocracy of seventeenth-century Japan supported a revival of

the culture of the Heian period (794–1185 CE), including customs such as poetry meetings – and the fleeting colours of autumn maple leaves were considered helpful to poetic expression. Participants would write verses on narrow slips and tie them to the branches of a maple tree in autumn, almost like an offering. Tosa positioned the trees at the outer end of each screen, leaving the centre filled with gold dust and gold squares, a luxurious setting for a court poetry meeting. The Japanese maple (*Acer palmatum*; *momiji* or *kaede* in Japanese) has an ancient

symbolism in Japanese culture, and references to *momiji* appear in Japan's oldest poetry collection, the *Man'yōshū* (*Collection of Ten Thousand Leaves*) which dates to the eighth century CE. The tree signifies peace, serenity and abundance and suggests elegance, beauty and grace. Because the maple is slow-growing and will grow in minimal sunlight, it also symbolizes patience and endurance.

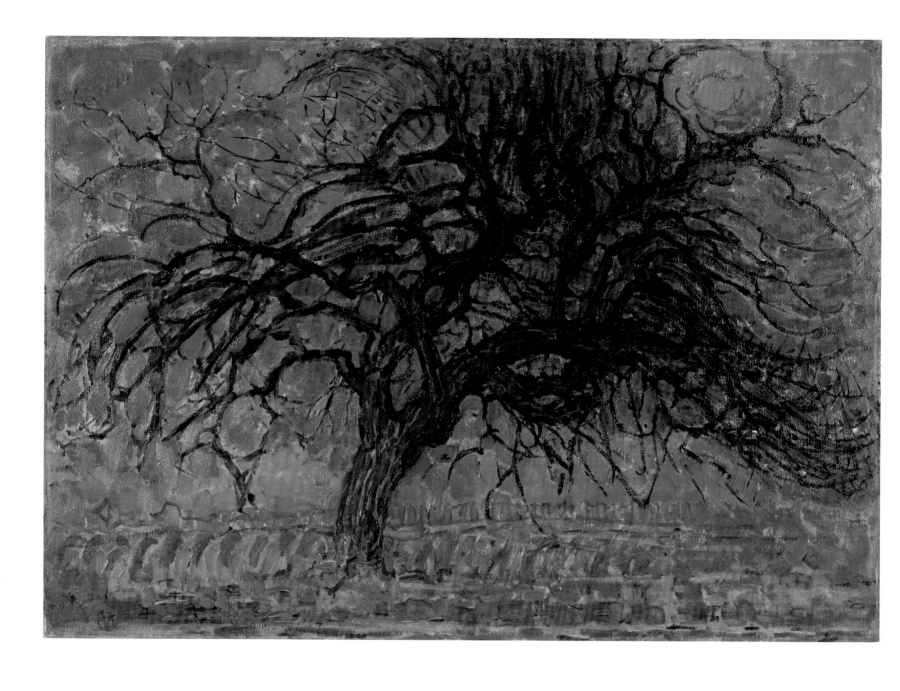

Piet Mondrian

Evening: The Red Tree, 1908–10
Oil on canvas, 70 × 99 cm / 27½ × 39 in
Kunstmuseum den Haag, the Netherlands

A solitary red tree stands against a deep blue evening sky in this work by Dutch painter Piet Mondrian (1872–1944). The painting may seem a departure for the artist, who is best known for his minimalist grids of primary colours. However, prior to developing his signature style in the early 1920s, Mondrian devoted considerable time to investigating the arboreal form. Between 1908 and 1913, he painted trees almost exclusively, fascinated by the geometric patterns made by the branches, which he saw as revealing the inherent ordering of nature. *Evening: The Red Tree* is a testament

to Mondrian's exploration of composition, colour theory and symbolism. His use of colour to convey emotion and meaning was a significant contribution to the Symbolist movement, in which artists often used imagery and indirect association to express mystical ideas, emotions and states of mind. Here, the lone tree, starkly outlined against the vastness of the sky, is a visual representation of these concepts. But this painting is also emblematic of Mondrian's transition from figuration to abstraction. While the arboreal form is still clearly recognizable, the brushwork and the interplay of warm

and cold colours departs from accuracy in representation. Branches speckled with daubs of red might suggest an apple tree. Indeed, on his visit to the coastal town of Domburg, the Netherlands, in 1908, Mondrian made several sketches of an ancient apple tree in his friends' garden (those friends would later buy the finished canvas). A key stepping stone in Mondrian's artistic journey, *Evening: The Red Tree* also shows the influence of theosophy – a spiritual philosophy popular during the late nineteenth century that emphasized the unity of all things and the spiritual essence of reality – on the artist.

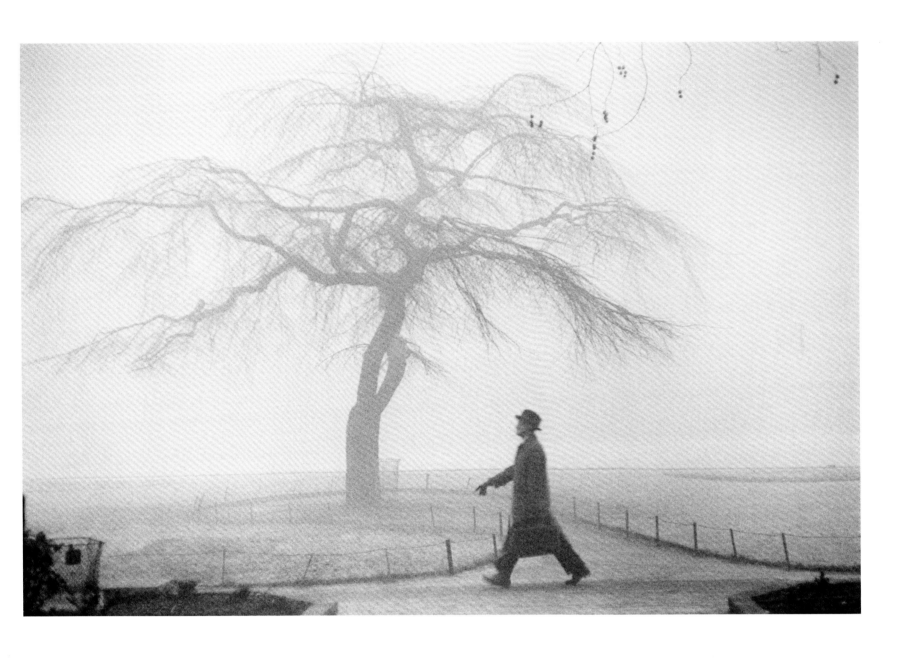

Robert Frank

Tree, London, 1951
Gelatin silver print, 22.1 × 33.1 cm / 8¾ × 13 in
Museum of Modern Art, New York

Striding purposefully along a winding path, a businessman navigates a London park, the winter fog obscuring what lies beyond the towering tree that dominates the frame. Captured in 1951, the image is one of a series documenting the city's daily life by American photographer and documentary film-maker Robert Frank (1924–2019). Born in Zurich to German-Jewish parents, Frank studied photography from an early age and apprenticed with graphic designers and photographers in Zurich, Basel and Geneva. At the age of twenty-three, he immigrated to New York as an artistic refugee from what he

considered to be the small-minded values of his native country. Over the next ten years, Frank worked as a commercial photographer for a range of publications, including *Harper's Bazaar*, *Fortune*, *McCall's*, *Vogue* and *Ladies' Home Journal*, and also as an assistant to American photographer Walker Evans (see p.268). Frank travelled extensively – London, Wales, Paris, Peru – and his cinematic, immediate images focus on the elements that express the character of the places he visited. However, it was his book *Les Américains*, first published in France in 1957 and then in the United States

as *The Americans* in 1959, that transformed Frank into one of the most influential photographers of the twentieth century. As part of receiving the 1954 Guggenheim Fellowship, Frank drove across the United States in a black Ford Business Coupe with two cameras and innumerable boxes of film, travelling more than 16,000 kilometres (10,000 mi) and taking more than twenty-seven thousand pictures, which he reduced to just eighty-three for his book. Reflecting the Beat Generation, Frank's raw and personally expressive style of everyday America changed the course of documentary photography.

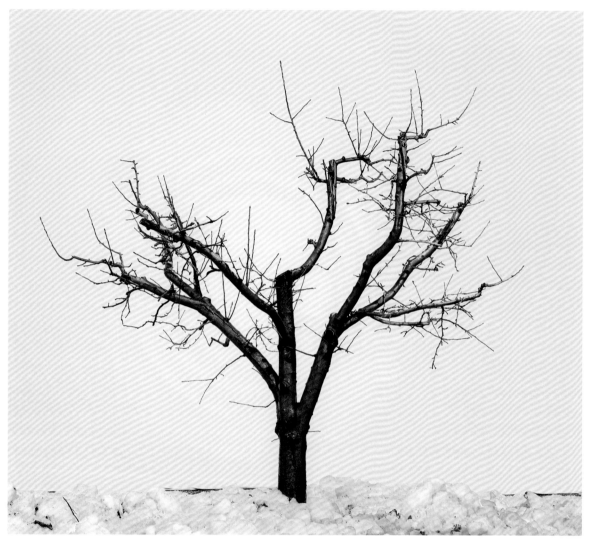

Tal Shochat

Lessons in Time #3, 2016
Colour prints, triptych, each 1 × 1.1 m / 3 ft 3 in × 3 ft 8 in

Exploring the passage of time, Israeli artist Tal Shochat (b. 1974) shows a yellow apple tree changing with the seasons in this photographic triptych. In the left-hand image, its branches are naked, shorn of their leaves and fruit, and snow blankets the ground; the centre image shows the tree in spring, as its fresh leaves and blossoms tentatively appear; and in the far-right image, the tree's branches are laden with ripe, golden fruit. One of Shochat's four-part series that features three solitary apple trees – green, red and yellow – and a single plum tree, the triptych shows the viewer a familiar subject in a completely new way. In a related series, Shochat photographs fruit trees growing in Israel – peach, loquat, pomegranate, persimmon and others – against a pure black backdrop, the ripe fruits appearing as vibrant, almost artificial-looking pops of colour. Playing on the perceptions of her audience is nothing new for Shochat: she has built her career on challenging the boundaries between reality and imagination, creating deceptively simple photographs of seemingly innocuous subjects that are rarely what they seem. The apple tree holds a central role in the Jewish faith, from the Garden of Eden, where Adam and Eve plucked an apple from the tree of knowledge, to the commandment *bal tashchit* from the Torah, which prohibits the destruction of trees. The Jewish holiday Tu BiShvat, which takes place on the fifteenth day of the Hebrew month of Shevat, loosely translates as the New Year for the Trees and is celebrated by planting trees.

Jeannette Klute

Apple Blossom, c.1950
Dye transfer print, 48.8 × 37.8 cm / 19¼ × 15 in
Akron Art Museum, Ohio

The intensity of the white-pink petals of an apple blossom glow in the sunlight while its buds – a gorgeous pale red – appear about to burst into life. This vivid image, alive with the promise of spring, is the work of pioneering American photographer and illustrator Jeannette Klute (1918–2009). Taking her large-format camera into her local woods in the Finger Lakes region of New York, she documented the change of the seasons. Here, the blossom leaps out at the viewer, revealing the beauty of the apple tree as if for the first time. This is a result of Klute's work in the then-new field of colour photography, more specifically the dye transfer colour process. This laborious process – more typically used in the movie industry to print Technicolor films – gave her a much higher degree of photographic control. It involved printing with three separate layers of dye – cyan, magenta and yellow – each applied by hand sequentially. Klute had studied photography at the Mechanics Institute in Rochester, New York, in the 1930s, thanks to President Franklin D. Roosevelt's Works Progress Administration (WPA) programme. The Eastman Kodak Company then hired her as a lab technician, which at the time was a highly unusual position for a woman. She spent a lengthy career at Kodak, heading up the Visual Research Studio by 1945, while developing her own distinctive colour photography. She is not only partly responsible for elevating photography into an art form but also helped establish women in a male-dominated industry.

Floyd MacMillan Davis

Johnny Appleseed, 1950s
Illustration for *The Saturday Evening Post*

With a spring in his step, a carefree Johnny Appleseed strides through the woods, scattering apple seeds with joyful abandon. This wholesome image of the footloose American folk hero by the celebrated commercial artist Floyd MacMillan Davis (1896–1966) reflects the popular image of a kind-hearted loner who is said to have wandered barefoot across the United States providing people with fresh, nutritious fruit. Yet his story is based as much on colourful folklore as on fact. John Chapman, the real person behind the legend, was an American

pioneer nurseryman of the late eighteenth century who is credited with introducing apple trees to large parts of the American Midwest. Born in Massachusetts, Chapman planted his first nurseries in Pennsylvania around 1798, after the Northwest Territory opened to settlers. He then travelled through Ohio, walking miles every day and sleeping under the stars. Although living frugally, he was a shrewd entrepreneur, anticipating where pioneers would travel to next, planting his seeds in those areas and then selling the seedlings to the settlers when they arrived.

The apple trees were especially important to settlers, who used their fruit to make cider vinegar for preserving fruits, vegetables and meats. They also made hard cider, because Johnny's apples were too sour for eating. Johnny Appleseed has been the subject of countless stories, films and artworks over the years. As aspects of his life were mythologized over time, the eccentric businessman became a benign symbol of the European settlement of America.

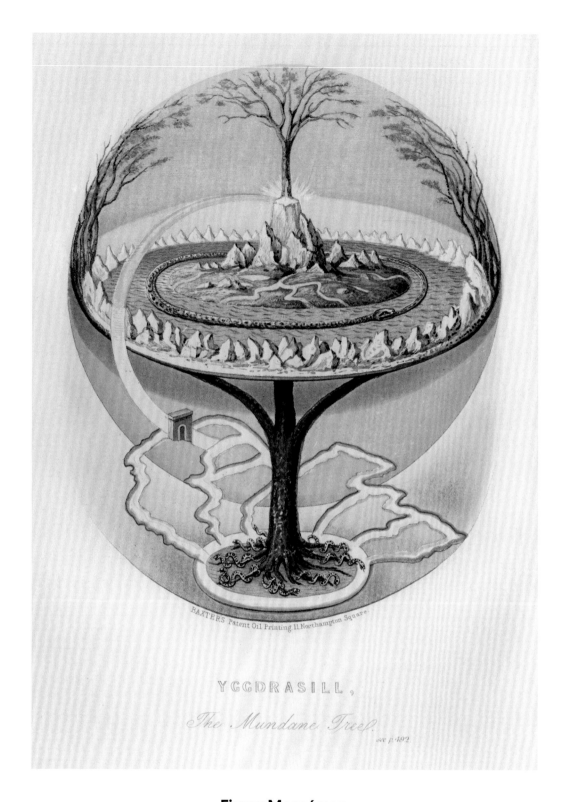

YGGDRASILL,

The Mundane Tree.

see p. 492

Finnur Magnússon

Yggdrasill, The Mundane Tree, from *Northern Antiquities: Or, an Historical Account of the Manners, Customs, Religion and Laws ... of the Ancient Scandinavians*, 1859
Printed book, 18 × 12 cm / 7 × 4¾ in
Norman B. Leventhal Map Center, Boston Public Library

At the centre of Norse legend is the giant ash tree Yggdrasill. With its branches in the heavens and its roots in the under-world, it is the life-affirming symbol that gives structure to existence. Although sacred, it is also mortal and must be watered, lest all the gods and their world perish. Fed by water from a magical well, Yggdrasill is sometimes tended by three fateful female figures, the Norns, and the Norse god Odin also has a special connection with the tree. In this nineteenth-century image, the trunk and branches of Yggdrasill support the world. At the heart of the upper

hemisphere, within a kind of bell jar, the central trunk sprouts above a circular mountain range from which rivers flow down through fertile lowlands towards the sea. An enormous reddish-brown serpent encircles the land, grip-ping its tail in its mouth, while a rainbow forms a bridge between the glowing central mountain peak and a man-made gate tower in a subterranean world below. Several green serpents coil themselves around the roots of the sacred tree. This depiction of Yggdrasill, captioned as 'The Mundane Tree', was copied from the original illustration

by Icelandic scholar Finnur Magnússon (1781–1847) for his book *The Eddic Lore and its Origin* (1824), and included as the frontispiece of the English translation of *Northern Antiquities* by Paul Henri Mallet. At that time, the word *mundane* (derived from the Latin *mundus*) meant 'worldly', sometimes with a sense of purity or nobility. The Norse legend also became a source of creative inspiration, most notably for Richard Wagner when creating his famous operatic *Ring Cycle*, in which the 'World Ash Tree' and the three Norns appear.

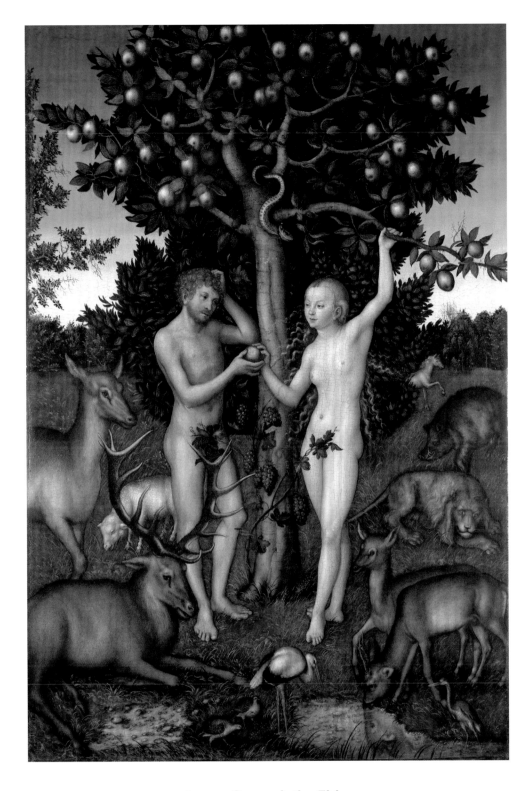

Lucas Cranach the Elder

Adam and Eve, 1526
Oil on panel, 117 × 80 cm / 46 × 31½ in
The Courtauld, London

In the Garden of Eden, Satan, taking the form of a serpent, encouraged Eve to taste the luscious-looking fruit of the tree of knowledge of good and evil, the only tree in the garden that God told Adam not to eat. She hands it to Adam, who scratches his head as if he is uncertain, but in the end, he also eats the fruit, an act of disobedience that leads to a range of hardships, including the necessity for physical labour and the pains of childbirth. Foreshadowing of these ill effects exists in the vegetation in front of the tree: the fig leaves the couple will use to cover their nakedness once they become conscious of sin, the grapes that indicate the redemptive power of Christ's blood. German Renaissance painter and printmaker Lucas Cranach the Elder (1472–1553) includes animals and birds peacefully together in a lush setting to show what was lost through this fateful act. Cranach and his workshop made more than fifty versions of the subject for patrons at the court of Saxony and the University of Wittenberg. These works cleverly combine seductive nudity with a stern Christian message. The Bible does not specify the species of the tree of knowledge of good and evil, simply using the Hebrew *peri*, a generic term for any fruit. In Western Christian art, it is usually shown as an apple tree, but this may be through a confusion of two similar words in Latin, *malum* for 'apple' and *malus* for 'evil'.

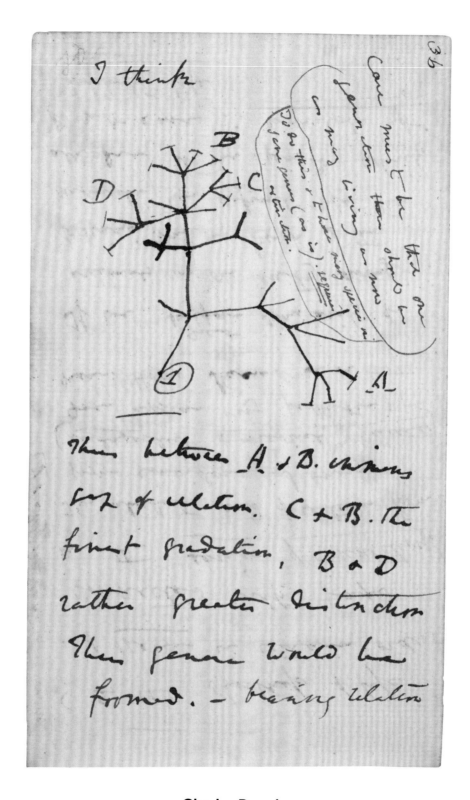

Charles Darwin

Page 36, from *Notebook B*, 1837–38
Ink on paper, 17 × 9.7 cm / 6¾ × 3¾ in
Cambridge University Library, UK

It is no exaggeration to say that this scribbled sketch of a tree is one of the most significant artefacts in humanity's quest to understand its own origins. Dating from 1837 to 1838, this rough ink diagram of an evolutionary tree is the work of Charles Darwin (1809–1882), the father of evolution, who drew it in the notebook where he first began to jot down his thoughts about the transmutation of species, drawing on his own observations and the ideas of contemporaries such as the French scientist Jean-Baptiste Lamarck. Darwin had returned the previous year from his five-year-long voyage as a naturalist on the HMS *Beagle*, which sailed along the coast of South America. His observations of flora and fauna, particularly on the Galápagos Islands, led him to first question and then refute the biblical explanation of God's creation of the world over seven days. Instead, Darwin's thoughts began to crystallize into a belief that species evolve over millennia to adapt to their circumstances, an insight he outlined in this treelike sketch mapping greater or lesser divergence between species. This sketch appears on page 36 of the notebook – the first thirty-five pages are largely an examination of the earlier work of his grandfather, Erasmus Darwin, hinting at the idea of evolution but without an explanation of why it occurred. It would be more than twenty years before Darwin fully worked up his idea of the theory of natural selection, which he delivered in his 1859 groundbreaking book, *On the Origin of Species*.

Lotta Olsson

Multi-Tree, 2007
Poster, 70 × 50 cm / 19¾ × 12½ in

This charming, whimsical picture of a reimagined tree is the work of Swedish illustrator Lotta Olsson (b. 1982), whose work is, by her own admission, an interpretation of nature. A love of the forests of southern Sweden and its associated folklore has led Olsson to amass a vast collection of visual images she calls her 'digital herbarium', from which she collates pictures that blend memories with her artwork using a mixture of digital photography, leaves, mosses, flowers, ferns and twigs. Her pictures become a combination of the digital and the real, with both having equal weight. For this work, she lays out a variety of leaves – she includes not just tree leaves, such as ginkgo and beech, but also ferns, clover and dandelion – all set out on delicately trained horizontal branches and a tiny trunk. The tree can be read as representing all four seasons, from the decay of winter, through autumn and summer, to the new growth of spring. For Olsson, there is as much drama and beauty in a single leaf as there is in an entire tree. Her obsession with trees reveals itself in the detail and shapes she gives her creations – scientific accuracy is of less concern to her. As she says, 'The forest is the place which feels most natural to me. The more you look, the more you see... When I create a tree, it's my own imagination that sets the limits.'

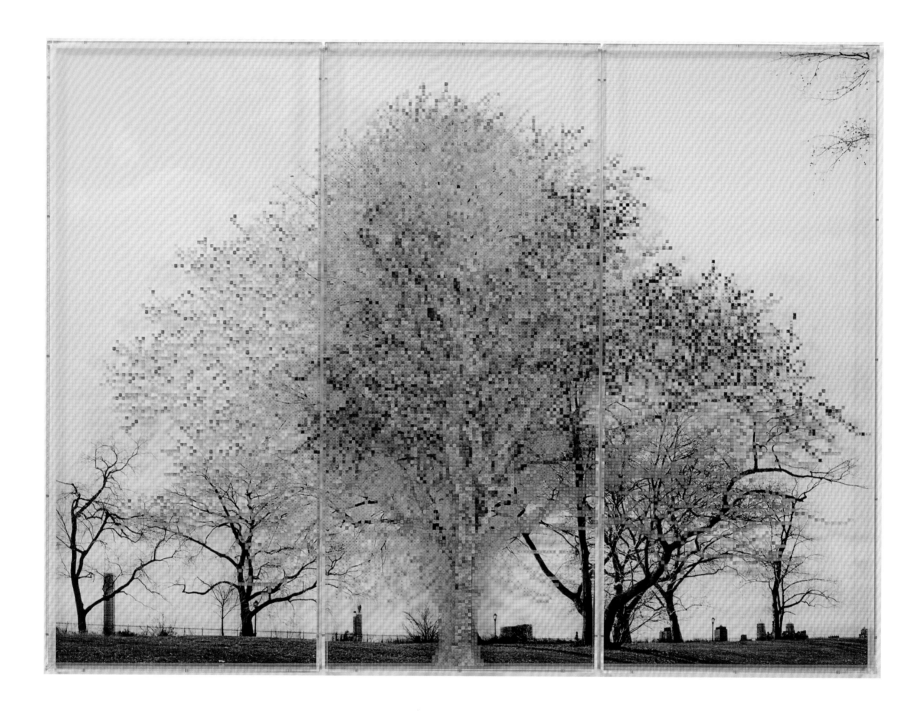

Charles Gaines

Numbers and Trees: Central Park Series II: Tree #4 Steve, 2015
Acrylic sheet, acrylic paint and photograph, 241.3 × 321.3 × 14.6 cm / 95 × 126½ × 5¾ in
Private collection

Hundreds of individually painted squares come together to create the coloured tree forms dominating this mixed media work, each silhouetted image having been carefully plotted onto a grid across three clear acrylic boxes containing a large black-and-white photograph of trees in New York's Central Park. This is the fourth part of 'Numbers and Trees: Central Park Series II' by American conceptual artist Charles Gaines (b. 1944), which comprises eight similar works all derived from different photographs of trees. Starting with a single blue tree in *Tree #1 Paula* (2015),

each successive work in the series adds another tree painted in a different brightly coloured hue on top of the last. As the series progresses, the imagery moves further away from recognizable trees towards the complex, layered compositions of *Tree #6 Fredrick* and *Tree #8 Amelia* (both 2016). Gaines has been making serial artworks in which aspects of nature are carefully transcribed into a succession of gridded marks or numbers since the early 1970s. Frustrated with the paintings of trees he was making at the time, Gaines sought to expunge any signs of his ego

from his works by turning to rigorous mathematical systems inspired by Tantric Buddhist diagrams. Gaines started incorporating trees into his work with his 'Walnut Tree Orchard' series (1975–2014), in which he photographed walnut trees and exhibited them alongside drawings that broke down their organic shapes into simplified marks on grids. Known collectively as Gridworks, all of these works interrogate the nature of representation, perception and objectivity.

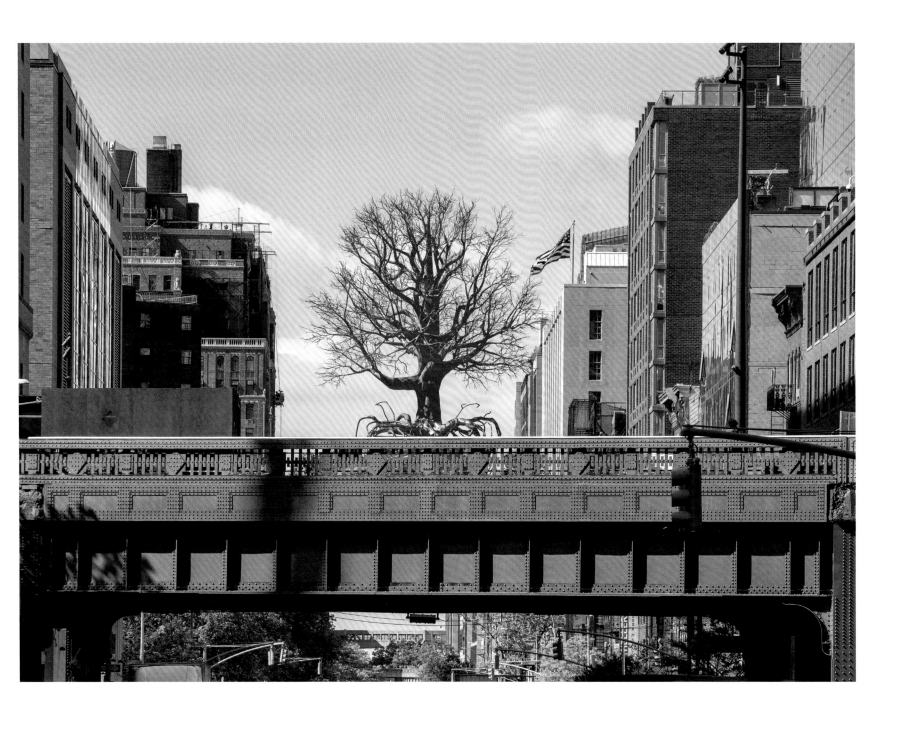

Pamela Rosenkranz

Old Tree, 2023
High grade epoxy, fibreglass and galvanized steel, 7.5 × 7 m / 24 ft 6 in × 23 ft
Installation view, High Line, New York

Visitors to the High Line between 2023 and 2024 were unexpectedly greeted by a colossal neon pink tree. The sculpture by Swiss artist Pamela Rosenkranz (b. 1979) was the third commission for the High Line Plinth that sits at the spur between Thirtieth Street and Tenth Avenue in the popular public gardens built on abandoned elevated rail lines above Manhattan – expanding since 2009 into a continuous 2.3-kilometre (1.45-mi) greenway with more than five hundred species of plants. Rosenkranz is known for her thought-provoking works that draw inspiration from philosophical concepts to natural phenomena. Here, Rosenkranz was inspired by the interaction of nature and urban settings, exploring the concept of the Anthropocene – the current geological epoch, during which human activities have become the dominant, and most detrimental, influence on the environment. *Old Tree*, in this context, serves as a symbol of nature's resilience against the relentless encroachment of urbanization. Created from epoxy, fibreglass and steel, the sculpture also blurs the boundaries between notions of naturalness and artificiality, reinforced by her use of unnaturally vibrant colours. The line between where the plantlike aspects of Rosenkranz's tree end and the human qualities begin is further obscured. The delicate branches and vivid colouration evoke the branching systems of the veins and arteries of the human body, as well as of human lungs, underscoring the continuity that ties photosynthesis to our breathing and thus our survival on this planet. Further metaphors can be found in the title of the piece, which recalls both the tree of life that connects spirituality and materiality and the theory of evolution as first suggested by Charles Darwin in 1859 (see p.106).

Henry Eveleigh

Planting the Tree of Nations, 1947
Offset lithograph, 60.7 × 45.5 cm / 24 × 18 in
Archives Charmet, Paris

Born from the rubble and ashes of World War II, the United Nations (UN) was established in 1945 with the objective of maintaining global peace and security. This colourful poster depicts a pair of hands planting a sapling whose leaves are the flags of the fifty-five countries that had joined the UN by 1947; today, there are nearly two hundred member states. Its simple yet powerful design symbolizes the flourishing of international cooperation and the hope for a fairer, more just future beyond old patterns of discord and conflict. Designed by Henry Eveleigh (1909–1999), the

poster won first prize in an international competition organized by the UN. Eveleigh was subsequently offered a job at the École des Beaux-arts de Montréal (EBAMA), where he established the school's department of graphic design and became an influential educator. He believed strongly in the social value of graphic design, teaching that advertising must inform, educate and help cultural development by promoting good taste, health, safety, citizenship and social harmony. Born in Shanghai to British parents, Eveleigh studied at the Slade School of Fine Art in London before

immigrating to Montreal in 1938. During World War II he designed posters for the Canadian war effort, but *Planting the Tree of Nations* is considered his major achievement. It has been translated into twenty languages and disseminated throughout the world to promote the UN's values of peace, compassion, respect and human fraternity.

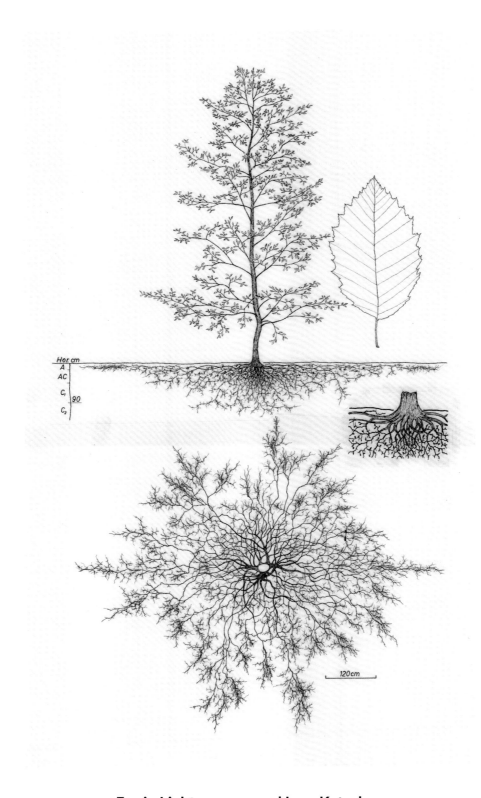

Erwin Lichtenegger and Lore Kutschera

Alnus incana, 2002
Ink on paper, 61 × 37 cm / 24 × 14½ in
Pflanzensoziologisches Institut, Bad Goisern, Austria

Unlike most depictions of familiar trees, in this drawing of the grey alder or speckled alder (*Alnus incana*), the focus is not just on the leaves, branches and trunk of the tree but its extensive root system. Part of a forty-year project of root excavations started at the Wageningen University in Austria by professors Erwin Lichtenegger (1928–2004) and Lore Kutschera (1917–2008), the intricate illustration shows the roots beneath the soil, their depth, growth patterns and how they appear from above. Over the course of four decades, Lichtenegger and Kutschera

researched, painstakingly excavated and then documented their findings with drawings of each plant with its root system, even as other researchers turned to photographing the plant specimens they studied. The result of their extensive research – primarily across Europe – was a staggering 1,180 diagrams of the roots of forest trees and shrubs, as well as several atlases featuring complex root systems. Even today, relatively little is known about these hidden parts of trees and the complexity and scale many root systems can attain. Roots not only allow plants to

gather water and minerals to grow, they provide homes for microbes, such as fungi and bacteria, and prevent soil erosion as they extend deeper into the earth. In forests, trees have developed what some scientists have come to refer to as the 'wood wide web', a system by which trees communicate with each other and share nutrients through their roots. Essential to these systems are the symbiotic relationships with microbes and fungi in the soil, which provide vital minerals to the trees, and in return the trees supply them with carbon through photosynthesis.

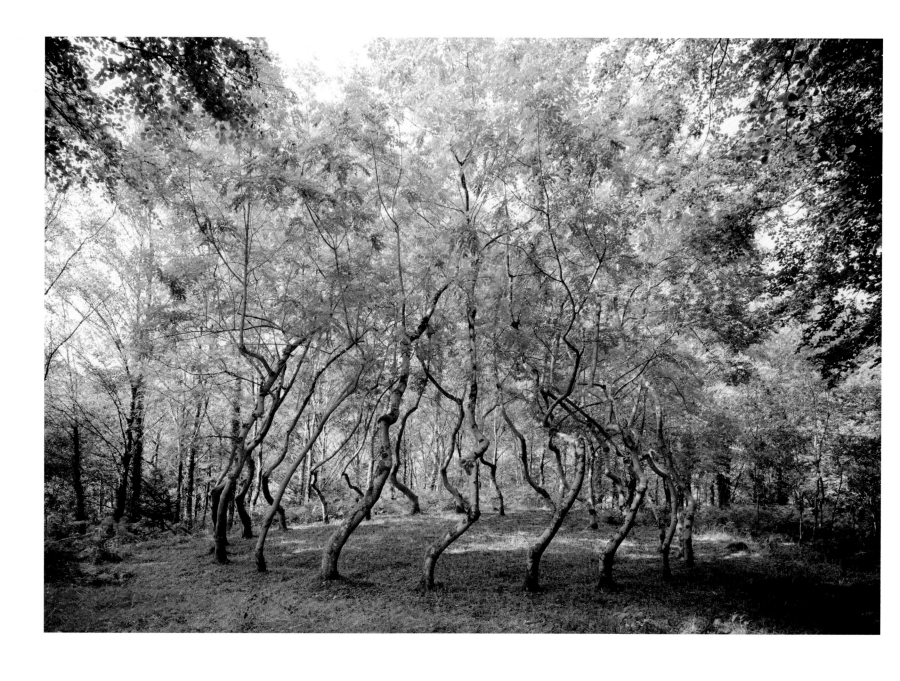

David Nash

Ash Dome, 1977–ongoing
Installation view, Wales

Much like a clan of druids caught under a spell, a circle of twenty-two ash trees is locked in a perennial magical dance. The surreal aura of this gathering is not the result of an inexplicable natural event but the work of British land artist and sculptor David Nash (b. 1945), who planted the ring of trees in a secret location near his home in the Welsh countryside in 1977. *Ash Dome* is a significant work in the realm of environmental art, with the ash trees at its core serving as a potent symbol of the artist's philosophy and approach. The ash tree is known for its strength and resilience, qualities Nash wanted to imbue into his artistic practice – works that grew and were sustained over time, rather than ones that were temporary installations on the landscape. It also reflected the desire for more long-term strategies for an environmental movement, the national policies of which Nash found to be far too short-sighted in the 1970s. Broader themes of cultural mythology, the cycle of life, and the relationship between humans and nature are inscribed in this highly original living artwork. By planting and tutoring the trees, Nash has blurred the line between what is natural and what is man-made. He has imposed a human design onto nature, yet the trees continue to resist and grow in their own way, suggesting a symbiotic relationship between human intervention and the relentlessness of natural processes. And with the emergence of ash dieback – a fungal disease that has devastated native ash trees across the United Kingdom and Europe since the late 1990s – Nash has accepted that his work may ultimately succumb to nature taking its course.

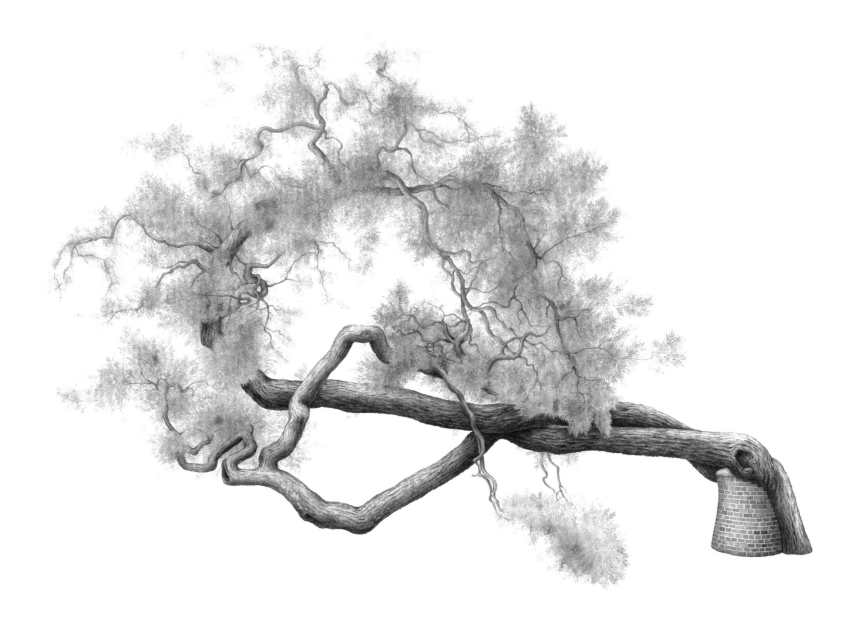

Masumi Yamanaka

Styphnolobium japonicum, 2013
Watercolour, 72 × 100 cm / 28¼ × 39¼ in
Royal Botanic Gardens, Kew, London

Bent double as if to rest its weary limbs, supported by metal props and a brick pier, this venerable Japanese pagoda tree, planted in 1762, is undoubtedly approaching the end of its long life. It is one of the five Old Lions at Kew Gardens in London, trees surviving from Princess Augusta's original 3.6-hectare (9-acre) botanic garden more than 250 years ago. The Kew-based Japanese artist Masumi Yamanaka (b. 1957), captivated by their history and majestic form, set herself the task of recording Kew's significant heritage trees as a permanent archive for

Kew's art collections and to inspire others to appreciate the fundamental importance of trees to our planet. The arboretum at Kew is home to more than 14,000 trees, representing more than 2,000 different species, of which there are 250 large 'champion' trees and 13 historic heritage trees. Yamanaka takes a respectful, spiritual approach to her subject, touching and stroking a tree and mentally 'seeking its permission' before taking photographs and making preliminary sketches. Each painting can take up to three months to complete. Despite its name, the

Japanese pagoda tree (*Styphnolobium japonicum*), which was often planted on the grounds of Buddhist temples, is actually native to China and was first introduced to Britain in 1753 by the nurseryman James Gordon. In addition to the Japanese pagoda, the other Old Lions – a name coined by John Smith, who worked at Kew from 1822 to 1864, and became its first curator – include a maidenhair tree (*Ginkgo biloba*), Oriental plane (*Platanus orientalis*), Caucasian elm (*Zelkova carpinifolia*) and black locust (*Robinia pseudoacacia*).

GLOOSKAP TURNING A MAN INTO A CEDAR-TREE.

Tomah Joseph, Charles G. Leland and Silas T. Rand

Glooskap Turning a Man into a Cedar Tree, from *Algonquin Legends of New England*, 1884
Printed book, sheet approx. 20 × 11.3 cm / 7¾ × 4½ in
University of Connecticut Libraries, Storrs

Glooskap, a foundational culture hero of the Wabanaki – Indigenous Algonquin tribes of the northeast United States and Atlantic Canada – extends his arm, casting a spell on the figure in front of him. The illustration accompanied traditional Algonquin tales collected by American folklorist Charles Godfrey Leland (1824–1903) and Canadian clergyman and ethnographer Silas Tertius Rand (1810–1889), who first recorded stories of Glooskap in English. The story illustrated here is one of wish fulfilment with a macabre twist, akin to the moralizing stories in other traditions

such as *Aladdin* and *The Monkey's Paw*. Men of preening self-importance seek Glooskap, wishing to be the tallest, oldest or most contentedly sedentary among their peers. Their desires are granted but obliquely so, as each is turned into a cedar tree – a species of tree sacred to the Algonquin people, who harvest its oil for purification rituals. Here, branches burst outwards and upwards from every limb, and feet have splayed into tripod roots affixing the man to the ground. More boughs encroach into the diagonally striped border, implying surrounding nature will claim the former

human once Glooskap departs. Along with the black cat or owl familiar perched above, the stormlike haze of horizontal lines adds an unsettling, almost Gothic air. The reality, like the creator Glooskap – despite his fearsome appearance – is more benign. The lines are those of the birch bark on which the book's illustrations were originally carved, likely by Tomah Joseph (1837–1914) – a Passamaquoddy artist and governor of communities in Maine – who recounted several stories to the book's authors and contributed the illustrated frontispiece.

Olga Ziemska

Stillness in Motion: The Matka Series, 2023
Locally harvested willow branches, 1.8 × 2.7 × 3.7 m / 6 × 9 × 12 ft
Installation view, Morton Arboretum, Lisle, Illinois

Looking like a windswept tree nymph, this striking 1.8-metre (6-ft) tall figure is composed entirely from hundreds of slender willow branches. Each reclaimed branch has been sawn at one end and painstakingly arranged to form the shape of a standing woman. As suggested by its title, the sculpture, though static, conveys a remarkable sense of motion, as the mass of sticks seems to billow behind the silhouetted form. Polish American artist Olga Ziemska (b. 1976) has made similar sculptures with tree branches in many different

countries, each time using locally sourced wood from the region in which she is working; in South Korea, she used bamboo, while in Romania she incorporated a mixture of different reclaimed woods. This example, using willow, was created at Morton Arboretum in Lisle, Illinois, where it was displayed in the open air alongside other large-scale works made from branches and natural materials gathered from across the Arboretum's 690 hectares (1,700 acres). Collectively known as *Stillness in Motion: The Matka Series* (*matka* meaning 'mother'

in Polish), the project began in 2003 and aims to highlight for viewers that all of life on Earth is derived from the same basic natural elements. (Indeed, in Polish, the artist's name 'Ziemska' aptly means 'of the earth'.) At the same time, these mother figures acknowledge the unique environment in which each one is made – a celebration of the diversity of different places as well as the similarities uniting them and our experiences of them.

Tom Uttech

Nind Awatchige, 2003
Oil on canvas, 3 × 2.8 m / 10 ft × 9 ft 4 in
New Orleans Museum of Art, Louisiana

Trees, in varying degrees of contortion, frame an autumnal scene of countless species of birds and a vibrant woodland bursting with life. Combining ideals of the perfect wilderness with a somewhat surreal Photorealism, this painting is the work of American artist Tom Uttech (b. 1942). Uttech, who grew up in Wisconsin, sets out to reimagine the North American wilderness in his depictions of landscapes around Lake Superior, Minnesota's Boundary Waters and Canada's Quetico Provincial Park in Ontario. Part of a larger body of work, this canvas reflects the artist's deep connection with

nature and his concern for the environment. The painting is rooted in the environmental movements of the late twentieth and early twenty-first centuries, which saw a growing awareness and concern for the preservation of natural landscapes and biodiversity. Uttech has also spoken of the influence of the local Ojibwe culture on his work. The title of the painting itself, *Nind Awatchige*, is an Ojibwe phrase meaning 'I do (it) in a sacred manner'. This reflects the deep respect and reverence for nature that is central to many Indigenous cultures and is a recurring theme in Uttech's

work. The artist's depiction of trees is unique in its intricate detail and the sense of awe-inspiring wilderness it evokes. Unlike many artists who use trees as mere backdrops or secondary elements, Uttech places them at the forefront, making trees the primary focus of the viewer's attention. His trees are not just individual objects but the structure that holds the whole ecosystem in place. In fact, they also literally hold his paintings in place, as Uttech constructs his own wooden frames – no mean feat for canvases that stretch up to 3 metres (10 ft) wide.

Fire Safe, California!

Rudolph Wendelin

50 Years ... and still going!, 1994
Printed poster, 60.9 × 45.7 cm / 24 × 18 in
Private collection

Smokey Bear has been educating people about the dangers of human-caused wildfires in the United States since 1944. Wearing his trademark ranger's hat and denim jeans, the character is familiar to generations as the face of the US Forest Service's public safety campaign. In 1994 this campaign celebrated its fiftieth anniversary with this poster featuring Smokey's famous slogan, 'Only *You* Can Prevent Forest Fires,' subsequently updated in 2001 to refer to wildfires in general. The nationwide campaign was launched during World War II, and the earliest posters framed the enterprise as part of the war effort when many experienced firefighters were serving abroad in the armed forces. The first poster to feature Smokey as the campaign's official mascot was designed by the popular illustrator Albert Staehle, in which he was depicted pouring a bucket of water over a campfire. From 1946 the campaign was illustrated by American artist Rudolph Wendelin (1910–2000) in a style familiar to the Depression-era posters of the Works Progress Administration. It is a misconception, however, that fire is always harmful to trees. By thinning the forest canopy, fires can allow more light into an ecosystem, while the burning of leaf litter and deadwood can trigger new growth. Some species, such as manzanita and lodgepole pine (*Pinus contorta*), even depend on fire to help them grow. Although controlled burning can re-create the beneficial effects of natural fire in a safe way, adhering to Smokey's advice has helped prevent countless unplanned, human-caused fires and the catastrophic damage they cause.

Alison Elizabeth Taylor

Silver Fox, 2013
Wood veneer and shellac, 1.3 × 1.3 m / 4 ft 3 in × 4 ft 3 in
Private collection

Incorporating a dazzling array of tinted wood veneers in tones of brown, grey and silver, this meticulously crafted composition is a celebration of the extraordinary diversity of the woodgrain patterns found in trees. While the early use of wood veneers for decorative purposes dates to ancient Egypt, the craft of marquetry, in which pieces of wood veneer are applied to furniture, was developed in Flemish centres of luxury cabinetmaking during the early sixteenth century. Reviving this Renaissance technique for the twenty-first century and transporting it from the

decorative arts to the world of fine art, Alison Elizabeth Taylor (b. 1973) creates complex, labour-intensive works characterized by their unique fusion of differently patterned wood, paint and collaged textures. Taylor turned to the unusual medium in the mid-2000s after visiting the Metropolitan Museum of Art and encountering the Studiolo from the Ducal Palace in Gubbio, a fifteenth-century room with walls that are decorated with thousands of inlaid wood pieces to create the illusion of three-dimensional cabinets and shelves filled with objects. Drawn to the expressive

and decorative qualities of woodgrain, the American artist has made the technique her own, using it to create richly patterned images of disquieting desert landscapes, urban scenes, abandoned homes and people at leisure, among other themes. Whereas her figurative works create a tension between the subjects depicted and their surfaces, *Silver Fox* emphasizes its flatness, the interplay of abstract veneers forming an 'all-over' effect recalling the work of Abstract Expressionist painters such as Janet Sobel and Jackson Pollock.

Jan Christiaan Sepp

Plate X, from *Icones lignorum exoticorum et nostratium Germanicorum*, 1773
Hand-coloured engraving, 29 × 22 cm / 11½ × 8¾ in
Getty Research Institute, Los Angeles

Nine flawlessly reproduced examples of different wood-grains, displaying the varying depths of colour and pattern, adorn this plate from the eighteenth-century volume *Icones lignorum exoticorum et nostratium Germanicorum (Icons of Exotic and Native Germanic Wood)*. The work of engraver and printmaker Jan Christiaan Sepp (1739–1811), a member of a four-generation Dutch publishing dynasty, the book was released in several editions in Nuremberg, Germany, from 1773 to 1778. In its foreword, Sepp argues that these beautifully detailed coloured etchings should serve not just as

a guide to the different timbers but should lead the reader to appreciate the woods in the same way they would any other plant or flower. Sepp was an accomplished illustrator whose book of Dutch birds long held the record as the most expensive book published in the Netherlands. Appealing to a similarly wealthy audience, *Icones lignorum* was dedicated to 'Kings, Princes and Lovers of Nature', since the pricey unusual and exotic wood samples were often collected for their intrinsic beauty as well as for practical use. The forty-eight pages of detailed wood samples – each wood is

shown with its true colours and unique woodgrain pattern, as here – would have helped patrons and their cabinet-makers in the choosing of an appropriate wood. Timber was then ubiquitous in daily life in Europe: used in ship- and house-building, carpentry and even, Sepp suggests, in medicine. However, its ubiquity did not detract from its variety and beauty. As Sepp sums up, 'When they are sawed in thin, flat pieces, and that no care or pain is spared in working and polishing them with all the art, they appear as beautiful as the finest marble tables.'

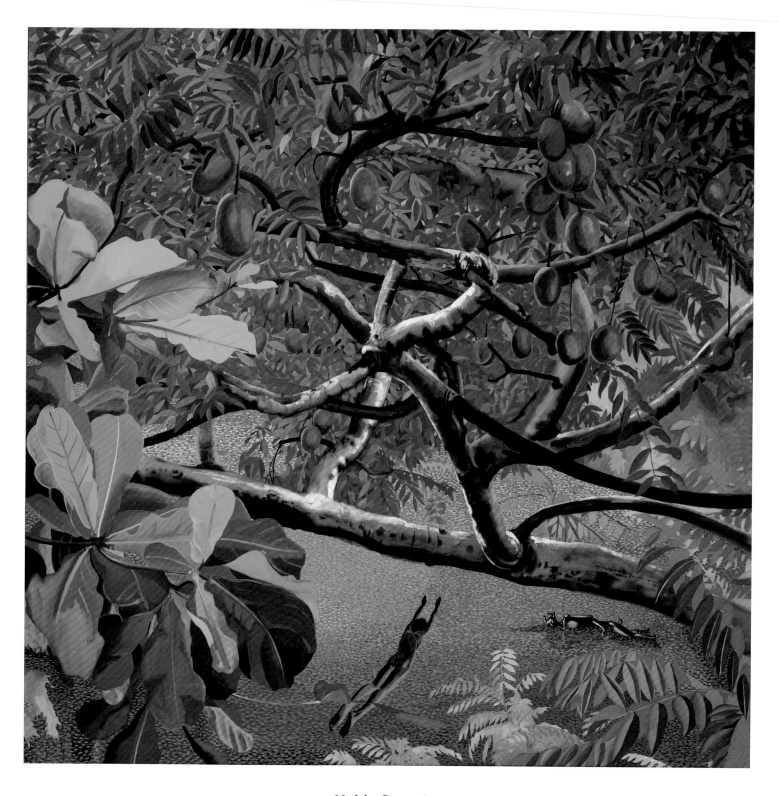

Hulda Guzmán

Dive into Love, 2021
Acrylic gouache on linen, 1.2 × 1.2 m / 3 ft 9 in × 3 ft 9 in
Institute of Contemporary Art, Miami

From a vantage point high up in a mango tree (*Mangifera indica*) laden with fruit, we see a naked figure diving into a shimmering tropical pool. Already swimming in the water, visible beneath the lush foliage and twisted branches, is a strange horned creature, its presence imbuing the scene with an uneasy tension. Trees are a constant source of inspiration to Dominican artist Hulda Guzmán (b. 1984), who paints from a remote beachfront studio surrounded by tropical forest on the Samaná Peninsula in the Dominican Republic. Feeling enamoured with the

seemingly infinite array of colours, shapes and textures within the natural world, Guzmán says she is compelled to observe, contemplate and paint the landscapes, trees and animals around her. Her vibrant compositions mix real-life observation and invented elements to create a world where children, adults, animals and imaginary creatures embrace the natural world in surreal, dreamlike scenes. Trees, such as the lofty mahogany and tall coconut palm, are often shown towering over her characters, empha-sizing the power of nature in relation to the creatures

sustained by its complex ecosystems. However, while her paintings always begin with a direct engagement with nature, their many elements are pieced together digitally on her computer before being committed to canvas. In this way, she highlights the human tendency to manage and cultivate nature – an impulse that can lead to exploitation and environmental damage, or to a harmonious, symbiotic existence with the natural world.

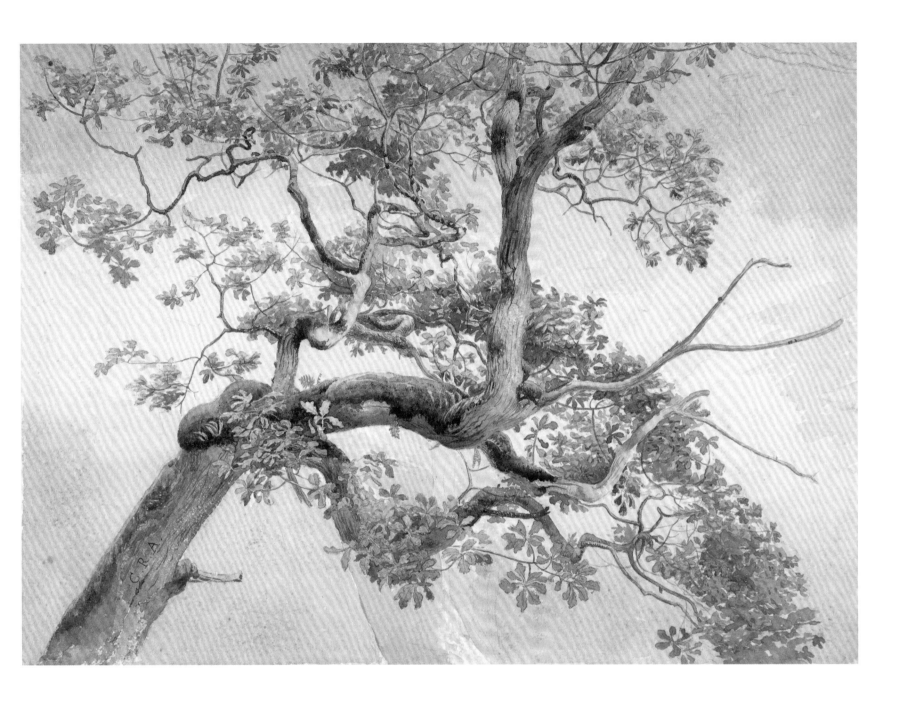

Charles Reginald Aston

Tree Branches, 1860–1900
Watercolour over graphite, 24.1 × 33 cm / 9½ × 13 in
Metropolitan Museum of Art, New York

The twisted branches of an old tree reach up to the sky in this graphite and watercolour study by British architect-turned-landscape painter Charles Reginald Aston (1832–1908). Much of the bark of the thicker lower bough is covered in delicately drawn moss, while succulent green leaves burst forth from its meandering branches. Aston painted the tree as if he were standing directly underneath it: the foliage and branches fill the page while the bleached-out background gives the merest hint of clouds in the sky. Aston's skilful use of shading, achieved by

painting some of the leaves a deeper green than others, creates a sense of the light and shadow of an English summer's day. Aston's apparent reverence for his tree – and by extension, the whole of the natural world – puts him squarely in the group of contemporary artists inspired by his fellow Victorian, artist and art critic John Ruskin (see p.141). Ruskin advocated that the artist should paint from reality and represent that reality with its inherent beauty and flaws; to this end, Aston includes the tree's dead branches. Aston's drawing follows Ruskin's premise

that a botanically accurate drawing would ultimately give more pleasure than an idealized fantasy, not just to the artist but to the observer. It serves to underline nature's unique quality. This painting represents something of a departure for Aston, who is better known for his scenic landscape paintings of Cornwall, Wales and Italy.

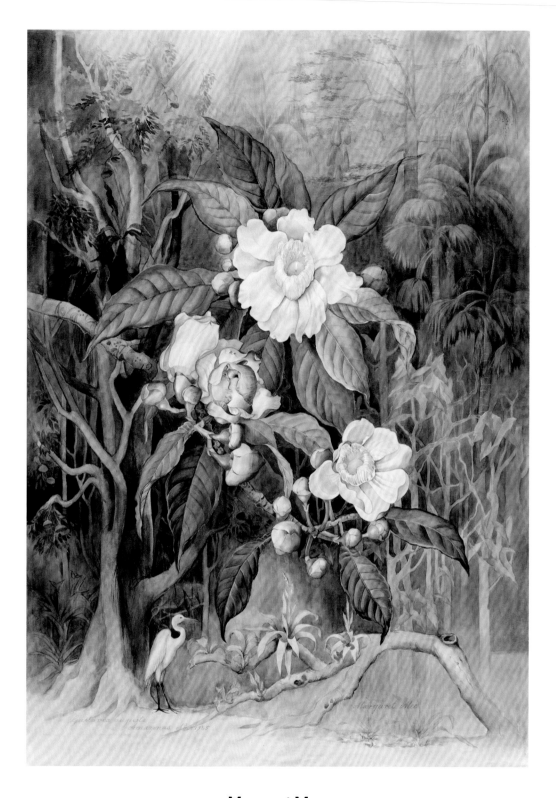

Margaret Mee

Gustavia augusta, 1985
Pencil and gouache on paper
Royal Botanic Gardens, Kew, London

Plump pink blossoms with golden centres emerge from a tree branch, appearing larger than life against a lush tropical backdrop. Painted in 1985 by English artist Margaret Mee (1909–1988), this depiction of the heaven lotus (*Gustavia augusta*), a small tree native to South America, bears many hallmarks of a traditional botanical illustration. Care has been taken to accurately depict the shapes and colours of the buds, blooms and leaves. However, unlike how most botanical illustrations are presented against a plain background, it stands out against

an ethereal scene of the ecosystem in which it grows: the Amazon rainforest. After attending London's Camberwell School of Arts and Crafts in the late 1940s, Mee travelled to São Paulo, Brazil, to look after her ailing sister. She spent the next three decades studying and painting the flora of Brazil on forays along the Amazon River and into the rainforest. Initially, the habitats she explored were largely intact, but after a decade, she began to increasingly witness their destruction at the hands of settlers, miners and prospectors. She added the unconventional

backdrops to her paintings to help raise awareness of the rainforest and the struggles of early conservationists to protect it. On her fifteen expeditions in the Amazon, Mee encountered several species that were new to science – some of which are now named after her, such as *Aechmea meeana* and *Sobralia margaritae*. Through her paintings and several books, Mee was a fierce advocate against environmental damage, pollution and species extinction until her untimely death in a car crash in 1988.

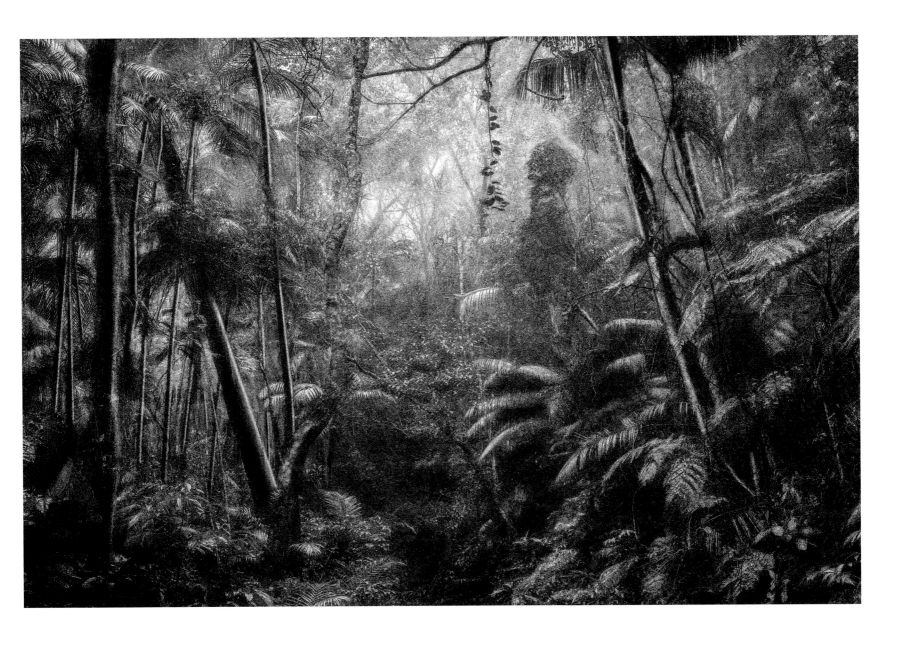

Cássio Vasconcellos

A Picturesque Voyage Through Brazil 37, 2015
Photograph, dimensions variable

Walking through the Amazon rainforest at night with his camera, Brazilian photographer Cássio Vasconcellos (b. 1965) captured the lush tropical vegetation of a nocturnal world reduced by moonlight to a monochromatic scene in this ethereal photograph. Between 2015 and 2019, Vasconcellos travelled through the vast Amazon on foot to create his series 'A Picturesque Voyage through Brazil', from which this image comes. Vasconcellos approached his forest walk as he might a stroll through the streets of his native city, São Paulo, capturing the

diversity of the understorey and the majesty of the canopy far above his head. This photograph is reminiscent of botanical drawings made during eighteenth- and nineteenth-century European-funded expeditions of the Amazon rainforest. In that, he followed in the footsteps of his great-great-grandfather, German-born botanist Ludwig Riedel, who spent several years on the Langsdorff Expedition in the Amazon rainforest between 1825 and 1829 and was the first foreigner appointed to work at Rio de Janeiro's botanical garden. Vasconcellos wanted to

capture the forest's immense biological wealth to highlight what might be lost through the threat to the world's forests from large-scale deforestation. Shown at a 2019 exhibition staged at the Fondation Cartier pour l'Art Contemporain in Paris titled 'Nous les Arbres' ('Trees'), the image celebrates the importance of trees in the global ecosystem. Long undervalued, recent research has proved not just that trees can communicate with each other but that they possess 'plant intelligence', which might just help save the planet.

Shyama Golden

Intertwined, 2020
Acrylic on canvas, 1.2 × 1.2 m / 4 × 4 ft
Private collection

Two trees are spectacularly anthropomorphized in this painting by Sri Lankan American artist Shyama Golden (b. 1983). Covered in vines, standing proudly to attention, the green human forms contrast with the spindly trees behind them as the moon rises in the background. The intention behind Golden's painting was, by her own admission, to subvert the fundamental character of both traditional landscape painting and portraiture. Her own unique portraits of trees draw on her Sri Lankan heritage, recalling the Yakkas, or devil dancers, who perform

exorcism rituals, and a desire to reflect both the drama of everyday life and its theatricality in the social dynamics of personal relationships. Golden's inspiration for *Intertwined* came from a trip to Jamaica, where she saw a pair of vine-covered trees on the Martha Brae River that she thought looked like lovers embracing. Having noticed those anthropomorphic trees, suddenly she saw them everywhere. Her thoughts were crystallized by Richard Powers' prize-winning 2018 novel *The Overstory*, which has at its centre the human qualities trees share, from

their social lives to how they communicate and share resources. These ideas were further reinforced for Golden by nuggets of information she learned, such as the fact that people's mental well-being is helped by walking in forests – as evidenced, for example, by the Japanese concept of forest bathing – and that research shows that patients in hospital rooms facing trees recover faster than those in rooms that do not face trees. Golden's painting blurs the boundaries between the tree and humankind, depicting two species irrevocably intertwined.

Tjanpi Desert Weavers

Minyma Punu Kungkarangkalpa (*Seven Sisters Tree Women*), 2013
Native grasses (minarri and ilping), found fencing wire, aviary mesh, second-hand clothing, acrylic pillow stuffing, acrylic wool yarn, jute string, cotton string,
raffia, emu feathers, sheep's wool, tree branches, foam and piping, dimensions variable, Museum of Contemporary Art, Sydney

An enchanted circle of seven figures – part trees, part women – is seemingly caught up in a timeless dance, the participants' branches and trunks thrumming with uncontainable movement. Fashioned out of bound grass, raffia, fencing wire, feathers, wool and other found materials, these are the Seven Sisters as envisioned by the Tjanpi Desert Weavers, a dynamic collective established by the Ngaanyatjarra Pitjantjatjara Yankunytjatjara (NPY) Women's Council. Their work is deeply enmeshed in the Anangu cultural heritage of the NPY communities living across the desert regions of Central and Western Australia. The story of the Seven Sisters is a tale of creation, morality and social structure that has been passed down through generations. It tells of the Seven Sisters of the Pleiades constellation, the eldest of whom is pursued by a man, the Morning Star. Protected by her younger sisters, she is able to summon enough strength to repel him. In Central Australia, the Pleiades constellation is seen often, rising soon after sunset and remaining low on the horizon. The female weavers reflect the close relationship between sky and earth by using native grasses (*tjanpi*) and other materials they find in the desert to make objects that are rooted in the red soil of the desert but joined to the heavens. Just as trees come from the land itself, so do the Seven Sisters. Using sculpture as a medium for storytelling and cultural preservation, the tree-women are not just physical entities but are imbued with the Anangu women's sense of strength, resilience and unity.

Tomás Sánchez

Aislarse, 2001
Acrylic on linen, 100.3 × 75.5 cm / 39½ × 29¾ in

Marooned on a small island within a stretch of calm water, a towering pillar of dense green foliage rises, tall and majestic, against a distant backdrop of forest. The massive central column of lush vegetation, tree trunks and canopy embodies a proud natural grandeur, each detail intricately painted and reflected in the still water. A sense of serenity and otherworldliness pervades this painting by the award-winning Cuban-born painter Tomás Sánchez (b. 1948), who now lives between Costa Rica and Florida. Titled *Aislarse*, meaning 'to isolate oneself', it is a nod both to the artist's lifelong practice of meditation and to the inner peace and heightened consciousness that can be found through nature. Inspired by Romantic artists, particularly the nineteenth-century German artist Caspar David Friedrich (see p.246) and the American Hudson River School, Sánchez strives to depict harmony between man and the natural world. His hyperreal landscape draws attention to nature's inherent spirituality in the face of constant change and the ongoing battle between humanity and nature for the planet's natural resources. In the muted colour palette of this unspoiled tropical vista lies the unspoken melancholy of a paradise that, while it appears pristine and untouched, is under constant threat. This is deliberate: best known for painting series of landscape paintings, Sánchez uses his art to depict the sociopolitical landscape of his Cuban homeland from exile. During the 1980s, Sánchez belonged to the Volumen Uno movement, which resisted the heavy censorship of art typical of Cuba under the rule of Fidel Castro. For Sánchez, nature is freedom. He says, 'I believe it's through nature that man finds freedom.'

Michael Kenna

Wānaka Lake Tree, Study 1, Otago, New Zealand, 2013
Photograph, dimensions variable

With its arching trunk appearing to grow directly out of the water, That Wānaka Tree, as it is popularly known, is perhaps the most famous tree in New Zealand and probably the most photographed – a particular favourite of the Instagram crowd. Located in Lake Wānaka, against the backdrop of the Southern Alps on New Zealand's South Island, about 300 kilometres (186 mi) from Dunedin, the tree started life as a fence post that was cut from the branch of a nearby crack willow tree (*Salix fragilis*) some eighty years ago. The willow post – evidently still

alive – took root on the edge of Lake Wānaka, becoming a symbol of hope and renewal. The crack willow – taking its name from its bark, which cracks easily – is a fast-growing tree, but the cold waters of the lake, which is fed by Roys Bay, have slowed the tree's growth. Why it has grown into its distinctive curved shape remains a mystery. Located just a few metres from the edge of the shore, the tree's increasing fame has made it harder to protect: in March 2020 it was vandalized when several of its branches were removed. In this ethereal image,

British photographer Michael Kenna (b. 1953) uses his signature minimalist approach to capturing nature, transforming the lake into a flat, motionless ground out of which the stark outline of the willow rises against a hazy background. Fascinated by light, Kenna uses long time exposures, which can last all night, to reveal details that the human eye cannot see, lending his images a meditative quality.

Efacio Álvarez

Untitled, 2020
Black ball pen on paper, 21 × 29 cm / 8¼ × 11⅜ in
Artes Vivas, Verena Regehr-Gerber Collection, Colonia Neuland, Chaco, Paraguay

Rendered in black ink on a white background, a jaguar stalks two deer in a forest. This intricate drawing is the work of Indigenous artist Efacio Álvarez (b. 1988) and depicts his ancestral homeland, the Gran Chaco, which was lost after the Chaco War between Bolivia and Paraguay ended in 1935. The dispossession brought about by colonization led to a substantial loss of autonomy and a deterioration in living conditions for the peoples of the Chaco. The war resulted in the expropriation of Indigenous land and the subsequent progressive destruction of much of

the forest. A self-taught artist, Álvarez's drawings emphasize the relationship between hunter and prey, the cycle of the forest, of eating and being eaten. Among the many species of trees and shrubs depicted in this drawing is the distinctive Samu'u tree (Ceiba chodatii), which stands out because of the distinctive bottlelike shape of its trunk and spiny bark. Humans and animals in the Chaco often found refuge in the tree's shadow under its generous crown. The spines that cover its bark are believed to protect the soft wood from predators. Indigenous people of the Chaco

have made use of the Samu'u, carving large sections of the trunk into canoes and containers for fermented beverages. Reflecting on the inspiration for his work, Álvarez says, 'I love trees and animals and like the forest because I learned to observe and draw there.'

Ibrahim El-Salahi

Meditation Tree, 2018
Larch wood, 2.4 × 2 × 1.8 m / 8 ft × 6 ft 5 in × 5 ft 10 in

With biomorphic branches protruding in all directions, this surreal-looking tree appears to have been transplanted from another world. Carved from darkly stained larch wood, the sculpture is one of several similar works by Sudanese artist Ibrahim El-Salahi (b. 1930) that reference an acacia tree known colloquially as Al-Haraz, which grows widely across the artist's home country. One of these large, thorny trees planted by his father grew in front of El-Salahi's childhood home, and the artist remembers it regularly bearing fruit. Yet, as the climate started to change, the tree began to die,

and though the roots of the Haraz are known to grow 80 metres (262 ft) deep in search of moisture, it had to be cut down. Created partly as an homage to that tree, *Meditation Tree* speaks to issues of climate change in Sudan, where increased droughts and erratic rainfall have led to soil erosion and the desertification of millions of acres of land. In past decades, the tree motif has become an increasingly important part of El-Salahi's practice, being represented both figuratively and abstractly in two- and three-dimensional works. The Haraz, which is widely

celebrated in Sudanese proverbs, poetry and songs, is noted for its unusual behaviour: the tree blossoms in the dry season while other trees are dropping their leaves. For El-Salahi, a central figure in the development of African modernism, its contrary nature is an apt metaphor for artistic identity.

teamLab

Resonating Trees, 2014
Interactive digitized nature
Installation view, Forest of Tadasu at Shimogamo Shrine, Kyoto

teamLab, a Tokyo-based international art collective, was founded in 2001 with just five members. Now there are numerous specialists, including graphic animators, computer programmers, architects, artists and mathematicians. Their collaborative practice seeks to navigate the confluence of art, science and technology through immersive works. The aim is to explore the relationship between self, the world and new forms of perception, including the continuity of time. Bathed in vibrantly coloured lights, *Resonating Trees* are a repeating feature in many of teamLab's outdoor

exhibitions, as seen here where the forest of Tadasu at Shimogamo Shrine in Kyoto was transformed into an interactive art space in 2014. For *Resonating Life in the Acorn Forest* (2020–24), silvery ovoids among the trees of Musashino Woods Park in Saitama, Japan, reflected the world around them. When pushed by a visitor or blown by the wind, they fell over, emitting a sonic resonance as they returned to an upright position. At night the ovoids were each illuminated by one of fifty-seven sound-specific colours. Responding one after another, the sounds and

up-lit trees created a magical, ethereal ambiance. As part of teamLab's ongoing *Digitized Nature* project, visitors to the annual exhibition *A Forest Where Gods Live*, pass through a *Resonating Forest* of cherry and maple trees in the historic Mifuneyama Rakuen Park in Takeo, Japan. Detecting a human presence, the trees begin to glow in response, then the lights fade as people pass, as if the environment is breathing. The visual experience is again harmonized with sound, creating a heightened sense of awareness not only of the presence of others but also of the forest as a living organism.

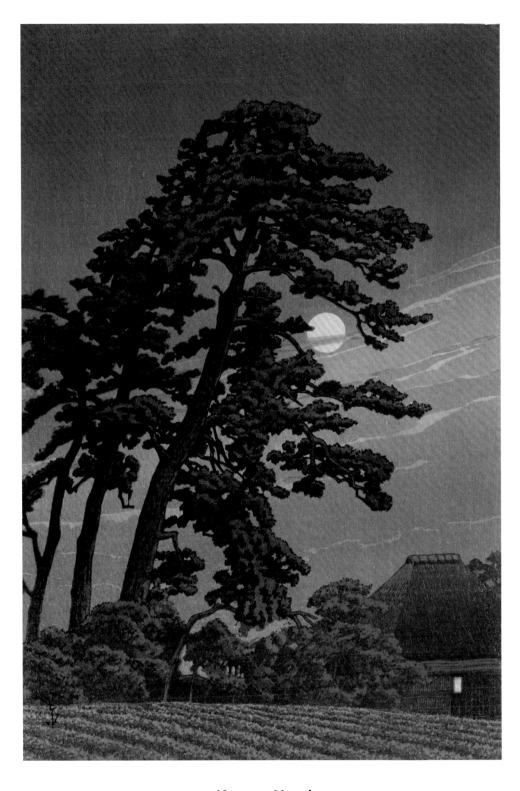

Kawase Hasui

Magome no tsuki (*Moon at Magome*), from *Tōkyō nijūkei* (*Twenty Views of Tokyo*), 1930
Woodblock, 38.7 × 25.9 cm / 15¼ × 10¼ in
Private collection

A group of towering pine trees dominates a peaceful night scene in this woodblock by the prolific Japanese printmaker Kawase Hasui (1883–1957). The rich blue sky and full yellow moon, partially hidden by wispy grey clouds, appear behind the deep green foliage of the gigantic conifers. In the lower right-hand corner is a small house, dwarfed by the pines, while the faint, orderly furrows of a ploughed field are also clearly visible. Hasui belonged to the early twentieth-century *shin-hanga* ('new prints') movement of Japanese woodblock printing. Revitalizing the earlier Edo school of *ukiyo-e*, or

'pictures of the floating world', and influenced by Western art, particularly the French Impressionists, the *shin-hanga* movement was synonymous with landscapes. Following in the tradition of artists such as Hokusai and Utagawa Hiroshige (see p.299), who both created numbered series of landscape prints, this image belongs to a series: 'Twenty Views of Tokyo'. When he created it, Hasui had just moved to Magome, a suburb of Tokyo, nicknamed Bunshi-mura ('writers' village'), as many novelists and artists had moved there from central Tokyo in the Taisho and early Showa eras. This print shows

Hasui's skill at capturing light – not just the moonlight that bathes the scene but also in the single illuminated window. Hasui travelled across Japan to create his art, sketching out the scene before him and then later adding colour. Pine trees were a common feature in his prints, as they are ubiquitous in Japan and are revered as a symbol of courage, endurance and longevity. His extreme shortsightedness, however, largely prevented him from including human figures in his images. In 1956 the Japanese government recognized Hasui as a national treasure for his contributions to Japanese culture.

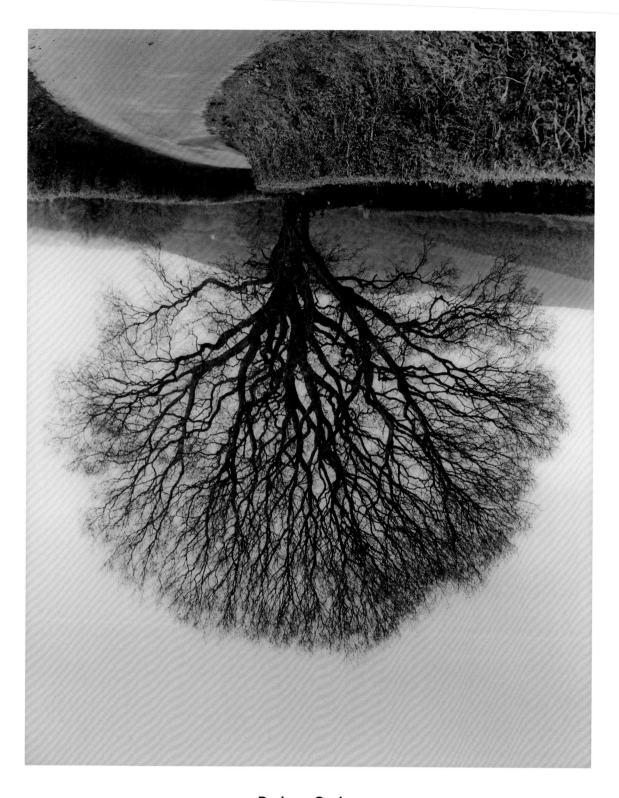

Rodney Graham

Welsh Oaks #1, 1998
Chromogenic print, 2.3 × 1.8 m / 7 ft 5 in × 6 ft
Metropolitan Museum of Art, New York

The majestic crown of a mighty oak tree appears like a complex root system in this disorienting upside-down image. The large-scale photograph is one of seven that Canadian artist Rodney Graham (1949–2022) created for his 'Welsh Oaks' series, each one a flipped portrait of a solitary tree in the British countryside. Shot with black-and-white film but printed on colour photo paper, the images are tinged with warm sepia and charcoal hues. Inverted trees are a recurring motif in Graham's work, drawing attention to the artifice of photography and serving as a vivid reminder that the lens of the human eye projects an upside-down image onto the retina before it is decoded by the brain to be perceived the right way up. While Graham used a conventional camera to take his later tree pictures, they relate to his early experiments in the late 1970s with a camera obscura, a room-size pinhole camera that enabled him to capture upside-down images of trees in rural Canada through a small aperture. Driven by an interest in perception and representation, the image of an inverted tree was for Graham also emblematic of humanity's oppositional relationship with nature. Each of his matter-of-fact images is steeped in the history of a specific place, as reflected by titles such as *Flanders Trees* (1993) and *Stanley Park Cedar* (1991), the latter interpreted by some as an allusion to the deforestation of British Columbia, which devastated the area's ecosystems.

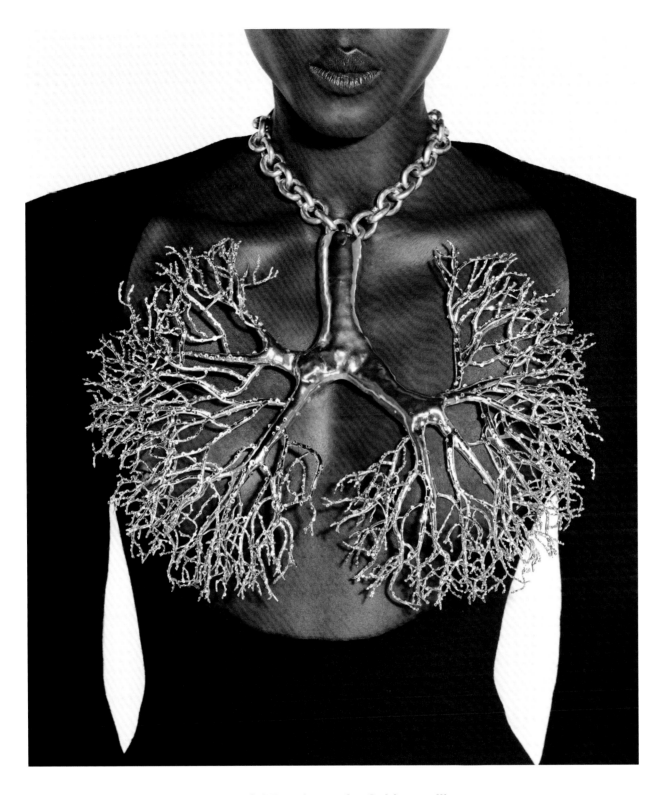

Daniel Roseberry for Schiaparelli

Look 11 (detail), from Haute Couture Fall/Winter 2021–22
Gilded brass with rhinestones, dimensions variable

When the supermodel Bella Hadid appeared on the 2021 Cannes Film Festival's red carpet, she stunned the world with a black wool crepe gown by Schiaparelli accompanied by this remarkable breastplate. Designed by the Parisian couture house's American artistic director Daniel Roseberry (b. 1985), the breastplate was inspired by the human lungs. In 2021 the worldwide COVID-19 pandemic and the terrible effect the disease had on the lungs of those who were infected were at the forefront of the news. Roseberry, who had previously used human anatomy in his jewellery design,

wanted to both highlight and celebrate the lungs. To that end, he created a gold-dipped bronchial tree made up of hundreds of filigreed bronchi – the airways that deliver oxygen to the lungs – suspended on upside-down branches and a trunk, resembling the human trachea, attached to an oversized choker chain. The intricate bronchi were dotted with rhinestones to represent the alveoli – the tiny air sacs where oxygen and carbon dioxide are exchanged – giving the piece a three-dimensional effect as it catches the light. The branching, fractal patterns of both lungs and trees is

perhaps not a coincidence as both evolved for a similar function: respiration. The length of the breastplate was purposefully set so that it would conceal the wearer's chest, which was left deliberately open by the cut of the dress. The creation of such a dramatic piece followed in the creative footsteps of the founder of the couture house, Elsa Schiaparelli, whose designs in the first half of the twentieth century celebrated Surrealism and who often used the human body for inspiration.

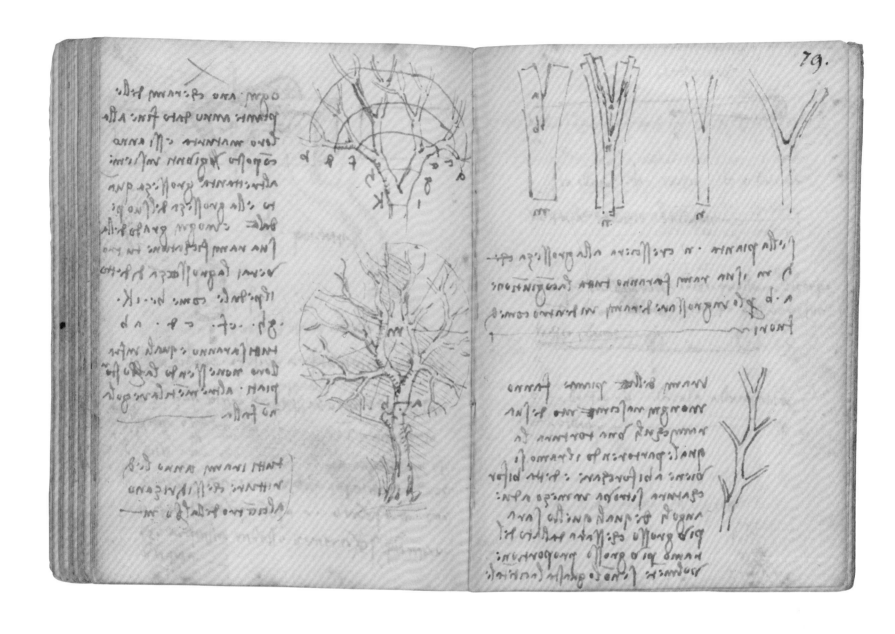

Leonardo da Vinci

Pages from *Manuscript M*, 1490–1500
Pen and ink on paper, each 10 × 7 cm / 4 × 2¾ in
Bibliothèque de l'Institut de France, Paris

Between 1478 and 1518, the Italian polymath Leonardo da Vinci (1452–1519) produced a series of notebooks in which he theorized and speculated about a vast range of different scientific subjects. This particular page sets out his Rule of Trees, together with two sketches. Writing in his mirror text – Leonardo wrote backwards from right to left for secrecy, so his writing must be read in a mirror – he argues that as a tree trunk grows, the thickness of its branches at a certain height will be the same as its trunk if the branches are combined. In a study of ratios, he observed that the total cross section of a tree remains the same along its height every time it branches. His drawings further expand on his thoughts, showing his thinking about how branches grow in relation to the trunk. Elsewhere he maps out his thoughts on the impact of natural variables such as the need to withstand wind, rain or snow or bear its fruit. Such speculation about the anatomy of trees was highly unusual in the Renaissance, and trees featured little in the art of the fifteenth and early sixteenth centuries. Leonardo broke the mould, and his fascination with exploring scientific relationships and properties found its way into his paintings, making them look more realistic. Such was the impact of his Rule of Trees that it became the accepted formula when modelling trees for scientific experiments. Remarkably, a 2011 experiment using computer-generated models concluded that trees do typically follow Leonardo's formula, helping them withstand strong winds, but a further study in 2023 showed that this does not apply to the vascular channels within trees.

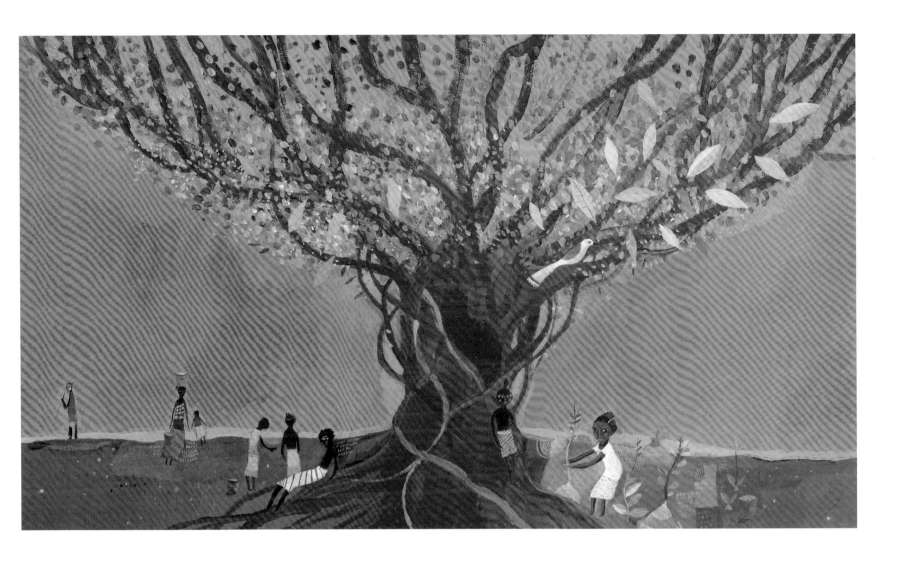

Aurélia Fronty and Franck Prévot

Illustration from *Wangari Maathai: The Woman Who Planted Millions of Trees*, 2011
Printed page, 26.3 × 52.6 cm / 10¼ × 20½ in

Beneath the sprawling canopy and among the winding roots of a *mugumo* tree, or strangler fig (*Ficus thonningii*), Wangari Maathai and other members of her village collect water and tend to a small garden. Illustrated by French artist Aurélia Fronty (b. 1973), the scene is one of many vibrant paintings included in the children's book *Wangari Maathai: The Woman Who Planted Millions of Trees*, written by Franck Prévot (b. 1968). The book tells the story of Maathai, the remarkable Kenyan environmentalist who was awarded the Nobel Peace Prize in 2004 in recognition of her efforts to empower women to bring peace and democracy to Africa through non-violent struggle. In 1977 Maathai founded the Green Belt Movement, which led to 51 million trees being planted in her native country as a symbol of achieving social change, inspired by Maathai's childhood experiences growing up in colonial Kenya. As a young girl, she had seen the colony's British rulers uproot millions of trees to use the land for tea, coffee and rubber plantations to grow crops for export. Maathai excelled in school from a young age, and in 1960 she won a scholarship to go to college in the United States. On her return to Kenya, the British had departed, but their legacy had left her country impoverished, with its corrupt leaders continuing to exploit its natural resources. Planting trees became an act of resistance for which she was imprisoned on more than one occasion, but Mama Miti ('the mother of trees'), as she affectionately became known, persisted. The first African woman and the first environmentalist to win the Nobel Peace Prize, her legacy persists in the Green Belt tree-planting programme, which continues today.

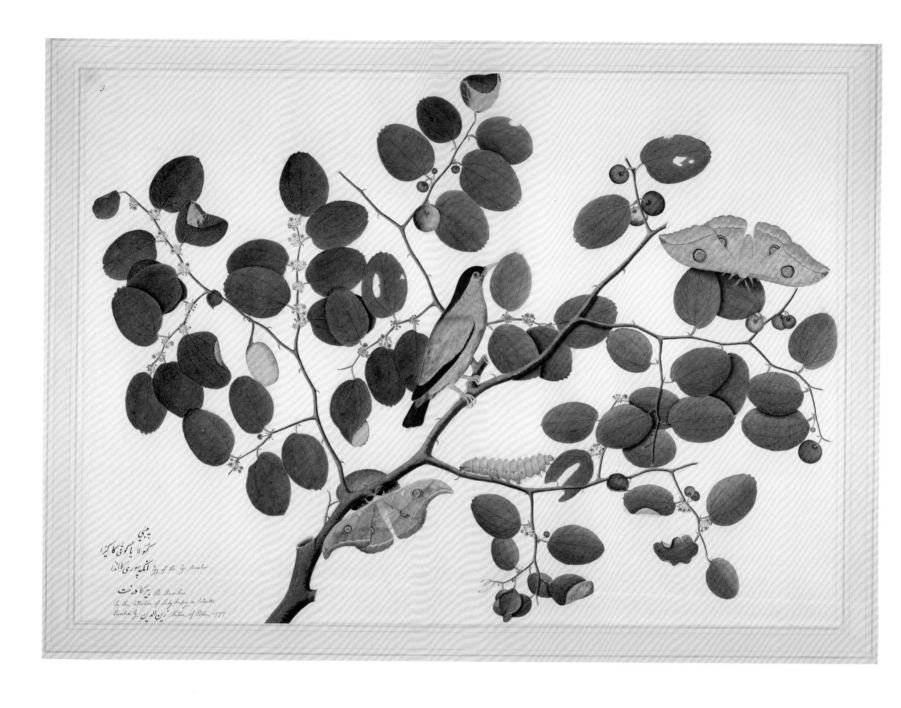

Sheikh Zain-al-Din

Brahminy Starling with Two Antheraea Moths, Caterpillar and Cocoon on Indian Jujube Tree, 1777
Opaque colours and ink on paper, 76.2 × 96.5 cm / 30 × 38 in
Minneapolis Institute of Art, Minnesota

A Brahminy starling sits among the leaves of a jujube tree (*Ziziphus mauritiana*) alongside two Antheraea moths, a caterpillar and cocoon. This image might be reminiscent of botanical prints from eighteenth-century Europe, but, in fact, it marks the emergence of a new style of painting as European tastes spread throughout the colonial world. It is the work of an Indian artist, Sheik Zain-al-Din (active 1777–1783), employed by the British East India Company, which by 1757 effectively ruled the Indian subcontinent. Known as Company Painting, this new school of painting

in colonial India brought together the exacting calligraphic styles of traditional Indian artists with the demands of British paintings. Zain-al-Din's painting is notable for the precision of its detail – not just of the bird and moths but also of the tree itself. The jujube grows throughout much of Asia, both in the wild and as a garden shrub, and is popular for its shiny green leaves, which have a woolly underbelly, its delicate white flowers and its small edible fruit, which resemble dates but taste of apple. Between 1777 and 1783, Zain-al-Din was commissioned by Lady

Mary Impey, alongside two other artists, to paint the collection of birds and animals on display at the menagerie and aviary at the Kolkata home she shared with her husband, the newly appointed chief justice of Bengal, Sir Elijah Impey. The result was the famous Impey Album, a record of India's indigenous flora and fauna in 326 paintings.

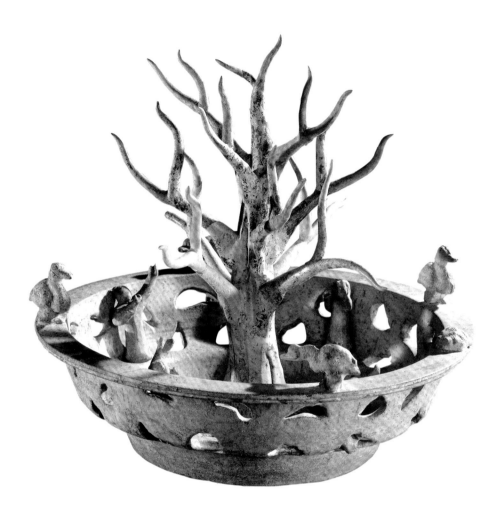

Anonymous

Glazed pottery pond with figures, c.1st–2nd century CE
Earthenware, H. 35.5 cm / 14 in
British Museum, London

This miniature ceramic model of a pond, complete with fish, frogs, a tortoise, ducks and other creatures sitting on its rim, has a tree at its heart, its bare branches standing at sharp angles. A figure at the left of the pond might have been shooting birds in the tree – but they have long since been lost – while another figure holds a net with which to catch fish. This idealized scene in what was probably a garden pond was created by an artisan during China's Han dynasty (206 BCE–220 CE), probably as a funereal object to be buried with someone after death. The Han believed the

afterlife was the same as the present life, so they buried the dead with the objects they would need to maintain their social position and lifestyle in their next life. Over the Han period, the type of objects placed in the tombs and their symbolism subtly changed. Models of buildings and their gardens – including everything from houses, granaries, wells and ponds – became popular burial objects. Unlike the renowned life-size terracotta warriors buried alongside the First Emperor to guard him during the previous Qin dynasty (221–206 BCE), miniature versions of

scenes were a much more affordable way to remind the deceased of the world they had left and ensure their comfort in the new life they embarked upon. By the late Han period, funereal objects and sculptures were no longer exclusive to the wealthy but became customary in the tombs of common people as well.

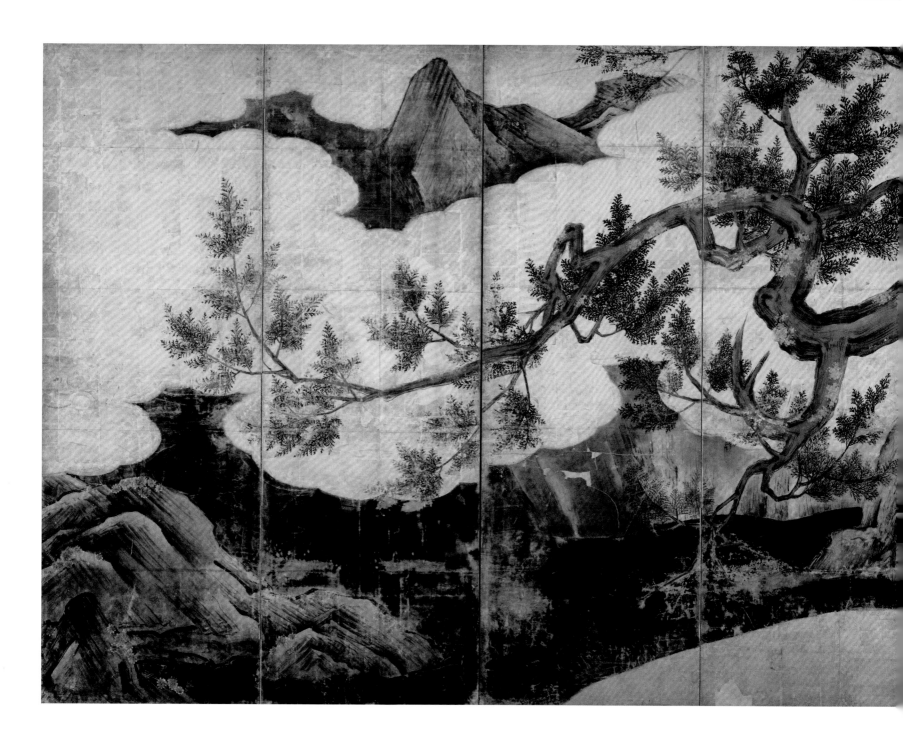

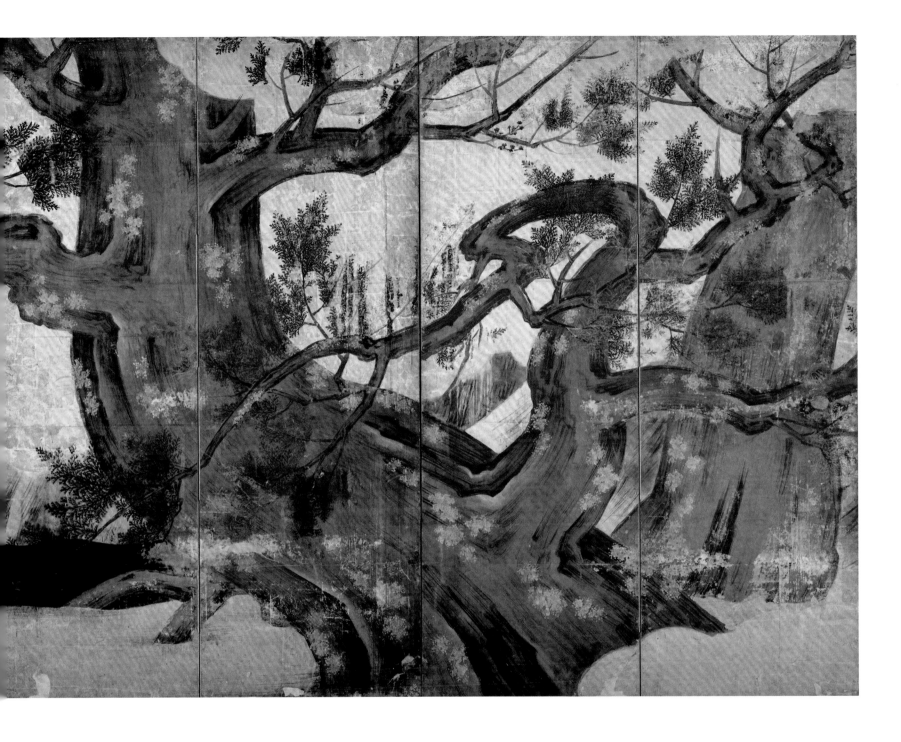

Kanō Eitoku

Cypress Trees, 1590
1.7 × 4.6 m / 5 ft 6 in × 15 ft
Tokyo National Museum

Sprawling across a golden background, a cypress tree dotted with moss and lichens stretches its gnarled branches towards a rocky seascape below. Renowned for his ability to create visually striking representations of the natural world, Japanese artist Kanō Eitoku (1543–1590) had a distinctive aesthetic approach characterized by bold and vibrant colours, intricate details and an overall sense of dynamism. Eitoku began painting at the age of ten and by his twenties had produced a large body of work in the Kanō style, two of which are now regarded as national treasures of Japan.

One of the most notable features of his masterpieces from the late Momoyama period is his skilful depiction of cypress trees. This beautiful folding screen is a prime example of the artist's ability to distil the true character of arboreal form in order to communicate important moral teachings. The contorted tree trunks and branches elegantly establish the rhythm and balance of the scene, generating a sense of contemplative calm and harmony. Eitoku's depiction of cypress trees frequently emphasized their towering height and magnificent presence, conveying a sense of reverence,

strength and resilience. In Japanese culture, the cypress tree is believed to possess purifying properties and is associated with sacred places, so it is often planted near shrines and temples. Because of its evergreen nature, which echoes the essence of eternal life, the cypress tree frequently signifies longevity and immortality, and the tree's ability to withstand harsh weather conditions and its sturdy nature also make it a symbol of endurance and perseverance. By incorporating cypresses into his paintings, Eitoku also aimed to convey the samurai's unwavering determination.

Mary Delany

Aeschelus hippocastanum (Heptandria Monogynia), Horse Chestnut, 1776
Collage of coloured papers with body colour and watercolour on black ink background, 32.1 × 22.2 cm / 12½ × 8¾ in
British Museum, London

This depiction of *Aesculus hippocastanum* – commonly known as the horse chestnut, a tree native to Turkey that was introduced to Britain in the sixteenth century – is one of the most notable works of English artist Mary Delany (1700–1788). Delany's attention to detail and balanced arrangement seems traditional, but closer scrutiny reveals that what at first appears to be a watercolour-and-pencil picture really is the result of careful collaging. Delany cut up more than two hundred pieces of coloured paper for each work, which she then delicately layered to produce

intricate shadowing and subtle overlays. This technique heightened the visual impact of her botanical creations, making them appear even more realistic. To bring her collages to life, Delany employed a variety of materials, including watercolour and glue made from a mixture of egg whites, flour and water. She completed 985 collages between 1774 and 1784 and only stopped creating them at the age of eighty-two, when her eyesight began to deteriorate. The artist's meticulous reproductions garnered acclaim due to the manner in which they depicted the

splendour of botanical life forms. Botanist Joseph Banks, of Kew Gardens, said that Delany's collages were the only imitations of nature he had seen from which one could 'describe botanically any plant without the least fear of committing an error'. Today, Delany is an endless source of inspiration for contemporary artists – a pioneer who invented her own medium at the intersection of art, craft and science. Her paper mosaics can be found in prestigious institutions across the world, preserving her remarkable legacy as a one-of-a-kind botanical artist.

John Ruskin

Chestnut Leaves, 1870
Pen, ink and watercolour on paper, 48.2 × 38.1 cm / 19 × 15 in
Indianapolis Museum of Art at Newfields, Indiana

In 1861 the Victorian polymath John Ruskin (1819–1900), today better known as an art critic but then a prominent thinker on a range of subjects, was invited to deliver a lecture at the prestigious Royal Institution in London. Much to the confusion of an audience expecting a talk more in keeping with the institution's tradition of discoveries by scientists such as Michael Faraday, Ruskin chose to talk about twigs. Specifically, he spoke about the development of trees, in particular the horse chestnut, the leaf of which appears in this watercolour he created to accompany the lecture. Living and working at a time of huge upheaval as Great Britain led the world in the Industrial Revolution, Ruskin became an outspoken critic of the dehumanizing effect of industrialization and the vital role of nature in human life. At the same time, he questioned the Renaissance portrayal of nature as idealized and perfect: he believed artists should copy their subjects from life without improving on what they saw. Each individual leaf of the tree, he argued, was a unique entity – complete with imperfections – that contributed to the creation of the horse chestnut tree as a whole. To illustrate this point, he accompanied his lecture with his own drawings, despite his avowed belief that he was no artist, in order to acknowledge the flaws of nature – and by extension life – with complete honesty.

Grant Associates

Supertree Grove, 2012
Reinforced concrete, concrete and steel with planting panels and photovoltaic cells, H. 25–50 m / 82–164 ft
Gardens by the Bay, Singapore

In 2005 the Singapore government announced a plan to create a new green waterfront space, with their overarching vision to celebrate plant life and make Singapore the world's garden. Named Gardens by the Bay, the project would eventually cover 100 hectares (247 acres) of land reclaimed from the sea. The first phase of development, Bay South, was awarded to the UK-based architectural firm Grant Associates, supported by Wilkinson Eyre, which was tasked with transforming 54 hectares (133 acres) of rough parkland. Two enormous glass conservatories, the

Flower Dome and Cloud Forest, and eighteen artificial Supertrees are at the core of the design. The Supertrees vary in height between 25 and 50 metres (82–164 ft) and have been planted with epiphytes including bromeliads, orchids, ferns and tropical climbers. Many have been fixed onto wire mesh trunks while others are supported by root-zone panels filled with free-draining growing media. Each tree has a different planting strategy, and all have become important habitats for birds and other animals. Two of the Supertrees are connected by an aerial walkway, accessed

by taking a lift up 22 metres (72 ft) to admire the panoramic views of the Singapore skyline, as well as the overall layout of the gardens below. One tree has a restaurant at its top to enjoy the views while eating. The Supertrees are also cooling towers for the two conservatories and vent their waste hot air, and their canopies have solar panels, which create enough energy to light them; at night the trees come alive, providing dazzling light displays.

Philip Treacy for Alexander McQueen

Headdress, from *The Girl Who Lived in the Tree*, Autumn/Winter 2008
Driftwood and coral, dimensions variable
Private collection

Fashioned from Caribbean driftwood and a delicate fan of coral with tiny branching extensions, this somewhat macabre skeletal peacock is, in fact, a headdress. It was designed by the often outrageous Irish-born, London-based milliner Philip Treacy (b. 1967) for his longtime – and equally avant-garde – collaborator, British designer Alexander McQueen (1969–2010). For his Autumn/Winter 2008 ready-to-wear collection, *The Girl who Lived in the Tree*, McQueen invented a fairy tale telling of a girl who descends from the tree in which she lives to marry

a prince and become a queen. The show's inspiration was a six-hundred-year-old elm tree in the garden of McQueen's Sussex home, and the designer's models paraded around a huge, fabric-covered tree, a nod to the Bulgarian artist Christo, who was famous for wrapping iconic buildings in various materials. With little collaboration beyond the initial commission, Treacy's brief was simply to create headwear that would not just complement McQueen's designs but would redefine what a hat could be. Both McQueen and Treacy shared a love of

the natural world, and the use of organic media was key to the design of the headdress. Treacy took unexpected materials – wood and coral specimens rarely make an appearance on fashion runways – and ingeniously combined them to create the gossamer fan of feathers, with twig legs and a body of gnarled wood. Although taking the shape of a peacock, the resulting headpiece also referenced the beauty of the old, smoothed wood itself, the importance of woodland in British history and the tree where McQueen's fictional princess made her home.

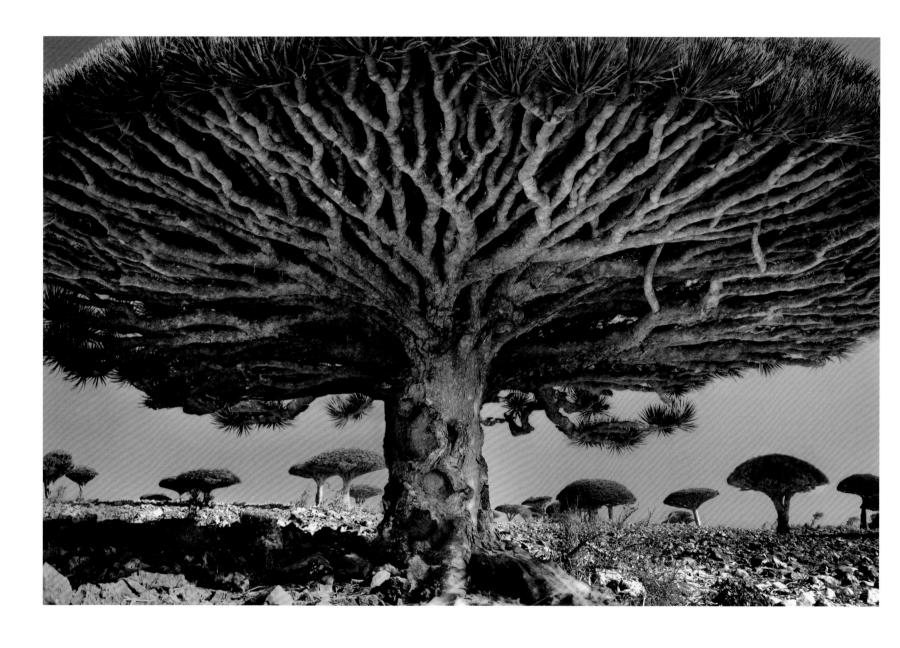

Beth Moon

Heart of the Dragon, 2010
Archival pigment inks on cotton paper, 81.3 × 121.9 cm / 32 × 48 in

Distinctive for its dense, upturned crown of gnarled and tangled branches topped with spiky leaves, the dragon blood tree (*Dracaena cinnabari*) appears ancient and otherworldly. To capture this dramatic image, American photographer Beth Moon (b. 1956) travelled to the Yemeni island of Socotra in the northwest Indian Ocean, an area rich in biodiversity that features unique flora and fauna. Named for its bright red sap, the dragon blood tree is native to the arid island, where once a forest of the trees thrived, but overgrazing, aggressive harvesting and prolonged droughts have since led to a significant decline in numbers, and the species is now endangered. According to folklore, the first dragon blood tree sprang up from the place where two brothers, Darsa and Samha, fought each other to the death; another tale tells of the tree sprouting from drops of blood shed by a dragon as it fought with an elephant. Moon's quest to record the fabled tree was dogged by logistical challenges, and it took three years before she was finally granted access to Socotra, where she spent her nights camped out under the umbrella-like trees, immersed in the surreal desert landscape. Inspired by the tree pictures of the earliest photographic pioneers, Moon spent fourteen years travelling the globe to chronicle the world's largest and oldest trees. Her black-and-white photographs, published in the book *Ancient Trees: Portraits of Time* (2014), are a celebration of endurance, survival and the wonders of nature.

Mayank Shyam

Shubh Milan, 2022
Acrylic and ink on canvas, 1.2 × 1.8 m / 4 × 6 ft
Sarmaya Arts Foundation, Mumbai, India

In a highly stylized painting of a tree, the Indian artist Mayank Shyam (b. 1987) pays homage to the beliefs of his people, the Gond, creating an exceptional fusion of conventional and modern motifs. The Gond tribe lives predominantly in Madhya Pradesh in central India, and as a community of forest dwellers, trees sit at the centre of their worldview. Trees are revered as sacred entities, often believed to be the abode of spirits and deities, and according to Gond mythology, trees are busy all day providing shelter and food for both people and animals. Shyam's work frequently depicts this harmonious coexistence of nature and humankind, reflecting his own upbringing and his belief in the interconnectedness of all living things. In *Shubh Milan*, the tree is a central figure, symbolizing life, continuity and spiritual connection. At the heart of this tree sits a huge bird, its wings seemingly turning into branches on which smaller birds perch. Beneath the tree is the extensive root system that allows the tree to stand upright. Protected by the giant bird and tree stand a man and a woman; the tree is depicted as a meeting place, a site of celebration and unity. This painting is something of a departure from much of Shyam's work, where his trees often symbolize solitude and introspection, serving as a space for individual characters to contemplate their place in the universe. The artist's upbringing in a community that values oral tradition has also influenced his artistic style, and he records the narratives that have been transmitted across generations in his paintings.

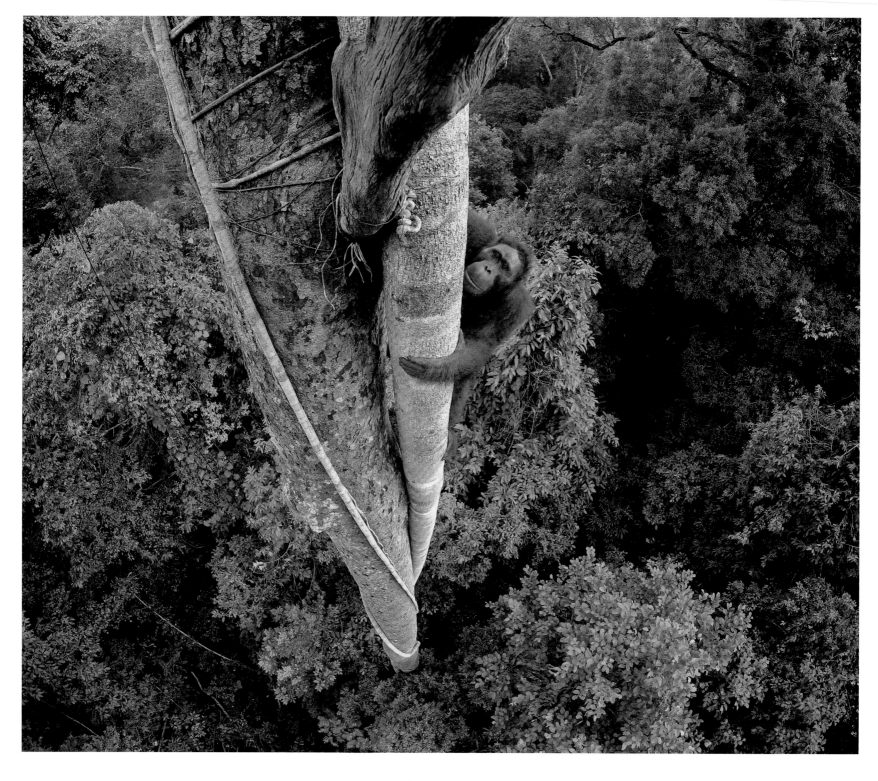

Tim Laman

Entwined Lives, 2016
Photograph, dimensions variable

This remarkable image taken from high in the canopy of the rainforest in Borneo captures a young male orangutan as he climbs a strangler fig (*Ficus* sp.) wrapped around the trunk of a host tree in Gunung Palung National Park. Using his considerable strength, the great ape makes his ascent above the crowns of the trees of the understorey, his bright orange-red fur contrasting with the green of the verdant foliage beneath. This image is the work of American photojournalist Tim Laman (b. 1961), whose doctoral thesis was on the orangutans and rainforests

in Borneo, which won him the prestigious Wildlife Photographer of the Year award in 2016. The orangutan (the name means 'man of the forest' in Malay) is the largest of all tree-climbing mammals and is mainly vegetarian, feeding on fruits and leaves. All three species of the ape are now legally protected – the Bornean orangutan (*Pongo pygmaeus*), Sumatran orangutan (*Pongo abelii*) and Tapanuli orangutan (*Pongo tapanuliensis*) – but they remain critically endangered, with fewer than sixty-five thousand remaining. The decline in their numbers is a

result of the ongoing destruction of their habitat, largely because of the deliberate felling of the rainforest to make way for palm oil plantations. Palm oil is used in the manufacture of processed food, and the palms grow best in humid tropical climates, with around 85 percent of all palm oil grown in Malaysia and Indonesia. Estimates suggest that around 40 percent of Borneo's rainforests – some 2.4 million hectares (6 million acres) – has been lost to palm oil since the start of this century.

Abel Rodríguez (Mogaje Guihu)

Terraza Alta II, 2018
Ink on paper, 70 × 100 cm / 27½ × 39¾ in
Private collection

The verdant lushness and astonishing biodiversity of the Amazon, the world's largest tropical rainforest, is captured in the exquisite ink drawings of Abel Rodríguez (b. 1941). The artist, whose name in his native language is Mogaje Guihu, was raised in the Indigenous Muinane community of Amazonas, Colombia, and is an elder of the Nonuya people. His artworks demonstrate a vast breadth of knowledge of the many types of flora and fauna that make up this fertile environment. Indeed, he was trained from childhood to be a 'namer of plants' – a figure who serves as a repository of

ancestral information about botanical species, such as their practical uses for food, clothing and dwellings, and their ritual importance in sacred customs. Following the violent displacement of his community by the Revolutionary Forces of Colombia (FARC), he relocated to Bogotá in the 1990s. There he began to transmit his expertise in detailed drawings, which he created entirely from memory, depicting the trees, plants, birds and animals that coexist in a particular season within the forest. Spanning multiple countries in South America, including Bolivia, Brazil, Colombia, Ecuador,

Peru and Venezuela, the Amazon rainforest has lost a substantial portion of its original extent since the mid-twentieth century due to multiple factors, including logging, agricultural expansion and the construction of infrastructure. As the devastating consequences to global ecology of such drastic deforestation have become increasingly understood, Rodríguez's work has gained new poignancy as authentic graphic representations of an interdependent ecosystem under threat.

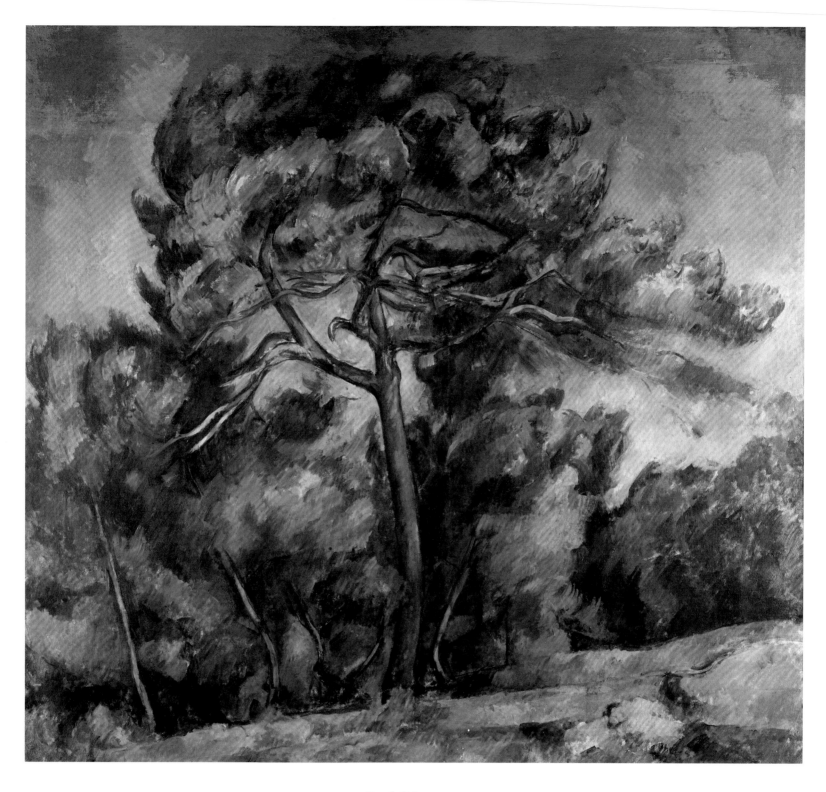

Paul Cézanne

The Great Pine, 1890–96
Oil on canvas, 85.5 × 92.5 cm / 33¾ × 36½ in
São Paulo Assis Chateaubriand Art Museum

Set against a moody grey-blue sky and rich green forest cast in shadow, a solitary pine tree towers over the landscape, its branches seemingly contorted by an invisible wind. Painted over the course of six years from 1890 to 1896, *The Great Pine* is a masterful work by Paul Cézanne (1839–1906), one of the most original artists of the Impressionist movement. Derided by critics because of his unconventional approach to painting, Cézanne spent most of the latter part of his career working in isolation. In the 1880s, in part to find shelter from the disruption caused by the Franco-Prussian

War, the painter moved away from Paris and relocated to his native Provence, where he focused on his work away from the distractions of the city. This period of solitude allowed him to develop his unique mature style, characterized by a focus on the underlying geometric shapes in nature, with a disregard for traditional perspectival structures and composition. Cézanne's focus on the natural world, particularly the Provençal landscape, radically changed his work. *The Great Pine* is a striking example of this slow but steady transitional moment. The artist's ability to capture the essence of

the landscape without resorting to realistic depiction was groundbreaking and influenced later artists such as the Fauvists and the Expressionists, and that eventually led to the invention of Cubism. One of the most significant techniques Cézanne pioneered through the making of this work is known as 'constructive stroke'. It involves the application of small, thick brushstrokes of colour that build up to form complex and faceted colour fields. Each stroke remains visible, creating a patchwork effect that adds depth and texture to the image, imbuing the pine with its own distinct character.

Giuseppe Penone

Idee di pietra – 1303 kg di luce (Ideas of Stone – 1303 kg of Light), 2010
Bronze and river stones, 10 × 5.2 × 4.4 m / 32 ft 10 in × 17 ft 1 in × 14 ft 5 in
Installation view, Domaine de Chaumont-sur-Loire, France

With his work *Ideas of Stone*, Italian artist Giuseppe Penone (b. 1947) defies the laws of gravity. From afar, it puzzles; closer up, it induces awe. Its sheer, impossible beauty is the result of skilled artistic craft. As one approaches the tree, its true sculptural character becomes apparent. Hidden among a copse of trees at the Domaine de Chaumont-sur-Loire in France, Penone has cradled massive boulders in the branches of a 10-metre (32-ft) tall bronze tree. By integrating these natural forms, the artist blurs the boundaries between the man-made and the natural, inviting viewers to

contemplate the intimate relationship that nature and art can form. In relation to this series of works, the artist said, 'A tree summarizes in an exemplary way the contrast between two forces: the force of gravity and the weight of life we are part of.' This sculpture appears to proudly overcome the force of gravity upon it and invites us to contemplate the strength of trees. It is only through the passing of time over many years that their resilience can be observed, as they withstand storms and long winters, relentlessly enduring. As a member of the Arte Povera

movement, Penone seeks to dissolve divisions between art and life by using familiar subjects and everyday materials. Over the course of his five-decade career, he has crossed these boundaries across mediums, from early performance-based works to works on paper and photography. In his sculptures, Penone often incorporates traces of human interaction with the natural world such as fingerprints, nails, wires and carvings. These remnants serve as evidence of the sculptures' man-made composition and the impact of human presence on the environment.

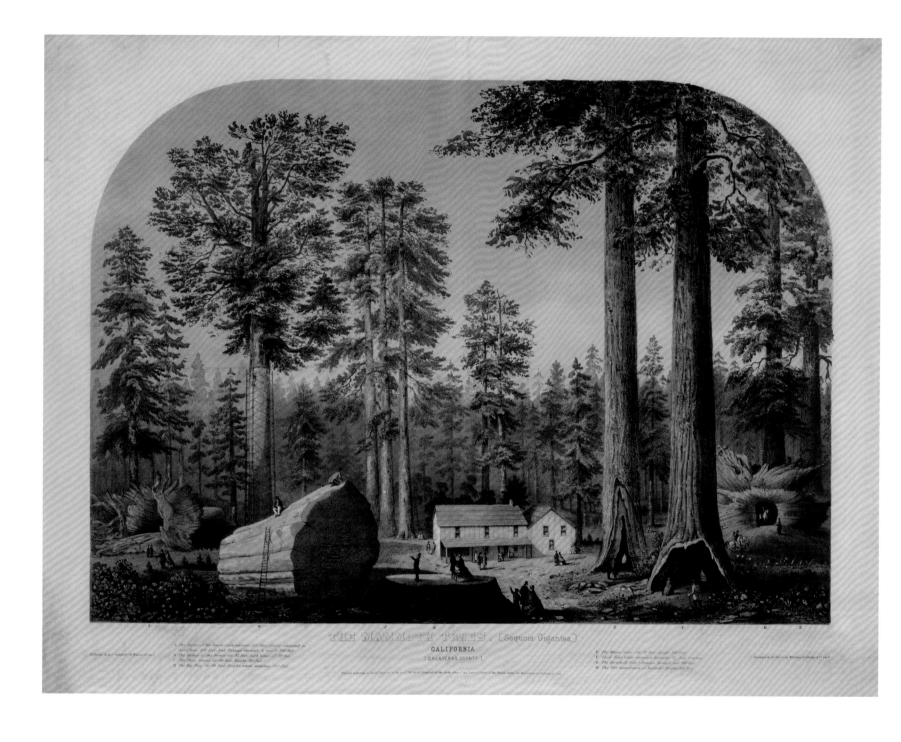

The Mammoth Trees (Sequoia gigantea), California (Calaveras County)
CALIFORNIA
(CALAVERAS COUNTY)

Middleton, Strobridge & Co.

The Mammoth Trees (Sequoia gigantea), California (Calaveras County), c.1860
Chromolithograph, 50.8 × 65.4 cm / 20 × 25¾ in
Library of Congress, Washington DC

Published at a time when the natural wonders of the western United States were becoming an object of national obsession, this illustration by the Cincinnati, Ohio-based Middleton, Strobridge & Co. shows the massive scale of the giant sequoia trees (*Sequoiadendron giganteum*) in Calaveras Grove, Calaveras County, California. Tunnels in some of the gargantuan trunks have been excavated large enough for a man on horseback to easily ride through. When this image was made around 1860, many of the surviving great sequoias in the North Calaveras grove were privately owned. The stump and felled trunk at the front of the image belong to Big Tree, known today as the Discovery Tree. It was thought to be around 1,224 years old when a team of five men hired by gold speculator and lumber baron Captain William H. Hanford felled it over the course of twenty-two days in June 1853. The tree's stump was later turned into an entertainment venue – the dance floor accommodated forty-nine people – and a saloon and two-lane bowling alley were constructed along the prostrate trunk. Behind Big Tree are trees that still stand today, the Three Graces, together with two other casualties named the Father and Mother of the Forest. The Mother of the Forest was stripped of its bark, which was reassembled as a towering column at New York's, and later London's, Crystal Palace. The destruction of two such ancient trees caused a public outcry, and initiatives to protect the remaining trees began as early as 1864. Attempts to incorporate the Calaveras Grove of trees into the Yosemite National Park were continually rebuffed; it was not until 1931 that the trees finally came under federal control.

Michael Nichols

Snow Tree, 2012
Digital photograph, dimensions variable

This iconic giant sequoia (*Sequoiadendron giganteum*) – fittingly named the President – has been growing in central California's Sierra Nevada Mountains for at least three thousand years. To celebrate the sheer size of the magnificent tree, American photographer Michael 'Nick' Nichols (b. 1952) proposed creating an unprecedented image of the President to appear in the December 2012 issue of *National Geographic* magazine. At the time, it was the second-largest single-stemmed tree ever measured (when measured by the volume of the trunk above the ground) as well as the sequoia with the largest crown, standing at a height of 75.3 metres (247 ft) above the ground. In order to photograph the tree's massive extent, Nichols and his team rigged a system of ropes to climb its limbs and shoot each section separately. That task took 32 days, after which Nichols selected 126 separate images to stitch together. The final image was much too large to do it justice in just a double-page magazine spread. Instead, the editors chose to publish it as a huge tear-out photograph that allowed the tree to be seen in remarkable close-up detail. The scale of the project and the size of the tree can be clearly understood here: two tiny orange-clad figures can be made out – one on the ground and one in the tree – both dwarfed by the mighty sequoia. Since this spectacular image was made, the President has continued to grow, but it is now considered only the third-largest tree in the world.

Albert Bierstadt

Giant Redwood Trees of California, 1874
Oil on canvas, 1.3 × 1 m / 4 ft 3 in × 3 ft 3 in
Berkshire Museum, Pittsfield, Massachusetts

Painted in a Luminist style, this elegiac portrait of California's giant redwood trees is the work of German American artist Albert Bierstadt (1830–1902). Bierstadt was a prominent member of the nineteenth-century Hudson River School of American landscape artists, who were inspired by the ideas of Romanticism in Europe. Better known for landscapes of the wide expanses of the American West, Bierstadt here paints several giant redwoods (*Sequoiadendron giganteum*) within a dense, dark forest. The biggest trees on earth, giant redwoods typically grow to a height between 50 and 85 metres (164 to

279 ft). They are only found on the western slopes of the Sierra Nevada mountains – the most famous being the enormous 'General Sherman' tree in today's Sequoia National Park, which is more than 2,300 years old. Here, Bierstadt celebrates a landscape largely lost to the great westward expansion as adventurers, gold hunters and settlers encroached on pristine lands, plundering the wilderness for their own gain. He included three Indigenous figures – two sitting by the lake and the third, a woman, gathering firewood – to give a better sense of the huge scale of the trees but also as a reminder of

a time before the European expansion that displaced many Indigenous communities and led to the destruction of many of California's forests. The botanical name of the redwood is also a nod to the Indigenous communities that long appreciated the trees before they were scientifically identified in the 1850s by European plant-hunters. While initially named *Wellingtonia gigantea*, commemorating the English Duke of Wellington, botanists finally settled on *Sequoiadendron* in honour of the Cherokee polymath Sequoyah, who created a written form of the Cherokee language.

The map labels include:

TO NORTH POLE

NICE FOR PIKNICKS

BEE TREE

BIG STONES AND ROX

KANGAS HOUSE

SANDY PIT WHERE ROO PLAYS

RABBITS HOUSE

RABBITS FRIENDS AND RALETIONS

POOH BEARS HOUSE

MY HOUSE

SIX PINE TREES

POOH TRAP FOR HEFFALUMPS

OWLS HOUSE

PIGLETS HOUSE

100 AKER WOOD

WHERE THE WOOZLE WASN'T

EEYORES GLOOMY PLACE

FLOODY PLACE

RATHER BOGGY AND SAD

DRAWN BY ME AND MR SHEPARD HELPD

Ernest H. Shepard

The Hundred Acre Wood, from *Winnie-the-Pooh*, 1926
Ink drawing on paper, 26.7 × 35.5 cm / 10½ × 14 in
Private collection

Illustrating one of the most famous forests in English literature, this hand-drawn map of the Hundred Acre Wood marks the locations of places mentioned in A. A. Milne's classic children's book *Winnie-the-Pooh* (1926). The whimsical map, illustrated by Ernest H. Shepard (1879–1976), is featured on the book's endpapers and has introduced generations of young readers to the fictional landscape frequented by Christopher Robin, who accompanies the lovable bear Pooh and his friends on their many adventures. Trees play a prominent role in the lives of Milne's

characters: Christopher Robin lives in an old sycamore and a tall beech is home to the diminutive Piglet. Owl's house is in another ancient beech at the wood's edge, and Pooh himself lives in a hollow walnut tree. The very first story introduces us to the Bee Tree, a large oak shown at the top of Shepard's map, from which Pooh amusingly fails to extract honey. In another story, Piglet and Pooh traipse around a copse of larch trees (at the bottom of the map) following the tracks of what they assume to be an elusive Woozle but are, in fact, their

own footprints. The Hundred Acre Wood was inspired by Ashdown Forest, near Milne's home in East Sussex, England, and many locations in the stories can be linked to real places. Shepard produced at least two preliminary drawings for this map; the trees were drawn first, and at Milne's suggestion, the characters were added to convey a sense of the enormity of the forest.

John Hancock Mutual Life Insurance Company

Calendar, 1898
Chromolithograph, 41.3 × 34.3 cm / 16¼ × 13½ in
Historic New England, Haverhill, Massachusetts

In the late nineteenth and early twentieth centuries, the Boston-based John Hancock Mutual Insurance Company – named after one of America's Founding Fathers, John Hancock – published an annual paper calendar. Each year the image chosen to illustrate the calendar celebrated an event from the Bay Colony's founding and Boston's role in the American Revolutionary War. In this edition from 1898, the illustration shows the Sons of Liberty, a group of American patriots, celebrating the repeal of the Stamp Act on 14 August 1766. The group is standing around the

Liberty Tree, an ancient elm that stood close to the Boston Common public park, which became a symbol of revolt in the colony of Massachusetts in the years before the War of Independence. Patriots gathered at the tree to protest against the much-hated Stamp Act introduced by the British in 1765, which required colonists to pay a tax on all paper documents, including playing cards. An embodiment of the colonists' opposition to British rule, the tree's image was spread across New England as a rallying call. Such was the growing potency of the tree's symbolism

that British troops felled the elm in August 1775, during the Siege of Boston. They used wood from the tree, which was thought to have stood since 1646, as fuel for their fires. The colonists, in a gesture of defiance, named trees throughout the British colonies Liberty Trees. A tombstone for the elm in the bottom right of the calendar reflects the devotion engendered by the original tree.

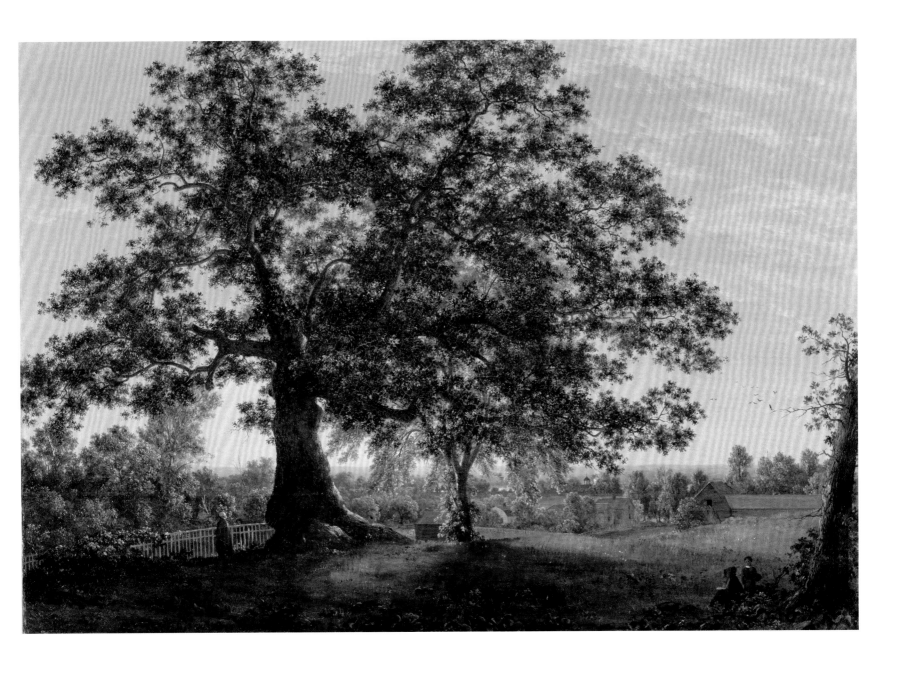

Frederic Edwin Church

The Charter Oak at Hartford, c.1846
Oil on canvas, 61 × 87 cm / 24 × 34½ in
Florence Griswold Museum, Old Lyme, Connecticut

In 1687 Connecticut was the only English colony to refuse the demands of King James II that the New World colonies relinquish some of their powers of self-government given to them by King Charles II in the 1662 Royal Charter. According to legend, when the refusing colonists met with the king's armed representatives in a local inn in Hartford, now the state capital, the candles went out, plunging the room into darkness. In the confusion that followed, the colony's original charter was hidden in the trunk of an ancient oak tree as an act of defiance. The tree became known as

the Charter Oak, and over the following decades, this white oak came to be seen as a symbol of American independence. Thought to date back to the twelfth or thirteenth century, the oak stood until 21 August 1856, when it blew down during a storm. Wood from its trunk was then used to make furniture for Hartford's capitol building. Many artists painted the original oak, including one of America's greatest landscape painters, Hartford native Frederic Edwin Church (1826–1900). While still a student of the painter Thomas Cole, founder of the Hudson River School,

Church returned to his hometown to paint the Charter Oak. By silhouetting the oak against the sky and deliberately excluding a nearby house, Church highlighted the tree as a symbol of America's pursuit of freedom against tyranny. This painting, along with several others he painted in Connecticut, linked the idea of freedom to places within the state – a nationalistic theme to which he often returned in his later landscapes.

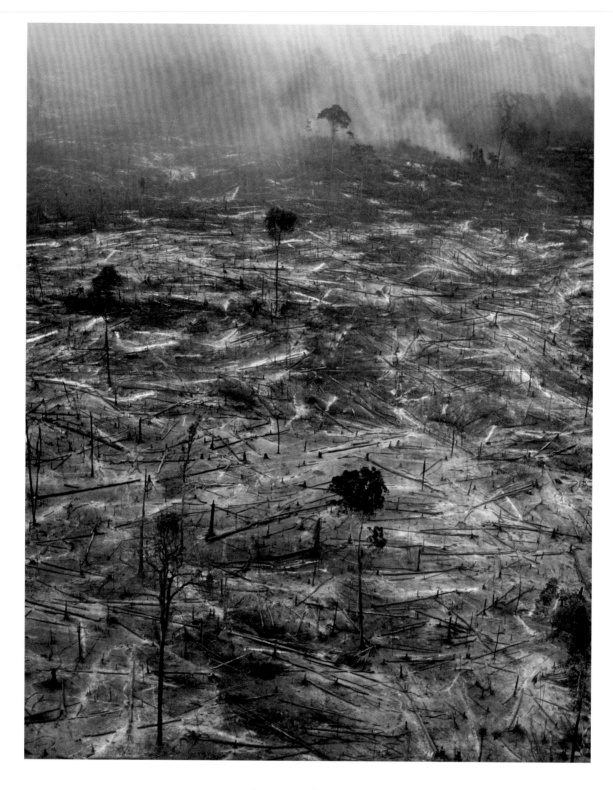

Jacques Jangoux

Destroyed Rainforest, c.2015
Photograph, dimensions variable

A monochromatic landscape has taken the place of a once vibrant and lush tropical forest. Captured by Brazil-based photographer Jacques Jangoux (b. 1938), *Destroyed Rainforest* is a powerful visual representation of the devastation to the Amazon rainforest caused by deforestation. Here, a section of the forest in Pará, in northern Brazil, has been cleared and burned to make room for cattle ranching – the single biggest cause for deforestation in the Amazon. The industry, primarily for export of beef, accounts for about 80 percent of the land's destruction, with illegal mining and logging also contributing.

And what starts as a contained clearing can quickly spiral out of control into wildfires, which resulted in 10.7 million hectares (26.4 million acres) of Brazil's Amazon rainforest being burned in 2023. A poignant symbol of the human impact on nature, the felled trees, once towering and majestic, are reduced to smouldering husks lying lifeless on the ground. Such reckless commodification of nature, where trees are valued more for their economic worth than their essential ecological roles, also results in the loss of key habitats for tens of thousands of plants and animal species. A renowned photographer and

environmentalist, Jangoux has consistently used his work to highlight the devastating effects of deforestation. Through his lens, he captures the urgency of the deforestation crisis, a destructive force that not only impacts the natural environment but also disrupts the delicate balance of ecosystems and contributes to global climate change. Moreover, Jangoux is deeply concerned about the Indigenous communities that rely on these forests for their livelihood, and his photographs often reinforce his belief that this issue is not just an environmental emergency but a social one as well.

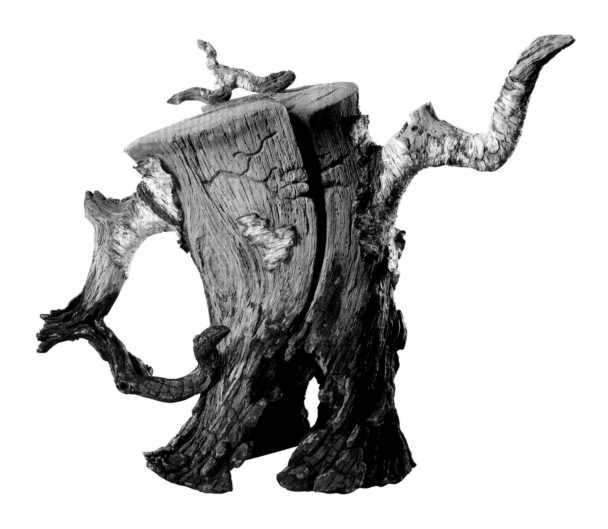

Eric Serritella

Charred Split Birch Log Teapot, 2013
Ceramic, 37.5 × 46.5 × 22.2 cm / 14¾ × 18¼ × 8¾ in
Smithsonian American Art Museum, Washington DC

At first glance, this teapot appears to be made from a split piece of charred and weathered birch log. In fact, it is a ceramic trompe l'oeil – a sculpture deliberately created by American artist Eric Serritella (b. 1963) to 'trick the eye' into believing it is a piece of wood. Serritella specializes in hand-carved ceramic sculptures that are more than what they first appear to be, mirroring the fragility and strength of the natural world. He chose the birch tree as his subject because its beauty – its grey-silver narrow trunk and wispy branches – belie its usefulness. A deep-rooted pioneer species, the birch improves soil nutrition wherever it grows. Patches of the birch's silver trunk appear on Serritella's pot; he turns a weathered branch into the spout, fashions a handle out of two soldered branches and creates a charred base that hints at the birch's destruction. Working out of his studio in Chapel Hill, North Carolina, Serritella deliberately uses clay as a material because ceramic is both easily broken and strongly resilient. Having come to pottery after a successful corporate career, Serritella cites the influence of Asian tea culture on his work; he is particularly inspired by seventeenth-century Chinese Yixing teapots, which are renowned for absorbing tiny amounts of brewed tea each time they are used, imperceptibly changing the taste of future brews. Each of Serritella's pots is unique, fashioned from a piece of clay using nothing more than his potter's wheel and his hands.

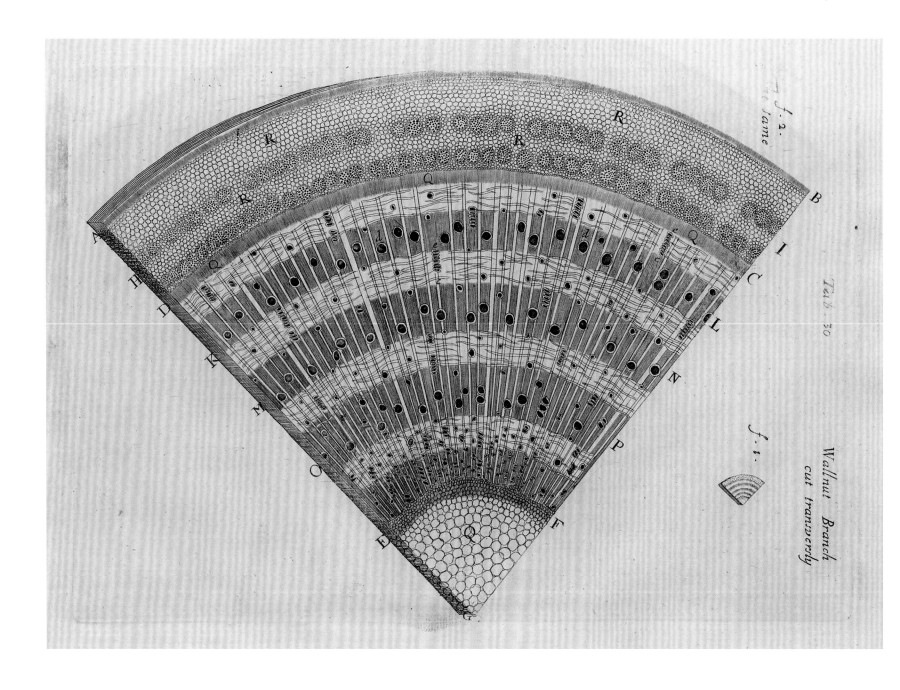

Nehemiah Grew and Marcello Malpighi

Wallnut Tree Branch, from *The Anatomy of Plants*, 1682
Engraving, 23 × 36 cm / 9 × 14¼ in
Peter H. Raven Library, Missouri Botanical Garden, St. Louis

This magnificent illustration of the dissected section of a walnut branch was made possible by early innovative work with the microscope, revealing the cellular structure by which the tree transports food, water and waste products through its structure. The invention of the microscope in the Netherlands at the start of the seventeenth century transformed humanity's understanding of the natural world, as demonstrated here by two pioneers of microscopic anatomy and botany, Italian-born anatomist Marcello Malpighi (1628–1694) and English natural philosopher Nehemiah

Grew (1641–1712). In *The Comparative Anatomy of Trunks* (1675), Malpighi and Grew compared what the eye could see with the magnification a microscope now provided – in particular, the microscopic structures that allowed a tree to live and grow. Malpighi and Grew readily collaborated and through their work brought into existence a completely new scientific discipline: plant anatomy. Grew, the secretary of London's Royal Society from 1677 until his death, collated the information from his study of trunks into his magnus opus, the four-volume *The Anatomy of Plants*, in

1682. He experimented with the best way to show the cellular structure of his different dissections and settled on a triangular wedge, as shown in the walnut branch here. Walnut trees are plants in the *Juglans* genus, of which there are about twenty species, ranging from southeast Europe to Japan and from southeast Canada to California, and further south to Argentina. The trees are prized for their hard timber and, of course, for their nuts.

John Grade

Middle Fork, 2017–present
Wood, 32 × 9 × 9 m / 105 × 30 × 30 ft
Commissioned by Smithsonian Museum of Art, Washington DC and Seattle Art Museum

More than 4,000 people have contributed to the creation of this intricately crafted tree sculpture, the hollow trunk and branches of which are formed from thousands of fragments of western red cedar and continue to grow as more pieces are added each time it is exhibited. *Middle Fork*, which continues John Grade's (b. 1970) exploration of the natural world and its diverse ecosystems, began when the Seattle-based artist selected a 150-year-old western hemlock (*Tsuga heterophylla*) near the middle fork of the Snoqualmie River in Washington's Cascades

mountain range. A non-destructive plaster cast of the massive tree was made in situ, which was then used as a mould for the lifesize wooden sculpture that was painstakingly built around it at Seattle's MadArt Studio. Large street-facing windows made the process visible to passersby, many of whom joined in with its construction over the course of a year, carefully gluing together pieces of salvaged wood to match the contours of the original tree. The growing sculpture, which has been shown at numerous venues, is exhibited horizontally, suspended

from the ceiling at eye level, its boughs and branches stretching outwards towards the walls, floor and ceiling. Peering into its interior, viewers gain new perspectives, engaging with its form in ways that would be impossible in nature. Instead of preserving the sculpture indefinitely, Grade's intention is to one day return it to the forest from where the mould was taken, where it will gradually decompose back into the landscape.

Douglas Leen and Brian Maebius

Joshua Tree National Monument, 2013
Silk-screen print, 48.3 × 24.5 cm / 19 × 13½ in
Private collection

The Joshua Tree National Park in California – which was declared a national monument in 1936 and made a national park in 1994 – protects about 325,000 hectares (800,000 acres) of arid ecosystems where two deserts, the Mojave and Colorado, meet. It is named after a remarkable plant, the Joshua tree (*Yucca brevifolia*), a member of the agave family that manages to grow in this harsh, unforgiving environment. For centuries, Indigenous communities have made use of this unique tree – from crafting sandals and baskets from the tough, leathery fibres to eating its seeds

and flowers. How the Joshua tree got its common name is something of a mystery, though. One story is that Mormon settlers likened the spreading branches to outstretched arms guiding their journey, like Joshua assisting Moses, as mentioned in both the Bible and the Koran. As a symbol of the park, the Joshua tree has featured widely in posters to draw attention to the fascinating landscape, such as in this bold print. It is the creation of Douglas Leen and Brian Maebius in the style of the 1930s and '40s posters produced by the Works Progress Administration (WPA)

for the US National Park Service. Under a cloudless sky and against the backdrop of bulbous yellow rock formations, the tall, branching Joshua trees – with their clusters of sharp, pointed leaves and panicles of creamy-white flowers – dominate in the foreground and middle distance. The tallest trees in the park reach a height of about 15 metres (49 ft), and they can live for more than 150 years. Growing in such a harsh climate as it does, the Joshua tree is widely regarded as a symbol of rugged endurance and survival.

Kieran Dodds

Hierotopia, 2018
Photograph, dimensions variable

Belonging to a series of aerial photographs titled 'Hierotopia' by Scottish-born photographer Kieran Dodds (b. 1980), this image shows a Byzantine church of Ethiopia's Tewahedo form of Orthodox Christianity surrounded by a small section of forest. This is one of many such green churches scattered across the arid landscape in the area east of Lake Tana, from which the Blue Nile River emerges. Hierotopy – from the ancient Greek words for 'sacred' and 'place' – is concerned with the creation of sacred spaces. Dodds uses his series of images to study the idea of sacredness both inside and outside

Ethiopia's Byzantine churches. The forests that surround them perform a sacred function as islands of biodiversity in an area where intensive farming has stripped the surrounding land of its greenery. During the twentieth century, more than 90 percent of Ethiopia's forests were destroyed, and drought has plagued the country for the last forty years. For the priests sequestered within the churches, however, the wooded sanctuaries that enclose their churches protect them from this degradation, meaning they have remained largely unaware of the extent of environmental destruction. Dodds used drones

to photograph the buildings from above, clearly revealing the desertification immediately beyond their boundaries. With the help of environmental scientists – including Dr Alemayehu Wassie Eshete and Dr Meg Lowman – the impact of Dodds's images has helped to kick-start projects across the country to extend the forests and protect them with stone walls. The goal is to eventually connect more than thirty-five thousand forest churches, as well as create a series of wildlife corridors – an alliance in which religious beliefs in the conservation of creation and science work together for the common good.

Wolfgang Laib

Pollen From Hazelnut, 2013
Hazelnut pollen, approx. 5.5 × 6.4 m / 18 × 21 ft
Bird's-eye view, Museum of Modern Art, New York

A swath of vibrant sunshine yellow pigment dominates the frame, its edges gently blurring into the grey background. Viewed from high above the atrium floor at the Museum of Modern Art in New York, the installation perhaps resembles a Mark Rothko work, but here the canvas is an elevated platform and the paint is, in fact, pollen. Created by German artist and sculptor Wolfgang Laib (b. 1950) in 2013, *Pollen from Hazelnut* measured a staggering 5.5 by 6.4 metres (18 by 21 ft), his largest pollen installation to date. Since the mid-1970s, Laib has produced his minimalist works,

which largely employ only one or two natural materials, from milk and rice to beeswax, and his signature element, pollen. Here, the pollen was sourced from the hazelnut trees (*Corylus avellana*) around the artist's home in rural southern Germany. In a slow, solemn, almost ritualistic method, Laib collected the equivalent of eighteen glass jars of the fine powdery substance, a process that he began in the mid-1990s. Working alone, he crouched down and rhythmically tapped the pollen through a sieve with a metal spoon. In a world of constant change, Laib placed

importance on using the same method over the course of two decades. Pollen is produced by most types of flowering and cone-bearing plants as a means of reproduction. While many trees rely on insects, birds or small mammals for pollen transfer, certain trees, such as the hazelnut, are wind-pollinated. Laib sees pollen as 'the potential beginning of the life of the plant', proclaiming that while the reductive beauty of his work can hold many meanings, 'It is as simple, as beautiful and as complex as this.'

Power And Syred

Pollen Grain of Sycamore Tree #1, 1995
Photograph, dimensions variable

What at first might appear as some kind of fluffy cushion is in fact a microscopic image of a pollen grain from the sycamore tree (*Acer pseudoplatanus*), also called the sycamore maple. It was more than 350 years ago that English polymath Robert Hooke first amazed the world with images of the objects he saw through his microscope in *Micrographia*, published in 1665. Since then, images revealing the previously invisible tiniest details of trees and other living organisms have proved consistently popular with viewers as the magnifying power

of microscopes has grown exponentially. Today, microscopes scan objects with a stream of electrons to produce scanning electron micrographs (SEMs) at a previously unthinkable resolution, depicting the smallest of all details and – as here – blurring the boundaries between science and art. In this image, British-based scientists Andrew Power and Ches Syred have not only coloured the original SEM but magnified it 2,360 times to reveal a triangular-shaped grain with a partial coat. When a pollen grain containing the male gametes lands on the stigma of the

sycamore flower, it germinates. A pollen tube grows out of the pollen grain of the stigma and the male nucleus travels down the tube to the ovaries, where fertilization takes place and a seed forms. Sycamores are particularly fertile and, as a result, have spread widely. Native to southern, central and eastern Europe, they spread easily, often to the detriment of native species, and they are therefore considered invasive in many regions.

Linda Vallejo

Electric Oak with Orange Sun, 2008
Acrylic on canvas, 60 × 60 cm / 24 × 24 in
Private collection

An orange sun illuminates an oak tree, painted in psyche-delic blues, pinks, reds and yellows in this painting by Los Angeles-born Chicana artist Linda Vallejo (b. 1951). By her own admission, Vallejo's work is full of symbolism; it is infused with the spiritual traditions of Native Americans, Mexicans and Chicanas as she seeks to understand how her Mexican American identity fits within the dominant popular culture of the United States. This painting forms part of 'Electrics', a series of paintings she made between 2008 and 2010 that sought to explore alternative states

of perception. Recalling the drug-fuelled hippy culture of the 1960s, Vallejo references other American artists and their work, such as Andy Warhol's Pop art, Chuck Close's pixel portraits and Peter Max's psychedelic paintings, alongside the ceremonial traditions of ancient Native American and Mexican cultures and the sensuality of the Austrian painter Gustav Klimt (see p.28). To capture the intensity of nature around her Topanga Canyon home in the Santa Monica Mountains of California, Vallejo blended computer-generated digital imagery with her

own painting. Her various experiments in portraying the largest of the Californian oaks, the valley oak (*Quercus lobata*), saw her trees become systematically more abstracted as she tried to capture the glow of the sun and the moon illuminating their branches: the ethereal light cast by the sun caused the tree to be divided into different shapes and the colour palette to change as the light was filtered through the oak's leaves.

Oscar Martin Soteno Elias

Homenaje al Arte Popular, 2021
Polychrome clay, H. 80 cm / 31½ in
Private collection

Bursting with colour, the branches of this ceramic *árbol de la vida* (tree of life) are covered with densely intricate details of life in Mexico, painted in vibrant shades of red, fuchsia, canary yellow and royal blue. Titled *Homenaje al Arte Popular*, the sculpture is the work of Oscar Martin Soteno Elias (b. 1971), a third-generation potter from Metepec, close to Mexico City. *Arte popular* refers to the genre of traditional Mexican folk art that celebrates a national culture, from artisanal crafts to dance and music. Soteno's trees are made from local red clay that

is dried and ground to a powder, then mixed with water and *plumilla*, the fibres of a local bulrush. The clay is then shaped over a wire skeleton and decorated with native flowers and foliage made from moulds, as well as with handmade figures depicting cultural objects from ordinary vases to fantastical creations, such as the musical mermaid or flower-bedecked skeletons seen here. The tree is dried and fired in a wood-burning oven in several stages and then meticulously painted. In the 1930s, Soteno's grandmother entered a field that was

traditionally dominated by male potters when she started to produce decorative ceramics that eventually evolved into trees of life. The tree of life motif in the region dates back to pre-Hispanic central Mexico, where a ceramic tradition started almost four thousand years ago. Spanish colonizers adopted such trees to teach Indigenous people about the Bible in their attempt to Christianize them. Over centuries, the trees' subjects have changed from illustrations of Bible stories, such as the Garden of Eden, to scenes of daily life.

René Magritte

The Sixteenth of September, c.1956–57
Gouache over pencil on paper, 35.6 × 27.6 cm / 14 × 10¾ in
Minneapolis Institute of Art, Minnesota

A towering tree rises into a rich blue night sky, seemingly displacing the luminous crescent moon at its centre. Created by renowned Belgian Surrealist artist René Magritte (1898–1967), *The Sixteenth of September* features his signature style of juxtaposition and illusion, proposing an array of open-ended narratives for the viewer to consider and interpret. Magritte's imagery is distinctively provocative, witty and at times humorously absurd, captivating viewers with its ability to challenge conventional thinking. With a simple and bold composition, the colours of the tree are muted against the dusky blue and purple background, inducing a sense of meditative contemplation. The tree's branches extend towards the sky while its roots dig deep into the ground, symbolizing the connection between the earthly and the divine. The tree serves as a focal point, but unlike traditional representations of single solemn plants, which invite a sense of confidence and solidity, Magritte's tree embodies a deeply enigmatic demeanour and fosters a sense of the uncanny. Throughout his career, the artist was preoccupied with existentialist philosophical issues, which frequently informed the choice of topic and context in his work. In this painting, as in others, Magritte adopts his 'objective stimulus' strategy – a Surrealist-inspired way to arrange everyday objects in incongruous and surprising ways to generate thought-provoking narratives through symbolic elements. Using this strategy, the representation of a waxing crescent moon in front of, rather than behind, the tree's fronds challenges our perception of reality and invites us to ponder the mysteries of the natural world as well as our place within it.

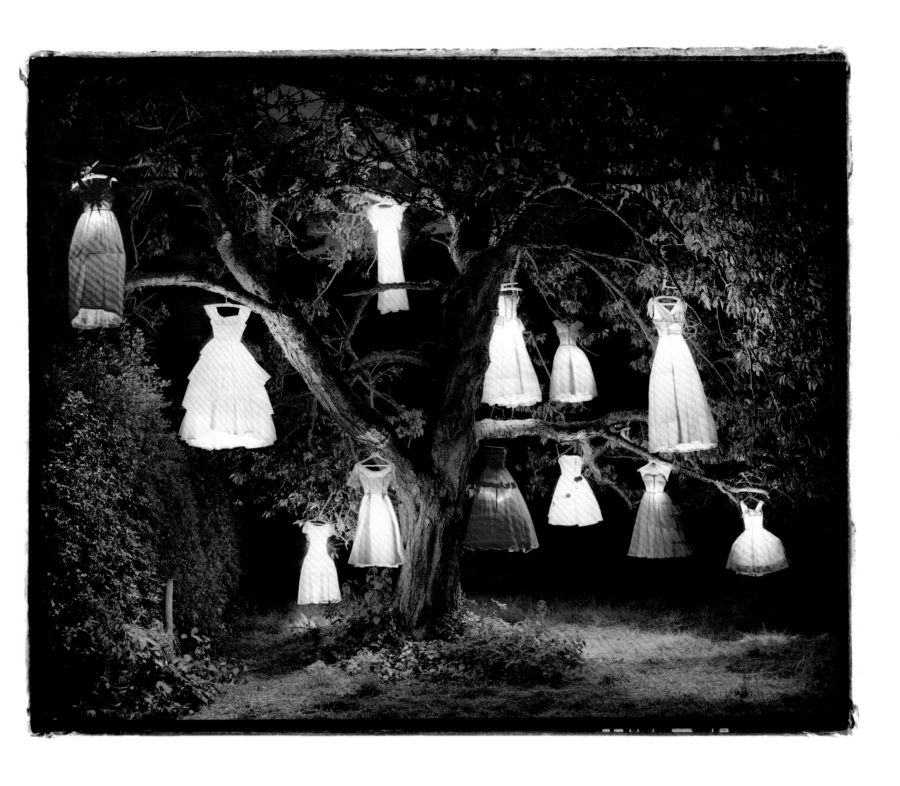

Tim Walker

The Dress / Lamp Tree, Eglingham Hall, Northumberland, England, 2002
Photograph, dimensions variable

Hanging like colourful fruit from the branches of a mature tree are a series of beautiful gowns dangling on wooden hangers, all illuminated from within to produce a series of neon pinks, blues, yellows, reds and greens. A pool of light radiates from the base of the tree, which is in full leaf, suggesting a late summer's evening. This image by British photographer Tim Walker (b. 1970) conjures up a bygone world of dressing up in old couture dresses and playing at the bottom of a large garden of an English country house. Known for his love of nature and his idiosyncratic British

aesthetic, Walker's inspiration for this 2002 photograph, which he originally photographed for *L'Uomo Vogue,* came from seeing ballgowns hanging from the ceiling in a vintage clothes shop in Bath, England. At night, he recalled, the store's lights would glow through the dresses, and the image made an indelible impression on him. To re-create his version of that image for his shoot, he required a perfectly still night in the gardens of Eglingham Hall, Northumberland (a favourite location of Walker's) so that the dresses did not move. *The Dress / Lamp*

Tree belongs to a series of photographs Walker took at Eglingham in which trees take a leading role: in other images, a huge doll lurks in a dark wood in wintertime, while a bed from the house hangs from a tree as the rest of the furniture is piled around its trunk.

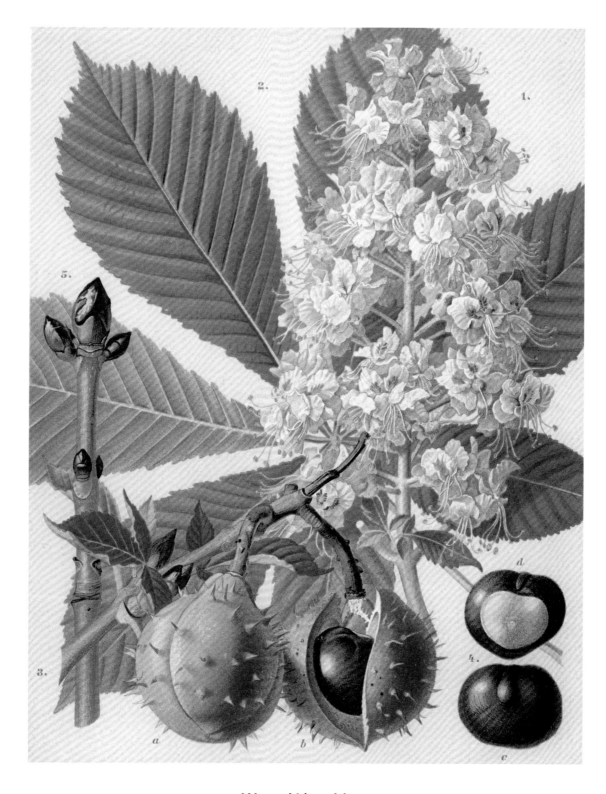

Wenzel Liepoldt

Aesculus hippocastanum, from *Die Bäume und Sträucher des Waldes*, 1889
Chromolithograph, 35 × 29 cm / 13¾ × 11½ in
Cornell University Library, New York

In a detailed drawing, Viennese illustrator Wenzel Liepoldt (1841–1901) has brought together the distinctive features of a familiar European tree, the horse chestnut (*Aesculus hippocastanum*). The composition includes elements from both spring and autumn. The pink, yellow and white multi-flowered panicle stands upright, free of the leaf behind it, clearly showing the structure of individual flowers, many with protruding stamens. Behind this is the compound leaf with its six large, parallel-veined leaflets. A section of twig on the left has the shiny, sticky buds of early spring and shield-shaped leaf scars, while at the front we see the spiky green fruits of September opening to reveal the familiar glossy brown seeds, commonly known as conkers. A favourite playground game, conkers – which uses these seeds – has been played across Britain for decades; there is even a World Conker Championship, which has taken place in Northamptonshire since 1965. *Aesculus hippocastanum* was introduced to Europe from the Balkans in the seventeenth century and recorded at Oxford's physic garden in 1648. The horse chestnut is a rapid-growing deciduous tree that can reach 35 metres (115 ft) tall and has characteristic large, palmate leaves; some specimens live up to three hundred years. The common name may derive from its use as a horse medicine: blacksmiths used a mixture of horse chestnut bark and seeds to treat horses with stomach complaints. Liepoldt illustrated this plate for *Die Bäume und Sträucher des Waldes* (*Trees and Bushes of the Forest*) by German writer Gustav Hempel and German botanist Karl Wilhelm.

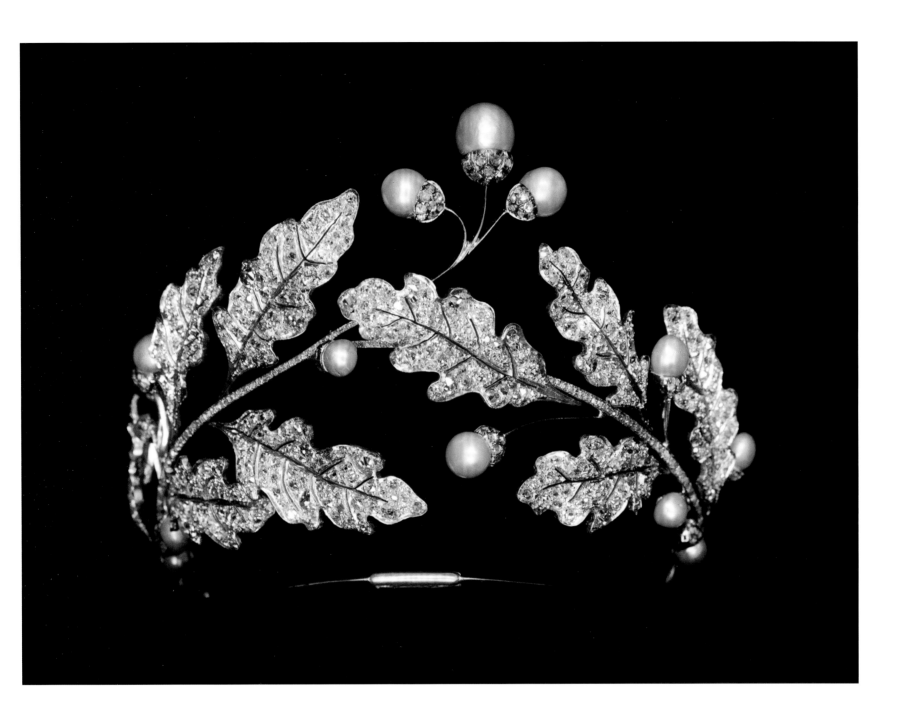

Chaumet

Oak Leaves Tiara, c.1903
Gold, silver, diamonds and pearls
Chaumet Collections

The oak has been a symbol of majesty venerated for millennia since Zeus, the king of the ancient Greek gods on Mount Olympus, adopted it as his emblem linking heaven and earth. This pearl and diamond tiara, designed by French jeweller Joseph Chaumet (1852–1928) of the eponymous Parisian jewellery house at the start of the twentieth century, pays homage to the iconic tree. Chaumet's tiara is fashioned from diamond-studded oak leaves and acorns made from pearls. Tiaras had their origins in ancient Greece, when wreaths made from laurel branches or oak

twigs and acorns were placed on the heads of victors at athletic competitions. In 1804 Napoleon Bonaparte set a new fashion for tiaras and wreaths when he chose to be crowned emperor of France with a gold laurel wreath. The women in the emperor's family attended the ceremony wearing sprays of diamond-studded laurel and myrtle in their hair. Napoleon's wife, Empress Joséphine, was well known for both her love of nature and her love of tiaras. After Joséphine made Chaumet's founder, Marie-Etienne Nitot, her official jeweller in 1805, tiaras became essential

headwear for the ladies of the court. The jewellery house was inundated with orders, establishing its credentials as makers of some of the most stunning tiaras of all time. More than a hundred years after its creation, this tiara appeared in the 2022 exhibition 'Végétal – L'Ecole de la Beauté', presented by Chaumet to celebrate the beauty of nature in all its artistic forms at its most exquisite.

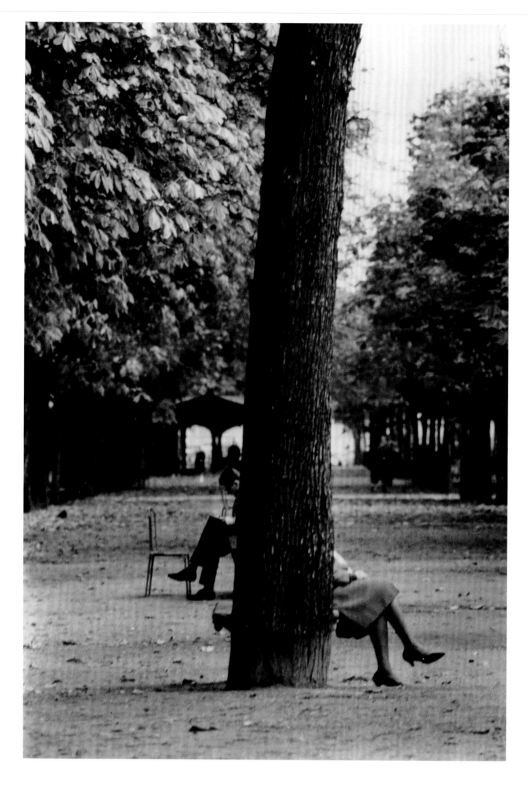

André Kertész

The Champs Elysées, Paris, 1929
Gelatin silver print, 24.7 × 16.5 cm / 9¾ × 6½ in
Metropolitan Museum of Art, New York

Dividing the photograph in half to a comical effect, two pairs of legs appear on either side of a tree trunk – the closer belonging to a woman, the other to a man – which is centred among an *allée* on the Champs-Élysées in Paris. The idiosyncratic image was captured in 1929 by Hungarian-born American photographer André Kertész (1894–1985). Before he immigrated to the United States in 1936, Kertész initially moved from Hungary to Paris, where his photographs of Parisian streets became highly influential as he sought to capture eccentric and unusual aspects of daily life in a modern city. Having begun photographing the Hungarian countryside after he acquired his first camera in 1912, Kertész continued to photograph nature, believing that photography wasn't simply a matter of seeing his subject: 'You don't see the things you photograph, you feel them.' Working in Paris at the same time as Surrealist artists such as Man Ray, Kertész borrowed from their visual approach, as well as from the work of contemporary photojournalists to create quirky, bizarre juxtapositions that captured the joy of city life. The Champs-Élysées he photographed is now a tree-lined avenue that stretches almost 2 kilometres (1.2 mi) from the Place de la Concorde to the Arc de Triomphe, an area that was originally a swamp. André Le Nôtre, chief gardener to the Sun King, Louis XIV, designed the avenue in the seventeenth century as a wide elm tree-lined promenade that extended the Tuileries Gardens. It was named the Champs-Élysées – the 'Elysian Fields', for a heavenly paradise in Greek myth – in 1709.

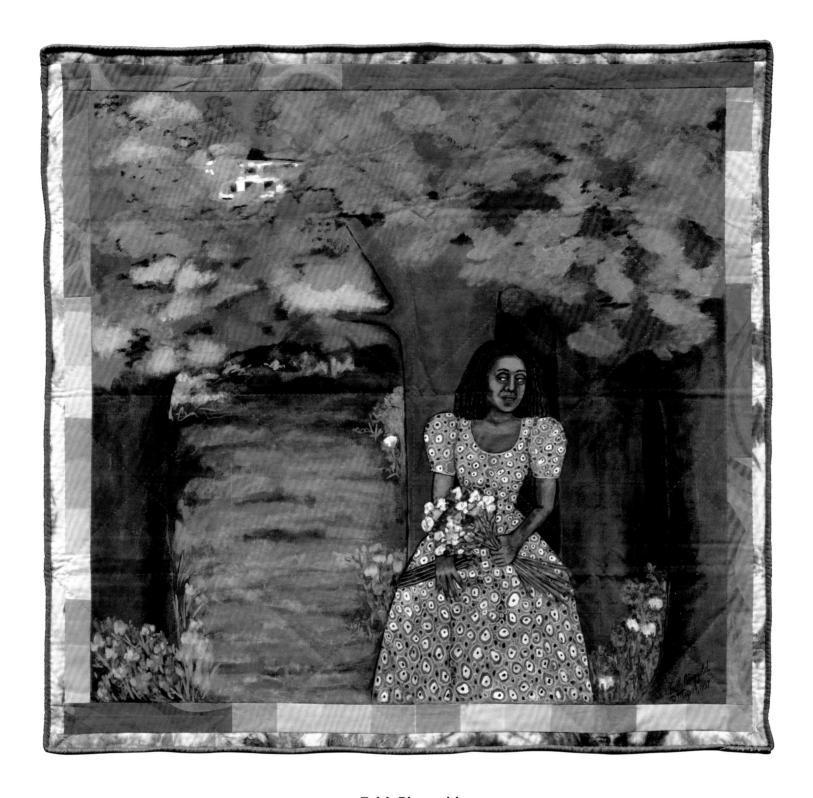

Faith Ringgold

Listen to the Trees, 1997
Acrylic on stitched canvas with stitched dyed fabric, 2 × 1.9 m / 6 ft 8 in × 6 ft 5 in
Private collection

Grasping a bouquet of freshly picked summer flowers, a young woman pauses among a grove of thick-trunked trees, down a verdant path from a grand white house obscured in the background. One of eleven quilt paintings (with a twelfth sketched but unmade) in 'The American Collection' series by Faith Ringgold (1930–2024), *Listen to the Trees* is a rich and colourful interpretation of a story quilt, an iconic medium for the artist. It is at once a meditation on the solitude found in nature and a depiction of Black female empowerment, a theme that is as central to this work as it is to the series to

which it belongs. The lady wearing a beautiful floral dress is Marlena Simone, a fictional character – often considered as a mirror of the artist – through whom Ringgold explores the status and constraints of Black women living in America. According to the narrative, Marlena has become wealthy and has no husband or children – attributes that cast her as a successful and independent woman who has been determined and capable of crafting an original path in her life. Ringgold, a pioneering member of a number of activist art groups, including the Art Workers' Coalition and the

Women Students and Artists for Black Art Liberation, frequently incorporates themes of social justice in her work while celebrating Black culture and heritage. Although Marlena sits alone in the forest in *Listening to the Trees*, the work embodies a multitude of voices that contribute to the Black experience, including Ringgold's own history. The trees stand witness for those who have been silenced or are often overlooked, and by listening to them, Marlena acknowledges their experiences and taps into their enduring wisdom.

John Henry Dearle for Morris & Co.

The Tree of Life, or The Garden, c.1909
Tapestry, 2.4 × 1.8 m / 8 × 6 ft
Private collection

Flowing across this intricate tapestry is a flowering tree with white blossoms and plentiful leaves, three birds perching on its branches while three others flutter among its foliage. Blossoming plants of springtime fill the space underneath the tree, and further flowers, both real and imaginary, wind around the border. Its designer, John Henry Dearle (1859–1932) was an associate of William Morris (1834–1896), whose dislike for the industrial mass production of his day led to the rise of the British Arts and Crafts movement. Morris set up a firm to revive the

craftsmanship of the Middle Ages, including the art of tapestry weaving. Tapestries were woven by hand on high-warp looms in his workshops at Merton Abbey Mills, south London, using wool that had been dyed with organic materials. Dearle began as a shop assistant for Morris & Co. and rose to become its head designer and, after Morris's death, art director. From an early stage, Dearle specialized in floral backgrounds, contributing details to the works of Morris and Edward Burne-Jones, one of the firm's cofounders, before making complete works of his own.

The tree may be a pear tree, growing in an English garden; or as its title suggests, it may be the tree of life in the biblical Garden of Eden, whose fruit promises eternal life. Trees, birds and flowering plants proliferate in Morris's own designs, and they suggest a bountiful paradise, like the examples found in medieval Persian, as well as English, textiles.

Charles Lippincott

Genealogical Tree of the Richard and Abigail Lippincott Family in America, 1880
Print, 2 × 1.2 m / 6 ft 6 in × 3 ft 9 in
Newberry Library, Chicago

A huge tree with thousands of individually drawn leaves, each with a single name inside, is a fitting genealogical monument to one of America's founders. Richard Lippincott and his wife, Abigail, both devout Quakers, left England to escape religious persecution and immigrated to colonial America in 1639. Finding the colonies even more repressive, they returned home before finally settling in Rhode Island in 1663. In 1880 thousands of their extended family members were painstakingly recorded in this genealogical tree by a descendant, Charles Lippincott. To distinguish the different generations of the family – records show the original Lippincotts had eight children – each generation is given a different coloured leaf. The eight children are given a larger red leaf, and more recent members of the family are shown on the furthest tips of the tree's branches. The sturdy tree trunk carries more information about the Lippincotts, including a copy of the family's coat of arms with their Latin motto, which translates as 'Upright in both prosperity and in perils'. The ornamental plate in the middle gives a short history of Richard Lippincott and how the couple came to the Americas, adding a brief history of his surname, said to be one of the oldest in England. Along the base of the tree are two boxes of explanation of the family's long lineage, which includes two former US presidents, both descendants of Richard's sons: George W. Bush was a descendant of Freedom Lippincott and Richard Nixon of Restore Lippincott.

Jacob van Ruisdael

Mountainous Landscape with a Blasted Oak Tree, 1660
Oil on canvas, 55.2 × 69.5 cm / 21¾ × 27¼ in
National Museum of Art, Architecture and Design, Oslo

A solitary oak tree at the edge of a field reaches its damaged limbs skywards against a mountainous landscape. The oak has been a symbol in art for centuries, often representing strength, endurance and longevity – its deep roots and sturdy branches standing as a metaphor for resilience and stability. In many cultures, the tree is also associated with wisdom and knowledge, as well as protection and fertility. In Western art, oaks have often been associated with religious and mythological symbolism and are frequently related with gods and goddesses,

such as Zeus and Jupiter, symbolizing power and divine protection. In Christian iconography, the oak is sometimes linked to the Tree of Life or Jesus's cross, incarnating spiritual nourishment and salvation. Its majestic presence in the landscape has made it a popular subject for artists, including Jacob van Ruisdael (1628/9–1682) a pre-eminent painter of the Dutch Golden Age. *Mountainous Landscape with a Blasted Oak Tree* showcases the artist's innovative approach to landscape painting and had a profound influence on the development of this artistic tradition during

the eighteenth century. Despite the naturalistic portrayal, it is hard not to note that the portrait of this lone oak is imbued with an anthropomorphic, existentialist essence. The tree, struck by lightning or damaged by other natural forces, serves as a reminder of the impermanence of life. This aspect of the representation adds a sense of melancholy and drama to the landscape, evoking emotions of awe and contemplation in the viewer.

Robert Games

Kew Mural, 1988
Wood, 1.5 × 3 m / 5 ft × 9 ft 10 in
Royal Botanic Gardens, Kew, London

In the early hours of the morning on 16 October 1987, an unexpected storm hit Great Britain with wind speeds and gusts of more than 100 kilometres per hour (62 mph). The most devastating storm to hit the British Isles since 1703, overnight the Great Storm, as it became known, transformed the landscape of southern England. Eighteen people died, and some fifteen million trees were blown down. In the Royal Botanic Gardens, Kew, alone some seven hundred trees were felled and five hundred more damaged beyond repair, many of them rare, unusual or scientifically significant. The

uprooted trees included rare species such as roble beeches (*Nothofagus obliqua*) planted in 1903 and an endangered Himalayan elm (*Ulmus wallichiana*). A then-sixteen-year-old schoolboy, Robert Games (b. 1971), wrote to the director of the gardens to ask for wood from the fallen trees to make a commemorative sculpture. He came away with a variety of timber, including black walnut (*Juglans nigra*), tulip tree (*Liriodendron tulipifera*) and Caucasian elm (*Zelkova carpinifolia*). After preparing a series of ideas from photographs of the devastation, Games approached local artist Terry

Thomas, who sketched out the mural design. With the help of his father, Gilbert, Games carved hundreds of individual pieces – which took more than one thousand hours to create – that were then assembled into the dramatic mural. The piece conveys the brute strength of the wind and fragility of the landscape while showcasing the grain, texture and tones of the rare and exotic woods. Among the devastation, some of Kew's iconic buildings stand in stoic resistance while the Chinese lions roar their defiance against the destructive spirit of the raging storm at the centre of the mural.

Paolo Uccello

The Hunt in the Forest, c.1465–70
Tempera and oil with traces of gold on panel, 73.3 × 177 cm / 28⅞ × 69⅝ in
Ashmolean Museum, University of Oxford, UK

Dozens of men on horseback and on foot, with their hounds rushing ahead after the fleeing stags, come together for a hunt beneath the canopy of a dark forest. This painting by Florentine artist Paolo di Dono (1397–1475) – better known by his nickname of Uccello (Bird), attesting to his love of painting animals and the natural world – reflects Italian Renaissance experimentation with linear perspective, a technique for representing depth on a flat surface by aligning angles with distant vanishing points. Uccello was one of the masters of this new

technique, as seen in this work: the forest's dark interior contrasts with the magnificent colours of the hunters, drawing the viewer's eye beyond the huntsmen and their animals towards the seemingly endless trees. Uccello emphasizes the sense of depth with his careful placement of the hunters' spears, cut branches and the chopped logs arranged on the ground, all aligned with a central vanishing point. Within the dark branches, Uccello adds gold flecks that illuminate the dark night and glitter against candlelight. Painted for a wealthy patron's home,

The Hunt in the Forest is a *spalliera* painting, intended to be viewed at shoulder height. The fact that the hunt is taking place at night – no one is certain why – adds a sense of mystery to the forest, which had a far more quotidian significance as the supplier of fruit, nuts, berries, game animals for food, and wood for fires and building. Uccello's work influenced later Renaissance masters, including Piero della Francesca, Leonardo da Vinci and Albrecht Dürer (see pp.134, 323).

Anonymous

Bayeux Tapestry (detail), late 11th century
Wool embroidery on linen, overall approx. 0.7 × 68.3 m / 2 ft 4 in × 224 ft
Musée de la Tapisserie, Bayeux, France

In this section of the famed Bayeux Tapestry, embroidered woodcutters are seen felling trees for the Norman fleet ahead of the invasion of England by the Duke of Normandy, William the Conqueror, in 1066. When news of King Harold II's coronation reached Normandy, William, who believed himself heir to the late king, Edward the Confessor, decided to invade England. He created an army of eight thousand infantrymen, archers and cavalry, and ships to transport them across the English Channel, and he did so in only a few months. At least eight hundred

ships were built, necessitating thousands of woodcutters, blacksmiths, carpenters and hauliers. The first test was finding enough trees (normally oaks but sometimes also beeches), because Normandy, unlike most of the rest of France, had few large forests. A moderately sized vessel required at least twenty large trees for the keel, ribs, stems (the curved edge stretching from the keel to the gunwale of the boat) and planking, and larger ships needed at least fifty. Long planks were carved from the trunks of sufficiently tall, straight-grained oak trees, but

few woodcutters in the Middle Ages would have been able to produce more than four planks from a single tree. On the tapestry, the woodcutters wear short trousers, whereas the men dragging boats are dressed in side-split tunics or shirts. The Bayeux Tapestry – which is in fact not a woven tapestry but rather embroidery on linen – was probably made by English women in Kent. It was commissioned in the 1070s by Bishop Odo of Bayeux, half-brother of William.

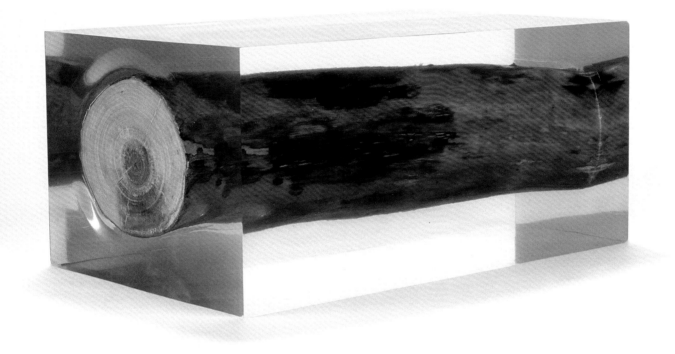

Vera Röhm

Branch in Cast, 1976
Wood and Plexiglas, 11 × 24 × 15 cm / 4⅜ × 9½ × 5⅞ in
Private collection

A section of a mature branch has been perfectly frozen in time, encased within a rectangular piece of translucent Plexiglas. Exemplifying the unification of opposites in the constructive use of two contrasting materials, *Branch in Cast* is an early piece from the 'Tree Works' of German-born sculptor and photographer Vera Röhm (b. 1943). Organic nature is surrounded by an artificial, modern material whose transparency increases the visibility of the tree within. Only at the cut edges is the view of the branch and the structure of the wood unobstructed.

The work is not the first time Röhm has explored the interaction of organic and artificial materials. In 1975 she created *The Tree*, cutting a trunk into slices and alternately replacing its horizontal planks with precisely copied Plexiglas panels. Also in the mid-1970s, the artist embarked on a series of sculptures entitled 'Ergänzungen' ('Integrations'), in which she broke beams of wood and reconstructed the fractures with Plexiglas or extended them in the same cross section of the square beams, resulting in impressive angular shapes and steles. As

part of her ongoing practice, Röhm continues to create 'Tree Works' using a range of materials, including polished metal and bronze, in addition to Plexiglas. There are reflective trunks and casts of an oak tree – light filtering through Plexiglas at the middle to flow over its longitudinal axis of up to 10 metres (33 ft) – as well as a large-format bronze sculpture of a sequoia tree. Throughout all of her work, Röhm continues to disrupt the concepts of artificiality and liveliness, forming a new poetic unity at the conjunction of those differences.

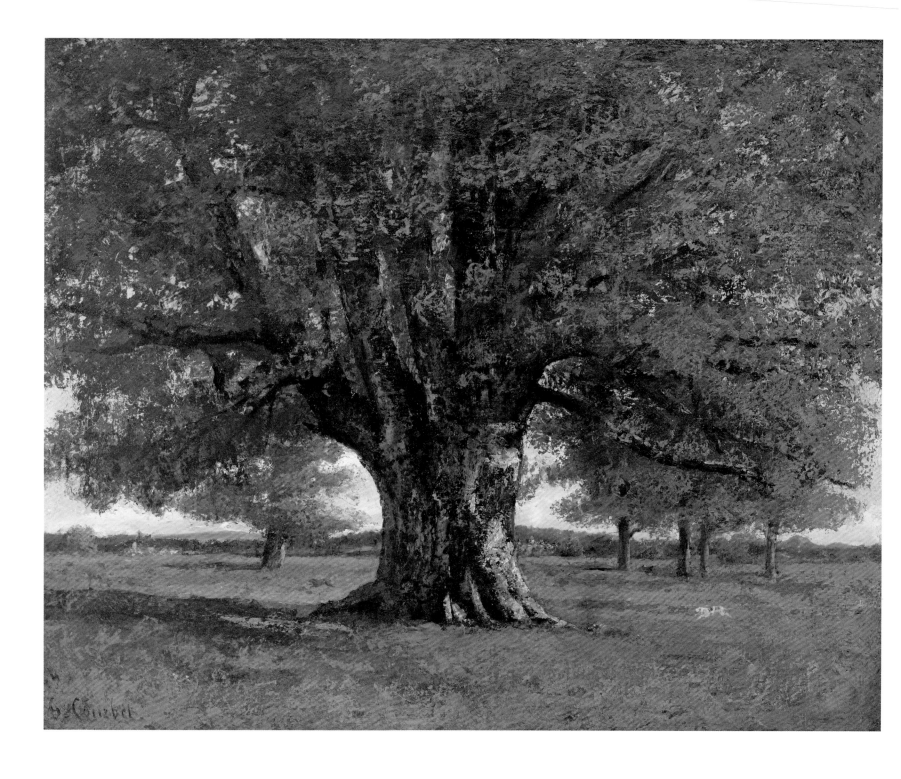

Gustave Courbet

The Oak of Flagey also known as The Vercingetorix Oak, Caesar's Camp Near Alesia, 1864
Oil painting on canvas, 89 × 111.5 cm / 35 in × 44 in
Musée Gustave Courbet, Ornans, France

This oil painting of a majestic oak tree in full leaf by the father of French Realism, Gustave Courbet (1819–1877), might seem somewhat ordinary, but it was, in fact, revolutionary. The renowned oak once stood in the village of Flagey, near Ornans, the town in southeast France where Courbet was born. On a visit to his family in 1864, he painted his only portrait of a tree en plein air – in the open air – a decision that marked a seismic change in the history of painting. Courbet, a friend of the philosopher Pierre-Joseph Proudhon and the poet Charles Baudelaire,

was the apostle of the new movement of Realism, which shunned the conventions of the Romantic style that then dominated France's cultural scene. The tree was also known as the Vercingetorix Oak, a reference to the siege of Alesia, during which the Roman soldiers of Julius Caesar finally ended the independence of the Gauls in France. In a deliberate political gesture, Courbet later gave the painting the subtitle *The Vercingetorix Oak, Caesar's Camp near Alesia*. This was seen as a sign of Courbet's rejection of the imperialistic rule of Napoleon III

and his Second Empire – which the artist associated with Caesar – and his support of democracy, as signified by the role of the Gallic hero Vercingetorix. The tree's trunk was so wide it was said that it took seven men to hold hands around it. It no longer exists, having been felled during a lightning strike in the middle of the twentieth century.

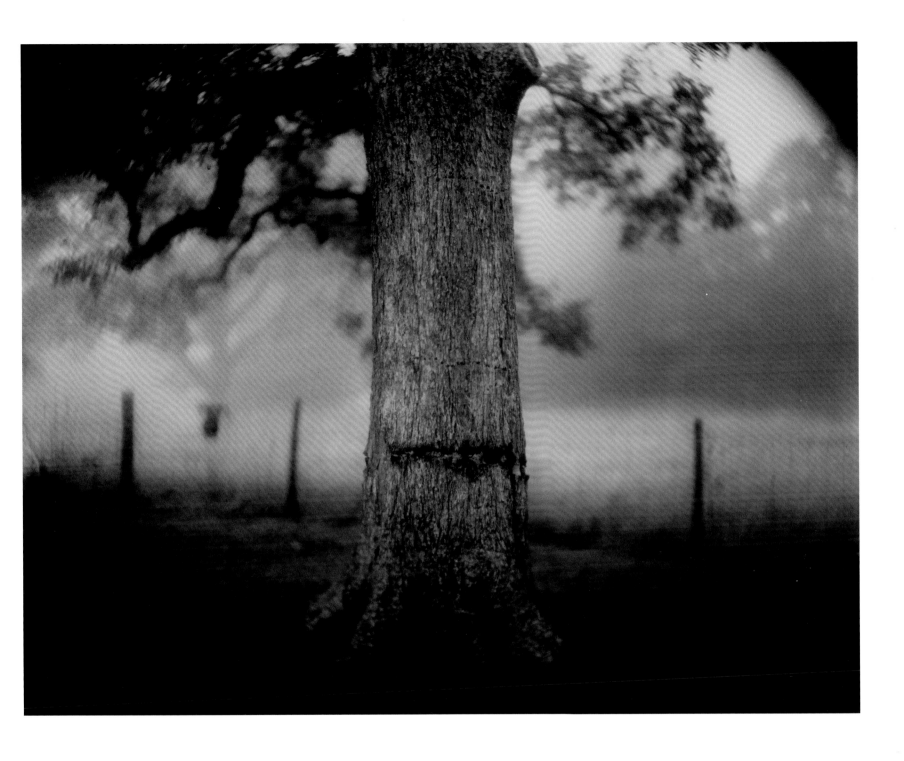

Sally Mann

Deep South: Untitled (Scarred Tree), 1998
Gelatin silver print, 1 × 1.2 m / 3 × 4 ft
National Gallery of Art, Washington DC

An ugly gash scars the large tree trunk at the centre of this brooding black-and-white photograph. While the thick bark is crisply focused, the fence and trees beyond are hazy and blurred, the ghostly radiance and heavy vignetting a result of the vintage camera and antique lens employed by photographer Sally Mann (b. 1951), who created the image for her 'Deep South' series. It pays homage to Gustave Le Gray's *Tree, Forest of Fontainebleau* (c.1856), a similarly composed photograph taken in the famous Fontainebleau Forest, south of Paris. Like the French photographer, Mann

does not show us the whole tree, though unlike him, her interest lies in the history of America's Southern states, where slavery was once rife and still legal in Le Gray's day. With that in mind, the wounded tree becomes evocative of an injured human body, resonant with associations to a brutal past and standing as a silent witness to former days. Mann is known for her luminous photographs, and here she has employed ortho-negative film, evoking a bygone era. Orthochromatic film was first developed in 1873 by Hermann Wilhelm Vogel – one of the earliest photographic

films – and unlike today's panchromatic films that are sensitive to all visible colours, it was sensitive only to blue light, resulting in high-contrast images. Mann, a native of Lexington, Virginia, embarked on her 'Deep South' project in an attempt to reconcile her affection for the South with its fraught heritage. Immersing herself in its landscape, she photographed trees, swamplands and decaying estates in Mississippi and Louisiana, attempting to unite the area's alluring beauty with its repellent history.

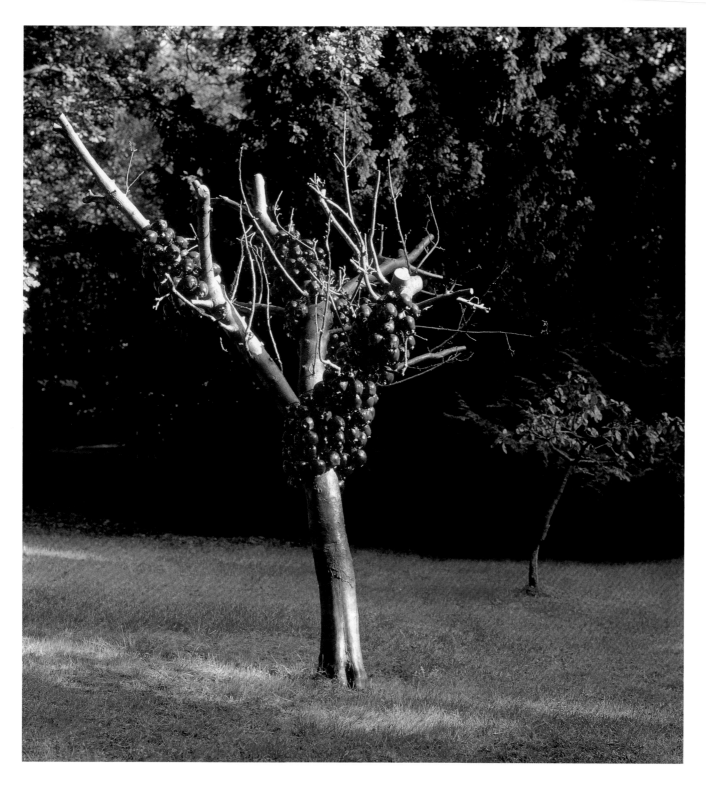

Anya Gallaccio

Because Nothing Has Happened, 2001
Direct-cast bronze apple tree, ceramic apples and rope, 2.8 × 2 × 1.5 m / 9 ft × 6 ft 6 in × 5 ft

A dead tree, branches cut and bare of leaves, has seemingly given its all to produce one last, overabundant harvest in this stunning installation by British artist Anya Gallaccio (b. 1963). Surprising the viewer with the juxtaposition of incongruent symbols, the installation consists of a direct cast of a tree, from which an exuberance of red ceramic apples hangs. Gallaccio is known for her use of natural materials, such as flowers, trees, sugar and salt, which she employs to challenge our conception of nature. This particular installation focuses on the monumentalization of natural processes and how society has traditionally attempted to appropriate these throughout the history of Western art. The composition is intentionally awkward and implausible. Apples do not grow in such large clusters at the end of a trunk but hang from thinner branches. Dramatically swaying from the classical representation of lush apple trees in Western art history, Gallaccio's work invites us to contemplate how artistic representation has for many centuries directly shaped our expectations and experience of nature. Is it ever possible to encounter an apple tree without thinking of either autumnal harvests or the biblical story of Adam and Eve? In Gallaccio's work, the apple is a recurring symbol standing for purity, temptation and the loss of innocence. The enigmatic title of this work, *Because Nothing Has Happened*, gestures towards the bronze and ceramic life form frozen in time and the impossibility of such a tree existing in nature.

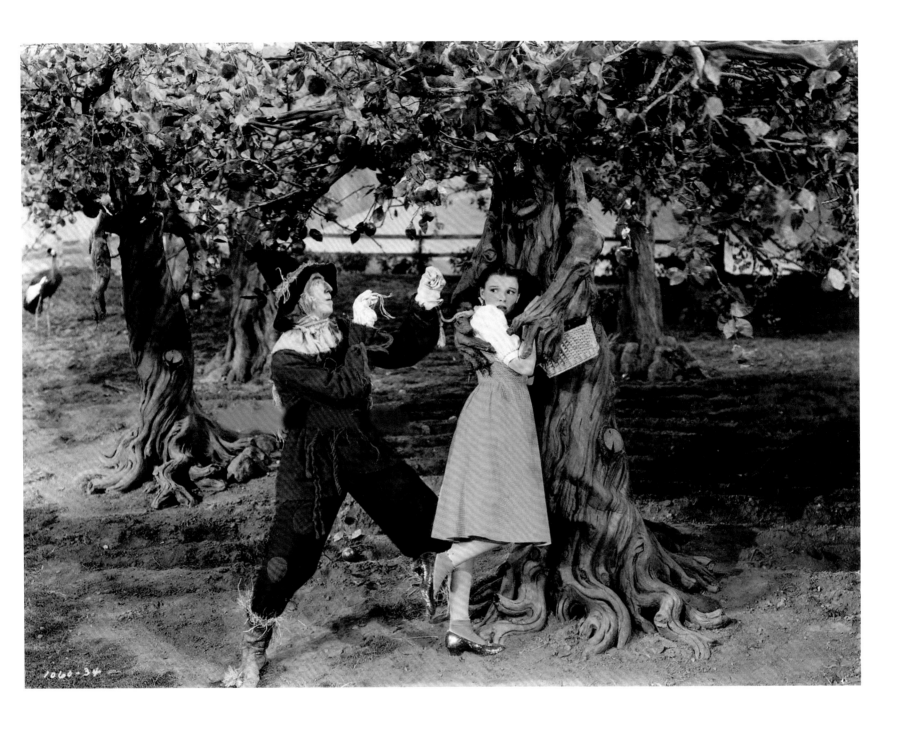

Metro-Goldwyn-Mayer

The Wizard of Oz, 1939
Film promotional image, dimensions variable

Dorothy Gale – played by Judy Garland – seems relatively comfortable in the grasp of a sentient apple tree, even as her Scarecrow companion raises his fist, ready to fight in this promotional image from the 1939 classic film *The Wizard of Oz*. Although the trees make a half-hearted attempt to stop Dorothy and the Scarecrow from reaching the Enchanted Forest on their eventful journey through Oz – they are most concerned with preventing anyone from stealing their apples – they present no real obstacles to the travellers. The trees are a far different

proposition in *The Wonderful Wizard of Oz*, the original book by L. Frank Baum, which was published in 1900. In the book, these sentient trees live on the border of Oz's southern quadrant, the Quadling Country; thousands of years old, they stand side by side in a line that stretches for miles to guard the Enchanted Forest. Able to repel intruders by using their branches as their arms and hands, the trees also have faces on their trunks that allow them to see and hear any threat. In the book, when Dorothy and her companions try to venture into the forest, the

trees pick up the Scarecrow and fling him to the ground not once but twice. Baum's story was an instant success, but its eventual transfer to the silver screen by Metro-Goldwyn-Mayer (MGM) was not an immediate box office hit, overshadowed by the approaching world war. Over the decades since, however, the film has become one of the most popular movies ever made.

Giuseppe Arcimboldo

Winter, 1563
Oil on limewood panel, 66.6 × 50.5 cm / 26¼ × 19¾ in
Kunsthistorisches Museum, Vienna

Known for his bizarre and extravagant portraits, Italian painter Giuseppe Arcimboldo (1526–1593) became particularly famous for his series of composite heads, where he arranged various objects, such as fruits, vegetables and even books, to loosely resemble the features of a human face. Born in Milan, Arcimboldo served as the imperial court painter to Emperor Maximilian II and later Philip II of Spain. His paintings often depicted the natural world, using elements such as twisted branches and the bark of trees to create intricate and intriguing

compositions. *Winter*, painted in 1563 as part of 'The Four Seasons' series of grotesque portraits, is perhaps one of the most menacing among the many paintings he produced throughout his career. The highly realistic depiction of bark, branches and roots, which Arcimboldo closely studied from nature, heightens a sense of arboreal sternness and resilience. However, the work not only serves as a representation of the toughness of winter but also signifies hope and renewal. Arcimboldo's depiction of fruits that ripen in winter, such as lemons and mandarins,

illustrates the potential for growth and the promise of life even in the most unforgiving of seasons. One striking feature of Winter's attire is the cape adorned with a large letter *M*, most likely the monogram of Maximilian II, to whom the series was presented in 1569. The cape also features a fire striker, symbolizing the Order of the Golden Fleece, to which Maximilian II belonged. Arcimboldo's creations were truly ahead of their time and continue to captivate audiences with their whimsy and uncanniness.

Gian Lorenzo Bernini

Apollo and Daphne, 1622–25
Marble, H. 2.4 m / 8 ft
Borghese Gallery, Rome

The Roman god Apollo pursues the nymph Daphne, running after her so fast that his drapery billows out behind him. At the crucial moment, when he at last puts his hand on her soft flesh, it turns to wood, her toes become rooted to the earth and her outstretched fingers grow into branches. She has escaped his advances but only by turning herself into a laurel tree. This lifesize sculpture, illustrating a story from Ovid's *Metamorphoses*, is one of the early works of Italian sculptor and architect Gian Lorenzo Bernini (1598–1680) and serves as a key example

of the Baroque style. Bernini was hailed as a prodigy for his skill in conveying so much movement and variation in texture in the hard material of marble, and for his success in making Daphne look seductive even as her body transforms into bark and leaves. He designed the sculpture to be seen from the side, so that the viewer can take in the expressions of both figures in an instant, but it is intricately carved in the round. According to the legend, Apollo consoled himself for his loss of Daphne by making a wreath of laurel. Thereafter, laurel wreaths became

a symbol of victory, initially for the athletes in games dedicated to Apollo and subsequently for the Roman emperors. In Italy graduating students still wear laurel wreaths today, and the association survives in terms such as *baccalaureate* and *poet laureate*.

Emily Carr

Forest, British Columbia, 1931–32
Oil on canvas, 130 × 86.8 cm / 51⅛ × 34⅛ in
Vancouver Art Gallery, Canada

Exuding a strange, ethereal atmosphere, this forest scene is illuminated by a mysterious glow emanating from within its depths. The foliage of the ancient trees has been painted to appear like draped fabric, disrupting the view through the woods with semi-abstract swirls and folds that suggest a theatrical stage set. A muted palette of earthy browns, blues and greens heightens the ambiguous sense of space, which seems to simultaneously draw us in and shut us out. Canadian artist Emily Carr (1871–1945) was captivated by the vast and wild landscapes of her country's Northwest

Coast and the cultures of its Indigenous people, becoming the first modern painter to make these her subjects. After travelling to New York in 1930 and seeing the work of American and European modernists, her paintings moved away from a preoccupation with First Nations themes towards more abstract concerns, in which the trees and forests of Canada became a recurring motif. This painting reflects her profound affinity for nature and love of Canada's forested landscapes. For Carr, the forest was a sacred place, sometimes dark and threatening but always

fertile and spiritually alive, holding a powerful, untamed energy that she sought to capture in paint. Along with the famous all-male Group of Seven landscape painters, Carr is regarded as a pioneering figure in twentieth-century Canadian art, though as a woman she was often considered an eccentric outsider, and her significant contribution was not properly recognized until late in life.

They saw that the cottage was made of bread and cakes.

SEE PAGE 20.

Kay Nielsen

Illustration from *Hansel and Gretel and Other Stories*, 1921
Printed illustration, 28.6 × 22.2 cm / 11¼ × 8¾ in
University of California, Los Angeles

Two young children stand deep inside a dark forest, dwarfed by huge tree trunks that twist up into the dark sky. Ahead of them, a colourful cottage made of cake, complete with a red picket fence and surrounded by luminous green trees that appear to glow against the dark backdrop of the forest, entices them to come closer. The illustration is the work of Danish-born illustrator Kay Nielsen (1886–1957), whose interpretation of the Grimm Brothers' classic fairy tale *Hansel and Gretel* piques an immediate curiosity about what might be inside the remarkable cottage. First

published in 1812, *Hansel and Gretel* had appeared in many versions by the time Nielsen illustrated this 1921 edition of the story. His forest, unlike those of his predecessors, is a curious, less foreboding place in which the trees help provide a cocoon for the scene. Nielsen's work was heavily influenced by the English illustrator Aubrey Beardsley, who in turn was heavily influenced by Japanese woodcuts and the myths and legends of Europe. Beardsley's illustrations for, among others, Oscar Wilde's *Salomé* in 1894, made him a cult figure, and Nielsen's drawings of the tree trunks

and branches bear Beardsley's influence with their bold, curving lines. A star of the golden age of illustration in the late nineteenth century, when falling printing costs led to a boom in book and magazine printing, Nielsen later came to the attention of Walt Disney, for whom he worked as an illustrator in Hollywood.

Anonymous

Pine Tree and Crane, 15th–18th century
Ink on paper, 1.9 × 1.5 m / 6 ft 5 in × 5 ft
National Museum of Korea, Seoul

A flock of cranes encircles a gnarled pine tree, flying above the ocean waves below and roosting among its branches. Both pine trees and cranes have important symbolic meanings in Korean culture, which was especially true during the long Joseon dynasty (1392–1910). The Korean pine (*Pinus koraiensis*) is revered as a symbol of virtue, longevity and wisdom. Pine boughs were traditionally left at doors to celebrate the birth of a new baby, and at the other end of a life, coffins were habitually made from pine. Because it is evergreen, it represents resilience, strength and endurance.

Some species of crane live to almost forty years old, and the birds mate for life; they symbolize good luck, harmony and purity, as well as respect for ancestors. Red-crowned cranes (*Grus japonensis*) represent family protection, keeping one's own counsel, and a balanced life. In this painting by an unknown artist, there are also a red sun and billowing waves: the sun represents longevity, as it traverses the sky without fail every day, and water is a general symbol of life, abundance and fruitfulness. The Joseon dynasty promoted neo-Confucianism and aggressively rejected Buddhism,

which had been practiced in Korea for a millennium. Artists in the court's Bureau of Painting were expected to create works that aligned with neo-Confucian ideals, painting meritorious subjects. Themes included filial piety, loyalty and bureaucratic achievement. Painters tended to echo northern Chinese painting styles, though some artists attempted a more Korean approach, using distinctly Korean scenes.

Anonymous

Blachia siamensis Bonsai, c.1920s
Potted live tree, dimensions variable
Private collection

A miniaturized tree grasps a pitted rock with its gnarled roots, and its thick, serpentine trunk twists around itself before it shoots skywards, culminating in a single leafed branch floating at its apex. Celebrated for its distinctive dark green foliage and reddish-brown bark, *Blachia siamensis* is found in Southeast Asia, particularly Thailand – formerly known as Siam – and is used in the Japanese practice of bonsai. While bonsai trees have been grown for thousands of years, this tree was created by an unknown Japanese master around a hundred years ago. Bonsai,

or the art of miniaturizing trees, originated in China, where the discipline is known as *penjing*, which translates as 'tray landscape'. The miniaturization process is achieved by carefully controlling a tree's resources, especially its nutrients. The root ball is given a limited amount of room to grow, the trunk is trained using wire, and the branches are precisely pruned over a long period of time so that the tree can be trained into the required aesthetic form. Constraining the miniaturized tree speeds up its natural growth, as the tree responds by twisting and turning in

pursuit of sunlight. The container that holds the bonsai was known in ancient China as a scholar's rock. Like the tree itself, the receptacle was carefully selected to reflect the tenets of Zen Buddhism and Confucianism in the pursuit and emulation of nature by humankind.

Laila Shawa

Rain Forest, Malaysia, 1990
Acrylic on canvas, 120 × 90 cm / 47¼ × 35½ in
Private collection

A full moon illuminates the dense flora of the Malaysian rainforest, transforming the leaves of banana trees and a variety of palms into a riot of green. In this vibrant acrylic painting, Palestinian-born artist Laila Shawa (1940–2022) captures the essence of one of the richest rainforests on Earth: several thousand species of vascular plants, including more than two thousand different species of trees, can be found in the rainy Malaysian biome. There are shrubs, lianas and many varieties of carnivorous pitcher plants, as well as epiphytes, a group of non-harmful parasites, including

ferns and orchids, that grow on other plants and absorb food from the humid atmosphere. Despite the dense forest canopy keeping much of the forest in perpetual gloom, a sliver of moonlight reaches through the thick forest vegetation. The exuberance and joy of nature in Shawa's image is perhaps an unexpected subject for an artist who was once called the 'mother of revolutionary Arabic art'. She often used her art to draw attention to the harsh realities of life in Gaza, and much of her multidisciplinary work concentrated on the plight of women in Palestine. After moving to London

in the late 1980s, works such as *The Impossible Dream*, which shows women in niqabs trying to eat ice cream cones, highlights the day-to-day struggles of Palestinian women. The rainforest Shawa paints is a world away from the arid Middle East – and Shawa's work captures the sheer joy she gets from seeing its luscious vegetation firsthand.

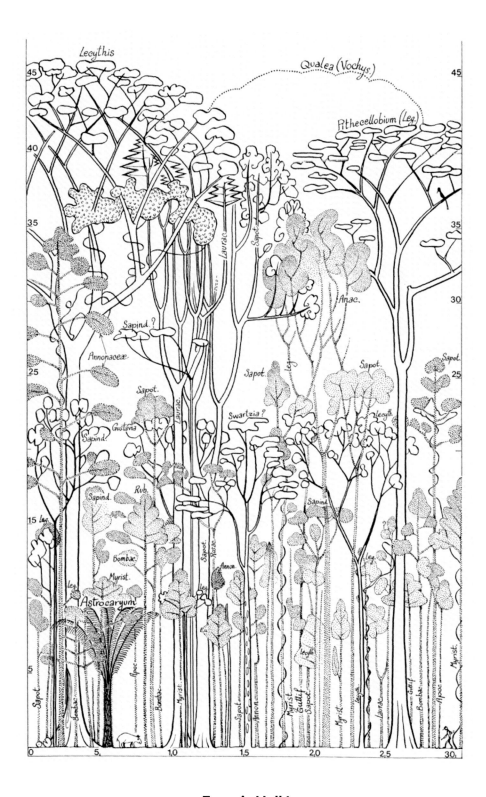

Francis Hallé

Forest Profile, Montagne la Fumée, Saül, French Guiana, 1978
Ink on paper

A lifelong love of trees has led French botanist, biologist and illustrator Francis Hallé (b. 1938) to dedicate himself to their study, particularly of tropical trees. Hallé's belief that the whole history of biological evolution is contained within the life of a tree finds its expression in his extensive writings and illustrations, which reflect years of research. This black-and-white sketch maps out a section of tropical forest: each named tree is shown relative to the other trees in the immediate environment. Over a six-decade career, Hallé has contributed to a catalogue of twenty-two 'architectural'

models of trees that he argues follow certain rules based on their genetic predisposition. When understood, these rules can be used by architects and landscape designers to help incorporate trees into their designs. The distribution and height of each tree, as Hallé draws them, support his theory that trees have their own structure, which enables them to grow together as a colony – witness the different heights of the sketched trees from the tall nut trees of the *Lecythis* genus to the short shrubs. Hallé's work has taken him across the world, but his main interest remains in

low-altitude rainforests and the life found in their treetops. He uses a blimp-borne raft to reach the tops of the trees to draw. Hallé's pioneering work is helping expand our knowledge of the rainforest's canopy, which he argues still remains a little-researched part of our world.

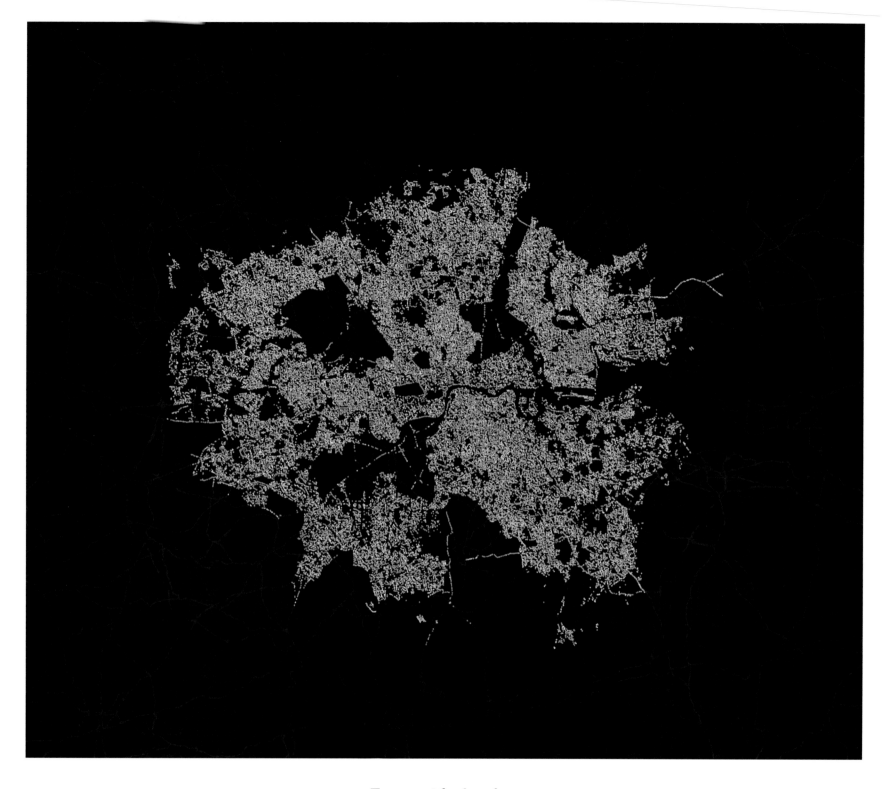

Transport for London

London Street Trees, 2021
Digital image, dimensions variable

Famed for its many parks, London has a reputation as one of the greenest capital cities of the world. This map, created by London's mayoral office in 2021, shows that the city's greenness is as much a result of its trees as its open spaces. Depicting an urban forest, this interactive map contains information for more than eight hundred thousand trees – a small portion of the estimated eight million trees within Greater London, most of which are located on the city's streets rather than in its parks. While the map is incomplete – only twenty-six of the city's thirty-three boroughs supplied data for its compilation – it clearly shows that the city is well served by its trees and their incredible variety. From hawthorn bushes to the willow trees that line many of its rivers and streams, London's common species include oak, lime, chestnut and the pretty cherry and apple trees that shed their blossoms like confetti each spring. But perhaps the king of London's trees is the London plane tree (*Platanus* × *hispanica*), a hybrid of the American sycamore and Oriental plane that was widely planted on London's streets in the late eighteenth century and is now valued both for its ability to absorb pollution and the shade its sycamore-like leaves provide. Fast-growing, the London plane can reach 35 metres (115 ft) tall and live for hundreds of years. Its distinctive greyish, olive-green bark has scaly plates that peel off and its strong roots are capable of lifting paving stones and pushing into sewer pipes.

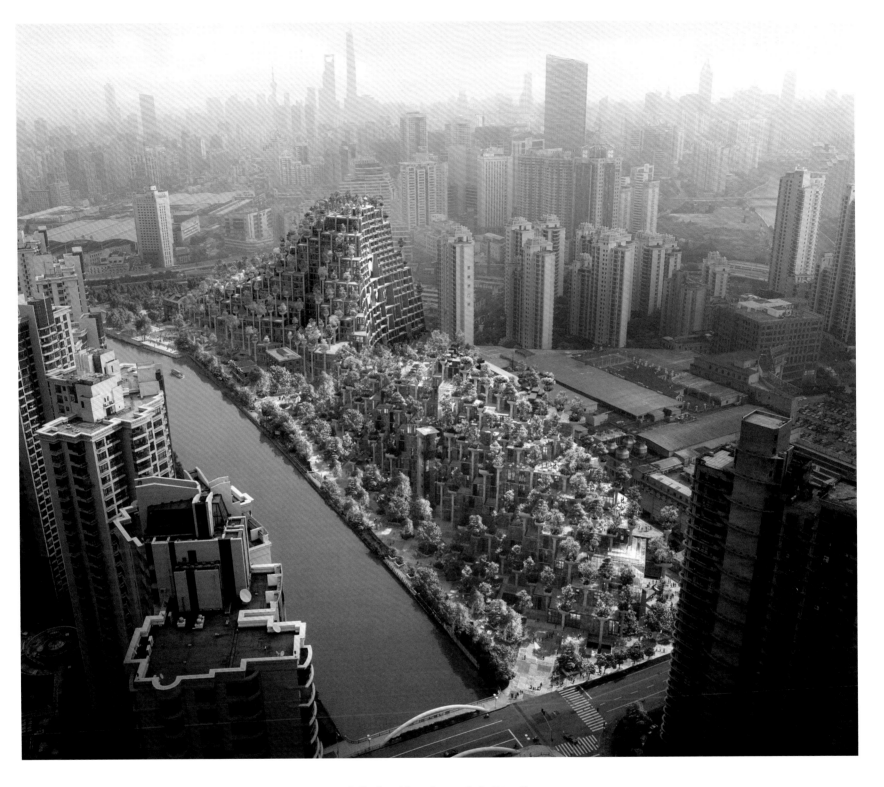

Mir for Heatherwick Studio

1000 Trees, 2020
Digital image, dimensions variable

Described as Shanghai's very own Hanging Gardens of Babylon, this tree-covered development on the Chinese city's Wusong River resembles a forest-covered mountain amid a sea of bland tower blocks. The complex was conceived by British design and architecture firm Heatherwick Studio and incorporates 1,000 trees and 250,000 plants, transforming an ex-industrial site into an innovative destination where nature and commerce collide. Wanting to distinguish the new waterfront buildings from the existing high-rises that dominate the area, lead designer Thomas Heatherwick opted to place the structure's mighty supporting columns on the outside and top them with giant planters containing a mix of evergreen and deciduous trees, shrubs and grasses. As seen in this rendering by digital studio Mir, the columns are arranged at varying heights, softening the architecture with an undulating topography of greenery. This allows for lighter and more open spaces inside the buildings, which are home to shops, cafes, restaurants, offices, a hotel and art galleries. An example of 'urban greening', *1000 Trees* increases biodiversity, which in turn helps to lower temperatures, absorb harmful carbon dioxide from the atmosphere and boost well-being. However, critics argue that the environmental benefits of such projects are outweighed by the carbon emissions associated with concrete and steel construction and the resource-intensive nature of maintaining the plants. In response to these concerns, Heatherwick Studio carefully selected more than seventy different species of trees that require minimal upkeep. Built with the aim of reimagining urban living and working, *1000 Trees* reflects Heatherwick's belief that cities should be filled with open, social spaces that are pleasant to inhabit.

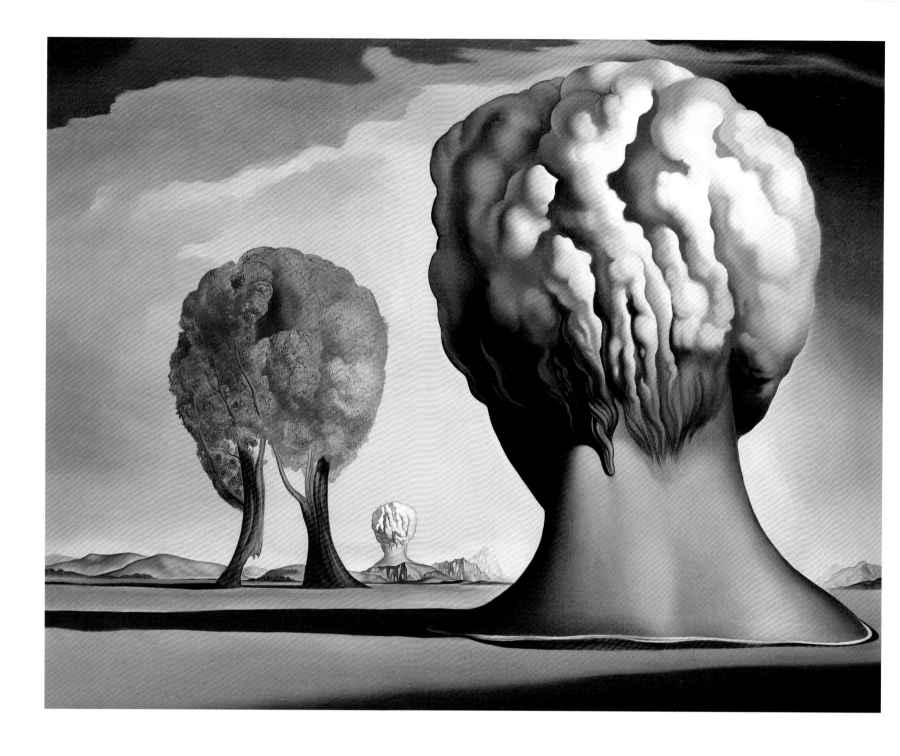

Salvador Dalí

The Three Sphinxes of Bikini, 1947
Oil on canvas, 40.6 × 51.4 cm / 16 × 20¼ in
Morohashi Museum of Modern Art, Fukushima, Japan

A thought-provoking Surrealist artwork underpinned by cryptic and dark symbolism, this is one of the most enigmatic paintings by Spanish artist Salvador Dalí (1904–1989). The title of the work, *The Three Sphinxes of Bikini*, references the Bikini Atoll in Micronesia, a region in the western Pacific Ocean where the United States carried out nuclear testing between 1946 and 1958. News of these experiments troubled Dalí and prompted him to paint this peculiar image as an admonition of uncontrolled scientific progress and the looming inevitability of nuclear warfare. The use

of the word *sphinxes* in the title is significant, drawing parallels between the treacherous creatures of ancient Greek myth and the indomitable nature of new weapons, as well as the uncertainty they brought to the world. Repetition is important in this piece, as it had been in prior works by Dalí, reinforcing the concept of history's cyclicality and the human predisposition to become locked in a loop that might lead to self-destruction. Positioned between the two hybrid figures in the foreground and background that conflate the form of an atomic mushroom with a human head

is a portrait of two intertwined, nondescript trees. It is these trees that, in the end, might hold the answer to the riddle and break the pattern. Through a subtle visual feedback, Dalí explores the separation between nature and technology, reminding us that humans have both the will to destroy and the will to grow firmly planted in their minds.

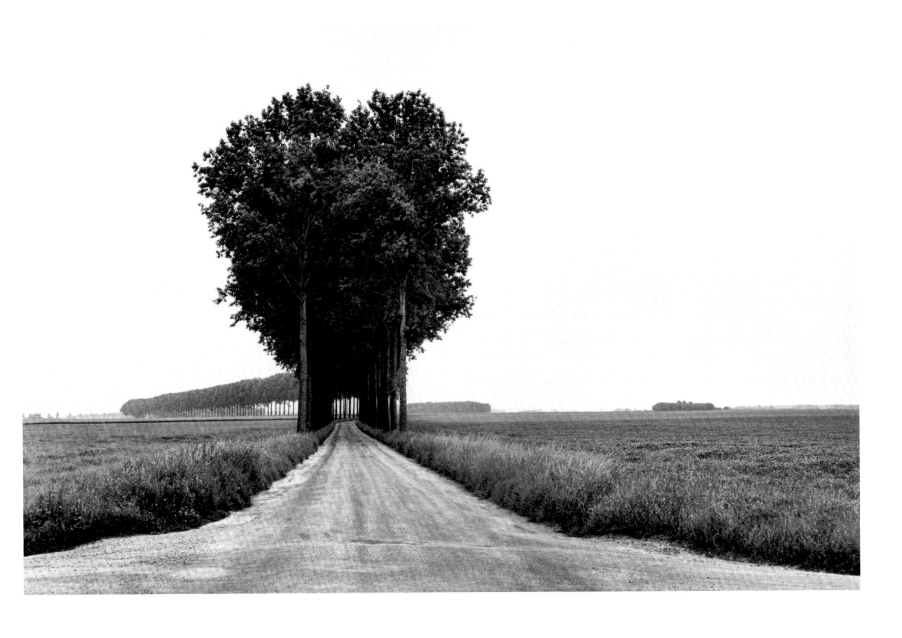

Henri Cartier-Bresson

Brie, France, 1968
Gelatin silver print, 33.2 × 48.9 cm / 13 × 19¼ in
Museum of Modern Art, New York

This technically impeccable photograph of a country lane lined by trees in Brie, France, is the work of photography master Henri Cartier-Bresson (1908–2004). Taken in 1968, the image captures a tranquillity and serenity that starkly contrasted with the turmoil brewing in nearby Paris. During that period, France was in the midst of its recovery from the devastation of World War II and a reconstruction process that fundamentally and rapidly redefined its identity. The nation's colonial stronghold had also begun to wane, calling into question France's position on the global stage. The protests that ravaged Paris in May 1968, at the same time this image was taken, shook the country. They were precipitated by a number of societal grievances, including dissatisfaction with the government, workers' rights and the rise of student movements. The protests led to widespread strikes, demonstrations and clashes with the police, resulting in a period of social unrest and political tension in France. It is in this context that the tranquillity of Cartier-Bresson's image acquires meaning as more than just a beautiful document. The photographer used central perspective to frame the solemn and elegant presence of old trees at the centre of the image. In a state of deep uncertainty instilled by current events, the trees provide a point of reference, simultaneously silent witnesses and timeless guardians. In this sense, the image serves as a reminder of the power of art to document and reflect on the world around us, providing a unique perspective on a specific time and place in history.

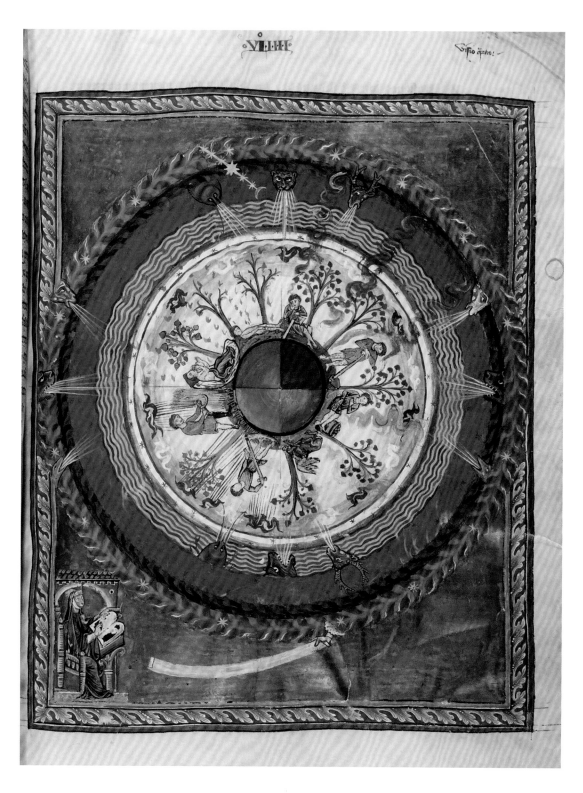

Hildegard von Bingen

Page from *Liber Divinorum Operum*, 1210–30
Illuminated manuscript, 39 × 25.5 cm / 15¼ × 10 in
Library of Congress, Washington DC

Workers tend trees through various seasons of the year in the centre of this depiction of the cosmos by German abbess Hildegard von Bingen (1098–1179), a renowned twelfth-century mystic. The cosmos, as von Bingen divined it, is bounded by an outer ring of fire referring to God's power, then an inner ring of water and air, with winds represented as the breath of wild creatures including a deer, a bear and, improbably, a lobster. Von Bingen was just a child when she began to experience religious visions. It was not until she was forty-three that

the veracity of her visions was confirmed by a committee of theologians, and she became known as the Sybil of the Rhine. Helped by a monk, the abbess then began writing down her visionary theology. Von Bingen began writing the last of her three works, the *Liber Divinorum Operum* (*The Book of Divine Works*) in 1163 and finished around 1174, and this gold-leaf painting – made by an unknown artist – was included in a thirteenth-century edition of the work. It is a remarkable depiction for the period, showing how advanced von Bingen's thinking was

in her understanding of the interaction between humanity and the natural world, specifically represented here as trees that require nurturing to flourish. In von Bingen's revolutionary vision, the life cycle of the trees – from the rain falling on the trees to make them grow to the harvesting of their fruit and their felling for wood – represents the bountiful nature that God has bestowed on humanity. Although von Bingen was referred to as a saint for centuries, it was not until 2012 that she was officially canonized by the Roman Catholic Church.

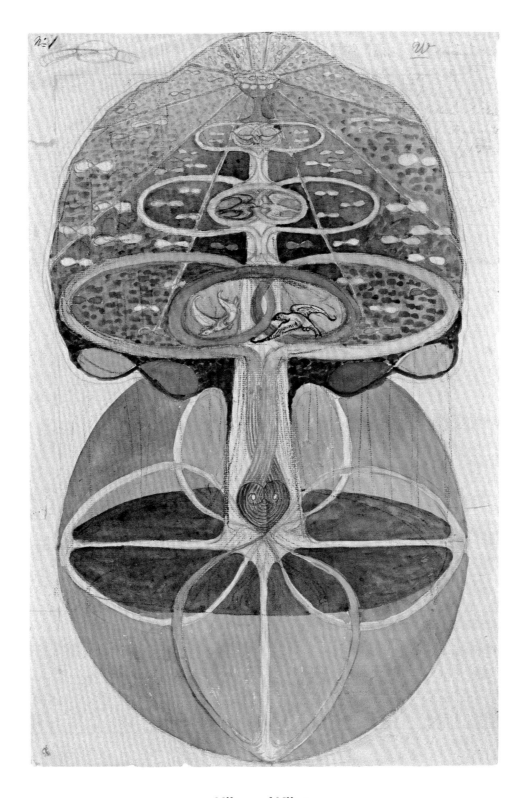

Hilma af Klint

Tree of Knowledge, No. 1, 1913
Watercolour, gouache, graphite, metallic paint and ink on paper, 45.7 × 29.5 cm / 18 × 11¾ in
Hilma af Klint Foundation, Stockholm

Known for her groundbreaking, pioneering abstract paintings, Swedish artist Hilma af Klint (1862–1944) was heavily influenced by theosophy, a spiritual movement popular with creatives in the early twentieth century. Her interest in esoteric literature, particularly Helena P. Blavatsky's *Secret Doctrine*, and her active membership in the Stockholm lodge of the Theosophical Society played a crucial role in shaping her artistic technique and subject matter. Af Klint's belief in different spiritual planes shaped her artistic language and form, and

theosophy provided her with a framework for exploring spiritual evolution and the connection between humans and the divine. Most notably, her compositions incorporated geometric and abstract shapes strongly inspired by the anatomy of plants, challenging traditional notions of art and pushing the boundaries of modern movements. Intrigued by their hidden meanings and ethereal qualities, af Klint undertook many studies and sketches of botanical themes, developing her own theory on the spiritual significance of plants as representations of stages of life

and consciousness. Her art sought to depict the invisible forces that existed beyond the material realm, capturing the spiritual essence of plants through her unique visual language. In theosophy, the tree of knowledge represents the interconnectedness of all existence and the spiritual evolution of the soul, a concept that strongly resonated with af Klint. By visually representing the tree of knowledge in her abstract paintings, af Klint believed she could convey a deeper understanding of the spiritual planes.

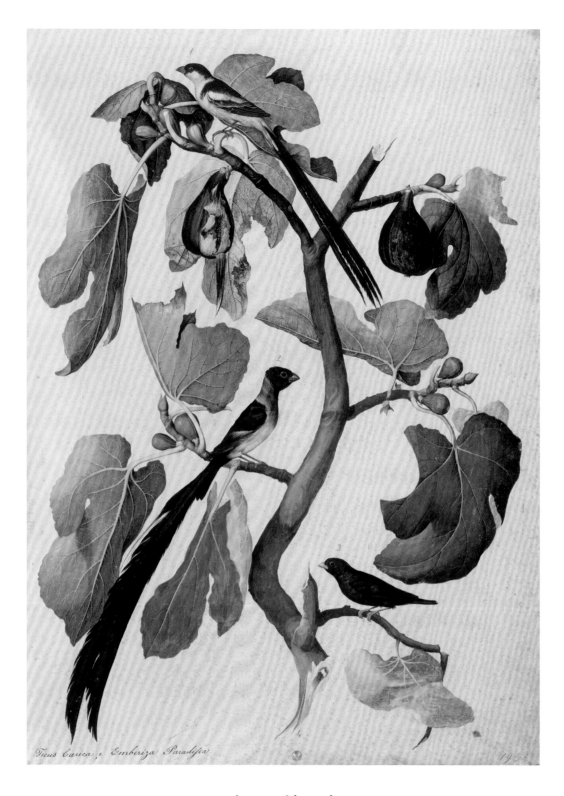

Ficus carica, e Emberiza Paradisea.

Jacopo Ligozzi

Fig Branch with Bird of Paradise and Exotic Finches, c.1603
Gouache on paper, 67.7 × 45 cm / 26½ × 17¾ in
Galerie degli Uffizi, Florence

In a superb example of sixteenth-century *natura viva* ('living nature') painting, the branches of a common fig (*Ficus carica*) serve as perches for exotic birds depicted so realistically that they can be confidently identified – a pin-tailed whydah (*Vidua macroura*), a paradise whydah (*Steganura paradisaea*) and a village indigobird (*Vidua chalybeata*). The S-shaped curve of the fig branch dominates the composition, and in the large leaves the artist has captured the shadows and different tones of the branches' upper and lower sides. The tree's figs, shown in assorted stages of

ripening, have an almost physical realism. This painting was rendered by the masterful hand of Jacopo Ligozzi (1547–1627). Ligozzi was an Italian painter, designer and miniaturist who became a court artist in Florence under Francesco I de' Medici and, later, the fourth grand duke Cosimo II. After the death of Giorgio Vasari in 1574, Ligozzi was appointed director of the guild of artists, the Accademia e Compagnia delle Arti del Disegno. He is known best for his depictions of flora and fauna, which reflect the scientific pursuits of the Medici, and his paintings of plant specimens are almost

portraits, including even dirt and roots. Ligozzi inserted butterflies and other insects, as well as birds, into his botanical paintings. And unlike most artists, who preferred to work from mounted specimens (*natura morta*, 'dead nature'), Ligozzi was able to paint directly from living models. In contrast to the Mannerist style of his work for the Medici court, at the beginning of the seventeenth century Ligozzi turned to dark religious paintings, influenced by the Counter-Reformation.

Hemmerle

Hazelnut Brooch, *Chestnut Brooch*, *Fig Brooch* and *Arbutus Brooch*, 2014
Diamonds, copper, white gold, obsidian, bronze, silver, spinels, colour changing garnets, demantoid garnets and sapphires, dimensions variable
Private collection

A collection of brooches, inspired by trees, leaves, fruits and seeds, show in exquisite detail clusters of hazelnut, fig, chestnut and arbutus. These remarkably realistic depictions are, in fact, made from precious and semiprecious stones fashioned into a unique jewellery collection, *Nature's Jewels*, by the German jewellery house Hemmerle. Taking woodland flora from around the world as its inspiration, the Munich-based company spent more than three years painstakingly crafting these lifelike pieces. Two shiny chestnuts peek out of their diamond-encrusted husks alongside autumn-tinged leaves made from precious metals, including white gold. Similarly, diamond-encrusted hazelnuts are nestled within their shells of copper and white gold. Celebrating the warmer climates where they thrive, the brooches depicting fig and arbutus – also known as the strawberry tree – allow the jewellers to showcase rare gemstones, including demantoid garnets. Demantoid garnets are better known as a favourite jewel of Peter Carl Fabergé – Tsar Alexander III of Russia's jeweller – who used them in his eponymous bejew-elled eggs (see p.255). The stones are prized because they sparkle more than diamonds (hence the name 'demantoid', from the French word *diamant*). Other unusual gemstones – spinels and colour-changing garnets – are used to create the authentic shading of the fig, while demantoid garnets and sapphires capture the red, orange and yellow fruit of the strawberry tree. Operating for more than 130 years, the fourth-generation, family-run Hemmerle is world-renowned for its exquisite craftsmanship. All of the house's jewelled creations are created at its on-site atelier, with more than five hundred hours often being dedicated to a single piece.

Sam Van Aken

The Open Orchard, 2022–ongoing
Multi-grafted fruit trees, dimensions variable
Installation view, Governors Island, New York

The Open Orchard, an art project on Governors Island in New York City, aims to restore the lost heritage of the area's fruit trees. Conceived by American artist Sam Van Aken (b. 1972) as a permanent yet constantly evolving artwork, the public orchard consists of more than a hundred hybrid fruit trees. A living archive, each trunk has been grafted with different varieties of fruit trees that are known to have grown in the New York City region over the last four hundred years. This means that through Van Aken's unique grafting process, a single tree can produce many different types of fruit, including peaches, plums, apricots, cherries, apples and nectarines. Over the years, many varieties of these fruits have disappeared as agriculture has become increasingly industrialized and farms have been lost to urban expansion. By restoring these heritage species, Van Aken hopes to introduce a new generation of New Yorkers to these trees and their fruits, thereby preserving their biodiversity for future generations. The orchard is intended to be an interactive experience: visitors are encouraged not only to observe the different fruits growing on each tree but also to taste and learn about them. Each tree becomes its own artwork as the seasons change: full of blossoms in the springtime, heavy with fruit in the summer, shedding their leaves in autumn, and hibernating for the winter. In addition to the orchard on Governors Island, the project is being extended across the five boroughs of New York City. Additional fruit trees are being given to community gardens so that these hybrid trees can be dispersed throughout the city and help to build a more resilient and food-secure future.

The Peare Quince, **137**

The Peare Quince
Rise October

John Tradescant the Elder (attrib.)

The Peare Quince, from *The Tradescants' Orchard,* c.1620–30
Glazed watercolour, H. 30 cm / 11¾ in
Bodleian Libraries, University of Oxford, UK

The plump, golden yellow fruits of a 'Peare Quince' appear ready to be picked off the page, painted at the peak of their ripeness in late autumn. Now referred to more simply as a quince (*Cydonia oblonga*), the trees are often grown for their ornamental qualities, though their tart fruits are also used to make jams and jellies. This painting is one of sixty-six images of fruit varieties in a bound volume dating to the early seventeenth century. Ranging from 'the Naples cherry' to the 'quene mother plum' and the 'grete Roman Hasell Nut', the paintings probably represent the earliest surviving display of painted fruits growing in England. Bound in a fragile leather book, they were among items donated by English scholar Elias Ashmole to the University of Oxford to establish the Ashmolean Museum, which opened in 1683. Although the artist remains unknown, the book has been attributed to John Tradescant the Elder (c.1570–1638), who is referenced within the collection as 'JT'. Known to Ashmole, Tradescant and his son, also John, were gardeners to the aristocracy who ran a nursery in South London and introduced many new plants to England. However, why these fruits were painted remains something of a mystery. One theory has it that several competent (but not professional) painters produced the images, with the collection's well-thumbed nature indicating that it may have been a form of nursery catalogue. Another proposes they were painted by Hester Pooks, second wife of the younger John Tradescant and a relative of distinguished Dutch artists, potentially as templates for embroidery. Whatever their provenance, the images provide evidence of varieties of fruits once grown in the United Kingdom, some of which survive but many of which have been otherwise lost forever.

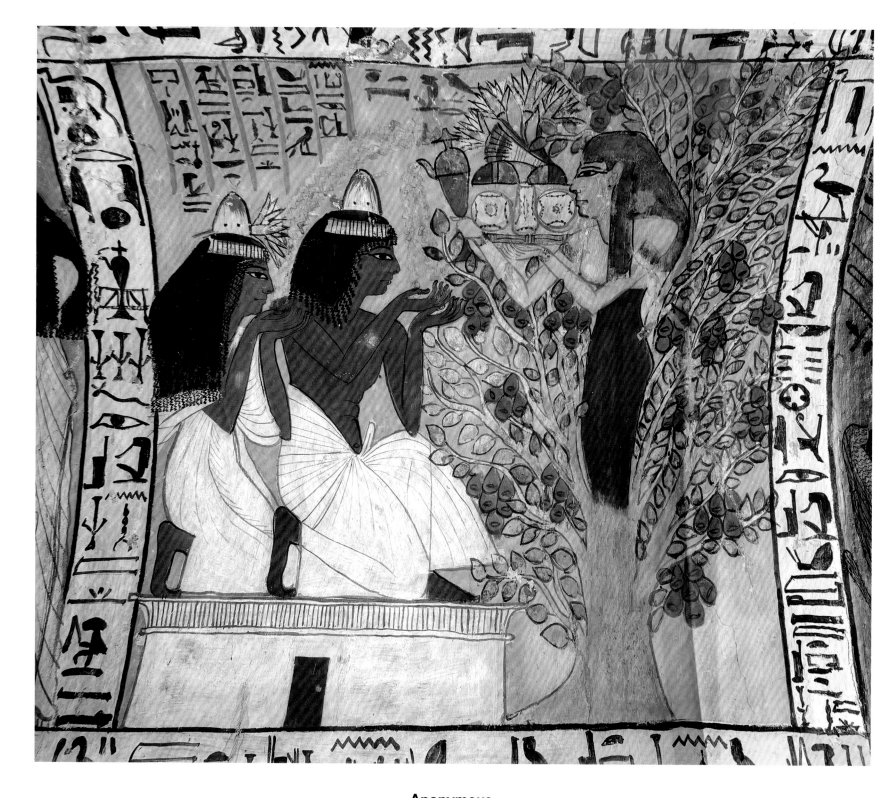

Anonymous

Sycamore Tree Goddess, *c.*1200 BCE
Fresco
Tomb of Sennedjem, Deir el-Medina, Egypt

On the ceiling of the inner burial chamber of the tomb of Sennedjem and his family at Deir el-Medina, on the west bank of the Nile near Thebes (modern Luxor), were eight painted scenes, vignettes from the Book of the Dead. One of these vignettes portrayed Nut, goddess of the sky and protector of the dead, as a sycamore tree (*Ficus sycomorus*). Dressed in festive clothing and kneeling on a building representing their house in the afterlife, Nut offers food and drink to Sennedjem and his wife, Iyneferti, who kneel before her. For ancient Egyptians, the sycamore was the tree of

life, connecting this world and the next. It is native to Egypt and the Near East, found in rich soils along rivers. It was regarded as a manifestation of the goddess Nut at Thebes, of the mother goddess Hathor at Memphis (modern Cairo) and of Isis elsewhere; they were all given the title Lady of the Sycamore. Many images show Hathor, Nut or Isis reaching out of a tree to offer food or water to the deceased; sometimes just the arms are represented. Other Egyptian deities were also associated with trees, including Horus, god of kingship, who was coupled with the acacia; Osiris,

god of the afterlife, who was connected to the willow; and Re, the sun god, who was also associated with the sycamore. The sycamore was the only native tree of useful size and strength, and burial in a coffin made from its wood was seen as returning to the womb of the mother goddess.

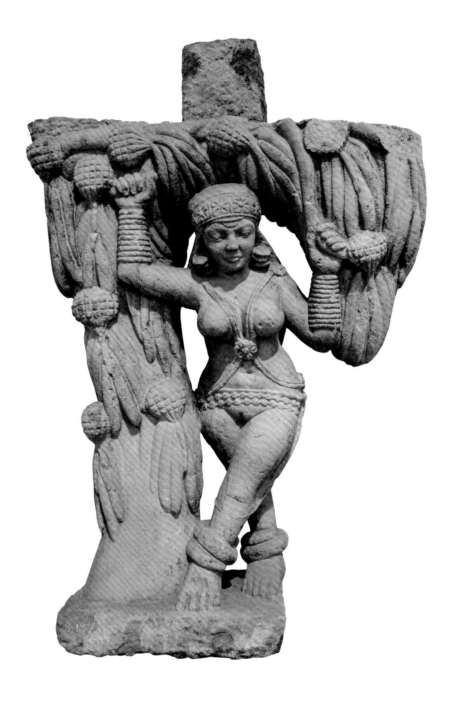

Anonymous

Statue of a *yakshi*, c.1st century CE
Sandstone, approx. 75 × 50.8 cm / 29½ × 20 in
Indian Museum, Calcutta

In this Indian sandstone sculpture, a tree spirit known as a *yakshi* grasps the branches of an ashoka tree (*Saraca asoca*). Native to South Asia, the ashoka is revered by both Buddhists and Hindus and considered the home of the female spirit. With her voluptuous figure, the *yakshi* was typically depicted naked apart from a great deal of jewellery, reflecting the belief that she possessed both the power of fertility and wealth. Here, she clings to the ashoka tree to show her deep connection with the natural world; both of her feet are firmly placed on the tree's trunk and each of her

arms is raised as she holds onto the tree's branches. The scene embodies a sense of fecundity, the tree clearly laden with flowers and fully in fruit – whether the *yakshi* is bringing forth the bounty from the tree or the tree is channelling its energy into the deity is unclear. Statues such as this were positioned at the entrance to Buddhist and Hindu temples, so the *yakshi* were seen as sacred gatekeepers, blessing worthy visitors with protection and good fortune. The ashoka tree is prized for its plentiful red flowers, and it was often found in royal palace gardens as well as temples.

Buddhists originally included the tree in their sacred sites, and it became absorbed into Hindu temple sculpture. The ashoka has often been confused with another sacred tree in Hindu scriptures – the sal, or sala – since the Sanskrit word for a *yakshi* holding a tree is *salabhanjika* ('breaking the branch of the sala tree'); in Buddhist teachings the word describes depictions of the birth of the Buddha near a sala tree.

YOU WILL BE ROBBED

YOU WILL BE ROBBED OF SPEECH

I NO LONGER BELIEVE

I KNOW THE PLOTS OF LAW ENFORCERS

WHAT I ONCE BELIEVED

YOU HAVE BEEN SWINDLED

THE MOMENT HAS GONE

LACKING THE COURAGE OF THE BONFIRE

William Kentridge

Untitled (Lacking the Courage of the Bonfire), 2019
Indian ink on found pages, 1.7 × 2 m / 5 ft 8 in × 6 ft 7 in
Private collection

South African-born artist William Kentridge (b. 1955) has long used his drawings, often of trees, to reveal the ambivalence he feels towards his native country. Using pages torn from an encyclopedia and stuck together to form a canvas, Kentridge drew – in his trademark charcoal – a single large tree against a backdrop of African scrub. Peppered within the foliage are typed phrases notable for their pessimism. These short statements include 'I no longer believe' to the left of the tree and 'What I once believed' to the right. Adding another layer to the work, trees were the source

of the paper for the book pages on which Kentridge drew. Kentridge simultaneously constructs and deconstructs not just the physical tree but also the idea it represents as a means of reading and furthering knowledge. Standing above all the surrounding foliage, the tree symbolizes those who dared to express their concerns about post-apartheid South Africa. *Untitled (Lacking the Courage of the Bonfire)* follows an earlier series of large Indian ink drawings of native South African trees Kentridge created in 2012, again on pages from an encyclopedia. Each drawing formed part

of a puzzle to be pieced together, which he then used in a lecture at Harvard University. *Six Drawing Lessons* examined art produced in the studio and the subsequent meaning that work acquired. The work, Kentridge explained, did not have to be an accurate representation but to express an emotion and show what he had observed.

Francis Hamel

Chestnut Tree in Winter, 2004
Oil on panel, 39 × 31 cm / 15¼ × 12¼ in
Private collection

Dominating the canvas, a towering chestnut tree exudes everlasting strength against the cold winter air. Beneath it lies a dense carpet of leaves in frosty shadow, while in the background a bright patch of grass provides a glimpse of the lingering autumn or oncoming spring. Close attention reveals the detail in what at first seems to be a somewhat stark representation. Shafts of sunlight pick out the characteristic fissures in the bark of the sturdy tree and illuminate the splashes of gold, blue and brown that form the tree's angular branches and twigs, while some

leaves have yet to fall to the frozen ground beneath. This endearing portrait was created by British painter Francis Hamel (b. 1963), who trained at the Ruskin School of Art and is currently based near Oxford, England, as well as in Le Marche, Italy. By the time Hamel attended the Ruskin School the institution had moved away from the principles of copying directly from nature established by its founder, John Ruskin (see p.141), but the teachings instilled in Hamel gave him an appreciation for observing his surroundings as Ruskin intended. This keen observation is apparent in all

of Hamel's work but particularly in his portraits of trees, where characteristic foliage, bark and structure are all faithfully painted. Hamel's main oeuvre consists of portraits, gardens, flowers and landscapes, and since 1997 he has lived and worked close to the famous William Kent gardens at Rousham, Oxfordshire, which has provided an enduring inspiration for his portraits of trees.

Émile Gilliéron

Sacred Grove and Dance, early 20th century
Watercolour on paper, 63.5 × 80 cm / 25 × 31½ in
Harvard Art Museums, Cambridge, Massachusetts

At least fourteen women perform what was once thought to be an ecstatic dance in the foreground of this 'miniature' fresco from Knossos, Crete, from a small shrine in the northwest wing of the palace. Reproduced in watercolour by Swiss archaeological draughtsman Émile Gilliéron (1850–1924) in the early twentieth century, the original fresco dates back to c.1600–1450 BCE. Two lines of men stride along a raised causeway in the West Court, left hands on chests, while a vast crowd watches the performance. A grove of olive trees (*Olea europaea*)

stands in the centre of the fresco, each tree represented in minute detail, with separate branches and even individual leaves. It has been thought that the gathering was to witness the epiphany of the Minoan goddess in the form of a high priestess. The focus of the ceremony was on the left (now lost) side of the scene, judging from the women's gestures and the crowd, enthusiastic with raised arms, also facing left. But scholars have pointed out that the 'dancers' exhibit no flying draperies or hair, which suggests that for all their gestures, they are not performing.

British archaeologist Sir Arthur Evans, who excavated the fresco, believed that a cult of sacred trees was a fundamental part of Minoan religions, and trees on frescos or in glyptic art represented divinities. Later scholars have suggested that tree ceremonies did not need to involve an exterior deity at all. Rather, rituals served to unite worshippers with specific elements of the landscape, such as trees and mountains, which were believed to be sentient. Here, the olive trees may be understood as interacting directly with the human figures.

Ruth Asawa

Untitled (S. 846, Freestanding Tied-Wire, Closed-Center, Six-Branched Tree Form), 1963
Galvanized steel wire and steel mount on redwood base, 91.4 × 99.1 × 101.6 cm / 36 × 39 × 40 in
Private collection

Meticulously constructed from galvanized steel wire, this delicate arboreal sculpture replicates the subtle intricacies of natural tree growth. Its industrial material is made to appear organic and sprightly, and although the tree is bare as in winter, it emanates a sense of life as its wiry branches reach out into space. Japanese American artist Ruth Asawa (1926–2013) was prompted to create this work after being gifted a desert plant from Death Valley in California. She initially attempted to sketch the tumbleweed-like growth, but it was so tangled that she decided instead to re-create it in wire in order to use it as a model for drawing. Starting with a tightly wrapped bundle of wires, she divided and tied the strands at regular intervals to form forking branches, a process that she repeated until only single twiglike strands remained. The resulting form was a revelation, inspiring numerous similar tied-wire forms. As here, some of the sculptures sit on wooden bases like bonsai trees, while others are suspended from the ceiling. In later works, Asawa experimented with electroplating the ends of the branches, creating small nubbins that resemble the buds on a tree in spring. Inspired by Mexican wire basket weavers, Asawa's material of choice set her apart from her peers, allowing her to make light and ethereal works that challenged conventional definitions of sculpture. Over time, her sculptures would become increasingly abstract, yet always maintain a connection to the complex beauty of nature.

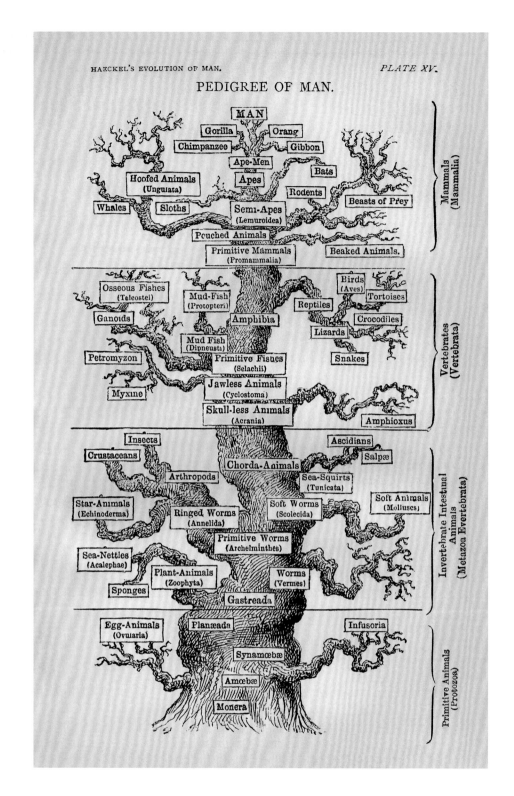

PEDIGREE OF MAN.

Ernst Haeckel

Pedigree of Man, from *The Evolution of Man*, 1879
Engraving, 20.3 × 13.9 cm / 8 × 5½ in
American Philosophical Society Museum, Philadelphia

What might initially appear to be an engraving of a thick, gnarled trunk with many branches leading from it is, in fact, an illustration of the theory of evolution first promulgated by Charles Darwin in *The Origin of Species* (1859). This diagrammatic explanation of the theory, titled *Pedigree of Man*, was created by German scientist Ernst Haeckel (1834–1919) twenty years later. Just as Darwin postulated, Haeckel's engraving puts man at the top of the tree of life, the pinnacle of evolution. At the bottom, among the tree's roots, are protozoa, the lowest form of

life. As the tree grows higher, the forms of life develop, from protozoa to invertebrates to vertebrates and finally to humans. Darwin had himself sketched a wispy, treelike diagram in which different forms of life diverged from one another as they evolved through successive generations (see p.106). Haeckel's more realistically drawn tree adds more detail to the process and includes living species amid its branches as well as those that have become extinct. Individual groups and species are carefully labelled, some with their Latin as well as vernacular names. Haeckel was

a great defender of Darwin's then controversial theory of evolution, publishing books on Darwinism in his native German that were translated into many languages. It is said that more people learned about the theory of evolution from Haeckel's works than they did from Darwin himself. A polymath, Haeckel discovered and named thousands of new species and made numerous sketches and watercolours of animals and sea creatures, a hundred of which are collected in his renowned *Kunstformen der Natur* (*Art Forms in Nature*, 1899–1904).

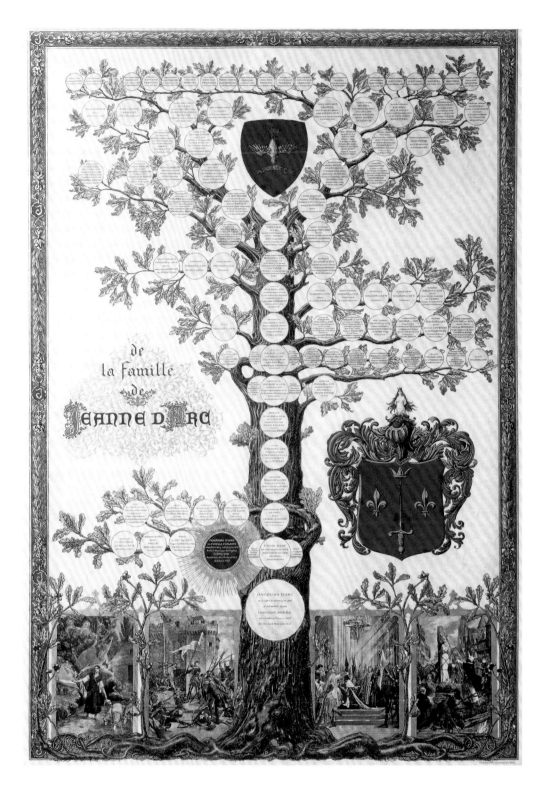

Anonymous

La Famille de Jeanne d'Arc, 20th century
Musée Municipal, Vaucouleurs, France

For a French peasant girl who, according to legend, single-handedly defeated the English during the Hundred Years' War between France and England that lasted for much of the fourteenth and fifteenth centuries, this family tree is a remarkable tribute. At the age of thirteen, Jeanne d'Arc (c.1412–1431), more widely known in English as Joan of Arc, began to hear the voices of saints giving her divine guidance. They told her to defend France in the war, and after a remarkable rise to royal attention, she led French troops to victory over the English at the Siege of Orléans.

She was subsequently arrested, tried and burned to death as a heretic by the English and their Flemish collaborators. Joan of Arc's guilty verdict was eventually overturned when she was posthumously pardoned and finally canonized in 1920, lauded as a heroine who awakened French nationalism. While this is not the story told by this family tree by an unknown artist, the inclusion of a coat of arms granted by King Charles VII to Joan's family after her death, and the scenes depicted at the bottom of the tree, indicate that this twentieth-century genealogy

belonged to an important personage. Many names appear on the branches of the tree, detailed within white circles, while Joan's details are clearly visible – in the same royal blue as her coat of arms and shield – written on the blue background surrounded by a radiating golden halo. It was typical for families from Joan's village of Domrémy to use their mother's surname, which perhaps explains the choice of illustrating the maternal lineage here.

Damien Hirst

Renewal Blossom, 2018
Oil on canvas, diptych, each panel 2.7 × 1.8 m / 9 × 6 ft
Private collection

The blossoming cherry tree is most associated with Japan, where the annual spring tradition of feasting beneath boughs laden with *sakura* (cherry blossoms) has a long cultural history. While native to East Asia, ornamental cherry trees can now be seen in many parts of the world – perhaps most famously in Washington DC, after many of the 3,020 specimens gifted to the United States by Japan in 1912 were planted in the city. The trees are also common in the United Kingdom since their introduction in the late nineteenth century, and the trees' distinctive clouds of pink or white flowers are a welcome sight at the end of winter. This positive evocation of nature's resplendence is captured in *Renewal Blossom* by British artist Damien Hirst (b. 1965). Painting has been an enduring strand of Hirst's practice since he rose to prominence in the 1990s, most frequently in extensive series. *Cherry Blossoms* comprises more than one hundred large-scale canvases produced over three years by the artist's own hand – differing from many of his earlier paintings, which were executed by others or by mechanical means. In some works, dark tree trunks and branches intersect the picture and make the subject easily recognizable. In others, such as this diptych, the density of blooms rendered in thick impastos of oil paint creates an almost abstract composition reminiscent of Action paintings, with mere glimpses of blue sky and twigs around the edges to indicate their figurative origins. *Sakura*, being short-lived, often symbolize the transience of beauty and ephemeral nature of life, yet here Hirst's title emphasizes not a finite end but an ongoing cycle of renewal that characterizes deciduous trees.

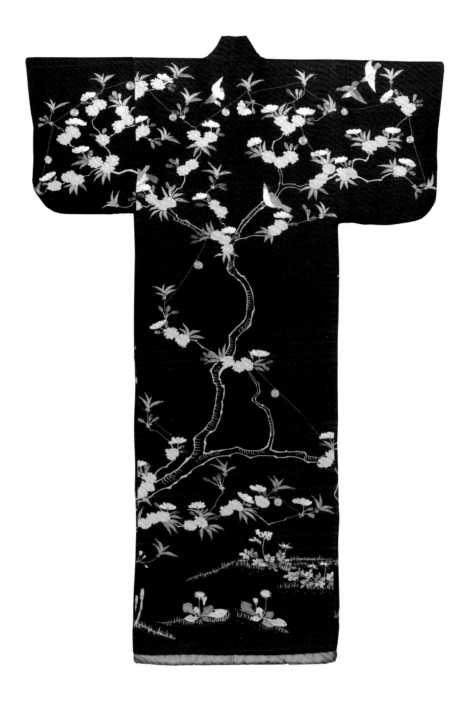

Anonymous

Court Lady's garment (*kosode*) with swallows and bells on blossoming cherry tree, 1868–1912
Silk crepe (*chirimen*) with silk embroidery and couched gold thread, 1.8 × 1.2 m / 5 ft 9 in × 3 ft 10 in
Metropolitan Museum of Art, New York

A single cherry tree spreads its branches, dotted with creamy white blossoms and vibrant pink buds, across the back of this silk court garment from the mid-nineteenth century, during Japan's Meiji period (1868–1912). Dyed a deep purple – which was achieved using European aniline dye, one of the first synthetic dyes – the cherry tree is intricately embellished with embroidered leaves, red strings with tiny gold bells, and swallows flitting around or sitting upon its branches. This type of garment, called a *kosode* – meaning 'small sleeves' – originated in the

Heian period (794–1185) as a plain silk undergarment for both men and women, as part of the multilayered court dress. With easing restrictions on these layers, the *kosode* evolved into outerwear during the Kamakura period (1185–1333) until it more closely resembled a modern-day kimono in the Edo period (1603–1867). Such was the garment's ubiquity that foreigners could be easily distinguished by the fact that they were not wearing one. The choice of fabric for the *kosode* – its colour, level of decoration and symbolism – became a shorthand that indicated

the wearer's social status in a very hierarchical society. The purple of this *kosode* shows it belonged to a lady of the imperial court. It would only have been worn during the spring since *kosode* with cherry trees in full flower were only to be worn during the cherry blossom season. As a decoration, cherry trees carried a special meaning: worn for leisure as here – like most other floral designs – the blossom signified the transitory nature of female beauty, so such motifs only appeared on women's clothing.

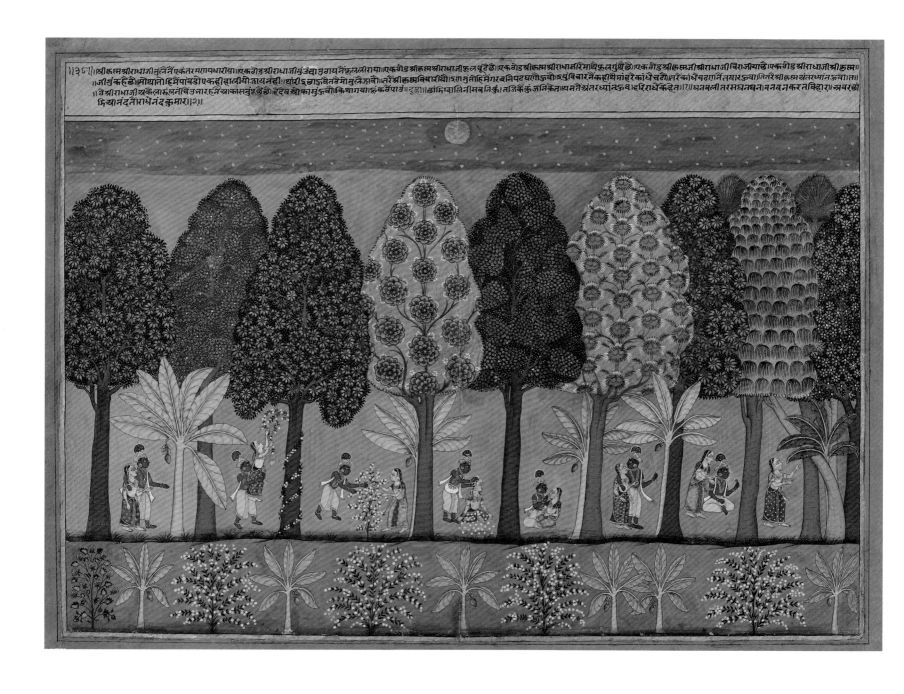

Anonymous

Krishna and Radha Pick Flowers, from the *Bhagavata Purana*, 18th century
Watercolour on handmade paper, 50.2 × 70 cm / 19¾ × 27½ in
Mehrangarh Museum Trust, Jodhpur, Rajasthan

Deep in a forest of beautiful trees under the light of a full moon and a sky full of stars, the blue-tinged god Krishna and his companion Radha – two of the most beloved characters of the Hindu religion – are enjoying their outdoor playground, decorating a tree with lights in one scene and serenading a tree in another. Dating from the eighteenth century, this watercolour of Lord Krishna and Radha in the forest is taken from the most popular of all Hinduism's eighteen Puranas, the *Bhagavata Purana*, which tells the story of the childhood and early life of Krishna. Puranas are

long poems that cover subjects ranging from the creation story to cosmology, medicine, astronomy and the deeds of the Hindu gods. According to the *Bhagavata Purana* – in a story that is similar to the Christian account of King Herod in the Bible's New Testament – after Krishna was born, his uncle was fearful of losing power, so he ordered all young males and babies to be killed to avoid the child growing up. Krishna was born royal but was sent by his parents to be brought up by *gopis*, or cowherds, where he met Radha. As a young man growing up in the forest,

Krishna had no idea about his true identity. The story describes an idyllic youth, in which the forest plays a key role in his happiness, as does his friendship with Radha. The pair fall in love, but according to some accounts, Radha was tragically already married.

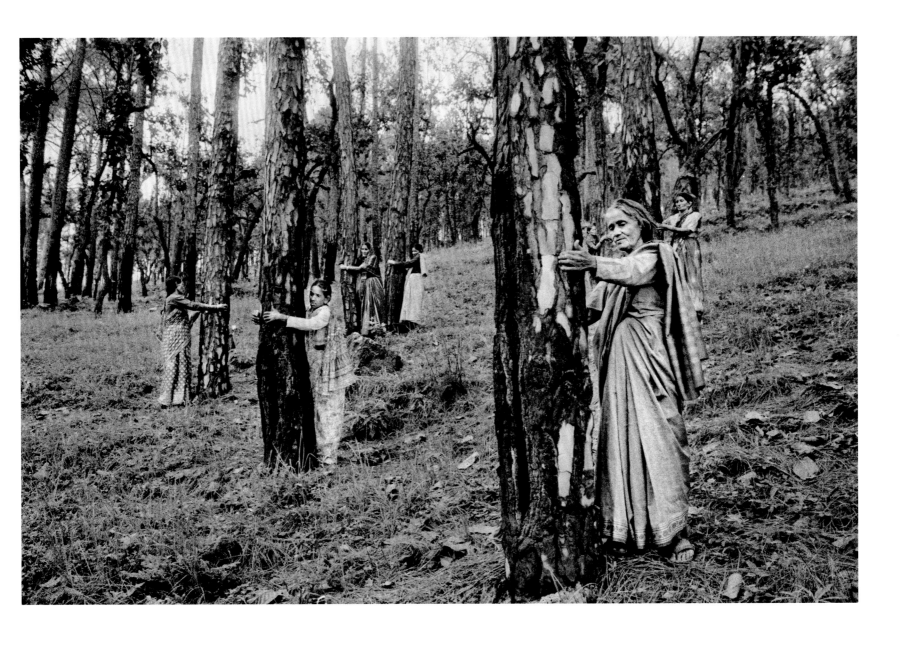

Pamela Singh

Chipko Tree Huggers of the Himalayas #4, 1994
Photograph, dimensions variable

In a powerful act of non-violent protest, Himalayan women wrap their arms around the trunks of trees to prevent them being felled by loggers. Indian photographer Pamela Singh (b. 1962) captured this indelible image while visiting the villages of the Garhwal hills in Uttarakhand, northern India, where the local women were embracing the peaceful resistance movement known as Chipko. From the Hindi *chipko andolan*, translated literally as 'embracing the tree', Chipko dates back to the 1920s when similar tree-hugging tactics were employed to resist the exploitation of the forests by British colonists in Uttar Pradesh. Singh grew up in the Himalayan foothills and spent many hours exploring the region's glacial peaks, lush meadows and ancient woodlands. By 1994 rampant deforestation had already resulted in landslides and flooding in some areas, and the loss of wood used for cooking and heating was further putting the lives of local people at risk. Upon learning that the destruction of yet more woodland was threatening local communities, Singh wanted to document the people's fight to protect the trees. When the loggers arrived, the women grasped hold of the trees and proclaimed, 'This forest is our mother's home. We will protect it with all our might.' The protests proved successful, resulting in a fifteen-year ban on tree felling in the Himalayan regions, preserving the people and resources of rural India and raising awareness of the ecological havoc caused by reckless acts of deforestation.

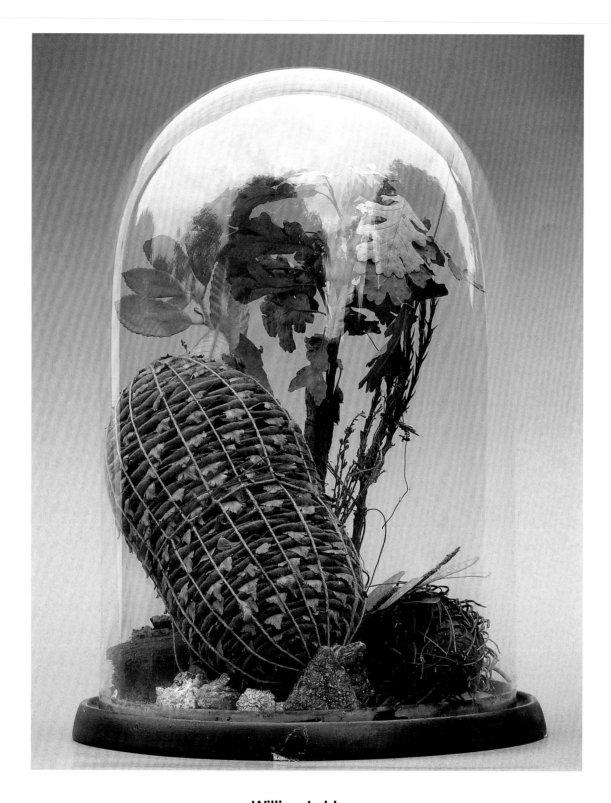

William Lobb

Tree specimens in glass dome, c.1849–53
29.5 × 18.8 cm / 11½ × 7½ in
Economic Botany Collection, Royal Botanic Gardens, Kew, London

Arranged within a fragile glass dome, a collection of several conifer cones with dried bark and chunks of minerals is a celebration of the natural resources of North America. The dome – a popular parlour decoration in nineteenth-century England used to display specimens from the natural world – was most likely created by professional English plant-hunter William Lobb (1809–1864). Commissioned by horticulturist and nurseryman James Veitch (see p.215), Lobb initially made two plant-collecting trips to South America between 1840 and 1844 with his brother Thomas to collect seeds of the monkey

puzzle tree (*Araucaria araucana*); he sent back three thousand seeds to London, helping make the plant a commercial success in Great Britain. While collecting seeds to order, Lobb – a self-taught amateur horticulturist – also collected specimens for his own interest on trips to California and Oregon between 1849 and 1853. The specimens inside the dome include the large American conifer cones of the Shasta red fir (*Abies magnifica* var. *shastensis*) and the endangered Santa Lucia fir (*Abies bracteata*), both skilfully bound and sealed with wax to prevent them from disintegrating. Also included is a cone of

the Monterey cypress (*Cupressus macrocarpa*) and bark from the giant redwood (*Sequoiadendron giganteum*) and several North American oak trees – two variants of tanbark-oak (*Notholithocarpus densiflorus*), Oregon white oak (*Quercus garryana*) and California horse-chestnut (*Aesculus californica*). It is thought that the dome was brought back to England by Lobb's sister, who cleared his house in San Francisco after his death. With no known images of Lobb and all of his sketchbooks lost, along with all of Veitch's records due to a fire, this dome is a unique artefact of the golden age of plant-hunting.

known, ripen in one season. In the CONIFERÆ a large proportion of the species also maturate their fruits in one season. In Pinus, Cedrus, Araucaria, Cupressus in part and Juniper maturation is not complete till the second season.* The seeds are dropped either by the falling away of the scales (Abies) or by a separation of them at a sufficient distance to allow of their escape. The hard cones of the Pinaster group of Pines, notably the Californian species *P. muricata* and *P. tuberculata*, often

Fig. 32. 1, Cone of *Abies pectinata*. 2, Bract and ovuliferous scale of the same seen from the outside. 3, The same seen from the inside and showing the two-winged seeds. 4, Longitudinal section of bract and ovuliferous scale showing a seed inserted on the latter. 5, A winged seed of *Abies pectinata*. 6, Longitudinal section of seed. 7, Ovuliferous scale of Scots Pine. 8, Ovuliferous scale of the Larch *(Larix europæa)* showing two ovules and bract below it. 9, Longitudinal section of the ovuliferous scale of the Larch. Fig. 1 natural size, all the others enlarged.

remain closed and attached to the trees for years, only opening when a forest fire or an exceptionally hot and dry season causes the scales to split asunder and liberate their seeds.

* The seeds of *Pinus pinea* are not mature till the third season, and this may probably be the case with other species of Pinus.

As already stated, the seeds are produced singly, in pairs, or in greater number according to the ovules in each scale, but sometimes fewer by abortion in those species in which the ovules on each scale are more than two (Cupressineæ and Taxodineæ). They are enclosed in a bony, leathery or membraneous tegument called the *testa* which in the Abietineæ is usually expanded into a membraneous wing. The endosperm enclosing the embryo consists of a farinaceous or fleshy albumen more or less impregnated with resin, but which in the case of a few of the larger seeds of Pinus as

Fig. 33. 1, Branchlet of Larch, *Larix europæa*, with ripe cone. 2, Branchlet of *Pinus rigida* with ripe cone. 3, Ovuliferous flower of *Cupressus sempervirens*. 4, Longitudinal section of the same. 5, Ripe cone of the same. 6, Single carpel of the same with numerous ovules. 7, Fruiting "spur" of *Ginkgo biloba*. Figs. 3, 4, and 6 enlarged.

P. pinea, *P. edulis*, *P. Sabiniana* is edible and occasionally used for food by the poorer inhabitants of the countries in which these Pines are abundant.

The seeds vary much in size and shape in the different genera, and even in species included in the same genus. Thus in Pinus they are mostly ovoid or obovoid, with the greater diameter of the smaller seeds as those of *P. Strobus* not more than one-fifth of an inch, whilst those

E

James Herbert Veitch and Adolphus Henry Kent

Veitch's Manual of the Coniferae, 1900
Printed book, each page 20.3 × 12.7 cm / 8 × 5 in
University of British Columbia Library, Vancouver

The goal of this remarkably comprehensive study of British conifers, *Veitch's Manual of the Coniferae*, first published in 1881, was to give the reader wide-ranging information about cone-bearing trees, including their distribution across the British Isles, their uses in arboriculture and their botanical history. The book was the work of James Herbert Veitch (1868–1907), who came from a family of distinguished horticulturists and was better known for his eponymous nursery in London's Chelsea district, and was written primarily by Veitch Nurseries' botanist Adolphus Henry Kent (1828–1913).

These pages of the manual describe *Abies pectinata* (now *Abies alba*), the European silver fir, with detailed illustrations of the structures of the tree's cones and seeds. Conifers are gymnosperms: they grow exposed cones instead of flowers or fruits with which to reproduce. Some trees contain both male and female cones while others grow only one or the other. Globally, there are more than six hundred species of conifer, of which around fifty species are found in Britain. Conifers are some of the oldest trees on the planet, with fossilized remains of conifers dating

back three hundred million years. Today, found predominantly in the cooler northern hemisphere, Pinales species include the giant redwoods of California. Veitch Nurseries were famous for their plant-hunters during the Victorian period, including Ernest Henry Wilson and William Lobb (see p.214). Veitch himself undertook an extensive world tour beginning in 1891, with the purpose of collecting unusual specimens for his family's nursery at a time when the British public were seeking more unusual plants during a period of booming interest in gardening.

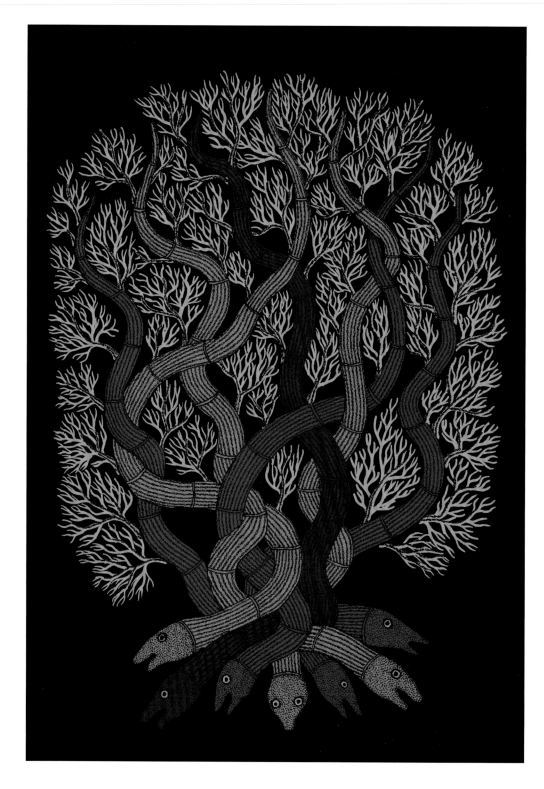

Bhajju Shyam

Snakes and Earth, from *The Night Life of Trees*, 2006
Silk-screen printed on paper recycled from cotton waste, 33 × 23 cm / 13 × 9 in

Undulating bodies of snakes weave together to form this remarkable tree, from the roots coiling above the earth to the trunk and up through the branches from which bright green shoots emerge. It is one of nineteen paintings included in *The Night Life of Trees*, a book celebrating trees and their central role in the lives of the Gond tribe, a community of forest dwellers who live in Madhya Pradesh state in central India. Award-winning Gond artist Bhajju Shyam (b. 1971) – one of the three Gond artists featured in the book – painted the tree at night, the only time when

the Gond believe trees' true spirits emerge. According to Gond mythology, trees are kept busy working all day to feed and shelter humans and animals. It is only at night that they are free to become their true selves, in this case in the imagined symbiotic relationship between Earth and the snake goddess, which the Gond believe are one and the same thing, which gives life to sacred trees. Gond artists take their inspiration from the natural world around them, depicting trees, birds and animals in animated detail and bright colours. Trees, in particular, lie at the heart of their

worldview and feature in nearly every Gond story – and every artwork. Asked to draw a bird, a Gond artist will draw a bird in a tree; asked to draw a river, the artist will draw one winding around a nearby tree. Paying respect to this spirit, each copy of the book is produced by hand – from silk-screening the artworks onto handmade paper to binding the book – at publisher Tara Books' workshop in Chennai.

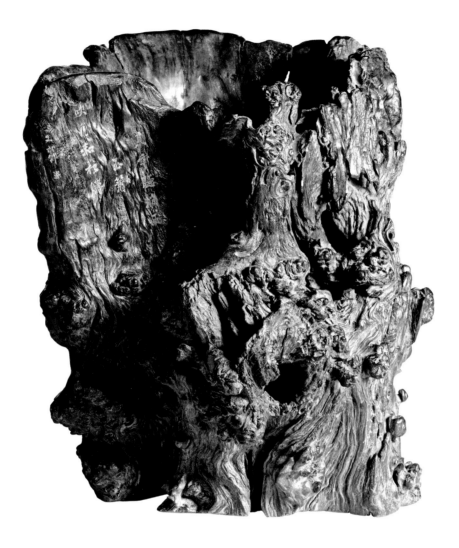

Shao Can

Tree trunk brush pot, before 1862
Wood, 32 × 31 × 29.5 cm / 12½ × 12 × 11½ in
Private collection

Hollowed out of a knotted and twisted trunk of an alder tree (*Alnus trabeculosa*), this Chinese pot (*bitong*) for holding painting and calligraphy brushes was incised with a poem: 'Listening to the babbling brook while melting the clouds in the stone *ding* vessel, harmonizing the waves of the pine while playing the jade flute to the moon.' The poem is followed by the seal of Shao Can (1803–1862), a Qing dynasty (1644–1911) official who also included his alternate name, Youcun, on the pot. A brush pot symbolized a Chinese scholar's sophistication and refinement and was frequently decorated with literati subjects, including appropriate poetry. Several objects made up the desk of a Chinese literatus: an inkstone for grinding ink, brushes of different sizes for calligraphy and painting, paper, a brush washer and a brush pot, where brushes were stored handle down, so that the hairs would keep their points. During the Ming (1368–1644) and Qing dynasties, brush pots were made of lacquer, porcelain or jade, but the preference among the literati seems to have been for bamboo and wood – organic, natural materials. Naturally occurring wood and roots might be used, as here, if they had an uncommon form or attractive woodgrain. Organic literati pieces reflected the discreet plainness and thoughtful qualities of a scholar's life. The literati valued beauty that was inspired by nature, and this predilection was richly echoed in the things they chose for their studios.

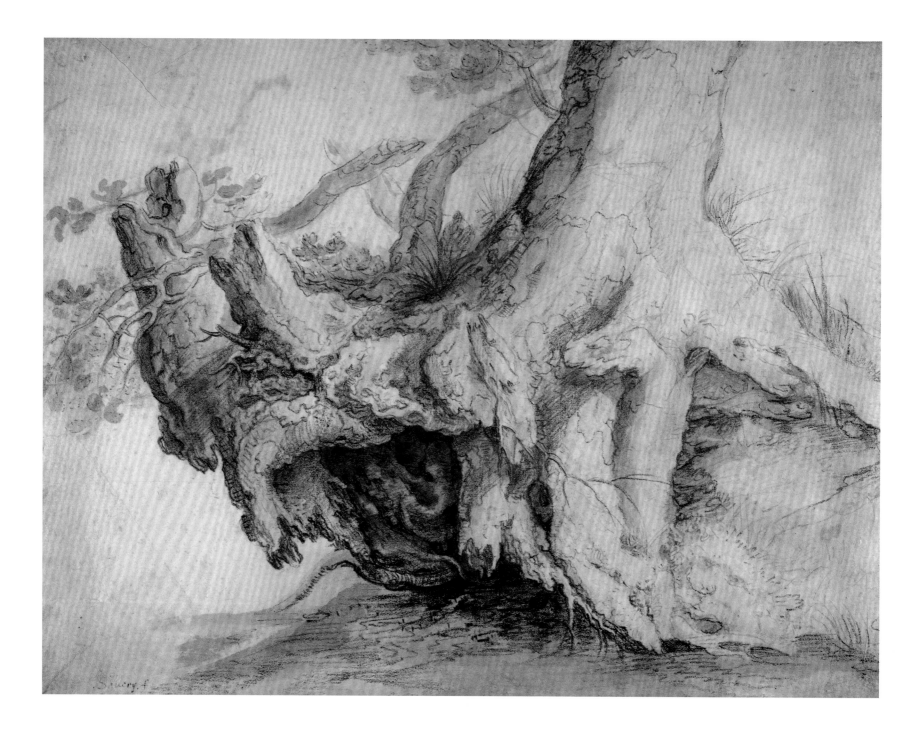

Roelandt Savery

Study of a Tree, c.1606–7
Grey watercolour wash, red chalk wash, charcoal dipped in oil and graphite on off-white laid paper, 30.6 × 39.4 cm / 12 × 15½ in
Metropolitan Museum of Art, New York

This delicate drawing of an uprooted tree trunk with its roots, broken branches and stump seemingly captures the tree as it was upended from the soil, straddling a moment where it was simultaneously dead and alive. The work of the Flemish painter Roelandt Savery (1576–1639), who is better known for his detailed oil paintings of landscapes and flowers, the drawing applies a similar level of meticulous attention to roots, perhaps the most overlooked element of trees. Between 1606 and 1607, Savery travelled to the Swiss and Tyrolean Alps on the orders of his patron, the Holy Roman

Emperor Rudolf II, a great champion of the arts, in order to study plants and 'to search for rare wonders of nature'. At the time, late Mannerist art was popular in Rudolf's court in Prague, where its artificiality was prized after the idealized naturalism of such Renaissance artists as Leonardo da Vinci (see p.134). Here, Savery combines the energy of the late Mannerist movement with a naturalist's attention to detail to produce a study that, with its highly charged forms, appears to have been drawn precisely as the tree was uprooted, revealing the subterranean world beneath. Savery worked

on his original graphite sketch on site, later building up layers of coloured washes with charcoal that he dipped in oil. Combining hatched and crosshatched strokes, Savery shaded the hollow that appeared as the tree fell in a dark wash, while he finished the falling trunk in light shading, creating the tension of the moment the tree trunk toppled.

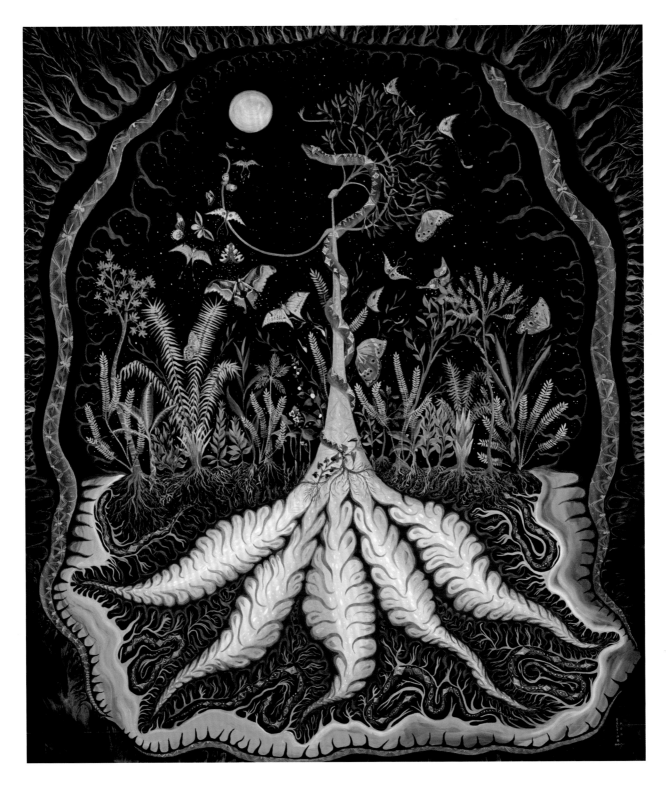

Delfina Mun

The Root, 2020
Acrylic on canvas, 110 × 90 cm / 43¼ × 35½ in
Private collection

Against a starlit night with the moon shining brightly, the jungle comes alive, butterflies flutter and a serpent-encircled tree reaches for the sky while its thick roots press into the earth. This extremely detailed and colourful acrylic painting by Argentine-born Indigenous artist and activist Delfina Mun (b. 1992) proposes a cosmological view of creation in which charged symbols hold together narratives of regeneration and hope. This piece was described by the artist as 'a mesmerizing journey beckoning us to embrace our essential connection to our Great Mother', and with it

Mun reflects on the interconnectedness of all life forms. An intricate root system dominates the painting, showing how trees are linked together in forests but also symbolizing how humans are linked to nature – the roots are strong and unyielding, a resilience of life. Earthy tones reflect the organic richness of the natural world, while bursts of vibrant colour embody life and vitality. Mun's journey in *The Root* is one from the depths of darkness into the light as a metaphor for the collective healing she feels the world is undergoing. Serpents represent transformation as

they dig at the roots of what must be changed in order to be free to ascend towards the light of the moon. A practising healer and visionary, Mun believes her work, which blends Indigenous traditions with contemporary aesthetics, has the power to heal by concentrating on the nurturing plants of Mother Earth. This is just one strand of a creative life that also encompasses music and poetry, heavily influenced by her homeland of Puelmapu, the Mapuche territory in the far southwest of Argentina, and her studies of the Amazon rainforest.

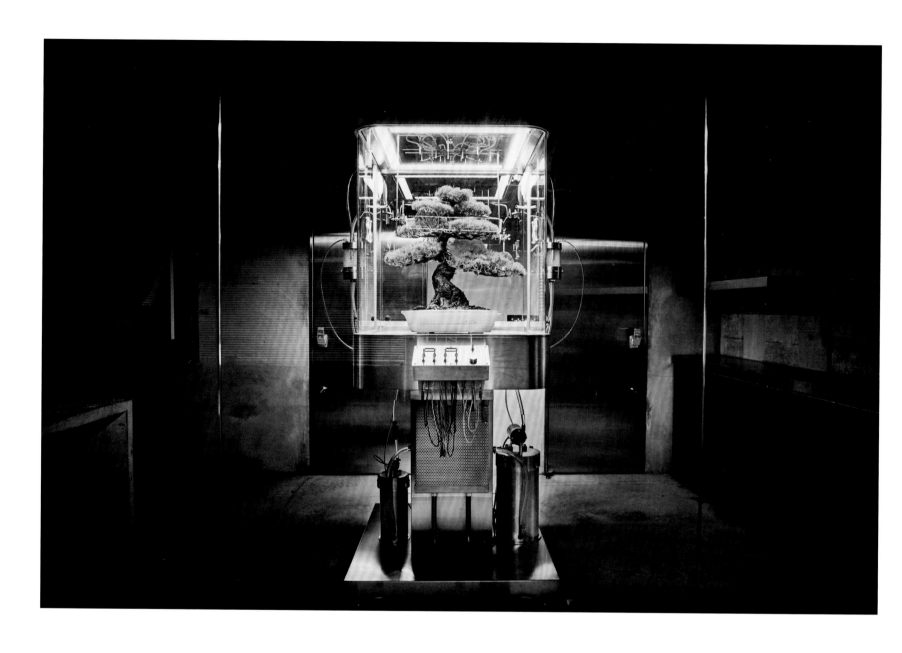

Azuma Makoto

Paludarium Tachiko, 2019
Stainless steel, glass and live tree, 200 × 90 × 84 cm / 78¾ × 35½ × 33 in

Enclosed within a futuristic-looking miniature garden grows a perfect bonsai tree. The work of Japanese artist and pioneering botanical sculptor Azuma Makoto (b. 1976), *Paludarium Tachiko* belongs to a series of artworks he created based on the nineteenth-century paludarium, a vivarium containing both terrestrial and aquatic elements. Unlike much of Azuma's other work, which seeks to highlight the Japanese concept of *mono no aware* (literally 'attraction to things that fade'), in this work he is concerned with creating the ideal artificial environment to allow the bonsai tree – itself a form of artifice – not

only to survive but to reach the peak of perfection. The paludarium's ecosystem combines the living tree and the inanimate water, air and container through energy flows and nutrient cycles. Azuma brings the paludarium into the twenty-first century and transforms a form of miniature greenhouse into a laboratory that excludes the outside world to create perfect living conditions for the tree. The art of bonsai requires the tree to remain miniaturized, limited by the size of its container, yet the glass container provides for growth. In the nineteenth century, these miniature greenhouses were prized for their

ability to keep plants alive that had been brought back to Europe from exotic climates. The Tokyo-based artist is known for his ongoing exploration of the relationships between plants and their environments, often placing them in spaces completely different from their natural habitats – for instance, he has launched a tree into the stratosphere, plunged flowers thousands of feet beneath the sea, and frozen floral bouquets. Here, Azuma pushes bonsai cultivation into a new age, in which the contrived tree is removed entirely from nature and preserved in its own sealed container.

Asuka Hishiki

Black Pine, Half Cascade Style Bonsai (Pinus nigra), 2015–17
Oil on paper, 71.8 × 92.7 cm / 28¼ × 36½ in
Huntington Library, Art Museum and Botanical Gardens, San Marino, California

The inspiration for this delicate oil painting of a miniature black pine tree (*Pinus nigra*) was a collection of bonsai trees that belonged to the grandfather of Japanese artist Asuka Hishiki (b. 1972). The love and care with which Hishiki's grandfather nurtured his collection of what the artist now says were probably not bonsai but 'potted trees' led to Hishiki's fascination with the interplay between nature and human intervention. In her painting, Hishiki renders every pine needle and the gnarled, flaking bark of the trunk and its pot with loving detail, each brushstroke

conveying her admiration for the beauty and health of the black pine. The difference between bonsai and potted trees can be hard to define – broadly, a potted tree is simply a tree in a container, while bonsai implies an almost philosophical approach to the artistic shaping of miniature trees by pruning their crowns and constraining their root systems in shallow pots. The art of bonsai originated in China in the eighth century CE before moving to Japan and then to the West. The aim was to replicate nature in all its perfection in miniature. Pine trees commonly grow

to a height of more than 45 metres (150 ft), although some are even taller: ponderosa pines on America's West Coast have grown to almost 82 metres (270 ft). With more than a hundred species – including the oldest living tree on the planet, the bristlecone pine (*Pinus longaeva*) – pines form the largest group of conifers and are known for their ability to survive the harshest weather conditions.

Aaron Siskind

Wishing Tree, c.1937
Gelatin silver print, 16.8 × 25.7 cm / 6¾ × 10 in
Museum of Modern Art, New York

Four dapper-looking boys are gathered around a tree stump in Harlem, in New York City. They are not here to play, however, but to wish. The focus of their attention is the stump itself, which was once a tall elm tree located on the Boulevard of Dreams near two of Harlem's top entertainment venues: the Lafayette Theatre and Connie's Inn. Dubbed the Tree of Hope by actor Percy Verwayne, the elm was said to bring good luck to any up-and-coming performer who rubbed it before taking the stage. Revered by the community, the tree came to symbolize the hope that

the vibrant cultural explosion of the Harlem Renaissance held for many Black Americans in the 1920s. Nevertheless, when 7th Avenue was widened in 1934, the local parks department felled the elm, to the dismay of local residents. By the time American photographer Aaron Siskind (1903–1991) took this photograph around 1937, the elm stump had been moved to the traffic island at 131st Street. Five thousand people attended the lively replanting ceremony, which was organized by Bill Robinson, the pioneering tap dancer better known as Bojangles. In 1972 the stump was

replaced by a colourful abstract steel sculpture by local artist Algernon Miller, which serves as an homage to the original tree. Another section of the legendary elm was installed at the famous Apollo Theater on 125th Street, where aspiring entertainers still rub it for good luck.

Joseph Beuys

7000 Eichen (7000 Oaks), 1982–2021
Installation view, New York

A solitary oak displays its sunlit autumn leaves against the grey walls and sidewalks of a New York City street. But this is no ordinary tree. It is one of many that are a part of the groundbreaking work *7000 Oaks* by German artist Joseph Beuys (1921–1986). Beuys, a pioneering conceptual and performance artist known for his strong interest in ecology, conceived of this project in 1982 as part of the prestigious art event Documenta in Kassel, Germany. It was a response to the indiscriminate urbanization that had radically changed the landscape in post-World War II Europe. This fraught historical moment led Beuys to explore themes including healing, regeneration and the relationship between humans and nature. Each tree planted across Kassel was accompanied by a 1.2-metre (4-ft) tall basalt stone to mark the artistic status of what otherwise might simply look like a tree growing in a city. The seven thousand stones for the project were piled on the lawn of the Fridericianum museum; each time a tree was planted, the pile shrunk, visibly reflecting urban renewal in action. A tree and a monolith – both vertical forms – symbolized the complex relationship and close alignment between architecture and the natural world. The project engaged local communities, evidencing their power to change their urban reality through simple yet defining acts. Beuys saw art as a form of political resistance, a means to bring about social change and to address the spiritual and emotional needs of society. Since its original iteration, *7000 Oaks* has expanded to New York, Baltimore, Sydney, Australia, and Oslo, Norway. The work is the quintessential manifestation of what Beuys called a 'social sculpture', where everyone has the potential to be an artist and contribute to the creation of a better world.

Sakai Hōitsu

Persimmon Tree, 1816
Two-panel folding screen; ink and colour on paper, 1.6 × 1.6 m / 5 ft 4 in × 5 ft 4 in
Metropolitan Museum of Art, New York

On a late autumn day, the few leaves remaining on a persimmon tree (*Diospyros kaki*) curl with the cold; its fruit has matured on a branch and is ready to be picked. On the ground, the grass is dying. The persimmon tree was introduced to Japan during the seventh century from China and was highly prized for its sweet fruit, which can stay on the tree into winter. Here, the graceful tree was rendered by Japanese monk and artist Sakai Hōitsu (1761–1828) in the early nineteenth century. Born into a wealthy samurai family, Hōitsu was a member of the influential Rinpa school of painting, which flourished during Japan's long Edo period, from 1603 to 1867. The Rinpa school style, started by the artist Hon'ami Kōetsu, took subjects from nature – such as flowers, birds and, as here, trees – and painted them against a plain gold-leaf background. Japanese art has a long tradition of painting flora, particularly during the spring and autumn, when it captured the transitory beauty of nature. The Rinpa style was distinguished by expensive pigments, its brush techniques and its use of *tarashikomi* ('dripping in'), a technique where paint was dropped onto a wet background to give a mottled effect, best seen here in the tree bark. Hōitsu painted this persimmon tree in the autumn of 1816, during a period of relative peace and prosperity in Japan. His works found a ready-made audience among the growing middle class of merchants and samurai, who were eager to emulate the tastes of the royal court.

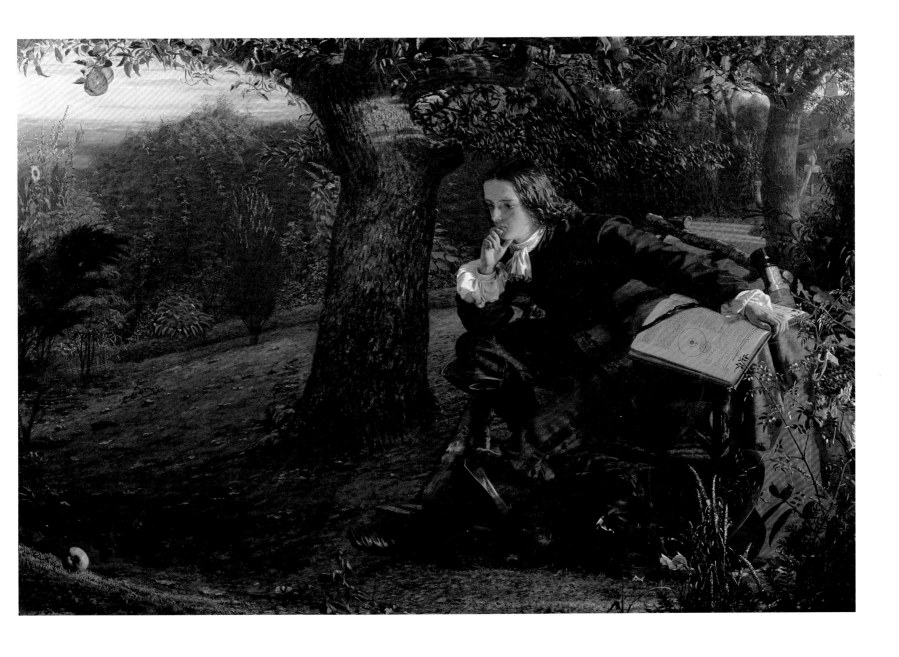

Robert Hannah

Master Isaac Newton in His Garden at Woolsthorpe, in the Autumn of 1665, early 1850s
Oil on canvas, 86 × 124.5 cm / 33¾ × 49 in
Royal Institution, London

Perhaps one of the most famous trees in history, or at least in modern lore, is the apple tree under which British scientist Isaac Newton developed his theory of gravity in around 1665. Newton is said to have formulated his theory when he saw an apple fall from the tree in his garden at Woolsthorpe Manor, Lincolnshire, in the east of England, and wondered what force made it fall. Captured in a rather idyllic scene by British artist Robert Hannah (1812–1909), Newton appears deep in thought beneath the apple tree, his dog by his feet and a fresh apple lying on the ground.

Little is known about Hannah, or why he chose Newton as a subject, but he exhibited the painting at the Royal Academy of Arts in London in 1856 and presented it to the Royal Institution in 1905, where he had been a trustee during the 1890s. To highlight the significance of Newton's discovery, Hannah includes visible ripe apples on the tree to echo the planets, while a crescent moon is barely visible in the background. Having deduced the existence of gravity, Newton was trying to ascertain whether gravity held the moon in orbit around Earth – and the planets around

the sun. Although many authorities doubt the story of the apple, a Flower of Kent apple tree (*Malus pumila*) that still survives in Newton's garden has been popularly identified as the iconic tree, and dendrochronology confirms that it is more than four hundred years old. Such is the fame of the tree, however, that many clones and descendants have been 'identified' around the world.

Lori Nix and Kathleen Gerber

Library, 2007
Archival pigment print, 1.2 × 1.5 m / 4 × 5 ft
Columbus Museum of Art, Ohio and Harn Museum of Art, Gainesville, Florida

An abandoned library is surrounded by the slow decay of human culture in this melancholic photograph. Part of a larger body of work called 'The City', by artists Lori Nix (b. 1969) and Kathleen Gerber (b. 1967), the image is one of a series that explores post-apocalyptic landscapes and interiors, created entirely by hand using miniature models and painstakingly assembled dioramas. The artists meticulously construct these scenes, paying attention to every detail to create an uncanny sense of hyperrealism. They then photograph each scene using a large-format camera,

capturing intricate and minute details. In *Library*, the tree in the centre of the image becomes the focal point of the composition, symbolizing the power and persistence of nature, which continues to grow and thrive in the absence of humans. The tree's branches, extending towards the ceiling of the library, suggest the limitless potential for intellectual exploration. In contrast to the gloomy atmosphere, the tree conveys a message of hope and the enduring strength of the natural world. But Nix and Gerber's work might also allude to the symbolic meaning of the tree

and its intimate relationship to knowledge as inscribed in the teachings of many religions. Just as a tree grows and branches out, signifying the expansion of wisdom, the tree in the library represents the accumulation of human knowledge and the wisdom contained within books. This image is a commentary on the fragility of human creations as well as the inextinguishable resilience and determination of nature. It invites viewers to contemplate the passage of time and to reposition our anthropocentric mindset towards a humbler conception of ourselves.

Anonymous

Divination book (*pustaha*), mid-18th–19th century
Wooden covers and bark paper, each panel 37.5 × 23 cm / 14¾ × 9 in
Yale University Art Gallery, New Haven, Connecticut

This *pustaha*, or book of magic, would have been made by a *datu* (priest) of the Batak people of northern Sumatra, in Indonesia. It consists of wooden covers and pages made of the inner bark of the alim (*Melanolepis multiglandulosa*) or the agarwood (*Aquilaria malaccensis*) tree, which was softened in water and folded in an accordion style. The text in the *pustaha* is read longways from left to right, and the book includes red and black drawings. The wooden covers were usually carved by the priest – and only the priest – with an image of a gecko, representing

Boraspati ni Tano, an agricultural fertility deity and god of the underworld. Although woodcarvers abound in Batak society, only the *datu* is allowed to carve sacred objects. The knowledge contained in a *pustaha* is used in magical spells, divination, prescriptions and ceremonies, and is known as *hadatuon*: 'knowledge of the *datu*'. The main types of instruction involve both white magic (the making of elixirs to cure illnesses, other medicines against curses, and amulets and charms) and black magic (how to actively inflict harm or damage to an enemy) as well as divination,

including astrology, leading to a knowledge of propitious or ill-fated days of the calendar, forecasting the weather or finding lost objects. The books use a syllabic script, called *poda* by the Batak, that is believed to descend from ancient Sanskrit. The obscurity of the language means it is extremely difficult to transcribe or translate.

Kaii Higashiyama

Autumn Colours, 1986
Colour on paper, 72.6 × 99.6 cm / 28½ × 39¼ in
Yamatane Museum of Art, Tokyo

With a palette of just three colours – gold, orange and a vibrant blue, with tints of a fourth colour, purple – Japanese artist Kaii Higashiyama (1908–1999) conjures a lyrical scene that captures the transient beauty of an autumn day. With meticulous detail, he paints the individual leaves of the maple trees in the foreground, which have turned autumnal, against a background of a forested hill of pines and other trees. As a young man, Higashiyama yearned to become a Western-style painter and travelled to Europe in search of new landscapes to illustrate. His travels only

persuaded him of the beauty of his homeland, and on his return, he spent his life capturing the ethereal beauty of Japan, using its landscapes to convey his inner thoughts. Higashiyama turned to the *nihonga* style: a centuries-old practice of painting on silk or *washi* (Japanese paper made from mulberry and plant fibres), using pigments made from natural sources such as powdered rocks, minerals, plants, shells and insects. The paper's absorption allows artists to create unusual tints such as the subtle gold and orange Higashiyama uses here. The maple leaf is the symbol of

autumn in Japanese culture. Autumnal foliage is divided into two different categories of colour: *koyo* describes the gold and orange tints seen here, while *momiji* is for the intense red shades of some maples. Known as *momijigari*, literally translating to 'maple leaf hunting', the viewing of autumn leaves has been a key part of Japanese culture since the Heian era (794–1185 CE).

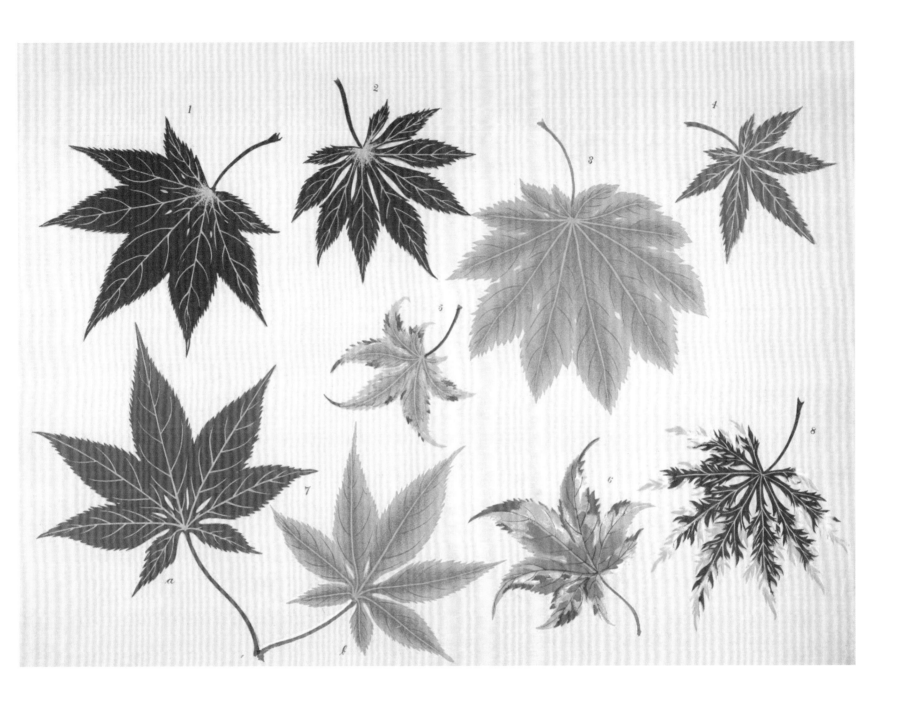

Yokohama Nursery Co.

Plate from *Maples of Japan*, 1898
Chromolithograph, 26 × 38 cm / 10¼ × 15 in
Private collection

Eight assorted maple leaves in a range of colours seem to float weightlessly across a page from the catalogue of the Japanese horticultural company Yokohama Nursery Co. Dating from 1898, the *Maples of Japan* brochure tapped into the growing popularity at the time for the trees and their distinctively colourful foliage outside Japan. In the late nineteenth and early twentieth centuries, the 'Japanese style' of gardening became very fashionable following Japan's opening of its borders to the outside world. The West's resulting fascination with all things Japanese led the

French art critic Philippe Burty to coin the word *Japonisme* in 1872 to describe the phenomenon. Taking advantage of this popularity, the Yokohama Nursery Co. became the most successful and enterprising of all Japanese plant exporters. Founded by Uhei Suzuki in Yokohama in 1890, the business catered to its overseas clients by issuing beautiful English-language catalogues specializing in Japanese plants and flowers, such as bamboo, Japanese laurel, cherry trees and magnolias. In 1892 renowned British plantsman James Herbert Veitch (see p.215) visited the nursery in

Yokohama to order plants to sell in his family's nursery back in England. The Yokohama Nursery Co. went on to open branches in London, New York and Shanghai, and is still in operation today. It also exhibited its plants at the 1893 World's Columbian Exposition held in Chicago – presenting the themes of 'Bonsai' and 'Japanese Garden' – and at the prestigious Chelsea Flower Show in London from 1916 until 1939. Considered a symbol of serenity and peace, the maple is highly prized in Japan for its beautiful leaves and for its autumnal display of magnificent reds, yellows and golds.

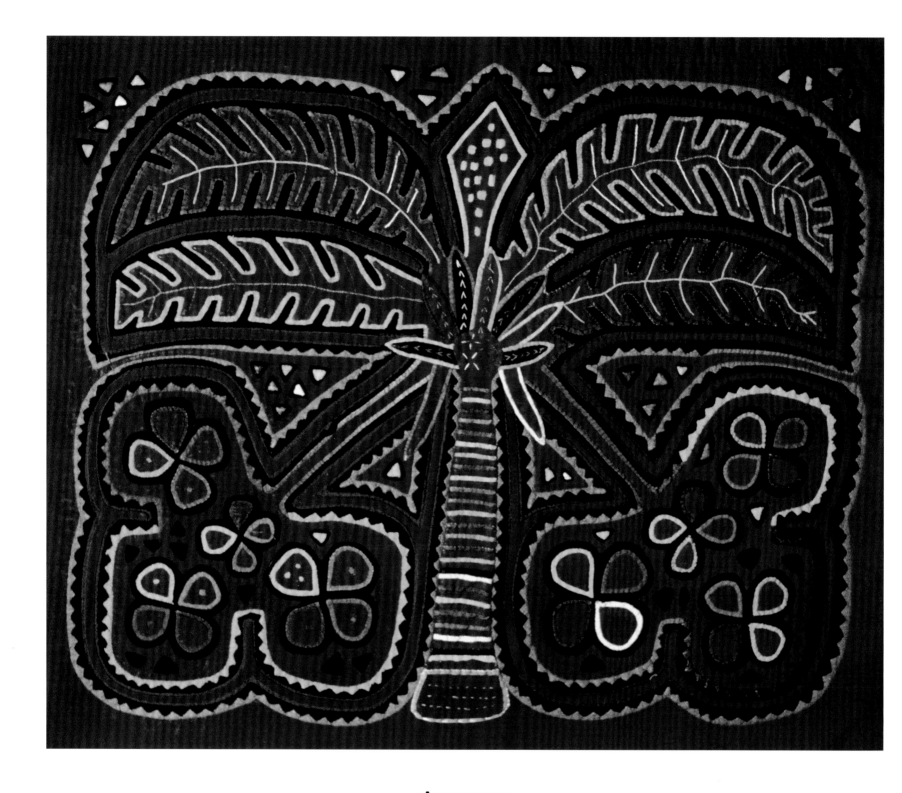

Anonymous

Coconut palm *mola*, mid–late 20th century
Reverse appliqué on cloth
Private collection

A flattened coconut palm with its leaves splayed out into almost abstract shapes and its colourful fruit gathered around its trunk adorns this *mola* made by an unknown artisan from the Indigenous Kuna people of Kuna Yala, many of whom live along the Caribbean coast of what is now Panama. The term *mola* comes from the Kuna word for 'cloth', and typically refers to a brightly decorated woman's blouse. However, it can also refer to the fabric of the blouse or the panels of colourful fabric themselves, which are produced in pairs, usually with one *mola* serving as the front of a blouse and another

as the back. Kuna women have been handmaking *molas* since the late nineteenth century, when the traditional custom of painting designs on the body was replaced by painting designs onto fabric. Eventually, a technique of reverse appliqué became favoured to painting. Depending on the complexity of the design, which often depict motifs from the natural world, *molas* can take from two weeks to six months to complete and often contain thousands of individual stitches. The choice of a coconut palm to adorn this *mola* reflects the significance the tree plays in the

Kuna's daily life. Kuna Yala is the largest coconut plantation in the world, and while most of the fruit is exported to neighbouring Colombia, the Kuna also use coconuts as currency for trading and as a natural resource. Every part of the coconut has a use, from the edible flesh and the water of the green fruit to the dry husk, the fibres from which are woven together to make rope that has the great advantage of being resistant to saltwater.

Spathodea campanulata var. nicotica

Christabel King

African Tulip Tree, 1993
Watercolour on paper, 26.5 × 36.5 cm / 10½ × 14¼ in
Shirley Sherwood Collection, London

Exquisite in its detail, this painting by British botanical artist Christabel King (b. 1950) of the African tulip tree (*Spathodea campanulata* var. *nicotica*) captures all the key aspects of the beautiful tropical species. The cup-shaped red and yellow flowers with their upright stamens and stigmas surround the cluster of horn-shaped calyx tubes from which more flowers are yet to emerge. To the left in monochrome is the fruit, splitting open to reveal the winged seeds inside, one of which is depicted in detail below. To the right is a flowering stalk showing

the evergreen compound leaves. The African tulip tree is native to dry tropical forests from Angola to Zambia, including Kenya, Uganda and Tanzania, but is also found as an exotic in many other countries, including Australia, India, Sri Lanka and tropical South America. It is widely planted as an ornamental, mainly for its large, showy flowers. The flowers are pollinated by birds and bats, including hummingbirds in South America, but are toxic to many insects, including certain species of bee, notably stingless bees in Australia. King is chief botanical

artist to the Royal Botanic Gardens, Kew, where she has illustrated plants for more than forty years. Much of her work has appeared in *Curtis's Botanical Magazine*, the world's longest-running continuously published botanical periodical, which was founded in 1787. King's association with Kew began in 1975 as an assistant to the editor of *Curtis's Botanical Magazine*, where she has worked ever since, mainly using material housed in Kew's herbarium collections but also by observing the gardens' live plants.

Maria Sibylla Merian

Plate LXIII, from *Metamorphosis insectorum Surinamensium*, second edition, 1719
Hand-coloured engraving, 52.3 × 36.7 cm / 20½ × 14½ in
John Carter Brown Library, Providence, Rhode Island

Several ripening pods of a cacao tree (*Theobroma cacao*) are on full display in this remarkable illustration, including one exposing pulp-shrouded cocoa beans (from which chocolate is derived). Among them are two kinds of caterpillar, chrysalis cases and butterflies. When German artist Maria Sibylla Merian (1647–1717) painted the image in the late seventeenth or early eighteenth century, her approach was highly innovative. Most naturalists of the day were focused on classifying individual species, but Merian chose to study and illustrate the life cycles of insects and

how those insects interacted with plants – something for which she was well qualified. Growing up around printers, engravers and illustrators, by the time Merian was thirteen she was combining her artistic flair with an interest in the natural world to document her efforts to raise silkworms. She went on to become a flower painter and engraver, while continuing to collect and rear larvae so she could study caterpillars and butterflies. Between 1675 and 1683, Merian published three illustrated books showcasing flowers and two depicting European butterflies. In 1699

Merian and her younger daughter, Dorothea Maria, undertook a purely scientific expedition to the Dutch colony of Suriname, in South America. Here, Merian painted the plants and insects she encountered, drawing heavily on the knowledge and assistance of people enslaved on Dutch plantations – which grew cacao, as depicted here, as well as sugar cane, coffee and cotton. The observations Merian made, which were published in *Metamorphosis insectorum Surinamensium* in 1705, offered early insights into the interconnectedness of biodiversity.

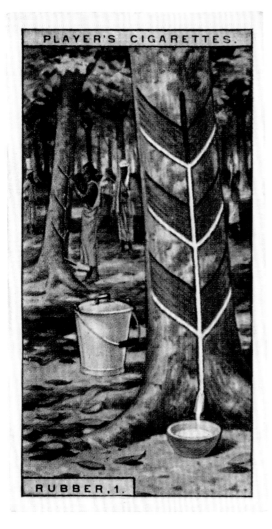

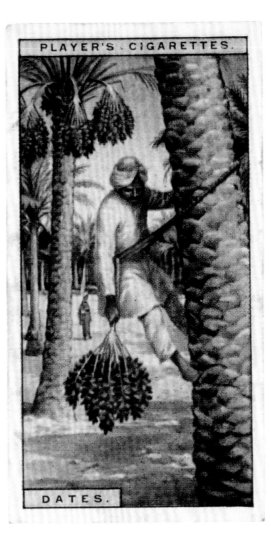

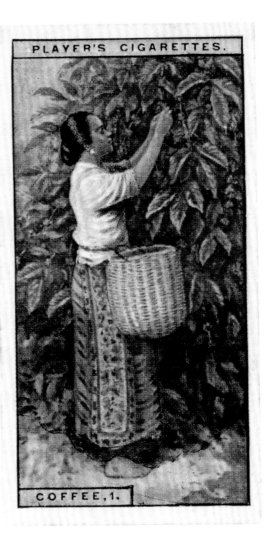

Player's Cigarettes

Products of the World, 1928
Printed card, each 6.7 × 3.6 cm / 2⅝ × 1½ in
Private collection

These three cigarette cards show different natural resources derived from trees around the globe: a rubber tree is tapped to extract its milk, a woman harvests beans from a small coffee tree and a worker uses a simple rope harness to descend the trunk of a date palm with a bunch of the fruit. An average rubber tree (*Hevea brasiliensis*) produces about 9 kilograms (20 lbs) of latex each year, which is collected by removing a thin layer of bark in a spiral pattern, down which the milk latex flows – a unique process that does not require the tree to be cut down. The trees are primarily in Asia, which supplies about 90 percent of the world's natural rubber supply, amounting to about 20 million tonnes (22.1 million tons) annually. Coffee trees (*Coffea* sp.) are native to tropical Asia and southern Africa. There are about 125 species, but the edible fruits, or 'beans', of *Coffea arabica* and *Coffea canephora* account for nearly 100 percent of global coffee production. Date palms (*Phoenix dactylifera*) are prized for their sweet fruits and have been cultivated throughout the Middle East, South Asia and North Africa for thousands of years – the earliest evidence of which was found in a Neolithic site in Pakistan dating to around 7000 BCE. These three cards belong to 'Products of the World', a set of fifty picture cards produced in 1928 by the British tobacco company Player's. Printed in the millions, the cards started during the 1920s as a practical solution to protect flimsy cigarettes wrapped in paper packets with a sheet of stiffer card. Before long, the card was used for advertising and then for collectable pictorial collections that would encourage brand loyalty and repeat purchases.

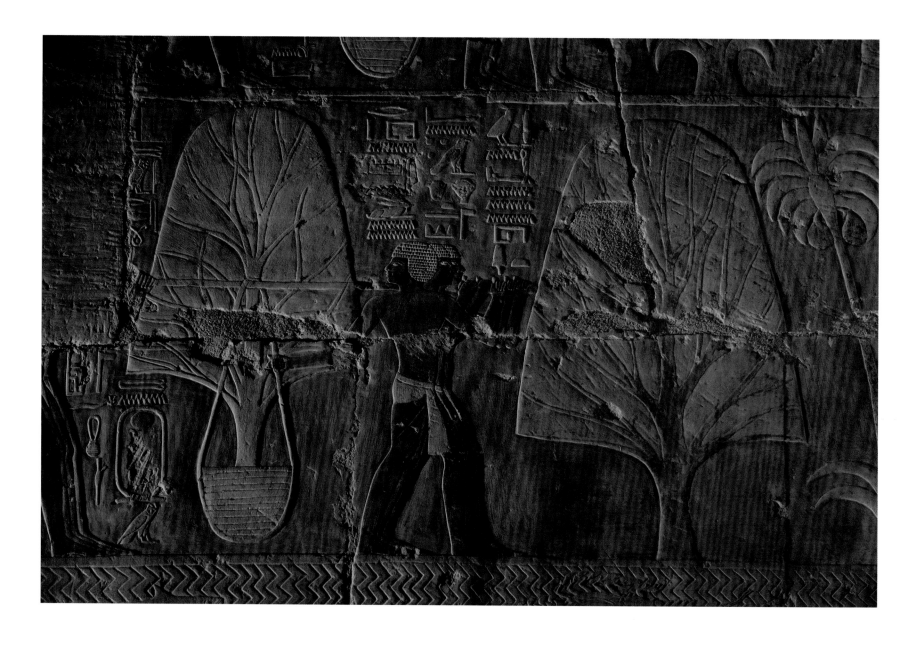

Anonymous

Punt reliefs (detail), 1479–1458 BCE
Painted bas-relief, 40 × 5 m / 131 ft × 16 ft 5 in
Installation view, Deir el-Bahri, Luxor, Egypt

Dating back more than 3,400 years, this ancient relief depicts men carrying an incense tree in a basket, the weight borne on poles across their shoulders. The scene forms part of a large relief recording a trading expedition to the Land of Punt in 1470 BCE, and is carved into the stone of Egyptian pharaoh Hatshepsut's Deir el-Bahri mortuary temple, which stands beside the Nile. Ordered by Hatshepsut, the mission was undertaken by 210 people in five sailing ships to source goods such as resins, gold, ivory, ebony, live animals and slaves. The exact location of the Land of Punt puzzled

Egyptologists for years. Then, in 2005, experts identified Mersa Gawasis, on Egypt's Red Sea coast, as the port from which expeditions set off, and they eventually determined Eritrea as a likely location for Punt, with this scene capturing the emergence of international peaceful commerce. Although the expedition was not the first of its kind, the relief is the earliest record of trees being deliberately moved and transplanted. According to the relief, thirty-one living trees, each with their roots carefully wrapped and placed in baskets, were included in the ships' cargo. Although the

exact type of trees remains unknown – identified only as *ntyw* – they were most likely *Boswellia* or *Commiphora*. The two trees were prized for their resins, which could be used to make frankincense and myrrh, respectively, both important aromatic substances in Egyptian religion and medicine. Hatshepsut, who first served as regent for her stepson, Thutmose III, was eventually crowned 'king' and essentially co-ruled with him. A prolific builder, Hatshepsut commissioned many construction projects, of which her Deir el-Bahri (northern monastery) complex was the greatest.

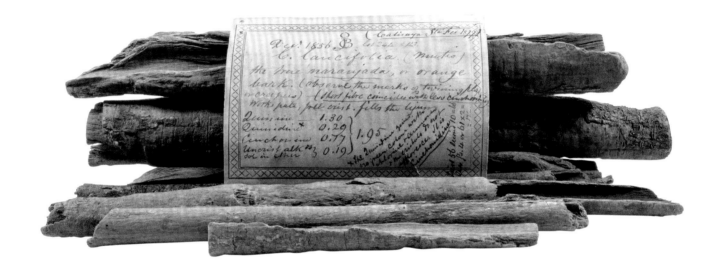

Anonymous

Cinchona bark specimen, c.1856
Kew Economic Botany Collection, London

The bark of the cinchona tree, as seen in this specimen of *Cinchona lancifolia*, is the unlikely common link between the perennial cocktail favourite gin and tonic and a centuries-old malaria treatment. Extracted from the dried bark of the cinchona or 'fever' tree, quinine is used to flavour tonic water and, more significantly, to prevent or treat malaria. The cinchona is native to the eastern slopes of the Andes in Ecuador, Peru and Bolivia, and the bark had long been used by Indigenous Andean peoples for treating the disease and for fevers generally. As the European colonizers expanded their empires into the mosquito-prone regions of the world, cinchona bark became highly valued. Jesuits sent supplies to Spain and Rome as early as 1632, but its fame was secured in 1638, when Ana de Osorio, wife of the Spanish viceroy of Peru, was close to death from malaria. Her physician suggested they try a local remedy, *quinquina*, and the countess miraculously recovered. Quinine was the only cure for malaria for 350 years, until a synthetic drug was developed in the 1920s. Brought back to Europe by the Spanish colonizers, it was known as countess or Jesuit bark; Oliver Cromwell, the Protestant ruler of England, was said to have refused the treatment for his own malaria because it was a Catholic import, ultimately condemning himself to death in 1658. While the Spanish failed to establish successful cinchona plantations, both the English and the Dutch successfully grew the trees in India and Indonesia, respectively, increasing its availability in Europe. The protection quinine offered against malaria saved thousands of lives, but it also enabled the spread of European colonization to vast regions of Africa and Asia.

Wan-Chun Cheng

A Group of Metasequoia Trees in a Ravine, Lichuan, 1948
Photograph, 5 × 7.6 cm / 2 × 3 in
Arnold Arboretum Archives, Harvard University, Massachusetts

Taken in August 1948, this photograph of giant dawn redwood trees (*Metasequoia*) in remote central China set the scientific community alight. Although these trees are fairly common today, found planted in temperate landscapes the world over, prior to the early 1940s, no one in the world of forestry, botany or taxonomy knew they even existed. As far as anyone knew, the coniferous trees had gone extinct several million years before and were only known to paleobotanists as fossils. Locals, of course, knew of their existence and referred to them as 'water firs': villagers believed their fruit-bearing was

a sign of the size of that year's harvest, and the withering of branches was a sign of an imminent death. After foresters in China stumbled upon a grove of these living fossils in western Hubei Province in the early 1940s, Ralph Chaney from the University of California, Berkeley, and Elmer Merrill, the director of the Arnold Arboretum at Harvard University, launched further investigations in 1944. They worked in close collaboration with colleagues in China, notably Wan-Chun Cheng (1908–1987), a dendrology professor from the department of forestry at the National Central University in Nanjing who

took this photo. Cheng's photograph was the culmination of an identification process that took several years and involved special expeditions to collect leaf and cone specimens from the tree, which he forwarded to the Arnold Arboretum for analysis. The trees, named *Metasequoia glyptostroboides*, were recognized as close cousins of the redwoods and giant sequoias of California but were given the name dawn redwood because of their deciduous leaves, a trait they share with their other close relatives the bald cypresses of southeast North America and the water pines of Southeast Asia.

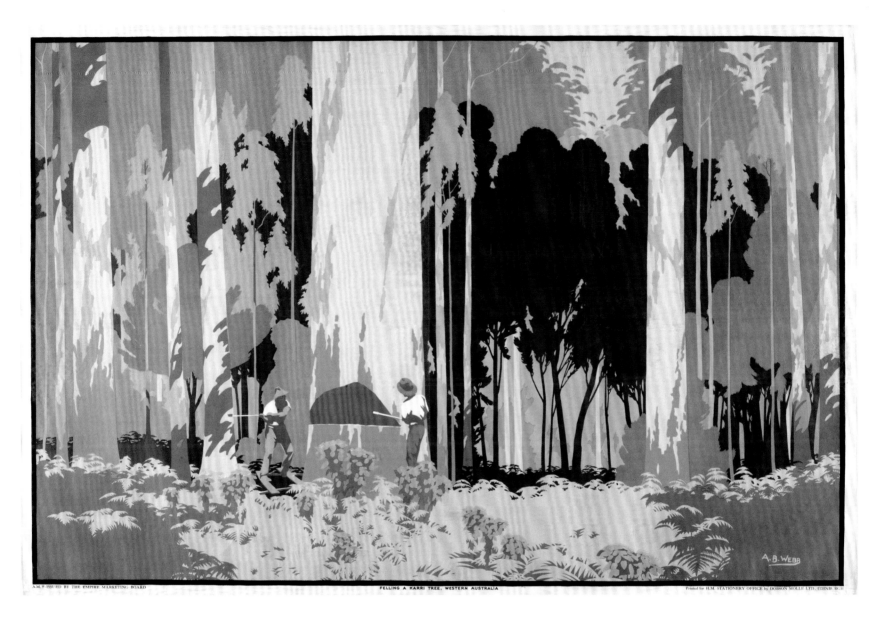

Archibald Bertram Webb

Felling a Karri Tree, Western Australia, from 'Australia's Wealth of Wheat and Wool', 1929
Colour lithograph, 1 × 1.5 m / 3 ft 4 in × 5 ft
Manchester Art Gallery, UK

Boldly illustrated in a contrasting, graphic style, two men work to chop down a massive karri tree (*Eucalyptus diversicolor*) in an Australian forest. As its botanical name suggests, one of the key characteristics of this eucalyptus is its fantastically patterned trunk, which changes colour as strips of old orange and yellow bark fall away to reveal the bright new white skin beneath. Commissioned by the Empire Marketing Board for a series of posters between 1926 and 1933 illustrating the British Empire's people, places and products, this lithograph is the work of English artist

Archibald Bertram Webb (1887–1944). Webb beautifully captures these forest giants in a way that is representative of the karri itself, with the orange, brown and green of the woodland background interrupted by the stark verticality of the lighter-coloured tree trunks. Indigenous to the south-western region of Western Australia, where it is the tallest tree in the forest and is at the centre of a diverse ecosystem, the karri was considered sacred to some Aboriginal communities and it was sometimes used to make traditional didgeridoos. With the arrival of the Europeans in the 1920s

and '30s – including Webb, who was born in England but immigrated to Australia for his health – the tree was valued for timber and was felled in large numbers to be used in the construction of buildings and as street paving. In *Felling a Karri Tree*, the effects of colonialism on native landscapes are starkly apparent as the woodsmen use axes to bring down an enormous specimen, presumably to be incorporated into some unknown building project in one of the towns and cities that were growing up around Australia at the time.

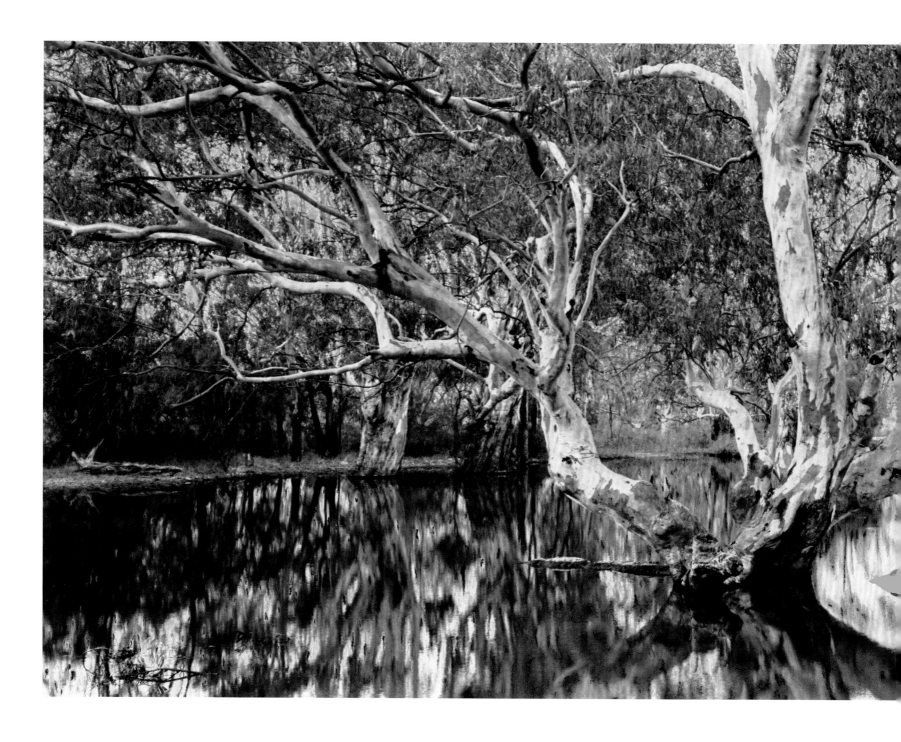

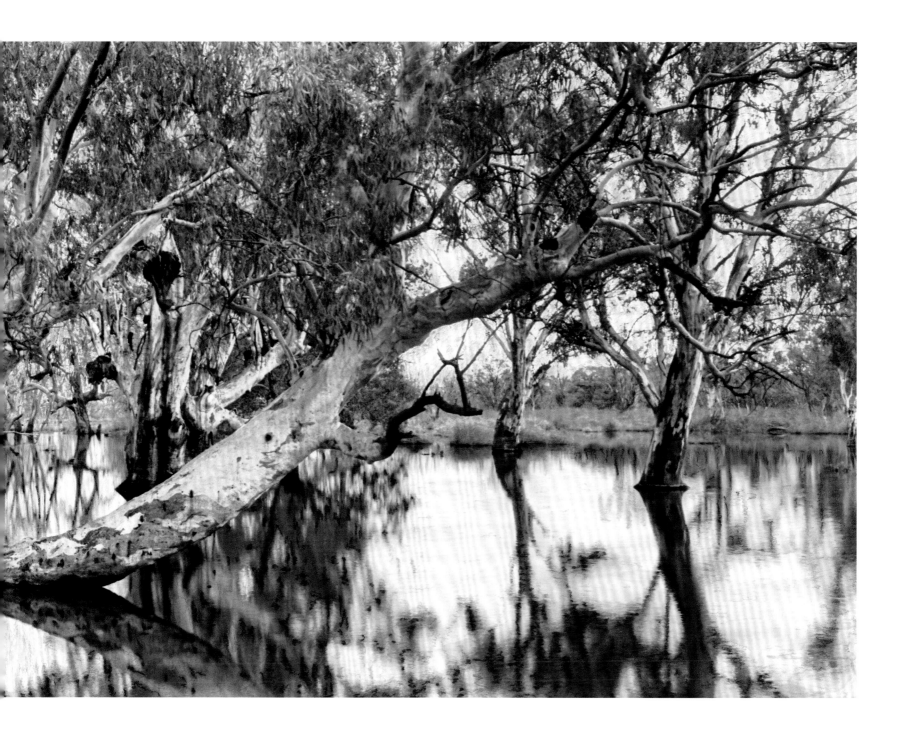

Nici Cumpston

Listening to the River, 2005/2021
Pigment inkjet print hand coloured with Stabilo crayons and pencils, 72 × 170 cm / 28⅜ × 67 in

A partially submerged tree, its branches greying and forlorn, stands in the middle of floodwater near Katarapko Creek, around the backwaters of the Murray River in South Australia. A testament to the cultural and ecological importance of South Australian waterways that have been endangered for decades, *Listening to the River* is the work of Barkandji artist, curator and writer Nici Cumpston (b. 1963). Cumpston's practice is deeply rooted in the landscape of the Murray River region, where she grew up, and seeks to draw attention to the delicate ecosystems there, which Indigenous Australians had successfully managed for centuries before federal policies contributed to the present environmental degradation. The Murray River, Australia's longest, has been facing a severe drought crisis for more than a decade – due to climate change, overextraction of water for irrigation and changes in land use – affecting both the ecosystem and the communities that rely on the river for their livelihood. Red gum trees, which line the banks of the Murray River, have taken a big toll. These trees play a vital role in the river's ecosystem, providing habitat for many species and helping to stabilize the riverbanks. However, the lack of water has led to a decline in the trees' health, with many trees showing signs of stress, such as leaf drop and reduced growth. This large, hand-coloured photograph was taken in 2005, two years before it was revealed that the water supply to the Murray-Darling Basin had been disturbed by diverting the water flow to Nookamka Lake, to cotton fields upstream. A government decision was later made to pump water back into Katarapko Creek in order to give the unique ecosystem the chance to survive and thrive once again.

Global Forest Watch

Tree Cover Loss by Dominant Driver, 2001–22
Digital image, dimensions variable

Making use of global satellite imagery, Global Forest Watch (GFW) provides invaluable insight into the current state of the world's forests. GFW was formed in 1997 as part of the World Resources Institute (WRI), based in Washington DC, whose remit was to protect and restore Earth's natural resources by using a research-based approach to record their depletion. In response to the rapid deforestation taking place across the globe, GFW took action. Starting as a network of NGOs reporting on the state of forests in just four countries, GFW has since grown into an online platform that monitors forests with near real-time information. Here, the map displays tree cover loss between 2001 and 2022 in areas where canopy density is more than 10 percent, with each colour representing a dominant driver. Red indicates commodity-driven deforestation; yellow, shifting agricultural practices and activity; green, forestry-related losses; brown, wildfires; and purple, urbanization. Maps such as this one are a stark reminder that only one-fifth of the world's original forest cover remains. One of GFW's initial research areas was mapping the location of the world's frontier forests – areas of land that are covered by a natural forest ecosystem where native tree species support other flora and fauna. Primarily located in northern Canada, northern Russia, the Amazon, central Africa and some islands in the Pacific, frontier forests are those that are largely intact, having been shaped only by natural forces and small-scale traditional activity of Indigenous peoples – making them a barometer of the health of the natural world. Frontier forests make up almost 70 percent of the world's remaining tree cover: a stark call to arms to protect the forest that remains.

Marinus Boezem

De Groene Kathedraal (*The Green Cathedral*), 1987–96
Lombardy poplar trees, 150 × 75 × 30 m / 490 × 246 × 98 ft
Almere, the Netherlands

There are no stained-glass windows, altars, vaulted ceilings or bells at this immense cathedral, which is constructed entirely from 178 living Lombardy poplars (*Populus nigra*). Here, rain pours onto the church floor and wind blows through the nave as the trees rustle and sway. Located near the city of Almere in southern Flevoland, the Netherlands, *The Green Cathedral* was planted in 1987 by Dutch artist Marinus Boezem (b. 1934) and laid out in accordance with the ground plan of the Gothic cathedral of Notre-Dame in Paris, with each tree positioned in the place of

a column or buttress. Between the mature poplars, which rise to a height of around 30 metres (98 ft), is a web of crisscrossing pathways, mirroring the elegant ceiling vaulting of the thirteenth-century cathedral on which it is based. Boezem considers Notre-Dame an icon of human achievement, much like the polders of Flevoland – land reclaimed from the seabed of the former Zuiderzee on which *The Green Cathedral* sits. While this monumental work of land art does not have an official religious function, it regularly plays host to wedding ceremonies and

concerts, and is a popular destination for summer picnics and relaxation. Boezem chose the poplar for its tall, slender form, rapid growth and lifespan of around thirty years, after which he intended to let the cathedral slowly decay. However, when several of the trees were toppled in a storm in 2018, it was decided that the work should instead be restored and preserved for future generations.

Edward Burtynsky

Clearcut #1, Palm Oil Plantation, Borneo, Malaysia, 2016
Photograph, dimensions variable

When forested landscapes are cleared of their trees, the change in appearance and character is stark, often jolting. To most people, it's a change that is largely hidden from view. Canadian photographer Edward Burtynsky (b. 1955), however, has committed his entire artistic practice to reframing the scale of human impact on the planet by showing the immensity and intensity of it in his striking aerial images. As a part of his multidisciplinary Anthropocene Project – intended to put on full display the vast imprint humans have made through resource extraction and land conversion – Burtynsky

photographed this palm oil plantation in Borneo, seemingly carved out of the native landscape. The austere straightened fields altogether contrast with the natural forest beside them, the striations of the clear-cut land extending nearly to the horizon, showing the magnitude of development. Malaysia is the world's second-largest producer of palm oil, and the country has lost nearly 20 percent of its old-growth forests since 2001. Though this piece showcases the conversion of a forest to a monoculture plantation in Borneo, Burtynsky could have just as easily

photographed the same phenomenon almost anywhere in the world, where deforestation and loss of biodiversity often makes the way for industry. For three decades, he has captured human influences on the natural world, from colossal mines, dams and quarries to factories, roadways and trash dumps. Burtynsky's landscapes are intended to generate awareness and educate the public about the serious threat human-caused degradation and industrial activities pose to the planet. Taken from the air, his images puts into sharp relief just how much we've already done.

Conrad Cichorius

Plate 29, from *Die Reliefs der Traianssäule* (*The Reliefs of Trajan's Column*), 1896
Photogravure, 37 × 52 cm / 14½ × 20½ in
University of Cologne, Germany

Created nearly two thousand years ago, Trajan's Column stands at a towering 38 metres (125 ft) high, the carved marble panels spiralling around its face to tell the story of two military campaigns against the Dacians, ancient occupants of modern Romania. The first Roman incursion took place in 101–102 CE (illustrated on the lower half of the column) and the second in 105–106 CE (shown on the upper half). Completed in 113 CE, the column was designed and constructed under the supervision of Apollodorus of Damascus. Here, in a reproduction by German historian

Conrad Cichorius (1862–1932) of one of the 155 scenes, Roman soldiers cut down trees in the emperor's Dacian wars, attempting to deforest the Dacian heartlands (scene XV). The trees that the Romans felled were oaks, realistically portrayed with lobed leaves and pitted, knotted trunks. Other deciduous trees on the column include the *Sorbus* genus (mountain ash or rowan) and the sycamore; conifers also appear. Of the 224 trees on the column, 222 are native to Dacia, and 48 are actively being chopped down. These trees have long been considered merely scene

dividers and background landscapes of a deeply wooded land, but recent research suggests that they had a political meaning as well. The trees on Trajan's Column demonstrate that the wars were not merely against the Dacians but against the land of Dacia itself. By means of its aggressive deforestation, the mechanized Roman army is making war on the landscape, as well as on the people of the land. Rather than mere scene dividers, the numerous tree-felling scenes function as a powerful metaphor for conquest.

Keith Henderson

Timber in Canada, c.1926–33
Colour lithograph, 102 × 64 cm / 40⅛ in × 25¼ in
Manchester Art Gallery, UK

Two lumberjacks are busy felling huge pine trees deep in a Canadian forest in this colourful poster commissioned by Great Britain's Empire Marketing Board. Designed by the prolific Scottish-born artist Keith Henderson (1883–1982), the poster was intended to boost British sales of goods both grown and made across the British Empire. The Empire Marketing Board was formed in May 1926 in response to a clear decline in Britain's economic situation following the end of World War I. Although the end of the conflict had left the empire at its largest extent, when it covered almost a quarter of the globe and contained more than four hundred million people, economic pressures and rising anticolonial sentiment were already beginning to undermine its stability. The Empire Marketing Board's brief to artists such as Henderson was to create uplifting images that reinforced the importance of the colonies to Great Britain itself. The European settlement of Canada had been based largely on the attraction of Canada's fur, fish and forests, the last of which became the basis of a huge trade in timber. The British government had tried to replace its timber supplies from the Baltic region with Canadian timber during the nineteenth century, but the longer sea journey meant the Canadian timber dried out on the voyage, making it less popular with the military and businesses. The efforts of the Empire Marketing Board to promote the trade proved short-lived: it ceased operations by 1933.

Richard Fisher

Third Thinning in Mixed White Pine and Hardwoods, 1930s
Mixed-media diorama, 91 × 91 cm / 35¾ × 35¾ in
Harvard Fisher Museum, Petersham, Massachusetts

Foresters work with a horse to extract timber amid a grove of hardwood trees against a background of dark coniferous pine forest. The trees in the foreground include the native white/paper birch (*Betula papyrifera*) and grey birch (*Betula populifolia*). Careful thinning at intervals has resulted in trees spaced about 6 metres (20 ft) apart with the space to grow to a size and shape ideal for timber. But this is not a photograph of loggers at work but rather one of a series of twenty-three remarkable dioramas at the Fisher Museum at Harvard Forest that depict scenes

in and around the forest that surrounds the museum. The dioramas were designed by founding director Richard Fisher (1876–1934), a pioneer of forestry and woodland ecology. Lifelike down to the finest detail, they show the beauty of the landscape with its streams, rocks and mixed woods, as well as telling the story of ecological change following European colonization. The dioramas were created by the artisan firm of Guernsey and Pitman of Cambridge, Massachusetts, using painted backdrops with a foreground filled with miniatures of people, animals and

trees handcrafted from wire, wax, clay and gesso. Harvard Forest was established in 1907 and covers some 1,620 hectares (4,000 acres). The forest now serves as a centre of fieldwork and research for students from Harvard's School of Forestry. It is among the most studied forest ecosystems in the world and is the site of long-term studies that have revealed important information about the functioning of forest ecosystems, findings that are of increasing importance in our era of climate change.

Caspar David Friedrich

Dolmen in the Snow, 1807
Oil on canvas, 61 × 80 cm / 24 × 31 in
Staatliche Kunstsammlungen Dresden, Germany

Three mutilated and weather-beaten oak trees surround an ancient grave, marked by heavy stones. A cold, clear light picks out every detail of their twigs and branches, each one covered by a thin layer of snow. The precision and sense of stillness are typical characteristics of the work of German Romantic landscape painter Caspar David Friedrich (1774–1840). In his paintings, tombs, ecclesiastical ruins and crosses are often combined with trees, either evergreens or oaks. The evergreens generally stand for eternal life, but the symbolism of the oaks is multilayered. Oaks live for hundreds of years and survive even when their crowns have been repeatedly struck by lightning and their trunks hollowed out. With such an enduring presence, they are widely regarded as emblems of perseverance and resilience. Friedrich based these oaks on pencil studies he had made from actual trees, but in the painting he exaggerates the extent of their damage, adding extra stumps where branches have been sawn off or have fallen naturally. Yet we can see that the trees are still alive and will produce leaves in the spring, so they can further represent the Christian belief in resurrection. The oaks also have a patriotic significance. Friedrich was deeply distressed by Napoleon's invasion of Germany in 1806, just a year before he completed *Dolmen in the Snow*. At the time, the oak was seen as a national tree, and the country's dolmens – thought to be megalithic tombs – as relics of a heroic German people. Shown together, Friedrich has positioned them as monuments to an enduring German spirit.

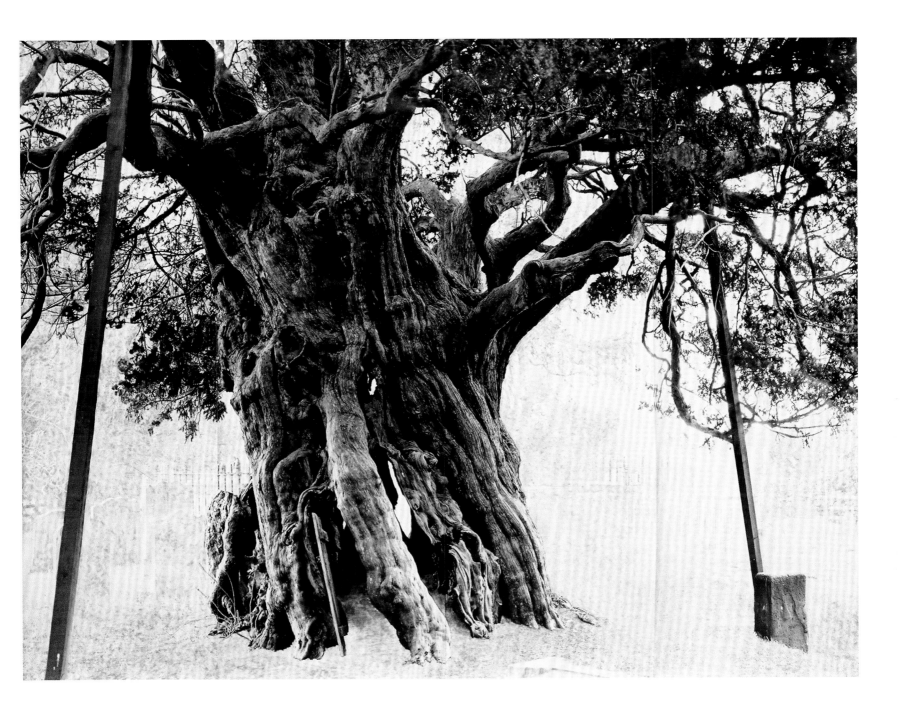

Tacita Dean

Crowhurst, 2006
Gouache on black and white fibre-based photograph mounted on paper, 3 × 4.1 m / 10 ft × 13 ft 5 in
Museum of Modern Art, New York

This ancient yew tree, found in St George's churchyard, in Crowhurst, Surrey, in southeast England, is one of the fifty Great British Trees chosen by the Tree Council to celebrate the Queen's Golden Jubilee in 2002. In 1630 the local parish noted its girth was an impressive 9.1 metres (30 ft); however, nearly four hundred years later it has increased to just under 10.1 metres (33 ft). The tree is completely hollow, and during the early nineteenth century it was furnished with tables and chairs, until the roof caved in during a great storm in 1845. Historian Thomas Pakenham noted in his book *Meetings with Remarkable Trees* (1996) that when the room was initially prepared, a 1.2-metre (4-ft) door was added; it can no longer be opened, however, as the tree has grown over the closing edge. Here, British conceptual artist Tacita Dean (b. 1965) has captured the Crowhurst yew as part of a series of photographs of famous and ancient trees in England. The project was sparked in 2005 when Dean began working on a series of found postcards of trees, which she transformed by painting out the backgrounds with white gouache. Although she works across a number of media, including photography, drawing and sound, she is perhaps best known for her work using 16mm celluloid film. In fact, the name of the Crowhurst yew links with Dean's 16mm colour film *Disappearance at Sea* (1996), which was inspired by the story of Donald Crowhurst, an amateur sailor who died while attempting an around-the-world voyage, during which he falsified his progress.

ARBRES D'ORNEMENT : 1. Robinier ou Faux-Acacia (*1 a*, rameau fleuri) ; 2. Marronnier rose (*2 a*, rameau fleuri) ; 3. Platane (*3 a*, rameau fleuri) ; 4. Paulownia ou Couronne impériale (*4 a*, rameau fleuri) ; 5. Sapin concolore (*5 a*, rameau avec cône) ; 6. Cyprès fastigié (*6 a*, rameau avec cônes) ; 7. Catalpa (*7 a*, rameau fleuri ; *7 b*, rameau avec fruits) ; 8. Ailante en fruits (*8 a*, rameau fleuri) ; 9. Glycine ou Wistaria (*9 a*, rameau fleuri) ; 10. Tecoma de Virginie (*10 a*, rameau fleuri) ; 11. Gleditschia (*11 a*, rameau avec un fruit) ; 12. Rhododendron ou Rosage (*12 a*, rameau fleuri) ; 13. Aubépine rose (*13 a*, rameau fleuri) ; 14. Chamærops ; 15. Pêcher de Chine (*15 a*, rameau fleuri) ; 16. Laurier-rose (*16 a*, rameau fleuri).

Adolphe Millot

Arbres d'ornement, from *Nouveau Larousse Illustré*, 1897–1904
Lithograph, 32 × 24 cm / 12½ × 9½ in
Private collection

Carrying on the tradition of botanical illustrations from centuries past, French publisher Larousse produced a series of identification posters such as this one around 1932 and included them as part of an update to one of their encyclopedic dictionaries. Known for making such visual dictionaries, Larousse had a long history of publishing detailed, visually rich illustrations that brought the natural world to life, including posters of sea life, flowers, mammals and human anatomy. With every updated edition, the dictionaries became even more laden with illustrations and

strove to include the most up-to-date scientific information. The images for this poster of ornamental trees, and many of the previous works in the series, were drawn by French illustrator Adolphe Philippe Millot (1857–1921), whose accessible style set the tone for Larousse's publications. Unlike botanical drawings produced by naturalists for strict scientific publication, focused on particular aspects of flower or leaf anatomy, these illustrations capture each tree's character more broadly, focusing on the parts important for identification by a general audience. Included in

the variety of trees are black locust (1, *Robinia pseudoacacia*), red horsechestnut (2, *Aesculus × carnea*), London plane (3, *Platanus × hispanica*) and imperial Paulownia (4, *Paulownia tomentosa*), among others, as well as some flowering shrubs and vines. From the angle of the limbs to the visual texture created by different foliage types, the trees appear as one would see them in a park, in their archetypal form, quite recognizable in their uniqueness. Insets of the bark, cones, fruits and leaves allow for identification of a specimen from afar or with a bough in hand.

Althea Braithwaite for The National Trust

The National Trust Tree Game, 1975
Printed cards, each approx. 9 × 6 cm / 3½ × 2⅜ in
Private collection

Reflecting a perhaps more simple, pre-digital era, this card game was published in 1975 to educate its players about British trees while they had fun. The game consists of twelve sets of four cards, each of which relates to a common British tree. Each set of four cards includes a master card – which describes the whole tree – and illustrated cards showing the tree, a leaf and a flower or fruit. The game itself resembles rummy, with players earning as many points as possible by collecting three or four cards belonging to the same tree or a sequence of three or four

tree, leaf, flower or master cards. While the master cards are packed with information about species such as sweet chestnut or plane, the others are purely graphic, featuring illustrations by British-born author and artist Althea Braithwaite (1940–2020), who is best known for her book *Desmond the Dinosaur* (1967). The game was produced by the National Trust, a charity founded in 1895 to protect properties and land of 'beauty or historic interest' across England, Wales and Northern Ireland. The National Trust's land holdings grew from the acquisition of large

estates that were left to the nation in lieu of death taxes, and it is now one of the largest landowners in Great Britain, owning 2,500 square kilometres (965 sq mi) of countryside and 1,260 kilometres (780 mi) of coastline. The National Trust's remit is to maintain the land while keeping it open for the public to use, and a vital part of that work is the preservation and planting of trees.

Niklaus Troxler

Dead Trees, 1992
Offset lithograph, 128 × 90.5 cm / 50¼ × 35½ in

When the first United Nations Conference on Environment and Development was held in Rio de Janeiro in 1992, thirty artists from thirty countries were invited to design a series of posters, each delivering a powerful environmental message. Award-winning Swiss graphic designer Niklaus Troxler (b. 1947) was asked to represent Switzerland in the project. The result was *Dead Trees*, a poster designed to be simple with a direct visual message that could be understood globally, without the need for written explanation. Using just three colours – Pantone Green 375C 2X to represent nature in good

health, Brown 477C for the tree bark and Warm Red 2X to represent the bleeding, dying trees – and minimal composition, Troxler communicated a striking visual message that we need to save the environment before it is too late. Designed by hand and produced as a silk-screen print in collaboration with the Swiss poster company APG|SGA, it was displayed at more than five hundred locations across Switzerland to wide public praise – posters were requested by schools and even by a preacher for his Sunday sermon. Troxler started drawing from an early age and went on to become an apprentice

typesetter and to study graphic design at the Lucerne University of Applied Sciences and Arts. He worked briefly as an art director in Paris before founding his own design firm, through which his work has gained international acclaim – especially his iconic record covers and posters (particularly those advertising Jazz Festival Willisau, which he organized from 1975 to 2009). Troxler has produced several other environmental activism posters, including one for the World Wildlife Fund in 2005 and another for La Ciudad Ligera, Madrid, advocating fewer cars and more trees in the city.

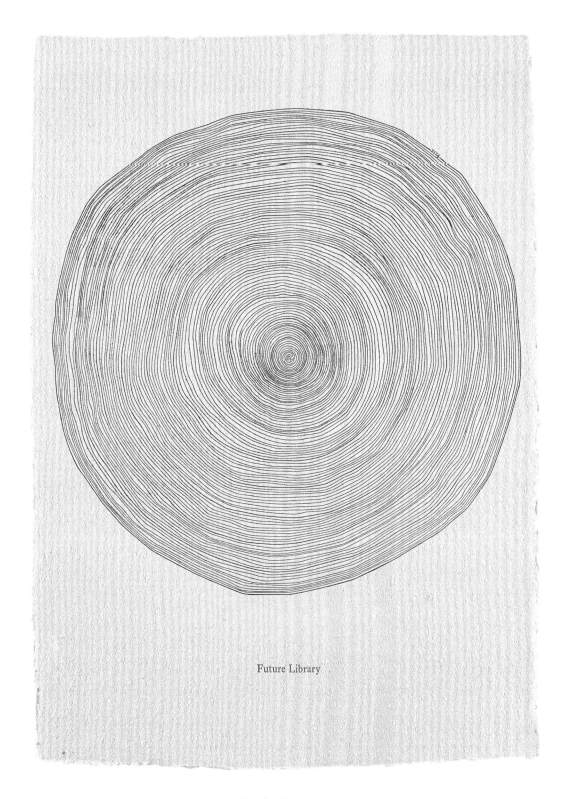

Future Library

Katie Paterson

Future Library: Certificate of Authenticity, 2014
Two-sided foil block print on paper, 43 × 30.5 cm / 17 × 12 in
Walker Art Center Library, Minneapolis, Minnesota

Each of the rings in this delicate drawing of a tree trunk by Scottish artist Katie Paterson (b. 1981) comprises a unique certificate that will ultimately entitle the bearer to a copy of a book – yet most of the certificate holders will not live to see their books. The books in the collection largely remain unwritten and the vast majority are not yet commissioned, and will not be printed for decades to come. In 2014 Paterson conceived of a living organic artwork that would connect the past with the future through the natural growth of trees. The project began with the planting of a forest of one thousand spruce trees just outside the Norwegian capital of Oslo, where they will be allowed to grow for a hundred years. In 2114 the trees will be felled to supply paper to print a unique collection of one hundred books that will be stored in a special Future Library room within Oslo's central library. Beginning with the trees' planting in 2014, each year a writer is commissioned to supply a text to be held in a small wood-lined room within the library – the Silent Room – to remain unprinted and unread until 2114. The first text was supplied by renowned Canadian novelist Margaret Atwood, and other writers include David Mitchell, Sjón, Elif Shafak, Han Kang, Karl Ove Knausgaard, Ocean Vuong, Tsitsi Dangarembga and Judith Schalansky. To celebrate the arrival of the latest commissioned text, each spring a handover ceremony is held in the forest where the spruce trees continue to grow alongside birch and pine trees.

Alfred Eisenstaedt

Rockefeller Center, Christmas Tree, 1950
Photograph, dimensions variable

This atmospheric picture by American photojournalist Alfred Eisenstaedt (1898–1995) captures the magic of one the most famous Christmas trees in the world. A significant cultural icon in New York City, the Rockefeller Center Christmas tree summons the vibrancy of the holiday spirit and speaks to the city's multicultural identity. The massive Christmas tree at the heart of Midtown Manhattan is a long-standing tradition that dates back to 1931, during the Great Depression, when construction workers placed a small, undecorated tree on the site of what would become Rockefeller Center. The

tree – usually a Norway spruce (*Picea abies*) – is adorned with thousands of lights and a large star, symbolizing hope and peace. The annual lighting ceremony in late November is a major event in the city and to viewers worldwide, representing the start of the holiday season. The tree remains lit and on display until mid-January, attracting an estimated 125 million visitors each year. Oftentimes, the tree stands as a testament to the city's resilience and unity, particularly in challenging times, and the decoration theme is chosen to allude to the city's current events. For instance, in 1942,

during World War II, patriotic red, white and blue globes were used for decoration. In 2001, following the 9/11 attacks, these colours returned to honour those who lost their lives. Moreover, the tree has come to reflect New York City's commitment to sustainability. Since 2007, the lights have been converted to more energy-efficient LEDs, and each January, when the tree is taken down, it is milled into lumber and donated to the non-profit organization Habitat for Humanity to build affordable housing, reinforcing the spirit of giving associated with the holiday season.

WORLD'S LARGEST LIVING COMMUNITY CHRISTMAS TREE

MERRY CHRISTMAS

WILMINGTON, NORTH CAROLINA THE PLAY-GROUND OF THE SOUTH

Service News Company

World's Largest Living Community Christmas Tree, 1950
Printed postcard, 8.9 × 14 cm / 3½ × 5½ in
Cape Fear Museum of History and Science, Wilmington, North Carolina

In 1928 the townsfolk of the Hilton Park suburb north of Wilmington, North Carolina, decided to decorate a Christmas tree. Lacking a traditional conifer, however, they simply hung 750 lights on a massive live oak (*Quercus virginiana*) dripping with Spanish moss. Crowds flocked to see it, and the tradition of the self-proclaimed 'world's largest living Christmas tree' was created. For the next eighty-four years – with a four-year gap during World War II – the holiday season in Wilmington only began once the tree had been illuminated. Thought to be at least three hundred years old, the live oak stood 23 metres (75 ft) tall, its branches spanning 64 metres (210 ft) at their widest. At the lighting ceremony's peak in the 1950s, when this postcard was created, national television amplified the celebration, and it featured Santa Claus, church choirs, local bands and Bible readings. By 1959 crowds of more than one hundred thousand – including many out-of-state visitors – flocked to the Christmas oak over the holidays. Nobody seemed to mind that the tree was not the traditional shape. Over the years, the level of decoration significantly increased until work crews were using cranes to put up seven thousand lights. However, by the start of this century, it was clear all was not well. The tree started to wither, age and weather, shrinking to just 15 metres (50 ft) tall and 23 metres (75 ft) wide. The decision was taken to retire the tree, and in 2011 it was decorated for a final time before being intentionally uprooted in 2015 due to safety concerns.

James Wigley

Poet Iohn Saxy upon his Yew-Tree Novr 1729, 1770
Hand-coloured etching, 34.9 × 25 cm / 13¾ × 9¾ in
British Museum, London

The crown of a gigantic ancient yew tree is topiarized into a geometric tower topped by a weathercock, while the tree's thick trunk is surrounded by wooden benches. The tree is the unusual subject of a poem by John Saxy, a parish clerk in Harlington, England, composed in November 1729. The lines of the poem surround the uniquely shaped tree in a 1770 engraving by British printmaker James Wigley (1700–1782). Wigley has placed two diminutive men – one of which is the poet, Saxy – on either side of the tree. A symbol of immortality and

an omen of doom, the yew is one of the longest-lived of all northern European native tree species. This yew, which is still living, is now thought to be more than nine hundred years old, making it old enough to be considered ancient. Yew trees are evergreens, found widely across southern England, often in churchyards – there are at least five hundred English churchyards with yews older than the churches themselves. One reason churches were built next to yew trees may be connected to the fact that yews were planted on the graves of plague victims in the belief

that the tree protected and purified the dead. It was also an effective way to stop livestock from grazing in graveyards, as the needles are extremely toxic. As the engraving suggests, the yew can grow as tall as 20 metres (65 ft), and unlike other conifers, its seeds are not contained in cones but in bright red fleshy berries.

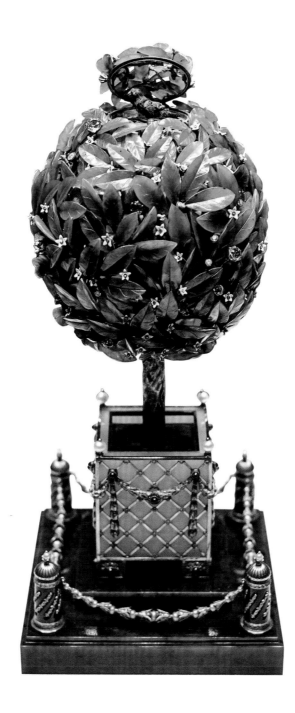

Peter Carl Fabergé

Bay Tree, 1911
Gold, diamonds, rubies, nephrite, rock crystal, amethysts, citrines, pearls, feathers and enamel, H. 28 cm / 11 in
Fabergé Museum, St Petersburg

Given as a gift by Tsar Nicholas II of Russia to his mother, the Dowager Empress Maria Feodorovna, for Easter 1911, this bejewelled and enamelled bay tree is, in fact, one of the famous eggs made by the house of the Russian jeweller Peter Carl Fabergé (1846–1920). The tradition of the emperor gifting Fabergé's celebrated Easter eggs dates back to 1885, when Tsar Alexander III commissioned Fabergé to make an egg for the empress. So impressive was the result that it started a tradition that was continued by Alexander's son, Nicholas. The only stipulation

given to Fabergé was that each egg should contain a surprise. As official goldsmith to the Russian Imperial Court, Fabergé introduced new fashions in jewellery: diamonds were gone, replaced by the prodigious use of coloured precious stones, enamelling and engraving. The *Bay Tree* egg contains all these elements. Hidden among the leaves is a tiny lever; when activated, the hinged top of the tree rises to reveal a feathered songbird, which not only flaps its wings and turns its head but opens its beak to sing. Scattered within the tree are diamonds,

rubies and pearls, as well as semi-precious stones such as amethysts. Standing at 28 centimetres (11 in) when open, the bay tree sits within its own bejewelled container on a plinth. Such was the quality of Fabergé's work for the Russian court that its popularity spread to European royalty and the global elite, and replicas still abound today.

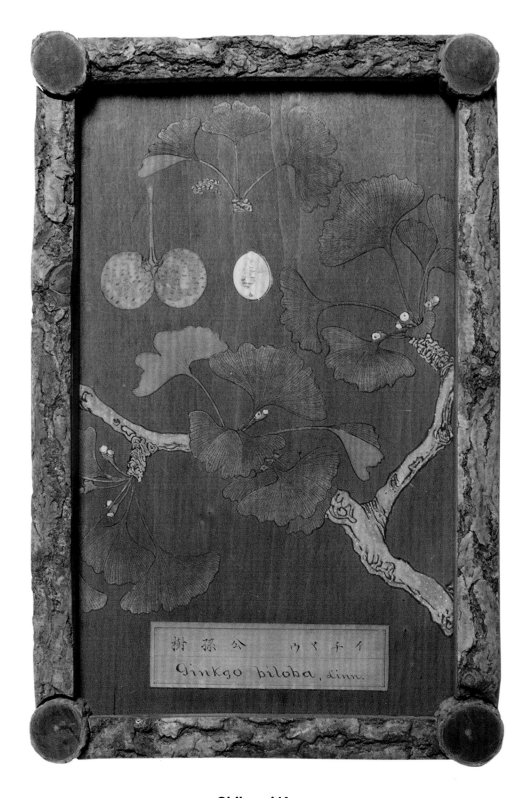

Chikusai Kato

Ginkgo biloba, 1878
Painting on wooden board, approx. 34 × 23 × 3 cm / 13⅜ × 9 × 1⅛ in
Royal Botanic Gardens, Kew, London

Framed by a border formed of its own bark, with small cross sections of wood at each corner, this item cleverly displays several of the key features of the maidenhair tree (*Ginkgo biloba*). Against the background of the tree's own wood, the painting shows a branching twig with groups of the highly characteristic long-stalked, leathery leaves, two revealing their paler undersides. At the top is a short sprig with a male flower, and below it is a pair of seeds from a female tree, one shown in section alongside. The illustration by Chikusai Kato (1818–1886), who was

employed by the Tokyo Imperial University and worked as botanical artist at Koishikawa Botanical Garden, blends Japanese and European styles. During this period, artists, including Kato, who had been trained to paint in a traditional Japanese style, also had access to and were influenced by Western styles and scientific botanical research, which can be seen here in the detailed separate depictions of the tree's features such as seeds and flowers. Kato's collection of woodblocks, known as a *xylotheque*, includes 136 species, most of which are

native to Japan. This block is one of twenty-five held in the Economic Botany Collection at the Royal Botanic Gardens, Kew, while another 152 are held in the Botanical Museum in Berlin-Dahlem, Germany. The unique boards were probably created by a team of artisans overseen by Kato using his own more detailed botanical illustrations as a guide.

Carl Ludwig Blume

Cinnamomum cassia and cinnamomum xanthoneurum, from *Rumphia, sive commentationes botanicae imprimis de plantis Indiae Orientalis*, 1835–48
Hand-coloured lithograph, 43.8 × 26.8 cm / 17¼ × 10½ in
SP Lohia Hand Coloured Rare Book Collection

Cinnamon, once more valuable than gold, is derived from the dried inner bark of a tree native to Sri Lanka, and has been used for thousands of years for medicinal uses and for culinary purposes as a spice. This illustration by German-Dutch botanist Carl Ludwig Blume (1796–1862) shows two varieties of bark: *Cinnamomum cassia* and *Cinnamomum xanthoneurum*. The lighter *Cinnamomum cassia*, or Chinese cinnamon, is native to southern China and is cultivated across the region. The darker *Cinnamomum xanthoneurum*, found in New Guinea, was

first identified in 1834 by Blume himself, who spent much of his career working as a botanist in Java, then a colony of the Netherlands. Long valued for its warm, delicately spicy fragrance, cinnamon was used by the ancient Egyptians in religious ceremonies and for embalming their dead. By the middle of the eighteenth century, the Dutch East India Company had established a hundred-year monopoly on importing the spice to Europe, where it was initially used to flavour stale or rotting food and drinks. Shipping cinnamon to Europe from its various colonies, including the

Spice Islands of the Dutch East Indies, made the company staggeringly rich. Because cinnamon was such a valuable commodity, cinnamon plantations were established where mature trees were trimmed back to stumps, encouraging the growth of new shoots. Those shoots were then cut and stripped of their outer bark, and the inner bark was then polished, stretched and rolled into the characteristic tube shapes.

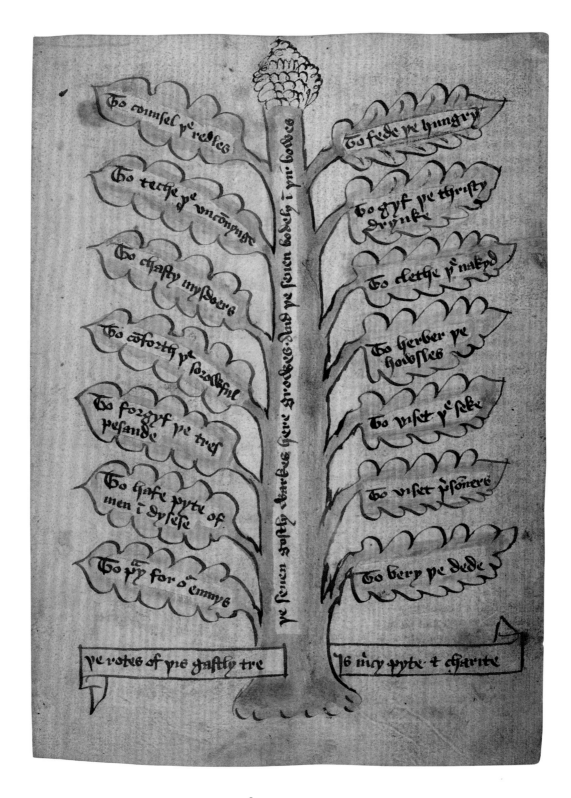

Anonymous

The Desert of Religion and Other Poems and Religious Pieces, 1460–1500
Ink on parchment, 27 × 20 cm / 10⅝ × 7⅞ in
British Library, London

Drawn onto a fragile piece of parchment during the Middle Ages is a healthy tree in full foliage, each leaf edged in green pigment and bearing several words. Further script appears written vertically on the tree's trunk, while the description written horizontally along the bottom of the tree is in a dialect of Old English known as Northumbrian. This is a 'tree of virtues', a pictorial representation of the allegorical poem 'The Desert of Religion', in which the spiritual battle of good and evil is represented by separate trees of virtue and vice. The tree of virtue – the labels list fourteen

separate virtues – is healthy and thrives; the tree of vice, in contrast, withers and dies. This tree of life was created by an anonymous monk belonging to the Carthusian religious order, which started in France in 1084 and arrived in Britain almost a hundred years later. The order distinguished itself from other religious orders by its choice of an austere way of life: its monks withdrew from the world to live as virtual hermits in their monasteries. Tree of life images appear frequently in Christian iconography, drawn in a vast array of forms by artists across the centuries, and

often list a number of virtues to be cultivated in devout followers. For a deeply Christian society in the Middle Ages, the collection of writings that included 'The Desert of Religion' was an early spiritual encyclopedia, guiding its readers towards a more virtuous life.

Anonymous

Money tree, 1st–2nd century CE
Bronze and green glazed earthenware, 147.3 × 62.2 × 62.2 cm / 58 × 24½ × 24½ in
Minneapolis Institute of Art, Minnesota

This money tree (*qian shu*) was found among the funerary goods buried in the tomb of a member of the Chinese Han dynasty (206 BCE–220 CE), who would have used it to purchase security and comfort for their soul in the afterlife. The work of an anonymous artisan between the first and second centuries CE, the trunk and delicate branches are made from bronze, anchored into a glazed earthenware base. Sitting atop the tree is a phoenix (*fenghuang*), a bird the Han believed brought good luck. On closer inspection, the tops of the branches are decorated with scenes of ancient Han rituals. The revered female deity Xi Wang Mu, or Queen Mother of the West – one of the most powerful of all the Chinese goddesses – sits in a canopied shrine above flying horses, mythological animals and performers who are responsible for entertaining the deity. Below these figures, within the lattice-shaped branches, are many coin-shaped designs that directly copy the coins used by the Han and give the tree its name. Money, in the shape of these coins, was vital to the soul's passage into the next life, where it would enjoy similar wealth to what its human form had enjoyed in life. Around two hundred money trees have been discovered in tombs, largely in southwest China; archaeologists have narrowed the probable period of their use to between the first and third centuries CE.

Ilse Bing

Tree, 1955
Gelatin silver print, 43 × 40.4 cm / 17 × 16 in
Cleveland Museum of Art, Ohio

A gnarled, leafless tree twists up towards the sky against a backdrop of a summer's day high up in the mountains. This stark portrait of a bristlecone pine (*Pinus* sp.) is an apt milieu for the species. The three species of bristlecones are found in isolated groves at elevations of 1,700 to 3,400 metres (5,600 to 11,200 ft) in Utah, Nevada, eastern California, New Mexico and Arizona. The tree's distinctive twisted form is the result of being shaped by the harshest of elements – from wind, rain and snow to extreme temperatures – over time, sometimes thousands of years.

The Great Basin bristlecone (*Pinus longaeva*) is thought to be the oldest known living tree on Earth, the famous Methuselah tree being the prime example at around 4,855 years old. The tree here was captured on film in 1955 by the Queen of the Leica, Ilse Bing (1899–1998), a perhaps unlikely subject for the German avant-garde photographer. Bing was friends with many leading photographers of the day, such as Alfred Stieglitz. In her career, which spanned much of the twentieth century in Europe and the United States, including the horrors of World War II, Bing primarily

photographed urban environments. Having moved to Paris in 1930 from her native Frankfurt, Bing used her 35mm Leica camera to photograph fashion, architecture and portraits as she worked as a photojournalist. Immigrating to the United States in 1941 to flee Nazi persecution, Bing settled in New York City. She turned to colour photography in the late 1950s, and by 1959 she had given up photography entirely. Her work, which reflected the influence of Stieglitz with its use of dark and light tones, as is clearly displayed here, was rediscovered in the 1970s.

Georgia O'Keeffe

Cedar Tree with Lavender Hills, 1937
Oil on canvas, 75.6 × 50.2 cm / 29¾ × 19¾ in
Reynolda House Museum of American Art, Winston-Salem, North Carolina

The twisted limbs of a long-dead tree, painted in bold parallel strokes of greys and browns, stand out against a desert landscape of pink, violet and orange earth. American modernist painter Georgia O'Keeffe (1887–1986) used to spend her summers at Ghost Ranch, a dude ranch on the eastern edge of the Jemez Mountains of New Mexico. When O'Keeffe created this work in 1937, she was living in a simple cottage in an isolated location several miles from the heart of the ranch. She noted that she had first drawn the gnarled tree when she arrived at the ranch three years earlier. It had been in her mind for some time, and when the painting was completed, she felt that, for the first time, her painting really looked like the landscape she could see from her window. The role of the dead tree in the composition is similar to that of the animal skulls that occupy the foreground of other colourful landscapes by the artist, representing the enduring strength and beauty of the desert and, by extension, the American spirit. Also known as red cedar, O'Keeffe's subject is probably a Rocky Mountain juniper (*Juniperus scopulorum*), a slow-growing tree that can live for centuries. A photograph taken for an exhibition of O'Keeffe's work in 2005 shows the tree still standing, and looking almost exactly the same as in the painting – a testament to her accuracy, as well as to the tree's power of survival in the dry conditions.

261

Grant Wood

Parson Weems' Fable, 1939
Oil on canvas, 97.5 × 127 cm / 38⅜ × 50⅛ in
Amon Carter Museum of American Art, Fort Worth, Texas

Just as Europe was becoming embroiled in World War II, Grant Wood (1891–1942) painted this portrayal of the original American myth: the story of a young George Washington, unable to tell a lie, admitting to having chopped down his father's cherry tree. Mason Locke Weems, usually known by his clerical title, Parson Weems, included the entirely made-up tale up in the fifth (1806) edition of his biography of Washington, of which the best-selling first edition was published in 1800. In Wood's painting, Weems pulls back a red velvet curtain to reveal the scene of the crime.

Six-year-old George – bearing his adult head as illustrated by Gilbert Stuart, which today adorns the US one-dollar bill – confesses to his father. Wood modelled the house after his own in Cedar Rapids, Iowa, and the enslaved couple in the background picking cherries makes this work an ensemble piece, alluding to Washington's history as a lifelong slave owner. Parson Weems wrote the fable in an attempt to highlight Washington's virtues, and with the escalation of fascism in Europe, Wood sought to remind Americans of the mythical aura surrounding the

first president. Aware of the patriotic mythologies of the German Reich, fascist Italy and the Soviet Union, Wood wanted Americans to be mindful of their own myths. The painting is a play within a play, reflecting Wood's love of the theatre, and is an ingenious depiction of a fabulist (Weems) revealing a false performance of not lying (Washington). Nevertheless, the painting was condemned by those who refused to accept that Weems had invented the story of young George and the cherry tree.

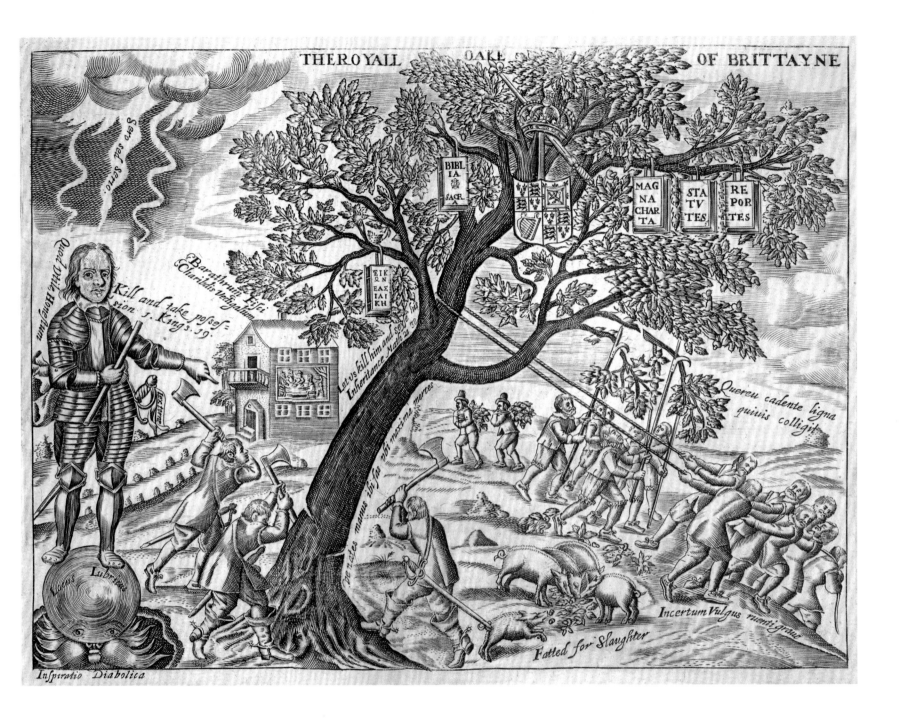

Anonymous

The Royall Oake of Brittayne, c.1649
Engraving, 23 × 17 cm / 9 × 6¾ in
British Library, London

The oak tree has become an enduring symbol of age, strength and endurance, and in this satirical image by an unknown artist, the tree is synonymous with the British monarchy. The illustration depicts the felling of the royal oak by Oliver Cromwell following the execution of King Charles I in 1649, a reference to Cromwell's dismantling of the king's regime. Cromwell, wearing full armour, stands to the left of the image, poised on a sphere bearing the words *Locus Lubricus*, or 'slippery place', above the diabolical mouth of hell. Latin and English quotations

link Cromwell to notorious biblical figures, including the tenants in the vineyard from Matthew 21: 'Let us kill him and steal his inheritance.' While labourers plunder the foliage and acorns to fatten pigs for slaughter, republican soldiers enthusiastically hew the oak, which is being hauled to the ground by ropes, taking with it the crown and sceptre, along with *Magna Carta* and the king's *Eikon Basilike*. Tyranny will lead to the collapse of law and order. The image may have been the frontispiece to the book *Anarchia Anglicana: or, the History of Independency*

Part 2, by pamphleteer Clement Walker. Another later story, dating from 1651 after the Battle of Worcester, tells of the fugitive prince, the future Charles II, who hid from Cromwell's troops in an oak tree near Boscobel House in Shropshire. Initially a supporter of the Parliamentarians, Walker became disillusioned with Cromwell, and this print would have expressed his unease. Walker was arrested for writing *Anarchia Anglicana* but died in 1651 at the Tower of London before he was tried.

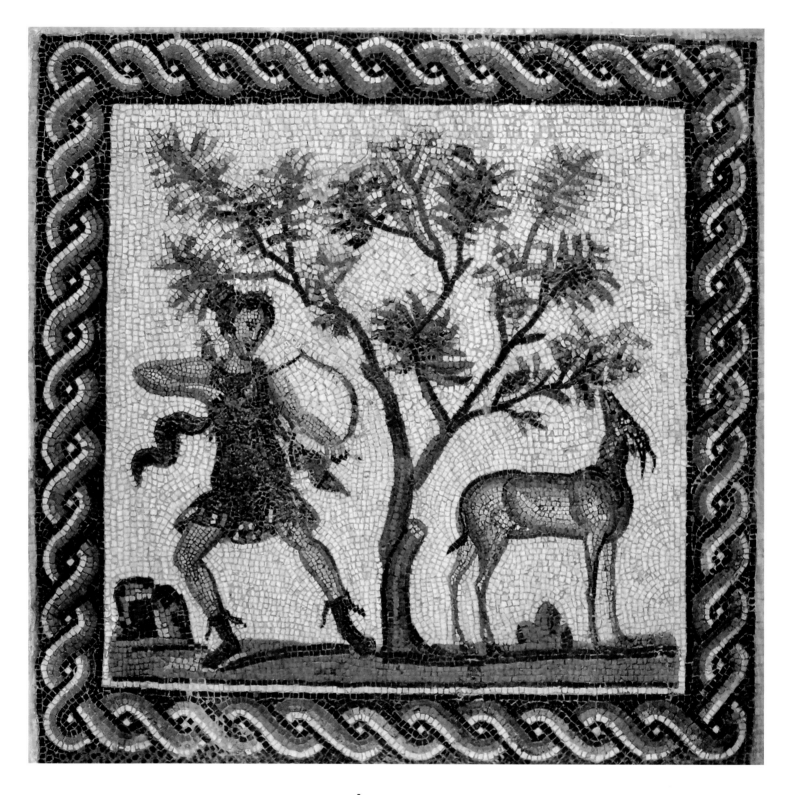

Anonymous

Diana the Huntress, late 2nd century CE
Mosaic
National Bardo Museum, Tunis, Tunisia

Diana, goddess of the hunt, wilderness and wild animals, takes aim with her bow at an African gazelle peacefully grazing below an acacia tree in this mosaic from the late second century CE. The Roman deity was assimilated from the Greek goddess Artemis, whom the Greeks had adopted in turn from the Near East. In that region, Cybele was a mother goddess as well as Mistress of Animals, which may have resulted in this complex virginal goddess being the deity who protected mothers in childbirth (though this may also relate to her role as goddess of the moon). One

of the most widely venerated gods in the pantheon, Diana was known as Potnia Theron, or Queen of the Beasts, and her primary sanctuary was a woodland overlooking Lake Nemi, north of Rome. Here she was worshipped as Diana Nemorensis, or Diana of the Woodlands. She became associated eventually with *villae rusticae*, farmhouses or countryside villas with agricultural land, thus amalgamating wilderness and civilization. In the Roman province of Africa, trees of the genus *Acacia* were associated in Egyptian mythology with the cosmic tree under which the gods were

born. In the myth of Isis and Osiris, Osiris becomes one with the acacia tree as god of the underworld. The roots, bark and resin of several species were used to make ritual incense, and today smoke from acacia bark is believed in some cultures to drive away demons.

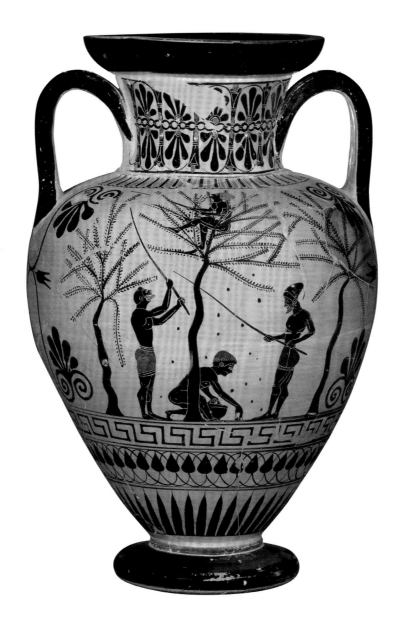

Antimenes Painter (attributed to)

Black-figure amphora, c.520 BCE
Pottery, H. 40.6 cm / 16 in
British Museum, London

Decorating the back of this black-figure amphora is a rather quotidian scene of an olive harvest. In the branches of the central tree, a naked boy uses a stick to shake down the olives. Two older, bearded men beat the trees with longer sticks; they wear purple loincloths, and the one on the right wears a *pilos*, a conical hat worn by workmen. At the base of the tree, another nude youth collects the fallen olives and deposits them in a woven basket. The amphora, a vessel for holding liquids – usually olive oil – is attributed to the Antimenes Painter, who was active

between c.530 and 510 BCE. While the front of the amphora shows a scene with Herakles, the wise centaur Pholos and the messenger god Hermes, the most famous story of the olive tree comes from Athens, where this vessel was made. In the contest between Athena and Poseidon to be patron deity of the city, Poseidon caused a saltwater spring to flow from the Acropolis, while Athena produced an olive tree, with its abundance of fruit. From this first olive, twelve new trees were planted in the sanctuary of the hero Akademos and were considered a sacred grove (see p.206). The

ancient Greeks used olive oil for lighting, cooking, as an unguent and as a prize for victors in the Olympic games. It became a crucial trading commodity, with some cities' entire economies dependent on it. An olive branch was one of the attributes of Eirene, goddess of peace, and today the olive branch is a global symbol of peace.

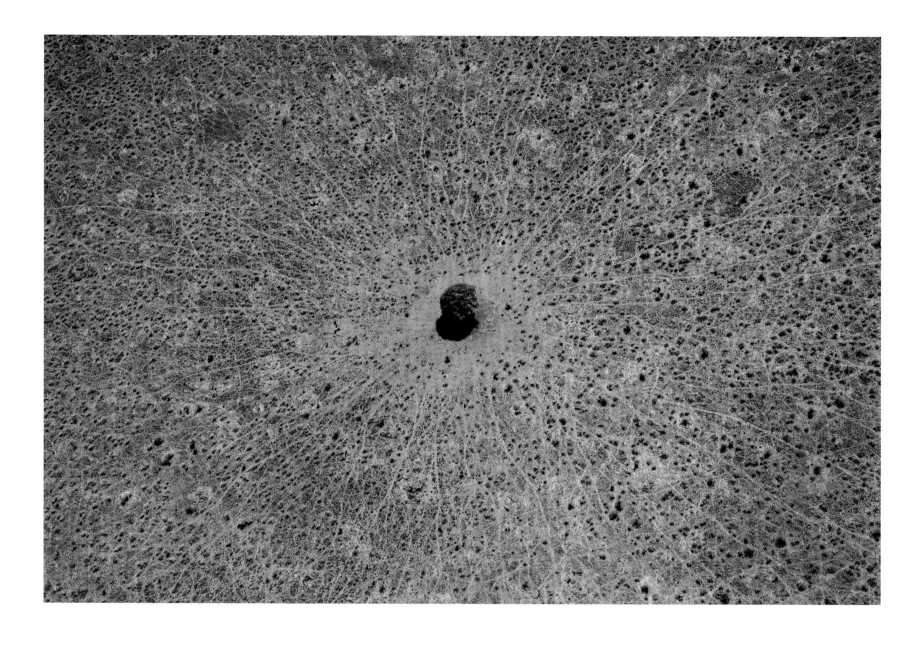

Yann Arthus-Bertrand

Tree of Life, Kenya, 1993
Photograph, dimensions variable

Viewed from high above Kenya's Tsavo East National Park, a solitary acacia tree (*Vachellia tortilis*) stands amid the semi-arid scrubland, its lush green canopy conspicuous against the golden savannah soil. The tree is a magnet for local animals and birds, which come to feast on its leaves, nest in its branches or shelter under its shady canopy. This aerial photograph was taken by French environmentalist, activist and photographer Yann Arthus-Bertrand (b. 1946) as part of his ambitious *Earth from Above* project, which, before the invention of drone photography, sought to

capture the world's most beautiful landscapes from the skies using helicopters and hot-air balloons. Located in southeast Kenya, Tsavo East is the largest and oldest protected area in the country and has more biodiversity than any other park globally. Other trees that grow in the park include the baobab and doum palm. The park is a haven for some of Africa's most iconic wildlife, such as elephants, rhinoceroses, giraffes and lions, the last of which Arthus-Bertrand studied for three years as part of a research project through which he discovered his

passion for photography. While animals are absent in this image, their presence is implicit in the radiating network of veinlike tracks etched into the dusty ground. Here, the acacia is presented as a symbol of life in a dry stretch of land; the tree is able to tolerate high temperatures, can survive drought and, through its interaction with symbiotic root bacteria, is known to fix soil nitrogen, an essential nutrient for plants.

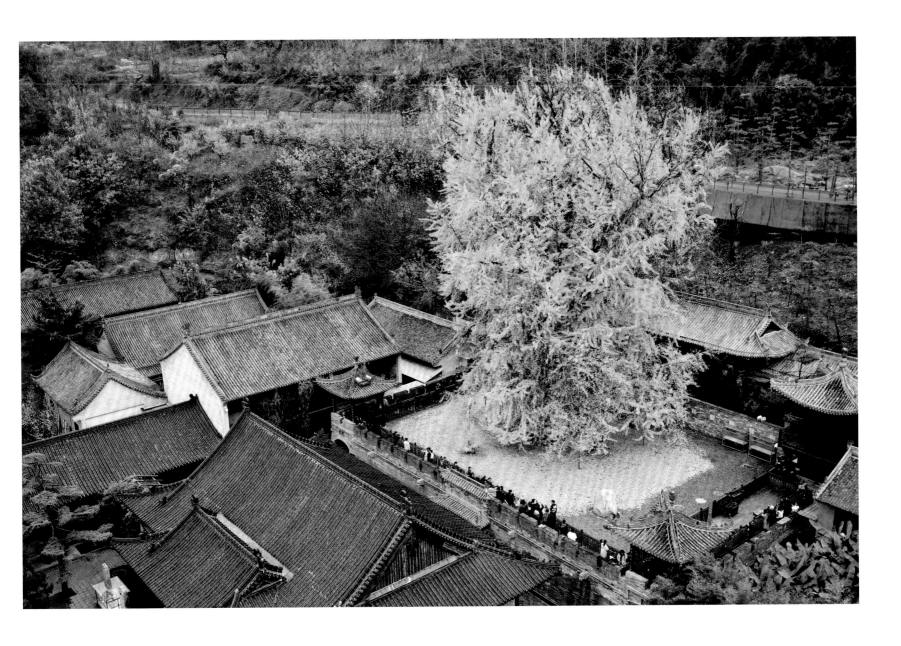

Liu Xiao

Ginkgo Tree, Guanyin Temple, 2019
Photograph, dimensions variable

Each year during the month of November, an estimated three thousand people visit the ancient Gu Guanyin Buddhist Temple in the Zhongnan Mountains of China's Shaanxi province every day to appreciate the beauty of an ancient ginkgo tree (*Ginkgo biloba*) shedding its leaves. Buddhist monks have been living in these mountains since Buddhism's introduction to China from India early in the first millennium CE. Thought to have been planted by Li Shimin, an emperor during the Tang dynasty (618–907 CE), this magnificent ginkgo tree is thought to be 1,400 years old. Planted around temples

and shrines in China, Japan and Korea, the ginkgo is widely linked to Buddhist practices and signals a point of control and balance. *Ginkgo biloba* – whose common name is the maidenhair tree – is one of the world's oldest tree species, predating dinosaurs. And it is the only living connection between ferns and conifers, having remained unchanged for two hundred million years. The oldest living ginkgo tree is thought to be 3,500 years old; surviving the Ice Ages, it was discovered as a relic in central China. Despite being considered endangered in the wild, the ginkgo is widely

planted as a street tree, as it is uniform in habit and tolerant of pollution, and it rarely has problems with disease. The tree is beloved for the elegance of its leaves, especially when they turn a vibrant yellow in autumn, and the fruits are considered a delicacy in China, where they are known as silver apricots. Widely used in traditional Chinese medicine since the eleventh century, ginkgo leaves and root bark have been found to contain a group of compounds known as ginkgolides, which have been used to treat a number of conditions, including migraines, dementia and Alzheimer's disease.

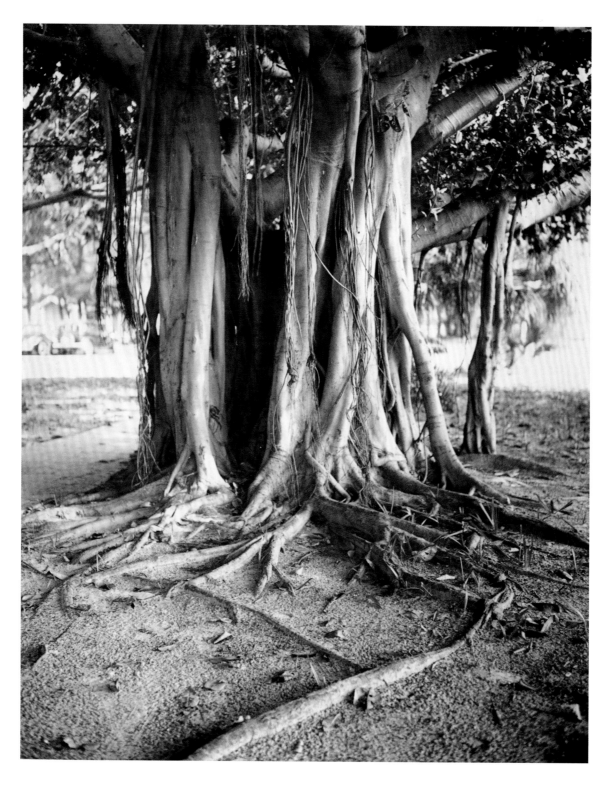

Walker Evans

Banyan Tree, Florida, 1941
Gelatin silver print, 22.4 × 18 cm / 8¾ × 7 in
Metropolitan Museum of Art, New York

The exposed roots of a majestic banyan tree fill the fore-ground of this 1941 black-and-white image taken in Florida by influential American photographer Walker Evans (1903–1975). The composition focuses the viewer's eye on the banyan's thick trunk and the roots that spread over the ground in a tangle that contrasts with the vertical lines of the vines that dangle from the tree's branches. While there are many species of banyan in the *Ficus* genus, *Ficus aurea* and *Ficus citrifolia* are both native to Florida. It is thought that the banyan originated in south Asia, where it

is a national symbol representing India and a sacred tree of the Hindu religion. Linked to the Hindu god of death, Yama, the banyan is often planted next to crematoria outside rural villages. The tree's association with death is appropriate: the banyan is a parasite that owes its exist-ence to the death of another tree – its host – earning the sobriquet 'strangler fig'. The banyan's seed only germinates in another tree, where the banyan begins to grow as a vine that eventually smothers the host tree as the vines thicken to become trunklike pillars strong enough to support

branches. Its roots grow from the branches down to the ground, thus extending the tree's footprint and earning it another name, the 'walking tree'. The banyan was a somewhat unusual subject for Evans, whose fifty-year career mainly concentrated on capturing the emergence of modern-day America. Walker more typically concen-trated on the everyday life of small-town America, a place of bustling main streets, filled with roadside architecture, hand-painted signs and family-run shops.

Les Baobabs.

Antoine de Saint-Exupéry

The Baobabs, from *Le Petit Prince*, 1943
Colour lithograph, 23 × 17.5 cm / 9 × 7 in
British Library, London

A young boy stands proudly on a tiny planet dominated by three huge baobab trees, floating among the stars, in this fantastical image from the modern classic *Le Petit Prince* (*The Little Prince*) by French aviator and writer Antoine de Saint-Exupéry (1900–1944). The book tells the fable of a child – the eponymous prince – who travels the universe gaining wisdom. One of the best-selling books of all time, it has sold more than two hundred million copies and has been translated into 571 languages and dialects since its publication in 1943. In the book, only two plants grow on asteroid B-612: the rose and the baobab. The rose represents love, prosperity and creativity; the baobab stands for hatred and destruction, and more generally, the obstacles in life. The baobab – known across Africa and Madagascar as the tree of life – is precisely the opposite in *Le Petit Prince*. The prince explains that the baobab must be carefully watched: what start as small seedlings will soon grow and take over, destroying not only the precious roses but the asteroid itself. Baobabs are extremely long-lived – one hundred years is not uncommon – and they adapt to their environment, storing water in their trunks, which swell to absorb the rain. A fierce opponent of the Nazi regime, Saint-Exupéry is said to have used the baobab trees as a warning that, if left unchecked and allowed to develop, evil – such as that embodied by the Nazis – will flourish and bring destruction to the world.

269

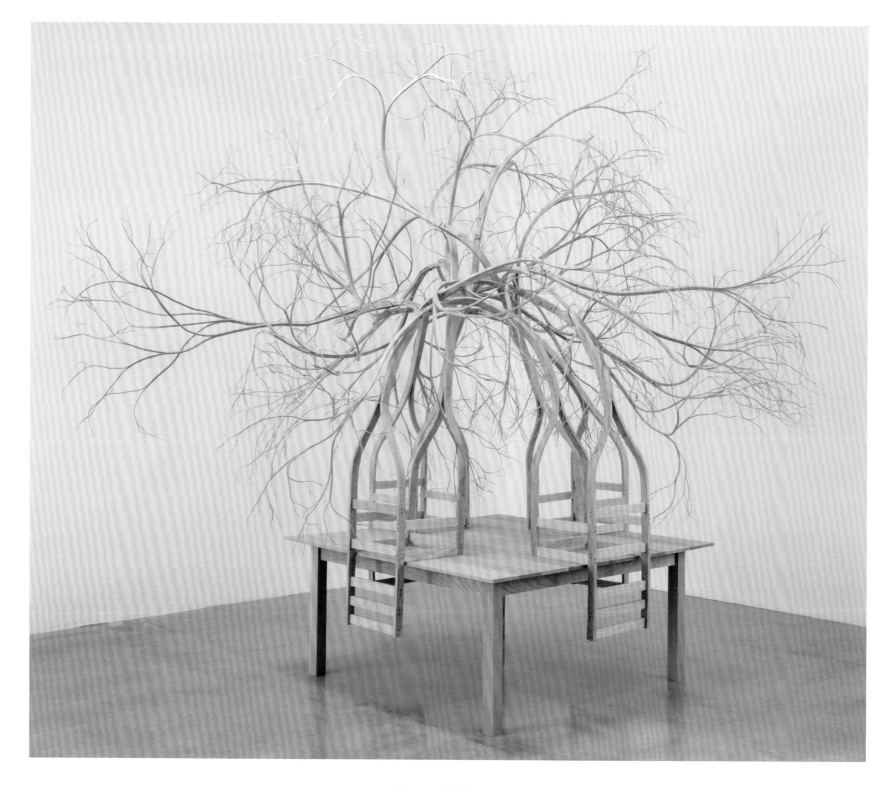

Pontus Willfors

Table with Four Chairs, 2015
Honey locust and white oak wood, 3.7 × 4.3 × 4 m / 12 ft × 14 ft × 13 ft 4 in
West Collection, Oaks, Pennsylvania

A table made from white oak and honey locust wood sits in the middle of an empty space, its four chairs upturned on its surface. The legs of the inverted chairs have sprouted into a series of interconnecting tree roots or perhaps wispy branches intermingling together. This sculpture is the work of Swedish-born, Los Angeles-based artist Pontus Willfors (b. 1973), who has garnered international acclaim for his thought-provoking works that explore the intersection between the organic and the industrial while they push the boundaries of conventional design and artistic

expression. By his own admission, the artist wants his sculptures to interrogate 'aspects of nature that are viewed by our society as product, nuisance or waste'. In shaping his sculpture, much of the wood Willfors used was destined to become waste. But by delicately carving the chair legs into their wispy trails, he reminds the viewer that his inanimate object was once a living thing, challenging their assumptions and expectations of everyday objects. Willfors' intention is that 'transforming things like tables and chairs, all crafted by hand, into wild, ornate, lyrical compositions

or evacuating these objects of their use' will lead viewers to look at those objects again, as if for the first time. In so doing, Willfors reimagines functional and utilitarian objects into delicate sculptures of beauty and impracticality. Here, the artist succeeds in taking wood into a different dimension, showing it as both natural and delicate but, at the same time, solid and industrial.

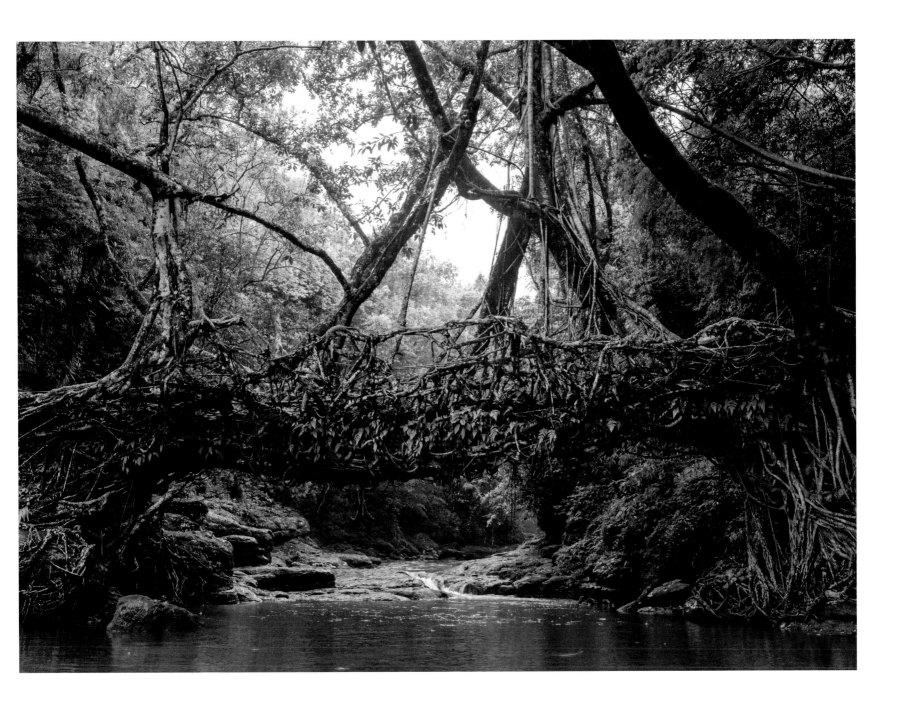

Aliaksandr Mazurkevich

Living Roots Bridge Near Riwai Village, Cherrapunjee, Meghalaya, India, 2017
Photograph, dimensions variable

The thick, ropelike roots of several Indian rubber trees (*Ficus elastica*) have become entwined, growing together to form a striking suspension bridge across a river in the depths of the lush rainforest of Meghalaya in northeast India. Living root bridges, such as the one in this photograph by Aliaksandr Mazurkevich, are marvels of human ingenuity, harnessing the power of trees in a functional and sustainable way. These crossings, of which there are numerous examples in the region, were created hundreds of years ago by local Khasi and Jaintia people.

First, seedlings were planted on each bank of the river or ravine. After the trees' aerial roots had sprouted, they were wrapped around a bamboo frame and trained to grow horizontally until, having reached the other side, they were planted in the ground. Over years, the roots thickened, lengthened, multiplied and fused together, creating incredibly strong structures that grow more durable with time. It can take up to twenty years for one of these bridges to become strong enough to support people, but the most established can hold the weight

of more than forty adults at one time. Root bridges are extremely important to local populations, as they connect remote areas. Many have been modified with bamboo railings, making them safer and easier to navigate. Unlike wooden and metal structures, they are able to withstand heavy monsoon rainfall and can last hundreds of years without needing to be replaced.

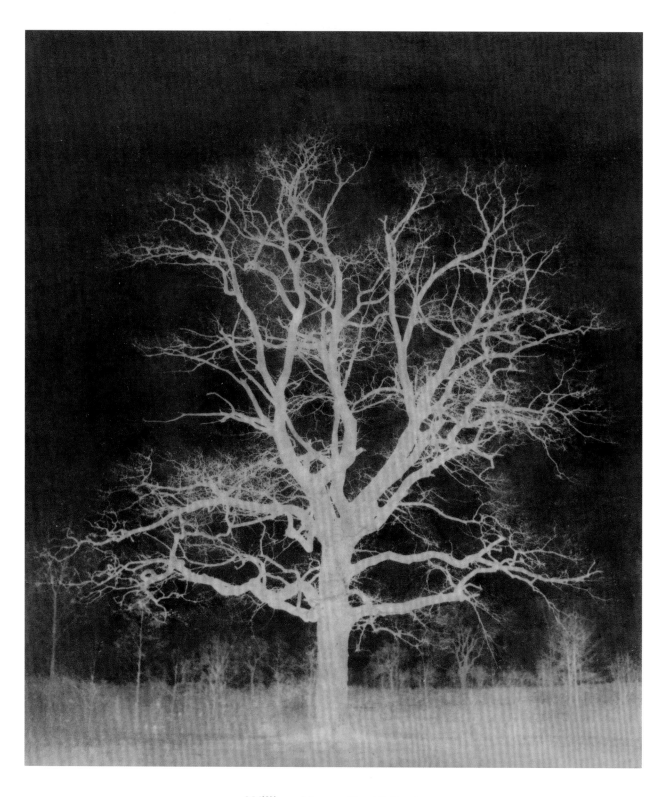

William Henry Fox Talbot

An Oak Tree in Winter, c.1842–43
Calotype negative, 19.5 × 16 cm / 7¾ × 6¼ in
British Library, London

British scientist William Henry Fox Talbot (1800–1877) was one of the great pioneers of photography, inventing the salted paper and calotype processes. Educated at Harrow School in London and Trinity College in Cambridge, Talbot published many articles in the fields of mathematics, astronomy, botany and physics. But it was his work with photography that proved to be his passion. He remarked in 1833, 'How charming it would be if it were possible to cause these natural images to imprint themselves durably and remain fixed on paper.' His photographic experiments

started in 1834, and by 1835 he had placed silver nitrate and table salt-coated paper sheets into small wooden boxes fitted with a microscope lens. Using this method, he photographed the oriel window in the South Gallery of his family home, Lacock Abbey, in Wiltshire, England, where he had moved in 1827. This 'negative' was so perfect that the two hundred diamond-shaped panes of glass are able to be counted. By 1840 Talbot went on to discover that by using gallic acid as a chemical developer, latent images could be made into 'full-strength' negatives and

faded negatives could be revived. He called this process calotype after the Greek *kalos*, meaning 'beautiful'. Promoting this technique, Talbot produced one of the first photographic books, *The Pencil of Nature*, between June 1844 and April 1846, which included one of these calotypes, *An Oak Tree in Winter*. Talbot's daughter Matilda later wrote: 'I have a pleasant feeling that Lacock is rather like a tree which will keep on growing, even if most of the people that sit under its shade have moved into another world.'

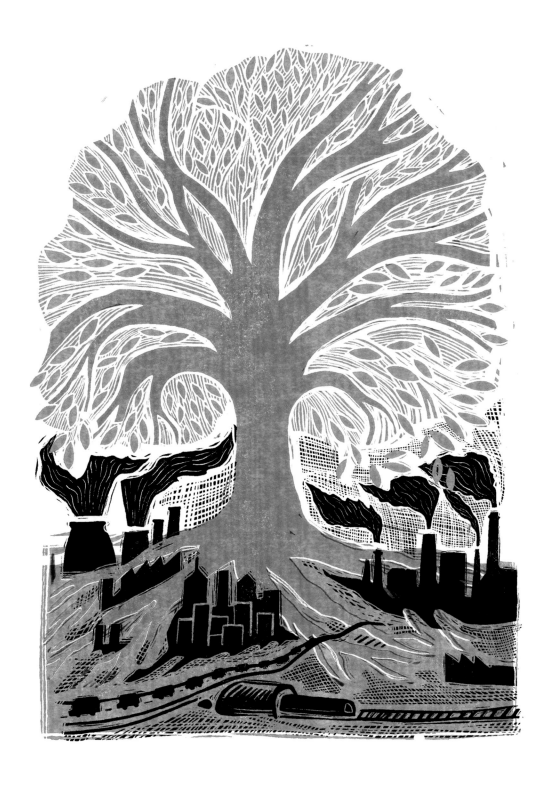

Rosanna Morris

Illustration from *Plant a Tree and Retree the World* by Ban Raskin, 2022
Linocut with digital edit, 30 × 20 cm / 11¾ × 7¾ in

An enormous green tree rises above billowing clouds of pollution, symbolizing the powerful role that trees can play in combating environmental problems. This linocut print is one of several created by printmaker Rosanna Morris (b. 1990) for *Plant a Tree and Retree the World* (2022), an essential handbook by British horticulturist Ben Raskin celebrating the many ways in which trees benefit our world, from fighting climate change and supporting biodiversity to helping clean the air in our cities and boosting mental health. Raskin explains how trees are vital in regulating our climate by absorbing greenhouse gases, including methane, nitrous oxide and carbon dioxide. In one chapter, he details the ways in which trees are effective at improving well-being by reducing stress, calming both mind and body. Tree planting is increasingly recognized as an empowering and relatively easy action that we can all take to improve our lives. Arguing that most landscapes would benefit from having more trees, Raskin outlines where and how to plant your own, including guidance on growing saplings and tips on caring for your tree. Among the author's 'forty best trees', selected for their environmental benefits as well as their ornamental value, are oak, hazel and mulberry, along with less common species such as Persian ironwood, which is known for its superb autumn colours. As Raskin makes clear, trees are among our greatest allies, working symbiotically with fungi, insects, animals and other plants to sustain environments essential to human flourishing.

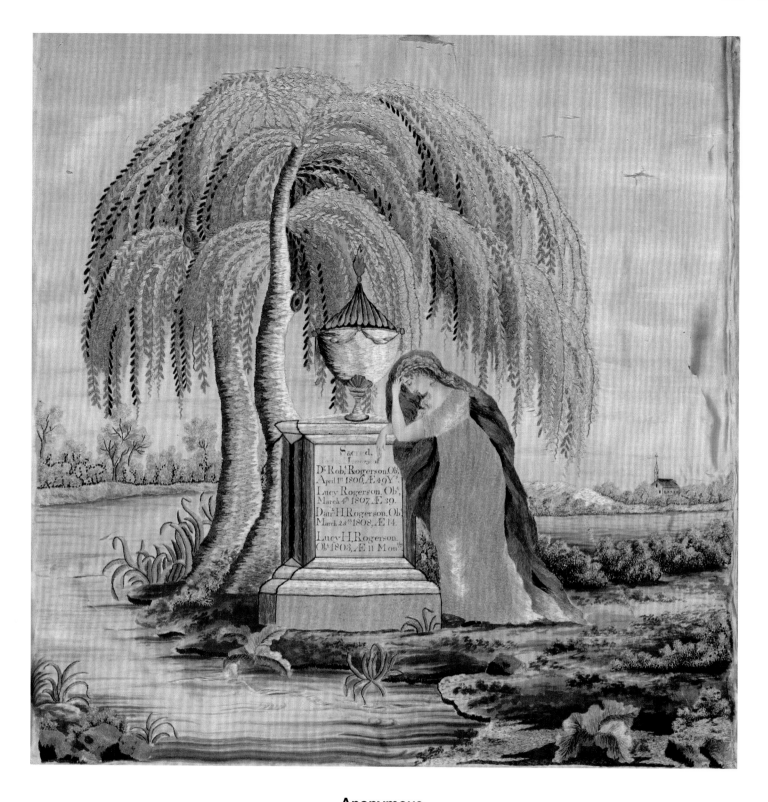

Anonymous

Mourning sampler, c.1810
Silk, painted and embroidered with silk, approx. 41 × 39.4 cm / 16⅛ × 15½ in
Cooper Hewitt, Smithsonian Design Museum, New York

A young woman, shaded by two weeping willow trees in full leaf, bows her head as she leans against a tomb in this silk sampler embroidered to remember dead family members. The young woman is pictured in grief, contrasting with the bucolic countryside scene embroidered behind the trees. Weeping willows have a long association with cemeteries and mourning, as does the classical Greek urn on top of the tomb, an expression of the death of the body but not the soul. During the sixteenth and seventeenth centuries, the willow was more usually associated with forsaken lovers

than death, but by the time this sampler was created – samplers were typically homemade exercises for young women used to develop their skills – illustrations of weeping willows often appeared on mourning cards and were carved onto gravestones. In the early nineteenth century, willow trees appeared in many images associated with grief, having been identified as so-called 'Christian' in Psalm 137 of the Bible, describing the Jews' exile in Babylon: 'By the rivers of Babylon we sat down and wept, when we remembered Zion. There on the willow-trees,

we hung up our harps.' English garden designer John Claudius Loudon advised in his publication On the Laying Out, Planning and Managing of Cemeteries (1843) that the landscape should evoke a state of quiet repose and thoughtful contemplation for mourners, favouring upright, dark evergreens that would not obstruct graves alongside weeping trees, such as the willow, which were symbolically appropriate. The willow in this sampler is likely to be an old semi-pendulous form known as S. alba var. vitellina and is now included in Salix × sepulcralis 'Chrysocoma'.

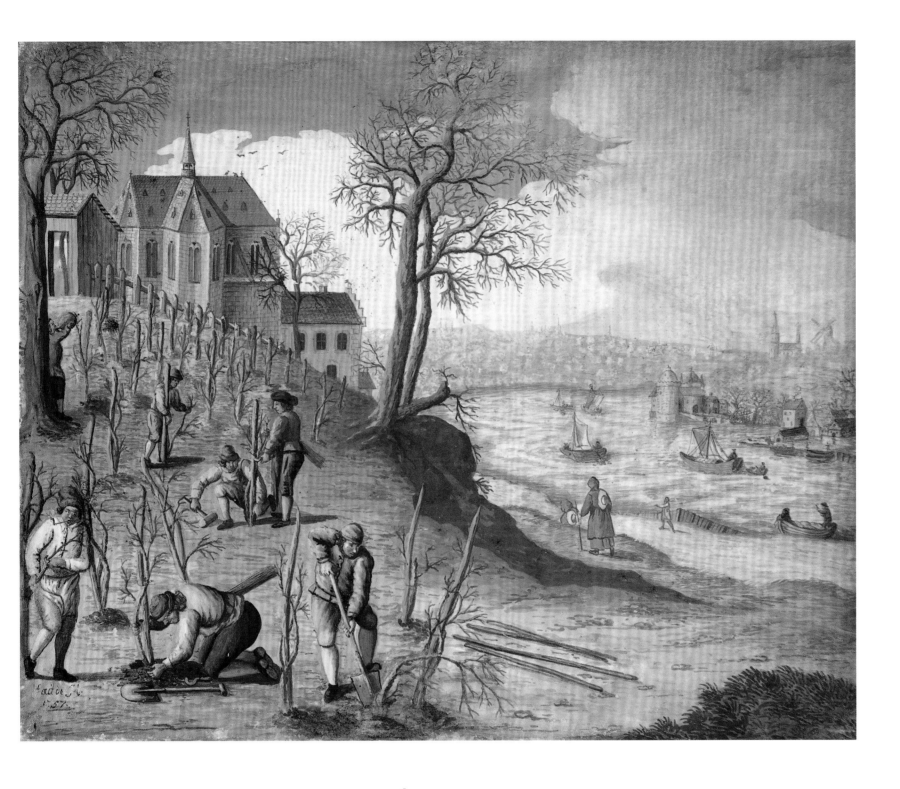

Anonymous

Planting Trees, 18th century
Gouache on vellum, laid down on panel, 15.9 × 19.1 cm / 6¼ × 7½ in
Metropolitan Museum of Art, New York

Against a backdrop of a busy river scene with a distant city spilling down to the water's edge, a group of men plant tree saplings. It is winter; the mature trees dotting the landscape have lost their leaves. In front of the wooden fence, the men dig holes for each sapling, driving in posts to which the young trees are then tied. Such practical advice on good husbandry is accompanied by a more lighthearted detail: a thirsty worker drinking from a flask. Meanwhile, a mature tree is desperately clinging onto the riverbank, where some of its roots have been exposed by erosion.

Then as now, trees were celebrated as protectors against erosion, their roots holding the soil in place to prevent it being blown or washed away in vulnerable locations. This charming depiction of planting trees in the countryside bears a resemblance to medieval paintings of agricultural tasks that were associated with the different seasons of the year and is also reminiscent of calendars for religious observances at the time. In fact, the painting was created by an unknown Flemish artist sometime in the mid-eighteenth century for more secular purposes – and reflected the

Enlightenment then sweeping Europe. Inspired in part by French philosopher Denis Diderot's comprehensive *Encyclopédie*, published in seventeen volumes between 1751 and 1765 (and later extended to thirty-five volumes), Europeans set out to catalogue and spread humans' practical wisdom – as in this painting – based on the idea that humanity had the agency to change its own world rather than having to rely solely on divine ordination.

Stanley Roy Badmin and Brian Vesey-Fitzgerald

The Ladybird Book of Trees, 1963
Printed book, 18 × 11.5 cm / 7 × 4½ in
Private collection

This book cover showing a horse chestnut tree (*Aesculus hippocastanum*) in full bloom with a towering poplar (*Populus* genus) and a weeping willow (*Salix babylonica*) in the background will be familiar to a generation of British readers, if not in terms of this specific volume then as a representation of the renowned 'Ladybird' series of educational books for children. The 'Ladybird' series was first published in 1914, but it gained widespread popularity only after World War II. Covering all aspects of postwar life, both fiction and nonfiction, the 'Ladybird' series made information readily accessible for children growing up in Britain, in an era long before the Internet. The books, which remain in print today, provided information all in the same format: each spread featured an illustration accompanied by a brief description. For this 1963 volume, naturalist Brian Vesey-Fitzgerald (1900–1981) described the characteristics of forty-six different trees, including their distribution across the British Isles and tips on how to identify them. The description of each tree was paired with a painting by English artist Stanley Roy Badmin (1906–1989). Both were acknowledged experts in their fields, highlighting the seriousness with which the series took its role of imparting information to its readers. Small enough to be popped into a pocket or backpack on a walk, the books were notable for their unique size: each measured 18 by 11.5 centimetres (7 by 4½ in), a format that remained unchanged for decades. Originally determined by wartime economics, the format was first introduced in 1940, when World War II was causing shortages of key resources such as paper – each 'Ladybird' book could be made from a standard printing sheet, folded into fifty-six pages, with no waste.

Tiffany Studios

Laburnum table lamp, c.1910
Leaded glass and patinated bronze, 81.3 × 54.6 cm / 32 × 21½ in
Private collection

Easily recognized by its glorious scented yellow flowers, which cascade down in golden streams, the laburnum (*Laburnum anagyroides*) is the subject of this stained glass Art Nouveau table lamp made by Tiffany Studios, the illustrious American design house of Louis Comfort Tiffany. Inspired by his travels in Europe and North Africa, Tiffany set about developing a new style of glassmaking to showcase his love of trees and plants. For this lamp, he used different shades of yellow to re-create the laburnum's delicate flowers, while the tree's leaves are rendered in

different greens and its branches in a reddish brown. With the help of a skilled English glassworker, Arthur Nash, Tiffany developed a technique whereby he blended different colours of pigment together while the glass was still molten. This allowed him to achieve subtle effects of shading, opalescence and intensity of colour to create rainbows of light. The laburnum – with its distinctive yellow – was particularly suited to the technique, which Tiffany named Favrile, from an Old English word, *fabrile*, which means 'hand-wrought'. The pieces of glass were soldered together

with a fusing technique that used lead and other alloys to create precise and complex designs, allowing for the curved shape of the lampshade. Tiffany – the son of the founder of the eponymous jewellers – also created stained glass windows and, with a large atelier, expanded into ceramics, jewellery, enamels, metalwork and glass mosaics, particularly for fireplaces and church interiors. However, he remains best known for his iconic, elegant lamps, which remain highly sought-after.

Laure Albin-Guillot

Bud from an Ashtree, from *Micrographie Décorative* (*Decorative Photo-Micrographs*), 1931
Photogravure, 27.5 × 21.5 cm / 10¾ × 8½ in
Museum of Modern Art, New York

This seemingly abstract image is, in fact, a cross section of the bud of an ash tree. The work of French photographer Laure Albin-Guillot (1879–1962), the image was produced from a negative that was transferred onto a metal plate and etched to create this spectral effect. Albin-Guillot's career began at just eighteen years old, when she was married to scientist and microscopy specialist Dr Albin-Guillot. Her husband encouraged her interest in microscopic images, and she became the first person in France to photograph objects through a microscope, an approach she called

micrographie. Something of a pioneer for women in the workplace, in 1931 – the same year she produced this photogravure – Albin-Guillot also became president of the *Union féminine des carrières libérales et commerciales*, an organization that supported working women. Her mastery of technology led her to combine science with art in her photographs, producing works that included animal organisms, microscopic specimens and, as here, plant cells. The ash tree has long been sacred in many cultures, including to the Druids of ancient Europe, who believed it

could ward off evil spirits. A hardwood, ash is prized for its longevity and for its strength, making it ideal for making furniture and sports equipment such as hockey sticks. Albin-Guillot's micrographs stand alongside her wider photographic cannon of fashion models – she was published in French *Vogue* – and celebrities, for whose portraits she remains better known.

Jason Ingram

Westonbirt Arboretum, 2017
Photographs, dimensions variable

Award-winning British photographer Jason Ingram (b. 1968) has captured the leaves, berries, buds and fruit of nine common species of British trees found in the Westonbirt Arboretum in Gloucestershire, England. The arboretum is home to 15,000 specimens from 2,500 species of trees from around the world, spread across 240 hectares (600 acres) of parkland. Now managed by Forestry England, the arboretum originally belonged to a wealthy Victorian landowner, Robert Holford, who created it in 1829 specifically to showcase the species collected by the global plant-hunting expeditions he sponsored. These examples are widely seen across the British Isles, where they are all thriving, with the exception of the common ash (*Fraxinus excelsior*, bottom right). Ash dieback, a disease caused by the fungus *Hymenoscyphus fraxineus*, first infected ash trees at Westonbirt in 2015, and it now threatens the ash's survival across the United Kingdom. The blackthorn (*Prunus spinosa*, top left), crab apple (*Malus sylvestris*, bottom centre), walnut (*Juglans regia*, centre left), hazelnut (*Corylus avellana*, bottom left) and sweet chestnut (*Castanea sativa*, top right) are popular trees for foraging: the hard, dark berries of the blackthorn – sloes – are picked to make sloe gin; crab apples are turned into crab apple jelly, while collecting chestnuts remains a favourite autumn activity for children who use them to play conkers. Also shown are the common hornbeam (*Carpinus betulus*, top centre) – commonly used as an ornamental tree – the wayfaring tree (*Viburnum lantana*, centre) with its bright red berries and the hawthorn (*Crataegus monogyna*, centre right), which is known for the rather unpleasant smell of its blossoms.

Jordan Casteel

Magnolia, 2022
Oil on canvas, 2 × 1.5 m / 6 ft 6 in × 5 ft
Private collection

The upright flowers of a vibrant pink-and-white magnolia tree seem to hover at eye level, the ground beneath strewn with fallen petals. A branch bears down towards the viewer, as though the magnolia is offering up the blossoms, in beautiful contrast to the scaly grey bark and hazy greenery in the background. The dispersed flowers and bare branches indicate a spring scene, and the tree here is probably a saucer magnolia (*Magnolia × soulangeana*), a hybrid that flowers in mid and late spring, mostly before the leaves appear. Magnolias can be deciduous or evergreen,

ranging in size from small shrubs to large trees, and mostly prefer neutral or acidic soil. The tree was cultivated in China and Japan as far back as the seventh century and was introduced to Europe a thousand years later. Although there is perhaps a suggestion of Japanese artistic tradition and an engagement with Vincent van Gogh's *Almond Blossom* (1890, see p.11), this work is by contemporary American painter Jordan Casteel (b. 1989). Casteel rose to prominence on the New York art scene with her first solo exhibition, 'Visible Man', in 2014, which consisted of nude

Black men in domestic interiors. Known for challenging conventional depictions of Blackness, much of her work focuses on portraits of people from the communities where she lives and works, including neighbours from Harlem, classmates from Yale and her own students from Rutgers University in Newark, New Jersey. As shown in *Magnolia*, in recent years Casteel has expanded her practice to incorporate still lifes of everyday objects and outdoor scenes, from a pair of Crocs in the garden to a profusion of flowers in a vase.

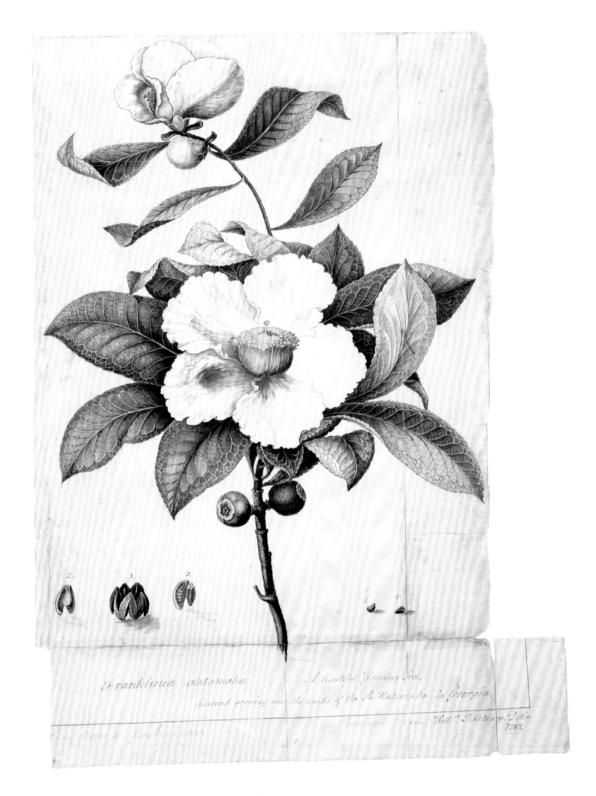

William Bartram

Franklinia alatamaha: A Beautiful Flowering Tree Discovered Growing Near the Banks of the R. Alatamaha in Georgia, 1788
Coloured engraving, 47.8 × 35.8 cm / 18¾ × 14 in
Natural History Museum, London

The renowned American botanical gardener and natural historian William Bartram (1739–1823) drew this branch of the Franklin tree in full leaf – its open camellia-like flower revealing the large petals and mass of stamens, with two spherical fruits below – in 1788, at a time when its namesake, Benjamin Franklin, was still alive. Bartram and his father, John, were two of the most important plant-hunters of colonial America. They are considered the first botanists of the young republic, and the Bartram estate, on the west bank of the Schuylkill River in Philadelphia,

is recognized as the first botanic garden in the United States. William and John encountered this American relative of the camellia in a 1.2-hectare (3-acre) grove not far from the Altamaha River near Fort Barrington, Georgia, in October 1765. They named it *Franklinia alatamaha* after Franklin, who was a friend of John's. The tree is now extinct in the wild, the last reliable sighting having taken place in 1790, but it still exists in cultivation thanks to seeds collected by William (illustrated at the foot of the drawing). In cultivation the small tree suckers freely, and

the deciduous leaves turn a deep red in the autumn. The original drawing was commissioned by the English apothecary and physician Dr John Fothergill; after Fothergill's death, it may have been sent to his friend John Coakley Lettsom, who catalogued Fothergill's garden.

William Jowett Titford

Plate 2, from *Sketches Towards a Hortus botanicus americanus*, 1811
Coloured engraving, 29.5 × 23 cm / 11½ × 9 in
Wellcome Collection, London

Displaying twenty-eight species, this charming botanical illustration is perhaps a departure from the more scientifically rigorous style of the nineteenth century, but it provides a remarkable documentation of American plant species. The illustration was included as one of seventeen plates by physician William Jowett Titford (1784–1823) in what is thought to be his only publication, *Sketches Towards a Hortus botanicus americanus*, published in six parts between 1811 and 1812. Born in Jamaica and raised in England by his uncle, Titford returned to his home country in 1802. Little is known of his life,

but he travelled extensively in the Americas and described himself as a corresponding member of the Society for the Encouragement of Arts. In addition to his illustrations, Titford's catalogue contained descriptions of many valuable plants of North and South America and the West Indies, as well as several others that are native to Africa and the East Indies, including native and introduced plants. Here, the top row includes, on the left, a calabash tree (*Crescentia cujete*), whose large fruits are used to make bowls, and at right a pomelo (*Citrus maxima*), the largest fruit of the genus. Next to this is a cocoa

plant (*Theobroma cacao*), while the large tree in the centre is a cotton tree (*Bombax ceiba*). Other notable species depicted in the centre row are breadfruit (*Artocarpus altilis*), whose large fruits are eaten in many tropical regions (left), flanked by maize (*Zea mays*), coconut (*Cocos nucifera*), pumpkins, a wild yam (*Dioscorea villosa*), the cereal sorghum (*Sorghum bicolor*) and a jackfruit (*Artocarpus heterophyllus*). On the bottom row, from left to right, are, among others, banana (*Musa paradisiaca*), papaya (*Carica papaya*), mango (*Mangifera indica*) and a huge ants' nest encircling a breadfruit tree.

Alan Fletcher

Barbados Palm Trees, 1995
Pen and ink, 60 × 40 cm / 23½ × 15¾ in
Private collection

This playful and stylized representation of palm trees is the work of Alan Fletcher (1931–2006), one of the most influential figures in British graphic design after World War II. His original approach to aesthetics combined European traditions with North American pop culture and was known for its witty slant. A founder of the design firm Pentagram, Fletcher shaped the look and feel of countless projects, ranging from books, posters and magazines to memorable corporate identities – each rendered with unusual inventiveness. Fletcher's designs often involved

reworkings of familiar objects, through which he explored the expressive potential of colour and form to the fullest. Which essential traits make a tree recognizable at just a glance? In this representation of palm trees, Fletcher opted for a radical and almost minimalist approach, steering clear of the clichés of tropical paradise imagery. Without turning to the descriptive powers of realism, he sampled the typical curvature of palm trees' trunks to convey a sense of arboreal harmony and peace. The fronds, flattened and stretched out, express the neat clarity of a collaged image,

emphasizing a desire to interpret rather than accurately document. And yet, despite his radical rendition of vegetal form, these trees can be accurately identified as foxtail palms (*Wodyetia bifurcata*). Highly recognizable because of their distinctively banded trunk, foxtail palms originate from Australia. The trees were first encountered in a remote location in Queensland relatively recently, in 1978, by an Aboriginal man named Wodyeti, from which the tree's name derives, and it has quickly become a landscaping fixture in warm climates around the world.

1. Ficus grandaeva. 18. Ficus spec. 13. Cecropia peltata. *(Moraceen.)* — 2. Monstera deliciosa. 10. Philodendron Wendlandii. 20. Anthurium reflexum. 23. A. Scherzerianum. 21. Xanthosoma violaceum. *(Araceen.)* — 3. Passiflora racemosa. 17. Carica Papaya. *(Passifloraceen.)* — 4. Chamaedorea oblongata. 5. Phytelephas macrocarpa. 14. Mauritia flexuosa. 15. Euterpe oleracea. *(Palmen.)* — 6. Epidendrum vitellinum. 7. Phalaenopsis Aphrodite. 8. Oncidium ampliatum. 19. O. Harrisonianum. 25. Cattleya Mendelii. 26. Dendrobium densiflorum. *(Orchideen.)* — 9. Begonia rex. *(Begoniaceen.)* — 11. 12. Alsophila spec. 24. Nephrodium spec. *(Farne.)* — 16. Bauhinia spec. *(Caesalpiniaceen.)* — 22. 27. Cordyline spec. *(Liliaceen.)* — 28. Tillandsia usneoides. *(Bromeliaceen.)*

H. Eichhorn

Plants of the Rainforest, 1898
Chromolithograph, 24 × 30 cm / 9.4 × 11.8 in

Brimming with meticulous detail, this botanical illustration showcases the rich and diverse plant life found within the world's rainforests. An array of tree species, ferns, climbing plants and radiant flowers inhabit this unspecified ecosystem, each one portrayed and labelled with scientific accuracy. Prominent in the foreground is a huge *Ficus grandaeva*, its thick buttress roots and trunk wrapped with wide-leaf cordylines, *Monstera deliciosa* and evergreen climbers. Fig trees are common to rainforests, and on the right is the parasitical strangler fig (*Ficus* sp.), its aerial roots having descended to the forest floor and wrapped themselves tightly around its host's trunk. Palms are another tropical staple, and in the foreground, to the left, is the small, single-stemmed *Phytelephas macrocarpa*, known for its large white seeds contained in clusters of spiky fruits that were once used for making buttons and ornaments. In the distance, against a hazy sky, are the tall and slender forms of three acai palms (*Euterpe oleracea*), a species native to Brazil and cultivated for its antioxidant-rich berries. Beneath these are the distinctive rounded crowns of the tall, swamp-loving moriche palm (*Mauritia flexuosa*) rising above an invasive trumpet tree (*Cecropia peltata*). This illustration was first published in 1898 based on the original painting by H. Eichhorn, a German illustrator active during the late nineteenth and early twentieth centuries. Little is known about Eichhorn's career, other than that he specialized in botanical subjects and his work was featured in several books by German publisher Hermann Julius Meyer and by scientist Otto Warburg.

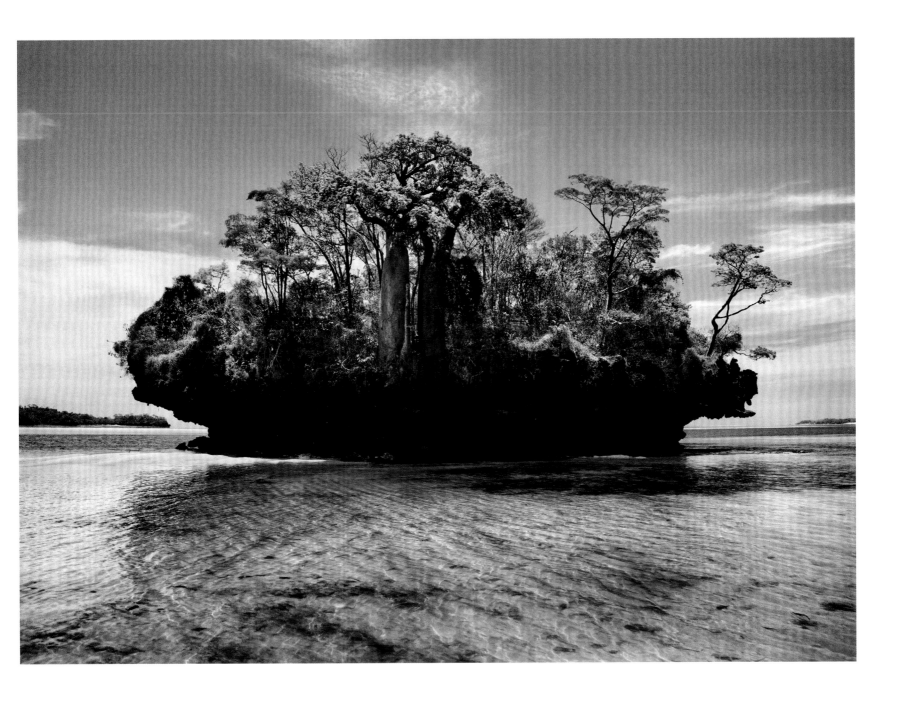

Sebastião Salgado

Baobab Trees on a Mushroom Island in Bay of Moramba, Madagascar, 2010
Photograph, dimensions variable

Two giant baobab trees dominate the dense tropical foliage in this black-and-white photograph of a mushroom island located in Madagascar's Bay of Moramba. The work of prolific Brazilian photographer Sebastião Salgado (b. 1944), who is perhaps best known for his unflinching photographs of humanity's degradation of nature, this image pays homage to the remarkable tree. A prehistoric genus that predates humankind, the baobab is widespread in Madagascar and Africa, and has been introduced to parts of Asia. Commonly known as the tree of life because

of its importance to animal and human communities, the baobab absorbs water during the rainy season and stores it in its huge trunk, which can expand to a circumference of up to 25 metres (82 ft). Every part of the tree has many uses: its fruit can be eaten, dried and pulped into liquid, and its bark can be turned into rope, paper and wood for shelter. A succulent, it is one of the longest-lived of all plants, living for more than a thousand years, and one of the tallest, reaching up to 24 metres (80 ft) high. Six of the nine species of baobab are native to Madagascar, where

Salgado shot this image in 2010 as part of *Genesis*, a project he undertook between 2004 and 2011 to photo-graph the world's unique ecosystems. His intention was to capture the unblemished face of nature before it was too late. His timing was prescient: since the start of this century, baobabs in southern Africa have been dying for as yet unknown reasons.

Anonymous

Textile fragment with pomegranate tree, 6th–7th century CE
Polychrome wool and undyed linen on undyed linen, 87 × 62 cm / 34¼ × 24½ in
Musée du Louvre, Paris

A stylized pomegranate tree laden with jewel-red fruit adorns this textile fragment, formed of tapestry weave on a ground of undyed linen. At the time it was made in the sixth or seventh century CE, images of the pomegranate were widely hung in houses, either as tapestries on walls or across doorways. Pomegranates (*Punica granatum*) have a rich history, ranging from Greek mythology to Zoroastrianism, the ancient religion of Iran, and are present in Judaism, Buddhism, Christianity and Islam. In Greek myth, the most famous story involves Hades' abduction of

Persephone, in which the pomegranate represents marriage and regeneration. When Hades takes Persephone to the Underworld to be his wife, she makes the mistake of eating three pomegranate seeds, which ties her to Hades for autumn and winter, thus creating the seasons. Roman brides wore wreaths woven from pomegranate leaves, a clear reference to fertility, and the fruit was also sacred to Venus. Pomegranate trees are native to Iran and Afghanistan, and in Zoroastrian lore, the hero Isfandiyar eats a pomegranate and becomes invincible. The fifth-century BCE Greek

historian Herodotus mentions gold pomegranates embellishing the spears of Persian warriors. In Jewish tradition, the pomegranate is said to have 613 seeds, signifying the 613 commandments of the Torah. Along with the citrus and the peach, the pomegranate is one of the three blessed Buddhist fruits, and in China, where it is a popular wedding present, it symbolizes fertility. In Christianity, the fruit is a symbol of resurrection, often found in images of the virgin and Christ child, and in Islam, legend holds that each pomegranate contains one seed from Paradise.

Pietro Fenoglio

Portone del Melograno, 1907
Wood and wrought iron
Turin, Italy

Festooned with green leaves and round red fruit, this ornate doorway is celebrated as one of the most spectacular in the Italian city of Turin. Its large wrought-iron design set in an elegantly carved wooden frame features two fruiting pomegranate trees, the sinuous branches of which twist and curve in fluid, asymmetrical shapes. Nicknamed the Portone del Melograno (Pomegranate Door) by local residents, it is located at number 4 Via Argentero in the popular San Salvario district of Turin, an area known for its pulsating nightlife. The highly stylized

imagery belies the stiff, spiny branches of an actual pomegranate tree (*Punica granatum*), which starts off as a shrub and slowly grows into a hardy, long-living tree that can reach between 5 to 10 metres (16 to 33 ft) in height. Its nutrient-rich fruit contains a white inner flesh packed with juicy, jewel-like seeds known as arils, which burst with flavour when ripe. The doorway was created in 1907 for a private residence by the Italian architect and engineer Pietro Fenoglio (1865–1927), an important pioneer of Art Nouveau in Italy, where it was known as *Stile Liberty* in

reference to the London merchants Liberty & Co., whose richly decorated textiles and ornaments imported from Asia became synonymous with the style. Under Fenoglio's influence, Turin developed into a major site for architectural expressions of the Liberty style, and many examples of the architect's nature-inspired designs can still be seen across the city.

ILEX Aquifolium

HOUX Commun. *pag.1.*

Redouté pinx!

Pierre-Joseph Redouté

Ilex aquifolium, Houx Commun, from *Traité des arbres et arbustes que l'on cultive en France en pleine terre*, 1801–19
Printed illustration, 50.4 × 32 cm / 20 × 12¾ in
New York Public Library

Nicknamed the Raphael of Flowers, Pierre-Joseph Redouté (1759–1840) has been called the greatest and most popular botanical illustrator of all time. A painter and botanist from Belgium, Redouté was best known for his watercolours of roses, lilies and other flowers, which he drew for numerous courtly patrons – including both Marie-Antoinette and Napoleon's two wives – having survived the turbulent political upheaval of the French Revolution. Combining great artistic skills with a pleasing personality, which assisted him with his influential patrons, he gained international recognition for his precise renderings of plants, which remain as fresh now as when first painted. Here, Redouté's painting of a sprig of European holly (*Ilex aquifolium*) occupies an entire page of the eighteenth-century French book *Traité des arbres et arbustes que l'on cultive en France en pleine terre* (*Treatise on Trees and Shrubs Grown in France in the Open Ground*) written by Henri-Louis Duhamel du Monceau, published in seven volumes from 1801 to 1819. It is one of a series of beautifully observed close-up images of plants. The holly leaves are dark grey-green, with bright red berries clustered near the stalk, given depth by shadows and sharp prickles against a white background. Holly is a small, distinctive, dioecious tree that grows to about 15 metres (49 ft) high. It has characteristic spiny leaves that are tough, glossy and dark green, each with several sharp thorns. Female trees have clusters of scarlet red berries that ripen from October onwards and often stay on the branches throughout the winter, giving a splash of colour, which is why they have become a familiar symbol of the holiday season in the northern hemisphere.

Bryan Nash Gill

Red Acorn, 2013
Ink on paper, 96.2 × 71.1 cm / 37⅞ × 28 in
Private collection

Encapsulating a profound connection with nature and an innovative approach to printmaking, *Red Acorn* holds a significant place in the body of work of American artist Bryan Nash Gill (1961–2013). This striking piece, like many others by Gill, is a direct print of a tree trunk, in this case a bifurcated oak. *Red Acorn* is a prime example of Gill's relief printing technique, which involved applying ink straight to the stump's surface and then pressing a sheet of paper onto it to preserve its faithful imprint. By using found natural materials as his subjects, Gill's work became a statement on the importance of environmental sustainability in art-making today. With each print, Gill attempted to capture a tree's essence, portraying the unique shape, character and experience of each individual tree. Recounting the passage of the seasons and the events that a tree has lived through, each concentric line visible in a tree stump marks a winter, and each band between two winters is a growth cycle encompassing spring and summer. Tree rings have become an important record of historical climates, documenting rainy seasons, droughts, past temperature patterns and significant events in a tree's life cycle, such as forest fires, insect infestations, structural damage and even if surrounding trees have been felled. Dating back hundreds, sometimes thousands, of years, these histories provide vital information about climate change. Spanning nearly forty years of growth, *Red Acorn*, as with other works by Gill, preserves the tree's history as written by the tree itself.

Anonymous

Codex Fejérváry Mayer, before 1521
Gesso and paint on deer hide, 17.5 × 17.5 cm / 6¾ × 6¾ in
World Museum, Liverpool, UK

Offering a unique insight into the Aztec belief system, this deerskin parchment – once held in a library of the Aztec capital city of Tenochtitlan, in present-day Mexico – is a rare survivor from the sixteenth-century Spanish conquest and destruction of the Aztec Empire. The first of twenty-three pages in an accordion-style book, or codex, this image illustrates the sacred calendar – *tonalpohualli* – of the Aztecs. The world is divided into five parts by four T-shaped trees at each of the cardinal directions. At left, representing the north, is a spiny tree, possibly a cactus;

at top stands a flowering blue tree for the east; at right, for the south, is a cacao tree, ripe with pods; and at the bottom is a maize plant taking the form of a tree, signifying the west. The fire god, Xiuhtecuhtli, holding spears and brandishing a spear thrower, or *atlatl*, stands in the middle of the page to reflect his position at the centre of the cardinal directions. In Mesoamerican mythology, each cardinal point has five signs attributed to it, including a tree or plant, such as the cactus and Xochitl flower, as well as different birds and animals, all of which were sacred to

the Aztecs. Each cardinal direction also represents one of the four preceding eras of creation and destruction. The Aztecs believed they were living in the fifth and final era, here represented by the centre. The Aztecs had two calendars: the sacred calendar of 260 days and an agricultural calendar, which had 365 days. Every fifty-two years (the length of each cycle of life), the two calendars coincided. To renew life and stop the world from ending, the Aztecs believed a great fire had to take place.

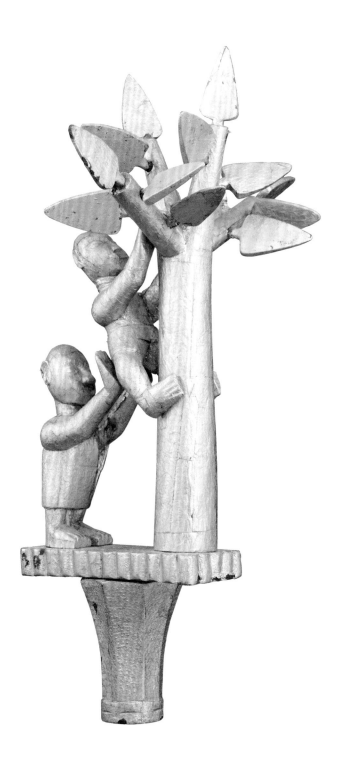

Anonymous

Linguist staff (*okyeame poma*), first half of 20th century
Wood and gold leaf, 160 × 24.7 × 20.3 cm / 63 × 9⅞ × 8 in
Dallas Museum of Art, Texas

'One who climbs a good tree always gets a push,' says an old Asante proverb. This black wood linguist staff showing a tree in leaf and two figures, finished with gold foil, was made in the first half of the twentieth century by an unknown craftsman. Carved separately, assembled and then fastened with dowels, it embodies the Asante belief that chiefs who act fairly will be supported by their people. The matrilineal Asante civilization, located in modern-day Ghana, dates from the 1670s. From the seventeenth century onwards, European trading companies

often presented ceremonial canes – similar to the canes used by a military parade – to the different rulers of West Africa's Gold Coast. Over time, these canes acquired significance as a means of communication between the European traders and the local chiefs. The Asante took the canes and reinterpreted them for their own needs. The Asantehene (the ruler of the Asante Empire) and his leading chiefs each had several official spokesmen or linguists (*akyeame*) who were experts in Asante laws and customs. Each officer had a staff, in effect a badge of office, that

was often carried in public processions and used by them to convey a chief's message to the people. To that end, the gold-leaf covering was significant: gold represented royalty. Similarly, the type of finials used conveyed the rank and status not only of the sender of the message but also of the message's contents and importance.

Guy Edwardes

Fig leaf (*Ficus carica*), 2009
Photograph, dimensions variable

Shown in spectacular detail, a close-up image of the magnified leaf structure of the fig tree (*Ficus carica*) clearly displays the leaf's midrib, the thick single vein that runs along the midline of the leaf from which the larger and smaller veins radiate. British photographer Guy Edwardes (b. 1974) photographed this small section of the middle of a waxy green leaf in Dorset, England. While the fig tree might be more usually associated with warmer climes, such as those found in its native Mediterranean and western and southern Asia, it has long grown successfully in the cooler British climate as a small deciduous tree with its eponymous edible fruit. The veins of the leaf carry food and water, while acting as a structure to support the rest of the leaf, allowing them to grow to their noteworthy size. Unseen here are the microscopic pores, or stomata, located on the leaf's underside – the fig is thus described as hypostomatic, as opposed to amphistomatic, where stomata appear on both sides of the leaf. Leaves primarily function to make food for the tree: the stomata absorb water and carbon dioxide from the atmosphere, which is then converted into glucose, a sugar molecule, through photosynthesis. Oxygen is released into the air as a by-product of the process and the glucose is transported through the veins on the upper side of the leaf through the plant's other vascular tissues – xylem and phloem – to the rest of the tree. Today, there are more than 750 species of *Ficus*, which continue to play a vital role in the modern ecosystem, from stopping soil erosion to providing food for humans, birds and animals.

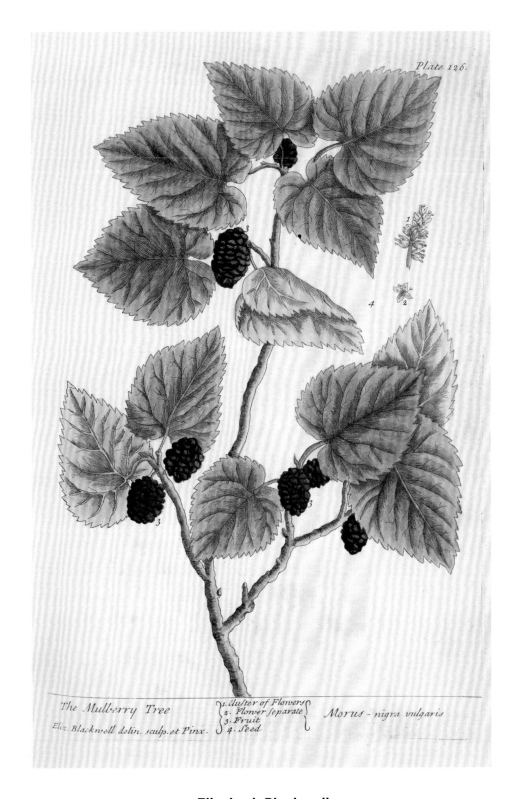

The Mulberry Tree, from A Curious Herbal, 1737–39
Hand-coloured etching and engraving, 36.8 × 23.5 cm / 14½ × 9¼ in
Missouri Botanical Garden, Peter H. Raven Library, St. Louis

Elizabeth Blackwell

The rich reddish-purple berries of a black mulberry tree (*Morus nigra*) dangle from its branches in this illustration from *A Curious Herbal*, first published in 1737–39 in several parts. The work of English botanical illustrator Elizabeth Blackwell (1699–1758), the herbal contained five hundred drawings of useful medicinal plants, many with hand-coloured plates. Blackwell took over production of the book from her husband after he was sent to debtors' prison. At the suggestion of the Chelsea Physic Garden's chief gardener, Philip Miller, and Sir Hans Sloane, Blackwell took lodgings close to the garden in London, which was founded to promote the growing of medicinal plants. She visited the garden frequently to draw its plants, including a black mulberry that had been planted before the seventeenth century. Spotting a gap in the market, Blackwell also included new species recently introduced to Britain from the Americas, and the herbal was a huge commercial success. Blackwell's earnings freed her husband from prison, but he returned to his wayward habits and was later executed for his part in a political conspiracy. A non-native species, the black mulberry was introduced to Britain by the Romans, who used its fruit to treat gastrointestinal illnesses and to make jam. The trees were subsequently planted in the infirmary gardens of medieval monasteries, but when King Henry VIII broke from the Catholic Church in the early 1530s and closed the monasteries, many were lost. Related members in the Moraceae family include paper mulberry (*Broussonetia papyrifera*) – which has been used in the Pacific Islands to make barkcloth since ancient times and has been cultivated in Asia since the first century CE for papermaking – and white mulberry (*Morus alba*), the primary food source for silkworms.

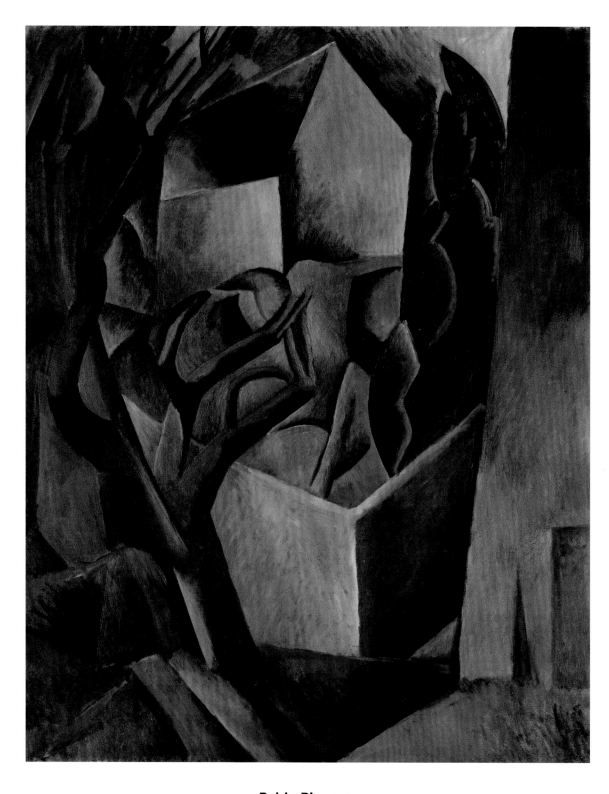

Pablo Picasso

House in the Garden (House and Trees), 1908
Oil on canvas, 92 × 73 cm / 36¼ × 28¾ in
Pushkin State Museum of Fine Arts, Moscow

This stunning example of early Cubism by Spanish artist Pablo Picasso (1881–1973) presents a highly stylized interpretation of a house surrounded by trees. In this canvas, the trees serve as a visual anchor, framing the composition and providing a sense of balance and structure to the scene, while adding a sense of atmospheric pathos. The image is ambiguous, the mood stern. Early Cubism, a style invented by Picasso in collaboration with French painter Georges Braque, was fundamentally concerned with the non-objective representation of space and the coexistence of multiple viewpoints and perspectives on the same canvas. These ideas were pioneered by French impressionist painter Paul Cézanne, who was known for his exploration of form and composition, and often depicted trees in his paintings as solid, geometric shapes, as well as other stylized forms in his landscapes (see p.148). Picasso, in his Cézanne-inspired landscapes, adopted this approach and portrayed trees as simplified, almost sculptural elements. Amid the humble and unassuming scene focusing on a small house, the trees stand tall, a solemn and imposing presence. This juxtaposition between the man-made structure and the essence of trees highlights the timeless quality of nature. The painting was made in 1908 during Picasso's stay at La Rue-des-Bois, a small village in northern France, and was exhibited in Paris late that year among others in the same style. The exhibition, which also featured works in a similar style by Braque, contributed to the recognition of Cubism as a new and important avant-garde movement and solidified Picasso's position as an influential artist.

Paul Strand

Driftwood, Gaspé, 1929
Gelatin silver print, 24.4 × 19.4 cm / 9¾ × 7¾ in
Philadelphia Museum of Art

Smoothed by decades of erosion and ocean waves, an almost sculptural piece of driftwood completely fills the frame, the interplay of light and shadows on its knotted form extending beyond the photograph's edges. Probably better known for sleek black-and-white photographs of the United States that captured the country as it modernized during the first half of the twentieth century, Paul Strand (1890–1976) – hailed as the father of modern American photography – was also an ardent documenter of the natural world. Here, the influence of modern

sculpture and painting is clearly visible in the close-up perspective with which he's chosen to capture the driftwood, beautifully illuminating the varied tones of the wood. In the mid-1920s, Strand frequently visited the home of his friend French sculptor Gaston Lachaise on Georgetown Island, Maine. It was there that he revelled in photographing nature – plants, tree trunks and, as here, pieces of driftwood – creating images that were as much works of art as pictorial records. Strand called these nature studies chiaroscuro, referring to the

contrast of light and dark tones, in a nod to the British art critic Clive Bell, whose 1914 book *Art* influenced Strand's approach to photography. The 1920s comprised a period of change in Strand's work as he came to appreciate and study in greater depth the natural environment around him, moving away from the industrialized and urban subjects that had made his name. Such was his love of nature that he eventually moved to France in 1950, where he concentrated on photographing his garden.

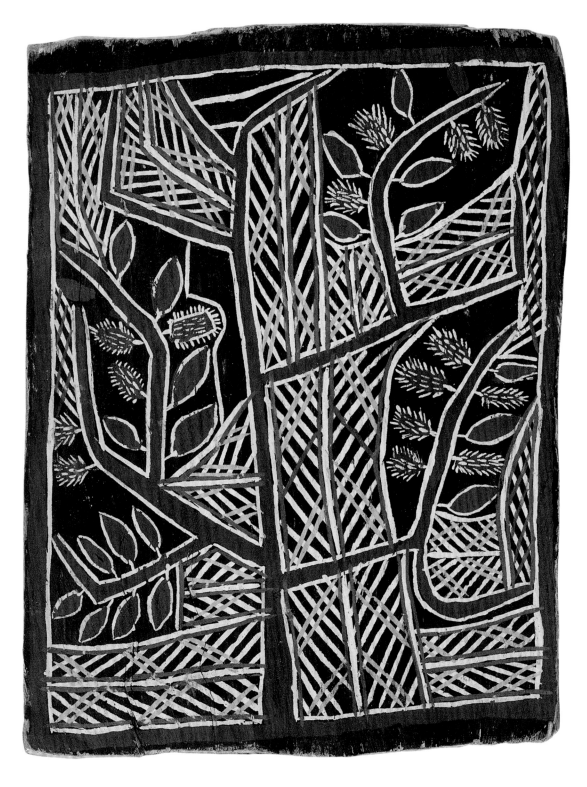

Anonymous

Tree, mid-20th century
Pigments on eucalyptus bark, 30 × 22 cm / 11¾ × 8½ in
Musée du quai Branly, Paris

To the Aboriginal peoples of Australia, the landscape comprises more than simply their geographic surroundings. There are places their ancestors traversed that are marked by songline walking routes and other features, where kinship is most potent. As part of this landscape, trees provide shelter, tools and medicine, are used in music and art, and play a spiritual role in Aboriginal culture. Specific trees are believed to possess protective properties and are involved in ceremonial rites of passage. Carved trees, too, are a vital form of visual communication, marking important places such as burials, initiation sites or boundaries. The tradition of bark painting is one way Aboriginal cultures have translated this complex, rich relationship with trees and the landscape into a remarkable art form. This bark painting of a tree was probably made in the mid-twentieth century by an artist of the Ingura people of Groote Eylandt (a large island off Arnhem Land's northeast coast), as indicated by its black background. The bark was likely cut from the stringybark tree (*Eucalyptus tetrodonta*) during the wet season, when the tree's high moisture content would have allowed its removal. The thin inner bark was then dried over a fire, after which the surfaces were scraped and flattened with weights. Traditional pigments came from kaolin, gypsum or chalk (white); iron oxide (red and yellow); and manganese oxide or charcoal (black), mixed with a binder of orchid juice, beeswax, fats, egg yolk or tree resin. Primary motifs for bark painting differ in the various regions of Arnhem Land but often include clan designs, geometric patterns, plants, animals or imagery from daily life.

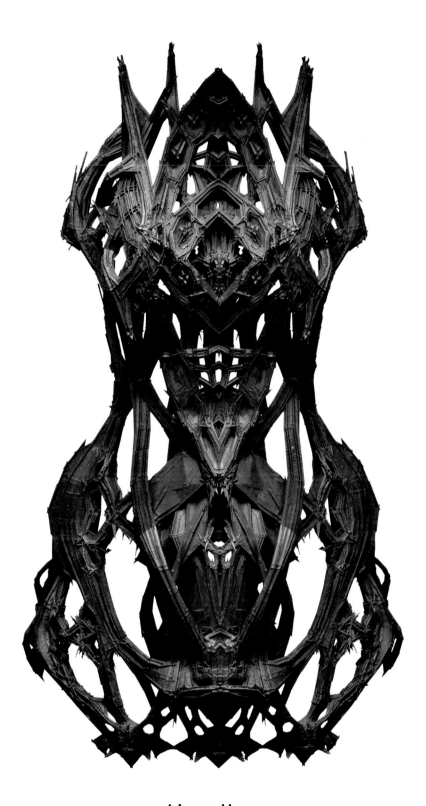

Iris van Herpen

Micro, 2012
3D-printed polyamide with copper-electroplating treatment, dimensions variable

This remarkable wooden skeleton might be reminiscent in many ways of the patterns of tree bark or the flying buttresses found in medieval European cathedrals, but, in fact, it draws on the cutting edge of technology and our understanding of the world to create something altogether modern: a sculptural dress. Dutch-born fashion designer Iris van Herpen (b. 1984) set out to make the invisible visible in her spring 2012 *Micro* collection, which was based on the world of microorganisms as revealed by leading British science photographer Steve Gschmeissner using

a scanning electron microscope, or SEM (see p.63). Van Herpen took Gschmeissner's revolutionary images and magnified them millions of times to create the shapes of her garments. She combined the latest 3D-printing technologies with handcraft techniques to design this intricate skeleton dress in collaboration with Belgium-based artist Isaïe Bloch. Van Herpen wanted to bring attention to research that shows microorganisms are increasingly significant to humankind's well-being. The choice of 3D-printing as a fashion technique reflects the foundation of van Herpen's

design philosophy: to create beautiful clothes that challenge preconceptions and constantly push boundaries. To that end, she has collaborated with architects, engineers and scientists – as well as milliners and shoe designers – in an attempt to help make fashion a sustainable force that considers its impact on the natural world. Here, the result is a dress that is a wearable work of art rather than a piece of disposable clothing.

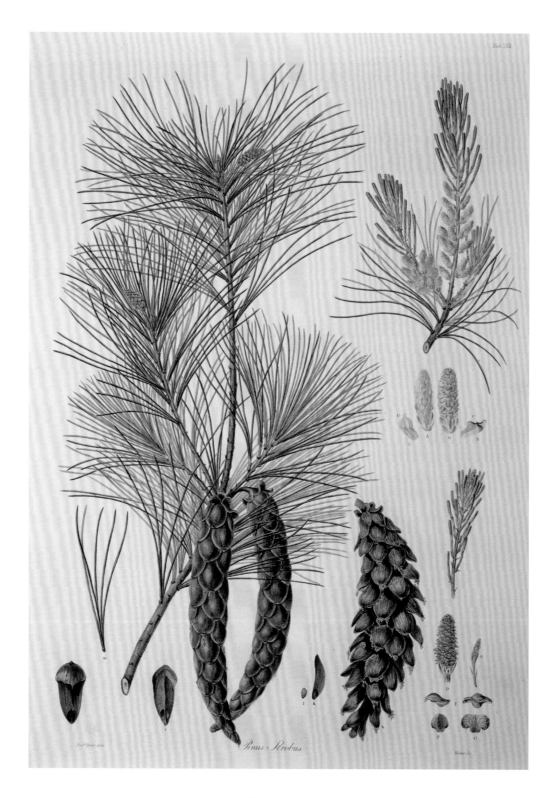

Ferdinand Bauer

Weymouth Pine (Pinus strobus), from *A Description of the Genus Pinus*, 1803
Coloured copper engraving, 55.3 × 42.8 cm / 21¾ × 16¾ in
Natural History Museum, London

Ferdinand Bauer (1760–1826) is generally acknowledged to be the finest botanical artist of the late eighteenth and early nineteenth centuries. Born in Feldsberg, Austria (now Valtice in the Czech Republic), on 20 January 1760, his father, Lucas Bauer, was court painter to the Prince of Liechtenstein. Little is known of Ferdinand's life, other than that he travelled extensively, most significantly on Matthew Flinders's circumnavigation of Australia on the HMS *Investigator* from 1801 to 1803. After observing that the true colour of specimens faded soon after death,

Bauer developed a referencing system, assigning each shade a four-digit number, meticulously recording the various codes on drawings in the field, then painting them in the studio. By the time he reached Australia, he had committed to memory more than a thousand shades from myriad types of plants. An obsessive perfectionist, Bauer's attention to detail is perfectly demonstrated in this botanical illustration of *Pinus strobus* found in Aylmer Bourke Lambert's *A Description of the Genus Pinus*, which included all known conifers at the time. Lambert, a British

botanist, was one of the first Fellows of the Linnean Society, and his book was published in several parts from 1803 to 1824. *Pinus strobus* once covered enormous areas in eastern North America and was used to make masts for ships; fine specimens are now comparatively scarce. The conifer was first called Lord Weymouth's Pine in the *Catalogus Plantarum* (1730) by London's Society of Gardeners – after the extensive planting of the species at Lord Weymouth's country seat in Longleat, Wiltshire, in England.

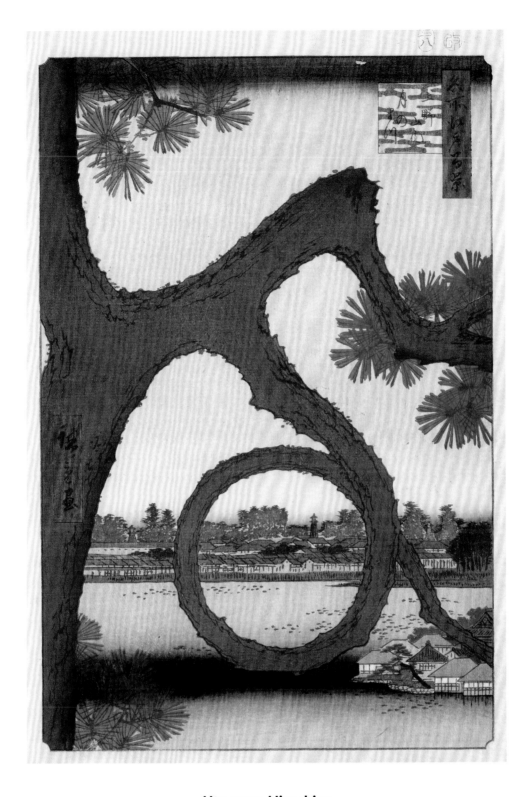

Utagawa Hiroshige

Moon Pine, Ueno, from 'One Hundred Famous Views of Edo', 1857
Woodblock print, 33.9 × 22.5 cm / 13½ × 9 in
Minneapolis Institute of Art, Minnesota

In the foreground of this woodblock print, dominating the image of a lakeside estate owned by one of Japan's great *daimyo*, or warlords, is a moon pine tree with a remarkable circular branch. The circular branch draws the viewer's eye to the lake, the estate on the far side and the collection of houses that appear on the right side of the scene. The tree's brown, contorted branches and green needles stand out against the pale blue sky and deeper blue water. The pine's artificially trained branches are spectacular and gigantic examples of the

art of bonsai. *Bonsai* translates literally to 'planted in a container', and typically refers to a single miniature tree grown as a replica of the full-size original. But here, Edo-era Japanese artist Utagawa Hiroshige (1797–1858) celebrates the application of a similar discipline to a real tree for a similar purpose to that of bonsai: quiet contemplation. Hiroshige's moon pine really existed, although not in the lakeside location where he places it but at a temple complex in Japan's ancient capital Edo (now Tokyo). It was damaged in a storm during the subsequent Meiji

era (1868–1912) but was restored in 2012. *Moon Pine, Ueno* belongs to Hiroshige's series 'One Hundred Famous Views of Edo'. The series of prints, created from 1856 to 1858, shows different scenes of the imperial capital and proved so successful that Hiroshige extended his views beyond the original 100 to a total of 118 prints.

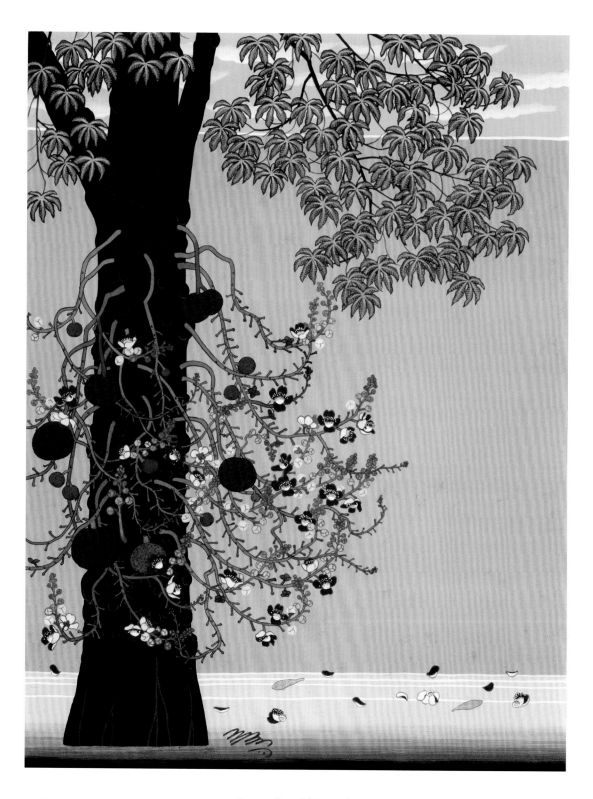

Arundhati Vartak

Kailashpati (*Cannonball Tree*), 1994
Poster colours on paper, 66 × 51 cm / 26 × 20 in
Shirley Sherwood Collection, London

Native to Central and South America and a member of the Brazil nut family, the cannonball tree (*Couroupita guianensis*) is captured by Indian artist Arundhati Vartak (b. 1958) in this portrait of one of the most unique trees in the world. Painted against a pale green background, the tree's colourful flowers – typically red or yellow on the outside and crimson or lilac on the inside – adorn long stalks that project directly from the trunk. Notable for their pleasant aroma, the large flowers' perfume is in stark contrast to that of its fruit. Similar in size and shape

to a cannonball – hence the tree's name – the mature fruit fall to the ground and break open, releasing a strong, fetid odour. The smell, however, does not deter native animal life from making a meal of the fruit. Inside are hundreds of seeds that pass through their digestive systems, protected by fine hairs surrounding the seeds. The animals excrete the germinated seeds to create the next generation of cannonball trees. Found principally in lowland forests around the Amazon Basin in South America, the species has been found as far north as

Panama and Costa Rica. Combining her deep understanding of Sanskrit literature and myth with her knowledge of the natural world, Vartak is best known for her portraits of trees in her native India. She follows the traditions of South Asian miniature paintings but crucially chooses to foreground and celebrate the trees that traditionally formed the background of miniature paintings. As Vartak says, 'When a tree puts on new leaves, Earth gets a fresh look and mankind a new hope.'

Kawahara Keiga

Pages from *Illustrated Album of Plants, Trees, Flowers and Fruits Drawn from Life*, early 19th century
Woodblock print, each page 30.1 × 19.3 cm / 11¾ × 8 in
Waseda University Library, Tokyo

A Persian silk tree (*Albizia julibrissin*), its distinctive pink flowers fanning out on the left, spreads its foliage across the pages of this early nineteenth-century botanical publication. It is one of four volumes of prints of Japanese plants, trees, flowers and fruits by Japanese artist Kawahara Keiga (c.1786–c.1860). An established artist, Keiga turned to botanical drawings after meeting German physician and botanist Philipp Franz von Siebold. Siebold, an enthusiastic naturalist, was stationed at Dejima, an artificial island off Nagasaki that operated as a Dutch trading post. It was the only place in Japan where trade with the West was permitted – the result of the Tokugawa shogunate's policy of *sakoku*, or 'closed country', that severely limited travel to and foreign trade with Japan between 1633 and 1853. Often created as part of scientific expeditions led by Siebold between 1823 and 1829, Keiga produced more than a thousand prints, drawing and colouring detailed and accurate images of Japanese flora and fauna for Western audiences. While impressed with Keiga's skill, Siebold also employed Dutch painter Carl Hubert de Villeneuve to instruct Keiga in Western painting techniques that would appeal to his potential buyers at home. The result was a new style of Japanese botanical drawing that combined Western scientific techniques with traditional Japanese painting. Keiga's illustrations represent one of the earliest systematic attempts to document plant life in Japan. The Persian silk, or mimosa, tree is a deciduous tree native to southwestern and eastern Asia, from Iran to China, Korea and Japan, where it thrives in the country's temperate climate. The flowers bloom in the summer, usually from June to August, and are known to attract a variety of pollinators.

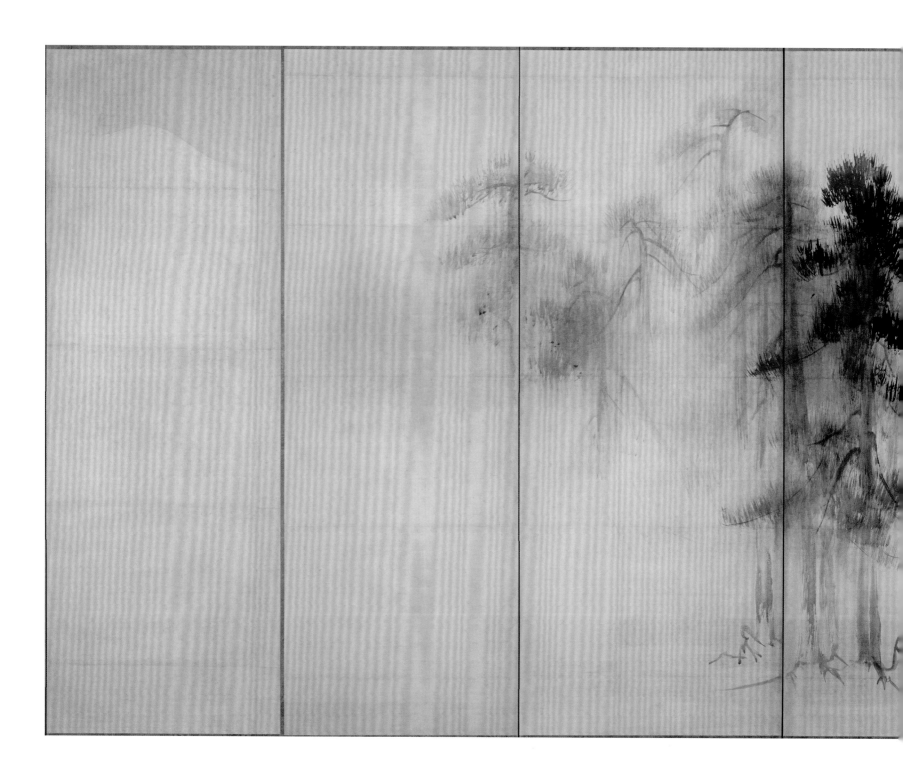

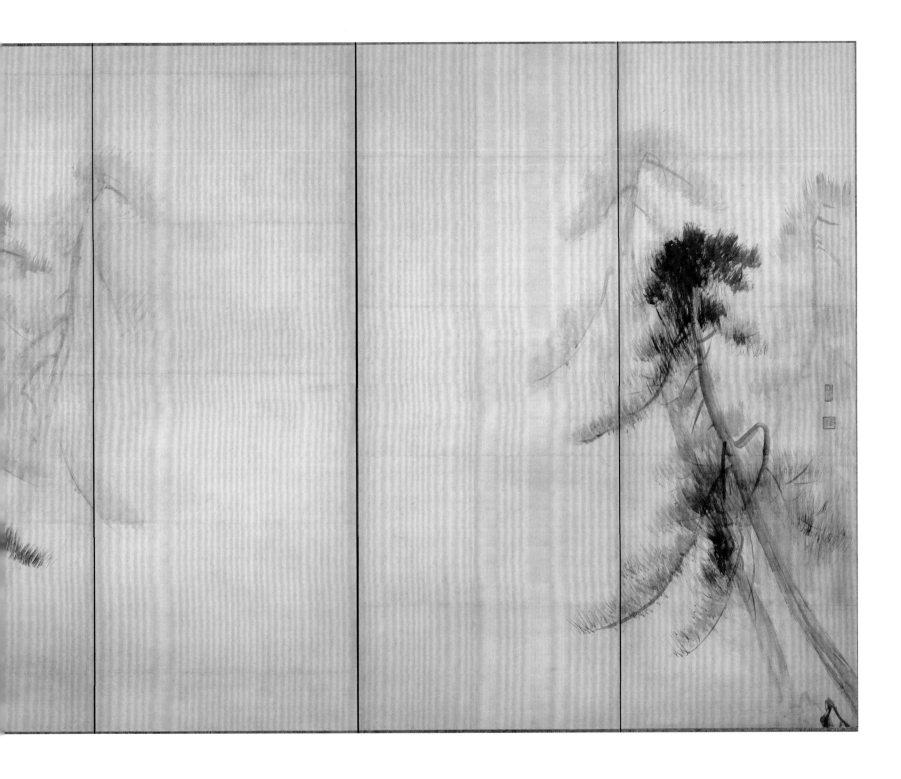

Hasegawa Tōhaku

Pine Forest (detail), late 16th century
Ink on paper, each screen 1.6 × 3.6 m / 5 ft 2 in × 11 ft 8 in
Tokyo National Museum

A grove of pine trees sways in the winter wind. The forest is shrouded in mist, and faint indications of snowy mountains recede behind the trees. Some trees tilt diagonally on the uneven ground, echoing the classical Japanese Noh dance, while others are blurred, as if being blown in a strong wind. Hasegawa Tōhaku (1539–1610) was renowned for his *suiboku-ga* (ink wash) paintings, and this work – one of a pair of large, six-panel folding screens – is considered his masterpiece. The composition illustrates the Zen Buddhist concept of *ma* (negative, empty space) and the Japanese

idea of *wabi* (representing the transient and imperfect elements of rustic nature). The large scale of the painting, combined with its few elements and monochromatic ink, all contribute to its sense of calm meditation. At a time when gold foil was used for most backgrounds, the work is purposely restrained. Tōhaku was influenced by the Chinese painter Muqi, who was active at the end of the Southern Song dynasty (1127–1279), but the Japanese painter worked in a more muted, reserved style. Tōhaku took a single motif and made it – for the first time in

Japanese art – the subject of a large painting, reflecting the minimalist aesthetic associated with Zen Buddhism. He seems to have used a straw brush or many brushes combined, and his different intensities of light are derived from gradations of ink. The contrast of shiny ink on dull, matte paper adds a freshness to the painting, suggesting the crispness of the pine scent in the cold, damp air.

Jennifer Steinkamp

Blind Eye 1, 2018
Video installation, dimensions variable

Three stills taken from a video by American installation artist Jennifer Steinkamp (b. 1958) show a line of birch trees shorn of the ground and the sky, like a series of vertical bars across the screen. The silent video of a year in the life of a birch forest shows the trees' trunks as the seasons pass: the birches' leaves grow and unfurl, change colour and then eventually fall from their branches. By concentrating on the trunks, Steinkamp obliges the viewer to watch as the trees transform into a row of bare, pale standing soldiers. The work's title, *Blind Eye 1*, Steinkamp

says, refers in part to the eyelike scars left on the trunks by fallen branches, but it is also a reference to human-kind's refusal to acknowledge the harm done to the natural world by turning a blind eye to ongoing climate-change crisis. The inspiration for her video installation was the forest outside the Clark Art Institute in Williamstown, Massachusetts, where the work was first exhibited. With no soundtrack to detract from the visual imagery, Steinkamp wanted the trees' continual movement to convey the invisible force of the wind as it whips the

dying leaves from the branches. For much of her career, Steinkamp has used digital art to show the power and beauty of nature. This study of the birch grove was moti-vated by new research that shows how trees can commu-nicate via an underground chemical exchange: unable to visually create that process, Steinkamp instead shows the sublime vitality of the trees over the course of a year.

Agnes Denes

Tree Mountain – A Living Time Capsule – 11,000 Trees, 11,000 People, 400 Years, 1992–96
Pine trees, 420 × 270 × 28 m / 1,377 × 886 × 92 ft
Ylojarvi, Finland

The brainchild of Hungarian-American conceptual artist Agnes Denes (b. 1931), *Tree Mountain* is one of the most original and forward-thinking works of land art ever made. This reimagined landscape is a living time capsule, symbolizing the interconnectedness of nature, humanity and the passage of time. By planting eleven thousand pine trees, Denes – a land art pioneer – created a powerful visual representation of Earth's biodiversity and its potential for constant regeneration. The sheer number of trees growing on the mountain highlights the magnitude of our impact on the environment and the urgent need for conservation and restoration efforts. *Tree Mountain* also serves as a reminder of the long-term consequences of human actions. With a lifespan of several centuries, the trees will continue to grow and evolve, bearing witness to the changes in the surrounding landscape and the world at large. This living artwork prompts us to reflect on our responsibility towards future generations, ecosystems and the legacy we leave behind. An original project that strongly relied on collaboration, *Tree Mountain* involved the participation of eleven thousand people who took part in the planting process. This collective effort emphasizes the importance of community engagement and widespread cooperation in addressing environmental challenges. By transforming a barren landscape into a thriving forest, Denes demonstrates the power of art and its ability to inspire hope and renewal. As the trees grow and interact with their surroundings, they will shape the landscape and contribute to the overall ecological health of the area, creating a unique and evolving experience for future generations to witness.

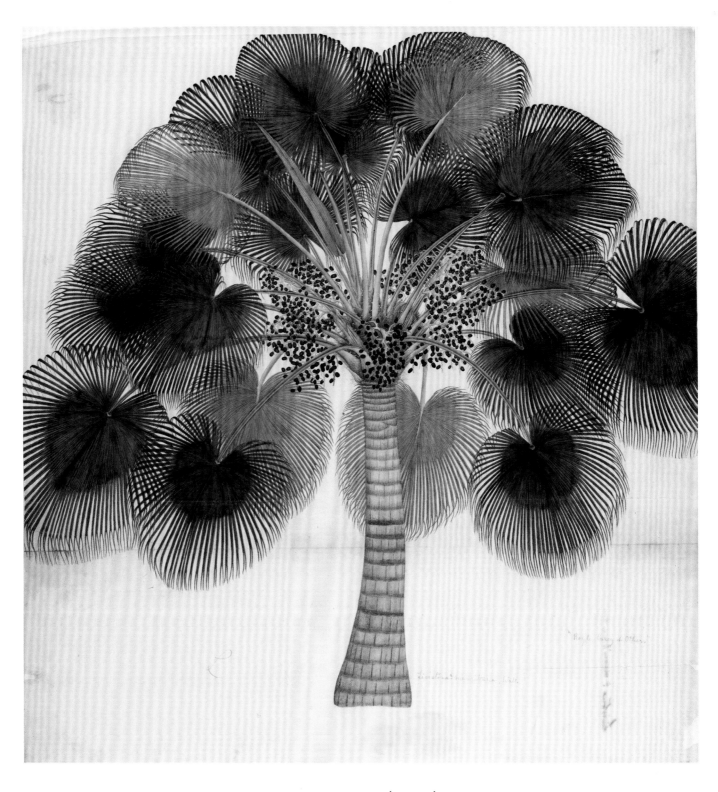

Vishnupersaud (attrib.)

Livistona chinensis, 1817–28
Watercolour, 58 × 54.5 cm / 22¾ × 21½ in
Royal Botanic Gardens, Kew, London

Rendered in a striking two-dimensional style, this exquisite watercolour of a Chinese fan palm (*Livistona chinensis*) was produced in India in the early nineteenth century. Commissioned by the British East India Company (EIC) to support the imperial desire for new commodities, its Indian artist's identity became submerged within the umbrella term *Kampani kalam*, or 'Company art'. Through recent research by Dr Henry Noltie of the Royal Botanic Garden Edinburgh, we now know that the painting was produced in the Calcutta Botanic Garden and was mostly likely painted by the artist

Vishnupersaud. The EIC had set up the garden in 1786 to cultivate species of interest to the British, and Vishnupersaud was one of a team of artists employed there. He skilfully executed artworks for several of the garden's superintendents, including Nathaniel Wallich, who was in charge between 1815 and 1846. Close inspection of the work revealed the name '*Livistona mauritiana Wall*', suggesting that it may have originated in Mauritius and that Wallich had named it. A reference in *Historia Naturalis Palmarum* (1823–50) by German botanist Carl Friedrich Philipp von Martius confirmed

that the plant was cultivated in the Calcutta Botanic Garden. Vishnupersaud's talent was noted by several EIC employees, and his drawings were reproduced in significant botanical publications, including Wallich's *Tentamen Florae Napalensis Illustratae* (1824) and *Plantae Asiaticae Rariores* (1829–32). The Royal Botanic Gardens, Kew, where this painting now resides, as well as other institutions, are working to provide new insights into the many unsung Indian artists who worked for the EIC, and the unique contributions they made to both the British empire and a global understanding of plant diversity.

Anonymous

Coins of Herod Antipas, c.4 BCE–39 CE
Bronze, Diam. 1.4 cm / ½ in
Private collection

Around two thousand years old, these bronze coins of Herod Antipas (r. 4 BCE–39 CE) feature a wreath, possibly laurel, and a date palm, fruit dangling from its lower branches. After the death of Herod the Great in 4 BCE, the Roman emperor Augustus divided his kingdom among his three sons. The youngest, Herod Antipas, was given Galilee and Peraea (Jewish Transjordan), two widely separated but exclusively Jewish regions. In a story that features in the New Testament, Herod Antipas divorced his first wife, a daughter of King Aretas IV of Nabataea, and married the wife of his half-brother (and niece), Herodias. John the Baptist denounced the marriage, for which Antipas had him beheaded. Afterwards, the divorce led to war with Aretas, in which Antipas was defeated. Then, when Pontius Pilate tried to send Jesus to Herod Antipas when he was first put on trial, Antipas declined to adjudicate, sending him back to Pilate's court. The bottom coin shown here – probably minted at Antipas's first capital, Sepphoris – is stamped on the obverse with the Greek inscription ΗΡΩΔΟΥ ΤΕΤΡΑΡΧΟΥ ('of Herod Tetrarch') surrounding a seven-branched date palm. Contained within the wreath of the coin on the top is the name of Antipas's new capital, TIBEPIAC (Tiberias) – named after the Roman emperor Tiberius – on the western shore of the Sea of Galilee, where the coin was minted. The date palm symbolized the Jewish lands over which Herod Antipas ruled, and its seven branches denoted the menorah, the seven-branched candelabra that stood in the temple in Jerusalem. Herod Antipas's coins were minted using an inferior alloy that was exceptionally prone to corrosion and deterioration, making any surviving pieces incredibly rare.

Cédric Pollet

Arctostaphylos obispoensis (Serpentine Manzanita), 2006
Photograph, dimensions variable

The reddish-purple bark of a manzanita tree (*Arctostaphylos obispoensis*) peels away during the early summer months in the San Luis Obispo region of California, revealing a wholly unexpected new layer shaded in neon yellows and oranges. Captured here by French photographer and horticulturist Cédric Pollet (b. 1976), this photograph is part of Pollet's ongoing project to travel the world to study and document the bark of hundreds of trees, showcasing bark's myriad forms and functions. Often overlooked in favour of trees' more aesthetically attractive leaves,

flowers and fruit, bark nevertheless plays a vital role in protecting the tree. It is the outermost layer of tissue that separates the inner cambium layer – the all-important vascular system of a tree – from disease, damage and desiccation. From a biological perspective, bark is an adaptive structure that ensures a species' survival by protecting these inner living tissues. The manzanita, meaning 'little apple' in Spanish, is a small evergreen with edible flowers and berries. Drought-resistant and able to tolerate poor soil, the tree is characterized by its smooth red or orange

bark and its twisting branches, and like most of its close kin, it does not keep its bark for long. Each year, a new layer of wood grows and, with it, a new layer of bark. As the tree's trunk thickens, the outer layers of the bark stretch and tear, exposing the brighter new bark beneath. Photographing bark so close up, often with a 35mm macro lens, Pollet reveals its often overlooked beauty – with wide variations in colour, texture and appearance – that frequently gives a tree its unique character.

Rory McEwen

Brittany, 1979
Watercolour on vellum, 30.5 × 30.5 cm / 12 × 12 in
Private collection

Set slightly off-centre, sitting closer to the top of the page than the bottom, is a single lifesize autumn leaf from a pear tree (*Pyrus communis*) in the early stages of decay. At first glance, this image may appear to be a photograph, but it is, in fact, an exquisitely detailed watercolour painted on vellum, the work of Scottish-born polymath Rory McEwen (1932–1982). Although he is now considered perhaps the greatest botanical painter of the twentieth century, McEwen did not go to art school. A fixture of 1960s London, he found fame as a musician

and the presenter of a groundbreaking television programme, *Hullaballoo*, featuring folk and blues music, but he abandoned his musical career to concentrate on his art in 1964. Working with a set of tiny brushes, McEwen captured every capillary and the uneven decay of a single leaf, its edges decaying faster than the rest of the form. To re-create the leaf on the page, McEwen used thousands of tiny brushstrokes of dry watercolour, bringing out the leaf's structure. The use of vellum was deliberate: it has the effect of enhancing the colour of the

finished leaf, since the paint sits on the surface. A common deciduous fruit tree, both wild and cultivated, the pear's leaves eventually turn golden then black in autumn. Having started as a painter of flowers, McEwen turned to leaves – particularly decaying leaves – after he was diagnosed with cancer in 1979, the year he painted this image.

Master of the Beaufort Saints

Tree of Jesse, from *The Beaufort/Beauchamp Hours*, c.1430
Illuminated manuscript, 21.5 × 15 cm / 8½ × 6 in
British Library, London

This richly decorated manuscript page depicts the Tree of Jesse, a medieval representation of the genealogy of Jesus Christ in which figures from his lineage appear in the branches of a tree. Reclining at the foot of this literal family tree is the Old Testament character Jesse, father of King David, the most famous monarch in Israel's history, who sits above, alongside his son King Solomon. Perched in the tree's highest branches is the Virgin Mary who, holding the infant Christ, is surrounded by golden rays of light. The Tree of Jesse trope derives from a passage in Isaiah 11:1 in the Bible: 'A shoot will come up from the stump of Jesse; from his roots a Branch will bear fruit.' Written some seven hundred years before Christ's birth, the text is accepted by Christians as referring to their saviour. Attributed to the Master of the Beaufort Saints, an unknown artist and illuminator active in the first half of the fifteenth century, this page is typical of the artist's sumptuous work, which is noted for its great variety of colours and intricate designs inspired by nature. The illustration was produced for a book of hours, a medieval devotional book containing prayers to be recited at different times of the day in accordance with the canonical hours (Matins, Lauds, Prime, Terce, Sext, None, Vespers and Compline). As here, the most luxurious books of hours contained painted devotional images. Dating to around 1430, this example has been identified as the prayer book belonging to the grandmother and mother of King Henry VII, Margaret Beauchamp and Lady Margaret Beaufort respectively.

Anonymous

Panel for a cabinet door, late 16th–early 17th century
Silk, metal wire, metal strips and coral beads, 33 × 28 cm / 13 × 11 in
Cooper Hewitt, Smithsonian Design Museum, New York

For a generation of home dwellers accustomed to mass-manufactured furniture, the sumptuousness of this handcrafted cabinet panel is a sight to behold. Dating from the late sixteenth or early seventeenth century, the rectangular, highly decorated panel has in its central oval an oak tree, its leaves and branches intricately embroidered to stand in relief against the background, with a salamander at the base of the tree's thick trunk. A hand-painted silk background of mountains and buildings, including what is perhaps a monastery, lies behind the tree, and from the tree's branches hang a wax limb, crutches and a censer to burn incense. A row of coral beads and two rows of couched metal thread surround the oval frame, surrounded by embroidered plants and serpents in each of the four corners. More coral beads and a scalloped lace edge finish the panel. The panel was the work of a team of professional male embroidery artisans; each member had a specific skill, whether it was stitching the tree trunk and its branches in silver metal thread or painting the silk background. The oak would have been considered a symbol of strength, the presence of the salamander signals regeneration, and the abandoned items hanging from the tree suggest that the panel was concerned with an overarching theme of healing. Together with the use of expensive materials, the anonymous artisans created an intriguing, if not slightly enigmatic, image that was likely for a wealthy client who might not have been in the best of health.

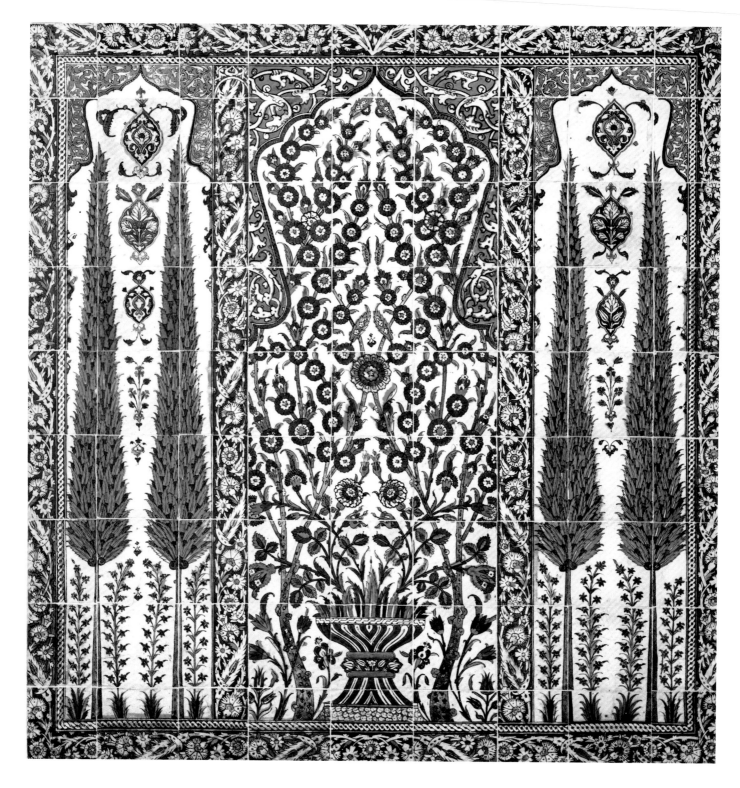

Anonymous

Tile panel with cypress trees, 17th century
Ceramic tiles
Topkapı Palace Museum, Istanbul

Inside the Topkapı Palace, centre of the Ottoman Empire for more than four hundred years, lay the Court of the Black Eunuchs (Kara Ağalar Taşlığı). Built in the 1560s, the court was destroyed by fire in 1665 and rebuilt in the 1670s. As part of the new construction, a *sofa* (a public room), a courtyard, dormitories and a mosque for the Sultan's harem – the black eunuchs' main task was to control entrances and exits to the harem – were completed and the rooms were decorated with Iznik mosaic tiles made using an underglaze technique, including

this cypress panel. The art of Turkish mosaic tiles (*cini*) can be traced back at least as far as the Uyghurs of the eighth and ninth centuries CE. Motifs typically include calligraphy, flowers such as tulips and carnations (usually in vases) and trees such as cypress. The Mediterranean cypress (*Cupressus sempervirens*) is an evergreen conifer, and its wood was used extensively for everything from buildings to coffins, furniture and statues. The tree was also used for aromatics and for medicinal purposes. The Persian epic poem *Shahnameh* (c.1000 CE) alludes to

the elegance and nobility of the cypress and influenced Ottoman ideas. Persian cultural influence is evident in Ottoman architecture and ceramics, and cypress trees were prominent motifs in the decoration of mosques and administrative buildings, including the Topkapı Palace. At the height of the Ottoman Empire in the mid-sixteenth and seventeenth centuries, bright colouring and naturalistic designs, including cypress trees, were featured on Iznik pottery.

Claude Monet

The Four Trees, 1891
Oil on canvas, 81.9 × 81.6 cm / 32¼ × 32⅛ in
Metropolitan Museum of Art, New York

At first appearing like an abstract composition of vertical and horizontal lines, four spindly poplars – coloured in blues, greens and purples – are silhouetted against a bright sky. Beyond them a further row of trees glows golden in the autumn sunlight. *The Four Trees* is one of a series of twenty-four views of poplars along the river Epte at Giverny, France, painted by Impressionist artist Claude Monet (1840–1926) during the summer and autumn of 1891. Monet worked on several canvases simultaneously during this period, so that he could capture shifting effects of light and colour. When the light changed, he would move from one canvas to another, depicting a slightly different scene on each. Monet painted some of the pictures from the riverbank and others, such as this one, from a boat specially fitted with grooves to hold multiple canvases. Rows of poplars are often planted as windbreaks, or along the side of a river to prevent erosion of its banks. The trees grow quickly, producing a light wood that can be harvested in a short rotation cycle of fifteen to eighteen years. This fast growth, however, nearly jeopardized Monet's series. Before the paintings were finished, the village of Limetz-Villez, across the Epte from Giverny, decided to sell the poplars at auction. Monet bought the trees himself and sold them to a local lumber merchant when he finished his artworks. Some of the poplar paintings were first exhibited as a series, when fifteen were shown in Paris in 1892.

Grandma Moses

Sugaring Off (detail), c.1952
Screen-printed linen, 2.8 × 1.2 m / 9 ft 3 in × 3 ft 11 in
Art Institute of Chicago

Repeated lines of maple trees, surrounding greenery and bustling people weave across this fabric design adapted by Riverdale Drapery Fabrics from an original painting by American folk artist Grandma Moses (1860–1961). Most of the figures are harvesting tree sap, a tradition in Moses's native Upstate New York, particularly in the Adirondack Mountains, where the process of 'tapping' trees was first perfected by the Indigenous Iroquois peoples. Groves of maple trees are known as a 'sugar bush', and traditionally a 'sugar shack', like the red cottage here, would be sited

for purifying the sap and then selling the resulting syrup. To the right of the shack, a figure in red holds a bucket to the tree trunk, collecting the sap that has dribbled from the metal tap. In front of the shack, a batch of boiled syrup is being poured onto a cauldron of packed snow to create a traditional sugary treat for the gathered children. Trees produce sugar via photosynthesis during the growing season, and these sugars combine with water to form sap, which is stored in the trees' trunks throughout autumn and winter. When the nights remain

cold, with temperatures below freezing, but are followed by warmer temperatures during the day, the sap of the maple trees flows, typically between February and April. The cycling temperature causes a change in pressure, which then forces the sap out of the metal tap. Despite being untrained as an artist, Moses expertly captures the exuberant energy of maple syrup season in her painting. A farmer's wife, she only began painting seriously in her late seventies, finding sudden popular fame as a visual antidote to avant-garde modernism.

Mary Vaux Walcott

Carolina Maple (Acer carolinianum), 1923
Watercolour on paper, 25.5 × 17.8 cm / 10 × 7 in
Smithsonian American Art Museum, Washington DC

The bright red fruits of this sprig of Carolina maple (*Acer carolinianum*) radiate from the paper in this splendid, lifelike painting by American botanical artist Mary Vaux Walcott (1860–1940). These maple fruits, known as samaras, grow in distinctive pairs, each one consisting of a single seed enclosed within a 'nutlet' attached to a flattened papery wing that aids their aerial transport when shed. Carolina maple, now known scientifically as *Acer rubrum*, is native to southern and eastern North America and has also been introduced to Europe (mainly

Great Britain and Poland). Also known as red or scarlet maple, its leaves and fruits turn a deep, rich red in autumn, adding their tint to the famous autumn displays of the mixed temperate forests of the American East. Born to a Quaker family in Philadelphia, Walcott began painting wildflowers at an early age, notably in the Canadian Rockies. In her late twenties, she began to concentrate seriously on botanical illustration and built up a collection of hundreds of detailed plant portraits. Between 1925 and 1928, four hundred of her illustrations were published

by the Smithsonian Institution in the five-volume *North American Wild Flowers*. Walcott was also an accomplished mountaineer and photographer who was particularly fascinated by glaciers. She was one of the first to document the retreat of a glacier, taking annual photographs from fixed points to record the recession of the Illecillewaet Glacier in British Columbia. A peak in Jasper National Park in the Canadian Rockies is named Mt. Mary Vaux in her honour.

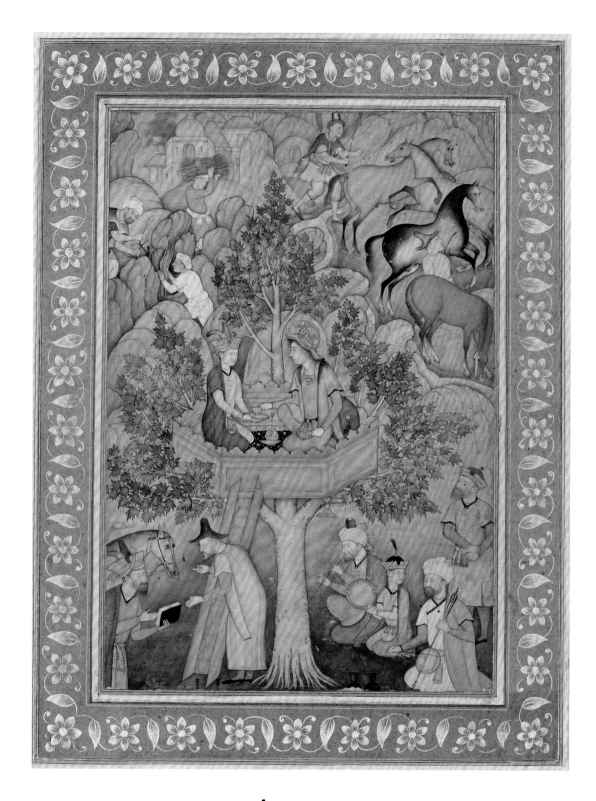

Anonymous

Eskandar in a Tree Pavilion, c.1610
Opaque watercolour and gold on paper, 43.8 cm × 28.8 cm / 17¼ × 11⅜ in
Aga Khan Museum, Toronto

Perhaps at odds with many people's conception of a tree house as a rather primitive structure, here two men share a cup of tea sitting in a luxurious raised pavilion. This watercolour by an anonymous Indian artist imagines a meeting between two of the most significant men of ancient history: Alexander the Great (Eskandar, 356–323 BCE) and the second Mughal emperor Humāyūn (1508–1556 CE). Elevated from the rest of the scene, both men sit on the floor, acknowledging that they are of equal status. Alexander, the Greek conqueror of a

vast empire that stretched from Macedonia to parts of India, takes the teacup he is offered by Humāyūn, who with Persian help conquered the Afghans to restore the Mughal throne in India. Around the tree pavilion are scenes of Mughal life and scenes that suggest, through the range of headwear, a meeting of the two cultures. This sense of mutual collaboration is further enhanced by the style of the painting, which combines Persian, Indian and European styles of art. The helmet Alexander wears – with the image of a horse, perhaps his beloved

Bucephalus – is in the Italian *all'antica* style ('in the manner of the ancients'), signalling the adoption of European motifs in Mughal India. Pavilions to take tea and provide shade were commonly shown in traditional Mughal paintings, but a depiction of a tree house is extremely rare. Here, the tree takes centre stage, symbolizing not just the status of the two men but also the sharing of knowledge and the coming together of two sophisticated cultures.

Dorothy M. Wheeler and Enid Blyton

The Magic Faraway Tree, 1943
Printed book, 20.3 × 12.7 cm / 8 × 5 in
Private collection

Imagine a gigantic tree that grows so tall its upper branches disappear into clouds that hide all kinds of magical lands, or a tree trunk filled with miniature houses that are home to pixies and colourful characters such as Moonface and the Saucepan Man. Such a tree was conjured from the imagination of prolific best-selling English children's writer Enid Blyton (1897–1968). The eponymous tree growing in an enchanted wood is the subject of a trilogy of children's books – *The Magic Faraway Tree* is the second in the series in addition to being the series

title – that provided thrilling adventures for the young siblings Jo, Bessie and Fanny and their cousin Dick. Blyton, whose childhood was blighted by her father leaving their family and a troubled relationship with her mother, knew the value of finding an escape to another world through storytelling. One of the most beloved of all children's writers, she wrote around seven hundred books, selling more than five hundred million copies. Like *The Magic Faraway Tree* trilogy, many of her stories fired her readers' imaginations with indescribable excitement, freedom

and adventure in the mid-twentieth century, a period of warfare, shortages and widespread hardship. This cover, from the book's first edition published in 1943, shows the children at the base of the tree with various characters they meet in the story. It was designed by English artist Dorothy M. Wheeler (1891–1966), who would illustrate the covers for each volume, complementing Blyton's fantasy of a world of make-believe – a fantasy maintained by the illustrators of the many subsequent editions of *The Magic Faraway Tree*.

Henry King

Taphoglyph near Dubbo, New South Wales, 1910s
Albumen print, 20.1 × 15 cm / 8 × 6 in
State Library of New South Wales, Sydney

Every aspect of the lives of Aboriginal Australians is governed by a deep spiritual connection to the land and a belief that they belong to it. For thousands of years, they chose to mark significant ceremonial sites by carving ornate designs, or taphoglyphs, directly onto the trunks of trees growing there, as shown in this early twentieth-century photograph by Henry King (1855–1923), an English-born Australian photographer who documented Australia's Indigenous cultures. The bark of the tree has been removed to expose the wood below and then etched with ornate patterns. The specific meanings of

the intricate circles, spirals, human figures and cross-hatches has been lost, but when they were carved, they were intended to endure. While generally the carved trees signalled a sacred place, it is known that they sometimes marked the burial sites of important men and that they also served as initiation symbols for boys marking their transition to manhood. The trees, however, were active members of the story – organisms growing, reacting and changing each year. Living cambium – the vascular system of a tree – and the bark that covers it slowly grew around and over the exposed inner wood, the

tree patiently, diligently rebuilding itself and enveloping the message etched into its trunk. It is thought that the practice of tree carving stopped around a hundred years ago, and today only a few of the trees survive. Their disappearance coincided with the forced relocation of Aboriginal Australians from their ancestral lands onto reservations as Europeans colonized much of the country. More than 7,500 Aboriginal-carved trees have been recorded in New South Wales, but today a total of only around 100 remain standing in their original locations, a legacy of land clearing, bush fires, farming and natural decay.

Beverly Allen

Beverly Allen

Araucaria bidwillii (Bunya bunya cone), 2019
Watercolour on vellum, 18 × 14 cm / 7 × 5½ in
Private collection

The majestic bunya pine (*Araucaria bidwillii*) is unique to Australia, where it traditionally played an important role in the lives of Aboriginal peoples who considered it sacred. As can be seen in this watercolour by Australian botanical artist Beverly Allen (b. 1945), the trees' cones contain nuts, which are a highly sought-after and nutritious delicacy, and groups would travel long distances to seek them out. In the Bunya Mountains of southeast and northern Queensland – one of the relatively few areas where the once-common bunya still grows in the wild – feuding Aboriginal groups would temporarily cease hostilities so that they could each gather and feast on the pine's nuts. The last recorded instance of these festivals took place in 1900, when the arrival of European loggers ending the gatherings. The loggers were attracted by the wood of the pine, which is highly prized – particularly to make sounding boards in stringed musical instruments. Often wrongly mistaken for the monkey puzzle tree, the bunya pine has a distinctive triangle-shaped symmetrical crown and is a living fossil that belongs to a family of trees that emerged during the Jurassic period, more than 150 million years ago, when they grew on the supercontinent of Gondwanaland. The cones can grow to a weight of 10 kilograms (22 lbs) and can drop from a height of 50 metres (164 ft) without any warning – presenting a significant risk to anyone who might be standing below.

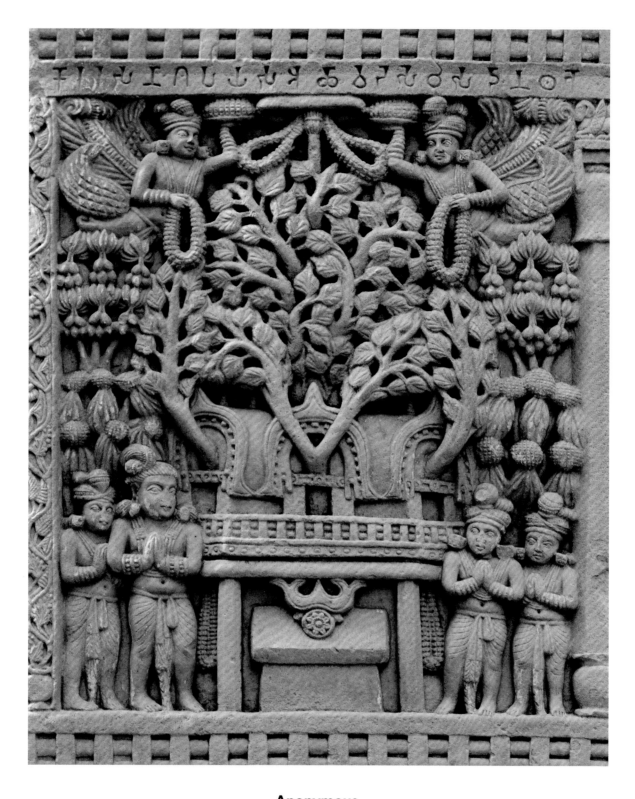

Anonymous

Bodhi Tree, Eastern Gateway (detail), early 1st century CE
Carved sandstone
Great Stupa at Sanchi, Madhya Pradesh, India

The Buddha first attained enlightenment beneath a bodhi tree at Bodh Gaya in Bihar, India. The bodhi tree (*Ficus religiosa*) is one of the most important symbols in Buddhist art, symbolizing enlightenment, knowledge and progress. Native to the Indian subcontinent and Southeast Asia, the tree is a member of the *Moraceae*, or fig and mulberry, family, and other names include the pimple, peepul, pipala and ashvattha tree. On the eastern gateway to the Great Stupa at Sanchi, in Madhya Pradesh, is carved just such a bodhi tree. At the base of the tree is an altar with the

wheel of dharma (Buddhist doctrine). The bodhi tree is an aniconic representation of the Buddha himself, who does not appear in human form on the gateways. At each of the other cardinal points, he is represented as a riderless horse, a parasol above an empty throne and footprints. The gateways (*toranas*) are the principle focus of sculpture at the site, rather than the stupa itself, and are entirely carved with narrative panels depicting early Buddhist iconography. The southern gateway was probably erected first, as the main entrance to the stupa – followed by the

north, east and west *toranas* – during the first decades of the first century CE. The stupa itself was built in the third century BCE by the Mauryan emperor Ashoka (reigned c.265–232 BCE). Beyond that of Buddhism, the bodhi tree also has a religious significance in the two other major religions that originated on the Indian subcontinent: Hinduism and Jainism. Hindu and Jain ascetics consider the tree to be sacred, and often meditate beneath it.

Ira Block

Bodhi Tree, 2012
Photograph, dimensions variable

Golden rays of sun illuminate a bodhi tree festooned with colourful prayer flags at the Maya Devi Temple complex in the Nepalese town of Lumbini, the traditional birthplace of Siddhartha Gautama, founder of Buddhism, around the sixth century BCE. According to Buddhist tradition, the young prince Siddhartha sat under a bodhi tree – also known as the peepul or bo tree – for forty-nine days until he received enlightenment, the main tenet on which he founded the religion. Known as the 'tree of enlightenment', the bodhi tree (*Ficus religiosa*) has deep spiritual significance and importance not just for Buddhists but as a broader symbol of spirituality. This image taken by the award-winning American photographer Ira Block (b. 1949) for *National Geographic* does not show the original tree beneath which the Buddha meditated in Bodh Gaya, which was destroyed in the seventh century. The present tree grew from a shoot and is thus so sacred that pilgrims never touch it; instead they wait, trancelike, until a sacred heart-shaped leaf detaches itself and flutters to the ground. Over the centuries, the bodhi tree has taken on such spiritual significance it has become common practice to plant one at every Buddhist monastery as a sign of the presence of dharma, or the teaching of Buddha. However, since there is no mention of the bodhi tree in the Buddha's early teachings, it remains a possibility that the cult of the bodhi tree belongs to a far more recent Buddhist tradition.

Robert White and Marcello Malpighi

Tab. XIII, from *Anatome plantarum pars altera*, 1678
Red chalk on paper, 31.6 × 21.5 cm / 12½ × 8½ in
Royal Society, London

These delicate red chalk and pencil drawings depict shoots and acorns of oak trees, including cross sections, in a degree of detail rarely, if ever, seen before their creation in the 1670s. Drawn by British artist Robert White (1645–1703), they illustrated the *Anatomes plantarum pars altera* (*Anatomy of Plants*) by Marcello Malpighi (1628–1694), which was published by the Royal Society of London in 1679. An Italian biologist and physician, Malpighi was the father of microscopic anatomy and also of embryology. Following the invention of the compound microscope by the Dutch in the early seventeenth century, scientists across Europe began to use the new invention to investigate plant and animal life. For Malpighi, microscopy revealed that a plant should be treated as a whole, and as part of an interconnected system. Revolutionary at the time, Malpighi's insights have become the standard basis for the modern understanding of plant anatomy, and many of the terms he invented are still in use today. Using his microscopic investigations, Malpighi was able to show the relationship of the many different parts to the whole organism – such as shoots and acorns to an entire oak tree – and the presence of the whole organism in the seeds. The exquisite details of White's drawings – copied from Malpighi's own microscopic investigations – show how Malpighi's research into plant anatomy represented a new revelation in the history of botany.

Albrecht Dürer

Spruce Tree (Picea abies), c.1497
Body colour and watercolour on paper, 29.3 × 19.4 cm / 11½ × 7⅝ in
British Museum, London

There is so much loving detail in the branches and needles of this spruce, growing in a somewhat shaggy and irregular way, that we can feel the artist engaging with the tree as an individual. The spruce is not simply drawn as a two-dimensional silhouette but has been given volume by precisely detailing the branches that project out towards the viewer. German painter and printmaker Albrecht Dürer (1471–1528) made watercolours of Alpine landscapes and trees as a resource for his prints and oil paintings. However, the tree in this watercolour does not appear to have been used for any of his other works, and in many of Dürer's studies the practical purpose is secondary to his aim of using art in a quasi-scientific way to explore the natural world. Although evergreen trees like the spruce have played a role in religious images as symbols of eternal life, they are more familiar to us today as Christmas trees, a relic of an earlier practice of bringing evergreen branches into the house in midwinter, perhaps associated with pre-Christian fertility rites and tree worship. Dürer's practice of making studies from nature in watercolour and the use of extensive landscape backgrounds in his finished works played a major part in the development of landscape as a subject in its own right. They have also provided inspiration for nineteenth-century Romantic artists such as Caspar David Friedrich and Samuel Palmer (see pp.246, 330).

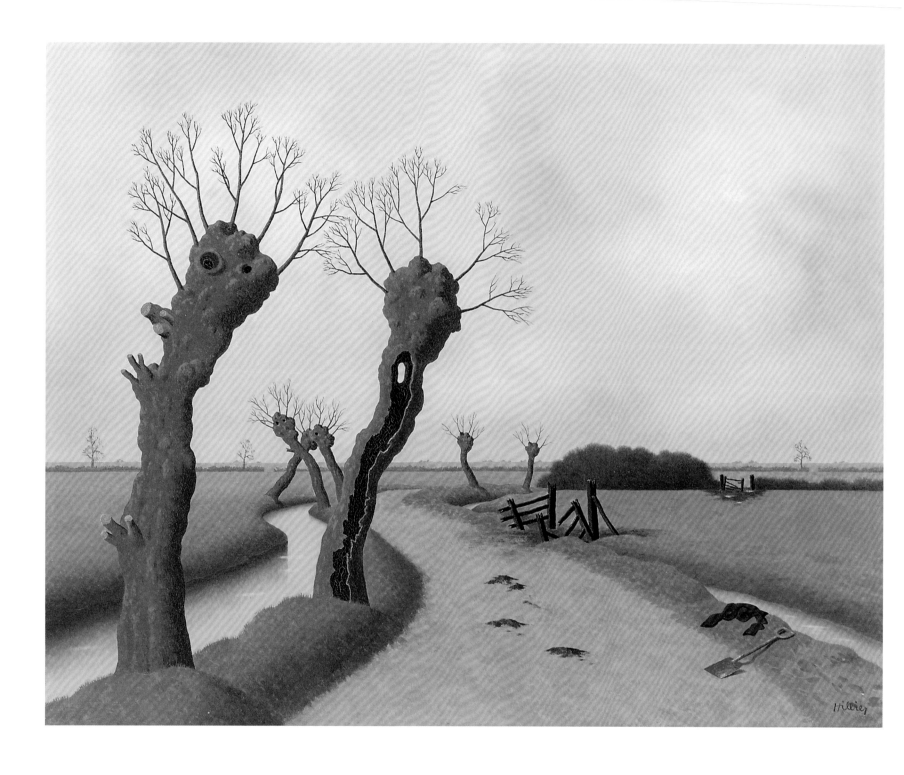

Tristram Hillier

Glastonbury Fen, 1980
Oil on board, 38.7 × 49.5 cm / 15¼ × 19½ in
Ingram Collection of Modern British and Contemporary Art, London

The seven gnarled willow trees that populate this bleak winter scene are an ominous presence on the landscape. Strange and intimidating, they lean precariously along the flooded ditches that run on either side of a deserted country track. One tree is completely hollow, rotted away by disease, its damaged trunk echoed by the nearby broken gate. To the right, an abandoned red sweater lies mysteriously on the grass next to a shovel, its owner nowhere to be seen. British artist Tristram Hillier (1905–1983) painted *Glastonbury Fen* near the

end of his life, though wintry landscapes with bare trees were a recurring theme throughout his work, alongside still lifes, architectural imagery and occasional religious subjects. The composition is typical of the painter's stark vision of the English countryside, its eeriness reflecting the influence of Surrealism, which he encountered in Paris in the 1920s. Its principal inspiration, though, lies in the unique landscape of the Somerset Levels, close to his home in southwest England, where the abundance of pollarded trees, like those seen here, contributes to the

area's distinctive character. Pollarding is the practice of cutting back a tree's branches to its trunk and dates back millennia. Commonly employed to provide firewood, timber and animal fodder, it is also used to prevent willows from spreading their branches along the ground and over-shading plants growing underneath. The cutting promotes the growth of multiple spindly branches that sprout from the top of the trunk, which Hillier paints here with characteristic detail and a meticulous finish.

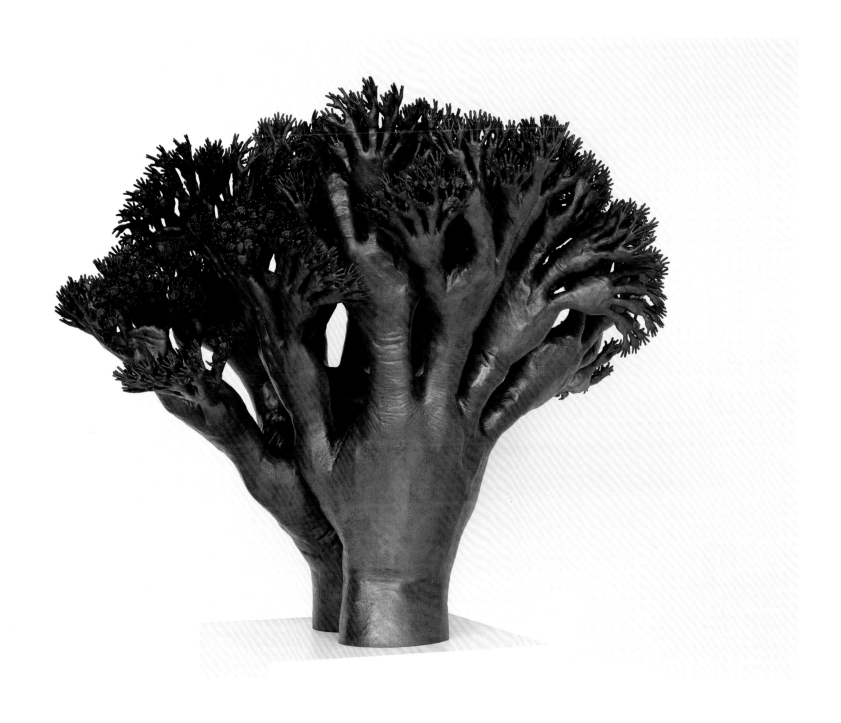

Tony Cragg

Manipulations, 2017
Bronze, 1.2 × 1.5 × 1.1 m / 4 ft × 4 ft 10 in × 3 ft 7 in
Private collection

Emerging from the gallery floor, two splayed hands of a large bronze sculpture rise like fleshy tree trunks. Growing from each are other, smaller hands, their branchlike fingers sprouting yet more hands, which together generate a surreal, treelike structure. As with the fractal patterns of nature, each branch of the sculpture resembles in smaller scale the shape of the whole. The primary concern of its creator, British artist Tony Cragg (b. 1949), is to invent new, unprecedented forms from the material of the world – the title, *Manipulations*, is perhaps a self-referential nod to

his own creative hand. In a related etching, *Manipulation I* (2017), Cragg uses the outline of his hand to construct a whole forest of these 'trees'. Working with bronze, glass, wood, steel, stone and more, the Turner Prize-winning artist is known for his organic undulating abstractions that evoke elements of the natural environment. His biomorphic works are the antithesis of the impoverished forms he sees in the built environment, and he actively avoids straight lines, right angles, simple geometries and flat surfaces, revelling instead in art's capacity to transcend

the ordinary by exploring the space between reality and the imagination. While many of Cragg's works echo the natural shapes of trees, he has never worked directly with them; in fact, he cannot bear the thought of cutting into a tree – even if it has died – because, he says, he feels their essence too strongly.

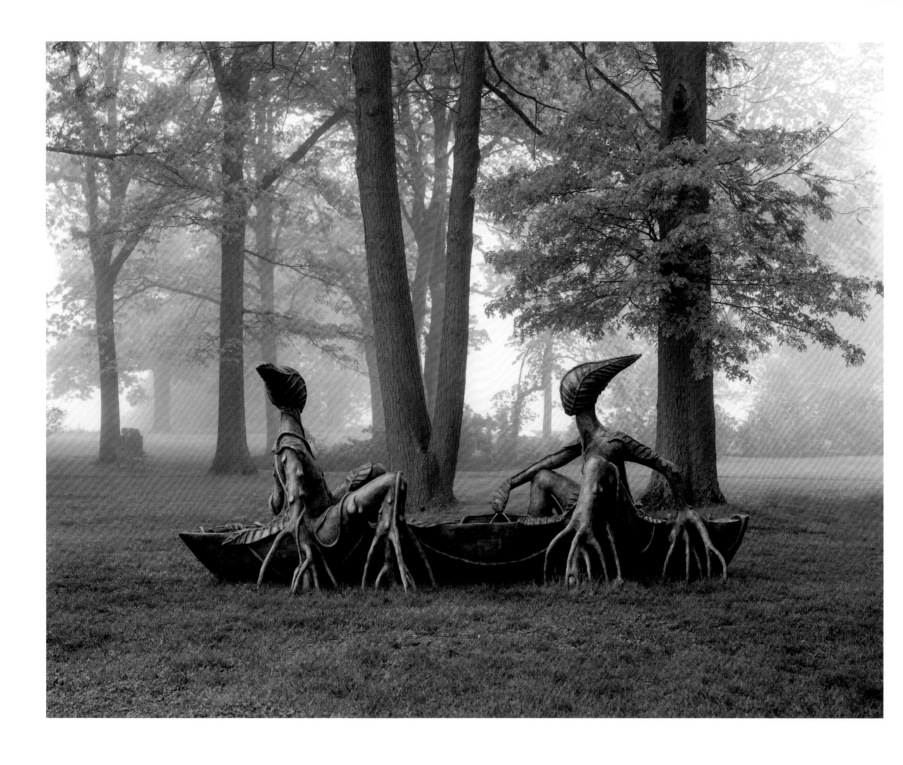

Wangechi Mutu

In Two Canoe, 2022
Bronze, 4.7 × 1.7 × 1.8 m / 15 ft 4 in × 5 ft 6 in × 5 ft 10 in
Storm King Art Center, New York

This otherworldly and thought-provoking artwork by Kenyan American artist Wangechi Mutu (b. 1972) explores themes of migration, identity and the human connection to nature. The phyto-humanoid creatures travelling together in the canoe invite viewers to reflect on the experiences of displaced communities and the challenges they face in their journey towards a better life. In this sense, the work can be seen to allude to the global refugee crisis. The enigmatic figures riding the canoe may represent the fragmented identities and experiences of these individuals as

they navigate unfamiliar territories and face the challenges of assimilation and integration. The roots that expand from their arms and legs, which closely resemble those of mangrove trees, symbolize a connection to one's ancestry and cultural heritage. They stand for the deep-seated history and traditions that shape an individual's identity. Mutu often explores themes of identity, femininity and the African diaspora in her work, and the arboreal motifs of *In Two Canoe* serve as a metaphor for these complex and intertwined narratives. Simultaneously, the roots can

be seen to evoke resilience and strength. Just like the roots of a tree, which provide stability and nourishment, they symbolize the ability to withstand challenges and adversity: embracing one's roots can provide a source of empowerment and a foundation for personal growth. In a broader sense, they also point at the interconnectedness that binds all living beings on this planet. Mutu's work ultimately encourages viewers to consider the importance of our shared roots and the essential roles they play in our collective human experience.

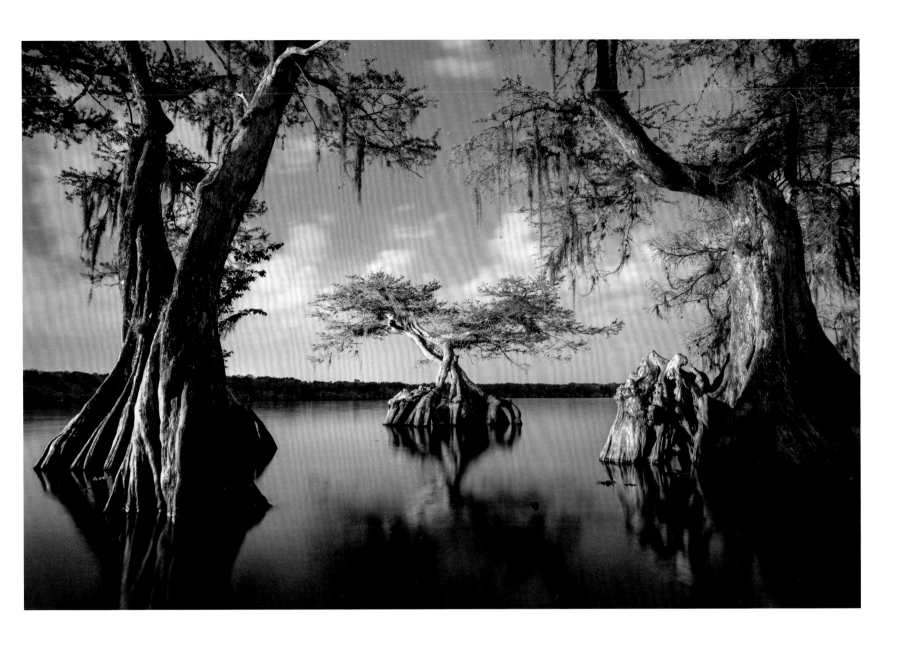

Mac Stone

Bald Cypresses, Sampit River, South Carolina, 2021
Photograph, dimensions variable

In this striking image by American photographer and conservationist Mac Stone (b. 1984), three bald cypress trees (*Taxodium distichum*) stand tall, their lower trunks submerged in the waters of the Sampit River in South Carolina. The raking light catches the cypresses' silvered trunks and the knobbed 'knee' buttresses of their roots that reach sturdily down into the still water. For Stone, photography is a tool in the fight to conserve unique ecosystems around the world. Here, he captures the ever-diminishing wetland habitat of cypress groves that once stretched along much of the southeast coast of the United States. Bald cypresses are among the oldest and hardiest trees in the world. In a patch of these trees along North Carolina's Black River, scientists have dated one tree to at least 605 BCE. Bald cypresses are also particularly resilient. Their buttressed bases and strong, intertwined root systems allow the trees to withstand high winds – especially useful in their hurricane-prone native range – even growing to heights of 45.7 metres (150 ft). They are able to adapt to a wide range of growing conditions, from swamps to dry soils, and though they are more salt-tolerant than other species, rising sea levels are now threatening bald cypress populations. Forested wetlands are turning into salt marshes, creating 'ghost forests' along the Eastern Seaboard. This latest threat comes after extensive harvesting of the bald cypress in the early twentieth century, owing to the rot-resistant and hard-wearing qualities of its wood. With the loss of these trees also comes the loss of the native flora and fauna – ivory-billed woodpeckers (see p.83), Carolina parakeets, yellow helmet orchids, not to mention the innumerable reptiles and aquatic species – that make their homes among the cypresses' roots and branches.

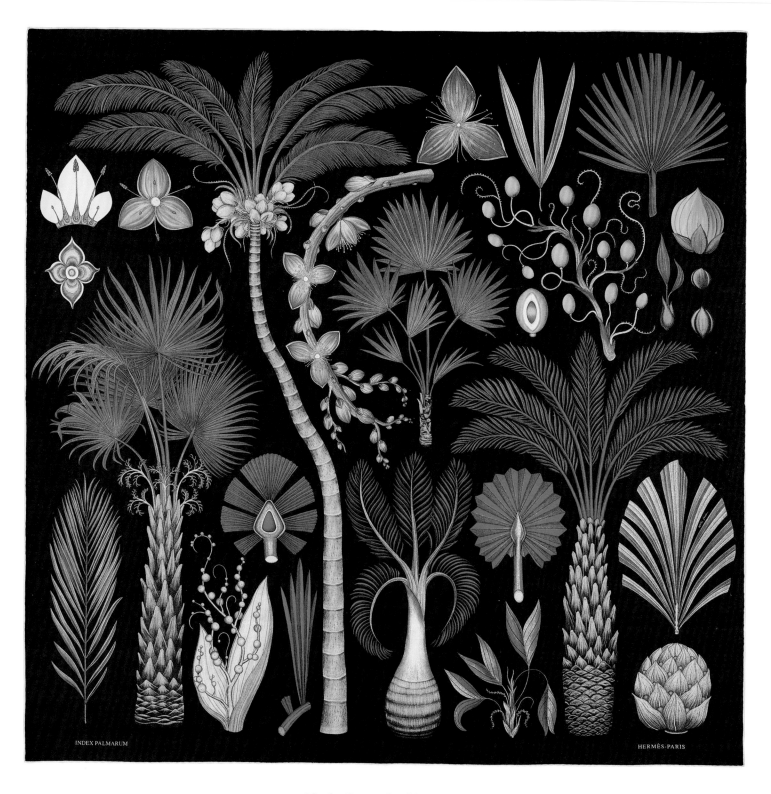

INDEX PALMARUM

HERMÈS-PARIS

Katie Scott for Hermès

Index Palmarum, 2019
Silk, 90 × 90 cm / 35½ × 35½ in
Hermès Collection, Paris

The inspiration for *Index Palmarum*, the first project by British designer Katie Scott (b. 1988) for Hermès, came from a nineteenth-century book about palm trees, the work of German botanist and explorer Carl Friedrich Philipp von Martius. Von Martius's treatise, *Historia naturalis palmarum*, was published in three volumes and set out the myriad forms and colours of one of the oldest plants on the planet, the palm, based on his travels in Brazil and Peru. On this scarf, Scott translates the original source material into vibrant trees, with the parts of the many

varieties of palm, from seeds to flowers and fronds, drawn here in rich blues, greens and golds. Selecting just a few specimens from the more than 2,500 different types of palms – including trees, climbers, ivies and plants without stems – Scott sets them against an inky blue background, underlining her observation that there is nothing more creative than Mother Nature. Hermès has a long history of commissioning illustrators for its prized silk scarf designs, which began in 1937 when the first screen-printed scarf *Jeu des omnibus et des dames blanches* was launched.

Now an iconic fashion accessory, the Hermès *carré* (French for 'square') has featured almost three thousand bold designs, showcasing a rich variety of themes, including natural history. Hermès Design Studio has since continued the long-standing collaboration between the house and the art world.

Anonymous

Palm tree floor lamps, 20th century
Gilt-metal, each 2.3 × 1.3 m / 7 ft 7 in × 4 ft 3 in
Private collection

In the middle of the twentieth century, palm trees in various guises became a standard element of home decoration as part of a then-fashionable tropical look inspired by easier and cheaper air travel and Hollywood films. Here, the palm appears as a pair of columned gilt-metal floor lamps standing more than 2.3 metres (7.5 ft) tall, with the bulbs concealed beneath their fronds and the wires hidden inside their vertical trunks. Whether printed on wallpaper, modelled as an ornament or featured as a living plant, the palm evoked the iconic 1950s style of America's tropical

states – Florida, Hawaii and California – and conjured up thoughts of sunshine, vibrant colours and a laid-back vibe. The creation of the fashion has been credited to the Parisian interior design company Maison Jansen, which opened in 1880. By the middle of the twentieth century, the company's stock in trade had been established as all things palm – not just floor lamps but also overhead lights and table lamps, all with the instantly recognizable jagged leaves. When 1950s-style retro design regained its popularity in the 1970s, the motif was adopted by other designers, most

notably German designer Hans Kögl. Redolent of lazy days on the beach, the tropical palm lends itself beautifully to design with its tall, narrow grooved trunk and long fronds. Franciscan monks are said to have first introduced the trees in California purely for decorative purposes in the eighteenth century, and in the early 1900s Los Angeles city planners had L.A.'s Division of Forestry begin planting these trees throughout the city. By the 1932 Los Angeles Olympic Games, forty thousand Mexican fan palm trees (*Washingtonia robusta*) had been planted across the city.

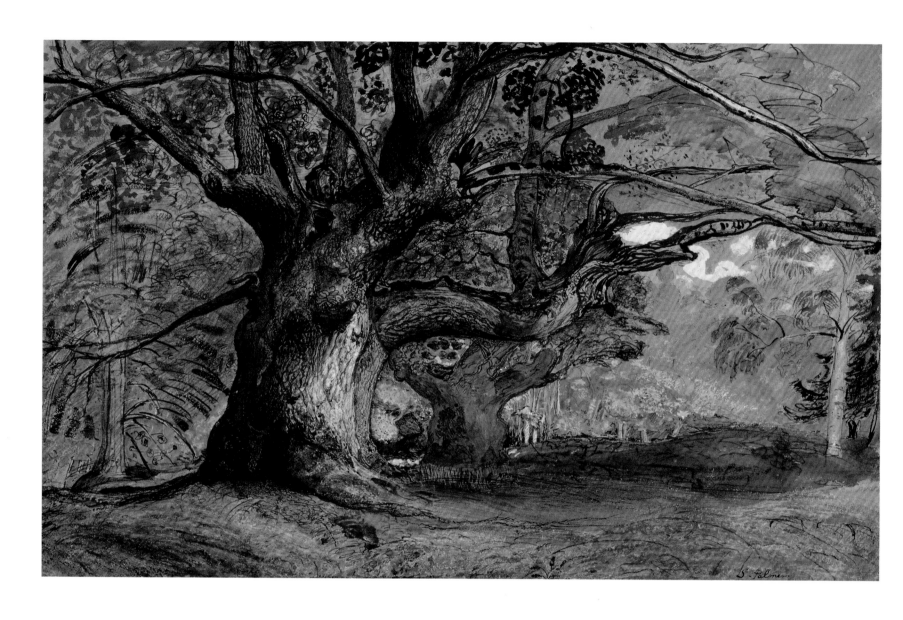

Samuel Palmer

Oak Trees, Lullingstone Park, 1828
Ink, graphite, gouache, watercolour and gum arabic on grey wove paper, 29.5 × 46.8 cm / 11¾ × 18½ in
National Gallery of Canada, Ottawa

The strongly textured bark of the massive oak tree in the foreground stands out against the brightly coloured hillside, receding into the distance in a blur of refulgent gold. The brown ink, gouache and watercolour mix gives a wild, knotty quality to the two oaks, at once naturalistic and surreal, as though lit by a blast of sunshine. Pillars of ghostly grey and white suggest upright trunks of birch and, together with the splashes of green foliage, contrast with the solid brown mass of the central oaks, which reach up and outwards at irregular angles,

commanding the centre of the image. The work of British landscape painter, etcher and printmaker Samuel Palmer (1805–1881), the scene depicts Lullingstone Park, part of an ancient village in the Darent Valley, near Shoreham in Kent, where Palmer loved to paint. Lullingstone Park is home to more than three hundred oak, ash, beech, hornbeam and sweet chestnut trees, some thought to be eight hundred years old. Most famous for his visionary watercolours of pastoral scenes, Palmer was influenced by his friends and mentors William Blake and John Linnell; the

latter commissioned him to paint the ancient oak of this image. Palmer described in a letter the tree's 'muscular belly and shoulders; the twisted sinews' with the dense textures of its trunk and the spirited curves of the branches. After Palmer moved from Kent to London, his work became less intense and more traditional. He travelled in England, Wales and Italy, producing many admired watercolours, and illustrated John Milton's two early poems, *L'Allegro* and *Il Penseroso*.

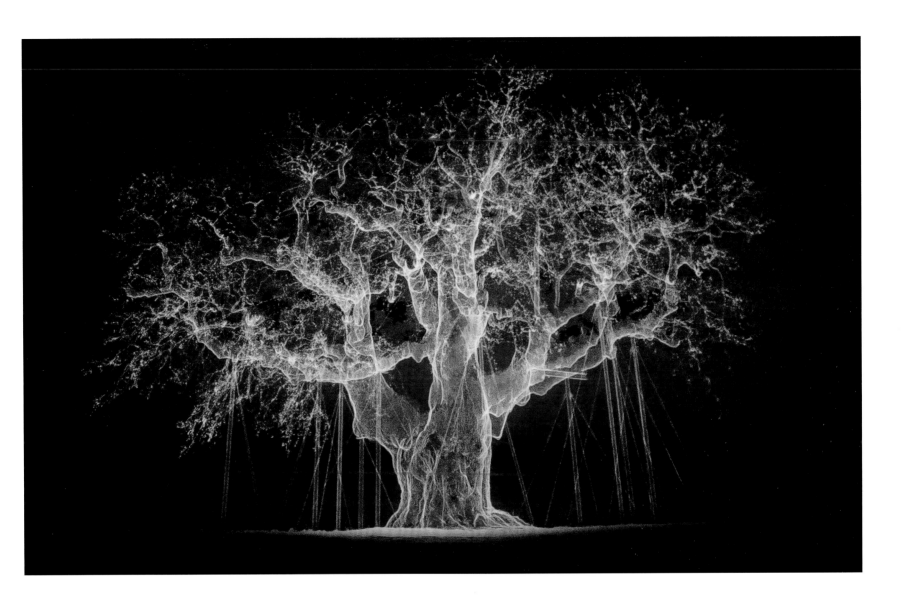

Mat Collishaw

Albion, 2017
Aluminium, media player, mirror, paint, scaffolding rig, stretching accessories, transparent mirror film, video projector and wood,
4.3 × 5.4 × 4.6 m / 14 ft × 17 ft 8 in × 15 ft, Fundació Sorigué, Lleida, Spain

A white tree, shorn of its leaves and supported by numerous crutches, rotates slowly in a darkened room. This ghostly apparition is a representation of the Major Oak, which can be found in the middle of Sherwood Forest, in central England (see p.18). Here, it is the subject of a three-minute video made by British artist Mat Collishaw (b. 1966). Collishaw titled this work *Albion*, an elegiac reference to the ancient name by which England was once known and an acknowledgement that, like ancient Albion itself, the original forests of the British Isles are in danger of disappearing. To create

the video, Collishaw used a nineteenth-century optical illusion known as Pepper's Ghost – named for Professor John Henry Pepper, who used the technique to make ghostly figures appear onstage as a way to popularize science. For Collishaw's project, the oak was laser-scanned and then projected as a hologram that appeared as a three-dimensional ghost tree when it was illuminated. A local landmark, the Major Oak is thought to be at least eight hundred years old and is one of the biggest oaks to be found in Britain, with a canopy spread of 28 metres (92 ft). Its name derives not from

its size but from a Major Hayman Rooke, who first referred to the tree when he published *Descriptions and Sketches of Some Remarkable Oaks, in the Park at Welbeck* in 1790. Over the centuries, and with significant numbers of visitors, the tree has suffered from root compaction and crown dieback, and it is now kept upright by metal supports to its branches that are fixed into the ground. Combining the natural world and the artificial, Collishaw has said he loves 'the way digital technology can seamlessly manipulate material when you walk into a gallery'.

Alex Katz

Young Trees, 1989
Oil paint on hardboard, 40.7 × 30.1 cm / 16 × 12 in
Tate, London

A trio of spindly saplings in leaf reach upwards from the sunlit ground, contrasting against a backdrop of dense foliage shrouded in shadows. Better known for the elegant simplicity of his large canvases with their exaggerated blocks of colours, American artist Alex Katz (b. 1927) is regarded as the forerunner of the Pop art movement. Having worked in a variety of media – from paper and wood cut-outs to printmaking – over the decades to produce his signature large-scale portraits, Katz focused primarily on landscapes in the 1980s. This work, which

dates from 1989, is unusual due to its size, measuring only about 40 by 30 centimetres (16 by 12 in). Katz sketched directly from life for such small paintings, saying, 'A sketch is very direct. It is working empirically, inside of an idea.' The technique recalls his days at the Skowhegan School of Painting and Sculpture in Maine, where he learned how to paint en plein air. Sometimes Katz worked these smaller sketches up into a bigger canvas, but here the visible brushstrokes and their economic execution reveal a work that was not intended to be upsized. The

artist's intention, with such tight cropping and the trees extending beyond the confines of the canvas, was to make the viewer feel enveloped by a landscape painted up close. Katz's landscape paintings in the early 1980s tended to be more abstract, evoking the idea or the nostalgic memory of a landscape. However, by the early 1990s he had become increasingly interested in the way the light played on the landscape, as is so clear in *Young Trees*.

Shota Suzuki

Heaven and Earth, 2023
Copper, brass, nickel silver and patina, 20 × 20 × 22 cm / 8 × 8 × 8½ in
Private collection

A young, green tree shoot emerges from a seed under the cover of fallen leaves, reaching upwards with new growth. But while a real shoot may be delicate, this remarkably detailed sculpture is made from durable copper, brass and nickel silver. The work is a reflection on the Japanese concept of *Mono no aware*, or the transitory nature of life, that underlines the work of Kyoto-based artist Shota Suzuki (b. 1987). A close observer of the ephemeral nature of life, Suzuki captures in *Heaven and Earth* the life cycle of a tree, from its inception to the decay implied by the dead leaves. Suzuki is attracted by the plants and trees of the city, from the dandelions that push up through the cracks in a sidewalk to the trees that self-seed on open ground. Having studied metalwork at university, Suzuki combines traditional Japanese and modern metalworking techniques to create lifelike sculptures finished with a natural-looking patina. Achieving the patina is the hardest part of the process: the chemical solutions used are so sensitive that changes in air temperature will alter the final colour. In his tiny studio, Suzuki creates his sculptures using a round vessel called a *yanidai*, on which he cuts and shapes the metal. He fills the top with pine resin that softens when it is heated, allowing him to work on the delicate metal surfaces without damaging them. Once the design is finished, he colours the metal with a range of different chemical solutions – including the juice of the daikon, or Japanese radish – to achieve remarkably naturalistic effects.

Timeline

470 million years ago	280 million years ago	60 million years ago

1

2

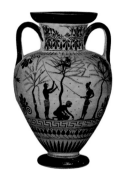

3

470 million years ago The first land plants arise on Earth. These are non-vascular plants – those lacking the capacity to transport nutrients and water around their structures – such as mosses and liverworts.

420 million years ago Spores released from an early plant are preserved in sediments that eventually form a sandstone rock in modern-day Herefordshire, UK. In the 1920s, these fossilized plant remains are found by botanist William Henry Lang. Tiny with simple structures, the fossils are given the name *Cooksonia*, after Australian botanist Isabel Cookson.

410 million years ago Plants with vascular tissues that can circulate fluids (such as *Rhynia*) and early branching systems (including *Psilophyton*) evolve.

390 million years ago Plants with sticklike leaves, known as microphylls, appear. These help the organisms to harvest sunlight, which they need to photosynthesize.

380 million years ago Plants evolve the ability to produce woody tissue (xylem) as they generate vascular cells. This confers them with rigidity, enabling them to grow taller. By now, roots have also evolved, which provide support for larger structures.

370 million years ago The earliest modern tree evolves. With a tall trunk and spreading branches, it is later named *Archaeopteris* (meaning 'ancient wing') on account of the feathery nature of its leaves. These are bigger than earlier microphylls; lower levels of carbon dioxide in the atmosphere have by now made it possible for large leaves to evolve. *Archaeopteris* is the first tree to form forests on a global scale.

300 million years ago The first conifers evolve. Unlike earlier plants, which reproduces by spores, these are gymnosperms, which have seeds. *Gymnosperm* means 'naked seed', which refers to the fact that the seeds are not enclosed in an ovary. The oldest known conifer now carries the name *Swillingtonia denticulata*, after the quarry near Leeds, UK, in which a fossil of it was found.

280 million years ago Conifers begin to dominate the global landscape.

260 million years ago A forest exists in Antarctica in which *Glossopteris* trees thrive under a much warmer climate than today.

250 million years ago A mass extinction event – the third of five such natural occurrences to affect Earth throughout its history – kills off half of all plant species. Mostly affecting woodlands, its victims include *Glossopteris*.

170 million years ago Early conifers have given rise to modern groups, including cypress, yews and monkey puzzles that exist today.

The genus *Ginkgo* evolves. Fossils from this time are recognizably related to *Ginkgo biloba*, the only species of ginkgo that now exists, endowing it with one of the longest botanical pedigrees of any plant. ↖ 1, see p.37

125 million years ago A rival to the gymnosperms arises in the form of angiosperms – flowering plants. These reproduce in a more efficient way than gymnosperms, with food to sustain an embryonic plant only generated after a seed has been fertilized. In contrast, gymnosperms are wasteful, as they provide all seeds with nutrients.

95 million years ago Angiosperms diversify; modern magnolias, among the earliest types of broadleaf tree that still exist, date back to this time. Some insects that evolve alongside the flowering plants also now pollinate them, receiving nectar as food in exchange. Soon, many trees that we might recognize today are on the scene: elms, birches, laurels, planes, maples, oaks and willows. ↑ 2, see p.48

65 million years ago Conifers and ginkgoes dominate at high latitudes. But 60 percent of plant species go extinct in Earth's fifth mass extinction event. It also kills off the dinosaurs, which have been evolving alongside trees for the past 180 or so million years.

60 million years ago Eucalypts evolve. However, it will take another fifty-eight million or so years before they diversify to form the wide array of species found in Australia today.

35 million years ago The development of polar ice caps helps conifers to spread across northern parts of the globe.

25 million years ago By now, broadleaf trees have spread across the world. They thrive in the generally warm global climate and lower oxygen levels than of the past.

4.2– 3.5 million years ago Early human ancestors who live in trees begin to move away from forests as they evolve to walk on the ground. They live nomadic lifestyles, hunting for meat and fish and gathering wild seeds, grasses, vegetables, nuts and berries.

2.4 million years ago– 9500 BCE Repeated ice ages affect the earth. Southern beech forests expand in the southern hemisphere and conifers repopulate the northern hemisphere.

9400 BCE Hunter-gatherers are swapping their nomadic lifestyles to settle in fixed locations. A community that forms the village of Gilgal I in the Lower Jordan Valley (in modern-day Israel) begins to cultivate the fig, the earliest known domesticated crop.

8000 BCE Someone paints a picture of people worshipping a tree on a cave wall in what is now the Serra da Capivara National Park in Brazil. This is the oldest known depiction of a plant. A similar ritual in which people surround a tree is still performed by local Indigenous groups today.

6000– 5000 BCE The first farmers in Europe construct and live in longhouses. These Neolithic dwellings are among the earliest known free-standing timber houses.

6000– 4000 BCE The olive tree is domesticated in the eastern Mediterranean. The cultivated trees, which probably derive from wild olive trees growing between modern Turkey and Syria, bear larger and juicer olives than wild varieties. ↑ 3, see p.265

2700 BCE	753 BCE	300 BCE	8 CE

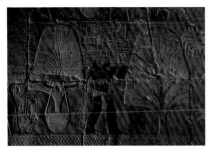

4	5	6	7

2700 BCE People of the Helmand culture, living in modern-day Kandahar, Afghanistan, draw bodhi or peepal (*Ficus religiosa*) leaf motifs on pottery. This is the earliest known use of the bodhi tree in human culture.

c.2600 BCE Inhabitants of Ur in Mesopotamia (modern-day Iraq) use wood, gold, shell and lapis lazuli to fashion a statue of a goat standing on its hind legs feeding from the leaves of a tree. It is deposited in a grave with seventy-four people, mostly bejewelled women, at the Ur's Royal Cemetery, where it becomes crushed by the weight of the soil. It is excavated in 1928–29 CE and later conserved.

From 2500 BCE People living in the ancient city of Harappa (in modern-day Pakistan) depict plants and animals in a series of seals made from clay. The seals indicate that these people worshipped trees, including the bodhi or peepal tree.

1470 BCE An expedition ordered by the female pharaoh Hatshepsut from Egypt to the 'Land of Punt' (likely modern-day Eritrea) brings back incense trees, among other luxury goods. Recorded on a relief at Deir el-Bahri, Hatshepsut's mortuary temple located across the river Nile from the modern-day city of Luxor, the trading mission is the earliest record of trees being deliberately moved and transplanted. ↑ 4, see p.234

1225 BCE The ancient Egyptian story *Tale of Two Brothers* is written, in which the younger of the brothers leaves his heart in a tree and dies when it is cut down.

865– 860 BCE A panel depicting a treelike symbol, now known as the Assyrian Sacred Tree, is carved in the throne room of the Assyrian king Ashurnasirpal II in the Northwest Palace at Nimrud, capital of the Assyrian Empire (in modern-day Iraq).

753 BCE Rome is founded, its name today reflecting that of its founder Romulus. According to Roman mythology, Romulus and his twin brother Remus had been ordered to be drowned in the river Tiber but the trough in which they were placed floated and came to rest beneath a fig tree (*Ficus ruminalis*). They founded the city at this spot.

c.700– 600 BCE The Hanging Gardens of Babylon are planted, most likely in modern-day Iraq and possibly within the stepped terraces of an ancient palace. Although they are later described in classical literature, no evidence has yet been found that unequivocally proves their existence and location.

640 BCE The Chinese empress Xi Ling-shi begins silk production in China. The fabric is produced by weaving threads unravelled from the cocoons of the Bombyx silk moth (*Bombyx mori*), which feed on white mulberry trees (*Morus alba*).

518 BCE The Persian ruler Darius I begins to build the Apadana palace in Persepolis, close to modern-day Shiraz in Iran. Reliefs on the walls, which celebrate the ancient Achaemenid Empire, include stylized depictions of trees.

500 BCE Siddhartha Gautama, the spiritual teacher now known as Buddha, attains enlightenment under a bodhi tree, located in Bodh Gaya, Bihar, India. ↑ 5, see p.320

Inspired by the natural strength of trees, the Chinese use dendriform dougong brackets to construct earthquake-resistant temples and palaces.

350– 287 BCE In his book *Historia plantarum*, Greek philosopher Theophrastus attempts to classify plants based on characteristics such as how big they are, where they live, how they reproduce and how they are useful. The third volume records Theophrastus's view that all wild trees grow from seeds or roots and that native plants can simply grow where soil is disturbed.

300 BCE The Great Stupa is built by Emperor Ashoka on a hilltop at Sanchi in Madhya Pradesh, India. Later, highly carved stone gateways are added, one of which depicts Ashoka visiting the bodhi tree under which Buddha attained enlightenment.

c.300– 50 BCE The 'Tree of Life' stone, one of several large stelae, is carved at Izapa, an ancient Mesoamerican site in modern-day Mexico. Depicting a central tree surrounded by human figures, it is subsequently interpreted as a creation scene. Connecting heaven, earth and the underworld, the tree of life is considered the axis around which life revolves.

260 BCE A branch from the bodhi tree under which Buddha gained enlightenment is brought to Sri Lanka by Buddhist nun Sanghamitta Theri at the emperor Ashoka's request. Still thriving today in the ancient city of Anuradhapura, it is the oldest tree in the world to have been planted by a human that has a known planting date and recorded history.

c.30– 20 BCE A mural is painted on the walls of the semi-subterranean dining room at the villa of Livia Drusilla, wife of the Roman emperor Augustus, in the suburb of Prima Porta in Rome, modern-day Italy. It accurately depicts many plants and animals, including strawberry trees, pomegranate, quince, oleander, Italian cypresses and English oak. It creates the illusion of dining in nature or a garden. ↑ 6, see p.77

Roman architect Marcus Vitruvius Pollio writes *De architectura*, the only treatise on architecture to survive from antiquity. He dedicates a chapter to timber, writing at length about the pros and cons of using different types of trees within construction. 'The oak, for instance, is useful where the fir would be improper,' he writes. 'The objection to fir is that it contains so much heat as to generate and nourish the worm, which is very destructive to it.'

8 CE The Roman poet Ovid recounts in his fifteen-book poem *Metamorphosis* the Greek myth of how the water nymph Daphne is pursued by Apollo but runs from his advances and is transformed into a laurel tree by her river-god father.

77 CE Roman naturalist, philosopher and military commander Pliny the Elder writes *Naturalis Historia*, which includes much information on trees. He writes of the utility of trees: 'It is by the aid of the tree that we plough the deep, and bring near to us far distant lands; it is by the aid of the tree, too, that we construct our edifices.'

113 CE Roman emperor Trajan erects a column in central Rome to commemorate his success against Dacia (roughly equivalent to modern-day Romania). Trajan's Column features 224 carved, stylized trees, 222 of which depict species native to Dacia. Almost fifty trees appear in scenes of deforestation, primarily showing Romans felling Dacian trees. It communicates a message of Roman superiority and dominance over a foreign enemy and its land.

421 CE Chinese politician, philosopher and poet Tao Yuanming writes the fable *Peach Blossom Spring*. In it, a stream of blossoming peach trees leads a sailor to find a utopian village where people live in harmony with nature.

600 CE The Nasca civilization of the Inca Valley of modern-day Peru breaks down after flourishing for eight hundred years. Its people had been accomplished at carving large, complex geoglyphs into the land. A modern theory for the Nasca's demise is that they cut down the local huarango trees (*Prosopis pallida*) that regulated temperatures and kept the land moist.

700 CE The Chinese art of *pun-sai* emerges, which involves using special techniques to grow dwarf trees in containers. ↑ 7, see p.189

710 CE	1521	1630	1771

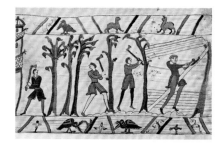

8

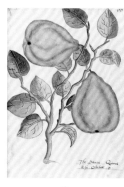

9

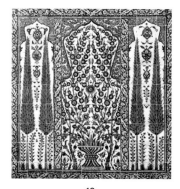

10

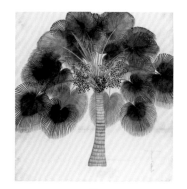

11

710–794 CE The first *hanami* – flower-viewing parties to admire blossoms on plum trees – take place in Japan. The practice soon becomes associated with cherry blossoms; today it is viewed as a hallmark of Japanese culture.

9th century CE The Chinese poet Zhu Qingyu writes the earliest recorded poem that references the Chinese art motif the 'three friends of winter' – pine, bamboo and plum – which symbolize steadfastness, perseverance and resilience.

980 CE In China, the monk Lu Tsan-Ning makes the first reference to the ginkgo tree in the *Ko Wu Tshu Than* (*Simple Discourses on the Investigation of Things*).

c.1070 The Bayeux Tapestry is embroidered in wool thread on linen cloth, depicting the events leading up to the Norman Conquest of England in 1066. Stylized trees are used to divide scenes, with oak and ash species both identifiable. ↑ 8, see p.178

1270 Yggdrasill, an enormous ash tree that connects nine worlds – including the underworld (*Niflheim*), the earth (*Midgard*) and the realm of the gods (*Asgard*) – is mentioned for the first time in three poems of the *Poetic Edda*. This is a collection of Norse mythological and German heroic poems written in Iceland but containing much older material.

c.1390 French author Honoré Bouvet completes the *L'Arbre des Batailles* (*Tree of Battles*), a synthesis of historical, legal, philosophical and literary information on the law of war.

1510 Men from the local merchants' guild in Riga, Latvia, decorate a tree with artificial roses, dance around it and set fire to it. This is the first known occurrence of a decorated Christmas tree.

1521 Sometime before this date, Aztecs paint the cosmos and its relation to their sacred 260-day calendar on an accordion-folded deerskin parchment. In one scene, T-shaped trees depicting each of the four compass points are arranged around Xiuhtecuhtli, the god of fire. Today, known as the Codex Fejérváry-Mayer, this work of art is one of few such pieces to have survived the Spanish invasion of the Aztec empire.

1557 French priest, explorer and writer André Thevet writes an account of Indigenous North American people extracting sweet sap from maple trees. The sap had long been used by the Abenaki, Haudenosaunee and Mi'kmaq people to cook or preserve meat. They tapped trees by cutting shaped notches into the bark or by inserting wooden tubes.

1594 The first recorded celebration of an Arbour Day – a holiday observed by planting trees – takes places in the Spanish village of Mondoñedo.

1609 English playwright William Shakespeare plants a mulberry tree in his garden in Stratford-upon-Avon in response to calls from King James I for landowners to plant the trees to kick-start a native silk industry. Mulberry trees feature in Shakespeare's plays *Coriolanus* (1607/8) *and A Midsummer Night's Dream* (1594/6).

1620–30 An unknown artist paints sixty-six watercolours of fruit varieties, including plums, cherries and quinces, a collection that becomes known as *Tradescant's Orchard* in reference to English gardener John Tradescant the Elder. Today, the collection represents the earliest surviving display of painted fruits growing in England. ↑ 9, see p.201

1622 Italian sculptor Gian Lorenzo Bernini carves a sculpture depicting the Greek myth of Daphne and Apollo, rendering in marble Daphne's transformation into a tree.

1630 The bark of the cinchona tree (*Cinchona officinalis*), referred to as Jesuit's, cardinal's or sacred bark, is used in South America by Jesuit missionaries to treat the symptoms of malaria; Indigenous peoples likely used it medicinally earlier than this date.

1662 English writer John Evelyn presents *Sylva, or, A Discourse of Forest-Trees and the Propagation of Timber in His Majesty's Dominions* to the Royal Society in London. It is published two years later as a book. Evelyn shows great foresight in suggesting new plantings should be made to meet future demand for timber. The book is highly influential, with new editions published until the nineteenth century.

1665 English physicist Isaac Newton sees an apple fall from a tree and deduces that Earth is exerting a force on the fruit. This experience forms the basis for his theory of gravity.

1670s As part of new construction at the Topkapı Palace, at the centre of the Ottoman Empire in Constantinople (present-day Istanbul), the rooms of the Court of the Black Eunuchs are decorated with Iznik mosaic tiles featuring cypress trees. ↑ 10, see p.312

1712 German botanist Engelbert Kämpfer includes a drawing of *Ginkgo* in his work *Amoenitatum Exoticarum*, alerting Western scientists to the species' existence after seeing the tree growing in a Japanese temple garden.

1741 Landscape gardener Lancelot 'Capability' Brown begins his first major commission working as head gardener at Stowe, UK, a 16th-century manor house and estate. Throughout his career, in which he popularizes the English Landscape style, Brown frequently uses cedar of Lebanon, London plane and evergreen oak trees.

1771 After being sent a specimen by British nurseryman James Gordon of the same tree encountered by Engelbert Kämpfer in Japan, Swedish biologist Carl Linnaeus gives the species the Latin name of *Ginkgo biloba*. He chooses *Ginkgo* based on the name used by Kämpfer, which was derived from the Japanese words *gin* (silver) and *kyo* (apricot). He selects *biloba* on account of the tree's unusual divided leaves.

1775 George Washington allegedly takes command of the Continental Army beneath an American elm tree on Cambridge Common, in Boston, Massachusetts. The Siege of Boston that ensues marks the start of the American Revolutionary War. The tree becomes known as the Washington Elm, despite there being no historical record to support its claim to fame. It survives until the 1920s.

1786 The East India Company establishes the Calcutta Botanic Garden to cultivate species of interest to the British market. Indian artists, such as Vishnupersaud, are commissioned to create botanical illustrations of the garden's collections. ↑ 11, see p.306

1791 Pierre Charles L'Enfant draws up his 'Plan of the City Intended for the Permanent Seat of the Government of the United States', in which he dedicates space specifically for trees. In 1872 Alexander 'Boss' Shepherd significantly boosts Washington DC's greenness when he plants 60,000 trees, almost bankrupting the city in the process. Today, it has 175,000 trees.

c.1798 American John Chapman plants his first nurseries in Pennsylvania. Chapman would travel, largely on foot, across much of the American Midwest, planting as he went and selling his seedlings – particularly of apple trees – to settlers, earning him the moniker Johnny Appleseed.

1800	1827	1872	1898

12

13

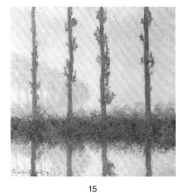

14

15

Early 1800s Chinese art scholars in Japan, discussing recent styles in the art of miniature trees, coin the term *bonsai*, a Japanese word derived from the Chinese *pun-sai*. By the late 1800s, the term *bonsai* is in common use in Japan to refer to dwarf trees potted in shallow vessels.

1807 German artist Caspar David Friedrich paints *Cairn in Snow*, a painting of three leafless trees against a wintry sky. With a melancholy air, the painting is subsequently interpreted as a meditation on life and death.

1809 French naturalist Jean-Baptiste Lamarck is the first person to use the tree of life concept in a diagram showing the evolutionary divergence or branching of organisms through time. Today, the tree of life is one of the most important organizing principles in biology.

1820 French chemists Pierre-Joseph Pelletier and Joseph Caventou extract and isolate quinine from the bark of the cinchona tree. Thereafter, purified quinine replaces the use of bark for treating malaria. ↑ 12, see p.235

1823 English botanist A. B. Lambert places a particularly lofty tree, which had been observed growing along the Pacific coast by Scottish naturalist Archibald Menzies, in the same genus as bald cypress, naming it *Taxodium sempervirens*. In 1847 German botanist Steven Endlicher, believing it to be of an entirely new genus, changes the name to *Sequoia sempervirens* – the coastal redwood.

1827 Artist Thomas Cole, founder of the first major art movement in the United States, the Hudson River School, paints *The Clove, Catskills*. A majestic representation of the natural world, it prominently features a gnarled tree. Cole uses dramatic forms such as this to imbue his paintings with a 'fearsome' element, to warn of the danger of destroying nature.

1827 Scottish explorer David Douglas sends seeds of a majestic tree he encounters in North America back to the UK. As a result, its common name – the Douglas fir – now commemorates him, while its Latin name, *Pseudotsuga menziesii*, recalls Scottish naturalist Archibald Menzies, who had observed the conifers on Vancouver Island (in modern-day Canada) in 1791. Indigenous peoples of North America had long known of the tree, with folklore telling a tale of a mouse hiding from a fire in a Douglas fir.

1829 The book *Sōmoku Kin'yō-shū* (*A Colourful Collection of Trees and Plants*) is published, stipulating criteria for achieving ideal form for bonsai. It is still considered important by classic pine bonsai aficionados today.

1852 Hunter Augustus T. Dowd enters the woods now known as North Grove in Calaveras State Park, California, and encounters a huge tree, which he names the Discovery Tree. This tree, and others found nearby (which we now know as giant redwood, *Sequoiadendron giganteum*), become a popular attraction. A year later the tree is felled and, from a count of its growth rings, is found to be 1,300 years old. The stump is used as a dance floor. ↑ 13, see p.150

1859 Charles Darwin publishes *On the Origin of Species* in which he lays out his theory of evolution. In it he lends his weight to the idea that the evolutionary history of all life forms equates to the branching structure of a tree: 'The affinities of all the beings of the same class have sometimes been represented by a great tree.'

1872 The first American Arbor Day, a time set aside for tree-planting and raising awareness of the importance of trees, takes place in Nebraska. It is initiated by journalist and politician Julius Sterling Morton, who feels the territory would benefit from the wide-scale planting of trees. Prizes are offered to counties and individuals who plant the most trees on the day. It is estimated that one million trees are planted in Nebraska. Today, Arbor Day is celebrated in all fifty US states.

1872 British botanical artist Marianne North arrives in Jamaica, painting the local flora. Travelling across 16 countries from 1871 to 1885, North would document more than 900 species of plants. ↑ 14, see p.85

1876 In an early act of biopiracy, Henry Alexander Wickham is sent by Kew Gardens, London, to South America to obtain seeds of the rubber tree (*Hevea brasiliensis*). These and subsequent seed collections go on to found vast rubber plantations across Southeast Asia.

1882 Antoni Gaudí begins building the Sagrada Família cathedral in Barcelona, Spain. Believing that God created nature – and wanting people to feel close to God when inside the building – he uses columns that branch out at the top, like trees, to create the impression that visitors are walking in a wood.

1885 Australian geologist Eduard Suess proposes that the southern hemisphere continents were once united in a supercontinent called Gondwanaland. He uses the existence of *Glossopteris* fossils in South America, Africa and India as evidence for this theory.

1890 Dutch artist Vincent van Gogh paints *Almond Blossom*, depicting pink-white blossoms against a turquoise sky, as a gift for his newborn nephew. In it, he borrows the subject, style and positioning of the tree from Japanese printmaking.

1891 French artist Claude Monet, a key figure in the Impressionist movement, starts painting a series of views of poplars along the river Epte at Giverny, France. He seeks to capture how their appearance shifts under different conditions of light and weather. When the work is threatened by the village of Limetz offering the trees for sale, Monet pays a local timber merchant to ensure they remain standing until he has finished. ↗ 15, see p.313

1898 UK urban planner Ebenezer Howard suggests the idea of developing garden cities in the UK to capture the benefits of both towns and the countryside. He envisages cities with tree-lined streets, biodiversity-rich public parks and high-quality gardens that are surrounded by a green belt of agricultural land.

1901 The first Christmas tree farm is established when American W. V. McGalliard plants twenty-five thousand Norway spruce (*Picea abies*) on his farm in New Jersey.

1905–9 Austrian symbolist painter Gustav Klimt paints his *Tree of Life* frieze for Palais Stoclet in Brussels, Belgium. A series of three mosaics, the central tree of life forms the backdrop to a female figure (Expectation) to the left and an embracing couple (The Embrace) to the right. Incorporating Byzantine imagery with golden, swirling branches that interlink heaven, earth and the underworld, the frieze symbolizes the cycle of life.

1908–13 Dutch painter Piet Mondrian produces an extensive series of tree paintings. Using a similar approach to the Impressionists, he hones in on larger branches and leaves out details of smaller branches and twigs. In this way, and with his use of a limited colour palette, he captures the essence of a tree.

1912 British explorer Robert Falcon Scott's expedition to Antarctica in 1912 gathers a fossil of an ancient tree with tongue-shaped leaves. Later identified as *Glossopteris*, it provides scientists with the first evidence that the tree once grew in Antarctica and helps to confirm that the icy continent was once much warmer.

1914 German geologist Alfred Wegener proposes the theory of continental drift, suggesting that Earth's continents move relative to each other over time. He draws on both Edward Suess's work and Robert Falcon Scott's fossils of *Glossopteris* from Antarctica. His theory goes on to form the basis of what we now know as plate tectonics.

1918	1941	1975	1991

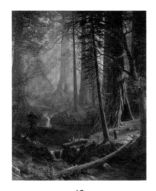

16

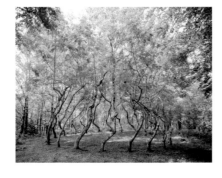

17

18

19

1918 Following the fall of the Ottoman Empire, Lebanon adopts a flag with a white background and green cedar of Lebanon (*Cedrus libani*). When the French take over Lebanon two years later, they combine the red, white and blue tricolour with the cedar tree in flags they use. Finally, in 1943, after Lebanon gains independence, it adopts as its national flag the cedar tree against a white backdrop, bounded top and bottom by red stripes.

1919 American photographer Ansel Adams joins the Sierra Club at age seventeen, developing his early photographic work on various club expeditions and remaining a member throughout his life. Established in 1892 by Scottish-American environmentalist John Muir, the Sierra Club was one of the first large-scale environmental preservation organizations in the world.

1922 American landscape architect Elbert Peets and German urban planner Werner Hegemann co-write *The American Vitruvius: An Architect's Handbook of Civic Art*. An atlas of architectural forms, it advocates integrating trees into streets and boulevards.

1931 A giant redwood known as General Sherman, which is growing in Sequoia National Park, California, is found to be the largest living tree on Earth (by volume). ↑ 16, see p.152

1932 Norwegian artist Edvard Munch begins work on *Apple Tree in the Garden*, which will take him ten years to complete. The tree is depicted fruit-laden, with a couple close by, in front of Munch's villa, Ekely. It calls to mind the Garden of Eden and offers a vision of home as paradise.

1937 The Laboratory of Tree-Ring Research is founded at the University of Arizona by A. E. Douglass, instigator of the modern technique of dendrochronology. Tree-ring dating is subsequently used in diverse applications, from identifying wrecked ships to supporting climate science.

1941 The American elm becomes the Massachusetts state tree to commemorate the alleged start of George Washington's command of the Continental Army beneath the Cambridge Common elm.

The genus *Metasequoia*, meaning 'new sequoia', is described from 150-million-year-old fossils of a species believed to be long extinct. Later in the year, three living conifers of the same species are found in China. The tree is eventually named as *Metasequoia glyptostroboides* – the dawn redwood.

1959 The lighting ceremony of the 'World's Largest Living Christmas Tree' in Wilmington, North Carolina reaches its peak, drawing crowds of more than 100,000 visitors to the festively decorated massive live oak tree (*Quercus virginiana*).

1965 The maple leaf – long a symbol of Canadian identity, as well as standing for pride, courage and loyalty among Canadian servicemen and women – becomes the central image on the new national flag of Canada.

1971 Around five hundred seeds of loblolly pine, sycamore, sweet gum, redwood and Douglas fir circle the moon on board the Apollo 14 space mission as part of an experiment to study the effects of prolonged weightlessness on seed germination and seedling growth. When they are brought back to Earth, they are planted by the US Forest Service and state forestry departments, and the resulting seedlings distributed to schools, universities, parks and other appropriate places. One such 'moon tree', a sycamore, now stands more than 15 metres (50 ft) high at the Goddard Space Flight Center in Greenbelt, Maryland.

1973 In response to the devastating impact of Dutch elm disease, which has been ravaging elm populations in Europe and the United States for a decade, a UK campaign calls for people to 'Plant a Tree in '73'. The campaign leads to the formation of the Tree Council.

1975 The Tree Council sponsors the first National Tree Week in the UK.

1977 British land artist David Nash plants a ring of twenty-two ash trees near his home in Wales, creating *Ash Dome*. Over the subsequent decades, Nash trains the trees to grow into specific forms, creating a living sculpture. ↖ 17, see p.112

1978 *Drawing a Tree* by Italian artist and inventor Bruno Munari is published. Inspired by Leonardo da Vinci's diagrammatic study of tree growth, it explores diversity and resilience through the science and art of trees.

1980 The US Congress creates the Reforestation Trust Fund to pay for the planting of trees in national forests in the aftermath of destructive events such as wildfires.

1982 The Japanese Ministry of Agriculture, Forestry and Fisheries coins the term *Shinrin-yoku* ('forest bathing') as part of a national public health programme drawing on Shinto and Buddhist teachings that promote immersing oneself in nature to enhance health and spiritual well-being.

German artist and teacher Joseph Beuys proposes the project *7000 Oak Trees*, which involves planting seven thousand trees alongside basalt stones across the city of Kassel, Germany. The project takes five years and is later replicated in other cities.

1987 The Great Storm, as it becomes known, razes fifteen million trees in the UK in a matter of hours. British student Robert Games creates a mural from the remains of the more than a thousand trees that were destroyed at the Royal Botanic Gardens, Kew. ↑ 18, see p.175

1991 A much-photographed sycamore tree that stands in a dip along the Roman fortification Hadrian's Wall, UK, features in the Hollywood blockbuster film *Robin Hood: Prince of Thieves*. It is tragically felled in 2023 in a deliberate act of vandalism. ↑ 19, see p.61

1992 A fungus (*Hymenoscyphus fraxineus*) that grows on Asian ash trees (*Fraxinus mandshurica* and *F. chinensis*) without being harmful is found to be causing ash dieback disease on European ash (*F. excelsior*) trees in Poland, from where it spreads to most countries in eastern, central and northern Europe. As European ash trees have no genes capable of resisting the disease, they quickly succumb to it. The disease is forecast to kill 95 percent of European ash trees over time.

1994 Officers working for the New South Wales National Parks and Wildlife Service encounter an unrecognized tree in the Blue Mountains, Australia, determine it to be in the family Araucariaceae. Its combination of features of the two living genera, *Agathis* and *Araucaria*, suggest it belongs to an ancient lineage that diverged from other species a long time ago. It is named *Wollemia nobilis*. The Royal Botanic Gardens, Kew, develops a propagation programme to prevent the one hundred or so remaining trees from being targeted by plant collectors. It is now possible to buy a Wollemi pine from many gardening outlets.

1995 The Food and Agriculture Organization of the United Nations launches the first *State of the World's Forests* report. It estimates the annual value of fuel wood and wood-based forest products to the global economy to be more than $400 million (£315 million) or about 2 percent of GDP.

1996 Hungarian-born American artist Agnes Denes completes her *Tree Mountain* project, in which she engages eleven thousand people to plant eleven thousand trees on an artificial mountain in Finland as part of a land-reclamation project. She aims to create a virgin forest, with the land protected for four centuries.

20

23

1996 Japanese multimedia artist Yoko Ono's art installation *Wish Tree* is exhibited for the first time in Santa Monica, California. Subsequently replicated around the world, the ongoing series involves a tree or trees being planted, with people invited to tie wishes to the branches. These are collected and buried at the base of the Imagine Peace Tower, a tower of light, in Finland, which is a memorial to Ono's husband, John Lennon.

1997 Research by Canadian scientist Suzanne Simard suggests that trees in a forest use a subterranean 'wood wide web' of fungal networks to share and trade food.

The World Resources Institute (WRI) establishes Global Forest Watch (GFW) as part of its Forest Frontiers Initiative. Starting as a network of NGOs reporting on the state of forests in just four countries, GFW grows into an online platform that monitors forests with near real-time information across the globe.
↑ 20, see p.240

1997–98 Artist duo Christo and Jeanne-Claude begin their *Wrapped Trees* project, in which they use 55,000 square metres (592,000 sq ft) of woven polyester fabric and 23 kilometres (14 mi) of rope to cover trees in Fondation Beyeler and Berower Park, Riehen, Switzerland.

1999 Scientists Michael Mann and colleagues use evidence from tree rings and other temperature proxies to reconstruct the average northern hemisphere temperature over the preceding one thousand years. The diagram they publish depicting the data becomes known as the 'hockey stick' graph because of the uptick in temperature it reveals for the last part of the twentieth century. The work contributes to a growing body of evidence showing that the observed rising levels of greenhouse gases in the atmosphere from human activity is causing planetary warming.

2000 In a special report, the Intergovernmental Panel on Climate Change – set up by the United Nations in 1988 to advance scientific knowledge about climate change caused by human activities – concludes that planting trees could remove around 1.1 to 1.6 metric gigatons (1.2 billion to 1.8 billion tons) of carbon dioxide per year. For comparison, the total global greenhouse gas emissions were 49 metric gigatons (54 billion tons) of CO_2 in 2004.

2001 The oak is voted in as the United States's favourite tree in an Arbor Day Foundation poll. Four years later, in a historic bill, it officially becomes the country's national tree.

2004 Kenyan social, environmental and political activist Wangari Maathai receives the Nobel Peace Prize for her work leading women in a nonviolent struggle for peace and democracy through reforestation. The first African woman to win the prize, her organization had planted more than thirty million trees in thirty years.

British artist Gary Fabian Miller experiments with camera-less photography, capturing the unique character of eighty-one beech leaves on photosensitive paper using a dye-destruction process.
↑ 21, see p.78

2006 The genome of a tree – a black cottonwood (*Populus trichocarpa*) – is sequenced for the first time. The effort takes four years and involves more than one hundred scientists in thirty-eight institutions across Europe, Canada and the United States. The species has more than forty-five thousand possible genes on its nineteen chromosomes.

2007 The African Union launches the Great Green Wall Initiative, which aims to create an 8,050-kilometre (5,000-mi) wall of trees and greenery across the southern Sahara, from Senegal on the continent's west coast to Djibouti in the east. It seeks to eradicate poverty and promote sustainable development and peace.

2012 A bristlecone pine (*Pinus longaeva*) growing in the White Mountains of California is found to be 5,065 years old and is named Methuselah. Likely to be the oldest non-clonal tree in the world, it would have already been growing when the Great Pyramid at Giza, Egypt, was built.

2013 Scientists calculate that the Amazon rainforest contains 390 billion trees, encompassing some 16,000 species.
↑ 22, see p.147

2014 In her book *The Sixth Extinction: an Unnatural History*, Elizabeth Kolbert examines evidence that suggests a sixth mass extinction is affecting Earth – caused by destructive human activity. She discusses how climate change is affecting cloud forests and stresses the interdependence of ecosystems and the need to preserve biodiversity.

2015 Apple pips from the tree that inspired Isaac Newton to discover gravity, which lives on in the garden of his birthplace, Woolsthorpe Manor, in Lincolnshire, UK, fly with British astronaut Tim Peake to the International Space Station. Eight of the seeds are germinated on their return to Earth by horticulturists at Wakehurst Place, part of the Royal Botanic Gardens, Kew. The seedlings are sent to UK attractions, including the Eden Project and National Physical Laboratory, to inspire future space travellers and seed scientists.

A study calculates that there are some three trillion trees on Earth, more than seven times more than previously estimated.

To commemorate the thirtieth anniversary of Heartland beer, art director Arata Kubota creates *Slice of Heartland*, in which a 3D replica of the brand's tree logo is sliced into one hundred cross sections.
↗ 23, see p.62

2017 Engineers at the Massachusetts Institute of Technology mimic the pumping mechanism of a tree's vascular system to create a 'tree on a chip'. Able to pump water and sugars at a steady flow rate for several days, it could potentially be used to create small hydraulic actuators for use in robots.

2018 The UK government reports that the services provided by the country's trees – related to timber, carbon sequestration, recreation, landscape and biodiversity – are worth £4.9 billion ($6.2 billion).

While conducting an aerial survey, scientists pinpoint the tallest tree in the Amazon rainforest. One of a group of around fifty *Dinizia excelsa* trees, it stands 88.5 metres (290 ft) high, equivalent to a three-storey house.

2019 Researchers determine that 2,300 species are associated with the sessile oak (*Quercus petraea*) and the English oak (*Q. robur*) in the UK, with 326 of the species only found on these trees.

Tropical regions lose about 12 million hectares (30 million acres) of trees to deforestation every minute. Nearly a third of the loss takes place in carbon-rich primary forests.

American novelist Richard Powers is awarded the Pulitzer Prize for Fiction for *The Overstory*, a book about nine central characters coming together to fight the destruction of forests through their unique, life-changing experiences with trees.

2020 The total value of the world's forests is estimated to be $150 trillion (£118 trillion), nearly double the value of the global stock market. By far the largest component of the total value (90 percent) comes from the ability of forests to regulate the climate by storing carbon in their trunks, branches, leaves and roots.

2020

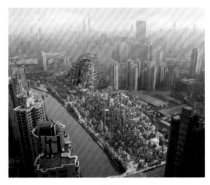

24

2020 A study finds that of the 1.6 billion people who live within 5 kilometres (3 mi) of a forest, more than 70 percent live in low- and middle-income countries.

British design firm Heatherwick Studio completes *1000 Trees* in Shanghai, China, a mixed-use development that incorporates 1,000 trees and 250,000 plants. ↑ 24, see p.193

2021 The REPLANT Act becomes law in the United States, with the goal of helping to reforest 1.7 million hectares (4.1 million acres) by planting 1.2 billion trees over ten years. The process of doing so is calculated to create 49,000 jobs, and to sequester 75 million metric tons (82.6 million tons) of carbon in a decade, equivalent to avoiding using 32 billion litres (8.5 billion gallons) of petrol.

The Botanic Gardens Conservation International *State of the World's Trees* report finds there are 58,497 known species of trees spread across 257 botanical plant families. They range from the tiny dwarf willow (*Salix herbacea*), which reaches a maximum height of a few centimetres, to the towering coastal redwood (*Sequoia sempervirens*) that can grow taller than 115 metres (377 ft).

Artist and environmentalist activist Maya Lin's *Ghost Forest*, a stand of forty-nine white Atlantic cedars, rises in Madison Square Park, New York. With Atlantic white cedars endangered on the US East Coast, the work is a metaphor for a looming environmental catastrophe. In nature, a ghost forest is a dead woodland that was once vibrant.

Third-generation potter and sculptor Oscar Martin Soteno Elias continues his family's tradition of creating *árboles de la vida* (trees of life). Reflecting the vibrant style of Mexican folk art, or *arte popular*, Elias's family has been creating the ceramic sculptures since the 1930s. ↗ 25, see p.165

2022

25

2022 The *State of the World's Forests 2022* reports that some 47 million hectares (116 million acres) of primary forests were lost between 2000 and 2020. It outlines three pathways for forests to be employed in tackling global threats that include food insecurity, poverty, climate change, conflicts, land and water degradation, and biodiversity loss. These are halting deforestation and maintaining forests, restoring degraded lands and expanding agroforestry, and sustainably using forests and building green value chains.

Spain's capital city, Madrid, begins work to create a 145,000-square-metre (1.6-million-sq-ft) urban forest in one of Europe's largest urban-renewal projects. The ultimate goal is to create a 100 percent sustainable city, with citizens getting around on foot, by bicycle or on public transport.

The first plant species to be described this year as new to science, an evergreen tree native to Cameroon's Ebo Forest, is named *Uvariopsis dicaprio* to commemorate actor Leonardo DiCaprio's campaigning work to protect the forest from logging.

Scientists calculate that the world would be 1° C (1.8° F) warmer without the cooling effects of tropical forests.

Kyoto's cherry blossoms, for which the city is famed, are reaching full bloom eleven days earlier than they would without the effects of the urban environment and climate change.

Scientists who analyze two decades of satellite data find that forests in arid, tropical and temperate regions are becoming less able to bounce back after damaging events such as drought and logging.

The Amazon rainforest is reported to be reaching a tipping point, beyond which trees may die off en masse.

Scientists suggest documenting every tree on the planet in order to help prevent further losses from deforestation.

2023

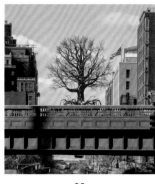

26

2023 The Global Tree Assessment, an initiative of Botanic Gardens Conservation International and the International Union for the Conservation of Nature's Species Survival Commission Global Tree Specialist Group, finds that at least 32 percent of all tree species are threatened with extinction.

A modelling study carried out by scientists in Spain indicates that doubling tree cover in Europe's cities could cut heat-related deaths by 40 percent.

Four specimens of Pernambuco holly (*Ilex sapiiformis*), a species not seen since first being identified by Scottish naturalist George Gardner in 1838 and considered extinct, are found growing in the city of Igarassu, northeast Brazil.

The rate of deforestation in the Amazon rainforest falls by 50 percent in comparison to the previous year, but the deforested area remains more than six times larger than New York City.

Dutch pianist Remko Kühne composes a piece inspired by Vincent van Gogh's *Almond Blossom* painting, rendering, in music, the blossom opening.

A wide-ranging study finds that the health benefits of spending time in forested areas, green spaces and trees outside of woodland encompass neurodevelopment in children, mental health and cardiometabolic health in adults, and cognitive ageing and longevity in the elderly.

A hot pink tree rises among the skyscrapers of New York City. Named *Old Tree*, it is artist Pamela Rosenkranz's creation for the High Line Plinth, a permanent space for contemporary art at West 30th Street. ↑ 26, see p.109

Chilean researcher Jonathan Barichivich and his team determine that a Patagonian cypress (*Fitzroya cupressoides*) known as Lañilawal in Alerce Costero National Park is likely more than 5,400 years old, making it the oldest tee in the world.

2024

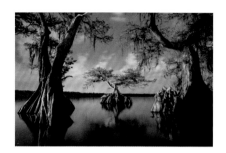

27

2023 Photographer Mac Stone travels down the Black River in North Carolina with dendrochronologist David Stahle, documenting the native bald cypress (*Taxodium distichum*), some of the oldest living trees in the world. In 2017 Stahle discovered one Black River cypress was more than 2,600 years old, dating to at least 605 BCE. ↑ 27, see p.327

2024 Scientists discover a 350-million-year-old tree fossil in an active rock quarry in New Brunswick, Canada, with its leaves and branches intact. The newly identified species, named *Sanfordiacaulis densifolia*, is found to have had a narrow trunk and extremely wide canopy, most likely the result of evolving to capture maximum amounts of sunlight.

Among the plant species named as new to science by the Royal Botanic Gardens, Kew, are two kinds of trees that live almost entirely underground. They had been encountered growing in the Kalahari sands of highland Angola in central Africa. One, named *Baphia arenicola*, meaning 'growing on sand', is a member of the bean family, with white flowers. The other *Cochlospermum adjanyae*, has bright yellow flowers. Only small parts of the trees, including the flowers, poke above the surface; the rest is hidden beneath the soil. The discoveries show that we still have much to learn about the magical world of trees.

Select Biographies

Ansel Adams
(United States, 1902–1984)

Ansel Adams was a pioneering photographer best known for his majestic, formally assured landscapes of the American West. A vocal proponent for the establishment of photography as an art form, he helped found the photography department at the Museum of Modern Art in New York in 1940. From 1934 to 1971, Adams was the director of the environmental organization the Sierra Club, and in 1980, he was awarded the Presidential Medal of Freedom for his documentation of America's national parks and his tireless activism for environmental conservation.

Giuseppe Arcimboldo
(Italy, 1526–1593)

Giuseppe Arcimboldo was an Italian Mannerist painter whose original, distinctive portraits depict grotesque figures made of fruits, vegetables, trees, fish and flowers. Arcimboldo was a court painter to Emperor Maximilian II, himself known for an interest in the biological sciences. Forgotten for centuries, Arcimboldo's works received renewed attention in the twentieth century and influenced Surrealists such as Salvador Dalí.

John James Audubon
(United States, 1785–1851)

Born in Haiti and brought up in France, Audubon moved to the United States in 1803. He tried various business ventures before combining his skill as an artist with his lifelong interest in ornithology in a project to find, identify and draw the birds of North America. The project took some fourteen years as Audubon travelled the country. Each bird was placed against a background of plants, depicted either by Audubon or by his assistant, Joseph Wilson. The resulting book, *Birds of America* (1827–38), with its huge lithographs of nearly five hundred bird species, is considered a landmark of natural history illustration.

William Bartram
(United States, 1739–1823)

From a young age, William Bartram accompanied his father, John, founder of the first American botanic garden, on plant-collecting expeditions throughout eastern North America, during which he developed a skill for botanical drawing. In the 1770s, he made his own four-year journey through the South and Florida, where he collected many new species; he published an illustrated account of his travels in 1791. From the late 1770s, Bartram ran his father's garden, but he also illustrated *Elements of Botany* (1803–4) by his friend Benjamin Smith Barton.

Ferdinand Bauer
(Austria, 1760–1826)

Orphaned as an infant, Ferdinand Bauer was brought up with his brother Franz by the monk Norbert Boccius, who taught them natural history and illustration. The brothers worked at the royal botanical garden at Schönbrunn Palace in Vienna before Ferdinand accompanied Professor John Sibthorp of Oxford University to Greece and Turkey, illustrating *Flora Graeca* (1806–40). Bauer later became a botanical artist on Matthew Flinders's expedition to Australia. His album of drawings, *Illustrationes Florae Novae Hollandiae* (1806–13), was a commercial failure, and Bauer died in relative obscurity.

Elizabeth Blackwell
(Britain, 1699–1758)

Trained as an artist in her native Scotland, Elizabeth Blachrie moved to London after secretly marrying her cousin Alexander Blackwell. When Alexander's poor business decisions led to his confinement in debtors' prison, Elizabeth sought to support her young family by illustrating a herbal of European plants, including many British wild flowers, which she found in the Chelsea Physic Garden. The first edition of *A Curious Herbal* (1737–39) included five hundred plants in two volumes and raised enough money to release her husband from prison. She travelled to Sweden, where she became court physician to Frederick I, but he was later accused of treason and executed. Little is known of the later life of Elizabeth, who remained in London.

Charles Darwin
(Britain, 1809–1882)

Charles Darwin was possibly the most influential naturalist who has ever lived. Born to a family of scientists, he studied natural history at Cambridge University before becoming a naturalist on board HMS *Beagle* in 1831, then setting out on a five-year voyage around the world. Darwin's observations of specialist adaptations in plants, birds and animals prompted years of further research before he published *On the Origin of Species* (1859), which outlined a theory of evolution caused by natural selection. Hugely controversial at the time, the idea of evolution quickly became accepted as historical truth by the vast majority of scientists.

Mary Delany
(Britain, 1700–1788)

Born into a well-connected English family, Mary Granville received a varied education before an unhappy marriage to the MP Alexander Pendarves. After his death, she married an Irish clergyman, Patrick Delany, with whom she lived for nearly twenty-five years in Dublin. Her lifelong interest in botany was encouraged by her friend the Dowager Duchess of Portland, who introduced her to such botanists as Sir Joseph Banks. After being widowed again in 1771, Mary began to create découpage flowers from cut paper, amassing a large collection that came to the attention of the royal family and is now in the collection of the British Museum.

Albrecht Dürer
(Germany, 1471–1528)

Albrecht Dürer was one of the most celebrated German artists of the Renaissance, best known for his highly skilled woodcuts and engravings, but he was also a pioneer of landscape painting. He worked mainly in his native Nuremberg, although he travelled as far as Italy to study art and corresponded with such contemporary artists as Leonardo da Vinci. Dürer was renowned for his printmaking, through which his influence spread across Europe.

Georg Dionysius Ehret
(Germany, 1708–1770)

Georg Ehret became one of the most influential European botanical illustrators for his pioneering work, first with the Anglo-Dutch collector George Clifford at his estate near Haarlem, where Ehret worked with the young Carl Linnaeus, and later in London. Trained originally as an apprentice gardener, Ehret was able to study many of the new species that were brought to the Netherlands and Britain as Europeans explored the Pacific, Asia and the Americas. In 1737 Ehret, Clifford and Linnaeus published the renowned *Hortus Cliffortianus*.

William Henry Fox Talbot
(Britain, 1800–1877)

The British aristocrat Henry Fox Talbot was famed for his discoveries during the early development of photography. Four years before the Frenchman Louis Daguerre announced his invention of the daguerreotype in 1839, Talbot used paper treated with salt and silver nitrate to capture images using a camera lens. Talbot's subsequent development of the calotype process shortened the length of exposure required to produce an image. His contribution to plant illustration came by placing leaves on photosensitive paper and exposing them to sunlight to produce 'photogenic drawings', one of which was included in the first photographic book, Talbot's *Pencil of Nature* (1844–46).

Nehemiah Grew
(Britain, 1641–1712)

Sometimes called the 'father of plant anatomy', Nehemiah Grew studied at Cambridge and Leiden, Holland, where he used an early microscope to study the structure of plants. Returning to London, his growing reputation for botany earned him election as a fellow of the Royal Society. Grew's major work, *The Anatomy of Plants*, was published in 1682 with eighty-two plates that reveal the inner structure of plants. Grew was the first to identify the fact that – like animals – plants have organs with different functions.

Kawahara Keiga
(Japan, 1786–1860)

The son of a painter in Nagasaki, Kawahara Keiga studied painting before obtaining permission from the Japanese government to work in Dejima, the 'factory' or trading post to which Dutch traders were confined as part of Japanese efforts to limit Western interference and influence. He painted many images of life in Japan for his Dutch patrons, including prints of Japanese flora and fauna commissioned by the botanist Philipp Franz von Siebold. Instructed by visiting European artists, Keiga was responsible for introducing Western artistic techniques to traditional Japanese painting.

Yayoi Kusama
(Japan, b. 1929)

The Japanese contemporary artist Yayoi Kusama now works predominantly with installations that are at once representational and abstract. Prone to hallucinations from an early age, Kusama transforms these experiences – how she sees the world – into her art. Repetitive patterns, often polka dots,

are obsessively mirrored and extended into infinite spaces that envelop the viewer. Her early work comprised paintings, referred to as 'infinity nets', of obsessively repeated tiny marks across large canvases, as well as performance.

Jacopo Ligozzi
(Italy, 1547–1627)

Born in Verona to a family of artists, Jacopo Ligozzi was a painter for the Habsburg court in Vienna before returning to Italy to work for the Medici family in Florence, where he replaced Giorgio Vasari as head of the artists' guild. Although Ligozzi was an accomplished painter of frescos and altarpieces, he is best known for his studies of plants and animals. In addition to working for the Medici, he recorded plants from the botanic garden created in Bologna by the naturalist Ulisse Aldrovandi.

Marcello Malpighi
(Italy, 1628–1694)

Educated at the University of Bologna, Marcello Malpighi earned doctorates in both philosophy and medicine before carrying out extensive research into the anatomy of plants and animals. One of the first generation of microscopic researchers, Malpighi discovered the structure of the lungs, for example, and the link between arteries and veins in organisms; in plants, he made drawings of individual organs for the first time, and drew the stages of development of legumes. His research was published in *Anatome Plantarum* (1679), with engravings by the Englishman Robert White.

Rory McEwen
(Britain, 1932–1982)

Born into an aristocratic Scottish family and educated at Eton, Rory McEwen initially became a musician; he was a leading figure in the rising popularity of folk and blues music in the 1960s. At the same time, he was a talented flower artist (influenced by his maternal great-grandfather, the botanist and artist John Lindley). In 1964 McEwen gave up music and devoted himself to floral art, painting large minimalist watercolours on vellum. Diagnosed with terminal cancer at the age of fifty, he committed suicide.

Margaret Mee
(Britain, 1909–1988)

Margaret Mee studied art in London with the British painter Victor Pasmore. His emphasis on observation, mass, shape and space influenced the flower paintings Mee produced after moving in 1952 to São Paulo, Brazil, where she dedicated herself to painting plants. From 1956 she made a series of expeditions into the Amazonian rainforest, during which she painted many species previously unknown to science. Her book *Flowers of the Brazilian Forests* was published in 1968. In 1976 she was awarded the MBE for services to Brazilian botany.

Maria Sibylla Merian
(Germany, 1647–1717)

Maria Sibylla Merian learned to paint when her stepfather introduced her to miniature flower painting. In 1680 she published *The New Book of Flowers* in Nuremberg,

intended as a model book for artists and embroiderers; it was followed by *The Caterpillar Book*, showing butterflies and moths. Merian later moved to Amsterdam, where her daughters Johanna Helena and Dorothea Maria also became noted as natural history artists; the latter accompanied her mother in 1699 to Suriname, where they collected specimens for *Metamorphosis Insectorum Surinamensium* (1705), a work that ensured Merian's reputation as a pioneering entomologist.

Adolphe Millot
(France, 1857–1921)

Born in Paris, Adolphe Millot was a member of the prestigious Salon des Artists Français. Millot was responsible for illustrating many of the natural history sections of the well-known French encyclopedia *Le Petit Larousse*, which first appeared in 1905. A highly regarded lithographer and entomologist, Millot worked as a senior illustrator for the Musée Nationale d'Histoire Naturelle in Paris, established by King Louis XIII in 1635 as the royal garden for medicinal plants.

Claude Monet
(France, 1840–1926)

Claude Monet was a leading member of the Impressionist movement, which took its name from his painting of 1874. For sixty years, Monet explored ways of translating the natural world into paint, with pictures that take viewers from the streets of Paris to the tranquil gardens of Giverny, where he painted his famous waterlily pictures. Monet's contribution to the painting tradition paved the path for twentieth-century modernism and revolutionized the way we view nature.

Marianne North
(Britain, 1830–1890)

Although not formally trained, painter Marianne North enjoyed two great advantages for a female artist in the nineteenth century: money and political connections (her father was the MP Frederick North). From 1871 she travelled widely, painting botanical species in North America, the Caribbean, Brazil, Japan, Australia, New Zealand, and Southeast and South Asia. The majority of her 848 paintings, many of which depict plants in wider scenes, are today housed at Kew in the Marianne North Gallery, which was built in 1882.

Georgia O'Keeffe
(United States, 1887–1986)

One of the leading American artists of the twentieth century, Georgia O'Keeffe had a conventional training before turning her back on realism in her twenties to experiment with abstraction. Her work was first exhibited in 1916 by the photographer and gallery owner Alfred Stieglitz, whom she married in 1924. From 1929 O'Keeffe spent much of her time painting flora, landscapes and animal bones in New Mexico, where she moved permanently in 1949.

Pierre-Joseph Redouté
(Belgium, 1759–1840)

Born into a family of decorative artists, Pierre-Joseph Redouté learned the family business before moving to Paris to paint theatre sets. Spotted sketching plants and flowers

by the botanist Charles Louis L'Héritier, Redouté contributed illustrations to L'Héritier's works; his images drew the attention of the flower artist Gérard van Spaendonck, who recruited Redouté to paint five hundred flower pictures for the collection known as the *Les Vélins du roi*. Redouté became official court painter to Marie Antoinette and, after the French Revolution, to Napoleon's empress, Josephine; he later worked for the restored Bourbon royal family. His most famous work, *Les Roses* (1817–24), confirmed his position as one of the most popular flower artists of all time.

Roelandt Savery
(Belgium, 1576–1639)

The Flemish painter and printmaker Roelandt Savery often painted rocky landscapes with animals and figures drawn from life – including allegedly a living dodo – and still lifes of flowers influenced by the work of Jan Brueghel the Elder. His family moved to Haarlem in the Netherlands in 1585 to escape the religious upheaval of the time. Savery joined the painters' guild there in 1587 and moved to Amsterdam with his brother Jacob in 1591. He travelled to Prague under the patronage of Emperor Rudolf II, but ultimately returned to the Netherlands.

John Tradescant the Elder
(Britain, c.1570–1638)

The English naturalist and collector John Tradescant was head gardener for Robert Cecil, 1st Earl of Salisbury, and later for the 1st Duke of Buckingham and King Charles I. Travelling widely throughout Europe on his employers' behalf, he collected bulbs, seeds and natural curiosities that he later displayed in an early example of a public museum in Lambeth, south London, where he and his son John Tradescant the Younger maintained a botanic garden.

Vincent van Gogh
(Netherlands, 1853–1890)

Vincent van Gogh is one of the foremost figures in the history of twentieth-century art. While his career as an artist was short, lasting only from around 1880 to his death, he was a prolific and imaginative painter whose innovations in brushwork and colour inspired generations of artists. In 1888 he moved to Arles, France, where the brilliancy of the light inspired him to make paintings of trees, flowers, orchards and fields, which remain some of his best-known works to this day.

Sheik Zain-al-Din
(India, fl.1777–1783)

Patna-born Muslim artist Sheik Zain-al-Din worked for the British expatriate elite at a time when the East India Company's control of India was growing. Trained in the Mughal style but influenced also by Western painting, Zain-al-Din combined his illustrations of birds and other animals with typically English botanical backgrounds. The Chief Justice of Bengal, Sir Elijah Impey, and his wife, Mary, commissioned the artist to catalogue their private menagerie at their Calcutta home. Working in watercolours and on paper brought from England, between 1777 and 1783 Zain-al-Din meticulously drew and illustrated most of a total of 326 paintings, helped by two other artists.

Glossary

Allée
A straight walk, path or ride bordered by trees or clipped hedges. A series of straight *allées* will often form an ordered geometric pattern.

Angiosperm
A seed-producing flowering plant; angiosperms are one of the most diverse groups of plants, containing about 350,000 species.

Anthropomorphism
The tendency for humans to interpret the physical appearance and behaviour of animals as similar to, comparable to or the same as those of humans.

Arboretum
A botanical collection of trees and shrubs – both coniferous and broad-leaved.

Arts and Crafts movement
The late nineteenth-century British movement, promoted by William Morris, John Ruskin and others, that encouraged a return to the perceived values of medieval craftsmanship as a reaction to increasing industrialization. In a garden context, Arts and Crafts style often refers specifically to the work of Gertrude Jekyll and Edwin Lutyens and their followers working in the first two decades of the twentieth century.

Baroque
The seventeenth- and eighteenth-century European style making exuberant use of ornamentation. In a garden context, the Baroque style is highly formal and features include *parterres de broderie*, **topiary**, **allées**, richly carved fountains and statuary.

Binomial system
The universal system of naming living organisms, including plants, with two names: a capitalized genus name plus a species name, e.g. *Cyclamen* (**genus**) and *coum* (**species**).

Biodiversity
Biological diversity, or the variety of life on Earth, considered at all levels. This includes genetic variety within species, the variety of species themselves, and habitat variety within an ecosystem.

Bosco
A grove of trees or a wood, natural or artificial, often incorporated into the design of an Italian Renaissance garden. Wilder in aspect than a **bosquet**.

Bosquet
A small clump of trees, or a decorative glade with statuary, enclosed by a hedge or fence, usually a part of seventeenth- or eighteenth-century French Baroque gardens.

Botanic(al) garden
A garden used for research into the relationships between plants – often associated with a university or professional botanical organization – and usually open to the public. The plants in botanic gardens are arranged either taxonomically, by geographical area or by habitat.

Calotype
A photographic process invented by William Henry Fox Talbot in 1841 in which paper coated with a silver chloride solution is exposed to light, resulting in a negative image. Unlike daguerrotypes, which could not be duplicated, the 'negative' can be developed into multiple prints.

Chahar bagh
Term meaning 'four gardens' and referring to the Islamic quadripartite garden form whereby four beds ('gardens') are defined by four perpendicular rills fed from a central water source and enclosed by paths.

Chinoiserie
The Chinese-style decoration as imagined by European designers from the seventeenth century onwards. It was based mainly on travellers' descriptions – although the architect William Chambers championed the style in the eighteenth century – and was influential throughout Europe, particularly in Germany.

Codex (pl. codices)
An ancient manuscript in the form of a book.

Conifer
Any member of the division Coniferae. Conifers are the largest group of **gymnosperms** and include pine, fir, spruce and other cone-bearing, woody trees, as well as some shrubs. Conifers are chiefly **evergreen** and usually have needle-shaped or scalelike leaves.

Cycad
Any member of the order Cycadales. Cycads are palm like woody **gymnosperms** and typically have crowns of large **pinnately** compound leaves, with cones at the end of a cylindrical trunk.

Deciduous
Describes a plant that loses its leaves each year in order to survive the harsh conditions of winter (some tropical plants are deciduous in the dry season in order to conserve water).

Dioecious
Describes plants that have the male and female reproduction organs in separate individuals.

Ecosystem
The system or web of movement of energy and nutrients between living (biotic) organisms and the (abiotic) environment.

Endemic
An indigenous species that is found only in a specific region owing to factors that limit its distribution and migration.

English Landscape style
The garden design style that arose in Britain in the eighteenth century, first as an art form analogous to literature, with complex symbolic and political meanings expressed as buildings and landscape features. It evolved through various expressions by Charles Bridgeman and William Kent, and later became a purely visual or painterly medium, evocative of a pastoral idyll – as with the work of Capability Brown. It was reproduced throughout Europe in the eighteenth and nineteenth centuries.

Engraving
Cutting a design into a hard surface such as stone or metal; also, a print reproduced from such a design.

Etching
A method of printing in which an artist incises a design on to a metal plate with a needle, then burns the metal with acid.

Evergreen
Describes plants that retain their leaves all year round. Evergreen leaves are often darker, thicker and tougher than deciduous ones. In hot and dry countries, evergreen leaves can be densely covered in hair, making them appear grey or silver.

Evolution
The process in which living organisms adapt and change over generations.

Family
A higher botanical classification group than **genus**. A family contains genera (pl. of genus) that are related to one another because they share certain fundamental characteristics. For example, the sage genus *Salvia* is related to the mint genus *Mentha* because both have square-section stems and hooded, tubular flowers; both genera belong to the family Lamiaceae.

Fertile
Describes a plant that possesses the capacity to reproduce, meaning that it is capable of producing fruit, seed-producing flowers or anthers containing pollen. Often hybrids are not fertile and thus unable to reproduce.

Flora
The collective name for flowering plants, or for plant life found in a specific region. Also denotes a publication describing the collective plants of a specific region.

Florilegium
A term that originally described a collection of plants gathered into a single bouquet, planter or urn, or a painting presenting such an arrangement of plants. Today it most commonly describes a treatise on flowers that concentrates on their ornamental rather than medical or botanical value.

Fruit
A seed-bearing structure that forms from the ripened ovary in flowering plants. Its purpose is to enclose the seeds in order to aid their dispersal, for example by being eaten or being carried by the wind.

Genus (pl. genera)
A subdivision of a botanical **family** that contains one or more species according to similar characteristics that show their close relationships. For example, the genus *Cyclamen* contains twenty-two species including the species *Cyclamen coum*, which has small, round leaves and short, squat flowers in spring; *Cyclamen hederifolium*, with ivylike leaves and narrow flowers in autumn; and *Cyclamen repandum*, with ivylike leaves and narrow flowers in spring. These all belong to the primula family, Primulaceae. The name of a genus is always written with a capital letter.

Germination
The first stage of a seed's growth, from embryo to the formation of its first root and then leaves.

Gouache
A type of opaque watercolour paint.

Gymnosperm
Any vascular plant that uses exposed seeds to reproduce, including **conifers** and **cycads**.

Herbal
A book or manuscript created to communicate the medicinal properties of plants.

Herbarium
A systematically arranged collection of dried and pressed plant specimens preserved for scientific study.

Horticulture
The science and art of growing plants.

Hortus conclusus
An enclosed medieval garden, made at certain monasteries and dedicated to the Virgin Mary, and often containing a fountain, statue of Mary and plants allegorically representing her virtues (for example, the white lily and red rose).

Hybrid
A genetic cross between two different species (usually but not always in the same **genus**). For example, *Primula × polyantha* is a cross between the cowslip, *Primula veris*, and the primrose, *Primula vulgaris*; the 'x' denotes that it is a hybrid with its own **binomial** name.

Indumentum
A coating of fine hairs, also called trichomes, on a plant, particularly the undersides of a leaf.

Intaglio
A design that is engraved or incised into a hard surface and used to create an image in relief.

Invasive
Describes plants that encroach on and invade the territory of other plants, often pushing them out of their chosen habitat.

Lithograph
An image that is prepared on a flat stone surface using grease or oils and then used to create an ink print.

Lobe
In a leaf, one of two or more projections or divisions (the leaf blade remains joined as one leaf, rather than being divided into leaflets). A maple leaf, for example, usually has three or five major lobes.

Materia medica
A Latin medical term for the body of collected knowledge about the therapeutic properties of any substance used for healing (i.e. medicine).

Micrograph
A magnified digital image taken through a microscope. Micrographs are used to study elements of a plant that are invisible to the naked eye.

Midrib
In a leaf, the central supporting vein or axis of the leaf blade or lamina.

Native
A plant that occurs naturally in a particular country or region. Native plants may occur in a number of places within a country or region (indigenous) or be restricted to just one place (**endemic**).

Naturalist
Someone who takes a keen interest in, and has a deep knowledge of, the natural world, usually from a broad, ecological viewpoint. They may or may not be academically trained.

Naturalize
To introduce a plant successfully to a new region. In some cases, naturalization can be overwhelmingly **invasive**, as with the introduction of gorse into New Zealand.

Natural philosophy
The philosophical study of nature and the natural world as the precursor of modern science from the time of Aristotle in the third century BCE until the separation of biology, physics and chemistry in the nineteenth century.

Nectar
A sugary substance produced in many flowers to attract pollinating insects.

Ornamental
A plant grown for its attractive appearance rather than for its medicinal or other uses.

Panicle
A many-branched inflorescence, or cluster of flowers on a stem. The branches of a panicle are often racemes, where a single flower is borne on a short stalk.

Perennial
A plant that lives for many years; the term is frequently used in association with herbaceous plants that die back to a rootstock every winter.

Pinnate
Describes a leaf consisting of several smaller leaflets arranged along a central midrib or leaf stalk. The leaflets are either opposite or alternate to one another along the midrib.

Plant-hunter
Someone who acquires or collects plant specimens for the purposes of research or cultivation, or as a hobby. Plant specimens may be kept alive, but they are more commonly dried and pressed to preserve their quality.

Pollarded
Describes a tree that has had its upper branches cut off, sometimes nearly to the trunk, in order to promote new, dense growth. This method of pruning keeps trees and shrubs at a smaller-than-natural size.

Pollen
Fine, powdery microscopic grains that are released by flowers' male organs and can fertilize other flowers' female organs.

Pollination
The means by which fertilization occurs in flowers. Pollen is carried by the wind or transported from flower to flower by insects (and, more rarely, birds and animals), which deposit it on the receptive stigmas.

Propagate
To reproduce a plant either from seed (sexual reproduction) or by taking cuttings, pegging down branches as layers, dividing plants or making grafts (asexual).

Resin
A sticky organic substance secreted by some plants, notably pine and fir trees. Resin deters foragers and lowers the freezing point of water in the plant, thereby maintaining life in extremely cold conditions. Resin also acts to reduce water loss in hot and dry conditions.

Sap
A life-maintaining fluid in a plant's stem and leaves, consisting of water, minerals and sugar.

SEM micrograph
A digital image from a scanning electron microscope, which scans the object using a beam of electrons.

Shrub
A woody plant that is shorter than a tree such as a bush.

Species
The basic unit of plant and animal classification within a **genus**. It is written in binomial classification with a lower-case letter, as in *Cyclamen libanoticum*. Species share close genetic relationships, but those that encompass a large geographic range may be further divided based on very minor characteristics such as size, leaf shape or flower colour. Such changes can be called **subspecies** (abbreviated to subsp., usually occurring in geographically isolated populations), **varieties** (var., usually within one population) or formae (f., very minor variation within a population).

Spore
A reproductive cell that enables primitive plants to reproduce. In some ways equivalent to pollen, spores are usually carried by wind and occasionally by water.

Stamen
The male organ of a flower, consisting of the filament stalk, anther (pollen-bearing structure) and pollen.

Subspecies
A group of plants that genetically belong within a **species** but have characteristics that make them distinct from it in minor ways. Subspecies are usually found as geographically isolated variants. For example, all primroses, *Primula vulgaris*, in western Europe have yellow or white flowers, but in Turkey all *Primula vulgaris* subsp. *sibthorpii* have pink or lilac flowers.

Further Reading

Succulent
A plant with swollen water-bearing stems and/or leaves that occurs naturally in desert regions in order to conserve water such as the cactus, Pachypodium or many euphorbias.

Sucker
To produce running underground stems from which a plant can reproduce by sending up new shoots that produce roots as they extend. The term is also used for the shoots themselves.

Taxonomy
The scientific study of classifying and naming plants.

Topiary
The art of clipping **evergreen** plants, such as box and yew, into geometric, abstract or figurative shapes.

Variety
A minor variant within a species that occurs naturally in the wild, for example, *Primula denticulata*, which has lilac flowers, and *Primula denticulata* var. *alba*, which has white flowers. The term usually refers to plants within a population that differ in one or two small ways from the typical species.

Vellum
A smooth material for writing on, made from animal skin.

Woodblock
A piece of wood engraved in relief and used for printing an image, typically called a woodcut print.

Adams, Max. *Trees of Life*. London: Head of Zeus, 2019.

Barnes, Martin. *Into the Woods: Trees in Photography*. London: Thames & Hudson, 2019.

Beresford-Kroeger, Diana. *Arboretum America: A Philosophy of the Forest*. Ann Arbor, Michigan: University of Michigan, 2003.

Beresford-Kroeger, Diana. *Arboretum Borealis: A Lifeline of the Planet*. Ann Arbor, Michigan: University of Michigan, 2010.

Beresford-Kroeger, Diana. *The Global Forest*. New York: Viking, 2010.

Beresford-Kroeger, Diana. To *Speak for the Trees: My Life's Journey from Ancient Celtic Wisdom to a Healing Vision of the Forest*. Toronto: Random House Canada, 2019.

Blunt, Wilfrid and William T. Stearn. *The Art of Botanical Illustration*. Suffolk: ACC Art Books, 2015.

Bynum, Helen and William Bynum. *Remarkable Plants That Shape Our World*. London: Thames & Hudson, 2014.

Cave, Roderick. *Impressions of Nature: A History of Nature Printing*. London: British Library, 2010.

Cook, Diane and Len Jenshel. *Wise Trees*. New York. Abrams, 2017.

DK. *The Tree Book: The Stories, Science, and History of Trees*. London: DK, 2022.

Drori, Jonathan and Lucille Clerc. *Around the World in 80 Trees*. London: Laurence King, 2018.

Fondation Cartier pour l'Art Contemporain. *Trees*. Paris: Fondation Cartier pour l'Art Contemporain, 2019.

Fry, Carolyn and Kathy Willis. *Plants: From Roots to Riches*. London: John Murray Press, 2015.

Gardiner, Jim, Barbara Oozeerally and Stephen A Spongberg. *Magnolias in Art & Cultivation*. London: Kew Publishing, 2014.

Harrison, Christina and Tony Kirkham. *Remarkable Trees*. London: Thames & Hudson, 2019.

Hobbs, Kevin and David West. *The Story of Trees and How They Changed the Way We Live*. London: Laurence King, 2020.

Kirkham, Tony and Katie Scott with the Royal Botanic Gardens, Kew. *Arboretum: Welcome to the Museum*. London: Big Picture Press, 2023.

Lowman, Meg. *The Arbornaut: A Life Discovering the Eighth Continent in the Trees Above Us*. New York: Farrar, Strauss and Giroux, 2021.

Moon, Beth. *Ancient Trees: Portraits of Time*. New York: Abbeville Press, 2014.

Pakenham, Thomas. *Remarkable Trees of the World*. London: Weidenfeld & Nicolson, 2003.

Pavord, Anna. *The Naming of Names: The Search for Order in the World of Plants*. London: Bloomsbury, 2005.

Phaidon Editors, with an introduction by Dr James Compton. *Plant: Exploring the Botanical World*. London and New York: Phaidon, 2016.

Phaidon Editors, with an introduction by Anna Pavord. *Flower: Exploring the World in Bloom*. London and New York: Phaidon, 2020.

Phaidon Editors, with an introduction by Matthew Biggs. *Garden: Exploring the Horticultural World*. London and New York: Phaidon, 2023.

Powers, Richard. *The Overstory: A Novel*. New York: W. W. Norton & Company, 2018.

Rix, Martyn. T*he Golden Age of Botanical Art*. London: Andre Deutsch, 2018.

Royal Botanic Gardens, Kew. *Marianne North: The Kew Collection*. London: Royal Botanic Gardens, Kew, 2018.

Saunders, Gill. *Picturing Plants: An Analytical History of Botanical Illustration*. London: KWS, 2009.

Smith, Paul. *Trees: From Root to Leaf*. London: Thames & Hudson, 2022.

Watkins, Charles. *Trees in Art*. London: Reaktion Books, 2018.

Wohlleben, Peter. *The Hidden Life of Trees: The Illustrated Edition*. London: Weidenfeld & Nicolson, 2018.

Wolfe, Art and Gregory McNamee. *Trees: Between Heaven and Earth*. San Rafael, California: Earth Aware Editions, 2018.

Yamanaka, Masumi, Christina Harrison and Martyn Rix. *Treasured Trees*. London: Kew Publishing, 2015.

Index

Publisher's Acknowledgements

A project of this size requires the commitment, advice and expertise of many people. We are particularly indebted to our international advisory panel for their vital contribution to the shaping of this book and their exhaustive, passion and advice in the selection of the works for inclusion:

Dr Giovanni Aloi
Author, editor, curator and
Associate Professor, School
of the Art Institute of Chicago

Dr Preston Bautista
Vice President of Learning and
Engagement, The Morton Arboretum,
Lisle, Illinois

Dr Diana Beresford-Kroeger
Author, medical biochemist
and botanist, Ontario, Canada

Fred Breglia
Big tree hunter and advocate and
Executive Director, Landis Arboretum,
Schoharie County, New York

Casey Clapp
Arborist, dendrologist and cohost,
Completely Arbortrary podcast,
Portland, Oregon

Jim Gardiner, VMH
Former Director of Horticulture of the
Royal Horticultural Society (RHS) and
Curator of RHS Garden Wisley, UK

Dr Andrew Hirons
Senior Lecturer in Arboriculture and
Urban Forestry, University Centre
Myerscough, UK

Tony Kirkham
Former Head of Arboretum, Gardens
and Horticultural Services at the Royal
Botanic Gardens, Kew, London

Margaret D. Lowman, PhD
Executive Director, TREE Foundation
and National Geographic Explorer,
Sarasota, Florida

Carlos Nobre, PhD
Senior Researcher, University of
São Paulo's Institute for Advanced
Studies and Co-Chair, Science Panel
for the Amazon, Brazil

John Parker
Chief Executive Officer, Arboricultural
Association, UK

Anna Pavord
Gardener and author of *The Tulip*,
The Naming of Names and *The
Seasonal Gardener*, Dorset, UK

Christiana Payne
Professor Emerita of History of Art,
Oxford Brookes University, UK

We are particularly grateful to Sara Bader and Rosie Pickles for researching and compiling the long list of entries for inclusion. Additional thanks are due to Rosie Pickles and Jen Veall for their picture research, Laine Morreau and Anita Croy for their editorial support, and to Caitlin Arnell Argles, Theresa Bebbington, Vanessa Bird, Olivia Clark, Diane Fortenberry, João Mota, Elizabeth O'Rourke, Jules Spector and Hans Stofregen for their invaluable assistance.

Finally, we would like to thank all the artists, illustrators, photographers, collectors, libraries, institutions and museums who have given us permission to include their images.

Text Credits

The publisher is grateful to Tony Kirkham for writing the introduction, Carolyn Fry for writing the timeline and additional thanks go to the following writers for their texts:

Giovanni Aloi: 12–13, 20, 33, 34, 42, 47, 50, 60, 64, 89, 98, 109, 112, 116, 125, 128, 139, 140, 145, 148–49, 156, 166, 171, 174, 182, 184, 194–95, 197, 219, 223, 226, 239, 252, 283, 289, 294, 301, 305, 326; **Matthew Biggs:** 36, 51, 61, 65, 93, 99, 127, 130, 150, 152, 161–62, 175, 214, 220, 235, 250, 274, 277, 293, 298; **Casey Clapp:** 22, 80, 151, 236, 242, 248, 308, 318; **James Compton:** 281; **Tim Cooke:** 41, 49, 54, 63, 68, 90, 96, 102, 106–7, 141, 155, 158, 163–64, 177, 215, 224, 228, 240, 244, 254, 269, 275, 278, 309, 319, 322; **Anita Croy:** 21, 28–29, 39, 43, 45, 62, 67, 69, 73–74, 76, 82, 92, 101, 111, 119, 121, 123–24, 133, 135–37, 143, 154, 157, 165, 167, 169, 170, 173, 179–80, 183, 187, 190–92, 196, 199, 204, 209, 211–12, 216, 221, 225, 229–30, 233, 249, 251, 253, 255, 257, 259–60, 268, 276, 279, 285, 290–92, 295, 297, 299, 300, 304, 311, 317, 321, 328–29, 332, 333; **Diane Fortenberry:** 24, 26–27, 31, 37, 52–53, 58–59, 66, 77, 83, 97, 178, 188, 198, 202, 206, 217, 227, 243, 262, 264–65, 286, 296, 303, 307, 312, 320; **Tom Furness:** 16, 114, 314, 327; **Carolyn Fry:** 85, 122, 201, 232, 234, 306; **Jim Gardiner:** 30, 48, 71, 86, 142, 247, 267, 272, 331; **Paula McWaters:** 113; **Rebecca Morrill:** 87, 147, 210; **John Parker:** 35, 46, 203, 237; **Christiana Payne:** 11, 18, 32, 38, 88, 105, 172, 185, 246, 261, 313, 323; **James Smith:** 15, 44, 55, 75, 134, 189, 200, 218, 258, 270, 316; **David Trigg:** 25, 56–57, 78–79, 84, 91, 103, 108, 110, 115, 117–18, 120, 129, 132, 144, 153, 159, 181, 186, 193, 207, 213, 222, 241, 266, 271, 273, 284, 287, 310, 324–25; and **Martin Walters:** 10, 17, 19, 23, 81, 94–95, 104, 126, 131, 146, 160, 168, 205, 208, 231, 245, 256, 263, 280, 282, 288, 315, 330.

Picture Credits

Nazar Abbas Photography: 80; © Aberdeen City Council/Archives, Gallery & Museums Collection: 93; © ADAGP, Paris and DACS, London 2024/© Minneapolis Institute of Art/Gift of Marguerite and Russell Cowles in memory of his uncle Russell Cowles/Bridgeman Images: 166; © ADAGP, Paris and DACS, London 2024/Purchase, Anonymous Gift, 1986. (1986.298)/Photo: Mark Darley/Metropolitan Museum of Art/Art Resource/Scala, Florence: 84; © Ansel Adams Publishing Rights Trust/Photo: Center for Creative Photography: 43; Courtesy Hilma af Klint Foundation/Photo: Moderna Museet-Stockholm: 197; © Aga Khan Museum: 316; © Takanori Aiba: 45; akg-images: 330; akg-images/Mörchel-Hartmann: 230; Collection of Akron Art Museum, gift of George Stephanopoulos 2006.300: 102; Album/Scala, Florence: 34, 148; Beverly Allen: 319; © Efacio Álvarez, Collection of Verena Regehr-Gerber, Chaco, Paraguay: 128; © Amon Carter Museum of American Art, Fort Worth, Texas: 262; © Aperture Foundation, Inc., Paul Strand Archive: 295; Image from Archive.org/Contributed by Getty Research Institute: 119; Image from Archive.org/Contributed by University of Connecticut Libraries: 114; © ARS, NY 2024/Photo Schalkwijk/Art Resource/Scala, Florence: 47; © ARS, NY and DACS, London 2024: 67, 76; © ARS, NY and DACS, London 2024/Christie's Images, London/Scala, Florence: 207; Artefact/Alamy Stock Photo: 28, 184; ARTGEN/Alamy Stock Photo: 152; © Yann Arthus-Bertrand: 266; Art Institute of Chicago/Kate S. Buckingham Endowment: 97; Art Institute of Chicago/Bequest of William McCormick Blair: 17; Ashmolean Museum/Bridgeman Images: 177; Christi Belcourt: 20; © Benaki Museum/Bridgeman Images: 59; © Joseph Beuys/DACS 2024/Photo: Bill Jacobson Studio, New York, courtesy Dia Art Foundation, New York: 223; © Estate of Ilse Bing/Courtesy Cleveland Museum of Art, Gift of George Stephanopoulos 2014.525: 260; Ira Block: 321; Photo © Bodleian Libraries, University of Oxford: 201; © Enid Blyton 1943/Reproduced with permission of the Licensor through PLSclear/Photo: Jonkers Rare Books: 317; Courtesy Marinus Boezem and Upstream Gallery Amsterdam/Photo by Vincent Wigbels: 241; Althea Braithwaite/The National Trust: 249; Bridgeman Images: 32, 178, 180; British Library Archive/Bridgeman Images: 269; © British Library Board, All Rights Reserved/Bridgeman Images: 10, 52, 258, 263, 272; British Library Board/Scala, Florence: 53, 254; © Trustees of the British Museum: 137, 140, 265, 323; © Edward Burtynsky/Courtesy Nicholas Metivier Gallery, Toronto: 242; Reproduced by permission of the Syndics of Cambridge University Library: 106; Courtesy Cape Fear Museum of History and Science, Wilmington, NC: 253; © Fondation Henri Cartier-Bresson/Magnum Photos: 195; Courtesy Jordan Casteel and Casey Kaplan, New York/The Nancy A. Nasher and David J. Haemisegger Collection: 280; *Wangari Maathai: The Woman Who Planted Millions of Trees.* Translation copyright © 2015 by Charlesbridge Publishing. Translated by Dominique Clément, French Cultural Center of Boston. Copyright © 2011 Rue du monde. First published in France in 2012 by Éditions Rue du monde, 5 rue de Port-Royal, 78960 Voisins-le-Bretonneux, France, as *Wangari Maathai, la femme qui plantait des millions d'arbres* by Franck Prévot and Aurélia Fronty. Used with permission by Charlesbridge Publishing, Inc. 9 Galen Street, Suite 220, Watertown, MA 02472, (617) 926-0329, www.charlesbridge.com. All rights reserved: 135; © Archives Charmet/Bridgeman Images: 110; © Collections Chaumet: 169; Thornton Dial Estate/Christie's Images, London/Scala, Florence: 41, 277, 329; Cooper Hewitt, Smithsonian Design Museum/Gift of Marian Hague, 1959-144-1: 311; Cornell University Library: 168; Photo: Michael Richter: 325; Crown Copyright and database right (2024)/Ordnance Survey 100032216 GLA/London Tree Officers Association/Transport for London: 192; Courtesy Nici Cumpston and Michael Reid Gallery: 239; Curtis, P.G., C.M. Slay, N.L. Harris, A. Tyukavina, and M.C. Hansen. 2018. 'Classifying Drivers of Global Forest Loss.' Science; Google Satellite Basemap. Google image acquired on January 4, 2024. Accessed through Global Forest Watch on 04/01/2024. www.globalforestwatch.org: 240; © Salvador Dalí, Fundació Gala-Salvador Dalí, DACS 2024/Morohashi Museum of Modern Art: 194; Image courtesy Dallas Museum of Art: 291; DeAgostini Picture Library/Scala, Florence: 209; Courtesy Tacita Dean, Frith Street Gallery, London and Marian Goodman Gallery, New York/Paris/Los Angeles: 247; © Agnes Denes/Courtesy Leslie Tonkonow Artworks + Projects: 305; Kieran Dodds/Panos Pictures: 161; Gokhan Dogan/Alamy Stock Photo: 312; Economic Botany Collection, Kew: 235; © Guy Edwardes/naturepl.com: 292; Alfred Eisenstaedt/The LIFE Picture Collection/Shutterstock: 252; © 2017 Olafur Eliasson/Courtesy the artist; neugerriemschneider, Berlin; Tanya Bonakdar Gallery, New York/Los Angeles/Photo: David von Becker/Installation view: Hamburger Bahnhof Museum, Berlin, 2017: 56; © Ibrahim El-Salahi, Courtesy Vigo Gallery. All rights reserved, DACS 2024/Image Courtesy Vigo Gallery and the Artist: 129; © Walker Evans Archive, Metropolitan Museum of Art/Art Resource/Scala, Florence: 268; Fine Art Images/Heritage Image Partnership Ltd./Alamy Stock Photo: 105, 139, 246; Courtesy Raffaella and Tobia Fletcher: 283; © Florence Griswold Museum/Gift of the Hartford Steam Boiler Inspection & Insurance Co./Bridgeman Images: 155; © Stuart Franklin/Magnum Photo: 12; © Charles Gaines/Courtesy the artist and Hauser & Wirth/Photo: Jeff McLane: 108; © Anya Gallaccio. All Rights Reserved, DACS 2024: 182; Created by Robert Games and based on original artwork by Terry Thomas/Photo: George Hall/Alamy Stock Photo: 175; Simon Garbutt: 214; © 2008 Kenneth Garrett, all rights reserved: 234; Estate Georg Gerster, Switzerland, www.GeorgGerster.com: 96; © Bryan Nash Gill: 289; Dimitar Glavinov/Alamy Stock Photo: 73; Courtesy Shyama Golden: 124; © Andy Goldsworthy/Courtesy Galerie Lelong & Co.: 57; John Grade: 159; © Rodney Graham/Courtesy the artist and Hauser & Wirth/Photo © Metropolitan Museum of Art/Art Resource/Scala, Florence: 132; © Grandma Moses Properties Co/Bridgeman Image/Digital image: Art Institute of Chicago/Art

Resource, NY/Scala, Florence: 314; Granger Historical Picture Archive/Alamy Stock Photo: 290; Steve Gschmeissner/Science Photo Library: 63; © Laure Albin Guillot/Gift of Alan Siegel. Acc. no.: 1580.2001.8/Digital image, Museum of Modern Art, New York/Scala, Florence: 278; © Hulda Guzmán/Courtesy the artist; Alexander Berggruen, New York; and Stephen Friedman Gallery: 120; Susana Guzman/Alamy Stock Photo: 77; © Francis Hallé: 191; © Francis Hamel. All Rights Reserved 2023/Bridgeman Images: 205; Keith Haring artwork © Keith Haring Foundation: 64; © President and Fellows of Harvard College, Arnold Arboretum Archives: 236; Harvard Forest Archives: 245; Heatherwick Studio/Mir: 193; Hemmerle, Maximilianstrasse 14, 80539, Munich, +49 89 24 22 600, hemmerle.com: 199; © Estate of Keith Henderson/Image © Manchester Art Gallery/Bridgeman Images: 244; Higashiyama Kaii, *Autumn Colours*, Colour on Paper, 1986/Yamatane Museum of Art: 228; © Estate of Paul Tristram Hillier. All rights reserved 2023/Bridgeman Images/Ingram Collection of Modern & Contemporary British Art: 324; © Damien Hirst and Science Ltd. All rights reserved, DACS/Artimage 2023/Photo: Prudence Cuming Associates Ltd: 210; © Asuka Hishiki: 221; Courtesy Historic New England: 154; © David Hockney/Photo: Richard Schmidt/Centre Pompidou, Paris/Musée national d'art moderne – Centre de création industrielle: 15; © Indianapolis Museum of Art/John Herron Fund/Bridgeman Images: 141; © Jason Ingram: 279; iStock.com/ZU_09: 284; Jacques Jangoux/Science Photo Library: 156; John Carter Brown Library/Biodiversity Heritage Library: 232; The June Leaf and Robert Frank Foundation/Digital image: Museum of Modern Art, New York/Scala, Florence: 99; Ilonka Karasz Collection: 29; © Alex Katz/VAGA at ARS, NY and DACS, London 2024/Photo: Tate: 332; Keir Collection of Islamic Art on loan to the Dallas Museum of Art, K.1.2014.653/Photo © The Dallas Museum of Art: 31; © Michael Kenna; Courtesy William Kentridge and Private collection: 204; © Estate of André Kertész, courtesy Stephen Bulger Gallery/Gift of Harriette and Noel Levine, 1981 (1981.1112.3)/Image: Metropolitan Museum of Art/Art Resource/Scala, Florence: 170; © Bharti Kher, courtesy the artist and Hauser & Wirth/Photo: Stefan Altenburger Photography, Zürich: 55; Client: Kirin Brewery Company: 62; © Yayoi Kusama/Photo © Robert Benson Photography: 33; Kutschera, L. & Lichtenegger, E., Wurzelatlas mitteleuropäischer Waldbäume und Sträucher, Graz: Leopold Stocker Verlag, 2002 (2nd ed. 2013): 111; Cover image of The Ladybird Book of Trees © Ladybird Books Ltd. 1963: 276; © Wolfgang Laib/Digital image, Museum of Modern Art, New York/Scala, Florence: 162; © Tim Laman/naturepl.com: 146; © Myoung Ho Lee/Courtesy Yossi Milo, New York: 75; © Leonardo da Vinci, Carnet M. Bibliothèque de l'Institut, Ms 2183 f.78 verso-79 recto: 134; Map reproduction courtesy Norman B. Leventhal Map & Education Center, Boston Public Library: 104; Library of Congress, Prints & Photographs Division, LC-DIG-pga-03140: 150; © Estate of Russell Limbach/Digital image: Whitney Museum of American Art/Licensed by Scala: 92; © Maya Lin Studio, courtesy Pace Gallery/Photo: Andy Romer, Courtesy MSPC: 90; Lloyd Library and Museum/Public Library of Cincinnati and Hamilton County/Biodiversity Heritage Library: 30; Lottas Trees/Lottas Träd: 107; Photo © Maas Gallery, London/Bridgeman Images: 172; Artist: Azuma Makoto/Photographer: Shinoki Shunsuke/AMKK: 220; © Sally Mann/Courtesy the artist and Gagosian: 44; © Kerry James Marshall/Courtesy the artist and David Zwirner London: 72; Mary Evans Picture Library Ltd./Minos Collection: 206; © Akihisa Masuda: 44; Aliaksandr Mazurkevich/Alamy Stock Photo: 271; © Steve McCurry/Magnum Photos: 51; Estate of Rory McEwen: 309; © Alexander McQueen/Victoria and Albert Museum, London: 143; © Estate of Margaret Mee and the Board of Trustees of the Royal Botanic Gardens, Kew: 122; Mehrangarh Museum Trust, Jodhpur, Rajasthan, India and His Highness Maharaja Gaj Singh of Jodhpur: 212; Maarten Mensink/500px Unreleased/Getty Images: 142; Metropolitan Museum of Art/Art Resource/Scala, Florence: 313; Metropolitan Museum of Art/Gift of Carole and Irwin Lainoff, Ruth P. Lasser and Joseph R. Lasser, Mr. and Mrs. John T. Marvin, Martin E. and Joan Messinger, Richard L. Yett and Sheri and Paul Siegel, 1986: 60; Metropolitan Museum of Art/Purchase, Anonymous gift in memory of Frits Markus; Harris Brisbane Dick Fund, and Joseph Pulitzer Bequest, 1999: 218; Metropolitan Museum of Art/Rogers Fund, 1930: 27; Metropolitan Museum of Art/Rogers Fund, 1957: 224; Metropolitan Museum of Art/Bequest of Alexandrine Sinsheimer, 1958: 275; Metropolitan Museum of Art/Purchase, Tomoko Trust, The Robert and Joyce Menschel Family Foundation and Josephine L. Berger-Nadler Gifts, 2018: 211; Metropolitan Museum of Art/Gift of Robert Tuggle, 2007: 121; MGM/Warner Bros. Promotional Image: 183; Garry Fabian Miller: 78; Courtesy Ministero Beni e Att. Culturali e del Turismo/Photo Scala, Florence: 198; Minneapolis Institute of Art: 48, 299; Minneapolis Institute of Art/Gift of Elizabeth and Willard Clark: 136; Minneapolis Institute of Art/Gift of Ruth and Bruce Dayton: 259; Missouri Botanical Garden, Peter H. Raven Library/Biodiversity Heritage Library: 293; Missouri Botanical Garden/Biodiversity Heritage Library: 158; © Mondrian/© Kunstmuseum den Haag/Holtzman Trust/Bridgeman Images: 68; Beth Moon: 144; Morgan Library & Museum/Art Resource, NY/Scala, Florence: 66; Rosanna Morris: 273; Morton Arboretum: 115; *The Root* by Delfina Mun: 219; © Musée Condé, Chantilly/Bridgeman Images: 46; Digital image: Museum of Modern Art, New York/Scala, Florence: 74; Museum of Modern Art, New York, Latin American and Caribbean Fund and gift of Ronnie Heyman, 2022/Photo courtesy Maria Magdalena Campos-Pons and Gallery Wendi Norris, San Francisco: 49; Museum of Modern Art, New York/Mrs. John Hay Whitney Bequest. 581.1998/Scala, Florence: 11; © Wangechi Mutu: 326; © Namatjira Legacy Trust/DACS 2024/National Gallery of Victoria, Melbourne/Presented through The Art Foundation of Victoria in memory of Emmanuel and Kamilla Mandl by Mrs Lisl Singer, Member, 1999/1999.196: 81; Courtesy David Nash/Photo © Jonty Wilde: 112; Nasjonalmuseet for kunst, arkitektur og design, Fine Art Collections: 174; © National Gallery, London/Scala, Florence: 88; Natural History Museum/Alamy Stock Photo: 26, 298; © Natural History

Museum, London/Bridgeman Images: 24, 281; National Museum of Korea/Dongwon 2906: 188; Newberry Library, Chicago, General Fund, 1926/Bridgeman Images: 173; New York Public Library, Rare Book Division: 288; Michael Nichols: 151; Courtesy the Lori Nix and Kathleen Gerber: 226; Image Courtesy Ojas Art, New Delhi/Collection: Sarmaya Arts Foundation, Mumbai: 145; © Georgia O'Keeffe Museum/DACS 2024/Courtesy Barbara B. Millhouse and Reynolda House Museum of American Art, affiliated with Wake Forest University, Winston-Salem, North Carolina: 261; Nature print by Pia Östlund, www.ostlundindustries.com: 23; © Trevor Paglen/Courtesy the artist and Pace Gallery: 25; © Katie Paterson: 251; Pejepscot History Center: 95; Courtesy Giuseppe Penone © ADAGP, Paris and DACS, London 2024/Photo: Eric Sander for the Domaine of Chaumont-sur-Loire: 149; Penta Springs Limited/Alamy Stock Photo: 131; Philadelphia Museum of Art/Gift of Stella Kramrisch, 1969: 21; © Succession Picasso/DACS, London 2024/Photo: Scala, Florence: 294; Pictures Now/Alamy Stock Photo: 103; © David Pillow/Dreamstime.com/ID 254189642: 202; Cédric Pollet: 308; © Paul Polydorou. All rights reserved 2023/Bridgeman Images: 203; Power and Syred/Science Photo Library: 163; The Print Collector/Print Collector/Getty Images: 310; Public domain: 39, 186, 229, 233, 243; Photo © Zev Radovan/Bridgeman Images: 307; Ranger Doug's Enterprises: 160; Dietmar Rauscher/Alamy Stock Photo: 255; RealityImages: 320; Realy Easy Star/Toni Spagone/Alamy Stock Photo: 287; Joe Rey/Alamy Stock Photo: 61; RHS Lindley Collections: 82; © Faith Ringgold/ARS, NY and DACS, London/Courtesy the artist and ACA Galleries, New York 2024: 171; RMN-Grand Palais/Jean-Gilles Berizzi/RMN-GP/Dist./Photo: Scala, Florence: 296; RMN-Grand Palais/Georges Poncet/RMN-GP/Dist./Photo: Scala, Florence: 286; Courtesy Abel Rodríguez (Mogaje Guihu) and Instituto de Visión/Photo: María Paula Bastidas: 147; © Vera Röhm/© DACS 2024/Photo: Octavian Beldiman: 179; Ghigo Roli/Bridgeman Images: 58; Courtesy Ugo Rondinone and Esther Schipper Berlin/Paris/Seoul: 42; © Pamela Rosenkranz/Courtesy the High Line, Karma International, Miguel Abreu Gallery and Sprüth Magers/Photo: Timothy Schenck: 109; © Board of Trustees of the Royal Botanic Gardens, Kew: 85, 256, 306; © Royal Institution/Bridgeman Images: 225; © The Royal Society: 322; © Ursula von Rydingsvard/Courtesy Galerie Lelong & Co. Storm King Art Center Archives: 87; © Sebastião Salgado/nbpictures.com: 285; © Tomas Sanchez, *Aislarse*, 2001: 126; © Joel Sartore/Photo Ark: 13; SBS Eclectic Images/Alamy Stock Photo: 274; Photo: Scala, Florence/Luciano Romano: 185; Courtesy Maison Schiaparelli: 133; Carré INDEX PALMARUM, dessin de Katie Scott © Hermès Paris, 2024: 328; From the collection of Sharon Sekhon and Bob Drwila: 164; © Eric Serritella/Photo: Jason Dowdle: 157; Book Cover from THE LORAX by Dr. Seuss, ® and copyright © by Dr. Seuss Enterprises, L.P. 1971, renewed 1999. Used by permission of Random House Children's Books, a division of Penguin Random House LLC. All rights reserved: 65; © Laila Shawa. All Rights Reserved 2023/Bridgeman Images: 190; Shawshots/Alamy Stock Photo: 248; Illustration from Winnie-the-Pooh by A.A. Milne © The Shepard Trust 1926, Reproduced with permissions from Curtis Brown Group Ltd on behalf of The Shepard Trust: 153; Shirley Sherwood Collection: 231; Shirley Sherwood Collection: 300; Courtesy Tal Shochat and Rosenfeld Gallery, Tel Aviv: 101; Art by Bhajju Shyam for The Night Life of Trees, Original Edition/© Tara Books Pvt Ltd.: 216; © David Allen Sibley and Scott & Nix, Inc.: 22; Courtesy Taryn Simon: 50; © Pamela Singh/Courtesy sepiaEYE, New York: 213; Smithsonian American Art Museum, Washington DC/Gift of Fleur S. Bresler, 2021.48.4/Scala, Florence. Reprinted with permission of SAAM and the artist, Kay Sekimachi: 79; Smithsonian American Art Museum, Washington DC/Gift of Mary Vaux Walcott: 315; Sorigue Foundation: 331; Oscar Martin Soteno Elias: 165; Sotheby's: 189; Sotheby's and Eskenazi Ltd: 217; SP Lohia Hand Coloured Rare Book Collection: 257; State Library of New South Wales: 318; steeve-x-art/Alamy Stock Photo: 264; Courtesy Jennifer Steinkamp and Lehmann Maupin, New York, Hong Kong, Seoul, and London: 304; Mac Stone: 327; Shota Suzuki: 333; © Alison Elizabeth Taylor: 118; teamLab, *Resonating Trees*, 2014, Interactive Digitized Nature, Sound: Hideaki Takahashi/© teamLab, courtesy Pace Gallery: 130; Alister Thorpe: 94; © Tjanpi Desert Weavers, NPY Women's Council/Image courtesy the artists and Museum of Contemporary Art Australia/Photo: Jessica Maurer: 125; Design and idea: Niklaus Troxler: 250; © Estate of Yoho Tsuda, courtesy the Naniwa Photography Club and MEM/Photo © Gift of the artist, 1980/Metropolitan Museum of Art/Art Resource/Scala, Florence: 36; Photo: Mike Tucker/www.zimfieldguide.com: 68; University of British Columbia Library/Biodiversity Heritage Library: 215; University of California/Courtesy HathiTrust: 187; The name and character of Smokey Bear are the property of the United States, as provided by 16 U.S.C. 580p-1 and are used with the permission of the Forest Service, US Department of Agriculture/Image Courtesy Chisholm-Larsson Gallery, New York: 117; © Tom Uttech, courtesy Alexandre Gallery, New York/The New Orleans Museum of Art: Museum purchase, Maya and James Brace Fund, 2004.29: 116; Courtesy Sam Van Aken Studio: 200; Courtesy Iris van Herpen/Photo: Bart Oomes: 297; © Cassio Vasconcellos, all rights reserved 2023/Bridgeman Images: 123; © Victoria and Albert Museum, London: 38; © Virginia Museum of Fine Arts/Gift of Ms. Sophie Black. Acc. no.: 120.1985.3/Museum of Modern Art, New York/Scala, Florence: 222; © Tim Walker Studio: 167; Waseda University Library: 301; © Archibald Bertram Webb/Image © Manchester Art Gallery/Bridgeman Images: 19, 282; Courtesy West Collection/Photo: Brica Wilcox: 270; Edward Weston © Center for Creative Photography, University of Arizona Foundation/DACS 2024/Scala, Florence: 86; Dirk Wiersma/Science Photo Library: 54; Wikimedia Commons: 16, 83, 208, 303; Wikimedia Commons/Kevmin: 39; Wikimedia Commons Nicole Wittenberg: 91; World Digital Library: 196; Liu Xiao/Xinhua/Alamy Live News: 267; Yale University Art Gallery/Promised gift of Thomas Jaffe, B.A. 1971: 227; © Masumi Yamanaka: 113; © Joseca Yanomami: 35.